True to Temperament: Van Gogh and French Naturalist Literature is the first book-length study of an acknowledged but neglected aspect of Van Gogh's development as an artist – his fascination with contemporary literature. Charting his reading habits from his youthful interest in the moralizing novels of English writers to the preference for Naturalist literature that characterizes his maturity, Judy Sund elucidates the intimate connection between Van Gogh's reading habits and his development as a visual artist.

Van Gogh considered reading to be "a matter of importance that greatly influences one's work," and though he resolutely avoided the anecdotal and illustrative in his art, his oeuvre is nonetheless marked by his literary pursuits. In this study, Sund reveals the multiple and often subtle ways in which Van Gogh used nonnarrative imagery to evoke beloved texts. Citing primary sources, she demonstrates that Van Gogh considered French literature of the late nineteenth century to be at the forefront of cultural production. Sund further argues that the works and theoretical stances of the writers whom Van Gogh most admired – Zola, Maupassant, Daudet, and the Goncourt brothers – informed his own notions of modernism, by providing a conceptual entrée into the world of the Parisian avant-garde. Thus, Van Gogh's artistic production and predilection for Naturalist prose are shown to be closely linked and mutually reinforcing. This study thus enhances our understanding of artistic *correspondance* in the late nineteenth century and explodes prevailing assumptions by examining the allusive, "Symbolist" dimensions of Naturalist practice.

True to Temperament

True to Temperament

Van Gogh and French Naturalist Literature

Judy Sund

CAMBRIDGE
UNIVERSITY PRESS

Published by the Press Syndicate of the University of Cambridge
The Pitt Building, Trumpington Street, Cambridge CB2 1RP
40 West 20th Street, New York, NY 10011-4211, USA
10 Stamford Road, Oakleigh, Victoria 3166, Australia

First published 1992

Printed in the United States of America

Library of Congress Cataloging-in-Publication Data
Sund, Judy
True to temperament : Van Gogh and French naturalist literature /
Judy Sund.
 p. cm
Includes bibliographical references and index.
ISBN 0-521-41080-0
 1. Gogh, Vincent van, 1853–1890 – Psychology.
 2. French literature – 19th century – Influence.
 3. Naturalism in literature.
 I. Title.
N6953.G63S8 1992
759.9492 – dc20 91–39151

A catalog record for this book is available from the British Library

ISBN 0-521-41080-0 hardback

For my parents, Warren and Patricia Sund

CONTENTS

ILLUSTRATIONS

All artwork is by Van Gogh except where otherwise noted. Color plates appear between pages xiv and 1.

Illustrations

FIGURES

ACKNOWLEDGMENTS

Take this as a work belonging to you and me as a
summary of our months of work together.
— Vincent van Gogh (LT643)

This book began as a dissertation at Columbia University, where it was
supervised by Theodore Reff. Professor Reff's graduate lectures at Columbia
introduced me to the intricacies of Van Gogh's art and thought, and the
seminar he conducted on Symbolism, in the spring of 1977, incited my
particular interest in the myriad interplays of the visual and verbal in nine-
teenth-century art. His work has immeasurably influenced my own, and this
study is deeply indebted to his example, guidance, and support.

Conversations with Meyer Schapiro also helped shape the project in its
earliest stages. I am most grateful to Professor Schapiro for his interest and
encouragement, and I hope that the present text still bears some imprint of
his thoughtful remarks on the work of Maupassant and Daudet.

My dissertation was carefully read and criticized by Allen Staley and
Michael Marrinan. I thank each of them for prodding me to make it better.

This project was supported through its many stages by the generosity of
several institutions. My initial dissertation research was funded by Columbia
University, through both a summer travel grant and a year-long Rudolf
Wittkower Memorial Fellowship. Two more years of research and writing
were financed by the Metropolitan Museum of Art, which awarded me an
Andrew Mellon Fellowship and subsequently renewed it. Later, the text of
the dissertation was expanded and substantially refigured during a junior
research leave from Duke University; additional funding for that year of
research and revision was provided by a grant from the American Council
of Learned Societies. I am most appreciative of all of this assistance.

Portions of Chapters 5 and 6 appeared in my article "Favoured Fictions:
Women and Books in the Art of Van Gogh" (*Art History,* 11 [1988],
pp. 255–67). My thanks to Basil Blackwell Ltd. for allowing me to reproduce
that material.

Throughout the research and writing of this book, Fieke Pabst, docu-
mentalist at the Rijksmuseum Vincent van Gogh, was very giving of her time

and knowledge, and helped me make use of the extensive holdings of that museum's libraries – even from afar. I am equally indebted to numerous colleagues and friends who over the course of this long project offered ideas, criticism, encouragement – and, in some cases, photographic services, archival legwork, and/or home-cooked meals. They include Paul Allen, Ronni Baer, Colin Bailey, Bill Broom, Elizabeth C. Childs, Loïc Couraud, Elizabeth Easton, Suzanne Fox, Peter Galassi, Fred Hamerman, Eloise Quiñones Keber, James Munson, Kirsten Hoving Powell, Aimée Brown Price, Mary Prevo, Marissa Wesely, and Annabel Wharton. I am especially grateful to Mark Roskill, whose erudition and scholarly generosity often seem boundless; his work, as well as his comments on my own, have both nourished and nudged me, and I am deeply grateful for his unstinting collegiality. I am also indebted to my students at Duke University, who challenged and bolstered me in the most unpredictable ways, providing regular and much appreciated doses of both skepticism and partisanship.

I wish to thank Beatrice Rehl, fine arts editor at Cambridge, for her receptiveness to the manuscript, and Michael Gnat for shepherding it through the production process with efficiency, care, and abundant good humor.

Finally, I am grateful to my family, whose belief in this project has sustained me throughout. My parents' financial and emotional contributions have been enormous, and I dedicate this book to them. My husband, Scott Gilbert, has never known me without this Van Gogh manuscript in progress, and he has attended its unfolding with requisite measures of patience, humor, love, and lawyerly nit-picking. His willingness to allow my work to take precedence over the comforts of a more conventional conjugality has been my salvation, and I thank him wholeheartedly.

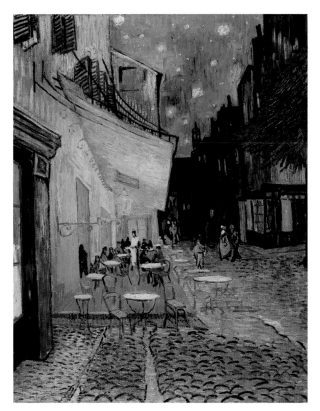

Plate 1. Van Gogh, *Café Terrace at Night*, 1888.

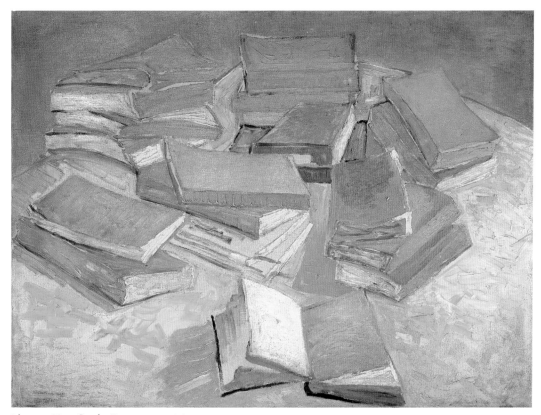

Plate 2. Van Gogh, *Romans parisiens*, 1888.

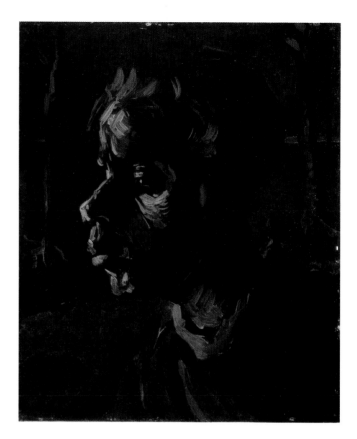

Plate 3. Van Gogh, *Peasant Woman, Head*, 1885.

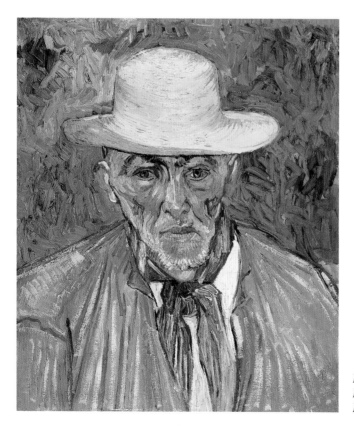

Plate 4. Van Gogh, *Portrait of Patience Escalier, "The Old Peasant,"* 1888.

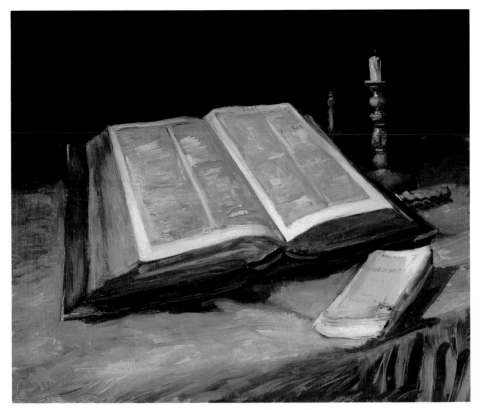

Plate 5. Van Gogh, *Still Life with Bible and French Novel*, 1885.

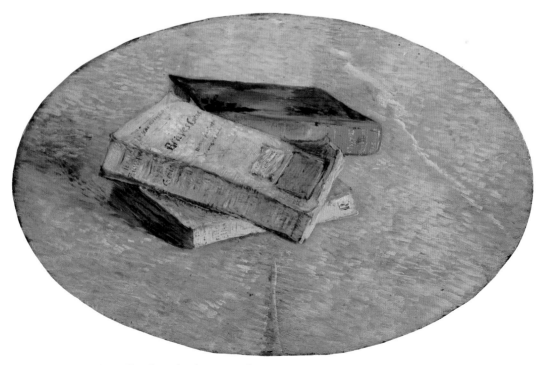

Plate 6. Van Gogh, *Still Life with Three Novels*, 1887.

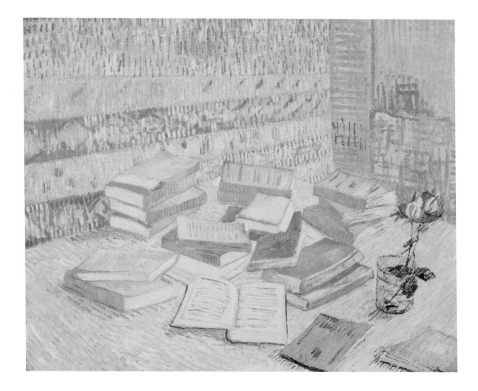

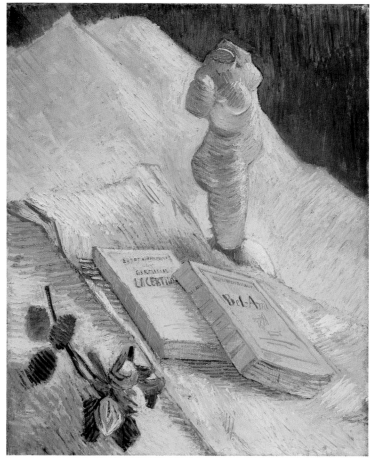

Plate 7 (above). Van Gogh, *Romans parisiens*, 1887.

Plate 8. Van Gogh, *Still Life with Plaster Cast*, 1887–8.

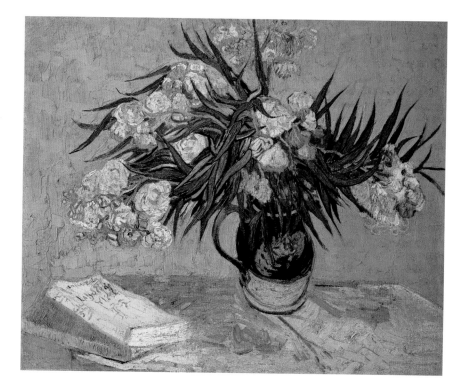

Plate 9 (above). Van Gogh,
Oleanders, 1888.

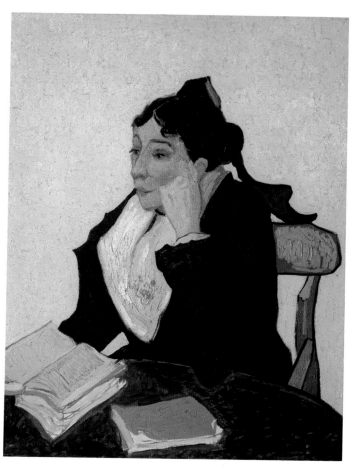

Plate 10. Van Gogh,
L'Arlésienne (Mme. Ginoux),
1888.

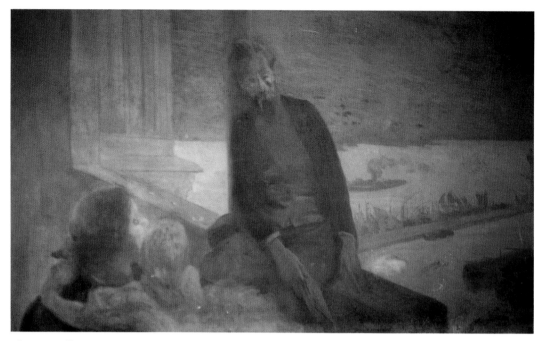

Plate 11. Albert Besnard, detail of *L'Homme moderne* (Fig. 49), 1883.

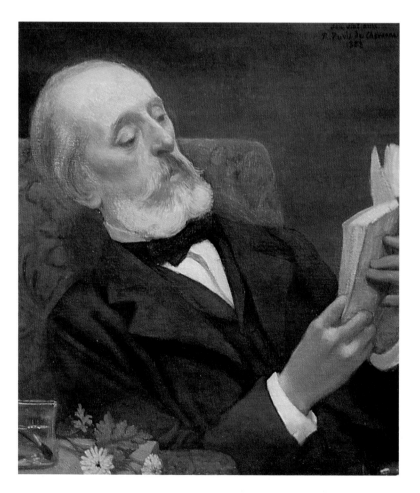

Plate 12. Pierre Puvis de Chavannes, *Portrait of Eugène Benon*, 1882.

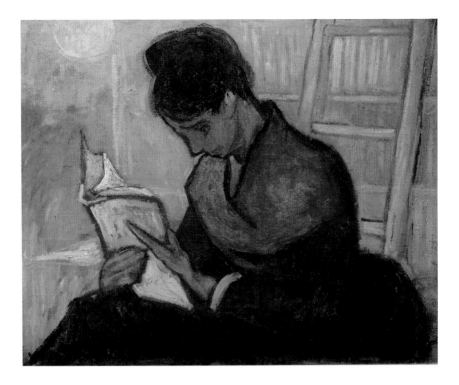

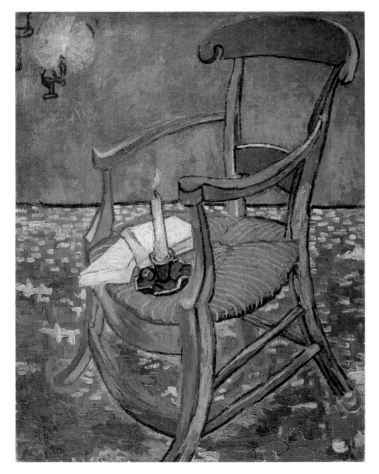

Plate 13 (above). Van Gogh,
Une Liseuse de romans, 1888.

Plate 14. Van Gogh,
Gauguin's Chair, 1888.

Plate 15. Van Gogh, *L'Arlésienne (Mme. Ginoux)*, 1890.

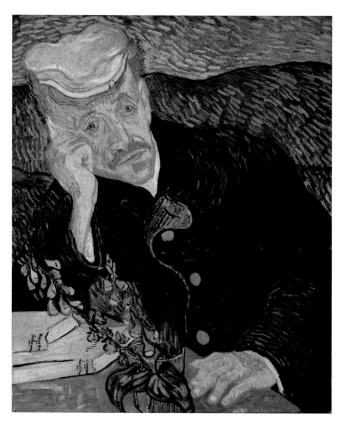

Plate 16. Van Gogh, *Portrait of Dr. Gachet*, 1890.

INTRODUCTION

A late bloomer as nineteenth-century artists go, Vincent van Gogh was almost 30 years old when, in 1882, he began to paint. His suicide at age 37 abruptly ended the brief but prolific career that has been relentlessly romanticized in the hundred years since, and the more sensational aspects of his biography – most especially his struggles with an undetermined nervous disorder[1] – have led many twentieth-century aficionados of his work to presume that Van Gogh's quirky but compelling pictures were products of a headlong plunge into frenzied self-expression. His exceptional production and productivity are ill-served by such supposition, however, for if Van Gogh the artist was consistently adventuresome, he rarely was rash. His work was not so much propelled by excited egoism as it was grounded in and nourished by a sustained study of older and contemporary art and a profound engagement with modern literature. Taking that second component as its focus, this book explores the quality and mutability of the distinctive light that Van Gogh's literary interests cast on his life and subsequent depictions of the world he inhabited; more particularly, it highlights the importance Van Gogh ascribed to French Naturalist literature – a nexus not only of novels, but of personalities and polemic – in the formulation of his art.

It was at Arles in 1888 that Van Gogh, after years of artistic experimentation, finally reached his painter's stride. He had rejected the midcentury Realists' earthy palette and crusty textures in favor of Impressionist and Neo-Impressionist modes of depiction, and his innovative rereading of avantgarde trends in light of a confirmed *japoniste* sensibility resulted in paint surfaces of great animation. Brilliant pigments, fresh from the tube, were laid on in striations and scallops, basket weaves, bricks, and dots as Van Gogh responded to the saturated hues of his Provençal environment and drew on a broad vocabulary of strikingly differentiated brushstrokes to produce the pictures for which he is now best known. Among them are a starlit

street scene known as *Café Terrace at Night* (Plate 1) and a still life with books that the artist titled *Romans parisiens* (Parisian novels) (Plate 2). Each is characteristic of his Arles oeuvre, and as such they are visually resemblant in their prismatic palettes and lively impastoes. In addition, both take as their formal foci the angular play of juxtaposed yellow and orange rectangles – some architectural, others simply architectonic – that bespeak illumination: the physical light of the café scene finds formal echo in the still life, where the metaphoric luminosity of intellectual enlightenment is suggested by the glowing hues of the books' covers.

Less visible but equally significant is these pictures' mutual bond to French Naturalism. Underlying the seeming disparity of their respective subjects – a view of a public space, on the one hand, and a glimpse of the artist's private domain, on the other – was Van Gogh's conviction that each painting reflected the literature that touched his life and shaped his aesthetic. The books of the still life were identified by Van Gogh as novels from his own extensive library of modern French fiction, and their bright paper bindings identify them as the pioneering production of his favorite authors. The night-time townscape, though the rendering of an Arlesian locale painted from life, at the same time struck the artist as the visual equivalent of a verbal image created by Guy de Maupassant in *Bel-Ami* (W7).[2] Underscoring these pictures' thematic ties to literary Naturalism, moreover, is the painter's intent in each to evoke the invigoration he felt on reading Naturalist prose – using formal rather than strictly illustrative means. The pictorial language Van Gogh constructed of bold hues and unprecedented textures was designed to parallel the creative daring he appreciated in his favorite authors; in March 1888, for instance, he wrote, "As you will observe when you read [Emile] Zola and Guy de Maupassant – what they absolutely insist on is a great richness and great gaiety in art . . . [and] this same tendency is beginning to rule the art of painting too" (W3). The chief aim of this study is to make the reader/viewer see and believe in (as Van Gogh himself did) the linkage of individual pictures to Naturalist passages and/or praxis.

Van Gogh's affinity for the written word is both undeniable and under-acknowledged. He was a prolific letter writer whose collected correspondence now fills multiple volumes[3] and a voracious reader who claimed "a more or less irresistible passion for books" (LT133). His letters are replete with references to and appraisals of books and authors; more than two hundred books are mentioned by title,[4] and many others are alluded to in less obvious ways. Scholars have routinely remarked and sporadically studied his wide-ranging readings,[5] but the popular image of Van Gogh as impetuous one-eared madman has been virtually untouched by evidence of his literary sophistication and verbal fluency. The fact that he was one of the best-read painters of his – or any – era remains a well-kept secret, perhaps because

his literary interests had little obvious impact on his art. Though he considered reading "a matter of importance, which greatly influences one's work" (R34), Van Gogh made few direct allusions to texts in his images. Unlike many artists of his time (and of preceding and succeeding generations), he did not look to books for dramatic incident to paint, and in fact rejected that most conventional mode of response to a text. Even as a novice artist interested in contributing to illustrated magazines, Van Gogh disclaimed tradition and saw no reason why images should be – in his words – "literally applicable" to the texts they accompanied (LT253). Thus, this study cannot and will not be an exercise in verbal and visual comparison through formal parallels of telling detail or amorphous narrative/pictorial "structures."[6] Instead, I will establish conceptual linkages between the work of Van Gogh and the French Naturalists, and show that the precepts of the literary movement – especially as outlined by Emile Zola – affirmed and solidified Van Gogh's sociopolitical and aesthetic convictions, as well as his conception of modernity.

Promoted by its adherents as an antidote to the lingering poetic excesses of literary Romanticism and to the moralistic sentimentality of mainstream fiction in the Second Empire, Naturalist literature is characterized by a commitment to verisimilitude in the portrayal of "real-life" characters and incidents drawn from contemporary life. Though rooted in the earlier work of Balzac, Flaubert, and the Goncourt brothers, the Naturalist movement self-consciously jelled in the late 1870s, after publication of Zola's *L'Assommoir*. A succès de scandale and the epitome of Naturalist fiction, *L'Assommoir* examines proletariat existence in a working-class neighborhood of Paris and, according to its author, is "a work of truth, the first novel about the people that doesn't lie, that has the smell of the people."[7] It established Zola's reputation for hard-boiled commentary on virtually unexplored sectors of French society and made him mentor to a circle of younger writers eager to emulate his ethos of candor. Beyond this clique of self-declared Naturalists – which included Guy de Maupassant, Paul Alexis, and J.-K. Huysmans – other, more established authors like Edmond de Goncourt and Alphonse Daudet were inducted into the movement, however unwillingly,[8] on the basis of their novels' perceived proximity to bona fide Naturalist projects.

In the years around 1880 Zola's clout as a literary polemicist peaked. His treatise on modern fiction, *Le Roman expérimental* (1880) – a manifesto of sorts – downplays the role of the imagination in the writer's practice[9] and likens the creative project to a scientific one. Inspired by the writings of positivist philosopher Hippolyte Taine[10] and the work of physiologist Claude Bernard,[11] Zola argued that the late-nineteenth-century writer should work in much the same manner as an experimental scientist, making the novel his

laboratory. Zola's own pseudoscientific intentions had already been made clear by the title he affixed to his magnum opus, *Les Rougon-Macquart: Histoire naturelle et sociale d'une famille sous le Second Empire*, begun around 1870. In writing the Rougon-Macquart series (twenty novels in which he aimed to record the inevitable effects of heredity and environment on five generations of a French family) he sought to place his "specimens" (individual family members) into an exhaustive series of meticulously reconstructed Second Empire milieux[12] and then to record – as an ostensibly impartial observer – the responses and interactions dictated by their genes and environment. In order to re-create accurately the realms in which his characters operate, Zola assembled extensive "documents" – his term for the detailed notes he amassed on chosen locales and their habitués, customs, legends, economics, and social and political hierarchies. Before writing his epic mining novel *Germinal*, for instance, the author undertook a fact-finding journey to France's coal country, interviewing miners, visiting their favored haunts, and descending into one of the pits himself.

Despite his claims of unbiased reportage, however, an agenda emerges from Zola's work; in reviling the depravity of the upper classes and satirizing the pretensions of the bourgeoisie, the author of *Les Rougon-Macquart* styles himself an empathic champion of "the people," a concerned observer eager not only to bring their grim existence to the fore, but to lay bare its causes and hint at potential remedies. It was this role – that of muckraking social crusader – that most angered Zola's critics, and even today he is best known as a would-be social scientist with several blood- and mud-stained axes to grind. It was this aspect of Zola's fiction that Van Gogh had in mind when, in 1885, he allied a group of peasant portraits he had made (e.g., Plate 3) to Zola's descriptions of miners in the newly published *Germinal*. Like the author, Van Gogh was eager to emphasize the grimy, hard-bitten aspects of a life-style he had witnessed at first hand – without deference to the refined sensibilities of a Parisian audience (LT418) – and he cited lines from Zola's novel as he described his production to his brother (LT410). At this point, he still was under the sway of the Realist aesthetic he had imbibed from the work of Millet and other Barbizon School artists,[13] and he set his subjects down with dark pigments, thickly applied. In his desire to conjure up the "truth" of peasant life, however, Van Gogh accentuated to the point of exaggeration the coarseness of his working-class subjects; with his murky palette and thick, choppy brushstrokes, he rendered the dark complexions, bulbous features, and sagging flesh he expected manual laborers to possess.[14] For instance, the highlighted profile of the female subject in Plate 3 – whose expression Van Gogh compared to that of a "lowing cow" (LT410) – is blunted by a series of short, disjunctive strokes and set between a pair of scraggly trees that mirror the emphatic ungainliness of the model.

Despite Zola's critical advocacy of journalistic accuracy, Van Gogh had no trouble reconciling the exaggerated aspects of his own portrayal with the precepts of literary Naturalism. He recognized early on that for all the author's stress on documentation, Zola's prose passages rarely were literal transcriptions of "reality." Van Gogh was impressed by the fact that Zola as author did not "hold up a mirror to things" but instead "poeticized" (LT429), manipulating his subjects to great effect. As the reader of a wide array of Zola's works, Van Gogh knew and admired a side of his fiction that today is nearly obscured by the author's scientific pretensions and crusader's stance: the lyrical side that declares itself in hyperbole and lavishly imagistic prose.

Coexistent with the conscientious researcher in Zola was what the author himself called the "poet in me."[15] Even as he acknowledged his "obsession with true details," he admitted a complementary proclivity to "leap into the stars from the springboard of exact observation."[16] Zola made a place for his own – and others' – artistic license by advocating two interlocking forms of "truth": truth to nature tempered by truth to one's own perceptions. The ideas he puts forward in *Mes haines* (1866) – a collection of essays which includes commentary on the visual arts – are more congruent with his actual practice than are the documentarist aspirations he outlines in *Le Roman expérimental*. Most notably, Zola's famous pronouncement in *Mes haines* that "art is a corner of nature seen through a temperament"[17] defines creative production as an amalgam of the "real" and the perceived; art, as he sees it, should be the manifestation of a particular subject's response to a given object[18] and, as such, an accurate indicator of the person who makes it.[19] Insisting that the artist be true to temperament, Zola declares in the same volume, "Make something real and I applaud, but above all make something individual and living, and I applaud more strongly."[20]

Zola's consecration of individuality held great resonance for Van Gogh, a self-taught artist who despite his work's lack of academic polish believed that he had "a chance of giving a true impression of what I see. Not always literally exact, or rather never exact, for one sees nature through one's own temperament" (LT399). The concept of temperament was one Van Gogh cherished throughout his career, and at Arles, as he wrote of his increasing reliance on arbitrary color, the artist asserted that the liberties he took conveyed the "emotion of an ardent temperament" (LT533). One of the peasant pictures he made there, the *Portrait of Patience Escalier* (Plate 4), is as brightly hued as his earlier peasant image (Plate 3) is dark. Both, however, indicate the artist's inclination toward evocation at the expense of strict realism. A patchwork of saturated prismatic hues, the Escalier portrait is meant to suggest the "height of harvesttime" in "sun-steeped" Provence, and though Van Gogh feared that some would "only see the exaggeration

as caricature," he found it true to the spirit of Zola's prose portraits of the working class (LT520).

His image of Escalier and Van Gogh's perception of its relation to Zola's prose reflect the painter's more refined understanding of that author's art by 1888. In the three years since he had painted peasants in Holland, Van Gogh had adopted a high-keyed palette that was not only inspired by his experience of avant-garde Parisian painting, but encouraged by his desire to formulate a visual equivalent to the verbal "richness" of Naturalist literature (W3, LT525). During his sojourn in the capital – surrounded by Impressionist pictures – Van Gogh came to recognize an aspect of Zola's style that initially was lost on him: the author's shrewd blending of the socially engagé sentiments expressed in Realist painting and literature and the up-to-date visual effects of the Impressionist aesthetic. In Zola's novels (and in many produced by his followers) Millet-like concern for the downtrodden, and frank, Daumier-like appraisal of modern urbanites are conjoined to effects of high color, movement, and the "accidental" glimpse that were inspired by the author's interest in avant-garde painting.[21] Van Gogh did not fully appreciate this timely alliance in Zola's work until he himself experienced the pictures the author had looked to; once he did, Van Gogh's own humanitarian impulses found expression in vibrant paintings that became the closest visual equivalents to Zola's alternately conscientious and rhapsodic prose. For all their formal differences, each of Van Gogh's peasant heads (Plates 3 and 4) reflects the contrapuntal encouragement Zola's example provided; like the author, the painter used direct observation as a springboard to artful invention, straddling the ostensibly opposed modes of realism and expressionism. The Naturalist project, as outlined in *Mes haines* and practiced by Zola and his school, made room for both.

While the focus of this study is his interest in French Naturalism, one of my first goals is to establish the general nature of Van Gogh's literary enthusiasms, which tended to be intense. Chronic difficulties in achieving and maintaining intimate relations of all sorts seem to have encouraged his reliance on books for advice, solace, and surrogate companionship; his letters reveal that his often solitary existence was peopled in an extraordinary fashion by the authors and characters of his favorite novels, of whom he sometimes wrote as casually and familiarly as if they were intimates of long standing. The incidents and individuals he encountered in fiction seem to have impressed him as deeply as those he experienced in daily life – indeed, he once wrote that "books and reality and art are alike to me" (LT266) – and as a result his perceptions of people, places, and situations were often colored by what he judged to be their fictive counterparts. That the level of Van Gogh's involvement with what he read was, if not unique, unusual –

even by nineteenth-century standards[22] – is suggested not only by his letters, but by the recollections of those who knew him; Paul Gauguin, for instance, remarked that "Daudet, de Goncourt, and the Bible scorched this Dutchman's brain."[23] I will show that a personal, emotional engagement with much of what he read affected Van Gogh's life and sensibilities long before he became an artist, and that by the time he began to paint, his literary bent was so ingrained as to become an integral component of his creative personality.

I also aim to document the development and evolution of Van Gogh's literary predilections, for previous studies of his reading have stressed its breadth and seeming eclecticism without recognizing what I believe to be significant patterns. Certain constants will be shown to have influenced his preferences, and my identification of these factors both arises from and shapes the material presented in Chapter 1. Formally, Van Gogh from his youth was drawn to a prose style known as word painting – writing that aims to create pictorial effects in textual "pictures" that are framed (by references to the lateral boundaries and horizon of the narrator's visual field), perspectival (by reference to near and far objects within said field), coloristically precise, and specific in detail. Van Gogh's interests in the verbal and the visual, which he saw as complementary – "One man wrote or told it in a book; another in a picture" (LT133) – dovetailed in the pictorial prose he admired throughout his life. In terms of content, he preferred social engagement to romance or adventure, and consistently praised and promoted novels that attempted serious commentary on the plights of those oppressed by modern life because of class, financial condition, unconventional behavior, and/or liberalist ideology. Van Gogh's religious upbringing, youthful piety, and brief career in an evangelical ministry instilled in him a strong sense of duty, a compassion for the unfortunate, and a tendency toward zealotry. When the unhappy end of his stint as a preacher caused him to reject organized religion (in 1879), he instead embraced the religious humanism preached by various nineteenth-century authors and became increasingly receptive to "issue novels." He was particularly partial to those authors who joined a painterly prose style to a compelling social message (e.g., George Eliot, Charles Dickens, and, later, Zola and the Goncourt brothers), and these aspects of his earliest enthusiasms endured.[24]

Despite the distinct continuities in Van Gogh's preferences, however, one can also discern a significant shift – from the moralizing and sentimental English-language literature he praised in young adulthood to the harsher "reality" of French Naturalism, which he favored in his thirties. Proceeding chronologically, I will demonstrate that by the mid-1880s Van Gogh had all but discarded his early fascination with Victorian literature and obsessive interest in the Bible in favor of more recent French fiction. Within the context

of an analysis of the change in his reading habits, I will show that Van Gogh's interest in Naturalism burgeoned in the very year he took up painting (1882) and peaked in tandem with his artistic career, and I will argue that the two were decisively linked and mutually reinforcing.

Van Gogh first read the Naturalists while living at The Hague, Holland's cultural center and – in the 1880s – a hotbed of francophilia. He found that the novels of Zola and Daudet addressed some of the same social and humanitarian issues treated by Eliot, Dickens, and Harriet Beecher Stowe – but in a less optimistic, more candid manner – and his long-standing affection for sentimental anglophone novels was gradually superseded as he immersed himself in a literature that was startlingly new to him. As he struggled in the meantime to throw off the artistic conventions preached by the dominant Hague School and find a bold, independent style suited to chronicling the activities of members of the city's working class and the places they frequented,[25] Van Gogh mentally allied his efforts to those of the Naturalists, whose painterly descriptions, striking character studies, and frank portrayals of modern life moved and motivated him. Even when he retreated to rural Holland in 1883, Van Gogh made a point of keeping abreast of recent French literature, and as his knowledge of Naturalism was regularly updated and expanded by the letters and novels his brother Theo sent from Paris, his identification with the Naturalist enterprise increased. Paraphrases of Zola began to dot his correspondence, real-life situations were interpreted in light of Zola's fiction, and for the first time Van Gogh claimed to have painted pictures under the influence of Naturalist literature. The novels and essays of Zola, Daudet, and the Goncourts reconfigured his image of Paris and seem to have provided Van Gogh mental entrée to the French avant-garde. Surely the sense of excitement their work created encouraged his move to Paris in early 1886.

Van Gogh arrived in the French capital convinced that Naturalism was on the cultural cutting edge – in 1887 he wrote that "one can hardly be said to belong to one's time if one has paid no attention to it" (W1) – and he clung to that conviction even as the primacy of Naturalism was challenged by the rise of Symbolism. He never acknowledged the decline of the movement, and in Paris he added "new" Naturalist authors – Maupassant and Jean Richepin – to his personal pantheon of creative personalities. He also became familiar with the early work of Huysmans, whom he would always categorize as a Naturalist, though Van Gogh can hardly have remained oblivious to Huysmans's clear break from the movement with the publication of *A Rebours*, the quintessential Decadent novel. Though he was living at the center of European culture, with the latest publications almost literally under his nose, Van Gogh – who had assiduously tutored himself in modern French literature while living in the hinterlands of Holland – now rejected

the opportunity to broaden or revise his conception of the vanguard. As Symbolism gained prominence and Naturalism lost adherents, he was loyal to the latter and unmoved by the former. He continued to find Naturalist aims and ideas congenial to his own and was disinclined to relinquish them for something new. Though one might laud his ability to know his own mind and remain aloof from the trendiness he later labeled "Parisian prejudice" (B21), it is clear that a certain conservatism narrowed Van Gogh's vision and led him to reject Symbolist literature after only a cursory examination.

Van Gogh left Paris for Arles early in 1888, and as his artistic productivity peaked that year, his reading fell off a bit, though he was often reminded of the southern roots of Zola and Daudet, and of the provincial types created by them and by Maupassant. Certain Symbolist issues continued to be raised for him by his correspondence with Emile Bernard and by the brief but provocative presence of Paul Gauguin in the last weeks of 1888. Though Van Gogh made a few efforts to work from memory and imagination as Gauguin urged, he remained strongly committed to the Naturalist principle of direct observation of motifs, and later recalled his forays into Symbolist "abstraction" with regret (B21); perhaps because of questions posed by his marginal acquaintance with Symbolist practice, he took particular pleasure in Maupassant's preface to *Pierre et Jean* (one of about a half-dozen novels he read in 1888). Maupassant's advocacy there of artistic license, particularly of the author's right to subjectivity within the context of realism, confirmed Van Gogh's own approach to his Arlesian subjects and seemed to him an enlargement on Zola's conception of art making as an inherently subjective processing of nature by temperament. The theoretical pronouncements of both Maupassant and Zola helped Van Gogh frame his own aesthetic at Arles and served to legitimize his increasingly idiosyncratic vision.

A second notable change in Van Gogh's reading habits came in early 1889, in the wake of his first nervous collapse. During the depression that prevailed in his last months at Arles, Van Gogh chose to return to the fiction of his childhood and youth, rereading Dickens and Beecher Stowe "so as to have a few sound ideas in my head" (LT582). After committing himself to a mental institution at nearby St.-Rémy, he read Shakespeare for much the same reason. In the environment of the asylum his artistic daring waxed and waned and his production became uneven. In this era of psychic distress that often compelled him to copy established compositions (both his own and those of other artists) rather than invent new ones, Van Gogh also tended to reread or recall familiar literature rather than venture into new terrain. The conservatism implied by his earlier rejection of literary Symbolism seems to have taken a stronger hold at St.-Rémy, where Van Gogh was reluctant to read anything new. Though his admiration for the Naturalists

continued, he seems to have felt unequal to them[26] and neither kept up with their new work nor reread their old. He became adamantly uninterested in the Russian novelists – including Tolstoy – of whom his sister was increasingly fond (and who were much touted in Paris in the 1880s),[27] and he advised her that he would stick to the French Naturalists, though he had ceased to read their work. To the final weeks of his life Van Gogh continued to express his fealty to the Naturalist movement – in his letters and in a portrait of Dr. Paul Gachet (see Plate 16), made in June 1890, that includes two novels by the Goncourts.

This study's emphasis on French Naturalism was prompted not so much by Van Gogh's sustained interest in the movement as by that interest's chronological coincidence with the nascence and maturation of his artistic career. This overlap hints at their interconnectedness, and indeed, despite the dearth of "literary" or even anecdotal pictures in his oeuvre, Naturalism can be shown to have left its mark there. In fact, Van Gogh's sustained abstention from painting fictional incident is itself an indication of his concurrence with Naturalist principles. The movement's imperative of empiricism discourages recourse to imagination and memory in favor of work in the physical presence of one's subject and must have sustained Van Gogh's early, seemingly intuitive aversion to making pictures inspired by texts rather than grounded in observed phenomena. It may be said – somewhat paradoxically – that Van Gogh's literary allegiance actually precluded his formulation of traditional "literary" pictures (i.e., imagined tableaux derived from texts). My goal, then, is to discover less traditional ways in which an artist may allude to a text under cover of the "reality" afforded by transcription of a seen motif. The most important task of this study is to elucidate the varied, idiosyncratic, sometimes oblique, and occasionally opaque means by which Van Gogh did just that.

His most obvious homages to Naturalist novels occur in images of actual books; they appear not only as objects in still lifes like *Romans parisiens*, but also as provocative props in portraits and figural pieces, such as his painting of Dr. Gachet. About a dozen of Van Gogh's pictures are enriched by the inclusion of contemporary novels, whose titles and themes evoke ideas, events, and personages that remain undepicted. Untitled books appear even more frequently than labeled volumes, and if less specific in meaning than their titled counterparts, these books are identifiably modern by virtue of their colorful paper bindings. In depicting them, Van Gogh seems to have meant to celebrate reading in general and, more particularly, the illumination he felt on reading them. He regularly paired books with the positive and hopeful imagery of lighted candles and budding plant life. Van Gogh's contemporaries probably would have been more sensitive to his meaning than

we are today; the artist's large still lifes of massed paperbacks seem to have something in common, for instance, with Henry James's mention of "lemon-colored volumes ... fresh as fruit on the tree" and the "sharp sense of initiation they represented." The young protagonist of *The Ambassadors* (1903) returns from Paris "with lemon-colored volumes in general on the brain, as well as with a dozen ... in his trunk."[28]

While his paintings of books are the most obvious indicators of the importance Van Gogh ascribed to French novels, his literary allusions take several other forms, many of them indecipherable without the aid of his letters. On rare occasions, a text elicited an immediate response from the artist – a case in point being a peasant head that Van Gogh claimed he "just had to paint after reading *Germinal*" (LT409). None of the several heads he painted in that era (including Plate 3) is, however, tied to Zola's novel by specific motif or detail; Van Gogh's impulse was to respond to the "spirit" of the book rather than to particulars. At the time he painted Patience Escalier in Arles, Van Gogh gave indication of the generality – and pervasiveness – of literary reference in his work when he wrote, "We've read [Zola's] *La Terre* and *Germinal*, and if we are painting a peasant, we want to show that in the end what we have read has come very near to being a part of us" (LT520).

Van Gogh's drawn and painted reactions to texts were not often so immediate as the peasant head prompted by his reading of *Germinal*, but even when a good deal of time elapsed between the reading of a passage and the making of a work he related to it, his responses almost always were the product of instinct and spontaneity rather than reasoned formula or design. His letters indicate that his experiences as a reader sometimes led him to seek out certain subjects to paint, but more often the motifs he encountered as an artist sparked reminiscences of things he had read. By these processes, remembered readings influenced his choice and perception of subject matter as well as his mode of presenting it – even as his work remained nonnarrative and only covertly "literary." Van Gogh was nonetheless conscious of this component in his art and occasionally went so far as to link a particular passage to a specific painting. He considered his *Café Terrace at Night*, for example, to be "approximately the same subject" taken up by Maupassant in the first pages of *Bel-Ami* (W7), and after painting another Arlesian work, *Tarascon Diligence* (see Fig. 40), Van Gogh wrote of the vehicle in his picture as if it were the same one described by Daudet in *Tartarin de Tarascon* (LT552). Careful comparison of passage with picture in each of these cases demonstrates, however, that Van Gogh was speaking loosely when he wrote of their similarities. The vagueness of the verbal–visual parallels earmarked by the artist himself firmly establishes the indirect nature of his allusions, and this, in turn, has encouraged me to posit other connections between Van

Gogh's art and readings that – though unremarked in his letters – seem tenable. Most notably, I will generically compare his renderings of urban life, rural labor, and empathic nature with treatments of those subjects in Naturalist prose and poetry.

On a broader level, I will demonstrate the impact of Naturalist polemic on Van Gogh's creative credo by presenting the artist's description of his goals and working methods against the backdrop of Naturalist theory and practice as they were known to him through contemporary critiques and the prefaces, explanatory essays, and defensive statements published by the Naturalists in his lifetime, and more particularly as they were represented by the artist in his letters. Perhaps the most profound connection between Van Gogh and his Naturalist mentors resides in the willful, artful merger of the observed and the emotive, a constant that – in the work of both the artist and his favorite authors – transcends individual themes and motifs.

Since my argumentation relies heavily on citations from Van Gogh's correspondence, it is essential to include a note on this primary source. Before 1886, Van Gogh corresponded mainly in Dutch, thereafter mainly in French. To make my work accessible to those who do not read Dutch, I have chosen my citations from the English-language edition of *The Complete Letters of Vincent van Gogh* (Boston, 1978). Since Van Gogh only occasionally wrote letters in English, this edition consists mainly of translations. Its editors, however, have chosen to leave some French phrases and citations from Van Gogh's Dutch letters intact. Thus, some of the letters I quote in English contain French passages; this indicates a Dutch letter with French digressions. When questions about Van Gogh's meaning arose in my mind, I checked crucial passages and ambiguous phrases against the original Dutch- and French-language letters, which appear in their entirety in *Verzamelde Brieven van Vincent Van Gogh*.[29]

Translations of the numerous literary and critical texts cited are my own (unless otherwise noted). Though I have sometimes sacrificed literal translation to comprehensibility and "ear feel," I have tried to keep such deviations to a minimum. Since those familiar with the French language will doubtless prefer to consult the original texts, these are included intact in the Notes.

VAN GOGH'S LITERARY INTERESTS BEFORE 1882

A child of the Dutch middle class, Van Gogh was descended from a line of clergymen, art dealers, and civil servants. His maternal grandfather was a fine craftsman whose wares earned him the title of "bookbinder to the king," and his paternal grandfather, a prizewinning student at the University of Leiden, became a country parson. Van Gogh's father, Theodorus, took a similar path; after completing theological studies at Utrecht, he was ordained in the Dutch Reformed Church and spent his life preaching in a succession of villages. It was in such a village, Zundert – in the Brabant region – that Vincent van Gogh was born.

Childhood memories do not figure prominently in Van Gogh's voluminous letters – the major source of information on his private life – and those recollections of his upbringing that are recorded there shed little light on the amount and type of reading Van Gogh did in his first years. Though he was an avid reader in adulthood, the only author he mentioned reading as a child was Charles Dickens (R30). Nonetheless, it has long been assumed that the Van Goghs' class affiliation and intellectual predilections ensured a "distinctly bookish environment."[1]

The young Van Gogh was sent to boarding school at age 12, but little is known of his studies there. His formal education ended when he entered his uncles' picture-selling business at age 16, and the first hard evidence of his literate upbringing surfaces in the letters he wrote in his first years of independence, while he was working as a picture dealer in London and Paris. His correspondence not only records his broad-ranging readings and reflections on them, but frequently includes transcriptions of poems and passages he wished to share with faraway friends and relations. Books often were the gifts Van Gogh selected for his family on special occasions (see LT51, LT84), and his letters indicate that disagreements over his choice of reading material eventually provoked heated arguments between Van Gogh and his father

(LT159). The intensity and emotionality of these literary dissensions give measure of the importance the Van Goghs attached to reading – clearly a shared and esteemed family activity.

In the decade before his discovery of French Naturalism in 1882, three major concerns shaped Van Gogh's reading habits: a sustained interest in the visual arts; a burst of intense religiosity; and a liberalist inclination toward "religious humanism," social issues, and reform. Though Van Gogh's specific literary allegiances shifted significantly as he aged and changed – from naïve young art dealer to pious schoolteacher, frustrated theology student, outcast lay preacher, and finally to struggling artist – these preoccupations prevailed. His engagement with the visual arts and social consciousness tinged by personal piety not only informed Van Gogh's earliest literary enthusiasms, but likewise established certain criteria that guided his preference thereafter – and drew him inevitably to the Naturalists in the 1880s.

TEXT AND IMAGE

The record of Van Gogh's literary interests begins in the early 1870s, when he was pursuing a career as an art dealer for the Goupil gallery in London. This early involvement with the art world surely informed his enduring interest in texts that evoked images, and images inspired by texts. Letters written from England to family and friends in Holland suggest that his work for Goupil not only prompted Van Gogh's conscientious perusal of the leading art journals (LT12, LT15), but also influenced his choice of avocational reading. Shortly after his arrival in London, for instance, Van Gogh noted that John Keats "is the favorite of all the painters here, and so I started reading him" (LT10a).[2] Keats's popularity with artists owed a great deal to the writer's strong visual sense,[3] and this aspect of his poetry surely was not lost on Van Gogh, whose London letters document the beginnings of a lifelong fascination with the multifarious intersections of verbal and visual imagery.

Like many of his contemporaries, Van Gogh was intrigued by the notion of verbal and visual "sister arts" – a conceit that originated in antiquity, was revived in the Renaissance, and attained its florescence in the eighteenth century, when English poets, their critics, and their public came to regard "word painting" as the apogee of poetic achievement.[4] Under the influence of Horace's much-quoted (and often overinterpreted) maxim, "Ut pictura poesis,"[5] several eighteenth-century poets laid the groundwork for later writers like Keats by consciously attempting to make poems akin to paintings. The resulting verses were known as "word pictures": verbal images that emulated the visual arts to such a degree that they were automatically envisioned by the reader in her or his mind's eye.[6] By the end of the eighteenth

century, word pictures constituted a popular pan-European genre governed by established conventions; to qualify as such by eighteenth- and nineteenth-century standards, a word picture was expected not only to feature careful color notation and a wealth of visual detail, but also to abide by the rules (and limitations) of painting.

As G. E. Lessing stressed in his *Laokoön* (1766) – a fulmination against the blurring of boundaries in eighteenth-century conceptions of poetry and painting[7] – the fundamental dichotomy between the verbal and visual arts resides in the fact that poetry is usually a temporal art (that unfolds sequentially), while painting is primarily spatial (and, most often, a "fixed reality" – the unified representation of a single scene that is apprehended almost at once).[8] Thus, in order to achieve a pictorial effect in verse, the poet is obliged to relinquish the temporality endemic to his or her own medium in favor of the characteristically arrested moment of painting;[9] movement, if mentioned, should be minimal and occur within the bounds of a still ground.[10] Moreover, the poet must attempt to suggest with words the spatial illusionism traditionally aspired to by painters; as Jean Hagstrum put it, poetic detail "must be ordered in a picturable way."[11] Analyses of such ordering abound in modern criticism;[12] in sum, the common spatial devices of poetic pictorialism are (1) a single, fixed vantage point;[13] (2) framing devices (i.e., references to lateral boundaries of the field to be envisioned); and (3) perspectival allusions (i.e., references to near and far objects within said field).[14] Spatial effects often are highlighted and enhanced by "pointing" words (e.g., *that* tree, *those* mountains, *yonder* cloud), whereas the more general visual aspirations of the poet may be emphasized by injunctions to the reader to "look," "behold," or "see."[15] Though some writers suggest the pictorial by means of direct reference to a well-known artist,[16] more usually a landscape type associated with a particular painter serves to create the allusion.[17] Such specifics are by no means obligatory, however; the writer might just as well present a scene through the eyes of an anonymous artist-spectator,[18] or may simply imply the presence of an artistic eye by employing terms borrowed from the vocabulary of the visual arts.[19]

A man of Van Gogh's literacy certainly was familiar with the basic precepts of word painting – which by the mid-nineteenth century had become a commonplace of both European and North American literature.[20] Its pervasive popularity is demonstrated by its nineteenth-century transmission from poetry to novels and on to nonfiction prose, and the extent of Van Gogh's admiration is indicated by the fact that he found and praised it in each of those genres. Indeed, the majority of the diverse passages he chose to transcribe from London are linked, in a general sense, by their concerted verbal allusions to the visual. The first poem Van Gogh copied for inclusion in a letter, "De Avondstond" by Jan van Beers, is a good example of poetic

pictorialism, and since it is in some ways characteristic of the sort of writing and subject matter Van Gogh admired throughout his life, the complete text follows. Testimony to the seriousness of his interest in this particular poem resides in the very fact that he took the trouble to transcribe its many lines two times over; one copy was sent to his brother Theo (see LT9a), another to friends in The Hague:

The toll of the curfew calling to prayer resounded
 lazily across the fields,
which blissfully lay bathed in the gold of the evening sun.
Right in front of him lay the village, with hills to the
 north and to the south,
between whose ridges the sun, sinking in the west with
 a crimson blush,
poured forth its whole wealth of colors and the magic
 of its rays.
Now the little bell in the gray steeple veiled in dark green
was silent. The brown sails of the mills, on yonder height,
hung motionless; the foliage was still; and over the cottages
little puffs of peat-smoke, tinged with blue, rose so straight
from the chimneys that they too seemed to hang
 motionless in the tingling air.
After the sun's good night kiss, it was as if this hamlet,
 this field, those hills,
everything around, silent and grateful, once more recalled
the richness and peace they had enjoyed,
before wrapping themselves in the cloak of evening dew to
 sleep.
Farther on ... but just beside the narrow footpath
followed by the Painter, the sudden loud peal of cheering
 met his ears.
Swaying to and fro, a wagon came rumbling toward him,
piled high with the harvest of buckwheat.
Horse and freight were decked with fluttering ribbons and
 flowering branches;
children, each with a wreath of flowers around his little
 flaxen head,
sat atop it, brandishing alder twigs,
or raining down a shower of leaves and flowers,
whilst below, around the wagon, a crowd of servant
 lads and lasses
leaped and sang, so as to startle the whole slumbering plain.
Behind the shrubs, the silently smiling Painter watched
the noisy throng wind its way along the bumpy road.
And thus, pondering the calm and deep delight the soul
savors in the country, or with his artist's mind
 reconstructing
in silent rapture the whole glorious scene of a
 short while ago,

he came, without perceiving it himself, sauntering into
 the hamlet.
In the west the purple and yellow had already faded to gray;
and in the east, quite close to the little church,
 the full copper-colored
disc of the moon, lightly shrouded in the haze of the
 gloaming, had risen
when he entered "The Swan," the inn where he was lodging.
 (trans. from *The Complete Letters of Vincent van Gogh*)

In "De Avondstond" Van Beers not only creates a set of highly imagistic tableaux, but pointedly underscores his aspirations to the visual by describing the vista as experienced by a painter protagonist. Though he relies on some poetic metaphor that is decidedly nonpictorial ("the sun's good night kiss" and the enwrapping "cloak of evening dew"), Van Beers's insistent framing of the scene ("right in front of him," "with hills to the north and south," the sun setting in the west, and the mills above), his development of its three-dimensionality ("between the ridges," "farther on"), his specificity of description, and his attentiveness to color create not just mood and narrative, but the *picture* of place and those who traverse it, presented as – in Van Beer's words – an artist would reconstruct it in her or his mind. A certain amount of movement and temporal progression is described (ribbons flutter, flowers and leaves rain down, and both the wagon and the painter move through space and time), but these incidents contrast the "motionless," "slumbering" whole delimited in the first stanza; those lines, taken alone, emulate the fixed and becalmed vistas of painted landscape.

Van Gogh throughout his life had an unwavering fondness for the sort of scene Van Beers describes: rural nature punctuated by a few humble man-made monuments and experienced by a sensitive, solitary spectator. In the nostalgia for home induced by his urban surroundings he characterized "De Avondstond" as "genuine Brabant" (LT9a), but as a rule Van Gogh was no great partisan of Dutch literature. He soon realized that similar scenes set in England, France – and even the United States – also roused his strong sentiments for country life.

Poetry held more appeal for Van Gogh in his twenties than later in his life, and in London a desire to hone his language skills apparently fueled his special interest in English-language verse;[21] in addition to Keats, he was particularly fond of Henry Wadsworth Longfellow. In 1873, as he prepared to send photographs of some paintings he admired to friends in Holland, Van Gogh noted Longfellow's connection to the art world:

Puritans Going to Church [one of the photos] is after [G. H.] Boughton, one of the best painters here.[22] An American, he likes Longfellow very much, and rightly so; I know three pictures by him inspired by "The Courtship of Miles Standish." Seeing these pictures has induced me to read "Miles Standish" and "Evangeline" again; I

don't know why, but I never realized these poems were *so* fine as I think them now. (LT11a)

Even as he claimed bafflement about the origins of his newfound enthusiasm, Van Gogh indicated that Longfellow's poetry – like that of Keats – had been validated for him by the knowledge that it was appreciated and imaged by an artist he admired. These comments also constitute Van Gogh's first actual acknowledgment of what was to become an almost obsessive interest: comparing textual and pictorial images of similar subjects.[23]

Van Gogh found ample opportunity to indulge that interest as he became engrossed in the writings of George Eliot, who in the mid-1870s became one of his favorite authors. The pictorialism popularized by eighteenth-century poets had become a standard feature of the Victorian novel,[24] and Eliot made a particular specialty of word painting. A keen interest in the visual arts inspired her conscious effort to create pictorial effects in her writing, and she duly noted them in pointed asides to her readers. Herself an amateur watercolorist, Eliot kept abreast of contemporary art by visiting both exhibitions and artists' studios. She also read art criticism and art history, and kept careful accounts of museums and artworks she saw in England and on her travels. While her choice of a favorite painting – Raphael's *Sistine Madonna* – situated her squarely in the mainstream of nineteenth-century taste, Eliot prided herself on her somewhat more adventurous appreciation of Dutch and English genre painting. In the often-cited chapter XVII of *Adam Bede,* she offers eloquent praise of the truth and simplicity of Dutch art, and compares her own writing to that mode of painting.[25] She also had an eye for nineteenty-century landscape painting, and particularly admired Jules Breton (as did Van Gogh).

Van Gogh apparently encountered Eliot's prose for the first time in the spring of 1875, when he read *Adam Bede.* Of the story – that of a simple carpenter who falls in love with a pretty but shallow girl who disappoints him – Van Gogh had little to say. Instead he focused on the author's description of landscape. To Theo (who also read *Adam Bede* at this time), Van Gogh wrote:

The landscape in which the fallow sandy path runs over the hill to the village with its clay or whitewashed cottages and moss-covered roofs, and with an occasional blackthorn bush on either side the brown heath and the gloomy sky with a narrow white streak at the horizon – it is like one by [Georges] Michel. But there is an even purer and nobler sentiment in it than in Michel. (LT23)[26]

In addition to affirming his admiration for Eliot's mode of description, Van Gogh's comments more particularly indicate his budding conviction that (1) the visual effects of a painting could be captured in words, and (2) verbally expressed sentiments could be similarly expressed by a visual image. The

fact that he not only envisioned Eliot's passage, but found it superior to the painted canvases of an artist he admired also suggests a nascent preference for the poetic concept as opposed to its material realization in painting.[27]

The ubiquity of verbal pictorialism in the nineteenth century is perhaps most strikingly documented by its incursions into nonfictional writing. The oeuvre of French historian Jules Michelet provides several cases in point, for Michelet – who once referred to himself as an "artist-historian"[28] – consistently infused his prose with vivid, imaginative tableaux marked by what one critic has characterized as "pictorial concreteness."[29] Not surprisingly, it was this aspect of his work that captured Van Gogh's attention during his stint with Goupil in London. The young art dealer first mentioned Michelet in 1873, in a letter to Dutch friends. Noting the enclosure of what he called a "*picture* of autumn" (LT11a; my emphasis), Van Gogh in fact referred to a passage he had copied from Michelet's *L'Amour:*

From here I see a lady, I see her walk pensively in a rather small garden, devoid of flowers early in the season, but sheltered, as you see them behind our cliffs in France or in the dunes of Holland. The exotic shrubs already have been put back into the hothouse. The fallen leaves unveil some statues. An artistic luxury that contrasts a bit with the lady's very simple, modest, sober attire, the black (or gray) silk of which is barely enlivened by a simple lilac ribbon...

But haven't I already seen her in the museums of Amsterdam or The Hague? She reminds me of a lady by Philippe de Champagne (n.b., at the Louvre), who found a place in my heart, so candid, so proper, intelligent enough, but simple, without the cunning to disentangle herself from mundane ruses. The woman has stayed in my mind for thirty years, obstinately coming back to me, making me say, "But what was her name? What happened to her? Did she have a little happiness? And how did she get through life?" (Cited by Van Gogh in French;[30] cf. *L'Amour,* pt. V, chap. 5)

L'Amour, a product of Michelet's late career (and second, late-life marriage) is essentially a treatise on the blissful domesticity engendered by partnership with a suitably passive, naïve, and cloistered woman, wherein the author sings the praises of woman as docile and isolated other – and conjures his ideal being to life in evocative word paintings like this one. Here, in accordance with the conventions of pictorialism, Michelet establishes a fixed vantage point from which he describes the setting and figure he claims to "see." His professed uncertainties of vision (French cliffs or Dutch dunes? black silk or gray?) serve to portray him as the candid recorder of a perceived actuality rather than the omnipotent creator of a verbal fiction. To evoke the feminine traits he esteems (passivity, modesty, disconnectedness from the world), Michelet presents an image filled with visual clues to those inner attributes. Brief color notes and an art reference add to the portrait status of this passage.

Van Gogh passed *L'Amour* on to Theo, and several months later the

brothers conducted an epistolary discussion of Michelet's ideas (LT20).[31] Nonetheless, it was the book's imagistic writing – not its conceptual content – that first drew Van Gogh's praise (LT11a). Michelet's "noble and beautiful" description remained engraved in his mind (LT114; see also LT82a, LT58, LT111), and Van Gogh's initial characterization of that passage as a *picture* was the first of numerous instances in which he described a verbal construct in visual terms. The practice itself was by no means new, however, and in adopting it Van Gogh emulated an established critical mode. Since the eighteenth century – and particularly in the nineteenth – literary critics in search of an appropriate response to the omnipresent pictorialism of their age routinely appropriated the vocabulary of art, and the literary review itself became a prime arena for "artful" nonfiction prose.[32] Van Gogh embraced this critical practice early on and gradually crafted ever more elaborate analogies between the sister arts. For instance, when he went on to read Michelet's *Le Peuple* in the early 1880s, he embellished his observation that it seemed hurriedly written with the following:

> Knowing his more polished works...I thought this one like the rough sketch of a painter whom I like very much, and, as such, it had a peculiar charm.... Michelet has strong emotions, and he smears what he feels onto paper without caring in the least how he does it, and without giving the slightest thought to technique or conventional forms.... To me *Le Peuple* is not so much a first idea or impression as an unfinished but well-thought-out and studied conception. Some parts are apparently done hurriedly from nature and joined to other parts which are more finished and studied. (LT266)

By the time he wrote this appraisal, Van Gogh's opinions were emboldened by the long-cultivated connoisseurship of both art and literature that began during his time with Goupil. His wide-ranging knowledge of each encouraged him to speculate on general equivalences between the verbal and visual imagery he admired, and he sometimes tinkered with a personal system of comparison – not without precedent in literary criticism[33] – that linked somehow-analogous pictures and texts. In a letter of 1879, for instance, he drew a series of such parallels:

> There is something of Rembrandt in Shakespeare, and of Correggio in Michelet, and of Delacroix in Victor Hugo; and then there is something of Rembrandt in the Gospel, or something of the Gospel in Rembrandt – whichever, it comes to the same if only one understands it properly, without misinterpreting it and considering the equivalence of the comparisons, which do not pretend to lessen the merits of the original personalities. And in Bunyan there is something of Maris or of Millet, and in Beecher Stowe there is something of Ary Scheffer. (LT133)

Van Gogh's interest in sister arts analogies also manifested itself in his own creative practice. Even before he became a serious artist, Van Gogh wrote of sketching under the influence of evocative texts (LT25, LT101).

Moreover, he himself dabbled in word painting; a letter written from Ramsgate, England, in 1876 contains one such passage:

Did I tell you about the storm I watched recently? The sea was yellowish, especially near the shore; on the horizon a strip of light, and above it immense dark gray clouds from which the rain poured down in slanting streaks. The wind blew the dust from the little white path on the rocks into the sea and bent the blooming hawthorn bushes and wallflowers that grow on the rocks. To the right were fields of young green corn, and in the distance the town looked like the towns that Albrecht Dürer used to etch. A town with its turrets, mills, slate roofs and houses built in Gothic style, and below, the harbor between two jetties which project far out into the sea. (LT67)

Once he became a full-time artist, Van Gogh's tendency to connect verbal and visual imagery became ever more pronounced. In 1881, for instance, as he was in the process of studying drawing, Van Gogh became enamored of a woman who did not return his affections. Her rejection of him became the focus of his letters, and at one point he gave this appraisal of his own epistolary account of the affair:

I should not be surprised, Theo, if my last letter made a somewhat strange impression on you. But I hope . . . to give you some idea of the whole situation. I tried to indicate the proportions and planes with long, straight charcoal strokes: when the necessary auxiliary lines have been traced, then we brush off the charcoal . . . and begin to draw the more intimate details. . . . This letter will be written in a more intimate, less harsh and angular tone than the former. (LT154)

By the time he wrote this letter (just a few months before reading his first Zola novel), two sorts of descriptive practice, the verbal and the visual, had become remarkably interwoven in Van Gogh's mind.

PENITENCE, PIETY, AND THE WILL TO PREACH

As the son and grandson of clergymen, Van Gogh had an almost inbred intimacy with Christian values and practice (see LT69). His family belonged to the Dutch Reformed Church (Netherlands Hervormde Kerk), the oldest Protestant denomination in the Netherlands and one of a decidedly fundamentalist stripe. As an evangelical church, it taught the authority of the Bible; the value of preaching over ritual; and salvation through personal rededication to Christ (i.e., being "born again") and the pursuit of a spiritually transformed life of devotion, morality, and proselytizing.

Though he had always been a believer and a churchgoer, Van Gogh experienced an unprecedented surge of religiosity in 1875 and entered an extremely devout period that endured for more than two years. He quickly lost his enthusiasm for the art trade and became engrossed in the lore of Christianity; he read the Bible more often and more closely, and explored

a wide range of secondary sources on the history and practice of the faith. Although he later renounced organized religion and rejected conventional piety, Van Gogh's religious focus in the middle to late 1870s fostered a deep-rooted spirituality that remained a guiding force in his life – and reading habits – throughout the 1880s.

This period of intense religiosity and its attendant investigation of Christian literature apparently were launched by an unlikely vehicle; early in 1875 Van Gogh wrote of his interest in the writings of Ernest Renan, a seminarian-turned-philologist/historian[34] who flagrantly refuted some of the most vaunted traditions of Christendom in his seven-volume opus, *Les Origines du Christianisme*. Van Gogh read the first installment of *Les Origines* (or a variation thereof)[35] – the biography of Jesus, which became one of the most controversial books of the nineteenth century. Renan's *Jésus* is an ostensibly objective account of a powerful and charismatic man who changed the course of history but who, according to the author, was neither divine nor a miracle worker. Renan was not the only nineteenth-century scholar intent on sifting historical fact from Christian legend,[36] but he was the first to treat Christ as an actual personage and to situate him convincingly in historical context. Like Michelet – whom he admired[37] – Renan believed it was not just permissible but necessary for a historian to bring imagination and intuition to the task of creating historical tableaux, and *Jésus* is filled with descriptive reconstructions intended to make Christ's person and progress vivid in the mind's eye.[38] The book's verbal imagery had a lasting impact on Van Gogh, who in 1889 remarked, "Isn't Renan's Christ a thousand times more comforting than so many papier mâché Christs that they serve up to you in... churches?" (LT587).[39]

When he first read *Jésus* in 1875, however, Van Gogh was more compelled by its message than by the manner in which it was written. Renan, who described himself as a "would-be priest" and maintained that to write religious history one must once have believed, wrote empathically of the ideals that motivated Jesus and sustained his followers; Van Gogh clearly was drawn to the author's sermonlike pronouncements on religious faith, for he appended one to his last letter from London (LT26). That passage, which advocates renunciation of worldly pleasures and pursuits,[40] is an apt swan song of the London era, for the next phase of Van Gogh's life was marked by staunch self-denial.

In May 1875 he was transferred against his wishes to Goupil's Paris gallery, where his interest in business steadily waned as piety engulfed him. He began to read more purely devotional literature, including poetry by the popular Dutch preacher P. A. de Genestet[41] and a French-language edition of the *Imitatio Christi* (*The Imitation of Jesus Christ*), a centuries-old devotional handbook often attributed to Thomas à Kempis (c. 1380–1471).

Esteemed by generations of Protestants and Catholics alike, the *Imitatio Christi* is an aphoristic primer on religious devotion that extolls liberation from mundane wants and concerns through calculated withdrawal from the world.[42] Though some reform-minded nineteenth-century Protestants, believing it discouraged rightful Christian engagement with social change, criticized the book as a "manual of sacred selfishness,"[43] Van Gogh seems to have taken the insular credo of the *Imitatio* very much to heart in 1875. He adopted as reclusive and ascetic a life-style as possible (to the obvious detriment of his career) and doggedly avoided the earthly pleasures he heretofore had enjoyed most: nature, art, and literature. In September 1875 he wrote:

A feeling, even a keen one, for the beauties of nature is not the same as a religious feeling.... You know that it is written, "This world passeth away, and the lust thereof."...
 It is the same with a feeling for art. Don't give yourself utterly to that. (LT38)

In a similar vein of renunciation he soon afterward told Theo, "I am going to destroy my books by Michelet, etc. I wish you would do the same" (LT39). By way of explanation, he cited biblical chapter and verse: "Therefore if any man be in Christ, he is a new creature: old things are passed away; behold, all things are become new" (LT39; cf. 2 Cor. 5:17). À few weeks later (presumably because Theo had not yet commented on his request), Van Gogh raised the issue anew, giving more emphatic and detailed instructions:

Have you done as I suggested and destroyed your books by Michelet, Renan, etc.? I think that will give you rest. I am sure you will never forget that page out of Michelet about the "Portrait of a Lady" by Ph. de Champaigne, and do not forget Renan either; but destroy them all the same. "If thou hast found honey look to it that thou eatest not too much of it, that it may become loathsome," is written in the Proverbs, or something like it. [cf. Prov. 25:16] Do you know Erckmann-Chatrian's *Conscrit*, *Waterloo*, and especially *L'Ami Fritz*, also *Madame Thérèse*? You must read them when you can get them. Change of food gives an appetite (but we must especially take care to have *plain* food, for it is written, "Give us this day our daily bread"), and the bow cannot always be kept bent. (LT42)

Ironically, the amount of pleasure Van Gogh derived from Michelet's *L'Amour* may be gauged by his decision to abstain from it at this juncture; though the same might be said for Renan's *Jésus*, that book's unorthodox content may have contributed to Van Gogh's decision to banish it from his library. It seems likely that his sudden change of heart about Michelet and Renan stemmed from the *Imitatio's* repeated exhortations against absorption in secular scholarship and its products,[44] but while many of his most devout Protestant contemporaries found the reading of secular fiction a waste of time better spent in religious pursuits,[45] Van Gogh was at this point unwilling to relinquish nonreligious reading completely.[46] The important role books

continued to play in his life is made clear by his characterization of them as dietary staples he could not do without. To extend Van Gogh's own metaphor, one might say that having eliminated the richness of Michelet's pictorial prose and the piquant argumentation of Renan from his regimen, he opted for the literary equivalent of synthetic sweetener when he reached for the simplistic and sentimental novels of Erckmann–Chatrian, which abound with studies in self-sacrifice and moral rectitude. Emile Erckmann and Alexandre Chatrian wrote as partners for almost forty years, specializing in historical fiction. Three of the four books Van Gogh mentioned to Theo are from their series of "romans nationaux," which chronicle the period of the first French Revolution and First Empire from the partisan viewpoints of fictional "common man" narrators.[47] In their fictive personalization and democratization of past events, Erckmann–Chatrian owed something to Michelet's approach to history,[48] but since Van Gogh did not mention reading Michelet's famous history of the French Revolution until 1877 (LT111, LT122), the parallel probably escaped him at this point, and he may well have seen the writings of Erckmann–Chatrian as completely different from Michelet's – merely as "*plain* food" that made for a healthy change.

The newly pious Van Gogh also was able to salvage George Eliot's fiction from the literary scrap heap instituted in his zeal; her work's inclusion in his literary regimen was made possible by Eliot's recurrent themes of religion and religiosity. He resumed reading her work toward the end of his stay in Paris, but no longer lauded the painterly prose that had so impressed him in *Adam Bede*. Instead he focused on her treatment of evangelicalism and personal piety – and thus found that Eliot's fiction could again serve to mirror his own enthusiasms, even if his posture before the mirror was radically changed. Indeed, the marked shift in his perception of Eliot's oeuvre provides a solid example of the extent to which Van Gogh's own preoccupations consistently colored and shaped his understanding and representation of that which he read.[49] In this case, he not only ignored the author's trademark pictorialism as he aimed to distance himself from the art world, but also siphoned off only the most positive images of religious fundamentalism from Eliot's often disparaging portrayals of clerical training, motivation, and pedagogy.

Each of the three books by Eliot that Van Gogh read during his first stay in Paris – *Felix Holt, The Radical; Scenes of Clerical Life;* and *Silas Marner* – deals with the impact of moral conviction (or its lack) on the lives and conduct of its characters. Van Gogh's favorite probably was *Felix Holt* (1866), "a book that impressed me very much" (LT51). He read it in January 1876 and returned to it in 1884, with praise for its focus on "deep things, said in a guilelessly humorous way" (R43). *Felix Holt* is an exploration of morality on both the public/political and private/religious levels; the book's

subtitle, *The Radical,* refers to both politics and religion, for Felix Holt is an advocate of workingmen's rights[50] and a member of the Dissent movement.[51] A secular saint of sorts,[52] he puts Christian values into earthly practice and becomes an exemplar for the novel's heroine, Esther Lyon. Though Esther is the foster daughter of a Dissent minister, she prides herself on her refined tastes in literature and art, and resents the shabbiness of her adoptive home. Felix at first strikes her as vulgar and abrasive, and seems to represent all she abhors about the Dissent life-style – particularly its earnestness and its willful grubbiness. Eliot's Esther, however, is no fool; she learns to look beyond Felix's rude exterior to his exquisite morality, and in the end forfeits a substantial fortune and an elegant gentleman suitor – things she had always coveted – in order to live an impoverished but morally satisfying life with Felix.

When he first read *Felix Holt,* Van Gogh doubtless identified to some extent with Esther's renunciation of worldly possessions and pursuits, but he seems to have felt an even stronger kinship with Eliot's hero, whom he took as a kind of role model.[53] Over the next few years, Van Gogh's life even came to bear an uncanny if fortuitous resemblance to Felix Holt's. In Eliot's novel, Felix, a child of the merchant class, repudiates his family's business (in bogus but profitable elixirs) to pursue his ideals; he not only embraces the causes of the working class, but assumes its dress and life-style.[54] He manages to support himself and his widowed mother with a manual trade (watchmaking) and by offering instruction to young boys. Van Gogh also left the family business (in 1876) in pursuit of a higher calling. He, too, worked as teacher, then as a lay preacher among working people whom he strove to emulate (LT129).[55] Even as an artist, he liked to think of himself as a manual laborer (LT194). The parallels between his life and Holt's did not escape Van Gogh's notice; several years after reading Eliot's novel – while working as an artist in The Hague in 1883 – he alluded to the similarity of sentiment that linked him to its protagonist. Writing to Theo about a batch of drawings he had made of almshousemen and soup-kitchen habitués, Van Gogh remarked:

When you see this group of people together, can you understand that I feel at home with them? Some time ago I read the following words in Eliot's *Felix Holt the Radical:*

"The people I live among have the same follies and vices as the rich, only they *have their own forms* of folly and vice – and they have not what are called the *refinements* of the rich to make their faults more bearable.

"It doesn't matter to me – I am not fond of those refinements, but some people are, and find it difficult to feel at home with such persons as have them not."

I shouldn't have thought of it in those terms, but I have felt the same sometimes. (LT272, Van Gogh's emphasis; cf. *Felix Holt,* chap. LI)[56]

Years later, in painting his bedroom at Arles, Van Gogh claimed to take *Felix Holt* as a model for the sort of "simplicity" he aimed to achieve in the creation and representation of his own environment (W15).[57]

Not long after reading *Felix Holt*, Van Gogh also read the trilogy of stories that had constituted Eliot's first published book, *Scenes of Clerical Life* (1858). Each scene details a dramatic era in the life of a small-town preacher, and English clerical life as described by Eliot is difficult, dreary, and often disappointing. Though Van Gogh praised the book as a whole (see LT73), the first two stories drew no specific comments from him. Both are accounts of the private miseries – rather than public ministries – of mediocre clerics who lose their wives in childbirth, and they seem to have interested the young Van Gogh much less than the last story, "Janet's Repentance," which he described to Theo as

> ...the story of a clergyman who lived chiefly among the inhabitants of the squalid streets of a town; his study looked out on gardens with cabbage stalks, etc., and on the red roofs and smoking chimneys of poor tenements. For his dinner he usually had nothing but underdone mutton and watery potatoes. He died at the age of thirty-four. During his long illness he was nursed by a woman who had been a drunkard, but by his teaching, and leaning as it were on him, had conquered her weakness and found rest for her soul. At his burial they read the chapter which says, "I am the resurrection, and the life: he that believeth in me, though he were dead, yet shall he live." (LT55)

As Van Gogh explained, Janet's story is also the story of Edward Tryan, the earnest young clergyman who effects her redemption even as he struggles with his own moral and physical weaknesses. Like Felix Holt, Tryan is an exemplar of Christian virtue – but a much less idealized one. In his youth Tryan seduced an innocent young woman who consequently poisoned herself, and now he must live with this grievous ethical lapse. He turns his sin to good use by confessing it to a despairing alcoholic, Janet Dempster. His admission of weakness and guilt (i.e., his humanity) convinces Janet that one need not be perfect to be saved. She is led to rebirth at the same time that Tryan is dying of tuberculosis; his confession helps redeem them both.

"Janet's Repentance" is a story of spiritual renewal and – as his thumbnail sketch of it makes clear – this aspect of the story was what appealed to Van Gogh, who was struggling to reform his own life at the time he read it. Though it is the most optimistic of the scenes, it also is the least lyrical; Eliot goes out of her way to underscore the lack of prettiness in her protagonists' lives.[58] Van Gogh's focus on this story, and his particular enthusiasm for details like squalid streets and cabbage stalks, suggest that his goals as a reader had changed considerably in the year that had elapsed since he had read *Adam Bede* and remarked on the beauty of Eliot's verbal pictorialism. The *Scenes* were written at the same time as that novel[59] and are equally

rich in carefully composed, brilliantly colored tableaux[60] – but Van Gogh, who now preferred preaching to poesy, failed to note them. Instead he told Theo, "If you can persuade somebody to read Eliot's *Scenes from Clerical Life* [*sic*] and *Felix Holt*, you will be doing a good deed" (LT73). He did not mention *Adam Bede* in this context, though it is as sermonizing a novel as any by Eliot and specifically chronicles the spiritual rescues carried out by a fervent young female evangelist.[61] Presumably its omission stemmed from the fact that Van Gogh had read it in a less pious era of his life and did not find and/or remember it as inspirational because he had not read it with that aim in mind.

Also omitted from the reference was *Silas Marner* (1861), a book Van Gogh probably read in Paris[62] but may have left unmentioned because he found its scathing portrayal of Protestant extremists puzzling or even offensive. This short novel served as a forum for Eliot's denunciation of the intolerance and stubborn irrationality she had observed among religious zealots in the era of her own youthful piety[63] and allowed her to vent her moral outrage at the psychic damage wrought by evangelical excess. Van Gogh's comments on the novel indicate that he either missed or rejected Eliot's point. At the beginning of the book that bears his name, Silas Marner is a member of the Lantern Yard chapel, which Eliot characterizes as a "narrow religious sect" in a large town.[64] Forced to renounce an interest in folk cures and herbal remedies learned from his mother,[65] Marner forges his reputation as a "young man of exemplary life and ardent faith,"[66] only to fall from favor abruptly when he is unjustly accused of theft by a fellow sect member and "proved" guilty by a drawing of lots augmented by prayer. Thus ostracized from his community, Marner leaves town "with that despair in his soul – that shaken trust in God and man which is little short of madness to a loving nature."[67] He settles in a rural village where churchgoing is "not severely regular"[68] and folk magic and age-old customs coexist with Christian tenets. Understandably wary of his neighbors after his experience with the Lantern Yard sect, Marner puts his trust in money and becomes a reclusive miser. Spiritual and psychological healing eventually come to him, however, via a foundling girl who becomes his foster daughter; Marner's belief in God is revived by his renewed faith in humankind and capacity for love. His love of nature and interest in herbal medicines also reassert themselves, and he finally feels the strength to return to his erstwhile community and vindicate himself. The Lantern Yard chapel, however, is gone, and a factory stands in its place; in Marner's words, "The old place is all swep' away."[69] This verb of cleansing seems particularly appropriate, for the demise of the chapel is the novel's final purgative.

Given Eliot's disparaging account of Lantern Yard, and its effect on the naïvely devout Silas Marner, it is surprising to read Van Gogh's epistolary

mention of it – an aside in which he presents the fictional sect in a remarkably positive light. After leaving France in April 1876, Van Gogh made a brief visit to London before his move to the coastal town of Ramsgate, and thinking back on London in May, he wrote:

There is such a longing for religion among the people in the large cities. Many a laborer in a factory or shop has had a pious childhood. But city life sometimes takes away the "early dew of morning." Still, the longing for the "old, old story" remains; whatever is at the heart's core stays there. In one of her novels Eliot describes the life of factory workers who have formed a small community and hold their services in a chapel in Lantern Yard; she calls it the "kingdom of God on earth" – no more and no less. There is something touching about those thousands of people crowding to hear these evangelists. (LT66)

Van Gogh seems to have recalled the following passage, in which the author describes Marner's initial infatuation with the comfortable but stifling familiarity, formulaic worship, and rigid hierarchy of the sect:

Lantern Yard... had once been to him the altar-place of high dispensations. The white-washed walls, the little pews where well-known figures entered with a subdued rustling, and where first one well-known voice and then another, pitched in a peculiar key of petition, uttered the phrases at once occult and familiar, like the amulet worn on the heart; the pulpit where the minister delivered unquestioned doctrine, and swayed to and fro, and handled the book in a long-accustomed manner; the very pauses between the couplets of the hymn, as it was given out, and the recurrent swell of voices in song: these things had been the channel of divine influences to Marner – they were the fostering home of his religious emotions – they were Christianity and God's kingdom upon earth. (*Silas Marner*, pt. I, chap. 2)

The author clearly wishes her reader to understand that Marner's appraisal was deluded,[70] that this place and these people did not constitute "Christianity" as she had come to understand and value it. This passage, moreover, comes after Marner's disillusionment with the sect; Lantern Yard is described in the past perfect tense, for Marner is by now an outcast returned to rural life:

... poor Silas was vaguely conscious of something not unlike the feeling of primitive men, when they fled thus, in fear or in sullenness, from the face of an unpropitious deity. It seemed to him that the Power he had vainly trusted in among the streets and at the prayer-meetings, was very far away from this land in which he had taken refuge. (*Silas Marner*, pt. I, chap. 2)

It is only in the country – far from the ministrations of Lantern Yard – that Marner experiences that which Eliot deemed the essence of Christianity: its human, rather than dogmatic, dimension. Her protagonist discovers that "God's kingdom" is literally "on earth."

Though Van Gogh would later reach a similar conclusion, Eliot's biting attack on evangelical sects seems to have left him unfazed in 1876; he apparently was unable to understand and/or unwilling to accept her criticisms.

Perhaps his imperfect command of English prevented him from fully comprehending Eliot's meaning; it is also possible that his enthusiasm for religious fundamentalism blinded him to Eliot's irony. These scenarios, however, may underestimate Van Gogh's perceptiveness as a reader and skill as a polemicist, for it is also possible that in his desire to validate his own religious sentiments, he willfully manipulated Eliot's text. Removed from context, her description in fact serves as an effective affirmation of his own (completely contrary) appraisal of evangelical religion, and his "re-presentation" of *Silas Marner* may well be an early example of Van Gogh's later habit of lifting phrases from favorite authors and applying them to his own life (often to vindicate himself when no one he knew would take his part). When he engaged in this practice, he sometimes disregarded the original function and meaning of the co-opted words – and that may have been the case here. For whatever combination of reasons, Van Gogh's accounts of Eliot's fiction certainly are much less consistent than the author's own style and attitudes.

When Van Gogh left Goupil and Paris for London in the spring of 1876, he seems to have had Eliot's fictional portrayals of English evangelicalism very much in mind. The introspective religiosity that characterized the first months of his rededication to Christ gradually was giving way to a search for outward application of his beliefs, and having turned away from his uncles' trade, Van Gogh was ever more interested in the profession of his father – but with a decided twist. He aimed to preach to working people as an empathic peer: a lay minister unschooled in dogma and classical languages, a man who had sinned yet found redemption (LT69). Though his desire to preach owed a great deal to his upbringing in a Dutch cleric's home, Van Gogh's interest in an unorthodox alternative ministry doubtless stemmed from his knowledge of recent developments in English evangelism. The novels of George Eliot and his own prior sojourn in England surely had given him an inkling of the great surge of lay proselytizers there,[71] and Van Gogh seems to have envisioned himself in a community like Lantern Yard (LT66), preaching Tryan's message of redemption with Holt-like commitment to the working class (see LT69, LT70). He soon learned, however, that at age 23 he was considered too young for such a post, and thus was obliged to work instead as a schoolmaster's assistant at a boys' school in Ramsgate. Some months later, he found a better-paid post at a school run by a Methodist clergyman, and there became a curate of sorts, obtaining the director's promise "that I shall not have to teach so much in the future, but may work more in his parish ... so that I shall find by and by what I want" (LT76). By the end of 1876 Van Gogh had indeed begun to do sporadic preaching in the surrounding area (LT79, LT81, LT82).

In 1876 Van Gogh's school duties prompted his brief exploration of inspirational reading for children. In addition to the Bible, he read his charges

Erckmann–Chatrian and the equally saccharine – but considerably less humorous – novels of Elizabeth Wetherall and Miss Mulock.[72] He also made use of Hans Christian Andersen's didactic *Fairy Tales*, which combine wild fantasy and lyrical description[73] with moral lessons and blunt portrayals of poverty, penitence, and death.[74] His own avocational reading in England was almost exclusively devotional; in addition to the Bible – which he read daily (LT73) and quoted often, widely, and sometimes at great length[75] – and the *Imitatio Christi*, Van Gogh made frequent allusions to John Bunyan's *The Pilgrim's Progress*, of which he declared himself "exceedingly fond" (LT82). Autobiographical at its core, this allegorical account of Christian struggle toward salvation is a mythical rendering of Bunyan's own conversion, which is presented as a long journey undertaken by a man burdened by sin. Calvinist theology and biblical quotations are the underpinnings of an episodic adventure story full of imaginary creatures, symbolic locales, and allegorical figures, but the aura of fantasy is held in check by earthy dialogue and the mundane details of daily life.[76] Published at the end of the seventeenth century, it had long enjoyed wide popularity, and Van Gogh may well have read it in his youth, but he was especially drawn to it in 1876, as he worked to attain sanctity in his own life – and in an English-speaking country. He mentally linked Bunyan's epic to a painting by George Henry Boughton that he liked to think of as "The Pilgrim's Progress,"[77] a picture he probably had seen while working in the art trade. In August 1876 he recalled it for Theo:

Did I ever tell you about that picture by Boughton, "The Pilgrim's Progress"? It is toward evening. A sandy path leads over the hills to a mountain, on the top of which is the Holy City, lit by the red sun setting behind the gray evening clouds. On the road is a pilgrim who wants to go to the city; he is already tired and asks a woman in black, who is standing by the road and whose name is "Sorrowful yet always rejoicing":

Does the road go uphill all the way?
 "Yes, to the very end."
And will the journey take all day long?
 "Yes, from morn till night, my friend."

The landscape through which the road winds is so beautiful – brown heath, and occasional birches and pine trees and patches of yellow sand, and the mountain far in the distance, against the sun. Truly, it is not a picture but an inspiration. (LT74).

The stanza of poetry that Van Gogh included is not by Bunyan, however, but rather by Christina Rossetti. Though Van Gogh never mentioned her by name, he often quoted or alluded to these particular lines, which open Rossetti's "Up-Hill," a poem in which Christian commitment is portrayed as an arduous journey.[78] Rossetti (1830–94) was familiar with *The Pilgrim's Prog-*

ress,[79] and her inspirational poetry sometimes bears the stamp of Bunyan, as Van Gogh clearly realized. He was inclined to think of Rossetti's lines in conjunction with Bunyan's book, and he tended to associate both with Boughton's painting – thus conflating textual and visual images of the same subject.

His description of Boughton's painting indicates that Van Gogh had not really rid himself of his love of pictures or pictorial writing.[80] Indeed, he included a verbal "reproduction" of Boughton's image (along with Rossetti's lines) in his first sermon, elaborating it with stronger color and with specific references to the visual field and the depth within it. Midway through, Van Gogh even moved his description into the present, the preferred tense of verbal pictorialists:

Our life is a pilgrim's progress. I once saw a very beautiful picture: it was a landscape at evening. In the distance on the right-hand side a row of hills appeared blue in the evening mist. Above those hills the splendour of the sunset, the gray clouds with their linings of silver and gold and purple. The landscape is a plain or heath covered with grass and its yellow leaves, for it was in autumn. Through the landscape a road leads to a high mountain far, far away, on the top of that mountain is a city whereon the setting sun casts a glory. On the road walks a pilgrim, staff in hand. He has been walking for a good long while already and he is very tired. And now he meets a woman, or figure in black, that makes one think of St. Paul's word: As being sorrowful yet always rejoicing. That angel of God has been placed there to encourage the pilgrims and answer their questions and the pilgrim asks her: "Does the road go uphill then all the way?" And the answer is: "Yes to the very end."

And he asks again: "And will the journey take all day long?"

And the answer is: "From morn till night my friend."

And the pilgrim goes on sorrowful yet always rejoicing – sorrowful because it is so far off and the road so long. Hopeful as he looks up to the eternal city far away, resplendent in the evening glow...[81]

Furthermore, in November 1876 Vincent even went so far as to ask Theo for a copy of the "picturesque" passage from Michelet he had forsworn the year before (quoted in the preceding section). In a multipage letter full of religious musings, biblical quotations, and devotional poems, Vincent wrote, "Do you happen to have kept that page from Michelet beginning, 'Je vois d'ici une dame' [From here I see a lady]? If you have, please copy it for me; I want it, but don't have the book anymore" (LT82a).

Yet despite occasional stirrings of his previous affection for them, art and literature remained temporarily relegated to the periphery of Van Gogh's thoughts in the era of his greatest piety – as is evident from the record of his short stint as a bookseller in the first months of 1877. Financial problems had forced him to leave England in December 1876, and on his return to Holland his family found a job for him at a bookstore in Dordrecht. At some other point in his life this might have been an ideal position for Van

Gogh; he later would remark that "so often, in the past, too, a visit to a bookshop has cheered me and reminded me that there are good things in the world" (LT112). At Dordrecht, however, he was preoccupied by his ambition to preach, and though he found himself surrounded by all manner of reading material, his only apparent interest was the Bible. "I read it daily," he wrote, "but I should like to know it by heart and to view life in the light of that phrase: 'Thy word is a light unto my path and a lamp unto my feet' " (LT88).[82] While he professed a particular interest in the life of Christ, which he studied from a catechism as well as from the Gospels (LT89, LT94), he made no reference whatsoever to Renan's *Jésus*.

After three months in the bookstore, Van Gogh won his final release from the world of commerce by convincing his family to support his desire to preach. His father apparently dismissed the idea of a lay training program in favor of the traditional clerical preparation he himself had had – that is, formal theological studies in a Dutch university – and to that end, Vincent was sent to Amsterdam, where he could be tutored for university entrance examinations under the watchful eyes of three uncles who lived there. One of them, the well-known Amsterdam preacher J. P. Stricker, guided his studies. Stricker engaged a professor of classics, Dr. M. B. Mendes da Costa, to help Vincent with Latin and Greek, and despite his conviction that classical languages were irrelevant to the sort of ministry he envisioned for himself,[83] Van Gogh studied them dutifully for more than a year. Since his course of study also included mathematics, geography, and world history, single-minded devotion to the Scriptures no longer was feasible, and despite his conscious effort to avoid "books and other things which I can very well do without, and which would divert my attention from the strictly necessary studies" (LT105), Van Gogh's year in Amsterdam served to broaden his horizons and reawaken old enthusiasms.

From the start of his stay in the city (May 1877–July 1878), Van Gogh's love of pictures strongly reasserted itself; he decorated his room with prints "to give it the right atmosphere, for that is necessary to get new thoughts and ideas" (LT95).[84] His letters contain several allusions to well-known works and indicate that he spent much of his free time in his Uncle Cor's art gallery in the Leidsestraat, where he examined prints and pictures and paged through a collection of journals that included *L'Illustration*, *L'Art*, and *Gazette des beaux-arts* (LT113, LT119, LT120). Van Gogh also visited the Trippenhuis (at that time the major art museum of Amsterdam) from time to time and frequented the shops of print-sellers. His enthusiasm for the print collection he had amassed in his own days as an art dealer returned, though his interest now took on a religious cast; as Mendes da Costa later recalled, Van Gogh "kept quite a number of the prints which he had collected ... lithographs after paintings, etc. He brought them to show me repeatedly,

but they were always completely spoiled; the white borders were literally covered with quotations from Thomas à Kempis and the Bible, more or less connected with the subject, which he had scrawled all over them."[85] Mendes's recollection not only attests to Van Gogh's penchant for intertwining texts and images, but also confirms that which his English sermon suggests: that he had become aware of art's potential as a tool of evangelism. If used to ignite spiritual yearnings, Van Gogh's mastery of art could be turned to worthy use and his continuing fascination with pictures justified. Indeed, the comments on art from his Amsterdam letters are indicative not so much of a connoisseur's love for beautiful or well-crafted objects as of a preacher's interest in finding effective prods to religious impulse. In August 1877, for instance, Van Gogh attributed his "irresistible longing" to reread the *Imitatio Christi* to a lithograph he owned;[86] a year later he reported that he was composing sermons for future ministerial use and noted that one such essay took Rembrandt's painting *The House of the Carpenter* as its subject (LT123).

Moreover, in Amsterdam Van Gogh's meditation on the Bible became increasingly visual in orientation. Within a month of his arrival he began to make impromptu sketches after passages that struck him; in late May, for instance, he reported:

Last week I read Gen. 23, Abraham's purchase of the field around the cave of Machpelah and the cave itself, for Sarah's burial. Involuntarily I made a little drawing of how the place appeared to me. (LT97)

By mid-June he remarked:

Now and then when I am writing, I instinctively make a little drawing.... This morning, for instance, Elijah in the desert, with the stormy sky, and in the foreground a few thorn bushes. It is nothing special, but I see it all so vividly before me. (LT101)

It is notable that Van Gogh insisted on characterizing such activity as the product of an impulsive instinct to make pictures from texts he read – as if his inclination toward visual imagery were something beyond his control. This may be seen as yet another means of excusing the love of art he still deemed too intense to be accommodated by his definition of piety.

In Amsterdam Van Gogh also warmed to secular literature again, though this was a more gradual process than his reimmersion in the world of images – and one that apparently was initiated by necessity. In his efforts to prepare for his entrance exams – an intellectual struggle he characterized as "*a race and a fight for my life*" (LT114; his emphasis) – Van Gogh relied on all manner of sources, from Hippolyte Taine (LT112) to Dickens's *Child's History of England* (LT114). His general studies dictated mastery of such diverse

narratives as Auguste Gruson's *Histoire des Croisades* (1844) and Fénelon's *Aventures de Télémaque* (1699), and eventually sparked the keen interest in the French Revolution that prompted him to read parts of Thomas Carlyle's account (LT112) and made him aware of Michelet's most important work, *Histoire de la Révolution française* (LT122).[87] Each of these four works – which drew particular praise from Van Gogh – has a notably religious dimension. Gruson's history of the Crusades is, by virtue of its subject, a Christian one, and though *Télémaque* poses as an action-packed "sequel" to the *Odyssey*, which recounts the adventures of Ulysses's son, it is a high-ranking clergyman's thinly veiled sermon on public and private morality.[88] Secular incident as recorded by Carlyle and Michelet often reveals the hand of a higher power;[89] though their respective visions of the Revolution are in some ways quite distinct,[90] they are linked in their allusions to this transcendent force. Carlyle's narrative is overlaid with sweeping moral reflections written in a biblical idiom,[91] and Michelet presents the Revolution as a kind of Second Coming – a religion in its own right through which all things are made new.[92] Carlyle and Michelet are also comparable in their conviction that historical personages and incidents should be imaged as vividly as possible before the mind's eye of the reader; each is known for his evocative descriptions and for a writing style that lends an aura of immediacy and authenticity to portrayals of the past.

Van Gogh's particular enthusiasm for the Revolution probably owed something to his earlier reading of Erckmann–Chatrian, and now – rekindled by the engaging pictorial prose styles of Carlyle and Michelet – it led him back to secular fiction. In October 1877 he lauded Dickens's *Tale of Two Cities* and claimed that in it – as in Carlyle's and Michelet's accounts – he found "something of the spirit of the resurrection and the life" (LT111). Indeed, resurrection is a haunting leitmotif of Dickens's novel, and in its final chapter the book's hero, Sydney Carton, ascends the guillotine with these words in mind: "I am the resurrection and the Life, saith the Lord: he that believeth in me, though he were dead, yet shall he live: and whoever liveth and believeth in me shall never die."[93] Carton, a dissipated drunkard who has squandered his talents, stands in for a wrongly condemned man (the husband of the woman he loves) and dies in his stead. In one of the most patently religious of his major novels,[94] Dickens shows Carton's life validated – and his spritual redemption effected – by the ultimate renunciation of worldly existence: a self-sacrificing death. Van Gogh found Carton "curiously striking" (LT133) and seems to have considered him an individualized exemplar of the general phenomenon of moral renewal through material destruction that informs Carlyle's and Michelet's accounts of the Revolution.[95] In an attempt to reconcile his pursuit of a devout life with his attraction to these secular authors, Van Gogh compared the amorphous

"spirit" of their writings to an equally vague representation of the spirit of the Bible – a tactic similar to that used to vindicate his resurgent interest in pictures. For a time, however, he remained conflicted about his renewed longing for nondevotional literature; even as he praised *A Tale of Two Cities* and admitted, "I should like to read more widely," Van Gogh checked himself, declaring, "But I must not; in fact, I need not wish it so much, for all things are in the word of Christ – more perfect and more beautiful than in any other book" (LT111).

At the same time – in the autumn of 1877 – he recanted earlier admonitions to his brother by allowing that Theo should "have a good time, [and] try to find something in art and in books" (LT111). His softened line on worldly pursuits is especially apparent in a letter of November 1877, wherein Vincent acknowledged receipt of the passage from Michelet he had once urged Theo to destroy. Reading it again in Amsterdam, he wrote:

Thanks for . . . that page from Michelet. . . . How noble and beautiful it is – with a peculiar, weird beauty, the finest expression of which we find in that story of Elijah near the brook Kishon and with the widow – it is written in simplicity of heart and simpleness of mind by one who was sorrowful yet always rejoicing. (LT114)

Over the next few months, Van Gogh became increasingly comfortable with the reading of nondevotional literature as he convinced himself that the products of secular culture could be made to serve spiritual aims. He seems to have been eager to make his brother understand these motives when in April 1878 he wrote:

As to being "homme intérieur et spirituel," couldn't that be developed by a knowl-edge of history in general and of particular individuals from all eras – especially from the history of the Bible to that of the Revolution and from the Odyssey to the books of Dickens and Michelet? And couldn't one learn something from the works of such as Rembrandt and from Breton's "Mauvaises Herbes," or "The Four Hours of the Day" by Millet, or "Bénédicité" by De Groux or Brion, or "The Conscript" by De Groux, or the one by Conscience, or "The Large Oaks" by Dupré, or even from "The Mills and Sandy Plains" by Michel?

. . . It is good to love many things, for therein lies true strength . . . If one is struck by some book or other – for instance, by Michelet . . . it is because it is written from the heart in simplicity and meekness of mind. . . .

One cannot do better than to hold onto the thought of God through everything, under all circumstances, at all places, at all times, and try to acquire more knowledge about Him, which one can do from the Bible as well as from all other things. (LT121)

His inclusive phrase, "all other things," clearly encompassed the works of art and literature he most admired. During his period of study in Amsterdam he had come to feel that "it is better to be high-spirited, even though one makes more mistakes, than to be narrow-minded and overprudent" (LT121),

and without relinquishing his faith, he made room for books and pictures. Perhaps because of the strength of his own convictions, Van Gogh no longer felt his religiosity threatened by art and literature that was not explicitly devotional. Instead he became increasingly attuned to implicit moral lessons – that which he once referred to as the "creed which all good men have expressed in their works" (LT121) – even in those secular works he had feared to the point of avoidance in the period of his great piety and penitence.

After more than a year of hard work, Van Gogh and his tutor decided he was not suited to the advanced academic work his father had envisioned for him. Vincent abandoned the goal of a degree in theology with little regret, but remained so adamant about pursuing a religious vocation that his father finally approved a less conventional course of action; in the summer of 1878 Van Gogh enrolled in a recently established training school for lay evangelists in Brussels.[96] Though he was the most advanced student in his class, his odd manner disturbed his teacher and peers,[97] and at the end of three months' training he received no nomination. As an alternative to a parochial assignment, however, he traveled on his own to a coal-mining district called the Borinage, where – funded by his father – he preached in a town meeting hall and proselytized from door to door. He won a temporary nomination to a coal-mining village in January 1879.

In the Borinage Van Gogh attempted to immerse himself in the life-style of his parishioners (LT129) and to that end relinquished the bourgeois lodgings provided him, gave away his clothes and possessions, and set out to learn what he could about the mines.[98] Though he taught and preached from the Bible (LT127, LT128, LT130), he soon ceased to quote Scripture in his letters.[99] The meditative and inward-turning, Kempis-inspired piety of his sheltered youth wilted quickly in his harsh new surroundings, for the miners' poverty, illiteracy, health problems, and hazardous working conditions clearly demanded something more than sermonizing. Van Gogh responded with a round-the-clock, hands-on ministry that involved nursing the sick and ill-nourished, as well as victims burned in a mine disaster, and if he began his mission in the Borinage as an evangelist in one sense of the word (i.e., one who preaches the Gospel), he soon aimed to embody the broader implications of the term: one so immersed in Christ's teachings as to live by – not just mouth – the words of the New Testament.[100] His efforts in that direction were duly noted by the overseeing committee who evaluated Van Gogh's six-month probationary period in the Borinage, but did little to further his career; his superiors found he lacked a "talent for speaking" and declined to renew his appointment.[101]

When another man was installed in his place in October 1879, Van Gogh abandoned his dreams of a lay ministry[102] and entered a period of deep depression, living from hand to mouth and severing all but the most rudi-

mentary ties to his family for some twenty months. Upon his reemergence in July 1880, he wrote his brother a long letter (LT133) in which he accounted for his time; he described a period of reading and reflection on art and literature – and their mutual relation to spiritual pursuits. Declaring his belief that "the best way to know God is to love many things," Van Gogh elaborated:

To give you an example: someone loves Rembrandt, but seriously – that man will know there is a God, he will surely believe it. Someone studies the history of the French Revolution – he will not be unbelieving, he will see that in great things also there is a sovereign power manifesting itself. . . . To try to understand the real significance of what the great artists, the serious masters, tell us in their masterpieces, *that* leads to God; one man wrote or told it in a book; another, in a picture.

In the conviction that "the love of books is as sacred as the love of Rembrandt," he indulged the "more or less irresistible passion for books" that he had reined in so long (LT133). Though his finances and location surely limited his choices, he had ample time for avocational reading and in addition to the Bible read Michelet, Shakespeare,[103] and some prime examples of the sorts of crusading "issue novels" to which he increasingly was drawn: Harriet Beecher Stowe's *Uncle Tom's Cabin*, Charles Dickens's *Hard Times,* and Victor Hugo's *Le Dernier Jour d'un condamné.*

SECULAR GOSPELS

The interest in social reform that informed Van Gogh's literary preferences in the 1880s had roots in his religious upbringing and blossomed in the Belgian coal country, where his observations and experiences challenged his original concept of evangelism and reconfigured his notions of Christianity and Christian commitment. The realization that Scripture could not offer concrete solutions to specific modern dilemmas led him away from preaching toward active involvement in his community, and his resultant dismissal by church authorities exacerbated his dissatisfaction with traditional Christian ministries, which he came to see as outmoded and hypocritical. Van Gogh severed his connections to organized religion, but did not renounce his faith; instead he sought an alternative vessel for his Christian convictions in a self-styled religious humanism that drew on the ideas of several nineteenth-century novelists, philosophers, and social crusaders, including Eliot, Michelet, Carlyle, Beecher Stowe, Dickens, and Hugo. Van Gogh came to see their writings as modern equivalents of the Gospels (see LT160, LT161, LT164), and under the impact of his dreary surroundings and these eloquent secular sermonizers, he channeled what remained of his religious zeal toward humanitarian issues.

His espousal of nineteenth-century causes like workers' rights ultimately was more verbal than active, and his reactions often naïve (as well as class-, race-, and gender-conditioned),[104] but from 1879 onward Van Gogh was wont to characterize himself as a liberal workingman committed to social change, and he routinely endorsed books and authors he judged to be reform-oriented. During his first year in the Borinage, Van Gogh read two such books: Harriet Beecher Stowe's landmark antislavery novel, *Uncle Tom's Cabin* (1852), and Charles Dickens's *Hard Times* (1854), a consciousness-raising account of life in an increasingly industrialized society. Though each had been written a quarter-century earlier – and in another country – Van Gogh found these volumes quite topical.[105]

Uncle Tom's Cabin, which details multiple offenses perpetrated upon African-Americans in the mid-nineteenth century, became a particular favorite of Van Gogh's. Though it has been widely criticized in the twentieth century as a perpetuator of offensive stereotypic views of both blacks and women,[106] the book constituted an earnest attempt to bring a sore subject to the fore – and as one of the best-sellers of its time, it succeeded in that goal. Like Van Gogh, Beecher Stowe was a minister's child who had lost faith in the church's determination to *act* in important, real-world arenas.[107] She turned her own Christian values to social commitment and considered abolition no mere secular goal but the will of God.[108] In both tenor and detail, her novel bears the stamp of the Bible,[109] and in this respect it must have seemed particularly accessible and "true" to Van Gogh. Its protagonist, Uncle Tom – whose name has since become a label of scorn – is drawn as a Christ-like martyr who consistently turns the other cheek, answering mistreatment with love and forgiveness. Tom is but the central victim among many whose stories form the intricate plot of this rambling and melodramatic denunciation of society's mistreatment of its weakest members (for, indeed, Beecher Stowe presents blacks – like women and children – as inherently weaker than adult white males).

From *Uncle Tom*'s tangle of specific incidents and characters Van Gogh seems to have extrapolated a central premise and its possibilities for broad interpretation, for he wrote, "There is still so much slavery in the world, and in this remarkably wonderful book that important question is treated with so much wisdom, so much love, and such zeal and interest in the true welfare of the poor oppressed that one comes back to it again and again, always finding something new" (LT130). Read thus, as a generalized plea against exploitation of the "poor oppressed" – whoever and wherever they might be – Beecher Stowe's social critique could sustain wide application (e.g., to the plight of Belgian miners) in the postabolition era. This seems to have been what Van Gogh was driving at when he assured Theo, "In *Uncle*

Tom's Cabin . . . the artist [*sic*][110] has put things in a new light; in this book, though it is becoming an old book already – that is, written years ago – all things have become new" (LT130). Contemporary critics might argue that Van Gogh was buying into the patronizing attitude that taints Beecher Stowe's novel – and his later peasant portraits[111] – by viewing his mining neighbors as latter-day slaves to be pitied from the empowered vantage point of a bourgeois commentator. But if both Beecher Stowe and Van Gogh were naïvely sentimental in their concern for the "welfare of the poor oppressed," each was undeniably sincere in the search for a Christian response to societal inequities. *Uncle Tom's Cabin* struck a deep chord in Van Gogh at the Borinage – where he read from it often (LT130) – and later in his life he would indeed return to it.[112]

Within weeks of mentioning *Uncle Tom's Cabin*, Van Gogh read *Hard Times* – a book that also applies Christian sentiment and biblical language to secular issues and is widely criticized today for its bathos and simplistic social vision. Set in a class-divided English factory town at midcentury, the novel is a lament for the working poor exploited and dehumanized by arrogant industrialists who flourish at their expense and a satiric indictment of smugly intellectual bourgeois who rely on rationalist philosophy to release them from their Christian duties toward the underclass.[113] Most particularly, the novel pits a self-satisfied banker–factory owner against one of his employees, the mill worker Stephen Blackpool. Though Dickens meant him to be a compelling mouthpiece for mistreated working people, Blackpool's passivity, befuddlement, unexplained motives, and ineffectual actions have generated disbelief and hostility among modern critics,[114] and although *Hard Times* is an ambitious social gospel,[115] its message, if well intentioned, is essentially reactionary, for Dickens – who was deeply suspicious of collective action toward reform – denounces burgeoning unionism. A heavy overlay of sentimentality obfuscates hard issues, and the author's proposed remedy to workers' problems – a vague admixture of religious sentiment and humanitarian concern on the part of benevolent employers who have been made to see the light – today seems not only unrealistic, but detrimental to the cause it highlights.[116]

Van Gogh, however, responded to Dickens's best intentions and felt pity for the mistreated laborers of *Hard Times;* like the author, he was a middle-class man whose sense of Christian duty inspired concern for the workers' plight – even as his class affiliation hindered his full comprehension of that plight and sentimentality clouded his vision. He seems to have found the novel particularly pertinent to his own experience of the Borinage – so much so, in fact, that when he described *Hard Times* four years later, he recalled Blackpool as a miner (see R30). In the summer of 1879, as he urged Theo

to read the book, Van Gogh wrote, "It is excellent; in it the character of Stephen Blackpool, a working man, is most striking and sympathetic" (LT131). Though he made no allusion to the novel's asides on religious practice, Van Gogh probably found this aspect of *Hard Times* applicable to his situation as well, for Dickens draws a clear distinction between the church- and chapelgoing of a self-righteous urban elite[117] and the direct experience of God that sporadically illumes the laborer's drab existence.

In the winter of dark depression that followed his dismissal (1879–80), Van Gogh reread Beecher Stowe and Dickens, and also became interested in the work of Victor Hugo, an extremely prolific novelist of sweeping Romantic vision whom Van Gogh compared to Delacroix (LT133).[118] Though Van Gogh claimed to have "studied" more than one of Hugo's books that winter (LT136), just a single title, *Le Dernier Jour d'un condamné*, occurs in his letters of the era, and this specific mention hints that he considered the book particularly notable. *Dernier Jour* (1829), a scathing critique of the French penal system under the Restoration government and an ardent denunciation of the death penalty, is an unusually short (100 pages) and stark book for Hugo. Written in the first-person singular, it records the musings of a solitary prisoner condemned to die, and since the crime and identity of the narrator remain unknown, he becomes an "everyman" of sorts – though a decidedly well-read and cultured one, with whom middle-class readers may identify.[119] Though Van Gogh may have picked up *Dernier Jour* by chance,[120] it probably struck an empathic note during this period in which he portrayed himself as "imprisoned in some cage" (LT133). In fact, Hugo's book may have inspired his elaborate imaging of himself as a creature entrapped; in a letter to Theo, Van Gogh pushed this metaphor, insisting, "Circumstances often prevent men from doing things, [and make them] prisoners in I do not know what horrible, horrible, most horrible cage.... A justly or unjustly ruined reputation, poverty, unavoidable circumstances, adversity – that is what makes men prisoners" (LT133). Beyond its apparent applicability to this self-image, Hugo's book surely appealed to Van Gogh as a humanitarian work that championed the "poor oppressed."[121]

His interest in Hugo might also be tied to Van Gogh's language shift in Belgium. Though he had learned French some years earlier, he seems to have made great strides toward complete mastery while living amid the miners,[122] and when he broke an eight-month silence by writing Theo a multipage letter in July 1880, he wrote in French instead of Dutch. He continued to do so until his return to Holland in April 1881.[123] There, he resumed correspondence in his native tongue, but his interest in French literature continued and indeed became more pronounced, for in rural Holland Van Gogh seems to have seen French as a means of mental transport from the provincialism of his upbringing and the conservatism of his parents. In November 1881, for instance, he told Theo:

Father and Mother are getting old, and they have prejudices and old-fashioned ideas which neither you nor I can share anymore. When Father sees me with a French book by Michelet or Victor Hugo, he thinks of thieves and murderers, or of "immorality"; but it is too ridiculous, and of course I don't let myself be disturbed by such opinions. . . . But then they bring up a story of a great uncle who was infected with French ideas and took to drink, and so they insinuate that I shall do the same. Quelle misère! (LT159)

Van Gogh's conviction that French authors were progressive doubtless was encouraged by his father's stodgy denunciation of them; the French language in and of itself seems to have incited the wrath of the Reverend Van Gogh, and his presumption of the foreign books' unseemliness apparently elated his now-rebellious son.

Van Gogh had returned to Holland to prepare for yet another career – as a graphic artist. He had begun to draw in earnest in Belgium in 1880, and by early 1881 wrote of his "hope to arrive at the point of being able to illustrate papers and books" (LT140). He felt his aspirations would be well served by reading, for "not only does drawing figures and scenes from life demand a knowledge of the technique of drawing, but it also demands profound studies of literature, physiognomy, etc., which are difficult to acquire" (LT140). In the spring of 1881 he took up residence in his parents' home, where he sought both financial and emotional support, but in the years apart from his family Van Gogh had discarded many of their values, and once settled at the vicarage in Etten (a farming community) he often found himself at odds with his parents and sisters. Intrafamilial hostilities worsened that summer, when Van Gogh fell in love with Kee Vos – a recently widowed young cousin who had come to visit – and pursued her against her wishes and over his parents' ardent objections.[124] Thwarted in love, and increasingly alienated from those around him, Van Gogh wrote long letters to his brother and took refuge in his books. To Theo he confided a desire "to work . . . systematically to get at least an idea of modern literature" and prided himself on his ability "to read a book in a short time without difficulty and to keep a strong impression of it," for "in reading books, as in looking at pictures, one must admire what is beautiful with assurance – without doubt, without hesitation" (LT148). His artistic ambitions rekindled his appreciation of picturable prose, and he clearly was drawn to that aspect of books by Dickens, Hugo, Honoré Balzac, and Charlotte Brontë.[125]

The author who held greatest sway in Van Gogh's thoughts in the early 1880s was not a novelist, however, but the historian and social philosopher Jules Michelet – a writer he admired on many levels. The producer of a highly imagistic prose that Van Gogh had appreciated since his days in the art trade, Michelet was also a self-proclaimed champion of the people, an advocate of real-world religiosity, and an author who had devoted two volumes to his ideas on love and marriage. His liberal bourgeois political

ideology – the generalized and pious hope that the social classes would cordially coexist with mutual love and understanding[126] – was roughly congruent with Van Gogh's, as were his anticlerical sentiments and complementary interest in "social gospels" that addressed secular issues in a biblical spirit.[127] In 1881 Van Gogh ranked Michelet's work beside the Bible and took the author as an idealized mentor and father figure.

Over a period of years (c. 1877–80), Van Gogh had read and reread Michelet's history of the French Revolution, and he obviously embraced the author's Christianized reading of that tumultuous time. That Van Gogh came to regard the Constitution of 1789 as "the modern Gospel, no less sublime than that of 1 A.D." (R35) is striking evidence of his esteem for Michelet, who in his account compares the drafting of that document to the virgin birth at Bethlehem. In 1880–1, however, Van Gogh seems to have been much more interested in Michelet's ahistorical treatises on domestic relations: *L'Amour* (1858), an old favorite that he now reread, and its near clone, *La Femme* (1859), which he discovered with delight. These two books – written about a decade after Michelet began his *Histoire de la Révolution française* – constituted something of a retreat for the author; dismayed by continuing social upheaval in France, Michelet looked to marriage and family as timeless bastions of stability, and in these volumes he presents the well-maintained wife and home as the ultimate refuge from the uncertainties of modern life.[128] Addressing a middle-class male audience,[129] Michelet preaches the sacredness of conjugality and – as he expounds on the vagaries and frailties of the female mind and body – offers advice on the successful care and tutelage of one's wife.

Though twentieth-century readers seem to have little patience for the preachy side of Michelet,[130] Van Gogh celebrated it as an updated alternative to Scripture; in November 1881 he told Theo:

I think you will derive more profit from rereading Michelet than from the Bible.

As for me, I could not do without Michelet for anything in the world. It is true the Bible is eternal and everlasting, but Michelet gives such very practical and clear hints, so directly applicable to this hurried and feverish modern life in which you and I find ourselves, that he helps us to progress rapidly; we cannot do without him. (LT161)

By contrast, Van Gogh noted, "Father and Mother are very good at heart, but have little understanding of our inner feelings, and ... in many cases they cannot give us practical advice" (LT155). One such case, clearly, was his ill-fated love for Kee Vos, and rejecting his parents' counsel Van Gogh instead turned to "father Michelet,"[131] who "expresses completely and aloud things which the Gospel whispers only the germ of" (LT161). "When this love took root in my heart," he wrote, "I reread Michelet's book *L'Amour et la Femme*

[*sic*], and so many things became clear to me that would have otherwise been riddles. I told Father frankly that under the circumstances I attached more value to Michelet's advice than to his own, if I had to choose which of the two I should follow" (LT159). Michelet's sentimental and often patronizing view of woman as an endearingly alien creature whose fragility demands compassionate protection had a permanent impact on Van Gogh's vision of the opposite sex; he memorized certain Micheletian maxims on women that cropped up in his letters to the end of his life (see, e.g., LT617). In 1881, however, his interest was urgent, as unrequited love impelled an almost frantic effort to get a handle on the female psyche. His preoccupation with love and marriage in this era apparently also inspired Van Gogh's keen interest in the late, domestic novels of Harriet Beecher Stowe and in Charlotte Brontë's compelling tales of thwarted passion, *Shirley* and *Jane Eyre*.

In *My Wife and I* and its sequel, *We and Our Neighbors* (both published in 1871), Beecher Stowe once again directed her religious convictions toward social and political issues. Written in the wake of the Civil War, these novels preach the restoration of moral order in the United States through a practical piety that begins in the home.[132] Berating suffrage as a divisive force, Beecher Stowe calls on women to recognize the sanctity of their mission as wives and mothers and work to attain feminine dignity and self-fulfillment within their rightful contexts: home and family. Beecher Stowe promotes her gender in terms of what she considers its strong suits – spirituality, nurture, compassion – and assures the reader that even cooking and home decoration can express and promote religious feeling.[133] Van Gogh found her ideas laudable and instructive, and noted, "Michelet and Beecher Stowe... don't tell you the Gospel is no longer of any value but they show how it may be applied in our time, in this our life, by you and me, for instance" (LT161).

Of Brontë's two novels, Van Gogh – unlike most nineteenth-century readers – seems to have preferred *Shirley* (1849),[134] which presents modern courtship dilemmas against a chaotic social, economic, and political background. Set in the author's native Yorkshire in the era of the Napoleonic Wars, the book takes as its foci the mechanization of the cloth trade and attendant divisions between labor and management, and parallel imbalances of power – based on wealth, class, and education – in the love relationships of its protagonists.[135] Though it is a socially engagé novel that addresses the burning midcentury issues of workers' rights and the role of women, *Shirley* ultimately proffers a standard Victorian remedy: love. What sets Brontë apart from her contemporaries, however, is the *sort* of love she advocates: a self-fulfilling and passionate love that has the power to override social convention and the abstemious forbearance advocated by clerics.[136] In *Jane Eyre* (1847) especially, Brontë insists on a woman's right to assert herself and satisfy her own, private needs; the eponymous protagonist, driven

by want of love and affection, rejects submissive and saintly self-denial and instead chooses to fight for a mundane goal: union with the man she loves.

Brontë was yet another disenchanted minister's child,[137] and her anti-church attitudes and defense of worldly satisfactions found a receptive audience in Van Gogh, who had become disillusioned with clergymen and with the "system of resignation, and sin, and God" they preached (LT164).

The clergymen call us sinners, conceived and born in sin, bah! What dreadful non-sense that is. Is it a *sin* to love, to need love, not to be able to live without love? I think a life without love a sinful and immoral condition.

If I repent anything, it is the time when mystical and theological notions induced me to lead too secluded a life....

I love, and how could I feel love if I did not live and others did not live; and then if we live, there is something mysterious in that. Now call it God or human nature or whatever you like, but there is something which I cannot define system-atically, though it is very much alive and very real, and see that is God, or as good as God. (LT164)

Increasingly satisfied with a personal morality unfettered by the cold narrow-mindedness he ascribed to most clergymen, Van Gogh scorned his father as a member of the enemy camp. "I cannot be reconciled to Father's system," he wrote. "It oppresses me, it would choke me. I too read the Bible occa-sionally just as I read Michelet or Balzac or Eliot; but I see quite different things in the Bible than Father does, and I cannot find at all what Father draws from it in his academic way" (LT164). What Van Gogh sought in the Bible and modern literature were workable solutions to real dilemmas and affirmation of the value of daily life and worldly experience. He favored those "few authors," he said, who "look at things in a broader, milder and more loving way than I do...because they know life better" (LT164).

In a letter to his brother written toward the end of 1881, Van Gogh tried to summarize the message he had gleaned from the secular gospels of nine-teenth-century literature. Though the authors he invoked were born of an-other age and almost all dead,[138] he saw them as laudably modern leaders of a new generation – his own. He embraced their spirit of reform and saw their morality as an active, workable one that could be applied to both societal and personal problems, even as it seemed touched by God:

For myself I learn much from father Michelet. Be sure to read *L'Amour et la femme* [*sic*], and if you can get it, *My Wife and I,* and *Our Neighbors* [*sic*] by Beecher Stowe, or *Jane Eyre* and *Shirley* by Currer Bell [Charlotte Brontë's pseudonym]. Those people can tell you more and better things than I can.

The men and women who may be considered to stand at the head of modern civilization – for instance Michelet and Beecher Stowe, Carlyle and George Eliot and so many others – they call to you:

"Oh man, whoever you are, with a heart in your bosom, help us to found

something real, eternal, true; limit yourself to one profession and love one woman only. Let your profession be a modern one and create in your wife a free modern soul, deliver her from the terrible prejudices which chain her. Have no doubt of God's help if you do what God wants you to do, and God wants us in these days to reform the world by reforming morals, by renewing the light and the fire of eternal love. By these means you will succeed and at the same time have a good influence on those around you...."

In my opinion these are the words that Michelet says to us in general. We are full-grown men now and are standing like soldiers in the rank and file of our generation. We do not belong to the same one as Father and Mother and Uncle Stricker; we must be more faithful to the modern than to the old one – to look back toward the old one is fatal. If the older people do not understand us, it must not upset us, and we must go our own way against their will; later on they will say of their own accord, Yes, you were right after all. (LT160)

By the end of 1881, Van Gogh was a wide-ranging and serious reader who saw his life, his work, and his reading as closely interconnected. Even as his personal concerns and interests influenced his literary preferences, his literary pursuits colored his perception of people, events, and circumstances. For Van Gogh, reading was not so much a pastime as a source of information and a tool he could use to understand and interpret his experiences. His artistic aspirations and his Christianity turned liberalist zeal made him especially receptive to writers who put pictorialist prose at the service of social commitment, and these paired interests made Van Gogh a ripe target for Zola's Naturalism – a movement he would explore and embrace in 1882, when his pursuit of his art led him to The Hague.

VAN GOGH IN THE HAGUE
The Artist Meets French Naturalism

Van Gogh's interest in French Naturalist literature blossomed at The Hague in 1882, when, impressed by a Zola novel he encountered by chance, he set out to master that author's oeuvre. Having done so with dispatch, he soon moved on to other writers of a similar stripe: Alphonse Daudet and Edmond and Jules de Goncourt. In just a few months' time, he navigated a new literary terrain – one that if unfamiliar to Van Gogh was well charted by The Hague's intelligentsia. Recent French novels enjoyed considerable vogue in Holland's cultural capital, and Van Gogh found his newborn enthusiasm mirrored by journalists and academics as well as by his artist peers.

One of the main motivations for Van Gogh's move to the city was his desire to study with Anton Mauve, a prominent painter of the Hague School.[1] Under Mauve's tutelage, Van Gogh at The Hague not only honed his drawing skills but began work in watercolor. His concurrent association with a younger painter, George Hendrik Breitner, encouraged him to expand his artistic repertoire by addressing urban street life – a subject realm that Hague School painters eschewed, but one that novelists like Zola, Daudet, and the Goncourts reveled in. Thanks in part to his relationship with Breitner, Van Gogh became convinced that Naturalist readings complemented his artist's aims (R34, R35).

Though his sense of the inherent interconnectedness of art and literature strengthened during his twenty months at The Hague, it continued to be vague. Even as he nursed an ambition to become a professional graphics artist, Van Gogh disclaimed illustrational art and was dismissive of those who did not understand his personal conception of the satisfying if loose linkage of images to texts (R12). Though certain works of his Hague period are thematically comparable to literary Naturalism, Van Gogh, wary of "the illustrative" (R12), conscientiously avoided it. Nonetheless, his approach to

his subjects and his ideas about art making were enriched and encouraged by his burgeoning acquaintance with Naturalist practice and theory.

SOCIAL AND CULTURAL LIFE AT THE HAGUE

In the first half of 1882, Van Gogh found little time to read. Pursuit of his artist's ambitions consumed most of his waking hours;[2] moreover, he was less solitary in this era than at any previous time in his adult life, enjoying the company of a lover as well as the camaraderie of fellow artists. About two weeks after his arrival in The Hague, he took in a sickly, pregnant prostitute whom he fondly called Sien[3] and with her formed the single conjugal relationship of his life. Sien brought a young daughter with her when she moved in and in July 1882 gave birth to a son (not Van Gogh's), who also joined the household. The four of them cohabited until Van Gogh left The Hague in September 1883. Though Mauve and others condemned his mistress and his domestic situation, Van Gogh willingly endured social ostracism in order to pursue a family life of sorts, and with the aid of Micheletian maxims – for example, "Woman is a religion" (LT215) or "Why is there a woman alone on earth?" (LT267) – he put Sien and his devotion to her in the most positive light possible.[4] In an 1882 letter to Theo he asserted, "Last year I wrote you a great many letters full of reflections on love. Now I no longer do so because I am too busy putting those same things into practice" (LT195).

In addition to this intimate involvement at home, Van Gogh in early 1882 became caught up in new professional alliances at The Hague. Before the estrangement occasioned by Van Gogh's liaison with Sien, Mauve did what he could to facilitate his young protégé's entry into the artistic community there. Since 1870 the most advanced Dutch artists had congregated at The Hague, drawn by the beauty of the city and its surroundings as well as by its pool of wealthy patrons.[5] In addition to Mauve, the most prominent artist residents during Van Gogh's stay were Jozef Israëls; Hendrik Willem Mesdag (who had just completed his ambitious *Panorama*); the Maris brothers – Jacob, Matthijs (often called Thijs), and Willem – all of whom were born at The Hague; and Hague natives Adolphe Artz, Bernard Blommers, and Jan Hendrik Weissenbruch. The existence of an identifiable "school" of painters in the city was first noted in 1875, by the well-known journalist Jacob van Santen Kolff.[6] In an article for a newly founded journal, *De Banier*, Van Santen Kolff described artists and pictures he found representative of a new trend in Dutch painting. While declaring himself pleased by the Hague School's "iconoclast" tendencies, the critic only reluctantly labeled its products "Realist" and was careful to emphasize that the new painting featured

a "healthy" mix of truth and art.[7] In fact, Hague School painting drew heavily on French art of previous decades, most notably that of the Barbizon School and Millet. Like those French antecedents, the Dutch artists rejected traditional narratives in favor of themes from daily life, but avoided urban subjects to produce a nostalgic rural realism.[8]

Two years after his initial article on the Hague School, Van Santen Kolff took a longer and closer look at its adherents and their predilections. In a second *Banier* piece, he addressed French precedents for the new Dutch art – not only in Barbizon paintings, but also in recent Realist fiction. He compared Hague School artists' attempts to capture "life, man and nature as they are" to that which Flaubert, Zola, Alphonse Daudet, and Gustave Droz had already achieved in print[9] and posited a loose connection between trends in literature and art. Van Santen Kolff referred to a shared "spirit" – away from Romanticism and toward Realism – but did not suggest any specific parallels, for few if any existed. Nonetheless, his remarks on the interconnectedness of the arts anticipated Dutch painters' profound interest in French literature in the 1880s.

Sister arts interaction at The Hague was most actively promoted by a club called the Pulchri Studio. Founded as a drawing society in 1847, Pulchri soon began to admit writer members as well, and by 1880 it was a cultural mecca where painters and literati mingled. In addition to evening drawing sessions, Pulchri organized exhibitions of members' work and staged weekly farces, pantomimes, and tableaux vivants after famous pictures, entertainments that fostered collaboration between painters and writers.[10] Through Mauve's connections, Van Gogh was granted a special membership at Pulchri, and in the first months of 1882 he drew there and sometimes attended the club's productions. Even after Mauve's friendly feelings toward him cooled, Van Gogh remained on good terms with other members.

In addition to occasional meetings with the older, prominent Pulchri artists, Van Gogh had more intimate contact with Théophile de Bock (a contributor to Mesdag's *Panorama*) and a short but fruitful friendship with George Hendrik Breitner (another of the *Panorama* collaborators). Breitner (1857–1923) had moved to The Hague in 1880, but did not follow in the footsteps of the older generation there; in contrast to the artistic establishment, he painted scenes of urban life.[11] His fascination with the city's popular quarters was fueled by the French Realist fiction he favored – particularly by the novels of the Goncourt brothers[12] – and Breitner encouraged Van Gogh's interest in depicting street life, which they sometimes sketched together (LT174, LT178, LT181). One early product of their urban sketching, a small pen and pencil drawing by Van Gogh (Fig. 1), shows a range of working-class types. Glimpsed from behind and afar, they are distinguished by costume, props, and posture rather than particularized physiognomies.

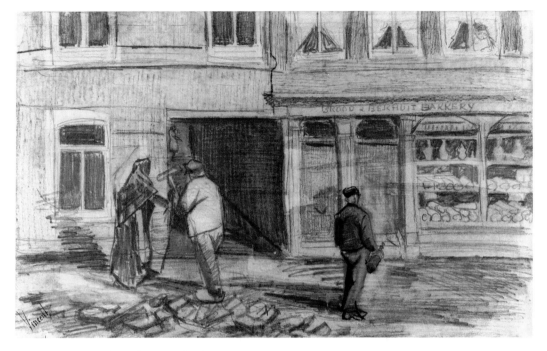

Figure 1. Van Gogh, *Bakery on the Geest*, 1882.

Labor – in the form of a burly, mallet-wielding street paver – coexists with shopping and social exchange, and the cluster of figures at left contrasts and underscores the solitariness of the bottle carrier at right. This compositional imbalance, in combination with the broad, loose marks in the foreground, suggests a random and quickly transcribed slice of action, but this apparently was not the case. Instead Van Gogh developed individual figures separately and built the composition piece by piece,[13] then signaled its completion with the signature at lower left.

Breitner was keenly interested in literature and in illustration,[14] and though Van Gogh was not doing much reading in the era of their friendship, he doubtless discussed books with his well-read friend. Almost certainly they talked about Alfred Sensier's recent biography of Millet (1881),[15] which each of them read soon after its publication, and in the same genre, both Van Gogh and Breitner read the Goncourts' *Gavarni, l'homme et l'oeuvre* (1873).[16] They probably also exchanged thoughts on Dickens – a chronicler of urban life whom both had long admired – and very likely each encouraged the other to read authors he had not yet experienced. Breitner, for instance, is thought to have read Michelet's *L'Amour* at Van Gogh's instigation,[17] and he in turn probably was responsible for inciting Van Gogh's interest in French Naturalism. At the time of their acquaintance, Breitner's knowledge of literature was much more up-to-date than Van Gogh's, and his tastes

more progressive. Whereas Van Gogh in 1882 characterized himself as "practically uninformed about what is being published nowadays" (R13), Breitner had read the novels of Flaubert, Zola, and the Goncourt brothers. The last-named were his favorite authors, and he considered *Manette Salomon* (1867) – a fictional account of artistic life in Paris – "one of their most beautiful creations."[18] Since Breitner noted (in a letter of November 1881) that he recommended that novel to "everyone, painters and nonpainters alike,"[19] he surely suggested that Van Gogh read it in the spring of 1882, and when Van Gogh eventually read his first Goncourt novel – a year later – he credited Breitner (who lent him *Soeur Philomène* [LT301]). In the meantime, without actually reading the Goncourts' fiction,[20] Van Gogh surely gained some sense of its character through his association with so outspoken an aficionado as Breitner.

Van Gogh's regular contact with his new friend was abruptly curtailed in April 1882 when Breitner entered the hospital for a long stay; after his release, Breitner took a teaching job at Rotterdam, and the two did not see one another again for almost a year. Van Gogh himself was hospitalized with a venereal disease for three to four weeks in June, and Sien was confined at the end of that month and gave birth on 1 July. After he, she, and her newborn son went home in early July, Van Gogh began a period of renewed and increasing isolation, during which he saw almost no one but Sien and her family. In keeping with his former habits, he turned to books in his solitude and read voraciously again during this era of ostracism and self-imposed exile.

ACCELERATED LITERARY PURSUITS AND THE ASCENDANCY OF ZOLA

Having entered the hospital armed with books to pass the time, Van Gogh began to read again during his convalescence. He had brought along a few volumes of Dickens and expressed enthusiasm for that author's unfinished last novel, *The Mystery of Edwin Drood*,[21] but by late June he complained to Theo that he had nothing left to read (LT208). Within a few days, however, he came across a copy of Zola's *Une Page d'amour* (1878), and in early July Van Gogh wrote of Zola for the first time – as an "artist" whose writings elicited a visual response. "Up to now," he wrote, "I knew only a few short fragments of his works, for which I tried to make an illustration – 'Ce que je veux' and another fragment which describes a little old peasant, exactly like a drawing by Millet" (LT212). Now, on reading *Une Page d'amour*, Van Gogh compared its elaborate descriptions of Paris to Theo's recent attempts at word painting, as well as to his own recollections of the French capital:

I want to tell you that the part of your letter describing Paris by night touched me very much. Because it brought back to me the memory of when I too saw "Paris tout gris," and was struck by that very peculiar effect with the black figure and characteristic white horse which gave the full value to the delicacy of that unusual gray. That little dark note and that toneful white are the key to the harmony. But by chance, while I was in the hospital, I was greatly impressed by an artist who describes this "Paris tout gris" with a master hand. In *Une Page d'Amour* by Emile Zola, I found some views of the city so superbly painted or drawn, quite in the same mood as the simple passage in your letter. And that little book prompts me to read everything by Zola. (LT212)

One can only speculate on the particulars that led Van Gogh to read Zola's *Une Page d'amour* during his stay in the hospital,[22] but given the vogue that recent French literature enjoyed among artists in The Hague in the early 1880s, it was almost inevitable that he read Zola during his residence there.

The first published notice of Zola's fiction appeared in Holland in 1873, when the critic Coenraad Busken Huet announced the publication of the first volume of the Rougon-Macquart series (*La Fortune des Rougon*, 1871).[23] Although Busken Huet predicted that Zola's work would have little appeal for the average Dutch reader, the novels caught on quickly, and by 1880 Zola's oeuvre was well known and much discussed in Holland.[24] A good deal of the Dutch interest in Zola was generated and shaped by the lectures and writings of Dr. Jan ten Brink, a lycée professor at The Hague (later a professor at the University of Leiden) and longtime member of the Pulchri Studio, who as editor in chief of *Nederland*, literary editor of *De Amsterdammer,* and a regular contributor to *Nederlandsche Spectateur,* was a familiar and respected arbiter of the literary scene. Ten Brink first read Zola in 1875 and in the following year discussed his work in a forty-page essay for *Nederland* entitled "The Latest Romantic School in France."[25] It was followed in 1877 by a four-part series of articles on Zola in which Ten Brink dubbed him a "literary Hercules"[26] and then by a number of shorter notices.[27] In 1879 Ten Brink combined past appraisals with some new material to produce a Zola monograph that was published at The Hague.[28] By the time Van Gogh chanced upon *Une Page d'amour,* he probably had read some of Ten Brink's criticism, and even if that was not the case, as a resident of The Hague, marginal member of Pulchri, and dedicated reader, he doubtless was indirectly aware of Ten Brink's widely disseminated views on Zola and contemporary French literature.

Though the title of Ten Brink's first piece on Zola's work indicates his awareness of its connection to earlier, Romantic fiction, the critic clearly was taken with its more up-to-date aspect – the usurpation of terms and procedures of the natural sciences; and his essays indicate an almost unquestioning acceptance of Zola's inflated theoretical proclamations and sci-

entific pretensions. But if Ten Brink appreciated the thoroughness of Zola's preparatory studies and the resultant strength of his descriptions and characterizations,[29] he remained uneasy with the Naturalist's ostensible dedication to the most banal reality.[30] Convinced that the "weak side" of French Realism resided in its subject matter (not only in the work of Zola, but also in that of Balzac and Flaubert), Ten Brink reminded Zola and his school that the writer should remain an artist when choosing his material.[31] And even as the Dutch critic admitted that realism was the inevitable course of nineteenth-century art, he warned his audience that the reality Zola chose to depict was sometimes horrible and shocking, demanding unflinchingness on the part of readers who sought to appreciate the author's "manly spirit" and "Herculean strength."[32]

Ten Brink's reviews of the late 1870s inspired great curiosity about and much enthusiasm for Zola's work, and were particularly influential among the Tachtigers, a group of young writers who emulated the czar of Naturalism in their own novels.[33] Their embrace of French Realism constituted a significant turnaround in prevailing literary taste and production, for most nineteenth-century Dutch literature before 1880 consisted of edifying and didactic writings by clergymen like De Genestet.[34] Taking recent French fiction as their model, the Tachtigers began to treat formerly taboo subjects in a blunt manner, and Zola's oeuvre in particular was widely and consciously imitated.[35] Books by Zola and other Naturalists also were popular among artists in The Hague. Jacob van Santen Kolff had already discussed the relationship between the new realism in Dutch painting and recent French literature,[36] and the assertions he made in 1877 anticipated – and perhaps encouraged – a much more profound interest in French Realism among a younger generation of painters. The emergent artists of the 1880s – Breitner, Van Gogh, De Bock, and Jozef Israëls's son Isaac, for instance – became much more caught up in recent French novels than their Hague School forebears had been. Recalling his years at The Hague, the watercolorist Philip Zilcken noted:

French literature . . . around 1880, had an influence on painting, though very relative. Personally, I know that the Goncourts, Zola, and the books of Fromentin contributed to the orientation of my artistic thoughts. And in those already-distant times, my masters and my friends the Marises, Breitner, [Willem] de Zwart, Isaac Israëls, [M. A. J.] Bauer, and almost all the young painters read Zola and [Flaubert's] *Salammbô* with passion, while *Manette Salomon* lay around on the divans of the studios.[37]

An entire generation of writers and painters was immersing itself in recent French fiction at The Hague in the 1880s, urged on by some of the city's most prominent critics. It is hardly surprising that Van Gogh became swept up in the tide of this enthusiasm.

In the letter cited earlier (LT212), Van Gogh not only praised *Une Page d'amour*, but also mentioned that he had read Zola's work before. Though his prior knowledge of the oeuvre was piecemeal, it already was wide ranging, for Van Gogh knew both "Ce que je veux" – a poem of private romantic fantasy – and the description of a "little peasant, exactly like a drawing by Millet" – that is, a prose piece on an altogether different topic. "Ce que je veux" (1859) is a youthful effort at light verse in which the 19-year-old Zola created the effects of a summery daydream by evoking an idealized southern landscape and the diminutive blond "queen of love" with whom he dreamt of sharing it. The peasant description Van Gogh mentioned conforms more readily to twentieth-century notions of the writer's work and might have been part of any number of short stories and sketches that Zola frequently sold to both French and foreign periodicals. As recently as 11 June 1882, one such piece had appeared in *De Amsterdammer* in Dutch translation, and Van Gogh may well have read it in the hospital. Titled "De Dood van de boer" (The death of a peasant farmer), this story is one of five short narratives that Zola initially published in French in 1876 under the umbrella title *Comment on meurt*. Its protagonist, Jean-Louis Lacour, a 70-year-old peasant, could easily have reminded Van Gogh of Millet's images of rural workers; as portrayed by Zola, Lacour is "tall and gnarled like an oak. The sun has dried him, has cooked and split his skin; and he has taken on the color, the ruggedness, and the calm of the trees. In aging, he has lost his speech. He doesn't talk anymore, finding that useless. With a slow and stubborn gait, he walks with the quiet force of oxen."[38] Whether or not this particular description was the one to which Van Gogh referred, it is clear that even before he began to read the Rougon-Macquart series, he had been exposed to the two distinct sides of Zola – Romantic and Realist – that he later would praise as complementary (LT426).

By 1882, Van Gogh probably had had some exposure to Zola's nonfiction as well, most likely to a collection of critiques entitled *Mes haines*.[39] As early as 1879, in a letter from the Borinage, Van Gogh transcribed a French phrase that seems derived from that source: "I still can find no better definition of the word art," he wrote, "than this, 'L'art c'est l'homme ajouté à la nature' [Art is man joined to nature] – nature, reality, truth, but with a significance, a conception, a character, which the artist brings out...'qu'il dégage' [that he extricates]" (LT130).[40] The use of French in this Dutch-language letter signals reference to an uncited text, and the idea expressed points to a concept Zola presents in an essay called "Le Moment artistique" (1866), which was reprinted in *Mes haines*. "A work of art," Zola writes there, "is never anything but the combination of a man...and nature." Knowledge of that essay is likewise indicated by a letter Van Gogh wrote from Etten in 1881; there he seems to have paraphrased Zola's well-known maxim, "That which I

look for before everything else in a picture, is a man and not a picture,"[41] when he wrote, "In general, and more especially with artists, I pay as much attention to the man who does the work as to the work itself" (R6). Also from Etten (in the autumn of 1881), Van Gogh described his approach to art making in a mode that smacks of Zola. "Nature always begins by resisting the artist," he noted, "but he who really takes it seriously does not allow that resistance to put him off his stride ... At bottom nature and a true artist agree.... One must seize her, and with a strong hand ... I think that 'serrer de près vaut mieux que lâcher' [clasping close is better than letting go]" (LT152). This evocation of the artist's physical struggle with the personified (and feminine) nature he [sic] takes as his subject bears comparison with Zola's portrayal of Courbet's practice in an essay on that artist: "He felt himself carried away by all his flesh – by all his flesh, you understand – toward the material world that surrounded him.... Stocky and vigorous, he had a keen desire to clasp [serrer] real nature in his arms."[42] And in much the same vein, Zola in "Le Moment artistique" urges the artist to take nature captive by forcible physical action.[43] Though none of Van Gogh's remarks is a direct quotation, individually and especially in sum they signal his familiarity with the gist of Mes haines,[44] as well as his attraction to Zola's image of the artist as a combative male whose enterprise consists of asserting his will over nature – a recalcitrant feminine opponent. The book probably was one of the works by Zola that Van Gogh knew "fragmentarily" when he wrote to Theo in June 1882, and at The Hague he eventually examined Mes haines more closely.

In the meantime, he immersed himself in the fictional world of the Rougon-Macquarts. Une Page d'amour (1878), the novel that constituted Van Gogh's fuller introduction to Zola's oeuvre, is one of the author's more lyrical works and provided the novice reader an innocuous entry to the often brutal familial saga. The eighth volume of the series, it details an impossible love between a reserved, well-to-do young widow and her child's Parisian physician (who is unhappily married). It is one of the most purposefully aestheticized novels of the collection, for Zola intended it as an antidote to the notorious novels that bracketed it: L'Assommoir (1877), the squalid saga of a laundress's drunken decline, and Nana (1880), the risqué sequel that details the rise and fall of the laundress's daughter, a Parisian prostitute.[45] In describing Une Page d'amour as "superbly painted or drawn" (LT212), Van Gogh was responding to the self-conscious artfulness of this carefully crafted novel. The book is broken into five parts of five chapters apiece, the final chapter of each part comprising a detailed vista of Paris. Keyed to the narrative, these verbal cityscapes suggest five distinct moods, which progressively reinforce developments in the plot and the emotive states of its characters.[46] Though the central motif – Paris seen from a high vantage point at the city's

western edge – remains constant, Zola's five versions of it are varied by times of day and the vagaries of weather, and as such they can be seen as verbal counterparts to the serial views that occupied Zola's friend Claude Monet from the 1870s onward.[47] Even on a less specific level, Zola's verbal tableaux clearly were conceived as translations of visual effects created by Impressionist painters.[48]

A childhood friend of Paul Cézanne at Aix-en-Provence, Zola in Paris became acquainted with many other artists and was a regular at the Café Guerbois, where the Impressionist circle congregated. He hobnobbed with some of the best artists of his era (in addition to Monet and Cézanne, Zola knew Manet, Degas, Pissarro, Bazille, Renoir, Fantin Latour, Whistler, and Alfred Stevens) and often came to their defense in print.[49] In an interview given shortly before his death, Zola declared: "I not only supported the Impressionists. I translated them in literature, by touches, notes, colorations, by the palette of many of my books. . . . I was in contact and exchange with painters. . . . Painters helped me paint in a new way, literarily."[50] Probably nowhere was his alliance with the Impressionists manifested in a more studied way than in the Parisian tableaux of *Une Page d'amour,* the first of which reads, in part:

A mist that followed the valley of the Seine had swamped both banks. It was a light, milky vapor, which the gradually higher sun illuminated. Nothing could be seen of the town under this floating weather-colored muslin. In the hollows the thickened cloud darkened to a bluish tint, while the transparencies over broad expanses became, with extreme subtlety, golden dust in which the concavities of streets could be guessed at; and, higher up, domes and spires tore open the fog, raising their gray silhouettes which still were shrouded by shreds of the haze they perforated. Now and then patches of yellow smoke broke loose with the heavy wingstroke of a gigantic bird, then melted into the air which seemed to drink them. And above the immensity of this cloud that descended and slept upon Paris, an unblemished sky of washed-out blue, almost white, unfurled its deep vault. The sun rose in a soft sprinkling of rays. A blond gleam, of the indefinite blondness of childhood, shattered and rained down, filling the air with its tepid tremor. (*Une Page d'amour,* pt. I, chap. 5)[51]

In this passage, Zola not only evokes the nuanced atmospheric effects of Impressionist painting, but also – by restating and clarifying his perceptions (e.g., "a washed-out blue, almost white"; "a blond gleam, of the indefinite blondness of childhood") – flaunts his fine-tuned visual sense and creates the impression of direct observation, as if the writer/artist were straining to be true to perceived shades of difference, rather than glibly transcribing a mental construct.

As an Impressionistic writer Zola aims to evoke the effects of rapid no-tations made before an ever-changing spectacle.[52] For example, in another

passage of the first tableau of *Une Page,* he writes of a group of pedestrians as an "active crowd of black dots,"[53] probably in conscious acknowledgment of the abbreviated figures – once derided as mere "tongue-lickings"[54] that people Monet's street scenes. Zola also uses a wealth of action verbs to evoke the transitory nature of natural effects – for example, light that "dances" over a scene or "runs" along rooftops.[55] Such action occurs, however, within a stable frame, for in constructing each tableau Zola seems to work from edge to edge of a specific, restricted view, cataloging with seeming precision the multiple forms, textures, and colors that fill it.

Many other passages of *Une Page* are likewise painterly, and intentionally so; in addition to sustained description of a children's masquerade party that is relentlessly "visual,"[56] Zola calls up images from Impressionist paintings in several shorter, less ambitious verbal images that are scattered through the novel. For instance, in describing a young girl's sunbath in a garden, the author suggests the irregular patches of sunlight that enliven Impressionist parks and yards when he writes: "What especially amused her were the round spots of beautiful golden yellow that danced on her shawl. They seemed like animals. And she threw back her head to see if they would climb up to her face."[57] In a Dutch-language review that appeared in May 1878, Jan ten Brink recognized Zola's painterly intent when he characterized *Une Page d'amour* as a "treasure trove of richy hued watercolors" and suggested that the artists among his readers might find inspiration in what Zola had done on his "literary canvas."[58]

Thus, Van Gogh's first appraisal of Zola – focusing on the author's "artistry" – was shaped not only by his own ongoing interest in verbal–visual parallels, but also by the fact that the novel he chanced to read was one of Zola's most willfully picturesque. By portraying the author as one who "describes with a master hand," Van Gogh indicated that Zola's creative process was – like a painter's or draftsman's – as much a manual as an intellectual endeavor, and in the same letter he told Theo, "Do you know that drawing with *words* is also an art, which sometimes betrays a slumbering hidden force, like small blue or gray puffs of smoke indicate a fire on the hearth?" (LT212; his emphasis).

Upon finishing *Une Page d'amour,* Van Gogh almost immediately acted on his desire "to read everything by Zola" (LT212). In early July he told Theo that he had begun to read *Le Ventre de Paris* (1873) and was finding it "confoundedly clever" (LT214).[59] The third volume in the Rougon-Macquart series,[60] it is a saga of social struggle (the disenfranchised lower classes vs. the comfortable bourgeoisie of the Second Empire), set in and around Les Halles, the major marketplace of Paris. Its protagonist, Florent, a political refugee, returns to France under an assumed identity and – aided by a sympathetic vegetable seller, Mme. François – makes his way to Paris.

There he is taken in by his half brother, Quenu, a successful *charcutier* who finds him an administrative post. Florent, however, remains aloof from the community of merchants and instead befriends a ne'er-do-well artist, Claude Lantier,[61] and a band of disgruntled Republicans. Such alliances lead to his social ostracism, and his resumed political activities eventually result in his deportation.

Zola characterized *Le Ventre* as another skirmish in the age-old battle between the world's fat (the haves) and thin (the have-nots).[62] Having identified this theme as the philosophical/historical thrust of the novel, he noted that its *artistic* dimension resided in the setting – most especially in the "gigantic still lifes of its eight pavilions."[63] This facet of the book is highlighted by the presence of an artist in its pages, and from their first meeting with Claude Lantier (who serves as the author's aesthetics-minded alter ego),[64] Florent and the reader are made aware of his painter's passion for the visual spectacle afforded by the market's abundantly stocked shops and stalls: "[Claude] prowled the flagstones all through the night [as Zola himself had done to prepare his "documents" for *Le Ventre*], musing on the colossal still lifes, extraordinary paintings. . . . [He] never even thought of these beautiful things as edible. He loved them for their color."[65] Throughout the novel, Zola describes Lantier's (thus his own) search for tableaux in the marketplace and its environs, but though the fictive artist's commentaries alert the reader to Zola's interest in things visual, the longest and most painterly descriptions of the novel are written in the third-person voice of the author himself – a voice Van Gogh evidently preferred. Whereas Van Gogh wrote of Lantier as "not the worst representative of that school which I think is called impressionistic" (a group he believed to be peripheral), and told Theo that he "would like to see Zola depict a different kind of painter" (LT248), he called the author himself a "glorious artist" (LT214) and declared, "How he *painted* those Halles!" (LT220; his emphasis).

Zola devotes pages-long sections of *Le Ventre* to description, and as the cityscapes of *Une Page d'amour* complement the moods of its protagonists and events, so the still lifes of *Le Ventre*'s stalls and shops reflect the looks, personalities, and sexual allure of the market women who preside over them. In several passages women and foodstuffs merge, as objects of delectation that tease the appetites of Zola's male protagonists – and readers.[66] In that vein, Florent's sister-in-law, Lisa Quenu, is compared to the abundance of prepared flesh that fills her shop: "She had a superb freshness; the whiteness of her apron and sleeves continued the whiteness of the dishes up to her fleshy neck and her rosy cheeks, where the tender tones of hams and the pallor of transparent fat were recalled."[67] The author goes on to heighten this connection by sustained use of mirror reflections (a device more common to the visual arts than to prose):

Florent ended up examining her to the point of undressing her in the mirrors around the shop. She was reflected from the back, front and side; even on the ceiling he found her again, her head lowered, with her tight chignon and her thin bangs glued to her temples. It was a whole crowd of Lisas, showing the breadth of her shoulders, the powerful set of her arms, the rounded bosom. . . . He especially liked one of her profiles, which he had in the glass next to him, between two half-pigs. All along the marbles and the mirrors, hanging on hooks, sides of pork and strips of larding fat dangled; and Lisa's profile, with its strong look, its rounded lines, its protruding bosom, introduced the effigy of a puffy queen amid this bacon and raw flesh. (*Le Ventre de Paris*, chap. II)[68]

Though this use of mirrors to multiply and aggrandize Lisa's image and show the reader/viewer more of her than an unaided eye could see at one time recalls a long line of pictorial images, it is more a harbinger of than a successor to trends in the visual arts. Zola's image does not so much draw on earlier pictorial (and literary) usage of mirrors as revealers (of true identity, inner secrets, future events) as forecast the playful and purposely puzzling ways in which mirrors would be used in both the late nineteenth and the twentieth centuries: to make described spaces complex and ambiguous, and draw unexpected parallels between objects within them. Zola's comparison of Lisa to the meats, for instance, is made much more immediate when her profile is brought into tighter visual conjunction with the pork by virtue of the reflection's flattening effect on space. Such an image gives clear indication of Zola's aggressively modern visual sense, which doubtless was indebted to his association with the artistic avant-garde of Paris – the very Impressionists Van Gogh disparaged.

At the time he read *Le Ventre*, Van Gogh was not much aware of recent trends in French art, but he too had been attempting to capture the vitality of contemporary urban life, particularly on the Geest in The Hague's market district (see Fig. 1),[69] and he probably was impressed by Zola's ability to make art of a similar subject. Moreover, he was struck by the book's depiction of social tensions between the self-satisfied shop owners and their more bohemian neighbors, scenes that were closer to his own experiences than were the amorous incidents recounted in the "high-class"[70] love story of *Une Page d'amour*. *Le Ventre*'s Florent is a child of the bourgeoisie who because of his unorthodox beliefs and associations is rejected by his class (much as Van Gogh himself had been throughout his adult life, and most recently at The Hague) and (again like Van Gogh) is forced to rely on the support of a younger, more conventional brother.[71] In discussing the novel with Theo, however, Van Gogh cast himself in the role of savior rather than victim, by stressing his kinship with Mme. François, a relatively minor character who is an obvious updating of the Bible's good Samaritan (Luke 10:30–7). Van Gogh wrote:

I just want to ask you what you think of Mme. François, who lifted poor Florent into her cart and took him home when he was lying in the middle of the road where the greengrocers' carts were passing.

Though the other greengrocers cried, Let that drunkard lie, we have no time to pick men up out of the gutter, etc.

That figure of Mme. François stands out so calmly and nobly and sympathetically all through the book, against the background of the Halles, in contrast with the brutal egoism of the other women.

See, Theo, I think Mme. François is truly humane; and I have done, and will do, for Sien what I think someone like Mme. François would have done for Florent if he had not loved politics more than her. Look here, that humanity is the salt of life; I should not care to live without it, that's all.

I care as little about what [people say] as Mme. François cared about the other women and greengrocers . . . and about all the noise and gossip. (LT219)

Van Gogh returned to the subject in the same letter:

I have already spoken a few words about the love for humanity which some people possess, for instance, Mme. François in the book by Zola. . . . I haven't any benevolent plans or projects for trying to help everybody, but I am not ashamed to say . . . that for my part I have always felt and will feel the need to love some fellow creature. Preferably, I don't know why, an unhappy, forsaken or lonely creature.

Once I nursed . . . a poor miserable miner who had been burned. I shared my food for a whole winter with a poor old man, and heaven knows what else, and now there is Sien. (LT219)

Attentive to fictional exemplars whose actions might elucidate and justify his own, Van Gogh clearly was drawn to passages that could be read as applied Scripture, and having now read a more politically and socially engagé novel than *Une Page d'amour,* he began to see Zola in the same light as Michelet and Beecher Stowe – that is, as an author who "show[s] how [the Gospel] may be applied in our time, in this our life" (LT161). He concluded his discussion of *Le Ventre* with a postscript advising, "Read as much of Zola as you can; that is good for one, and makes things clear" (LT219).

By late July, having read yet another Zola novel, *Nana,* Van Gogh was increasingly eager to put the author's work into historical perspective. "Zola," he noted, "is really a second Balzac. Balzac the First describes society from 1815 until 1848. Zola begins where Balzac leaves off and goes on until Sedan, or rather until now. I think it's splendid" (LT219). The connection between Zola and Balzac is an obvious one that had been insisted upon by Zola himself;[72] the scale and schema of the Rougon-Macquart series rely on the example of Balzac's *Comédie humaine* (1829–47), the multiple volumes of which are tied together by recurring characters and their connections to a specific historical period (the Restoration and July Monarchy). Almost any reader familiar with both authors would have seen the parallel, but Van Gogh's confident overview of the Rougon-Macquart series ("Zola begins

where Balzac leaves off and goes on until Sedan, or rather until now") is too broad to depend on his having read a few randomly selected novels;[73] for one thing, Zola's volume concerning the French defeat at Sedan, *La Débâcle,* would not be written and published until 1892, two years after Van Gogh's death. It may thus be assumed that by now he had read (or heard discussed) contemporary commentary on Zola and his project, and Jan ten Brink's work seems a likely source. In his 1879 monograph on Zola, for instance, Ten Brink surveyed the series as it existed at that point, revealed Zola's plans for future novels, and delved into his literary roots as well.[74] Portraying Balzac as the "father of literary Realism in French letters,"[75] Ten Brink pointed to Flaubert, then Zola, as the heirs to that tradition.[76]

Gradually, however, Van Gogh's assessments of Zola's achievements became both more specific and more personalized; in describing the connection between his love of figure painting and his literary preferences, for instance, Van Gogh wrote:

I always feel greatly attracted by the figures either of the English draftsmen or of the English authors because of their Monday-morning-like soberness and studied simplicity and solemnity and keen analysis, as something solid and strong which can give us strength in the days when we feel weak. So, among the French authors, the same is true of Balzac and Zola. (LT237)

Thus, whereas his earlier comparison of Zola to Balzac (probably indebted in part to Ten Brink's scholarship) highlighted the conceptual and structural similarities of their projects, their subsequent linkage in Van Gogh's mind had to do with modes of execution — issues of depiction that the artist could personally surmise and relate to.[77] He allied the authors' work to that of a good draftsman — the thing he himself most wanted to be — and he focused on the simple, sober aspects of their verbal imagery as qualities that joined them not only one to the other, but to the English authors and artists he had long admired: Eliot,[78] Dickens,[79] Hubert Herkomer, Luke Fildes, Frank Holl, William Small, and others (see, e.g., LT252).[80] His refined appreciation was the result of Van Gogh's increasing acquaintance with Zola's work. Between late July and late September 1882 he more than doubled his intake of Zola novels,[81] reading *La Curée* (1872), *Son Excellence Eugène Rougon* (1876), *L'Assommoir* (1878),[82] and *La Faute de l'Abbé Mouret* (1875). In the conviction that "one must read the whole of Dickens or of Balzac or of Zola to understand their books separately" (R13; see also R35), he read a good deal in a short time and, in so doing, experienced multiple facets of Zola's opus: chronicles of both the high and low life of Paris — presented in alternately cynical and empathic tones — as well as a rural love story that revealed the author's most Romantic voice.[83]

Nana, La Curée, and *Son Excellence Eugène Rougon* are all accounts of the struggles of individual members of the Rougon-Macquart family to attain power and prestige in Paris during the Second Empire. Whereas Nana, a descendant of the illegitimate Macquart side of the family,[84] achieves her success in the demimonde, her cousins Eugène Rougon and his brother Aristide,[85] members of the legitimate branch, attain prominence in the hauts mondes of politics and finance. *Nana* and *La Curée* contain lavish descriptions of the haunts, pastimes, and vices of the most privileged members of Second Empire society, and *Nana* also provides glimpses of the lives of its derelicts. *Son Excellence* is a much more restrained piece of writing; despite its focus on political intrigue under Napoleon III, it is one of the driest books in the series and never has enjoyed wide readership.[86] These three novels, which denounce corrupt politics and a crass, money-oriented social system, probably confirmed Van Gogh's sense of Zola's relation to Balzac, whose subject matter is much the same, albeit situated in a different historical frame. *L'Assommoir,* by contrast, was the closest Zola had come to Dickens at this point, and surely this novel more than any other in the Rougon-Macquart series prompted Van Gogh to compare Zola's prose portraits to English images of the urban poor.

Set in a popular quarter of Paris (that of the rue de la Goutte-d'Or, which was then on the city's northern periphery), *L'Assommoir* details the travails of the city's working class. As the book opens, its heroine Gervaise, a displaced provincial, finds herself alone in Paris, deserted by Lantier, the father of her two illegitimate sons (one of whom is Claude, the painter of *Le Ventre de Paris*). Forced to earn her living, Gervaise finds work as a laundress and, through honesty and diligence, attains modest success. She marries Coupeau, a roofer (by whom she has Nana), and manages to open her own laundry before her luck and genes turn on her. Coupeau has an accident and starts to drink; Gervaise falls into another affair with Lantier, becomes increasingly lax and self-indulgent, and – betrayed anew by her lover – eventually joins her husband in alcoholic excess. She loses the modicum of material wealth and self-respect she struggled to attain and dies alone, of alcoholism.[87]

In order to write *L'Assommoir,* Zola did research on both the neighborhood and its slang. In its prose passages as well as its dialogue, *L'Assommoir* reflects the idiom of the urban working class.[88] In his preliminary sketch for the book, the author described his intent

to show the milieu of the people and explain their mores by means of this milieu; how it happens in Paris that drunkenness, broken homes, violence, the acceptance of all sorts of shame and misery come from the very conditions of working-class existence, hard work, promiscuity, slovenliness. In a word, a very precise picture of the life of the people, with its dirt, its loose life, its crude language.[89]

Later, in response to critics who expressed disgust at his realization of those goals,[90] the author noted (in his preface to the 1877 edition of *L'Assommoir*), "My crime is to have had the literary curiosity to gather together and pour into a very elaborate mold the language of the people. Ah! form, that's the great crime!"[91] Asserting that *L'Assommoir* was in fact the "most chaste of my books," he declared it to be "a truthful work, the first novel about the people that doesn't lie and that has the smell of the people."[92] Though his attitudes toward the underclass are marked by condescension, they are not condemnatory; assuming the stance of a benevolent patriarch, Zola reminds his (probably middle-class) reader that "one must not conclude that the whole working class is bad, because my characters aren't bad, they are only ignorant, and spoiled by the environment of harsh labor and poverty that they inhabit."[93] For all her weaknesses, Gervaise is drawn sympathetically, and the author aims for pathos, not derision, as he charts her decline.

In the laundress's story, Van Gogh saw parallels to Sien's, and as his relationship with his companion deteriorated, he tried to explain her with the help of Zola's novel. In a letter of spring 1883, for instance, he closed ranks with the author as – regarding the lower-class Sien with the distanced sympathy of a *bon bourgeois* – he cited a passage from the preface of *L'Assommoir:* "Yet these women are not bad, the impossibility of [living] a straight life in the midst of the gossip and slander of the faubourgs is the cause of their faults and their fall" (LT280).[94] And before leaving Sien that summer, he came back to the novel, telling Theo:

What Zola says seems to me to be true.... You know what I mean, from *L'Assommoir.* I know there is difference too, but there are also similarities between my attitude toward her and that passage in *L'Assommoir* where that blacksmith sees how Gervaise goes wrong but hasn't the slightest influence on her; because of her hypocrisy and her inability to see things clearly, she cannot make up her mind what course to choose. (LT317)

Though the aesthetic pleasure Van Gogh took in reading the novel – "How beautiful Zola is; I often think of *L'Assommoir* especially" (LT281) – remained in his memory for years (see LT543), his more immediate fascination derived from his comparison of its situations to his own increasingly unhappy one. Months after his break with Sien he continued to view her in terms of Zola's novel, and speculating from afar on her potential reform he told Theo, "I had hoped to have news... that she had started a small laundry with her mother" (LT326).

In contrast to *L'Assommoir* – and Zola's other Realist portraits of Paris – *La Faute de l'Abbé Mouret* is extravagantly escapist Romantic fiction, set in the South of France (where Zola grew up). A full-blown descendant of the fantasy developed in "Ce que je veux,"[95] it takes its story line from the

biblical account of Adam and Eve (Gen. 2–3),[96] but updates the latter only in a general sense, for *La Faute* is much less specifically tied to its Second Empire time frame than are most of the Rougon-Macquart novels.[97] Its protagonist, Serge Mouret (a Macquart), is a naïve young priest assigned to an isolated village. His parishioners are peasants of a type often presented as reassuring constants in French art and literature of the nineteenth century: rural laborers who live, work, and die as in centuries past, oblivious to modern mores and social upheaval. Moreover, much of the book's action takes place in a vast private garden that is surrounded by legend and seems to stand outside real time and place.

La Faute is a tale of sexual awakening, the seeds of which are planted when Serge is asked to call on the caretaker of an abandoned local estate that is renowned for its extensive garden, Le Paradou. Planted in the reign of Louis XV, Le Paradou was abandoned after a single season, when its owner's young lover died mysteriously within its walls. Since then, the garden has flourished untended in the southern sun. By the mid-nineteenth century, its only human occupant is Albine, the caretaker's pubescent blond niece. Like the garden, she has grown up unrestrained and uncultivated, an *enfante sauvage* who spends her days roaming Le Paradou. Serge is involuntarily attracted to both the garden and its mistress, and shortly after his visit, he falls into a feverish delirium. Oddly enough, he is taken to Le Paradou to convalesce under Albine's supervision, and he awakens there – conveniently – an amnesiac. As such, he freely expresses his affection for Albine, urged on by the atmosphere of sensual abandon that reigns in the garden. He is, in effect, reborn and transformed by his natural surroundings and unaffected companion.

As Zola himself admitted, he sometimes lost sight of his goals of scientific exactitude and objectivity when writing about nature, and *La Faute* is full of passages that qualify as what the author labeled "descriptive debauches ... nature-induced excesses."[98] Zola presents Le Paradou as an animate entity whose overgrown bowers ooze fecundity; the garden's warmth, smells, sounds, and sights stimulate the young couple and encourage them to give in to sexual impulse.[99] When they finally make love within its precincts, Zola stresses the complicity of their environment:

It was the garden that had wanted the transgression. For weeks it had been party to the slow apprenticeship of their tenderness. ... It was the tempter, whose every voice taught love.

...Under every leaf, an insect conceived; in every tuft of plants, a family sprang up; flies on the wing, glued to one another, didn't wait to land in order to mate.

...So Albine and Serge ... gave in to the garden's demands.

...The garden strongly applauded. (*La Faute de l'Abbé Mouret*, pt. II, chap. 15)[100]

Predictably, this modern myth ends with expulsion from the garden and sad reprisals. Serge regains his memory and repentantly returns to the priesthood. Albine commits suicide.

Van Gogh shared the interest in empathic and evocative nature that so strongly informs Zola's novel; indeed, it was that aspect of landscape that made it interesting to him. In a letter written toward the end of 1882 (and shortly after reading *La Faute*), Van Gogh acknowledged that although his primary subject was the figure,

> sometimes I have such a longing to do landscape, just as I crave a long walk to refresh myself; and in all nature, for instance in trees, I see expression and soul, so to speak. A row of pollard willows sometimes resembles a procession of almshouse men. Young corn has something inexpressibly pure and tender about it, which awakens the same emotion as the expression of a sleeping baby, for instance. (LT242)

Comparably anthropomorphized images of flora abound in *La Faute;* a huge tree, for instance, is portrayed as Le Paradou's reigning patriarch, and a bed of roses compared to a horde of wanton women.[101] Conversely, Serge, in his convalescent fragility and emotional infancy, is likened to a young plant.[102] Zola's insistence on the power of nature to reflect – or even animate – human emotion probably reinforced Van Gogh's tendency to view his surroundings that way, and his rekindling interest in landscape painting in this era may well have been encouraged by Zola's sustained exploitation of nature's metaphoric possibilities and emotive potential in *La Faute de l'Abbé Mouret.*

As he studied the landscape surrounding The Hague, however, Van Gogh adopted a somber vision that reflected his own hardships there and outwardly had little in common with Le Paradou. The artist himself noted this disparity of outlook in a letter written in the spring of 1883, within the context of his description of a recent quarrel with Sien. In the wake of their argument, he wrote, "I went far out in the country [to Leidendam] to talk with nature" (LT319).

> You know the scenery there, splendid trees, majestic and serene, right next to horrible green toy summerhouses.... Now at that very moment, high over the meadows, boundless as the desert, one mass of clouds after the other came sailing on, and the wind first struck the row of country houses with their clumps of trees on the other side of the canal.... Those trees were superb; there was drama in each *figure* I was going to say, but I mean each tree. But the scene as a whole was even more beautiful than those scourged trees viewed apart, because at that moment even those absurd little summerhouses assumed a curious character, dripping with rain and disheveled....
>
> Yes, for me, the drama of storm in nature, the drama of sorrow in life, is the most impressive.
>
> A "Paradou" is beautiful, but Gethsemane is even more beautiful. (LT319; his emphasis)

Yet even as he acknowledged the polarity of the natural scenes he and Zola described, Van Gogh perceived each as the analogue of an emotional state, and thus presented Zola's evocation of a garden of earthly pleasure as the logical counterpart to his own vision of landscape as a garden of earthly sorrow, or Gethsemane. His comments suggest Van Gogh's belief that though their resultant images were opposed, his enterprise before nature was somehow comparable to Zola's. Both — by venturing beyond the limits of strict empiricism — reformulated nature as expressive art.

Le Paradou seems to have captured the imaginations of both Van Gogh brothers, for reference to this mythic locale of love recurs in Vincent's letters. When Theo, for instance, wrote of an amorous outing with a woman friend, Vincent replied: "I am glad you are having a good time just now – 'Le Paradou' must have been glorious indeed. Yes, I should not mind trying my hand at such a thing: and I do not doubt you two would be very good models" (LT286). Zola's steamy saga of love in the out-of-doors apparently planted a picture in Van Gogh's mind, and in his next letter – which included a sketch of some workmen – he noted, "This 'Peat Cutters' is quite different from 'Le Paradou,' but I assure you I also feel for 'Le Paradou.' Who knows, someday I may attack such a Paradou subject" (LT287). The image of Zola's southern paradise lingered in his mind (see LT506), and if Van Gogh ever really painted his "Paradou subject," it was years later in the South of France, when his surroundings and outlook changed considerably (see Chapter 5).

In November 1882, Van Gogh read what was then Zola's most recent novel, *Pot-Bouille*, published just seven months earlier. The tenth novel of the Rougon-Macquart series, *Pot-Bouille* is the story of Octave Mouret (brother of Serge, the abbé), a provincial who arrives in Paris to climb the social and economic ladders – the rungs of which, in his case, are the women he charms and seduces. Set in a newly built bourgeois apartment house, *Pot-Bouille* is an attack on the vulgarity, hypocrisy, and frequent cruelty of the middle class, an episodic novel that takes the reader from one flat to the next to witness myriad infidelities, financial squabbles, and gossipy exchanges. While Mouret is its ostensible protagonist, his story is fragmented and often forgotten amid a wealth of other characters and incidents.[103] Dutch critics complained, moreover, about the book's lack of local color and descriptive effects.[104] Van Gogh, however, found no formal faults and in fact remarked on "how well constructed the book is" (LT247); his own predilection for figure studies may account for his delight in *Pot-Bouille*'s wide cast of characters – a verbally realized portfolio of types, "drawn confoundedly well" (LT247).

Though he seems to have embraced the novel's cynical spirit (particularly its "bitter" summation [LT247]), Van Gogh's favorite scenes were those of

a sentimental cast, which focus on hardships endured by the novel's most sympathetic characters:

I finished Zola's *Pot-Bouille;* the strongest passage I think is the confinement of Adèle, the cook . . . in the dark attic. Josserand is also drawn confoundedly well and with sentiment, like the rest of the figures; but those two somber ones, Josserand writing his addresses in the nighttime and that servant's attic, impressed me most. (LT247)

The first passage to which Van Gogh refers is one of the most blatantly sensationalist in Zola's oeuvre. Adèle, a housemaid in fear of losing her job and dreading the gossip of fellow domestics, gives birth alone in her room, then wraps the infant in newspaper and leaves it in a passageway near the apartment house. Though she is a peripheral character whose pregnancy is not even revealed until the last chapter of the book, Zola renders her birthing process in great detail, apparently in an effort to demonstrate his unflinching forthrightness and – not incidentally – to affront the very bourgeois whom *Pot-Bouille* attacks. In his review of the novel, Ten Brink noted that the pages devoted to Adèle's confinement, while correct from an obstetric viewpoint, were unnecessary to the narrative, and he predicted that even Zola's admirers would blush at them.[105] Van Gogh clearly did no such thing, probably in part because of the "enlightened" interest in women's bodily processes encouraged by Michelet.[106] During Sien's pregnancy and confinement, for instance, Van Gogh had taken a very active interest in her progress and quizzed her doctor on many specific issues (see LT192, LT199, LT210).

The other character mentioned by Van Gogh, Josserand, figures more prominently than Adèle, but nonetheless has a minor role, overshadowed by his domineering wife and shrill daughters. In an attempt to clothe and dower the latter, Josserand, a cashier by day, is forced to moonlight as a label writer: "Under the meager light of the little lamp . . . he spent entire nights on this thankless task, hiding himself, seized with shame at the idea that someone could discern their financial difficulties."[107] Josserand came to represent a type in Van Gogh's mental inventory of figures, and several weeks later (in February 1883) the artist wrote: "It is pathetic to see so many gray, withered faces come out-of-doors . . . not to do anything special, but as if to convince themselves that spring is there. . . . Sometimes a dried-up government clerk, apparently a kind of Jusserand [*sic*] in a threadbare black coat with a greasy collar – to see *him* next to the snowdrops is a fine sight!" (LT265; his emphasis).

If anything about *Pot-Bouille* displeased Van Gogh, it was the book's protagonist. For all his flaws, however, Octave Mouret clearly engaged Van

Gogh – so much so that he wrote of the fictive opportunist as if he were an acquaintance:

Don't you think Octave Mouret, really the principal figure, can be considered typical of those persons whom you recently wrote about, if you remember? In many respects he is much better than most of them; however, he will satisfy neither you nor me, and I feel a shallowness in him. Could he have done otherwise? – perhaps not, but you and I can and must act differently, I think. For we have our roots in a different kind of family life than Mouret, and besides, I hope there will always remain in us something of the Brabant fields and heath, which years of city life will not be able to wipe out, especially as it is renewed and strengthened by art.

He – Octave Mouret – is satisfied when he can readily sell his bales of "nouveautés."...He doesn't seem to have any other aspiration except the conquest of women, and yet he does not really love them, for Zola perceives correctly, I think, when he says, "où perçait son mépris pour la femme" [where his contempt for women broke through].

Well, I do not know what to think of him. He seems to be a product of his time – in reality more passive than active...(LT247)

Both Van Gogh brothers found Octave Mouret a particularly fascinating character,[108] and they would discuss him again and in even greater detail when he resurfaced as the hero of *Pot-Bouille*'s sequel, *Au Bonheur des Dames* (see Chapter 3, this volume).

In less than five months of 1882, Van Gogh had read all or most of the then-existing Rougon-Macquart novels.[109] Thenceforth he eagerly awaited the appearance of new volumes and read the next six – *Au Bonheur des Dames* (1883), *La Joie de vivre* (1884), *Germinal* (1885), *L'Oeuvre* (1886), *La Terre* (1887), and *Le Rêve* (1888) – in sequence as they were serialized and published. In the meantime, he read at least one of Zola's earlier works, *Thérèse Raquin* (1868), a haunting tale of murder motivated by sexual passion. Van Gogh never mentioned its story line, but he did note the fact that Thérèse's lover Laurent was a painter – and lamented the fact that he, like Claude Lantier, seemed to be a "kind of impressionist" (R38).

Van Gogh by his own account had no clear idea of what Impressionism was (see LT383, LT402), and though he claimed to recognize its tenets in the painters Zola described, it was not a style he associated with the author's own descriptive methods, which Van Gogh mentally conjoined instead to those of his artist-heroes, Millet and the English illustrators. He variously referred to Zola as both painter and draftsman, perhaps by way of suggesting the author's success at sweeping, coloristic evocations as well as more somber, analytical delineations.

The use of arts analogies to describe an author's work was certainly nothing new for Van Gogh, but the insistency of his emphasis on the visual aspects of Zola's prose is notable. The frequency of such remarks (see LT212,

LT214, LT220, LT237, LT247, R38) may be attributed in part to the fact that Van Gogh's immersion in the Rougon-Macquart series coincided with his nascence as a painter; after much discouragement in the first half of 1882 (see LT169, LT170, LT182), he saw great progress in his work that summer and was most excited by his experiments with oils (see LT225, LT226).[110] His self-described absorption in his painting (LT228) can only have underscored his interest in the painterly dimensions of Zola's novels, and he responded with enthusiasm to the self-conscious "artistry" of the author's verbal renderings of city- and landscapes. Because of his own continuing dedication to the figure, Van Gogh also discerned a quality comparable to fine draftsmanship in Zola's "well-drawn" character studies; he found the author's portrayals confirmed by his own experiences and useful to his own work. In 1883, for instance, he told fellow artist Anthon van Rappard[111] that Zola's novels – like those of Hugo and Dickens – were "figure painter's books" and claimed to "find a certain emptiness in these figure painters' studios where the modern writings are absent" (R35). Remarks like these are at once enticingly suggestive and frustratingly vague, since they raise questions about the nature and extent of the influence Van Gogh's readings had on his work from the Hague period that seemingly can be answered in only a roundabout way.

THE ARTIST AS ILLUSTRATOR

The clearest indication of Van Gogh's attitudes toward the interrelatedness of texts and images while living at The Hague can be gleaned from his attempts at illustration. Throughout his stay, an eagerness to earn his own living kept alive Van Gogh's ambition to work as an illustrator, though his desire to produce salable images (LT195) was tempered by a wish to succeed on his own terms (see LT185, LT272). Those terms were somewhat unorthodox, for Van Gogh apparently was wary of pictures that depended too directly on texts. His own notion of illustration is evidenced by a figure study he made in April 1882 under the inspiration of a poem by Thomas Hood, "The Song of the Shirt."[112] Having inscribed his drawing of a half-length nude (Fig. 2) with an English-language title – *The Great Lady* – Van Gogh sent it to Theo with this explanation:

The little sketch enclosed is scrawled after a larger study which has a more melancholy expression. There is a poem by Thomas Hood, I think, telling of a rich lady who cannot sleep at night because when she went out to buy a dress during the day, she saw the poor seamstress – pale, consumptive, emaciated – sitting at work in a close room. And now she is conscience-stricken about her wealth, and starts up anxiously in the night. In short, it is the figure of a slender, pale woman, restless in the dark night. (LT185)

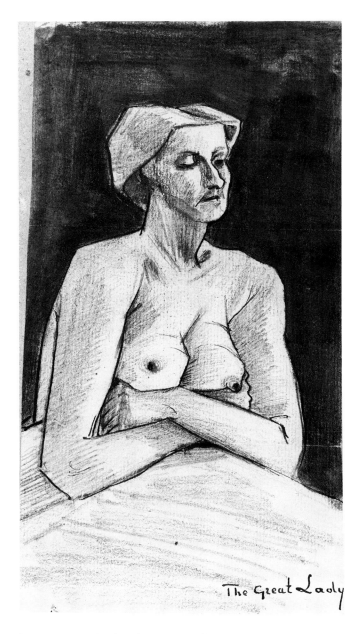

Figure 2. Van Gogh, *The Great Lady,* 1882.

Though vivid enough in Van Gogh's account of it, the remembered text made remarkably little impact on his image. The drawing holds no allusion to the confrontation of rich and poor that is at the heart of the poem, and the single figure Van Gogh chose to portray can be related only loosely to Hood's protagonist – even as she is represented by Van Gogh in his letter. A bed and nighttime setting are vaguely hinted, but the model's half-closed

eyes and immobile features do not call up a startled (or even "restless") sleeper awakened by anxiety and consumed by guilt. The figure is by no means slender, and her nudity is incogruent with the bedtime toilette of a pampered woman of wealth. The revealed body – broad, hunched, and sagging – is more plausibly that of a haggard workingwoman. Indeed, without the guidance of his letter, one might more likely assume that Van Gogh's inscription was an ironic one-liner than the key to a literary subtext.

Van Gogh's approach to illustration is further elucidated by a drawing from December 1882, *Man Reading a Bible* (Fig. 3). According to the artist, it was inspired by Thomas Moore's "The Light of Other Days" (LT253), a poem in which the author describes an old man's nighttime musings on the past – boyhood, love and courtship, long-dead friends – and on his current loneliness, "all but he departed!" Though Van Gogh supposedly recalled Moore's lines as he drew an elderly model, the resultant image is at odds with them; the man reads rather than reflects on his past, and his face gives no indication of the rueful reverie Moore's poem describes. Another inconsistency between text and image was noted by Van Gogh himself: "I had ["The Light of Other Days"] in mind when drawing that little old man, though it is not literally applicable to it – for instance, it is not night in the drawing" (LT253). Though he often recalled texts as he worked, Van Gogh's simple philosophy that a picture need not be "literally applicable" to the verbal image it was intended to complement kept his work from looking "illustrational" – a term of derision among some of his acquaintances at The Hague (R12).

Despite his interest in and wide-ranging knowledge of literature, Van Gogh only rarely aimed to evoke specific texts in his work. Instead he sought to fill his portfolio with drawings of general interest. Ideally, he wished to make "Dutch drawings... destined for workmen's houses and for farms," images that could be inexpensively reproduced and widely distributed, as "a public service, not a publishing venture" (LT249). He explained to Theo that such prints – sold both separately and in sets – "would form a whole in a linen cover with a short text, not referring to the drawings – which speak for themselves – but explaining... how and why they are made, etc." (LT249). His insistence that his images "speak for themselves" probably accounted for Van Gogh's lack of interest in book illustration. He instead looked to illustrated magazines like *Harper's Monthly*, *La Vie moderne*, *The Graphic*, and *London News* as potential customers (LT230, LT245, LT252, LT288), and in the hope that such journals might buy drawings of topical subjects with broad appeal, he spent a good deal of his time "sketching... scenes of working people," for "these are the very things which, with some practice, might serve as illustrations, I think" (LT231). He felt that drawings of common people might prove versatile enough to be used in a variety of contexts

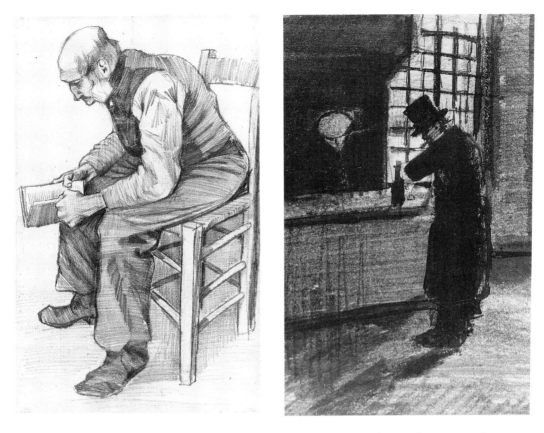

Figure 3. Van Gogh, *Man Reading a Bible*, 1882. *Figure 4*. Van Gogh, *Gentleman at an Inn*, 1882.

and evocative enough to tell their own tales, if necessary. To demonstrate that point, he sent a sketch (Fig. 4) to Theo, with the following gloss:

Enclosed... is a little scratch I made in ... a dreamy mood. It represents a gentleman who, having missed a coach or something, has been obliged to spend the night in a village inn. Now he has got up early in the morning, and while he orders a glass of brandy against the cold, he pays the landlady (a woman in a peasant's cap). It is still very early in the morning, "la piquette du jour," he must catch the mail coach; the moon is still shining, and through the inn's parlor window one sees the snow glittering, and every object casts a peculiar, whimsical shadow. This little story is of no importance whatever, nor is the sketch, but the one as well as the other will perhaps make you understand ... that lately everything has a certain air which makes one long to dash it off on paper. (LT276)

Little in the sketch bespeaks the particular narrative that Van Gogh related to Theo; it is essentially a mood piece that could be used with any number of stories or – without a text – could suggest one.

Though he had no desire to produce "literary" pictures that depended on particular verbal annotation or decipherment, Van Gogh nonetheless felt

that reading enhanced his perceptions and thereby affected his work. That he saw the two as decidedly – if inexplicitly – intertwined is clear from a letter to Van Rappard:

I just can't believe that a painter should have no other task and no other duty than painting only. What I mean to say is, whereas many consider, for instance, reading books and such things what they call a waste of time, on the contrary, I am of the opinion that, far from causing one to work less or less well, rather it makes one work more and better to try to broaden one's mind in a field that is so closely allied with this work – and that at any rate it is a matter of importance, which greatly influences one's work, from whatever point of view one looks at things, and whatever conception one may have of life. (R34)

LITERARY REAPPRAISALS AND REALIGNMENTS

From June 1882 onward – even when he found himself working at his art "from early in the morning until late at night" (LT227) – Van Gogh once more made time for reading. After exhausting his supply of Zola novels that fall, he returned to some of his favorite authors and read Erckmann–Chatrian's *Les Deux Frères* (1873), Michelet's *Le Peuple* (1846), Eliot's *Middlemarch* (1872), and at least four novels by Victor Hugo – *Notre Dame de Paris* (1831), *Les Misérables* (1862), *Quatre-vingt-treize* (1874), and *L'Histoire d'un crime* (1877).[113] At The Hague his perspective on literature changed somewhat as he began to measure long-esteemed authors against more recent discoveries. Concerning *Middlemarch*, for instance, he wrote, "Eliot analyzes like Balzac or Zola – but English situations, with an English sentiment" (LT267). In a similar vein, he noted, "I know very well that Victor Hugo analyzes in a different way than Balzac and Zola do, but he gets to the bottom of things just as well" (LT281). Van Gogh now considered many of the authors he had long admired – Hugo, Dickens, Erckmann–Chatrian – to represent an older generation he regarded with nostalgia. He told Theo, for instance:

After Zola's book [*Pot-Bouille*], I at last read *Quatre-Vingt-Treize* by Victor Hugo. Here we are in quite a different field. It is painted – I mean written – like Decamps or Jules Dupré, with expressions like the ones in the old pictures by Ary Scheffer. …The sentiment in which this book is written becomes more and more rare, and among the new things, I really have not found anything nobler. (LT247)

A few months later he wrote, "I am reading *Les Misérables* by Victor Hugo. A book which I remember of old, but I had a great longing to read it again, just as one can have a great longing to see a certain picture again" (LT277). He seems to have reacted in much the same way to Erckmann–Chatrian's *Les Deux Frères* – a book that made him muse on times past, "when there

were so many artists in the Alsace" (LT232) – and in a letter to his friend Van Rappard, Van Gogh acknowledged that in reading Zola he had realized that "that time of Balzac and Dickens, that time of Gavarni and Millet – how far away it is" (R13). He summed up his wistfulness for the past with the recollection of another old favorite, writing, "Once I read in Eliot, 'Though it be dead, I think of it all as alive'" (R13).

Although his experience of Zola's oeuvre sparked misty-eyed longings for the good old days, Van Gogh's taste of Naturalist fiction also whetted his appetite for more and led him to seek out the latest in literature even as he lamented its outmoding of the old. During the latter half of his stay at The Hague, Van Gogh read novels by the Goncourt brothers (whose nonfiction he knew already),[114] as well as books by Zola's contemporaries, Alphonse Daudet and Camille Lemonnier.[115] Associating all of these authors with Zola, Van Gogh generally referred to them as Naturalists, a label that in fact annoyed both Daudet and Edmond de Goncourt. For Van Gogh, however – as for many Dutch critics of his era – "Naturalism" simply implied the latest realist trend in French-language literature.[116]

Daudet, a southerner born at Nîmes, is today best known for his regional short stories, *Lettres de mon moulin* (1869), his autobiographical novel, *Le Petit Chose* (1868), and his fanciful saga of the exploits of an unlikely southern hero, *Tartarin de Tarascon* (1872). In his own time, however, he was a member of the prominent Parisian circle of Realist writers that included Flaubert, Edmond de Goncourt, Zola, and Russian expatriate Ivan Turgenev, and he won renown as a novelist and playwright of that stripe. In the decade between 1874 and 1884, Daudet produced seven Realist novels set in Paris,[117] which led his contemporaries to label him a Naturalist, despite the author's avowed independence from any school.[118] He was presented as such (with some qualifications) by the Dutch press in the 1880s,[119] and Van Gogh not only thought of Daudet as a Naturalist (W1), but consistently linked his work to Zola's (see, e.g., LT294, LT298), probably in part because his introduction to Daudet consisted of three novels from the author's Realist period: *Les Rois en exil* (1879), *Le Nabab* (1877), and *Fromont jeune et Risler aîné* (1874).[120]

The story of deposed foreign monarchs living in Paris, *Les Rois en exil* is a melodrama that tapped Van Gogh's attraction to character studies and to pathos; he later told Theo, "There is much heart in those books by Daudet – for instance, in *Les Rois en Exil,* that figure of the queen 'aux yeux d'aigue-marine' [with eyes of aquamarine]" (LT242). *Le Nabab,* a roman à clef centered on politics and big business under the Second Empire, provides a broader view of Parisian society and features a large cast of characters. Its pictorial prose led Van Gogh to describe it as a "masterpiece," and he especially recalled "that walk of Le Nabab and Heinerlingue, the banker,

on Père Lachaise in the twilight, while the bust of Balzac, a dark silhouette against the sky, looks down on them ironically. That is exactly like a drawing by Daumier" (LT242).

Fromont jeune et Risler aîné takes up the working class, and Risler – a sincere and industrious man who is duped and ruined by a faithless and scheming wife – seems to have struck a personal note with Van Gogh. In a letter to Theo he wrote:

You have read *Fromont jeune et Riszler aîné* [*sic*], haven't you? Of course I do not find you in Fromont Jeune but in Riszler [*sic*] aîné – in his being absorbed in his work, his resoluteness *there,* for the rest a simple fellow and rather careless and shortsighted, wanting little for himself, so that he himself did not change when he became rich – I find some likeness to myself. (LT315; his emphasis)

Though he began by comparing Theo to Risler, Van Gogh in the process of describing the character saw himself even more clearly, though seemingly unexpectedly. Given his rapidly deteriorating relationship with Sien and his tendency to associate her with Zola's Gervaise Coupeau of *L'Assommoir,* it is likely that Van Gogh identified with Risler's domestic woes as well as with his devotion to work. But perhaps fearing that Theo would make such a supposition, Van Gogh attempted to negate it a priori; in the same letter, he continued:

Now I mention Riszler [*sic*] aîné again . . . and I call your attention to the fact that the man's appearance was more or less like mine, that he spent his life working at his designs and machines in the garret of the factory, not caring about or minding anything else, his greatest luxury being to take a glass of beer with an old friend.

Mind, the plot of the novel does not matter at all here, other things in the book are of no consequence, but I call the character to your attention, Riszler [*sic*] aîné's way of living, *without arrière-pensée of anything else in the story.* (LT315; his emphasis)

His remarks on Risler indicate Van Gogh's tendency to project himself into what he read and to represent himself within its context. His emphatic denial of other parallels between Risler and himself is suspiciously overstated and – in addition to countermanding his claims – underscores Van Gogh's sensitivity to the interrelatedness of life and art, the real and the fictive.

Van Gogh encountered the work of Camille Lemonnier in May 1883, when he read the recently published *Un Mâle* (1881). One of the most prominent Belgian writers of the nineteenth century, Lemonnier was a great admirer of Zola, and unlike Daudet, he aspired to be a Naturalist. Zola's precepts strongly influenced Lemonnier's first novels, particularly *Un Mâle,* which takes the standard Naturalist view of peasants as animallike others[121] and dwells on the unbridled passions and violent tendencies of the inhabitants of a woodland village. Van Gogh was quick to divine the ancestry of *Un*

Mâle and called it "very well done, in the manner of Zola. Everything observed from nature, and everything analyzed" (LT284).

Because they adhere to the comparative mode he favored, Van Gogh's comments on Lemonnier are as revealing of his general impressions of Zola's oeuvre as of his reaction to *Un Mâle*. Similarly, it seems that the real impetus to read the fiction of Edmond and Jules de Goncourt finally came from Van Gogh's understanding that they worked "in the manner of Zola" (LT298). Though he surely had heard their fiction discussed months before by Breitner (and possibly by others of the Pulchri circle) it was only in the summer of 1883 that Van Gogh sought it out – perhaps encouraged by the laudatory essay on the Goncourts that appears in *Mes haines,* a book Van Gogh was in the midst of reading.[122] During a visit to Breitner in Rotterdam, he borrowed a copy of the Goncourts' *Soeur Philomène* (1861), the story of a sexually repressed nursing nun who becomes infatuated with an intern.[123] Van Gogh found it "very good" (LT301), but neither elaborated nor mentioned it again. He does not seem to have read any other novels by the Goncourts until October 1885.[124]

VAN GOGH'S EARLY ASSESSMENT OF NATURALIST CRITICISM AND THEORY

In July 1883 – a year after his immersion in Zola's fiction – Van Gogh undertook a close reading of the collection of critical essays the author published under the title *Mes haines.*[125] A compendium of writings on literature and art, the book presents both an overview of Zola's aesthetic convictions and several examples of their application to particular works. The "hatreds" of the book's title refer to the animosity he professes toward mediocrity in the arts and the narrow-mindedness of critics and audiences. In its preface (written in 1866) Zola denounces the sheeplike complacency of writers and artists, readers and viewers who work and respond according to formulas devised by others[126] and portrays himself as anarchic and antidogmatic, a subscriber to no school, no ideal.[127] "I am in favor of free manifestations of human genius," Zola writes. "I believe in a continuous series of human expressions, in an endless gallery of living pictures."[128]

In two early essays, he attacks P.-J. Proudhon's call for an art committed to effecting social change.[129] Art, Zola argues, should not attempt pedagogy[130] and should serve no ideal but that of individual expression. In a now-famous passage he asserts:

For myself, I take the position, in principle, that a work lives only by originality. I have to recognize a man in every work, or the work leaves me cold. I bluntly sacrifice humanity to the artist. My definition of a work of art, if I were to formulate it, would be: *a work of art is a corner of nature* [création] *seen through a temperament.* ("Proudhon et Courbet, I", his emphasis)[131]

Zola presents "temperament" (in the sense of individual sensibility) as a key determinant of artistic production, a given in the simple equation of art making that he has deduced empirically. In an essay on Victor Hugo's "Les Chansons des rues et des bois," for instance, he notes the disappointment of those who – misled by its title – expected unprecedented earthiness from Hugo and then emphasizes the equanimity of his own response: "Given Victor Hugo and the subject of idylls and eclogues, Victor Hugo couldn't produce anything different from *Les Chansons des rues et des bois.*" Some lines later, Zola reiterates, "The book is, I repeat, the logical and inevitable product of a certain temperament put before a certain subject."[132] Similarly, in "Le Moment artistique" (an explanation of "my way of looking at art"), Zola elaborates the artistic equation he proposes then promotes throughout *Mes haines:* "There are, in my opinion, two elements in a work: the real element, which is nature, and the individual element, which is man.... The real element, nature, is fixed, always the same.... The individual element, man, is, on the contrary, infinitely variable."[133]

Though he claims that careful reproduction of the real is not so important to him as a work's individuality,[134] Zola portrays the "real" world (nature) as an integral part of his formula for valid creative practice; his notion of viable production thus is circumscribed by the assumption that it consists of response to observed phenomema. This attitude, for instance, informs his essay on Gustave Doré, which Zola himself characterizes as a "realist's judgment of an idealist." Though the author here discusses an oeuvre in which a particularized sensibility dominates, he chides Doré for squandering his talents on a dream world of his own invention, rather than engaging the seen: "Never has an artist been less concerned than he with reality."[135] Thus, the absolutes Zola denounces throughout *Mes haines* are replaced in his own criticism by dogma born of materialist bias. This issue emerges again in "Le Moment artistique," wherein Zola derides the prevailing conception of art as something outside mundane existence.

The word 'art' displeases me; it contains within it certain ideas of requisite arrangements, of an absolute ideal. Isn't making art doing something that is outside man and nature? For myself, I want a person to make life; I want a person to be alive, to create afresh, outside everything, according to his own eyes and his own temperament. That which I look for before anything else in a picture is a man and not a picture.[136]

Using corporeal metaphor to image the predetermined if individualized processes of a macho male generator,[137] Zola declares that "like everything, art is a human product, a human secretion; it is our bodies that sweat the beauty of our works."[138]

Van Gogh had mixed reactions to *Mes haines,* which he wrote of at length

in a letter to Van Rappard in July 1883. He began his commentary with a paraphrase of Zola, noting:

I should like to apply Zola's own words about Hugo to Zola's *Mes Haines:* "Je voudrais démontrer qu'étant donné un tel homme sur un tel sujet le résultat ne pourrait être un autre livre qu'il n'est" [I wanted to demonstrate that given such a man writing on such a subject, the result could only be such a book]. And moreover Zola's own words on the same occasion: "Je ne cesserai de répéter: la critique de ce livre, telle qu'elle s'est exercée, me paraît une monstrueuse injustice" [I won't stop repeating: the criticism of this book, as it is exercised, seems to me a monstrous injustice]. (R38)

Following Zola's lead, Van Gogh sought to accept *Mes haines* as an expression of personality:

I'll very gladly begin this matter by saying that I consequently do *not* belong to those who think ill of Zola for writing such a book. Through it I come to know Zola, I come to know Zola's weak point – deficient ideas on the art of painting – *préjugés* instead of *jugement juste* in this special matter. But, my dear friend, shall I feel offended by a friend of mine because of a fault in his character? – far be it from me. On the contrary, I love him all the more for his fault. So I read the articles on the Salon with a very peculiar feeling; I thought him enormously mistaken, his ideas entirely wrong, except partly his appreciation of Manet – I think Manet clever too – but it is very interesting to read Zola's ideas about art, as interesting, so to speak, as a landscape by a figure painter, for instance. It isn't his genre, it's superficial – incorrect, but what a conception! – not carried through – never mind – not quite clear – never mind – it makes one think and is original and at least sparkling with life. But for all that it's wrong and most inaccurate and unjustified. (R38; his emphasis)

Since Van Gogh did not elaborate on his objections to Zola's Salons, that which irritated him is perhaps most easily deduced by a process of elimination. First, it is clear that he had not finished the book when he wrote to Van Rappard, for Van Gogh lamented Zola's inattention to Millet,[139] an artist the author discusses in the next-to-last chapter of *Mes haines*.[140] Second, it seems that Van Gogh responded positively to the general tenor of the book; he agreed with Zola's cynical characterization of the general public's taste as "utterly banal" (LT297), and later both sympathized and identified with Zola's declaration in the preface that (as Van Gogh paraphrased Zola) "if at present I am worth something, it is because I am alone, and I hate the fatuous-minded, the impotent, the cynics, the idiotic and stupid scoffers" (LT305).[141] It is thus unlikely that Van Gogh took issue with the first two essays of the book's Salon section, which lambast the jury system of official exhibitions. The third essay, "Le Moment artistique," is a generalized one that touches on ideas Van Gogh later quoted with enthusiasm, and the fourth, on Manet, elicited a mainly favorable response in R38. That leaves Zola's

essay on Gustave Doré (which appears in the first section of the book – i.e., not among the Salons) and an essay entitled "Les Réalistes du Salon."[142]

Since Van Gogh had long admired Doré – particularly his scenes of London in a Realist vein (see, e.g., LT84, LT140) – he may well have disagreed with Zola's appraisal, which was written before the London series was published.[143] Van Gogh's objections to "Les Réalistes du Salon" probably were less specific and at the same time more complex, for this essay includes both a general attack on contemporary notions of "Realism" – a word Zola found distressingly imprecise and inclusive when used as an artistic label[144] – and specific critiques of five ostensibly Realist painters:

There are realists at the Salon – I no longer say temperaments – there are artists who claim to present real nature, with all its rawness and all its violence. To firmly establish that I scoff at more or less exact observation when there's not a powerful individuality that brings the picture to life, I'm first going to give my unvarnished opinion of Messieurs Monet, Ribot, Vollon, Bonvin and Roybet.[145]

After lauding Monet – "There's a temperament for you, there's a man in the crowd of these eunuchs"[146] – Zola derides the work of the other four. Though Van Gogh's letters indicate no great prior loyalty to any of them,[147] he may well have been angered by Zola's dismissive accounts of their efforts and by the author's seeming ignorance of Millet.[148]

Even as Van Gogh acknowledged the painterly quality of the author's own prose – "I have read descriptions by Zola of a village churchyard and a deathbed and the funeral of a poor old peasant which were as beautiful as if they were Millets"[149] – he told Van Rappard that "Zola has this much in common with Balzac, that he knows little about painting" (R38).[150] He was willing, however, to credit the author with literary expertise, and though the reviews in *Mes haines* take some of his favorite authors to task,[151] Van Gogh allowed that here, at least, Zola "doesn't shoot so wildly at random" (R38).[152] He also granted the validity of Zola's repeated pronouncements on the importance of originality and personality in a work of art, views that surely ratified some of Van Gogh's own convictions. (Shortly before he made reference to *Mes haines*, for instance, the fledgling artist noted, "If one tries honestly and freely to fathom nature ... one may make mistakes, one may perhaps exaggerate here or there, but the thing one makes will be original" [LT295].)[153]

Zola, in both his criticism and his fiction, positioned himself at the juncture of empiricism and subjectivity, and his vigorous and succinct articulation of their complementary functions in the best modern painting and literature gratified Van Gogh, who had arrived independently at a similar conclusion: "One must seek a way to express what one feels and venture a little outside the ordinary rules to render them exactly as one wants" (LT294). As he read

Mes haines, Van Gogh told Theo that "there are some good things in it" (LT297), and once he got beyond his irritation with the book's specifics he found himself in agreement with some of its broader concepts. In the summer of 1885, for instance, he acknowledged: "Though in my opinion he makes colossal blunders in his judgment of pictures, Zola says a beautiful thing about art in general in *Mes Haines,* 'dans le tableau (l'oeuvre d'art), je cherche, j'aime l'homme – l'artiste' [in the picture (the work of art) I seek, I love the man – the artist]" (LT418). As an autodidact, Van Gogh found Zola's antiacademic stance reassuring,[154] and he was very much attuned to the concept of temperament. Within a month of reading *Mes haines* he found Zola's definition of art validated by a reexamination of paintings by the Barbizon artists Dupré, Troyon, and Rousseau, and wrote:

The dramatic effect in those pictures is a thing which, more than anything else in art, makes one understand "un coin de la nature vu à travers d'un tempérament" [a corner of nature seen through a temperament],[155] and "l'homme ajouté à la nature" [man joined to nature]; and one finds the same thing, for instance, in portraits by Rembrandt. It is more than nature, it is a kind of revelation. And it seems to me that one must feel all respect for it, and not join those who often say that it is exaggerated or mere mannerism. (LT299)

Around the same time, Van Gogh also made the first of several references to temperament as a factor in his own work. Reporting on a continuing aesthetic disagreement with his former employer Tersteeg, manager of Goupil's gallery at The Hague, Van Gogh wrote:

I think of Tersteeg's opinion that I must make water colors....

I cannot understand how these figures...would retain their individuality if I made them in water color. The result would be very mediocre, the kind of mediocrity which I don't want to surrender myself to.[156]...

But the question is, if my temperament and personal feeling primarily draw me toward the character, the structure, the action of the figures, can one blame me if, following this emotion, I don't express myself in water color, but in a drawing with only black or brown? (LT297)[157]

Especially in his early years as an artist, as he struggled with basic techniques and had no hope of painting in an accomplished, anonymous academic style, Van Gogh took particular comfort in Zola's celebration of subjectivity in artistic response and cited "temperament" as a justification for his way of working (LT309, LT399). Later, when he was less inclined to make apologies for the way he worked, Van Gogh still invoked that amorphous term to denote his personal aesthetic; writing from Arles in 1888 on the palette of his recent paintings, he remarked, "It is color not locally true from the point of view of the delusive realist, but color suggesting some emotion of an ardent temperament" (LT533).

By the time he left The Hague, in September 1883, Van Gogh had had

broad exposure to Naturalist precepts and practice – through the fiction and essays of Zola (as well as secondary sources on his aims and production), and through related works by Daudet, Lemonnier, and the Goncourt brothers. In addition to his appreciation for the pictorial aspects of Zola's and Daudet's prose, and their presentation of modern characters and situations with which he could identify, Van Gogh felt respect for the analytic qualities of the Naturalist style (see, e.g., LT281, LT284). Though he did not yet draw any direct parallels between Naturalist practice and his own, Van Gogh felt a theoretical affinity for its methods; at The Hague he stressed his own powers of analysis (LT237) and his aim to document observed "truths."[158] In the summer of 1882, for example, he wrote of "taking notes from nature" (LT221) and later that year explained, "I myself try to make something of what one sees on the street every day" (LT240).[159] He tended to scorn those who worked from memory (see LT221) or from the imagination (see, e.g., LT298; LT299),[160] but nonetheless acknowledged that "half romantic, half realistic [is] a combination of styles which I don't dislike" (LT298). While he sought to "work faithfully and firmly after nature" (LT314), Van Gogh accepted, even embraced, the subjective element inherent in his response and aimed to be true to his own temperament.

THE ASSIMILATION OF FRENCH NATURALISM
Van Gogh in Drenthe, Nuenen, Antwerp

Discontented with Sien and longing for country life, Van Gogh left The Hague in September 1883. He spent the next two years in virtual isolation, painting rural laborers and landscapes and making great strides in his work. (His first major painting, *The Potato Eaters,* was completed in 1885 at Nuenen, the last Dutch village to which his father was posted.) Despite his distance in miles and milieu from contemporary French culture, Van Gogh in this era also furthered his knowledge of Naturalist authors and their writings. In addition to new novels by Zola, he read fiction and nonfiction by Daudet and the Goncourts, and by 1885 these authors represented for him the vanguard of modern creative practice and production. Moreover, as he thought retrospectively of Zola's *Mes haines*, Van Gogh was increasingly sympathetic to its author's convictions and ideals, and the persona he ascribed to Zola became ever more heroicized.

Van Gogh's letters suggest that his admiration for Naturalist precepts and practice shaped his perception of and approach to art making from 1884 onward, but the links between his readings and art remained general during his first twenty months in rural Holland. As before, he drew several specific parallels between fictional characters and situations and the people and events of his own life, but it was not until the spring of 1885 that Naturalist prose affected his work in a particularized, acknowledged way. The first instance was a peasant portrait inspired by a passage from Zola's *Germinal* – that is, a visual image prompted by the artist's response to a verbal description; a few months later (in the autumn of 1885), Van Gogh made a different, more direct allusion to his literary interests when he included a clearly titled book, Zola's *La Joie de vivre,* in a still life – the first of several such works in which the title and themes of an actually imaged volume enrich and expand a picture's connotations.

FICTION'S ALLURE IN "A COLD AND MISERABLE COUNTRY"

Upon leaving The Hague, Van Gogh spent the autumn of 1883 painting in Drenthe, a sparsely populated district on the border between Holland and Prussia. Then, in December, financial woes forced him to seek the hospitality of his parents, who had since moved to Nuenen, a farming community in the Brabant that also was a weaving center.[1] Though this retreat to his father's parsonage was initially regarded as a stopgap measure by all concerned, Van Gogh remained at Nuenen for almost two years, during which relations with his family continued to be antipathetic and were further blighted by the scandal surrounding Van Gogh's affair with a member of his father's congregation. After the sudden death of the Rev. Van Gogh in the spring of 1885, tensions eased for a time, but bickering dominated familial relations at Nuenen during Van Gogh's residence there.

His alienation was profound and undisguised, and often extended to Theo, who enjoyed cordial relations with their parents and sisters and urged Vincent to be respectful, conciliatory, and discreet. Such advice rankled, as did Theo's modest success in the art business; Vincent's continued financial reliance on his younger brother frustrated and unnerved him, and his oft-stated disdain for his brother's work as a dealer soured their relations. Assuming alternately aggressive and defensive postures, Van Gogh self-righteously portrayed himself as a man whose high ideals made him an outcast (a conception of self that owed something to the authorial position Zola assumed in *Mes haines*; see LT336). In a letter of January 1884 (i.e., shortly after his move to Nuenen), Van Gogh used heavy-handed allegory to make his point; in a classic case of biting the hand that feeds, he presented Theo with a story that pits one course of life – the (morally superior) pursuit of art – against another – the (base) quest for worldly wealth:

I know an old legend, I don't know of what people, which I love; of course it did not happen literally, but it is a symbol of many things.

In that story, it is said that the human race descends from two brothers.

These two were allowed to choose what they wanted above all things. The one chose gold, and the other chose the book.

The first, who had chosen gold, became prosperous; but the second one fared poorly.

The legend – without explaining exactly why – tells how the man with the book got banished to a cold and miserable country, and got *isolated*. But in his misery he started reading that book, and he learned things from it. So he managed to make his life more bearable, and invented several things to get out of his difficulties, so that at least he acquired a certain power, but always by working and struggling.

Then afterward, just when he had become stronger with the book's help, the first one grew weaker; and so he lived long enough to learn that gold is *not the* axis round which *everything* turns.

It is only a legend, but for me there is a depth in it which I find true.

"The book" does not mean *all* books or literature, it is at the same time conscience, reason, and it is art. (LT351; his emphasis)

At Nuenen Van Gogh saw himself banished once more to a "cold and miserable country," where books – and the far-off worlds of art and learning they emblematized – would be his solace and salvation. Indeed, during his time there, Van Gogh's sense of isolation[2] was most effectively offset by reading, for books – particularly recent fiction – provided a link to contemporary culture and served to broaden his mental horizons.

While still in Drenthe, Van Gogh began to reappraise *Mes haines*. He expressed contempt for the "triumph of mediocrity, nullity, and absurdity" (LT331)[3] to which he had been alerted by Zola's critiques of contemporary taste, and in a subsequent letter he paraphrased the author as he vaunted his own unconventionality. Railing against notions of social standing and what he called the "safe position," Van Gogh noted:

Zola says, "Moi, artiste, je veux vivre tout haut – *veux vivre*" [I, as an artist, want to live life to the hilt – *want to live*],[4] without mental reservation – naïve as a child, no, not as a child, as an artist – with good will, however life presents itself, I shall find something in it, I will try my best on it. Now look at all those studied little mannerisms, all that convention, how exceedingly conceited it really is, how absurd, a man thinking he knows everything and that things go according to his idea, as if there were not in all things a "je ne sais quoi." (LT336)

Zola's stated aims gradually merged with Van Gogh's, and *"vivre tout haut"* became a favored motto; in the same letter he wrote that extended discussion of one's aspirations was essentially boring and deadening, and declared, "Live – do something – that is more amusing, that is more positive" (LT336).

The Zola that emerged from the pages of *Mes haines* was to Van Gogh's mind a man of action and audacity, unfettered by the rules and suppositions of his society; one of a handful of nineteenth-century writers and artists who had touched on the "soul of modern civilization," he possessed that which Van Gogh called the "eternal quality in the *greatest of the great:* simplicity and truth" (LT339a; his emphasis).[5] That Van Gogh continued to consider the thoughtful reading of Zola a means of self-enrichment is made clear by his comment to Theo that "a few things have happened to you which I don't think unimportant. You have read Zola's books in a different and better way than most people do – I consider them among the very best of the present time" (LT333). Clearly, Van Gogh believed that he, too, had read Zola "in a different and better way" than most – presumably with an eye to their broadest implications about life and work in the modern world.

During his first months at Nuenen, where access to contemporary literature probably was limited,[6] Van Gogh contented himself with the reading materials he found close to hand. He read a good deal of poetry[7] and reread

Eliot's *Felix Holt* – a book that presents a peaceful rural setting of the sort Van Gogh nostalgically sought in Nuenen and evokes, albeit briefly, the weaver's trade, which fascinated him in the early months of 1884.[8] Within a few months, however, he obtained a few Naturalist novels, and by mid-1884 they again became the focus of his literary pursuits. The tenor of his remarks on literature – Naturalist and otherwise – changed in this era. During his first year at Nuenen, he was less apt to give Theo updates on what he was reading and to appraise specific books when he read them; casual, oblique references to books read at some unspecified prior date are more common than in previous correspondence. This shift probably had more to do with Van Gogh's strained relations with his brother than with a significant change in his selection, response to, and modes of evaluating books, for he later reverted to more elaborate and enthusiastic discussions of his readings. Despite this temporary reticence about literary matters, we know that by the summer of 1884 Van Gogh had read a new volume in the Rougon-Macquart series – *Au Bonheur des Dames* (1883) – as well as three novels by Daudet: *Numa Roumestan* (1881), *L'Evangéliste* (1883), and the newly published *Sapho* (1884).

Sapho – the story of a young provincial's long, degrading, and ultimately debilitating relationship with an aging Parisian prostitute – was the only book of the four that inspired Van Gogh to comment on its style. He found it "very beautiful, and so full of vigor, so 'la nature serré de près' [nature clasped close], that the heroine lives, breathes and one *hears* her voice, literally *hears* it, for one forgets one is reading" (LT373; his emphasis).[9] His appreciation of the book, and more particularly his mode of characterizing its verisimilitude, seem indebted to Van Gogh's familiarity with *Mes haines*. There, in an appraisal of Courbet, Zola writes: "He felt himself carried away by all his flesh – by all his flesh, you understand – toward the material world. . . . He had a keen desire to clasp [*serrer*] real nature in his arms."[10] Stressing the physicality of Courbet's process, Zola describes the artist's embrace of nature in terms that probably inspired Van Gogh's phrase, "la nature serré de près," in *his* comments on Daudet. In writing *Sapho*, Daudet had taken a "reality" Van Gogh (in the wake of his break with Sien) surely identified with and – holding it close – refigured it as art. Such a process doubtless struck Van Gogh as not just laudable but appealingly imitable as he strove to work along similar lines. A few months before, he had written of a personified nature from Drenthe: "You listen to the still voice of nature, and at times nature will seem a little bit less hostile, until at last you are her friend. . . . But nature demands a certain devotion, and she demands a period of struggling with her" (LT339).[11]

Though his remarks on *Sapho* indicate a continuing interest in Naturalist modes of representation, the most extensive literary asides in Van Gogh's

letters from the first year at Nuenen were shaped by and directed toward events in his own life. In December 1883, for instance, having noted that he would rather fight than reconcile with his father, Van Gogh relied on a phrase from *Mes haines* to support his decision, declaring, "*Vivre tout haut* is simply one's duty" (LT348; his emphasis). In letters of early 1884, both Theo and Vincent referred to Zola in commenting on Theo's faltering relations with a woman friend (LT362, LT363), and Vincent quoted both Zola and Daudet in an effort to elucidate the brothers' own misunderstandings (LT358, LT362). It is therefore not surprising that Vincent's half of the brothers' extended epistolary discussion of the year's most dramatic event in his personal life – an affair with a local woman named Margot Begemann – is filled with literary reference. He seems, in fact, to have distanced himself from the distressing denouement of their liaison – an unsuccessful suicide attempt by the distraught Begemann (whose sisters had denounced her) – by using literary parallels to mediate his account of its events. In relating the drama to Theo, Van Gogh compared Begemann to the "*first* Mme. Bovary" (LT375, LT376; his emphasis), and in a subsequent letter he blamed the scandal on "women's intrigues" of a sort described by Daudet in *L'Evangéliste* – a novel that chronicles the brainwashing of a young woman by a group of radical female evangelists (LT378).[12] Van Gogh had mentioned Daudet's book a few months earlier as he disparaged overdone piety (LT358) and now recalled it as he fulminated against Margot's sisters, whom he believed to have involved themselves in his affair with self-righteous maliciousness.[13]

Amid all the turmoil and moralizing brought about by their families' discovery of his involvement with Begemann, Van Gogh strove to maintain an attitude of "*vivre tout haut*." While he regretted the results of his actions, he prided himself on the actions themselves, which to his mind bespoke "manliness" and a refusal to be bound by conventions of propriety in the free expression of his emotions and "temperament" (LT377). In a long letter to Theo (LT378), he even turned for support to the maxims of Octave Mouret, the womanizing protagonist of Zola's *Pot-Bouille* whom Van Gogh once had disdained as a seducer with no real love for women, a man "more passive than active" (LT247). In the interim, however, he had read the continuation of Mouret's story in *Au Bonheur des Dames,* a book in which Mouret "pleases me much better" (LT378). Indeed, Mouret became for Van Gogh a fictional embodiment of the personal daring Zola championed in *Mes haines* – and which the burgeoning artist aspired to in both his work and his relationships.

Octave Mouret – who married a woman of wealth at the end of *Pot-Bouille* – is shown at a different stage of life in *Au Bonheur des Dames:* He is older and more assured, extremely aggressive, and highly successful. Par-

laying his wife's fortune into a nineteenth-century businessman's dream, Mouret has built and now presides over one of the immense new *grands magasins* that changed the course of commerce in Paris. Called Au Bonheur des Dames, it is a monument to Mouret's lifelong pursuit of women and success at pleasing them. Along with his prosperous department store has come Mouret's entry into the haut monde, and as a young widower (his wife died in an accident on the site of the store) he now seduces the cream of Parisian society rather than the bourgeois housewives who were such easy prey for him in the pages of *Pot-Bouille*. His sexual conquests mirror his entrepreneurial triumphs;[14] Mouret's marketing prowess has driven the small shopkeepers of the neighborhood to their knees. His self-congratulatory egoism is subdued, however, by an unlikely object of desire: an orphaned Provençal shopgirl named Denise who finds work in Mouret's store. Over the protests of both his prim, cautious second in command, Bourdoncle, and of Denise herself, Mouret vows to marry his new employee, the woman who has reawakened his taste for the simple pleasures of life (Mouret, a Macquart, was born in Provence). At the novel's end, Mouret is ostensibly humanized and redeemed by his submission to love and the consequent enfranchisement of Denise, whose gender, class, and financial status heretofore marked her the underdog.[15]

In this incarnation, Mouret appealed to Van Gogh as a man who lived life to the fullest, with the knowledge of what he wanted and the drive to obtain it. When Theo responded to his brother's account of the Begemann affair with shocked disapproval, Vincent reminded him of Mouret's words (from *Au Bonheur des Dames*): "Action contains its own reward; to act, to create, to fight against facts, to *conquer* them or *be conquered by them*, *therein* lies all human happiness and health! ... *I would rather die of passion than die of boredom*" (LT378; Van Gogh's emphasis).[16] Haunted by the book, he noted, "I find the *greatest* and *best* things in it" (LT378; his emphasis) and told Theo:

You say that you like *Octave Mouret*, you say, You are like him....

You – *of late*, this past year and a half, haven't you developed in *Bourdoncle's direction?*[17] You should have stuck to Mouret, that was and still is my opinion. But for the enormous difference in circumstances, yes, direct difference in circumstances, I incline, however, more toward Mouret's direction *than you may* think in the matter of my belief in women, and that one needs them, must love them. Mouret says, "*chez nous on aime la clientèle*" [we love our clientele].

Please think this over, and remember my regret at your saying that you had "cooled down."...

Why? Because it leads to mediocrity. And I do not want to see you among the mediocrities, because I loved you too much for that, and I still love you too much for that – I cannot endure to see you congeal. I know it is difficult. I am aware that

I know too little about you – I know that perhaps I am mistaken. Never mind. In any case just read your Mouret over again. (LT378; his emphasis)

So that Theo would know exactly what "Mouret" to read, Van Gogh appended several passages from the novel's chapter XI, most drawn from a conversation between Mouret and a pessimistic friend. Mouret's lines (which include those cited earlier) are entreaties to *vivre tout haut*, even if living life at full tilt involves mistakes and suffering; for example, "If you think you are strong because you refuse to be stupid and suffer . . . well, you're nothing but a dupe, nothing more."[18] Mouret lauds risk taking even in the face of potential failure and insists that one must *act* in order to produce and succeed.

When Van Gogh cited these lines apropos his relations with Begemann, he implied that he was a passionate man who preferred error to inaction and suggested that Theo's failure to understand this marked him as a Bourdoncle – that is, a narrow-minded moralist with no zest for life and a dangerous tendency toward mediocrity. For fear of similar mediocrity, Van Gogh refused to alter his own attitudes and behavior:

Oh, Theo, why should I change myself? I used to be very passive and very soft-hearted and quiet; I'm not anymore, but it's true, I am no longer a child now that I sometimes feel my ego. . . . I tell you, if one wants to be active, one must not be afraid of failures, one must not be afraid of making some mistakes. Many people think that they will become good by *doing no harm*; that's a lie, and you yourself used to call it a lie.

It leads to stagnation, to mediocrity. (LT378; his emphasis)

In the next few months, action became Van Gogh's byword and "cool" his label for those who – like Zola's Bourdoncle and Daudet's evangelicals – were more cautious than energetic. When he told Theo, in later letters, "You are too cool for my taste" (LT386a; see also LT385, LT386), Van Gogh was comparing his brother to those fictional foes of generative "passion." Moreover, Van Gogh strove to suggest that the same impetuosity and disregard for stricture that had fueled his affair with Begemann were components of his creativity: "Many painters are afraid of the blank canvas," he wrote, "but the blank canvas is afraid of the really passionate painter who is daring – and who has once and for all broken that spell of 'you cannot'" (LT378). Van Gogh likewise feared that widespread restraint – "coolness" – threatened the art market and argued that the situation would improve if only "we had *Mourets* in the art trade, who would know how to create a *new* and *larger* buying public . . . who would buy and sell in a way different from the old routine" (LT379; his emphasis). He badgered his 27-year-old brother to "*act and be daring like a young man. If you are no artist in painting then try to be an artist as a dealer like Mouret. As for myself . . . I*

don't intend to be bored – *do a great deal* or *drop dead*" (LT379; his emphasis). Following the same tack in subsequent letters, Van Gogh declared, "Risking one's all, is the best thing to do. But the cooler characters doubt this – the Bourdoncles.... In the matter of *carrying* something *out*, of per-servering in it and winning through... they relapse into their doubts and hesitations" (LT384; his emphasis). "I have decided to push on with passion rather than prudence, because this is more in character" (LT386).

As his admiration for Mouret led Van Gogh to look beyond similarities of "character" to find equivalencies in their (fairly disparate) enterprises, he argued that the passion Mouret felt for his business and clientele could be compared to an artist's passion for his work and subjects (hence to the intensity of expression Van Gogh admired in the prose and paintings of Zola, Jules Breton, and Jean-François Millet and aimed for in his own work):

I spoke of the difference and *yet* the similarity between Mouret and what I should want. Look here, Mouret worships the modern Parisian woman, all right.

But Millet, Breton, worship the peasant woman *with the same passion*.

These two passions are one and the same.

Read Zola's description of a room with women in the twilight, women often already over thirty, up to fifty, such a dim, mysterious corner.

I think it splendid, yes, *sublime*.

But to me, Millet's "Angelus" is just as sublime, *that* same twilight, that same infinite emotion, or that single figure of Breton's in the Luxembourg[19] or his "Source."

You will say that I have no success – I don't care to conquer or to be conquered, [but] in any case one has emotion and action, and that is more the same thing than it appears. (LT378; his emphasis)

In the passage from *Au Bonheur des Dames* cited here, Mouret – a salesman in suitor's guise – presides over a ladies' tea at which he displays new products and seduces his audience en masse.[20] His easy mastery of a circle of women, detailed by Zola in a langorous, pages-long description, kindled Van Gogh's desire for a parallel success: to turn his maleness to the service of his craft and induce women to do as he wished – in this case, to pose for him. As he struggled to master the figure, Van Gogh had begun to equate the pursuit of models with rituals of courtship at which Mouret excelled,[21] but he noted that their respective targets differentiated him from Zola's hero; Van Gogh did not seek to captivate the elegant Parisienne, but instead to capture the peasant woman à la Breton and Millet. Though his comments on Zola's passage indicate an awareness of its pictorial aspects, Van Gogh's reaction to *Au Bonheur des Dames* was more closely tied to his fascination with Mouret's drive and salesmanship – and to a wistful desire to devise a viable pitch of his own.

PEASANT PAINTING AS NATURALIST ENTERPRISE

After several months' work on images of weavers, Van Gogh turned his attention to field laborers in the late spring and summer of 1884, and that fall he began a series of bust- and waist-length portrait studies of them. Whereas the loom operators he had depicted were men, the farmhands he portrayed were mostly women, and though he acknowledged that he might have liked to paint "heads of girls such as our sister" – that is, middle-class Protestants like the Begemanns – Van Gogh conceded, "I . . . am not the personality to have much chance of getting on a sufficiently intimate footing with girls of that sort for them to be willing to pose for me" (LT395). Deciding that bourgeois and upper-class women were the province of ladies' men like Octave Mouret, Van Gogh chose to follow the lead of Breton and Millet by devoting himself to peasants. He found his subjects among the district's Catholic working class and paid them to model; early in 1885 he wrote, "Perhaps I am . . . prejudiced against women who wear dresses. . . . My territory is more those who wear jackets and skirts" (LT395).

To chart his chosen territory, Van Gogh spent the winter of 1884–5 painting and drawing dozens of studies of Nuenen's underclass. Since their farm chores were fewer (and their incomes lessened) in winter, Van Gogh found several of them willing to pose, and he set out to paint as many portrait studies as his time and allowance permitted. Though very much at home with figure studies, he still felt the restrictions of his self-taught skills and saw his work as rehearsal for a larger – though as yet unspecified – project. He emphasized his need of practice before living models (rather than recourse to memory or imagination) when he told Theo, "Every day I am more convinced that people who do not first wrestle with nature *never* succeed" (LT393; his emphasis). A longtime partisan of rural scenes, Van Gogh declared himself eager to explore the "life and reality" that informed such imagery (LT393), and chiding his now-urban brother, he wrote, "Isn't it a pity that you, for instance, seldom or hardly ever go into those cottages, associate with those people, or see that sentiment in the landscape, which is painted in the pictures you like best?" (LT393). His own intention was "to dwell and to live in the very midst" of that which he painted (LT397), and though he kept his room at the parsonage Van Gogh spent a good deal of time in the close, dimly lit cottages of his models.

Though he did not mention the Naturalists in this context, Van Gogh's insistence on close contact with his subjects and their milieu was consonant with those writers' insistence on "documentation" gathered at first hand. His rendering of his observations also conforms to the Naturalist mode prescribed by Zola, for despite his determination to work before

Figure 5. Van Gogh,
sketches of women's heads,
1884–5.

nature/"reality" (that which Zola called the fixed element), Van Gogh's "representation" of his subjects was selective and predetermined (by conditions of individual temperament that according to Zola make the artist the variable in the equation of picture making).[22] His resolve to emulate Millet, for instance, led him to seek out specific physiognomic types ("rough, flat faces with low foreheads and thick lips, not sharp, but full and Millet-like" [LT372]), and memories of a certain sort of Millet[23] not only informed his dark palette but encouraged him to overstate the coarseness of his models' blunt features with broad, often redrawn outlines, and short, thick strokes of his brush, pen, or chalk (Fig. 5). The paintings have a particularly rough-hewn aspect as a result of heavy, uneven application of murky pigments (Fig. 6). Most of the studies are close-up, bust-length portraits that detail facial features but lack allusion to particularized surroundings;[24] the models are marked as laborers by visage, hair (LT372),[25] and costume rather than by task or dwelling – though the dark backdrops that set off most of the heads suggest the dusky interiors of peasant cottages in winter gloom.

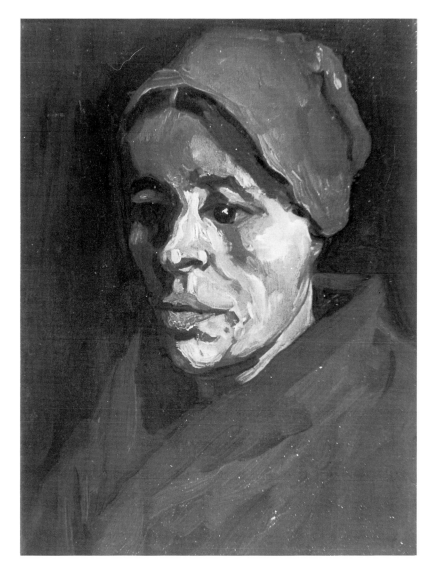

Figure 6. Van Gogh, *Peasant Woman, Head,* 1884–5.

When he first announced his project, Van Gogh described the peasant head series as the most readily available means of honing his skills as a figure painter, but as his work progressed he seems to have been increasingly attentive to the *content* of his studies and their potential impact on a bour-geois viewer. Acknowledging that the heads probably would be considered "unfinished" or "ugly" by most, he also expressed the hope that they would speak to "a few people who, having been drawn into the city and kept bound up there, yet retain unfading impressions of the country, and remain all their lives homesick for the fields and the peasants" (LT398). Yet despite his

apparent wish to appeal to such nostalgic longing, Van Gogh's growing sense of the less than idyllic lives of his subjects seemed to dictate images that denied rosy visions of rural existence and instead provided glimpses of the drab countryside urbanites had escaped:

It is dreary outside, the fields a mass of lumps of black earth and some snow, with mostly days of mist and mire in between, the red sun in the evening and in the morning, crows, withered grass, and faded, rotting green, black shrubs, and the branches of the poplars and willows rigid, like wire, against the dismal sky.... It is quite in harmony with the interiors, very gloomy, these dark winter days.

It is also in harmony with the physiognomy of the peasants and weavers ... [who] look as little cheerful as the old cab horses or the sheep transported by steamer to England. (LT392)

A dawning sense of purpose prompted Van Gogh's "brooding over a couple of larger, more elaborate things" as the winter ended (LT396) – presumably works that would build upon but move beyond the peasant studies (which now numbered more than a hundred) to present a totalizing image of "real" peasant life. Though the steady stride of his work was temporarily broken when his father died suddenly at the end of March, Van Gogh recovered himself by mid-April and began work on a picture of peasants at table that he had been thinking of for some time. The resultant painting, *The Potato Eaters* (Fig. 7), was six weeks in the making (an inordinately long time for Van Gogh to spend on a single work), and entailed several studies – of individual figures, parts of figures, and various objects, as well as various versions of the composition as a whole. Whereas Van Gogh dismissed the peasant heads as mere "studies" that were not intended to bear critical scrutiny (see LT395), he conceived *The Potato Eaters* as a major work that would demonstrate his skills as well as his ambitions, and from the beginning he felt anxious about its eventual reception. Even as he reported to Theo that he had begun the picture – sketching it out on a "rather large canvas" – he admitted that the drawing was somewhat faulty and conceded,

Now I know quite well that the great masters, especially in the period of their ripest experience, knew both how to be elaborate in the finishing and at the same time to keep a thing full of life. But certainly that is beyond my power for the present. At the point I am now, however, I see a chance of giving a true impression of what I see.

Not always literally exact, or rather never exact, for one sees nature through one's own temperament. (LT399)

Under cover of Zola's defense of the individual artist's idiosyncratic response to nature, Van Gogh proffered the technical imperfections of his work as manifestations of temperament, and even implied that his autodidact's clumsiness was a testament to the unvarnished "truth" of his portrayal.

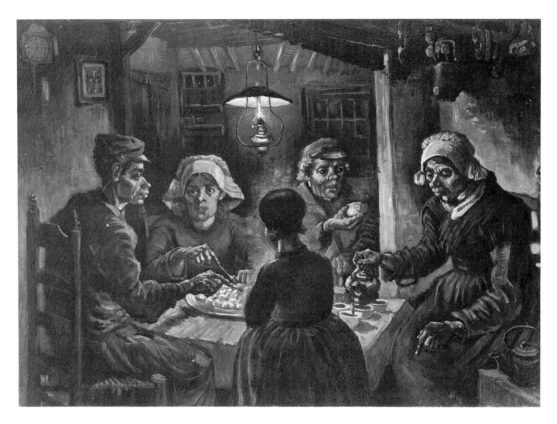

Figure 7. Van Gogh, *The Potato Eaters,* 1885.

He seems to have harked back to *Mes haines* once again – if less obviously – when in a subsequent letter on *The Potato Eaters* he dismissed "realism in the sense of *literal* truth, namely *exact* drawing and local color," and asserted, "There are other things than that" (LT402; his emphasis). His words recall the general premises of Zola's broadened conception of artistic realism that shapes the essay "Les Réalistes du Salon." There, the author proclaims, "I scoff at more or less exact observation when there's not a powerful individuality that brings the picture to life" and insists, "I ask the artist only to be personal and powerful. . . . Thus, no more of realism than of anything else. Some truth, if one wants it, some life, but especially different flesh and hearts interpreting nature in different ways."[26]

The inclusive spirit of Zola's pronouncements on realism bolstered Van Gogh's confidence as he worked on a picture that failed to conform to more traditional criteria. The artist declared himself willing to forsake exactitude in favor of "sentiment" and a truth to nature that was *felt* rather than optically precise (LT401), and – probably most convincingly – he argued

that a high finish would prove counterproductive to his attempts to produce an authentic picture of peasant life:

> It would be wrong, I think, to give a peasant picture a certain conventional smoothness. If a peasant picture smells of bacon, smoke, potato steam — all right, that's not unhealthy; if a stable smells of dung — all right, that belongs to a stable; if the field has an odor of ripe corn or potatoes or of guano or manure — that's healthy, especially for city people.
>
> Such pictures may *teach* them something. But to be perfumed is not what a peasant picture needs. (LT404; his emphasis)

By means of this verbal strategem, the artist aimed to turn his lack of proficiency to his own advantage, implying that his crude means complemented his quest to candidly portray his vulgar and ungainly subjects.

By the time he next wrote Theo, Van Gogh had carried this premise a step further and reported:

> All the heads were finished, and even finished with great care, but I immediately repainted them, inexorably, and the color they are painted in now is like *the color of a very dusty potato, unpeeled of course.*
>
> While doing this I thought how perfect that saying of Millet's about the peasants is: "Ses paysans semblent peints avec la terre qu'ils ensemencent" [His peasants seem to be painted with the earth they sow]. (LT405; his emphasis)

Van Gogh not only expunged such finish as he had achieved in his picture, but furthermore strove to give his paint surface the look of caked earth, in ostensible emulation of his models' lives, but also with Millet (and commentators on Millet's work) in mind. The observation that Van Gogh took as his own guide to peasant painting – "Ses paysans semblent peints avec la terre qu'ils ensemencent" – actually was penned by Théophile Gautier in his 1851 Salon and had been revived more recently by Sensier, who cited Gautier in his biography of Millet.[27] The concept became – in Van Gogh's words – a "solid base for my theory" (LT406), and he paraphrased the line time and again as he sought to defend the unconventional palette and execution of *The Potato Eaters* (see also LT402, LT409, LT410).

In a conscious attempt at synesthesia, Van Gogh sought to use color and texture to evoke not only the look, but the *smell* of peasant life – smoke, cooking odors, crops, manure – which he now had experienced at first hand. He linked his aspirations to those of illustrious forebears, noting, "Millet, [Charles] De Groux, so many others have given an example of character, and of not minding criticisms such as nasty, coarse, dirty, stinking, etc., etc., so it would be a shame to waver. No, one must paint the peasants as being one of them, as feeling, thinking as they do" (LT404). Though Van Gogh in the same letter emphasized the otherness of his subjects and his own role of distanced observer – "I have wanted to give the impression of a way of life quite different from that of us civilized people" (LT404) – here he vaunted

his (clearly impossible) attempt to "be one of them" and "feel, think" as peasants do – or at least to suggest to other members of his class that he had attained comprehension of farm laborers' thoughts and sentiments by entering their cottages to paint them.

Van Gogh's goals, methods, and ultimate middle-class distance from his lower-class subjects find parallels not only in the work of earlier "peasant painters"[28] but in Naturalist fiction as well; though *L'Assommoir,* for example, is a saga of *urban* labor, its conception and execution bear general comparison to the processes behind *The Potato Eaters.* Zola, too, minimized his middle-class heritage as he claimed intimate knowledge of his lower-class subjects: "I lived among the people for a long time," he wrote. "I was very poor and I saw them up close. It's that which has permitted me to speak of them without lying."[29] And when Zola claimed, in his 1877 preface to *L'Assommoir,* that the book was the "first novel about the people that doesn't lie and that has the smell of the people,"[30] he was speaking literally as well as figuratively, for in addition to chronicling the work, drinking habits, cramped quarters, and violent quarrels of urban workers, he also elaborated on the smells of their cooking and laundry.[31] As Van Gogh claimed to do, so Zola had tailored his means to his working-class subjects, making crudeness a part of the construct: The book's narrative as well as its dialogue are written in the vernacular of the streets and peppered with vulgar terms and phrases. Both writer and artist worked closely enough to their subjects to see, smell, and hear the grimy details, but each maintained the role of middle-class observer and as such sought to refigure the observed as art and exposé for bourgeois consumption.

The precedents set by *L'Assommoir* perhaps never occurred to Van Gogh as he worked on *The Potato Eaters,*[32] but shortly after completing the picture, he did emphasize its affinity to Zola's prose when he read the latest volume of the Rougon-Macquart series, *Germinal* (1885). An "issue novel" of the sort Van Gogh came to admire while living in the Borinage, *Germinal* – like Beecher Stowe's *Uncle Tom's Cabin* and Dickens's *Hard Times* – takes up that which Van Gogh once termed the "welfare of the poor oppressed" (LT130). More specifically, it describes unrest and revolt among workers – topics also explored by Charlotte Brontë in *Shirley* and George Eliot in *Felix Holt.* None of these predecessors, however, is as harsh and seemingly veristic as *Germinal,* which details the working and living conditions of hard-pressed mining families in the coal country of northern France. Zola not only visited the region but researched the coal industry in order to provide extensive information on the layout of mines and the way they were worked.[33] Van Gogh – who had been regularly reminiscing about the Borinage as he painted workers in the Brabant (see LT380, LT392, LT400) – was excited by news of the book's publication and eager to have it sent to him (LT408).[34] When

it arrived in late May, he "started to read it at once" and found it "splendid" (LT409).

In addition to chronicling the miseries of hard-working but impoverished miners, *Germinal* – conceived by Zola as a "socialist novel"[35] – was intended as a warning to the well-insulated and oblivious urban bougeoisie.[36] It charts the rise of workers' movements throughout Europe[37] and forecasts a radical restructuring of society by an enraged proletariat operating en masse. Though the novel portrays the clumsy beginnings of organized protest, including the miners' failed first efforts at revolt, its conclusion as well as its title highlight the irreversible growth processes of the sown seeds of revolution. Writing from a bourgeois perspective,[38] Zola underscores the inevitability of class conflict by presenting the viewpoints of several constituencies: from the comfortably naïve, paternalistic shareholders, M. et Mme. Gregoire; to the frustrated and ultimately impotent mine manager, Hennebeau; to the Maheus, a large family of longtime miners whose members are scarred by injury, illness, malnutrition, and resignation. The book's protagonist, Etienne Lantier (son of *L'Assommoir*'s Gervaise Coupeau), is an itinerant worker whose consciousness is raised by his travails in the coal country; his burgeoning acquaintance with reformist political philosophies spurs his appeal for collective action by the miners, and he mobilizes them in a brief and ill-fated uprising that nonetheless signals a new era in capital–labor relations.[39]

Despite his oft-reiterated enthusiasm for the "splendid" *Germinal* (see LT409, LT410, LT412),[40] Van Gogh wrote no substantive appraisal of the book's style or content. Surely it appealed to the displaced Christian zealotry that drew him to books of serious message and moral purpose; indeed, Zola's evocations of a workers' uprising are exalted by biblical metaphor and the fervor of his miners in revolt compared to that of the early Christians striving to usher in a new era,[41] whereas organized religion is denigrated for its ineffectual response to the workers' plight.[42] All of this must have vividly recalled Van Gogh's own experiences and emotions in the Borinage, and even before he had finished the book he expressed his hope to "earn a little more" so as to "go and paint the miners' heads someday" (LT409). His more specific reaction to *Germinal* must be gauged, however, by two long passages he transcribed for Theo (though his brother already had read the book) and by his painted response(s) to Zola's prose.

In early June 1885, shortly after he finished the novel, Van Gogh sent his brother a shipment of paintings that included – in his words – "a head which I had to paint after reading *Germinal*" (LT410). His use of the imperative voice implies an urgent, almost impulsive response to a text[43] – presumably the text Van Gogh then proceeded to cite, which describes a public hanging in Russia. Among the victims is the lover of Souvarine, a Russian anarchist whom Etienne Lantier befriends in the mines.

Figure 8. Van Gogh, *Peasant Woman with Green Shawl,* 1885.

"Did I tell you how she died?"

"Whom do you mean?"

"My woman over there in Russia."

Etienne made a vague gesture, wondering at the trembling of the voice, and at this sudden need of confidence in this habitually reticent fellow, in his stoical detachment from others and from himself. He only knew that the woman was his mistress, and that she was hanged in Moscow.

Souvarine resumed: "The last day in the square, I was there . . . It was raining – the clumsy fellows lost their heads, upset by the pelting rain, they had taken twenty minutes to hang four others. She stood waiting. She did not see me, she was looking for me in the crowd. I got on top of a stone pillar and she saw me, our eyes never left each other. Twice I wanted to cry out, to hurl myself over the heads to join her. But what would have been the good of it? One man less, one soldier less; and I guessed that she was saying no with her big fixed eyes, when they met mine." (LT410; trans. from *The Complete Letters of Vincent Van Gogh*; cf. *Germinal*, pt. VII, chap. 2)[44]

Though he earmarked this particular passage by citing it so fully, Van Gogh apparently did not allude to it in any specific way in his work. Though most of the busts he painted in this era are female heads of somber cast (e.g., Fig. 8), none can be said to depict a condemned Russian anarchist standing in

the rain on a gallows. Van Gogh may merely have meant to ally the desolate mood of the transcribed incident or its general theme of victimization to his peasant heads, and possibly he cited the execution passage as an aside that he did not consciously connect to the head he "had to paint after reading *Germinal*."

In the next sentence of his letter, however, Van Gogh either returned to the subject of *that* head or commenced discussion of another when he mentioned a "variation" on his other peasant busts, which he described as a profile against "la plaine rase des champs de betteraves, sous la nuit sans étoiles, d'une obscurité et d'une épaisseur d'encre [the open plain of the beet fields, under the starless night, dark and dense as ink]"; this is a direct citation from *Germinal* (pt. I, chap. 1), which, though transcribed in French within a Dutch-language letter, is not set off there by quotation marks. By way of elaboration, Van Gogh went on to write that the image he had made was

the head of a herscheuse or sclôneuse [i.e., a female miner] with an expression as of a lowing cow, a person from: la campagne était grosse d'une race d'hommes qui poussaient, une armée noire vengeresse, qui germait lentement dans les sillons, grandissant pour la récolte des siècles futurs, et dont la germinaison allait bientôt faire éclater la terre [the countryside was pregnant with a race of men who grew, a black avenging army, slowly germinating in the furrows, increasing for the harvest of future ages, and whose germination would soon explode the earth]. (Van Gogh again quoting from *Germinal* in French; cf. pt. VII, chap. 1)

This head is readily identifiable (see Plate 3), since it is unlike others in the series in both its orientation and in the inclusion of a dark landscape behind it, thus – as Van Gogh noted – a "variation." Whether he also meant to connect this profile to Zola's description of Souvarine's mistress (who was, after all, no *herscheuse*) remains unclear, however, and the tangle of associations implied by Van Gogh's letter suggests that the creation of a single visual equivalent to a particular verbal construct was not his goal. In keeping with views he expressed earlier at The Hague, he seems to have preferred a loose connection of image to text – hence, an evocative rather than illustrative role for his picture. This supposition is supported by his next assertion in LT410: "That last expression [i.e., that of "a lowing cow"] is, I think, better in the study which I have signed [Fig. 9],[45] and which I made *before* I read it, *so without thinking of Germinal,* simply a peasant woman coming home from planting potatoes, all covered with dust from the field" (his emphasis). Apparently Van Gogh took greater satisfaction in conjoining a painting made without prior knowledge of *Germinal* and an inclusive mental image of oppressed womanhood inspired by Zola's novel than he did in the self-conscious creation of a visual likeness for a specific text. His stress on ostensibly unforeseen coincidence in their work – with its attendant hint of linked concerns, methods, and/or results – seems to be a bid for self-validation by way of Zola's success. The generalized female laborer that *Germinal*

Figure 9. Van Gogh, *Peasant Woman, Head,* 1885.

conjured for Van Gogh (his comments mark her as a pitiable victim with the aspect of a mournful beast, one of an oppressed mass tied to gloomy surroundings) was reassuringly similar, he suggested, to the peasant women he was already codifying in his own work.

Further indication of Van Gogh's mental image of peasant women – and of his own perceived relation to them – can be discerned from another long passage from *Germinal.* Also transcribed in LT410, it is a text in which Zola presents the most intimate thoughts of Hennebeau, the mine manager, as he endures both personal and professional crisis in enraged and self-pitying

silence. Traumatized by the discovery of his wife's ill-disguised affair with his young nephew, Hennebeau almost simultaneously is confronted by a miners' march on his home. Watching the workers from the room where his wife and nephew betrayed him, Hennebeau indulges in escapist fantasy as he imagines abandoning his tortured existence for the "freedom" of peasant life. Unrestrained by bourgeois upbringing and education, the lower-class object of Hennebeau's envy indulges his instincts without reflection and finds the contentment afforded by low standards. Van Gogh apparently accepted – and empathized with – Hennebeau's vision of liberation through subsumption in the peasantry. To Theo, he wrote:

I can't spare the time, otherwise I should have much to say about *Germinal*, which I think splendid. Just one passage though: "Bread! Bread! Bread! Fools, repeated Mr. Hennebeau, am *I* happy? A fit of anger rose within him against those people who did not understand. He would gladly have made them a present of his huge revenues if he could only have a tough skin like theirs and their easy indulgence without regrets. Oh, that he could not let them sit down at his table and stuff them with his pheasant, while he went out to fornicate behind the hedges, tumbling the girls without caring a rap about those who had tumbled them before him! He would have given everything, his education, his well-being, his luxury, his power as a director, if only he could have been for a single day the least of the wretches who obeyed him, master of his flesh, enough of a brute to slap his wife's face and take his pleasure with the women of the neighborhood. He also wanted to starve, to enjoy an empty belly, his stomach twisted by cramps that staggered his brains by fits of dizziness; perhaps this would have killed the eternal pain. Ah! live like a beast, having no possessions of his own, flattening the corn with the ugliest, dirtiest female coal trammer, and being able to find contentment in it. How stupid those hollow dreams of the revolutionaries were, they would increase the unhappiness of the earth, someday they would howl with despair when they had left behind the *easy satisfaction of their instincts* by raising them to the *unappeased* suffering of the passions." (LT410, Van Gogh's emphasis; trans. from *The Complete Letters of Vincent Van Gogh*; cf. *Germinal*, pt. V, chap. 5)[46]

Though Zola intended Hennebeau's fevered musings to serve as a parodying overstatement of bourgeois romanticization of the underclass, Van Gogh took them at face value; his failure to comprehend the author's irony probably derives from two factors. First, the narrative voice of *Germinal* is a decidedly bourgeois one that often corroborates Hennebeau's wildest dreams; as imaged by Zola himself, the miners are openly promiscuous and oftentimes brutal, but therefore more vital than their upper-class opponents, whose notions of "correctness" have engendered their cold aversion to unrestrained passion.[47] Though Zola as narrator assumes a more distanced stance than the frenzied Hennebeau, his supposedly objective observations consistently reinforce the class stereotypes that inform the mine manager's inner monologue.[48] Second, it is clear that Van Gogh's own dissatisfaction with middle-class life – predicated by his failure to meet its standards – predisposed him to accept, even embrace, an aggrandized vision of that which

stood beneath it. Dismissed from Goupil and rejected by the church, ostra-
cized by outraged members of the Hague School and by the scandalized
middle-class Protestants of Nuenen, Van Gogh had nearly exhausted his
bourgeois options, and thus alienated from his family and peers, he indulged
in a fantasy of acceptance and fulfillment within a less exacting group.
Moreover, his sexual rejection by "respectable" women and/or their families
led him to seek the company of lower-class women; refused by his cousin
in 1879, he regarded his relationship with Sien as an antidote,[49] and once
banished by the Begemanns at Nuenen he sought the company, if not the
sexual favors,[50] of working women or – as he called them – "those who
wear jackets and skirts" (LT395). Zola's suggestion of the sexual availability
of such women clearly did not offend Van Gogh, and the author's assertion
of their animality probably encouraged the painter to unleash the "beast"
he saw within himself – a creature his own class had regularly shunned.

Van Gogh at Nuenen once attempted to express his anguished sense of
profound otherness from his upbringing by imaging himself as an unruly
animal unfit for bourgeois society. When he arrived there in December 1883,
his parents' discomfort at his presence provoked him to write:

I feel what Father and Mother think of me *instinctively....*

They feel the same dread of taking me in the house as they would about taking
a big rough dog. He would run into the room with wet paws – and he is so rough.
He will be in everybody's way. *And he barks so loud.* In short, he is a foul beast.

All right – but the beast has a human history, and though only a dog, he has a
human soul, and even a very sensitive one, that makes him feel what people think
of him, which an ordinary dog cannot do....

The dog feels that if they keep him, it will only mean putting up with him and
tolerating him *"in this house,"* so he will try to find another kennel. The dog is in
fact Father's son, and has been left rather too much in the streets, where he could
not but become rougher and rougher....

And then – the dog might bite – he might become rabid, and the constable would
have to come shoot him. (LT346; his emphasis)

Even as he characterized himself as a beast – and a potentially dangerous
one at that – Van Gogh did not assume the guise of a wild creature, or even
a field animal, but instead portrayed himself as a house pet gone astray.[51]
This particular dramatization of his plight emphasized his marginality to
both society and nature: Too rough for well-bred company, he was none-
theless too "sensitive" to enjoy the carefree oblivion of a full-blooded beast.
This fanciful self-image can be extended to illuminate Van Gogh's sense of
his class affiliation, for he regularly positioned himself at the boundary of
the middle and lower classes – not really belonging to either of them. Like
Hennebeau, he longingly regarded the simplicity of the underclass from the
disillusioned but informed vantage point of a roughed-up bourgeois. Indeed,
just weeks before he read *Germinal*, Van Gogh had written: "I often think

how the peasants form a world apart, in many respects so much better than the civilized world. Not in every respect, for what do they know about art and many other things?" (LT404).

Unwilling to renounce "art and many other things," Van Gogh nonetheless sought respite from the "civilized world" in a vision of the rural proletariat that was not just escapist but nostalgic; bound to childhood memories of a less industrialized Brabant,[52] his musings probably reflected a desire to turn back the clock on his life as well as on his native region. In another epistolary mention of *Germinal*, Van Gogh in June noted that "painting...especially painting rural life gives serenity, though one may have all kinds of superficial worries and miseries. I mean painting is a *home*, and one does not have that homesickness, that peculiar feeling Hennebeau had" (LT413; his emphasis). In his eager identification with the mine manager, Van Gogh glossed over the cuckold's urge to avenge himself through brutal sexual domination and instead wrote of a "homesickness" he sought to associate with his own pining for an idealized rural past.[53] His radical misrepresentation of Hennebeau's "peculiar feelings" seems not just self-serving but self-deluding, a means by which he avoided admitting his own attraction to the text's celebration of bestial lust. Van Gogh continued:

That passage I copied for you lately struck me particularly, because at the time I had almost literally the same longing to be something like a grassmower or a navvy. And I was sick of the *boredom* of civilization. It *is* better, one *is* happier, if one carries it out – literally though – at least one feels one is really alive. And it is a good thing to be deep in the snow in winter; in autumn, deep in the yellow leaves; in summer, amid the ripe corn; in spring, in the grass; it is a good thing to be always with the mowers and the peasant girls, with a big sky overhead in summer, by the fireside in winter, and to feel that it has always been so and always will be.

One may sleep on straw, eat black bread; well, one will only be the healthier for it. (LT413; his emphasis)

Though Van Gogh years later admitted with some swagger, "I have always had the coarse lusts of a beast" (LT544a), at this point he minimized that aspect of his conception of a "healthy" life and instead invoked a soft-focus rural utopia in which "peasant girls" shared the spotlight with mowers.[54]

That Van Gogh related Hennebeau's fantasies to his own choice of subjects to paint is intimated by further remarks to Theo. Urging his brother to give up his cautious middle-class existence, Van Gogh in the same letter wrote, "If in your case...the desire to become an artist took the form of, let me say, Hennebeau in *Germinal*, apart from difference in age, etc. – what pictures you could make then!" (LT413). Since Theo had no great desire to be an artist, the remarks do not really apply to him, but instead suggest Van Gogh's own interest in an artistic enterprise motivated by attitudes comparable to those expressed by Hennebeau – those "peculiar feelings" of

Figure 10. Van Gogh, *Peasant Woman with Sheaf,* 1885.

"homesickness" that in fact exalted the uncivilized otherness of peasants and their life. Thus, throughout the summer of 1885, Van Gogh continued to image the underclass – particularly women – at work in their homes and on the land. His earlier focus on bust-length portraits of his subjects now gave way to vigorous figure studies of often faceless individuals (e.g., Fig. 10). Most of the era's drawings and paintings are single-figure studies in which the bulky forms of the laborers are monumentalized against scant landscapes, filling the sheet or canvas and breaking the horizon. Memories of Millet (see Fig. 11), Jules Breton (see Fig. 12), and other painters of rural genre clearly colored Van Gogh's perceptions of his Brabant models, and comparison to his artistic antecedents helped him measure his progress (see LT418).

He likewise, if less often, compared his summer enterprise to that of Naturalist writers he admired. When he read "L'Histoire de mon livre" (Daudet's account of the genesis of *Les Rois en exil*),[55] Van Gogh was impressed by the author's insistence on verisimilitude and compared it to his own struggles toward authenticity. For instance, as harvesttime tasks claimed the time of the field hands who formerly had posed for him, Van Gogh wrote that though "it is twice as hard to get models...I became more

and more convinced that one cannot be too conscientious, that one always must exert oneself on what Daudet calls 'the search for the model'" (LT414).[56] Yet despite this stress on the commitment to direct observation that necessitated pursuing and paying people to pose, Van Gogh was increasingly attentive to the subjective component he brought to his work, and in July he again cited Zola in defense of his unconventional results:

Though in my opinion he makes colossal blunders in his judgment of pictures, Zola says a beautiful thing about art in general in *Mes Haines*, "dans le tableau (l'oeuvre d'art) je cherche, j'aime l'homme – l'artiste" [in a painting (a work of art) I look for, I love the man – the artist].

Look here, I think this perfectly true; I ask you what kind of a man, what kind of a prophet, or philosopher, observer, what kind of a human character is there behind certain paintings, the technique of which is praised? – in fact, often *nothing*. . . . The technique of a painting from rural life . . . brings difficulties quite different from those of the smooth painting and pose of a [Jules] Jacquet or Benjamin Constant.[57] It means living in those cottages day by day, being in the fields like the peasants, in summer in the heat of the sun, in winter suffering from snow and frost; not indoors but outside, and not during a walk, but day after day like the peasants themselves. (LT418; his emphasis)

Van Gogh believed that his conscientious efforts to observe his models at close hand, in "real" contexts, entitled him to interpret what he saw in the manner he deemed appropriate. Indeed, he argued that such modifications as he made contributed to the "truth" of his renderings:

I should be desperate if my figures were correct. . . . I do not want them to be academically correct. . . . I adore the figures by Michelangelo though the legs are undoubtedly too long, the hips and the backsides too large. . . . For me, Millet and [Léon] Lhermitte[58] are the real artists for the very reason that they do not paint things as they are, traced in a dry, analytical way, but as *they* – Millet, Lhermitte, Michelangelo – feel them. . . . My great longing is to learn to make those very incorrectnesses, those deviations, remodelings, changes in reality, so that they may become, yes, lies if you like – but truer than the literal truth. (LT418; his emphasis)

Though the exemplars he invoked were visual artists, the spirit of Van Gogh's defense of their practice – and his own – was decidedly Zolaesque, and specifically reminiscent of a remark from *Mes haines:* "What importance does truth have," Zola writes, "if the lie is perpetrated by a particular and powerful temperament?"[59] Later that year (in October 1885), Van Gogh recalled Zola more specifically when he linked the practices of a string of admired painters to that author's verbal procedures (LT429). Defending his own rejection of "true" local color in favor of hues that "have something to say for themselves," he wrote:

I study nature, so as not to do foolish things, to remain reasonable; however, I don't care so much whether my color is exactly the same, as long as it looks beautiful on my canvas, as beautiful as it looks in nature.

Figure 11. Van Gogh, *Women Digging,* 1885.

Figure 12. Van Gogh, *Peasant Woman Carrying Wheat,* 1885.

...Starting from one's palette, from one's knowledge of the harmony of colors is quite different from following nature mechanically and servilely.

...Do you call this a dangerous inclination toward romanticism, an infidelity to "realism," a "peindre du chic," a caring more for the colorist's palette than for nature? Well, que soit. Delacroix, Millet, Corot, Dupré, Daubigny, Breton, thirty names more, aren't they the heart and soul of the art of painting of this century, and aren't they rooted in romanticism, though they *surpassed* romanticism?

Romance and romanticism are of our time, and painters must have imagination and sentiment. Fortunately realism and naturalism are not free from it. Zola creates, but does not hold up a *mirror* to things, he creates *wonderfully*, but *creates, poetizes*, that is why it is so beautiful. So much for naturalism and realism, which are still connected with romanticism. (LT429; his emphasis)

More than ever before, Zola's maxims and practice ratified Van Gogh's strengthening commitment to artistic license within the context of naturalism.

Moreover, it is likely that Zola's graphic descriptions of working women in *Germinal* more specifically informed Van Gogh's artistic decisions as he depicted female laborers in the months that followed his enthusiastic reading of that novel. Though Van Gogh sought to link his oddly proportioned figures to those of Michelangelo, the bulbous shapes that dominate his depictions of field workers bear few formal similarities to the taut, muscular forms that Michelangelo's name evokes. Rather, the ungainly poses Van Gogh chose for several of his female models and the prominent and ostensibly unselfconscious display of their provocatively ample buttocks (see Figs. 13, 14)[60] suggest the impact of Zola's repeated references to the mining women's heedless assumption of postures that stimulate their male coworkers' lust. For example:

Nothing could be heard but the regular calls of the pit boys and the snorting of the *herscheuses* arriving on the level, steaming like overloaded mares. A blast of bestiality blew through the pit, the sudden masculine desire [that arose] when a miner encountered one of these girls on all fours, her backside in the air, hips splitting her boy's pants. (*Germinal*, pt. I, chap. 4)[61]

More specifically, Van Gogh's images of women who present their massive backsides to the viewer suggest particular reference to La Mouquette, one of the more sympathetic female characters of *Germinal*. La Mouquette is the proverbial good-hearted slut, a lively and generous woman who gives her life for her class's cause and gives her body to almost anyone who wants it: "An eighteen-year-old *herscheuse,* a girl whose enormous bosom and buttocks burst her jacket and pants.... Amid the wheat in summer, against a wall in winter, she took her pleasure in the company of her lover of the week."[62] La Mouquette's rump is her claim to fame and she displays it to great effect. In one of the novel's early scenes, while warming herself at a communal stove, La Mouquette drops her pants to dry her shirt and "there

Figure 13. Van Gogh, *Peasant Woman Seen from Behind*, 1885.

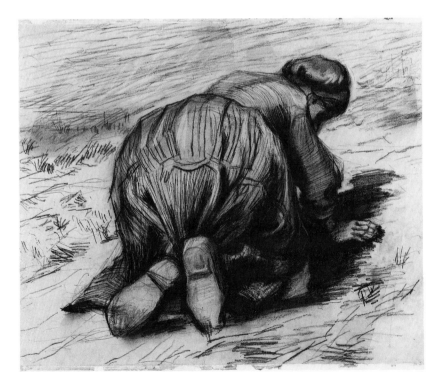

Figure 14. Van Gogh, *Kneeling Peasant Woman, Seen from Behind*, 1885.

was a burst of laughter, because all of a sudden she showed her derriere, which was, for her, the utmost expression of disdain."[63] But what begins as a bawdy physical manifestation of her mocking manner and unrepressed sexuality becomes a revolutionary emblem as La Mouquette becomes politicized. On a protest march with fellow miners,

[La Mouquette] was on the lookout for bourgeois, at their garden gates and at the windows of their houses; and, when she spied them, not being able to spit in their faces, she showed them what was for her the summit of her contempt.... Brusquely she lifted her skirt, stuck out her buttocks, showed her enormous behind, naked in a last blaze of sun. There was nothing obscene about it, this derriere, and it was not laughable, [but] fierce." (*Germinal*, pt. V, chap. 5)[64]

In a dramatic scene of confrontation, La Mouquette repeats her defiant act once more, inciting the soldiers who kill her:

La Mouquette was choking with rage at the thought that soldiers wanted to shoot women. She had spit all her obscenities at them, but couldn't find an insult low enough, when, suddenly, having nothing but this mortal offense to bombard the troops with, she showed her butt. She lifted her skirt with both hands and stuck out her backside, [and] set the enormous rotundity loose.

"Here, that's for you! And it's way too clean, you bunch of bastards!"

She plunged, somersaulted, and turned so that everyone got his share, repeating herself with every thrust she delivered.

"That's for the officer! That's for the sergeant, that's for the soldiers."

A storm of laughter rose.... Even Etienne himself, despite his gloomy forebodings, applauded this insulting nudity. (*Germinal,* pt. VI, chap. 5)[65]

As analyzed by Sandy Petrey, La Mouquette's gesture is, in the end, no mere insult, but a declaration of war that is emblematic of the workers' intent to restructure prevailing social discourse.[66]

If the preponderance of looming buttocks in Van Gogh's work of summer 1885 can indeed be linked to his lingering mental image of La Mouquette, the recurrent presentation of his models' backsides to the viewer might be read as his own restrained adaption of her applauded gesture of contempt. At the very least, his models' thrust-up bottoms suggest Van Gogh's own disregard for standard visions of feminine allure, and they might also be seen as expressions of his known disdain for middle-class notions of propriety (though the brunt of his effrontery is, of course, borne by lower-class models whose postures did not reflect their own ideological convictions – as La Mouquette's eventually did[67] – but rather their simple need for the money they earned as artist's models).[68] We know that at least a few middle-class sensibilities were offended by Van Gogh's act and/or mode of posing his lower-class subjects; by late summer he complained that the Catholic priests of Nuenen had warned their parishioners away from him and had told Van Gogh himself that "I ought not to get too familiar with people below my

rank" (LT423). By mid-September he wrote, "I could by no means get anybody to pose for me in the fields these days" (LT423), and as autumn commenced he began to paint still life (a genre he had hardly explored) by default (see LT425).

A STILL LIFE WITH BOOKS

Though he much preferred life drawing, Van Gogh found still life a useful vehicle for the experimentation with color that became his obsession in this era (see LT426, LT428, LT429). Among his favorite still life objects in the autumn of 1885 were birds' nests, crockery, potatoes, and fruit, but in one instance – his *Still Life with Bible and French Novel* (Plate 5) – he worked with books, creating the first of several paintings in which readily identifiable works of literature lend extrapictorial connotations to his visual imagery.

In his only mention of the painting, Van Gogh described the *Still Life with Bible and French Novel* as a color study: "a still life of an open – so a broken white – Bible bound in leather, against a black background, with a yellow-brown foreground, with a touch of citron yellow" (LT429). He referred to it as his answer to Theo's recent description of the color harmonies of Manet's *Dead Toreador* and hoped it would demonstrate "that when I say that I have perhaps not plodded entirely in vain, I dare say this is because at present I find it quite easy to paint a given subject unhesitatingly, whatever its form or color may be." He also proudly noted that the picture was painted "in *one rush,* on one day" (LT429; his emphasis). These descriptions of the picture and of the way it was painted suggest that this still life was just a "given subject" randomly glimpsed and quickly transcribed. But since the objects and format Van Gogh selected conform to those of the standard *vanitas* still life, it would seem that formal issues were but one component of the artist's intention.

Beginning in the seventeenth century, books and burned-out candles were commonly paired – often in the company of a skull – to suggest the fragility of worldly possessions (knowledge as well as objects) in the face of death (Fig. 15).[69] In painting his *Still Life with Bible and French Novel*, Van Gogh, a former art dealer well versed in the history of visual representation, doubtless was aware of his own contribution to a well-established mode. The objects he presented, however, would seem to carry a good deal of private meaning as well: The Bible included in the picture had belonged to Van Gogh's recently deceased father,[70] and the French novel – clearly titled – is Zola's *La Joie de vivre* (1884), a recent work by one of the artist's favorite writers. Such novels had long been bones of contention between Van Gogh and his father, and in this pictorial context *La Joie de vivre* suggests rebellion, contemporaneity, and – by virtue of its title – life in the face of death. A

decidedly up-to-date artifact, it lends a modern and autobiographical cast to this heir to the *vanitas* tradition and a bright French note to its musty Dutch surroundings.

Even on a formal level, the two volumes included in *Still Life with Bible and French Novel* are at odds. Edged into the lower right corner of the composition, precariously close to the edge of the table it rests on, the small, bright yellow paperback seems a scrappy newcomer beside the somber, venerable mass of the leatherbound Bible it jostles. Even as the Bible spreads expansively across the tabletop, it recedes to the dark backdrop, whereas the novel, at a counterangle, juts outward, its turned-back corner a visual suggestion of its proximity to the picture plane. Whereas the Bible's pairing with extinguished candles – traditional mementos mori – hints at its waning influence and firmly links it to things past, the yellow book is startlingly contemporary, and its haphazard placement and dog-eared silhouette indicate recent and earnest use.

In a pioneering study of *Still Life with Bible and French Novel* (published in 1947), Carl Nordenfalk connected the Bible and burned-out candle of Van Gogh's painting to the death of his father six months before, but noted that the biblical chapter invoked ("Isaie," "Chap. LIII" is legible on the upper half of the Bible's right-hand page),[71] a passage that recounts the "suffering and glorification of the servant of the Lord," was meant to refer to Van Gogh's view of himself.[72] The French novel, in Nordenfalk's view, represents Van Gogh's opposition to his father, since "it was modern French literature that had opened his eyes to the narrowness of his father's Calvinistic view of life."[73] Whereas some later scholars have argued that the Bible represents Van Gogh's father and the Zola novel Van Gogh himself,[74] it is probable that – as Nordenfalk first proposed – the artist felt a personal connection to both books. Surely the Bible called up memories of his own early life – his years as a minister's son, theology student, and lay preacher – and thus of his previous closeness to his father and his father's way of life. Its presence may be read as a suggestion of the weight of Van Gogh's past.

The yellow paperback, by contrast, would seem to represent the artist's most recent (and rebellious) direction and interests, and his hope for the future as well. Its placement in the foreground and its vibrant yellow color suggest immediacy, and in the midst of such dusky surroundings its bright hue lends it the look of a beacon. Zola had been heroicized by Van Gogh and perceived as a guiding spirit who – like other authors before him (e.g., Michelet and Beecher Stowe) – had usurped the role once played by the artist's father and by the Bible. Naturalist novels represented the up-to-date viewpoints and methods of a new generation of creative personalities whom he aimed to emulate. During the period of isolation in Nuenen ("a cold and miserable country") they served as reminders of the worlds of art and eru-

Figure 15. Damien Lhomme, *Vanité,* 1641.

dition (see LT351) and as links to contemporary culture – particularly to Paris, its hub. When, two years later, Van Gogh wrote from the French capital of the Naturalists' devotion to "truth" and "life as it is" and then asked – cryptically – "Is the Bible enough for us?" (W1), he elucidated the oppositional roles these writings played in his mind. In the *Still Life with Bible and French Novel,* Zola's book should be seen as a modern, secular rejoinder to the esteemed but old-fashioned volume it abuts.

Its title forms so obvious a contrast to the message of the Bible that even the viewer unfamiliar with the story line of *La Joie de vivre* senses the dichotomy inherent in the juxtaposed texts. This surely occurred to Van Gogh, and the verbal punch its title afforded probably encouraged his use of this particular novel (rather than *Germinal* or some other recent book). The significance *La Joie de vivre* held for him, however, doubtless extended beyond its cover, and the contents of this well-thumbed novel must also have had something to do with its presentation here. Though the painting's broad suggestions of opposed eras and mores are readily discerned by most viewers, other and more particularized levels and layers of meaning are available to

a privileged audience familiar with both the artist's situation and the narrative of the novel he used so emblematically.[75]

Though Van Gogh's letters contain no specific reference to *La Joie de vivre* (which was the twelfth novel of the Rougon-Macquart series), he clearly read it at Nuenen. It was published a few months after his arrival there, and Van Gogh's painted description of a well-worn paperback copy demonstrates that he was quite familiar with the book by October 1885. Van Gogh probably read it in the months of estrangement from Theo that preceded their father's death, an era in which the brothers' literary discourse was minimal. A hint of his acquaintance with it appears shortly thereafter, in a letter of April 1885: While painting *The Potato Eaters* Van Gogh made a single, ironic reference to what he called "la joie (?) de vivre" (LT399). The questioning spirit of his usage of the phrase is in keeping with the cynical manner in which Zola applied this standard expression of ebullient hedonism to a disparaging account of human existence as a series of thwarted ambitions and unfulfilled desires.

La Joie de vivre in fact seems to be about anything but the joy of life, and yet its resolution is an affirmation of sorts. It is the story of Pauline Quenu (the daughter of Lise Macquart and the *charcutier* Quenu, she was introduced in *Le Ventre de Paris*), who at the beginning of the novel is a 10-year-old orphan sent to be raised by distant relatives, the Chanteaux, on the Normandy coast. A chronicle of Pauline's girlhood, puberty, and young womanhood, Zola's narrative recounts in great detail her sexual awakening and emotional maturation, especially through her relationship with her ne'er-do-well cousin Lazare. Lazare, almost a decade her senior, is at first a surrogate brother to Pauline; then, in her adolescence, he becomes an object of desire. Pauline experiences brief bliss when her love for Lazare is reciprocated and they discuss marriage, but her high hopes are dashed by a succession of mishaps and tragedies. When Pauline's once-ample inheritance is eaten up by her relatives' household expenses and by ill-advised loans to Lazare, the formerly fond Mme. Chanteau turns against Pauline and pushes Lazare into the arms of a family friend. Pauline then endures the pain of M. Chanteau's debilitating illness, Mme. Chanteau's sudden death, and Lazare's subsequent depression and morbidity. He finally marries the well-dowered Louise, who moves into the Chanteau household and uses Pauline as a nursemaid when their child is born. Pauline endures all of this with stoicism and – in the end – incredibly cheerful resignation. Though still a young woman, she becomes the matriarch of her adoptive family, dedicating herself to the care of her uncle and of Lazare's son. When, at the novel's close, the family's longtime servant hangs herself in despair, Pauline is nonplussed, unable to imagine why anyone would willingly relinquish the joys of life.

Though Van Gogh's failure to comment specifically on the characters and

situations of *La Joie de vivre* restricts our notion of his reactions, speculation on his identification with its major characters and situations is warranted by his longtime habit of doing so and by the several parallels that link his reality to Zola's fiction. The travails of Pauline Quenu, for instance, are readily compared to those Van Gogh perceived at Nuenen: An outsider looking in, she is forced to live in rural isolation with family members who are exploitative and mean-spirited. Loving, and yearning to be loved, Pauline encounters hardship and disappointment, but keeps steadfastly on. Her fortitude in the face of difficulties and hopefulness in the face of death doubtless appealed to – and perhaps encouraged – Van Gogh. On the other hand, his situation also bears comparison to that of Lazare, a young man who constitutes one of Zola's several renderings of the creative persona at odds with the world. A longtime pianist, Lazare is – at the book's beginning – completely caught up in music, despite the dismissive attitude his mother takes toward his work. Like Van Gogh's father, Mme. Chanteau is a damper on her son's artistic impulses; as Lazare works on a symphony he is determined to write, for instance, his mother insists, "You would do better...not to waste your time on foolishness."[76] She urges him to find an "honorable career" and Lazare, "furious, violently closed the piano, while screaming that she was a 'a dirty bourgeoise.'"[77] Though Lazare pronounces himself willing to kill himself before abandoning music, he eventually gives in and goes to medical school, but when he fails to succeed in the career his family advocated, he returns to their home at loose ends and unable to support himself – much as Van Gogh had returned to Etten and, two years later, to Nuenen. Lazare, however, feels his talent and dreams desert him as the reading of Schopenhauer shapes his increasingly morbid outlook. His mother's death provokes fear and a feeling of powerlessness in Lazare, as does his wife's childbirth; Pauline, by contrast, attends to both with courage and skill.

Van Gogh probably identified to some extent with each of Zola's protagonists, for *La Joie de vivre* presents several situations and relationships that can be seen to mirror those he faced at Nuenen: isolation in a closed community, a love affair sabotaged by "well-meaning" outsiders, the striving to create in discouraging surroundings, the death of a parent who is at once hated and esteemed. The book's pairing with his father's Bible in Van Gogh's still life is thus rich with inference, though none of these issues was addressed directly by the artist.[78]

BROADENED HORIZONS

Though Zola's primacy in Van Gogh's literary pantheon remained constant throughout 1885, that author got serious competition from the Goncourt

brothers, who began to figure prominently in Van Gogh's letters. Though he had read their biography of Gavarni in 1881, heard their praises sung by G. H. Breitner at The Hague, and eventually read *Soeur Philomène* in 1883, Van Gogh's praise for the Goncourts remained tepid until – in October 1885 – he encountered the recently published *Chérie* (1884),[79] which Edmond de Goncourt had written single-handedly (Jules died in 1870). Even then, it was not the book itself so much as its polemical preface that appealed to Van Gogh.

Goncourt himself allowed that *Chérie* could not really be called a novel;[80] a compilation of short sketches – more than a hundred of them fill an approximately 350-page volume – it is a loose-jointed chronicle of the upper-class heroine's maturation, which takes her from age 9 to 21.[81] *Chérie's* story, such as it is, seems to have had little impact on Van Gogh, who made no mention of the book's eponymous protagonist but instead remarked after reading it, "De Goncourt is always beautiful, and his way of working is so honest and he drudged on it so hard" (LT426). This notion of the author's "drudgery" surely stemmed from Goncourt's introductory remarks; in the book's preface – which the author calls a "sort of literary testament"[82] – he not only describes his aspirations and practice but reminisces about the lengths to which he and his brother always went to achieve their goals.

In the first section of the preface, Goncourt reviews his literary convictions, stressing the importance of novelty, originality, and personal style. He rejects the more traditional ideal of *l'éternel beau* in favor of an inclusive aesthetic – a position that surely held much the same resonance for Van Gogh as did Zola's celebration of the idiosyncratic artistic temperament. After asserting that any number of modes may be equally valuable and beautiful, Goncourt – in remarks that suggest the ascendancy of form and collate the verbal and visual – writes:

The novelist who has the desire to live on after his death will continue to make every effort to put poetry into his prose, continue to require rhythm and cadence in his sentences, continue to seek painterly imagery, continue to pursue the singular epithet, continue, in the words of a delicate stylist of this century, to combine *le trop* and *l'assez* in one expression. (Goncourt's emphasis)[83]

His notes on style are succeeded by the nostalgic and self-congratulatory second section of the preface, in which Goncourt – after announcing that *Chérie* will be his last book ("I'm tired, I've had enough, I leave my place to the others")[84] – describes the unstinting long-term effort he and his brother gave to their literary pursuits and assures the reader (and himself, it seems) that even if their work is not properly appreciated in 1884, it certainly will be recognized by future generations. Putting his boldest assertions into his long-dead brother's mouth, Edmond notes that it was their novel *Germinie*

Lacerteux (1865) that launched the Naturalist movement[85] and claims that their taste for the art of the eighteenth century and for things Japanese substantially predated the interest their peers had in either. "These are the three great literary and artistic movements of the second half of the nineteenth century," Edmond remembers the dying Jules saying as they walked together for the last time in the Bois de Boulogne, "and we will have led them, poor obscure us.... Well! When you've done that, it's really hard not to be *somebody* in the future."[86]

Van Gogh was moved by this account and repeatedly urged Theo to read it. At the end of December he explained:

The preface to *Chérie*, which you will read, tells the story of what the de Goncourts went through, and how at the end of their lives they were melancholy, yes, but felt sure of themselves, knowing that they had *accomplished* something, that their work would remain. What fellows they were! If we were more of one mind than we are now, if we could agree completely, why shouldn't we *do the same?* (LT442; his emphasis)

A few weeks later, in February 1886, he mused, "More and more I believe that l'art pour l'art, to work for work's sake, l'énergie pour l'énergie – is after all the principle of all great artists, for in the case of the de Goncourts one sees how necessary obstinacy is, for society will not thank them for it" (LT448). Shortly thereafter, he mailed his copy of *Chérie* to Theo "especially because of the preface, which will certainly strike you. And I wish that we too might work together somewhere at the end of our lives, and looking back, might say – 'Firstly, we have done *this,* and secondly *that,* and thirdly *that'*" (LT450; his emphasis).

The precedents set by the Goncourts' fraternal alliance excited Van Gogh, who often dreamed of Theo becoming an artist so the two of them might work side by side.[87] He was also braced by the Goncourts' hard-won success and Edmond's attendant belief that sustained effort was eventually rewarded. In a subsequent letter, Van Gogh told his brother:

I am sending you that novel by de Goncourt, especially for the preface, which gives a summary of their work and aims. You will see that those people have not been exactly *happy,* in the same way as Delacroix said of himself, "Je n'ai pas du tout été heureux dans le sens où je l'entendais, le désirais autrefois" [I have not been at all happy in the sense in which I understood it, desired it, in the past]. Well, it may come sooner or later, but for you too there will come a moment when you know *for sure* that all chance of material happiness is lost, fatally and irrevocably. I feel sure of it, but remember that at the same moment there will be a certain compensation in feeling the power to work within one's self.

What cuts me to the heart is the beautiful serenity of the great thinkers of the present, as, for instance, that last walk of the two de Goncourts, of which you will read the description. (LT451; his emphasis)

Moreover, Edmond de Goncourt's prefatory asides in *Chérie* on the brothers' landmark art-historical study, *L'Art du XVIIIe siècle* (1875), piqued Van Gogh's interest; within days of reading the novel, he wrote to Theo: "There is a book by de Goncourt [*sic*] about *Chardin, Boucher, Watteau,* and *Fragonard;* I must read that; have you got it or one of your friends perhaps? I am afraid not, but do you happen to know if it is very important?" (LT427; his emphasis). This halting inquiry soon gave way to impatient desire – "I am especially longing to hear something from de Goncourt about Chardin" (LT428) – and in early November Theo obliged him by sending the first volume. Van Gogh "began to read it at once, and though of course I shall read it over again quietly, this morning I already had a general view of the whole – I had been longing for it so much" (LT431).

A series of thirteen individual monographs,[88] *L'Art du XVIIIe siècle* was originally published at the Goncourts' own expense between 1859 and 1870. The entire collection was published in two volumes in 1875, with additions, corrections, and a preface by Edmond. According to that preface, this collection of essays was the brothers' favorite project, and work on it comprised a yearly vacation for them. The Goncourts' intent was to rectify what they perceived to be their contemporaries' virtual ignorance of French art of the previous century, and their studies of individual artists contain biographical data, elaborate verbal evocations of artists' works, and descriptions of their techniques (these last presumably were written by Jules, for the younger Goncourt was himself an accomplished etcher and watercolorist). On the day he received this "splendid book," Van Gogh devoted almost an entire letter to *L'Art du XVIIIe siècle,* commenting on his favorite descriptions and anecdotes and pronouncing himself ready to try his hand at pastel (LT431). He was especially pleased by the Goncourts' studies of Boucher ("I do not think he [*sic*] praises Boucher too much"), Watteau ("Watteau was just as I expected"), and Chardin ("I have often longed to know something about the *man*" [his emphasis]).[89] Van Gogh was particularly gratified by the Goncourts' account of Chardin's technique and told his brother:

I am more convinced than ever that the true painters did not finish their things in the way which is used only too often, namely correct when one scrutinizes it closely.

The best pictures, and, from a technical point of view the most complete, seen from near by, are but patches of color side by side, and only make an effect at a certain distance.

...In that respect Chardin is as great as Rembrandt....

I should like to tell you a great deal more, especially about what Chardin made me think about color and...not painting the local color. I think it splendid. (LT431)

By the time he received the second volume of *L'Art du XVIIIe siècle,* Van Gogh had moved to Antwerp. Continued disagreements with his family and

with local clergymen had encouraged his departure from Nuenen. Moreover, a trip to Amsterdam and the Trippenhuis in October 1885, along with his reading of several accounts of the art world – including J. F. Gigoux's *Causeries sur les artistes de mon temps,* Charles Blanc's *Les Artistes de mon temps,* and the Goncourts' history of eighteenth-century artists – made Van Gogh keenly aware of his isolation from an artistic community. Increasingly dissatisfied with his existence "completely outside the world of painters and pictures," he resolved "to go back to them, at least for a time" (LT434), and in November he moved to Antwerp, a smaller city than either Amsterdam or Paris, but one with an established community of artists and the urbanity Van Gogh had come to miss. He was enthralled by the city's docks and street life,[90] as well as by his visits to picture dealers, museums, and churches,[91] and by mid-January he had begun to attend drawing and painting classes at the city's arts academy.

In Antwerp he also became caught up in the vogue of *japonisme,* which had burgeoned in the 1860s (a few years after Japan was reopened to the West) and by the 1880s had moved beyond elite art circles to become a popular fad.[92] Van Gogh's enthusiasm for Japanese woodblock prints – which he began to collect in this era[93] – was, if not instigated by the Goncourts, at least encouraged by their partisanship, and – as Fred Orton has suggested[94] – it probably is no coincidence that Van Gogh began amassing such prints within weeks of reading the preface to *Chérie,* wherein Edmond describes his and his brother's longtime taste for and promotion of Japanese art. Again putting words into Jules's mouth, Edmond recalls their "description of a Parisian salon furnished with japonaiseries" in their first novel, *En 18..* (1851); their first purchases of Japanese bronzes and lacquerware shortly thereafter; the brothers' ostensible "discovery, in 1860, at the Porte Chinoise, of the first Japanese album known in Paris"; and "the pages devoted to things Japanese in *Manette Salomon* [and] in *Idées et sensations.*"[95] "Don't [those things] make us," Edmond recalls Jules asking, "the first propagators of this art, this art undoubtedly in the process of revolutionizing Western ways of seeing?"[96] Van Gogh seems to have accepted Edmond's overstated account[97] of the Goncourts' primacy in this arena, and in this era the brothers became strongly associated in his mind with the cult of Japan (see LT437). This linkage can only have been enhanced when Van Gogh moved to Paris, where he experienced a more full-blown *japonisme* and at the same time read *Manette Salomon* – with its paean to the prints[98] – as well as *La Fille Elisa* (1877) and *Les Frères Zemganno* (1879) – both of which include descriptive asides that rely on the reader's familiarity with the look of Japanese woodcuts.[99] In the meantime, Van Gogh himself began to draw analogies between things he saw in Antwerp and the piquant delineations of Japanese printmakers:

I have walked along the docks and the quays several times already.... It is an unfathomable confusion. One of de Goncourt's sayings was: "Japonaiserie forever."[100] Well, those docks are a famous Japonaiserie, fantastic, peculiar, unheard of – at least one can take this view of it.

I should like to walk there with you, just to know whether we see alike. One could make everything there, city views – figures of the most varied character – the ships as the principal things, with water and sky a delicate gray – but above all – Japonaiserie. I mean, the figures are always in action, one sees them in the queerest surroundings, everything fantastic, and at all moments interesting contrasts present themselves. (LT437)

Van Gogh's rapid reimmersion in the world of art at Antwerp was further diversified by his reading of the Goncourts' second volume on the eighteenth century[101] and by his chance encounter with Zola's new novel, *L'Oeuvre*, which was being serialized in a Parisian newspaper, *Gil Blas*. The segments of *L'Oeuvre* he read gave Van Gogh an inkling of the issues and personalities that lately had rocked the artistic community in Paris and his support for the rebellion against prevailing modes that Zola recounts there is indicated in a letter to Theo: "I think that this novel, if it penetrates the art world somewhat, may do some good" (LT444). Presumably by "art world" Van Gogh meant the arts establishment, and perhaps more specifically the Salon juries Zola lambasts in *Mes haines* as well as in *L'Oeuvre*. Though he saw only a part of the novel while in Antwerp, Van Gogh wrote that he found *L'Oeuvre* "very striking" (LT444). He read it in its entirety some months later, when it appeared in book form in Paris (see Chapter 4).

By the mid-1880s, Van Gogh's formulation of his artistic aims and procedures was increasingly influenced by his sense of the most recent French painting and literature – that is, the practice he considered "Naturalist." The fiction and nonfiction of Zola, the Goncourts, and Daudet – as well as Zola's praise for the most hard-hitting modern artists – fueled Van Gogh's desire to tackle unsavory subjects in a candid way, and writing from Antwerp of some recent figure studies, for instance, he told Theo:

I know that you are sufficiently convinced of the importance of being *true* so that I can speak out freely to you.

If I paint peasant women, I want them to be peasant women; for the same reason, if I paint harlots I want a harlot-like expression.

...This is a new thing for me, and it is essentially what I want. Manet has done it, and Courbet, damn it, [and] I have the same ambition; besides, I have felt too strongly in the very marrow of my bones the infinite beauty of the analyses of women by the very great men of literature, a Zola, Daudet, de Goncourt, Balzac. (LT442; his emphasis)[102]

The examples of these "great men" pushed Van Gogh toward greater daring in his work and – more than that – gradually reconfigured his view of his world, for he esteemed them not only as members of an alluring cultural

vanguard, but as the "great thinkers of the present" (LT451), social philosophers to whom he could look for guidance:

Do you want a *motive* for keeping one's serenity even when one is isolated and misunderstood? . . .

This one thing remains – *faith;* one feels instinctively that an enormous number of things are changing and that everything will change. We are living in the last quarter of a century that will end again in a tremendous revolution.

. . . We certainly shall not live to see the better times of pure air and the rejuvenation of all society after those big storms.

But it is already something not to be duped by the falsity of one's time, and to scent the unhealthy closeness and oppressiveness of the hours that precede the thunderstorm.

And to say, We are still in the closeness, but following generations will be able to breathe more freely.

A Zola and the de Goncourts believe in it with the simplicity of grown-up children. They, the most rigorous analysts whose diagnoses are both so merciless and so exact.

And the very ones you have mentioned too, Turgenev and Daudet, they do not work without an aim or without looking ahead. But all avoid, and with reason, prophesying Utopias. . . .

You see, the thing that supports one is that one doesn't always have to be alone with one's feelings and thoughts when one works and thinks together with other people. (LT451; his emphasis)

Van Gogh's admiration for the Naturalists and enhanced comprehension of their work blossomed into a sense of fraternity with them that sustained him in his own pursuits. Their writings stimulated him from afar and relieved the sense of isolation he had felt at Nuenen. Eager to embrace contemporary culture, Van Gogh sought to steel himself for both its thrills and hardships by adopting the unflinching attitude he admired in his favorite modern authors. His goal, he wrote, was "freedom of scope for my career," and he noted:

If one analyzes from up close, one sees that the greatest and most energetic people of the century have always worked *against the grain,* and they have always worked out of personal initiative. Both in painting and literature. (I do not know anything about music, but I suppose it has been the same there.) To begin on a small scale, to persevere quand même, to produce much with small capital, to have character instead of money, more audacity than credit, like Millet and Sensier, Balzac, Zola, de Goncourt, Delacroix. (LT454; his emphasis)[103]

Antwerp provided only short-term satisfaction of his appetite for art and urbanity, and he soon became anxious to move to Paris, a much grander metropolis. The appeal of the French capital surely was enhanced for him by its centrality in the oeuvre of Balzac, Zola, Daudet, and the Goncourts. Moreover, the preface to *Chérie* continued to stimulate Van Gogh's longtime belief that he and Theo could develop a more productive relationship by

working together more closely (see LT453). By January 1886, he regarded Antwerp as a mere way station on the road to Paris and began to besiege his brother with requests to migrate on. His longing was great and his patience limited; in March – tired of waiting for Theo's invitation – Vincent turned up on his doorstep. Thus began a two-year sojourn in the City of Light.

"ROMANS PARISIENS"
Reading Naturalism in Its Habitat

Appraisals of Van Gogh's life and thoughts during his two-year stay in Paris are hindered by the paucity of correspondence from that era. When he arrived in the city early in 1886, he went directly to Theo's apartment in Montmartre, and when it became apparent that he had no immediate intention of moving on, Theo found a larger space on the southern slope of the Butte, where the brothers lived for the duration of Vincent's sojourn.[1] This cohabitation with Theo, his primary correspondent, substantially reduced Van Gogh's letter writing in Paris, but both John Rewald and Bogomila Welsh-Ovcharov have pieced together detailed accounts of his life there.[2] By his own reckoning, the artist found Paris and its cultural life exceedingly – even excessively[3] – stimulating. His work changed radically over the course of his stay, but his attitudes and activities as a consumer and producer of urban culture must be characterized as disjunctive. Whereas on the one hand Van Gogh not only grew accustomed to the most recent modes of visual representation but adventurously employed them, on the other he more or less rejected the products and pronouncements of the city's most radical literati, and in that sphere became ever more *retarditaire* as the months went by.

During his first year in Paris – probably in the fall of 1886 – Van Gogh spent three to four months as a student of Fernand Cormon, a 40-year-old academic painter. Cormon's work was uninspired, but his reputation for open-mindedness attracted many progressive young artists to his studio, where he enrolled about thirty pupils at a time. Though Emile Bernard (who eventually became an intimate of Van Gogh in Paris) recently had been expelled, Henri de Toulouse-Lautrec and Louis Anquetin were in attendance when Van Gogh joined the studio, and he befriended both before deciding that formal instruction was not "so useful as I had expected it to be" and left the Cormon atelier to work on his own (LT459a). Initially suspicious of the artistic avant-garde,[4] he soon warmed to Impressionism (LT459a) and

devoted the summer of 1886 to flower paintings that served as vehicles for the intent study of colors that gradually led him to lighten and brighten his palette.[5]

At the same time, the Parisian art world was ruffled by the momentous debut of Georges Seurat's *Sunday Afternoon on the Grande Jatte,* which was shown at the eighth (and last) group exhibition by the Impressionists (in May and June 1886) and again at the Salon des Indépendants in August. Van Gogh, whose interest in color theory dated to 1884 – when he read Charles Blanc's *Les Artistes de mon temps* (LT370)[6] – was intrigued by Neo-Impressionist divisionism and soon became acquainted with Paul Signac, the mouthpiece and future historian of the movement; the two shared ideas on color as they painted together in Parisian suburbs in the spring of 1887.[7] Though several of the paintings Van Gogh made that year bear the marks of divisionism – small dots and dashes of paired complementary hues – his paint application was more intuitive than systematic, his results more decorative than scientific.[8]

His exposure to the most recent trends in French painting was complemented by reacquaintance with the older art he admired at the Louvre and Luxembourg museums; moreover, in 1887, a major retrospective focused attention on Van Gogh's foremost artist-hero, Millet.[9] At the same time, however, he became increasingly interested in Asian art and built his eventually extensive collection of Japanese prints (most were bought at Samuel Bing's establishment).[10] Toward the end of 1887 he made paintings after woodcuts he owned.[11] His gradual assimilation of the aesthetics of Japanese graphic art accounts for the strong but disjunctive line, animate plays of distinctive patterns, and broad areas of flat, bright color that are characteristic of Van Gogh's mature style,[12] which was formulated in Paris if honed at Arles. The pronounced *japonisme* of his work in winter 1887–8 linked it to that of Anquetin and Bernard, who were in the midst of devising the style that came to be known as Cloisonism, and the three showed together in an informal group exhibition late in 1887.[13]

The period of Van Gogh's residence in Paris was one of great literary as well as artistic ferment, as he surely was aware. But whereas the course of his art shifted significantly in these two years, his literary preferences remained intact. His appreciation of Naturalism and sense of kinship with its practitioners can only have been enhanced by his renewed relationship with Paris, the birthplace and natural habitat of the movement.[14] As he later told Emile Bernard, "Coming to France as a foreigner, I, perhaps better than Frenchmen born and bred, have felt Delacroix and Zola, and my sincere and wholehearted admiration for them is boundless" (B13). In Paris in the mid-1880s, Naturalist literature was not the rarefied commodity it had been for

Van Gogh at Nuenen, but a readily available staple that surrounded him. Newly published novels by little-known and famous writers alike were common accoutrements of urban culture, and Van Gogh saw them stacked in bookshops,[15] widely read by his peers, and serialized and/or commented on in almost any newspaper he picked up. In 1887 and 1888, he documented his engagement with Naturalist novels in a series of still lifes that feature what he called "romans parisiens" (Plates 6–8)[16] – books that no longer were evocations of a faraway, slightly exotic place, but instead provided images of the city he inhabited and depictions of the sorts of people and neighborhoods he sought to capture in his own work. Indeed, several of his Parisian vistas and scenes of urban life seem to parallel verbal descriptions from the French novels he admired,[17] and it seems that his interest in Naturalism not only survived but deepened in the era of the movement's gradual eclipse.

THE SYMBOLIST OFFENSIVE

In the 1880s, as Impressionism's primacy was being challenged by the re-formulations and hybrid styles that attracted Van Gogh's interest, so, in the literary arena, were Naturalist precepts openly overruled by writers and critics with new agendas. The era was marked by debates, manifestos, re-alignments, and much discussion of Idealism, Decadence, Symbolism, and musicality in the verbal and visual arts.[18] A plethora of small and short-lived journals appeared, their offices and mastheads peopled by the same core group, a verbose clique that sought to change the shape of art in the 1880s. Its ranks included critics Félix Fénéon, Edouard Dujardin, and Téodor de Wyzéwa and poets Gustave Kahn, Jean Moréas, and Jules Laforgue. Variously known as Decadents and Symbolists,[19] they vaunted Schopenhauer, Wagner, Mallarmé, and the "scientist" Charles Henry and promoted an art of infinite *suggestion*.[20] Some of their most sustained publishing ventures included *La Revue indépendante*, founded in 1884 and edited by the 23-year-old Fénéon (who was later assisted in this task by Dujardin); *La Vogue*, begun in 1886 and headed by Kahn (with Fénéon as an important contributor); and *Revue wagnérienne*, founded in 1885 by Dujardin and the Polish-born Wyzéwa. In their quest to publicize their ideas, however, Symbolist polemicists sometimes sought less obscure forums; in September 1886, for instance, Moréas's Symbolist "Manifeste" was published in *Le Figaro littéraire*, and his assertions there provoked a prompt factionalist rebuttal by Kahn, whose "Réponse des symbolistes" appeared in *L'Evénement* ten days later.

In his piece for *Le Figaro littéraire*, Moréas declared that Symbolist poetry

was the "enemy of instruction, of rhetoric, of false sensibility, of objective oratory."[21] Exalting the transcendent "Idea" – a Platonic notion revived by Schopenhauer and Mallarmé[22] – he described the Symbolists' attempt to

...clothe the Idea in a tangible form that, nonetheless, would not be an end in itself but, while serving to express the Idea, would still remain the subject. The Idea, in turn, must never let itself be seen without the sumptuous robes of external analogy, because the essential character of symbolic art consists of never going so far as the apprehension of the Idea in itself.[23]

Moréas concluded that concrete phenomena such as "nature's tableaux" and "human actions" exist as "perceptible appearances destined to represent their esoteric affinities with primordial Ideas."[24]

Kahn downplayed the esoteric aspects of Symbolism, and in his succinct – hence much-quoted – description of Symbolist goals remarked, "The essential purpose of our art is to objectify the subjective (the exteriorization of the Idea) in lieu of subjectifying the objective (nature through a temperament)."[25] Thus did this critic explicitly indicate his (and his colleagues') dissatisfaction with Zola's view of art as a strong-willed individual's presentation of a personal vision of nature. He noted that Symbolists sought instead to suggest – but by modern, "scientific" means – a higher, universal reality that existed outside the material world (i.e., nature) and beyond the limits imposed by personal sensibility. Kahn added, moreover, that "the same purely idealist philosophical principle which makes us reject the reality of matter, and only admit the existence of the world as representation" now held sway in the most up-to-date music and art, for it had motivated Wagner and – more recently – the Neo-Impressionists.[26]

Kahn's dismissal of Naturalism, perhaps most notable for its restraint, was certainly not anomalous in this decade of literary upheaval. In December 1886, Jules Lemaître, writing in *Le Figaro*, remarked that "Naturalism seems very close to having run its course,"[27] and in March 1887 *La Nouvelle Revue* carried a piece in which Raoul Frary expressed relief at Zola's loosening stranglehold on French literary practice:

Some years ago a powerful and popular master threatened to tyrannize and discipline his fellow novelists....The public very nearly ratified this literary *coup d'état;* Naturalism was like a dictatorship, and the human document banished novelistic romanticism. Happily this was nothing but a false alarm. Fantasy reclaimed its rights.[28]

Though Zola remained a powerful presence in European letters, he was himself aware of the trends that threatened his position,[29] and as the 1880s progressed he saw his influence on the younger generation of Parisian writers wane considerably. The most notable defection from his circle of disciples was that of Joris-Karl Huysmans at middecade. As a second-generation Naturalist Huysmans had written a string of Realist novels – including *Marthe*

(1876), *Les Soeurs Vatard* (1879) and *En ménage* (1881) – but in 1884 he rocked the Parisian literary world with *A Rebours,* the novel for which the label "Decadent" was coined. Though, as Sven Lövgren has noted, it conforms in some respects to Naturalist modes,[30] the content of *A Rebours* signals a rising antipositivist tide. Its protagonist, Jean des Esseintes, is an eccentric, self-absorbed aesthete who – dissipated by society life – retreats to the privacy of his well-appointed home in Fontenay-aux-Roses and devotes himself to philosophical musings and the exploration of avant-garde art (the nuanced poetry of Mallarmé and Verlaine and esoteric imagery of Odilon Redon and Gustave Moreau). Des Esseintes's private fantasies and hallucinatory celebrations of his own senses constitute the "action" of this study in self-willed reclusion. The quintessential Decadent novel, *A Rebours* was a harbinger of fin-de-siècle vogues.

Van Gogh's awareness of the inroads made by Symbolism in the 1880s may be assumed – not only because he was an avid reader of both novels and literary criticism, but also because several of his Parisian acquaintances had ties to the Symbolist movement. Signac, an enthusiast of Naturalism in his youth,[31] inclined toward newer trends by the time Van Gogh met him. He socialized at the Brasserie Gambrinus (a favorite Symbolist haunt) and at the offices of *La Revue indépendante;*[32] moreover, Fénéon and Kahn were regulars at the Monday night soirées Signac hosted in his studio. Anquetin and Toulouse-Lautrec were friendly with fellow Montmarte residents Wyzéwa and Dujardin,[33] and it was the latter's essay for *La Revue indépendante* that first publicized Cloisonism.[34] Emile Bernard, an avid reader and aspiring poet,[35] also embraced Symbolism, and his advocacy of Idealist prose and verse surely informed the literary discussions he later recalled having with Van Gogh in the 1880s.[36]

Van Gogh himself was summarily acquainted with the players and products of literary Symbolism. He met both Kahn and Dujardin during his sojourn in Paris,[37] and according to Bernard, he read *A Rebours* in this era.[38] Furthermore, Van Gogh's growing interest in Wagner and his knowledge of Walt Whitman's poetry suggest his exposure to Symbolist periodicals, which promoted both. Van Gogh probably was familiar with the *Revue wagnérienne* (it appeared from 1885 to 1888), and even if he was not, he surely was aware of the Wagnerian ideals of synthesis and emotion in art that were widely circulated by Wyzéwa and others in the 1880s.[39] As for Whitman, his verse appeared (in translation) in both *La Vogue* and *La Revue indépendante* in the mid-1880s,[40] and the Van Gogh brothers' known interest in the American poet[41] probably was initiated by the notice he received in the Parisian avant-garde press.

Though Van Gogh's few letters from Paris contain no allusions to Symbolism, his exposure to the movement and his attitudes toward that which

he called "decadent or impressionist literature" (LT580) can be discerned from the disdain he later expressed for "[the Decadents'] passion for saying the most obvious things in the most wildly contorted phrases" (LT502; written in 1888). Unmoved by the younger generation's efforts to reform poetry and prose, Van Gogh remained faithful to Naturalist precepts and continued – whether from obstinacy or naïveté – to ascribe primacy to Zola and his school. More than halfway into his stay in Paris, Van Gogh told his sister (in a letter of summer 1887): "The work of the French naturalists, Zola, Flaubert, Guy de Maupassant, de Goncourt, [Jean] Richepin, Daudet, Huysmans, is magnificent, and one can hardly be said to belong to one's time if one has paid no attention to it" (W1). The characterization of Huysmans in 1887 as a Naturalist, and of Naturalism itself as the literary cutting edge, was anachronistic, and his remarks indicate Van Gogh's distance – intellectual if not physical – from the Parisian avant-garde.

ZOLA EMBATTLED, 1886–7

Even as Zola lost ground to Symbolism in the mid-1880s, he was attacked on different, less theoretical grounds when his novels *L'Oeuvre* (1886) and *La Terre* (1887) appeared. Both caused minor scandals, and their author's profile remained high, if battle-scarred, during Van Gogh's residence in Paris. *L'Oeuvre*, the story of an artist's blind struggle to succeed in the Parisian art world, effectively foreclosed Zola's once-cordial relations with the Impressionist circle, and *La Terre*, a biting portrayal of French farm life, was – like *L'Assommoir* and *Germinal* before it – widely scorned as gratuitously crude and pessimistic.

Based on Zola's intimate friendship with Cézanne and his longtime association with Manet and several of the Impressionists, *L'Oeuvre* is an extended meditation on artistic aspiration and practice. It presents an updated and disturbing portrait of Claude Lantier, the painter introduced in *Le Ventre de Paris* in 1877. The mature Lantier is an ambitious Impressionist whose single-minded devotion to the creation of a huge, pathetically misguided "masterpiece" destroys his home life and culminates in the artist's madness and suicide. Though Zola's characterization relied to some extent on his lifelong relationship with Cézanne, Lantier is a composite figure whose fictitious successes, failures, aims, and amours were based on incidents from the careers of several artists Zola knew, as well as on the author's own efforts to produce.[42] Most readers, however, regarded the book as a straightforward roman à clef in which Zola was represented by Lantier's journalist friend Sandoz. Van Gogh was one such reader, and like most of his contemporaries he assumed that the recently deceased Manet (d. 1883) had served as the model for Lantier (LT452).[43] Few suspected Zola's reliance on aspects of

Cézanne's life and personality (since that artist was a virtual unknown at the time of *L'Oeuvre's* publication), but Cézanne saw enough of himself in Lantier to sever ties with his boyhood friend. Monet was another of those offended by the book; fearing it would discredit the Impressionist movement (which after years of individual and collective effort was finally enjoying renown), he wrote Zola a letter in which he calmly registered his objections. *L'Oeuvre* was a critical and popular success,[44] but it rendered the author a pariah among former friends.[45]

Though Van Gogh had felt little affinity with Claude Lantier as he read *Le Ventre de Paris* (see LT248), when he perused excerpts from *L'Oeuvre* in Antwerp he found Zola's account of the art world and painters' procedures "striking" and "well described" (LT444, LT452). Once he gained a better understanding of Impressionist practice, Van Gogh suspected the author of some inaccuracy, but nonetheless insisted, "We must not criticize Zola's book" (LT543). He was especially intrigued by one of *L'Oeuvre's* small character studies: that of Bongrand, an aging painter who attained great success in his youth and now agonizes over living up to his reputation. Though almost nothing could have been further from his own situation, Van Gogh was "deeply touched" by a dialogue in which Bongrand describes the anxiety engendered by high repute, and he paraphrased it in a letter to Theo from Arles (LT524).[46]

La Terre, nowadays considered a better novel than *L'Oeuvre,*[47] was, at the time of its publication, much more widely and vehemently maligned – doubtless because it addressed a topic of national political interest: tensions in French agrarian communities. Set in La Beauce, a farming region just south of Paris, *La Terre* takes as its theme the overwhelming lust for land that propels a grasping peasantry toward heinous acts. Disruptive and divisive greed – a commonplace of midcentury descriptions of rural laborers[48] – permeates Zola's saga of a farm family of relatively small holdings but abundant self-interest. When the elderly patriarch finally parcels out his acreage to three offspring, the plot devolves in a predictably *Lear*-like manner as avarice triumphs over filial and fraternal loyalties and intrafamilial warfare results in the gruesome deaths of its weaker members.

In *La Terre* – the fifteenth novel of the Rougon-Macquart series – Zola sought to address pressing problems in French agriculture, and risking anachronism, he raised issues of the 1880s within the predetermined Second Empire time frame of the series.[49] *La Terre* also debunked comforting popular notions of the rural underclass as naïve and gentle folk of rough-hewn nobility who lived peaceful, simple lives, reaping nature's bounty and giving thanks to God – an image fostered by Millet's most popular work (particularly the late paintings, which Zola once dismissed as "feeble").[50] Like a host of others before him – including Michelet in *Le Peuple* and the Abbé

Joseph Roux in his recently published *Pensées* (1886)[51] – Zola took umbrage at the pious and sanitized peasant of popular imagination and portrayed French farmers as ruthless, avaricious brutes. And within the context of fiction, he was able to illustrate such general assessments of character with colorful specificity. The laborers of *La Terre* lead violent lives in harsh, sometimes squalid surroundings, cursing God and their fate[52] and continually scheming to defraud kith and kin. The earth they work and covet is, by contrast, majestic and implacable. Its grand scale, cyclical rhythms, and uncorrupt beauty transcend the petty squabbles and miseries of those who literally would kill for an additional field.

Zola researched and structured *La Terre* in much the same way he had worked on and organized *Germinal*. After background reading and conference with an "expert" (Jules Guesde, the author of several articles on French agricultural problems), the novelist made a brief tour of the region he sought to portray.[53] Factual information gleaned from interviews and on-site observation in La Beauce clearly was conjoined, however, to Zola's preconceived image of the rural underclass. The laborers of *La Terre* have much in common with those of *Germinal* and are virtually indistinguishable from the farmers Zola had already depicted in *La Faute de l'Abbé Mouret* and *Comment on meurt:* animalistic others who manifest a quasi-erotic attachment to their land.[54]

The detailed accounts of daily life, agrarian practice, and momentous occasions that resulted from Zola's "documentation" are set against a mythic rendering of the land – worked earth that, as in *Germinal*, the author describes as an entity of overwhelming dimensions and continuity, the impassive source of wealth and misery, and the locus of life, death, and regeneration. In his *ébauche* for *La Terre*, Zola envisioned a "living poem of the earth":[55]

I want to paint…the peasant's love for the earth, an instantaneous love, the possession of the most land possible, the passion to have a lot of it....It has been said that the peasant is the fierce, murderous animal in the midst of the calm, beneficent land. To paint this without pushing too much toward the dark side…[56]

Both novels take a large family as their focal point, but in *La Terre* as in *Germinal* that family is not part of the Rougon-Macquart tree. Instead, a representative of the series' sprawling namesake clan appears on the scene as an outsider; Etienne Lantier's counterpart here is Jean Macquart, a soldier looking for a new life. Like Lantier's, Macquart's acceptance in the tight-knit rural community is hard-won and transient, and – like Zola himself – *La Terre*'s protagonist remains somewhat distanced from the agrarian culture he infiltrates, viewing the ambitions and maneuvers he encounters with bemusement, dismay, and – at times – disgust.

La Terre was published serially by *Gil Blas* from 29 May to 18 August 1887 and appeared in book form on 15 November. Advance comment on the project began to appear once Zola had previewed his aims in an interview with Arsène Alexandre for *L'Evénement* in January 1887,[57] and in March, for instance, Ferdinand Brunetière – editor of the *Revue des deux mondes* and a longtime foe of Naturalism's methods, subjects, and *"grossièreté"* – expressed his hope that the movement's demise was imminent.[58] Once serial publication began, such anti-Naturalist sentiment – which lately had been rampant in Paris – focused on *La Terre,* which was widely criticized for its relentless, seemingly one-sided emphasis on the brutality and bestiality of rural workers. One reviewer characterized the book as a "monomania of filth" marked by "bestial obsession,"[59] another as a "monomania of degradation and baseness,"[60] and a third wrote that *La Terre* was not only "quite dirty" but also "quite boring."[61] Many commentators acknowledged the book's epic scope and occasional lyricism[62] – some even as they described repulsion at its contents. An anonymous reviewer for *Le Livre* noted, for instance, "*La Terre* proceeds directly from pure romanticism: it is a representation of truth, seen through the enlarging eye of a poet." The same writer lamented, however, that the "fantasy and macabre aspects of Romanticism" give way, in *La Terre,* to the "filth and hysteria" of Naturalism.[63]

The most notorious attack on Zola in the summer of his great embattlement was the so-called Manifeste des Cinq, an open letter signed by five young men who claimed to be erstwhile disciples of the author. Denouncing his recent work, most especially *La Terre,* they accused Zola of allowing his sexual inadequacies to skew his vision and announced their resolve to disassociate themselves from their former "master." The signatories – Paul Bonnetain, J. H. Rosny, Lucien Descaves, Paul Margueritte, and Gustave Guiches – were in fact unacquainted with Zola, who scarcely recognized their names.[64] Nonetheless, their manifesto was published by *Le Figaro* on 18 August and reprinted in full in *L'Echo de Paris* the following day. Several other journals picked up extracts of the letter, in which Les Cinq summarized their mutual reaction to *La Terre:*

The disappointment has been deep and painful. Not only is the observation superficial, the material outmoded, the narration trite and undistinctive, but the obscene note is exacerbated, sinking to such low dirtiness that now and then one would believe oneself to be before a scatological compendium: the Master has descended to the depths of filth.[65]

The editors of *Gil Blas* were quick to discredit Les Cinq. In a column published on 20 August, a writer who signed himself Montjoyeux held that though *La Terre* may have merited their criticism, Zola himself deserved more respect. Addressing the young men directly, he wrote, "If one pardons

Zola, who is a master, for that which you rightly call the brutality of his precepts...I doubt that the literary public forgives you, his students, for already having the pretension to judge and condemn your teacher."[66] The following day *Gil Blas* carried an attack on the credentials of Les Cinq – in a column signed by Ferdinand Xau – as well as Zola's own response to their comments, wherein he denied knowing any of the young writers and claimed to attach little significance to their criticisms. Zola was disturbed, however, by a suspicion that their attack on him had been engineered by former colleagues. The men who called themselves Les Cinq were members of Edmond de Goncourt's "Grenier" (an attic social club for sympathetic literati, headed by Goncourt and his close friend Daudet), and rumor held that their *Manifeste* had been written under the supervision of these rival Naturalists, both of whom had cooled toward Zola in recent years.[67] Though Goncourt and Daudet were vigorous in their denials, Zola and his public remained unconvinced.[68]

For a few days in late August Les Cinq provided grist for satire,[69] but their remarks were virtually forgotten once more reputable critics launched assaults on *La Terre*. On 28 August, Anatole France – a novelist and satirist of well-known conservative convictions – declared in *Le Temps:* "Never has man made a comparable effort to degrade humanity, to affront images of beauty and love, to deny all that is well and good."[70] A few days later, on 1 September, Ferdinand Brunetière claimed to see his dreams fulfilled; in an article entitled "La Banquerote du naturalisme" Brunetière pronounced *La Terre* Zola's worst novel to date and sounded the movement's death knell. "Never has [Zola] more audaciously substituted the obscene or grotesque visions of his overheated imagination for reality," he wrote. "Void of conscience and void of observation, void of truth."[71] In conclusion, Brunetière huffed, "Images of debauchery, odors of blood and musk mixed with those of wine or of manure, *voilà La Terre,* et *voilà,* one goes on to say, the last word from Naturalism!"[72]

Octave Mirbeau took much the same tack when he joined the chorus of detractors on 21 September; in a review for *Le Gaulois* he lamented Zola's ignorance of French peasants and accused the author of overstatement and undue negativity:

[Zola] has immeasurably amplified that which one calls the peasant's faults, his vices; he has unfairly diminished his sublime qualities. But the opposite happens in nature. Amid the splendor of things, the faults of the peasant, his vices, and that which is called his ugliness, are pushed to the background, and he appears in all his austere nobility, in the divine grandeur of his mission – the most pure, the most august, that has fallen to man. It is necessary, however, to see him as the Gothics saw him, it is necessary to understand and love him as Millet understood and loved him, [Millet] who completely naturally, without seeking to aggrandize, constructed

[the peasant] in his charcoal sketches, with the plastic form and sculptural beauty of a marble by Michelangelo.[73]

It was Mirbeau who most clearly conjured the peasant whom Zola's detractors preferred to envision: a creature apart, to be sure, but one whose unpleasant, classed differentness ("that which one calls the peasant's faults," "that which is called his ugliness") was softened by the haze of a timeless pastoral vision and rendered "sublime." The peasant of Mirbeau's fancy presumably attended to the same monthly labors as his medieval forebears, recorded by sculptors on the façades of Gothic cathedrals and pursued with soothing regularity since – as nineteenth-century images like Millet's *Les Travaux des champs* (1852) suggested.[74] Recourse to the example of Millet was almost inevitable in this year of the artist's retrospective, for controversial as he had been in the 1850s, Millet won acceptance and admiration by the time of his death in 1875. Mirbeau, using Millet's work to counter Zola's, seems conveniently oblivious to the fact that Millet's workers, too, had once outraged the public with their *"sauvagerie"* and *"rudesse."*[75] Mirbeau's ideal laborer conformed to more recent appraisals of Millet's; without being unnaturally aggrandized, the worker was enobled, aestheticized, even classicized, in accordance with high art norms. It would seem that such a peasant – like Millet's *Sower* (1849–50) – might agilely walk the line between crude reality and poetic grandeur.[76] But whereas Millet made the "savage" aspects of his peasant images palatable by operating within the bounds of an established pastoral tradition, Zola apparently had stepped too far outside the parameters of peasant imagery that Millet had helped to expand. Though the author aimed for poetry, most critics felt that *La Terre's* lyric effects were too few to mitigate its brutality. Mirbeau and others justly rejected as exaggerated Zola's stark contrasting of the peasants' ferocious animality and the earth's calm beneficence, but the alternative they proposed generally was skewed in the opposite direction, to highlight the workers' oneness with nature (rather than assertion within it) and their inherent otherness from the urban bourgeoisie. Many of *La Terre's* critics preferred to believe that France's vast rural underclass basked in and reflected the "splendor" of the nation's agrarian regions.[77]

In contrast to Mirbeau, Van Gogh accepted Zola's characterization of the rural work force and would later ridicule those who naïvely assumed that "country folk" were "simple and artless" (see LT514). Moreover, he had long believed that Zola's peasants were apt counterparts to Millet's. In his very first mention of Zola's work, Van Gogh noted a "fragment which describes a little old peasant, exactly like a drawing by Millet" (LT212), and later he noted that some passages from Zola's writings on rural life were "as beautiful as if they were Millets" (R38). Though he surely was aware

of the controversy it raised, *La Terre* did not diminish Van Gogh's belief in the accuracy and artistry of Zola's descriptions of peasants but, contrarily, enhanced it; when he began to paint rural life again – at Arles in 1888 – Van Gogh wrote, "We've read *La Terre* and *Germinal,* and if we are painting a peasant, we want to show that in the end what we have read has come very near to being a part of us" (LT520; see Chapter 5).

A NATURALIST LOYALIST AGAINST THE TIDE

Despite the critics' nearly incessant attacks on Zola and his peers' increasingly jaundiced view of Naturalism, Van Gogh continued to champion the leaders and precepts of the movement during his years in Paris; if anything, his fealty intensified as battle cries rose around his foremost writer-heroes. Van Gogh's few epistolary accounts of his life in the French capital – along with reminiscences of his acquaintances there – indicate his ongoing enthusiasm for Naturalism, steady consumption of its products, and, consequently, a broadening and deepening of his knowledge of the movement. He continued to read novels by Zola and Daudet, and progressed from a nodding acquaintance with the Goncourts' fiction to enthusiastic familiarity. His interest in the brothers' fraternal relationship was stoked by *Les Frères Zemganno,* and his reading of *Germinie Lacerteux* provided Van Gogh perspective on the roots of the practice he labeled Naturalist. He also became aware of the latter-day offshoots of 1870s Naturalism: Guy de Maupassant's lighthearted variant, Jean Richepin's darkened rendering, and the pre-Decadent Huysmans's accomplished, slightly distanced version.

At the time he moved to Paris, Van Gogh was more familiar with Daudet's work than with that of any other Naturalist save Zola. Having read a series of Daudet's urban Realist works while still in Holland, Van Gogh in France discovered another, more distinctive side of Daudet's work: the regionalist writings that won the author his initial renown – and for which he is best known to twentieth-century readers. Born and raised at Nîmes, Daudet drew on his Provençal background to write *Lettres de mon moulin* (1869), the collection of short stories that launched his career. Ostensibly composed in an abandoned windmill near Arles, the *lettres* (which take the form of short stories) describe regional characters and vistas and recount colorful Provençal legends and customs. Three years later, Daudet cemented his success with a novel-length slapstick adventure story, *Tartarin de Tarascon* (1872). Its eponymous hero – the quintessential Provençal – was such a popular success that Daudet revived him in two sequels: *Tartarin sur les Alpes* (1885) and *Port Tarascon* (1890). At some point during his stay in Paris Van Gogh read the first of the Tartarin novels,[78] and once he moved to Arles (where he read *Tartarin sur les Alpes*) the jovial, blustery Provençal of Daudet's fiction

became a sort of alter ego for the displaced Dutchman (see Chapter 5). Given the interest in the Midi that Van Gogh conceived in Paris (which culminated, of course, in his move to the South) it seems likely that he also read *Lettres de mon moulin,* though he never made specific mention of Daudet's short stories.

In the first novel of the Tartarin trilogy, Daudet's hero is introduced in his natural habitat: a large but cluttered house in the heart of Tarascon (a small town between Avignon and Arles), surrounded by a garden of exotic plants. Though no match in quirkiness for Huysmans's Des Esseintes, Tartarin is, like him, an eccentric man of means with an abundance of leisure time in which to indulge his fantasies. This rotund middle-aged bachelor is an armchair adventurer who longs to see the world and perform daring deeds, but at the same time dreads the thought of relinquishing the comforts of home and the pleasures of Tarasconnais life. Tartarin is famed in his hometown as a sharpshooter, despite the absence of local game (long since annihilated by the region's fanatic huntsmen). The men of the town instead demonstrate their prowess by shooting at caps tossed in the air; their *"chasse aux casquettes"* is a weekly ritual, and a bullet-riddled cap an accessory of great distinction (so much so, Daudet tells the reader, that entrepreneurs peddle preshot hats to lackluster marksmen). Since no one's hat is so full of holes as Tartarin's, his friends goad him into making a lion-hunting expedition in North Africa and commission him to bring home skins for one and all. The reluctant Tartarin – who has never before left Provence – lands in Algeria to discover lions have disappeared from that region, and the body of the novel is a burlesque detailing of the misadventures of an innocent abroad.

Though Daudet's descriptions are forthrightly fanciful, they helped to shape Van Gogh's image of the Midi and its inhabitants – as the artist's letters from Arles make clear (e.g., LT469). His decision to leave Paris for the South almost certainly was encouraged by Daudet's evocations of the region and its people, and once he arrived there Van Gogh told his sister: "I am getting to think the country here more and more beautiful. Have you read *Tartarin de Tarascon* by Daudet? You should, you know, and *Tartarin sur les Alpes,* for they are certainly not among the least of Daudet's novels" (W6). His eagerness to acquaint his sister with this side of Daudet's writing suggests Van Gogh's belief that the author's imagery – however caricatural – would give her some idea of a place and people Van Gogh himself found enticingly foreign.

In reading Daudet's regional novels (as in reading Zola's *L'Oeuvre* and *La Terre*) Van Gogh was honing his knowledge of an author whose work was already quite familiar to him. In the case of the Goncourts' novels, by contrast, he tackled an oeuvre he had known mainly by word of mouth since

his discovery of Naturalism at The Hague in 1882. Though he had read the Goncourts' art-historical studies with great concentration in 1885, Van Gogh's interest in their fiction remained lukewarm until 1886 or 1887, when in a burst of enthusiasm he took up *Germinie Lacerteux* (1865), *La Fille Elisa* (1877; a solo effort by Edmond), and – probably – *Manette Salomon* (1867) and *Les Frères Zemganno* (1879; another of the novels Edmond wrote on his own).[79]

By the time Van Gogh arrived in Paris, Jules de Goncourt was long dead and Edmond had ceased to write novels (his final effort in that genre, *Chérie*, was published in 1884). The brothers, however, were very much in the news during his stay, for publication of their *Journal* commenced in the summer of 1886.[80] This volumes-long diary, begun in 1851, is a compendium of private and professional thoughts: memories and projects; opinions and recorded emotions; reports on conversations, social gatherings and their participants; criticism of and praise for their literary peers and forebears. After Jules's death in 1870, Edmond continued to add to the *Journal* with the intention that it be published posthumously, twenty years after his own demise. He was, however, persuaded to begin publication of an abridged version (from which potentially embarrassing and offensive passages were expunged) in *Le Figaro* starting in July 1886, and the Charpentier publishing house brought out the first volume in book form in 1887. Reactions to the memoirs were mixed; generally speaking, those left unscathed by the Goncourts' acerbic appraisals were receptive, whereas those targeted by the authors' invective (or insulted by a lack of notice) railed against them.[81] Writing in *Le Figaro* (which naturally sought praise for the venture), Philippe Gille remarked on the brothers' fraternal devotion (the dimension of their private life that Van Gogh most admired): "That which strikes one first," Gille wrote, "is the tender affection of these two twins of letters, the perfect harmony of this literary ménage. Their intimate journal shows us they didn't love each other just for the purpose of writing."[82] Van Gogh's fascination with the Goncourts' private life (already apparent in his letters from Antwerp; see LT442, LT451) leads one to suspect that he read at least part of the *Journal* as it appeared in *Le Figaro* and that the publicity generated by the *Journal*'s publication spurred him to explore their fiction at this time.

Like most of the Goncourts' novels, *Germinie Lacerteux* and *La Fille Elisa* are in-depth portraits of contemporary women.[83] The figure of Germinie, based on the secret life of the Goncourts' own servant,[84] is probably the most vivid in their fiction. The novel recounts the sordid and painful existence of an urban domestic who successfully conceals her drinking, sexual adventures, huge debts, and even her pregnancy from the proper spinster who employs her. Despite the sensational aspects of the story (and their personal chagrin at having been duped by their own household help) the Goncourts

claimed to aim for a candid, well-documented account of a working-class character — and prided themselves on what they considered a successful mental foray beyond the boundaries of their own upper-class existence (and the expectations of a bourgeois public) to attain their goal. In their preface to the novel, they write:

We must ask the public's pardon for giving them this book, and warn them of that which they will find here.

The public loves false novels; this is a true novel.

They love books that give the appearance of going into the world; this novel comes from the street....

Why then have we written it? Is it simply to shock the public and scandalize its tastes?

No.

Living in the nineteenth century, in a time of universal suffrage, of democracy, of liberalism, we asked ourselves if those whom one calls "the lower classes" didn't have a right to the Novel.[85]

Thus, with the authorial paternalism so typical of their times, the Goncourts acknowledged the working woman's "right" to her own novel — albeit written from the voyeuristic (and in this case, resentful) vantage point of the upper-class male.

The preface to *Germinie Lacerteux,* published when Zola was but 25 years old, reads like a Naturalist manifesto *avant la lettre,*[86] and the book obviously made a strong impression on the younger writer, who initially reviewed it for a Lyonnais newspaper[87] and later included his essay on the book in *Mes haines.* Celebrating the "depraved" and "sickly" aspects of the novel almost two decades before the vogue of Decadent literature,[88] Zola was at least equally stimulated by its down-to-earth, "factual" quality. The Goncourts' documentary aims and verisimilar product influenced his later thoughts on fictional writing[89] – as Edmond de Goncourt was inclined to point out (as in his preface to *Chérie*) and as Zola himself often acknowledged.[90]

Van Gogh was attentive to the similarities between the Goncourts' working women and those described by Zola, and he emphasized the hardboiled candor of such Naturalist depictions when he told his sister, "If . . . one wants truth, life as it is, then there are for instance de Goncourt [*sic*] in *Germinie Lacerteux, la Fille Elisa,* Zola in *La Joie de Vivre* and *L'assommoir* and so many other masterpieces" (W1). In addition to admiring the seeming veracity of the Goncourts' portrayal, Van Gogh was especially moved by their evocation of Germinie's despair, which he recalled years later at St.-Rémy. As he made a copy there after Delacroix's *Pietà* (Fig. 16), Van Gogh wrote of the Virgin's "grayish white countenance, the lost, vague look of a person exhausted by anxiety and weeping and waking, rather in the manner of

Germinie Lacerteux" (W14). The Goncourts describe Germinie's temperament as passive and sluggish, the classic "lymphatic" type that declares itself in the pallor of her skin, that "whiteness, at once unhealthy and angelic, of non-living flesh."[91] Van Gogh was struck by this aspect of the authors' description and later not only mentioned Germinie's coloring in relation to the copied *Pietà*, but also – in one of many discussions of the superiority of painted to photographic portraits – stressed the expressiveness of individual coloring by citing Germinie as an example. "Would Germinie Lacerteux really be Germinie Lacerteux without her color?" Van Gogh asked rhetorically. "Obviously not" (LT540).

The Goncourts had been doing research for *La Fille Elisa* when their maid's death brought her story to light and set them to work on *Germinie Lacerteux* instead. It was not until years later, after Jules's death, that Edmond returned to their notes on Parisian prostitution and women's prisons and wrote *La Fille Elisa* on his own, as the life story of a young woman whose childhood bout of typhoid fever leaves her psychologically unstable. Prone to mood swings, Elisa is emotionally unfit for midwifery (her mother's profession) and instead drifts into prostitution. Beneath the callous face she assumes before most of her clients, Elisa clings to a personal ideal of untainted love, and in one of her agitated states she murders the one man she truly cares for because his sexual advances destroy her cherished image of their romance. Her subsequent imprisonment provides Goncourt a vehicle for journalistic exposé and a forum for his advocacy of prison reform.

Written in a drier, more documentary style than *Germinie Lacerteux*, *La Fille Elisa* suffered by comparison with the earlier novel – and with Zola's *L'Assommoir*, which was published in the same year and vastly outsold it.[92] Though Van Gogh's only comment on *La Fille Elisa* was an assertion of its truth to "life as it is," the novel seems to have affected him strongly – probably in part because he had frequented prostitutes throughout his life and had seen the profession's debilitating effects at particularly close range during his months with Sien. In his memoir, *Avant et après*, Paul Gauguin claimed that Van Gogh thought of Goncourt's novel as he offered charity to a woman on the streets of Paris; according to Gauguin, Van Gogh – himself without funds – offered his last five francs to a prostitute in Montmartre who "smiled at the painter, wanting his business. The beautiful white hand came out...[and] Van Gogh, being a reader, thought of la fille Elisa and his five-franc piece became the property of the unhappy creature. Quickly, embarrassed by his own charity, he ran away, his own stomach empty."[93] Though Gauguin's recollections are not always to be trusted (and this particular anecdote has a suspiciously literary quality), it is likely that the two men (who visited brothels together at Arles) discussed their personal reactions to *La Fille Elisa* and that Gauguin's story is somehow faithful to Van Gogh's sentiments.

Figure 16. Van Gogh, copy after Delacroix's *Pietà*, 1889.

Manette Salomon – which takes its name from yet another Parisian woman – was one in a series of nineteenth-century fictional accounts of artists and studio life.[94] Though Van Gogh was often disappointed by novels in this genre, he had read a number of them (see LT232, LT248, R38), most recently *L'Oeuvre* (a novel that had been so strongly influenced by the story line of *Manette Salomon* that Edmond de Goncourt accused Zola of plagiarism).[95] Male paranoia anchors both narratives, as in each the artist-protagonist's energies are sapped, hence his production interfered with, by the domestic duties his once-enticing mistress demands once she becomes a mother and wife. But unlike Claude Lantier's muse Christine, whom Zola presents as passive, sweet-natured, and pitiable, Manette Salomon, the mistress of the Goncourts' artist-hero Coriolis, is an overbearing, grasping nag. Though Manette's Jewish "exoticism" contributes to her initial appeal, the authors' racism is revealed by their insistence upon the heroine's innate shrewishness. Once she bears his child Coriolis finds her unendurable. The novel's anti-Semitism and misogyny intensify as the Goncourts detail the disasters that befall a serious artist with familial obligations, and the book's central premise

– echoed to some extent by Zola in *L'Oeuvre* – is that an artist should remain unencumbered. The Goncourts (themselves lifelong bachelors disdainful of women)[96] seek to demonstrate that unchecked sexual appetite and – worse – the conjugal and paternal duties that often ensue inevitably undermine the (masculine) artist's endeavors.[97]

Though Van Gogh had once held that a wife and children were assets to a painter (see, e.g., LT161, LT215, LT217), in his midthirties he became less inclined to idealize his relations with women and increasingly resigned to life alone. Indeed, in the last years of his life he sometimes professed an attitude similar to that manifested by the authors of *Manette Salomon*. In a letter from Arles, for instance, he told Theo, "If your very brain and marrow are going into your work, it is pretty sensible not to exhaust yourself more than you must in love-making" (LT521). His comments to Emile Bernard on the same subject were more explicit: "Painting and fucking a lot are not compatible; it weakens the brain. Which is a bloody nuisance" (B7). In another letter to Bernard, Van Gogh noted that he had sex in a brothel every other week, and admitted, "It's not very poetic, but I feel it my duty after all to subordinate my life to painting" (B8).

While the Second Empire art world described in *L'Oeuvre* is dominated by an Impressionist aesthetic, *Manette Salomon* opens in the 1840s and has special praise for the Barbizon School – a group of artists Van Gogh had long admired. A carefully developed historical context envelopes the fictional events of the Goncourts' narrative, and though the story's main characters are fictional,[98] many real-life painters are mentioned by name, and their work described and commented on. *Manette Salomon* gives evidence of its authors' erudition; well versed in the art of their era, they describe it with the same eloquence that characterizes their studies of the eighteenth century, and though Van Gogh often felt dissatisfied by writers' portrayals of artists (see LT248, R38), he made no disparaging remarks about those developed in *Manette Salomon*. Moreover, in his only extended reference to the novel,[99] he expressed agreement with a sweeping assessment of midcentury painting put forth by one of its characters:

In *Manette Salomon* they are discussing modern art, and some artist or other, speaking of "what will last," says, "What will last is the landscape painters" – that has been rather true, for Corot, Daubigny, Dupré, Rousseau, and Millet remain alive as landscape painters, and when Corot on his deathbed said – "I saw in a dream landscapes with skies all pink," it was charming. Well then – in Monet, Pissarro, and Renoir, we see those skies all pink, so it is the landscape painters who last. Very good, it was damned true. (LT604)[100]

Les Frères Zemganno is another – if less orthodox – meditation on the asceticism demanded by successful artistic practice and by far the most per-

sonal of Goncourt novels. Written by Edmond alone (in memory of Jules), it is a thinly veiled autobiography in which the brothers' relationship — particularly their intense fraternal affection and sustained professional co-operation — is mirrored by that of two circus acrobats, the Zemgannos, who join bodies rather than minds in order to perform complex, hazardous stunts. The elder brother, Gianni, is the brains behind the act (he devises the tricks they practice and perform together); the younger, Nello, supplies its beauty.[101] Neither indulges in sexual activity, for as Goncourt explained in his notes for the novel, "There would be a religion of muscles in the brothers that would make them abstain from women and from everything that diminished strength."[102] This self-imposed stricture frustrates and eventually enrages a circus equestrienne who is attracted to Nello, and she vengefully sabotages the brothers' act, engineering a fall that disables the object of her desire. Gianni subsequently abandons acrobatics, for fear of causing Nello grief or inciting his envy. The basic elements of this story line parallel those of the Goncourts' literary alliance, which was cut short when the effects of tertiary syphilis rendered Jules incapable of continuing.[103] During the course of his long illness, the brothers were baffled by its symptoms and bewildered by its progress, but Edmond's fictionalization neatens the victim's undoing, not only by making it quick and comprehensible, but by identifying its source and assigning blame. His invention of a flesh-and-blood female perpetrator apparently derived from ingrained mysogyny rather than knowledge that a sexually transmitted disease killed Jules, for the brothers' correspondence and journal give no indication that they — or their peers — linked Jules's decline to his syphilitic episodes.[104] The Goncourts and their circle attributed it instead to the mental and nervous strains of overwork and to the unhealthy effects of the writer's sedentary life.[105]

Noting that *Les Frères Zemganno* "perhaps roughly sketches [the Goncourts'] life story" (LT550), Van Gogh was eager to compare certain aspects of the novel to his own relationship with Theo; like Gianni, Van Gogh was an elder brother who devised arduous projects, then enlisted his brother's support — always fearful, he claimed, that he might "exhaust" him (though financially rather than physically) (LT550). In a letter to Theo, Van Gogh wrote, "I might be more daring perhaps if I had not read [*Les Frères Zemganno*], and even after reading it my only fear is of asking you for too much money. If I come to grief myself in the attempt, it would do me no harm" (LT551). Goncourt's dramatic figurative description of the creative acts he and Jules performed together made a strong impression on Van Gogh, and under its influence the painter envisioned himself as a performer of dangerous feats who did not want to take his brother along should he fail and fall.

Among the other Naturalists Van Gogh read in Paris, his favorite find was Guy de Maupassant (1850–93), a former protégé of Flaubert and a

marginal member of Zola's literary circle, who by the mid-1880s was a well-known and extremely prolific contributor to several Parisian newspapers.[106] Maupassant's rise had been rapid. His first (and last) volume of poetry, *Des vers*, saw print in 1880, but he soon abandoned verse in order to write the numerous short stories and novellas on which his fame now rests, encouraged by the warm reception of his first published short story, "Boule de suif," which appeared in *Les Soirées de Médan* (1880), a collaborative project designed by Zola and his followers (each author contributed a tale inspired by the Franco–Prussian war). In the early 1880s Maupassant also made his debut as a novelist. His first book, *Une Vie*, came out in 1883, followed two years later by *Bel-Ami*. During Van Gogh's years in Paris, two more novels by Maupassant appeared: *Mont-Oriol* (1887), which was serialized in *Gil Blas* from December 1886 to February 1887, and the critically acclaimed *Pierre et Jean* (1888), serialized by *La Nouvelle Revue* from December 1887 to January 1888. If Van Gogh read *Une Vie* (the story of a woman's life, in the mode of *Chérie* and *La Joie de vivre*), it went unmentioned in his letters. He did read both *Bel-Ami* and *Mont-Oriol* while living in Paris (W1), and later – at Arles – he also read *Pierre et Jean*.

In a letter written to his sister in the summer of 1887, Van Gogh mentioned Maupassant for the first time, characterizing his writings as an antidote to melancholy – much more effective, the artist believed, than the tomes more commonly recommended to alleviate depression:

If with good intentions we search the books which it is said shed light in the darkness – though inspired by the best will in the world, we find extremely little that is certain, and not always the satisfaction of being comforted personally. And the diseases which we civilized people labor under most are melancholy and pessimism.

So I, for instance, who can count so many years in my life during which a desire to laugh was grievously wanting...I, for instance, feel first of all the need of a thoroughly good laugh. I found this in Guy de Maupassant.

...Maupassant's masterpiece is *Bel Ami;* I hope I shall be able to get it for you. (W1)

Maupassant, a talented storyteller, had a knack for relating telling incidents and quickly evoking character. His production is often characterized as charming but superficial, for he sidestepped both social commentary and sustained philosophizing. His work lacks the purposeful tenor that is so much a part of Zola's, Daudet's, and the Goncourts' oeuvre; moreover, Maupassant was much less concerned with "documentation" than were the older Naturalists. He instead sought to rely on his personal perceptions of human nature, and his writing is the lightest of Naturalist fare: colorful, clever, often ironic. Van Gogh appreciated it as a change of pace and did not include Maupassant's novels in the category of "truth, life as it is."

Instead, Maupassant amused him. "There are some not-too-serious things which I like very much," Van Gogh later remarked, "such as a book like *Bel Ami*" (LT590).

Bel-Ami is the story of Georges Duroy, a young man who parlays a few fortuitous social connections and an almost incredible attractiveness to women into a successful career, two opportune marriages, and a good deal of material wealth. Neither hardworking nor particularly bright, Duroy is simply a charismatic opportunist who tumbles headlong into one success after another. The novel is a patchwork of episodes that chronicle his rise through Paris's journalistic ranks, into politics, and on to the haut monde – always with a woman on his arm. Reading like an exaggerated, cartoon version of Zola's Octave Mouret, Duroy became linked to that character in Van Gogh's mind; both, Van Gogh wrote, had gone "whole hog" (LT528). As an aspiring figure painter, Van Gogh often longed for a modicum of the charm that the fictional journalist Duroy seemed to possess in excess, for he was convinced it would be an invaluable aid in his pursuit of models (see LT482). Duroy's nickname, Bel-Ami (bestowed on him by an enthusiastic female admirer), came to be Van Gogh's term for a winning fellow, and Bel-Ami's personality became confounded in his mind with that of Maupassant. At Arles Van Gogh dreamed of an artist who would paint as that author wrote, a "Bel Ami of the Midi...whom I feel to be coming...a kind of Guy de Maupassant in painting" who would revolutionize art by depicting the "beautiful people and things here lightheartedly" (LT482). Though Van Gogh claimed to feel inadequate to such a task (LT525), these remarks surely elucidate his own aims at Arles.

Maupassant's *Mont-Oriol,* a romance set at a health spa in the Auvergne, failed to elicit significant comment from Van Gogh, though he did mention reading it (W1). He or (more likely) Theo seems also to have owned a few volumes of collected short stories by Maupassant[107] – *La Maison Tellier* (1881), *Mademoiselle Fifi* (1882), *Miss Harriet* (1884), and *Monsieur Parent* (1885) – for Van Gogh made several direct and oblique references to their contents in his letters.[108] His discussions of the stories he read indicate that Van Gogh was more attentive to content than to style, and he often found parallels to his own life in the anecdotal incidents Maupassant recounts (see LT506, W8). Appraising the author's work on a general level, Van Gogh called it both "gay" (LT476, W8) and "comforting" (LT555), and pointed out that even when the author takes up "sad" subjects, he "lets things end ...humanely" (LT555). "In the end," Van Gogh remarked, Maupassant's characters "are resigned and go on in spite of everything" (LT555). The artist often aspired to such stoicism in his own reactions to life's misfortunes and more than once remarked on the therapeutic effects of reading Mau-

passant's work. Very likely he came across some of the articles and fiction the author published in Parisian periodicals between early 1886 and early 1888, and read them as well.

Another of Van Gogh's literary finds in the Paris years was Jean Richepin, a writer he classed among the Naturalists (W1). Mainly a poet of neo-Romantic persuasion, Richepin was also a dramatist of some note, but Van Gogh knew him as a novelist who in the 1870s and 1880s had fallen under the sway of Naturalism.[109] Richepin's work in that category tends toward overdone violence and crudeness; the assertive excess of his poetry marks his prose as well.[110] Though many of his peers felt Richepin's writing was more Romantic than Naturalist,[111] Van Gogh – who had long since noted those movements' interconnectedness[112] – would not have disqualified him on those grounds. He eventually read three of Richepin's novels – *La Glu* (1881), *Braves gens* (1886), and *Césarine* (1888) – though only *Braves gens* (which is subtitled *Roman parisien*) can be definitively linked to his stay in Paris. His letters contain no mention of the novel, but it is included in a still life with *La Fille Elisa* and *Au Bonheur des Dames* (see Plate 6).

Braves gens is the story of two performing artists, a musician and a mime. Their mutual dedication to revolutionary art forms the basis of their friendship, and Richepin devotes many pages to their aesthetic and intellectual discourses. Among the notions they address is that of the incompatibility of carnal love and sustained productivity. Yves, the musician, succeeds in marrying a particularly well read woman who becomes his muse and soulmate; they make a modest but comfortable life for themselves in Brittany, one that allows Yves to pursue his art in peace and attain his potential. Tombre, the mime, is less fortunate. The controversial aspects of his work provoke its alteration and debasement by an insensitive theater director, and Tombre alleviates his frustration in drink, which he ostensibly uses to spark creativity.[113] He falls in love with a fickle actress by whom he is ill-used, and together they sink into a life of poverty and alcoholism. Tombre manages to salvage what he can from his life by turning his most wretched experiences into a wrenching pantomime that addresses the plight of modern man, but realization of his talent comes too late, and he dies a premature death. *Braves gens* is an emotive and idealistic book that – as its title implies – lionizes artists and empathically explores the trials of creative endeavor.[114] Van Gogh surely responded to the author's homage to artistic dedication and integrity, and since he had, by his own account, begun to drink heavily in Paris (see LT480, LT481), he may have found Richepin's description of Tombre's reliance on alcohol particularly pertinent to his own difficulties with the life-style of a Parisian artist (see LT544).[115]

Van Gogh may also have read *La Glu* in Paris. One of Richepin's early novels, it focuses on a Parisian prostitute who retreats to Brittany and there

seduces a innocent young provincial named Marie-Pierre. "La Glu" is the woman's sobriquet, and Richepin portrays her as evil, unrepentant, and ugly – yet almost magically attractive to men. Marie-Pierre becomes so infatuated that he gladly relinquishes his family, and La Glu's spell over him is not broken until his mother – a pious Breton matron – splits the prostitute's head with an ax. Though Van Gogh denounced the novel's "blood and horrors" (LT555), he nonetheless read Richepin's similarly violent *Césarine* when it appeared in 1888 (see Chapter 5).

Van Gogh also became acquainted with J. K. Huysmans's work in this era, apparently first through the Naturalist novel *En ménage*.[116] Like *Braves gens, En ménage* examines Parisian artistic life – but from a more ironic perspective. Its characters enjoy privileged existences and seem to invest minimal energy and passion in their respective pursuits. André, a writer, and his painter friend, Cyprien, are self-proclaimed Naturalists of private means. Companions since their school days, they are allied by their interests, "both smitten by Naturalism and modernity" and possessing a "melancholic vision of life."[117] André, like many Naturalist writers, tries his hand at journalism, but since he prefers (and can afford) to spend his days wandering the streets or leafing through his well-stocked library, he soon quits his job. The more bohemian Cyprien takes on odd jobs to supplement his own less generous income; still, very little of his time is taken up by such work. *En ménage* evokes the indolence of such arty young men: their late nights and mornings in bed, their overindulgences at table followed by several rounds of drinks. The book opens with André's decision to leave his wife and take a place of his own, much to the delight of Cyprien, who remarks, "You'll work better now that you're free."[118] André agrees, recalling his wife's pouting objection to the time he spent at his desk. Huysmans – if less pointedly than the Goncourts – portrays the (male) artist's (female) spouse as an encumbrance, but gives indication that in André's case the wife is as much an excuse as a damper. The body of the novel concerns André's largely unsuccessful attempts to live and work on his own, and in the end he willingly sacrifices his freedom to write for reconciliation with his wife. Cyprien, too, gradually abandons his youthful enthusiasms and ideals, and decides to settle down with the fat, faded prostitute who coddles and amuses him.

In this undramatic account of two congenial dilettantes, Huysmans implies that serious artistic production and peaceful domesticity are at odds, for both protagonists choose the former at the expense of their work. On the other hand, one senses the author's good-humored dismissal of those whose commitment to art is so lackadaisical as André's and Cyprien's. As Cyprien concludes, "In the end, cohabitation is as good as marriage since both relieved us...of artistic preoccupations and carnal woes."[119] And when André asks him, "Well then, what about the pictures?" the painter shrugs off his former

ambitions and declares, "The pictures, who cares? Sometimes it's nice to muse on those you'll never make, in bed at night when you can't sleep!"[120] The pathos of a novel like *Braves gens* is completely foreign to this easygoing account of compromises made by dabblers in the arts.

Van Gogh apparently was fond of Huysmans's mildly depreciatory look at this sector of the Parisian art world; according to Emile Bernard, he had great admiration for the author and often spoke of *En ménage* as his favorite of Huysmans's books.[121] Moreover, in a letter to Bernard from Arles, Van Gogh – mulling on a picture he imagined himself painting – wrote, "When shall I paint my *starry sky*, that picture which preoccupies me continuously? Alas! alas! it is just as our excellent colleague Cyprien says in J. K. Huysmans's *En Ménage:* 'The most beautiful pictures are those one dreams about when smoking pipes in bed, but which one will never paint'" (B7).

It is tempting to suppose that Van Gogh knew Huysmans's *Croquis parisiens* as well, because that book, published in 1880, can be characterized as a series of word pictures. The descriptions included in sections entitled "Types de Paris" and "Paysages" seem particularly comparable to the urban subjects Van Gogh drew and painted at the French capital, and the more symbolist prose of "Natures mortes" (which foreshadows that of *A Rebours*) is emphatically painterly. Though Van Gogh never mentioned *Croquis parisiens* in his letters (he did not refer to *A Rebours* either), its availability is certain and its conformity to the artist's interests notable.

STILL LIFES WITH PARISIAN NOVELS

The most clear-cut painted indicators of Van Gogh's literary enthusiasms in Paris are three still lifes with books he made in this era. Though clearly linked to the *Still Life with Bible and French Novel* painted at Nuenen in 1885, these later still lifes (Plates 6–8) have little to do with the clash of old and new that is so much a part of their antecedent. Instead, dominated as they are by contemporary novels with bright paper bindings, the Parisian still lifes are frank celebrations of modern literature – and most specifically of Naturalism.[122] In addition to documenting his love of reading, the volumes in Van Gogh's still lifes, particularly those that are titled, surely carry more specific meanings as well, meanings that may derive from personal associations related to the books' names, their contents, and/or the circumstances under which they were read. Though A. M. Hammacher has cautioned scholars to avoid "overstressing the iconological elements" of Van Gogh's still lifes with books,[123] to ignore the possible implications of the volumes chosen is to underestimate the artist's sensitivity as a reader and to risk missing the paintings' subtler points.

The first of Van Gogh's Parisian still lifes with books (Plate 6) evidently

was made in the spring of 1887.[124] Painted on a small oval panel that once was the cover of a tea chest, it shows three novels compactly grouped on a cloth-draped surface. All are closed and legibly titled: Zola's *Au Bonheur des Dames*, Richepin's *Braves gens* (its subtitle, *Roman parisien*, is included), and Edmond de Goncourt's *La Fille Elisa* (which Van Gogh mistakenly attributed to "E. et J. Goncourt" – an indication that the motif was not strictly copied from a real volume). *Au Bonheur* has a red and brown binding that suggests a hardcover book; the other two volumes, stacked X-like in front of it, are bound in the yellow paper common to the era[125] and recall the battered copy of *La Joie de vivre* that Van Gogh included in his *Still Life with Bible and French Novel*. Though all three novels were recent works by contemporary authors, Zola's (like the Bible of the earlier picture) is in this painting set apart by color and placement; perhaps Van Gogh intended to cast it in the role of precursor. Zola's oeuvre was at the foundation of Van Gogh's Naturalist partisanship, and though *Au Bonheur des Dames* (1883) actually was published six years after *La Fille Elisa*, Van Gogh may have thought of it as a predecessor to Goncourt's novel,[126] for in terms of his personal experience, it was. He had read Zola's book within a year of its publication, long before he read *La Fille Elisa* and the recently published *Braves gens* (1886). It is perhaps pertinent to note as well that despite its date of publication, *Au Bonheur des Dames* – like all the Rougon-Macquart novels – is set in the Second Empire, which ended years before *La Fille Elisa* and *Braves gens* were written. Thus Van Gogh's personal perception of the books' chronology, rather than their actual dates of publication, may have influenced the composition of this still life.

The three books in the oval still life are not only Naturalist novels, but more specifically "romans parisiens" – novels written in and about Paris – and the most prominently displayed of them, *Braves gens*, is so labeled.[127] Their selection may have stemmed in part from the artist's wish to acknowledge his affection for the city he now inhabited. The fact that they are books written by three different authors, of three generations, documents Van Gogh's broadening knowledge of Naturalism, and perhaps a desire to allude to his own wider-ranging acquaintance with Naturalist fiction led him to include three such disparate examples of the genre. While *Au Bonheur des Dames* is a tale of bourgeois dreams come true, *Braves genes* explores the intellectual preoccupations and marginal existences of a bohemian under-class, and *La Fille Elisa* details the travails of a demimondaine. *Au Bonheur* is a modern success story with a happy ending; the hero not only advances his business but gets the girl. Its counterparts in this still life present, by contrast, the downside of Parisian life, portraying those who are victimized and ultimately defeated by the pressures of urban life and by inability to cope with their professions' demands.[128] Thus, Van Gogh's formal opposition

of the reddish brown volume and yellow paperbacks may also – or alternatively – have been prompted by their respective contents.

On a second oval panel, of identical origins and dimensions, Van Gogh painted a companion piece to the *Still Life with Three Novels* in the depiction of a basket filled with sprouting bulbs (Fig. 17). This pair of panels constitutes the first of several instances in his oeuvre in which books and plant life are conjoined[129] – apparently to express the energy, fecundity, and promise of renewal that the artist found in modern literature (see W1).[130] Toward the end of his life, Van Gogh suggested the symbolic linkage he perceived between books and growing things when he wrote:

I think that I still have it in my heart someday to paint a book shop with the front yellow and pink, in the evening, and the black passersby – it is such an essentially modern subject. Because it seems to the imagination such a rich source of light – say, there would be a subject that would go well between an olive grove and a wheat field, the sowing season of books and prints. I have a great longing to do it like a light in the midst of darkness. Yes, there is a way of seeing Paris beautiful. (LT615)

In this passage, the artist projected a radiant image of both physical and intellectual germination by invoking and allying the vitality he ascribed to trees, crops, and the modern novels that illuminated his existence.

The prevailing yellow tonality of his next painting with books (Plate 7) – which he retrospectively titled *Romans parisiens* – reflects Van Gogh's notion of literature as an elucidating force. Made in the second half of 1887, the painting seems awash with sunlight, and seventeen of its twenty-one books are golden yellow. In haphazard stacks of varied height, the yellow books encircle a pink- and a green-bound volume, the colors of which are echoed by an arrangement of rosebuds at the picture's outer edge. In the foreground, a thin blue book adjoins the still life's focal point: an open volume whose deep red binding offsets its light, bright pages. This open book, oriented toward the viewer, at first appears an invitation to read, but closer inspection reveals that the lines of its text are only summarily indicated, by green striations that complement the volume's red outline. Not a single word can be discerned here, or on the covers of the other, closed books (where Van Gogh made marks that suggest letters but remain illegible). But if the books' specific identities and contents remain indecipherable, we nonetheless know from the painting's title that these are Parisian novels – books written in, and presumably set in, the French capital. Though this designation allows for inclusion of authors like Balzac and Hugo, Van Gogh in 1887 probably was thinking primarily of the Naturalists,[131] whose books must have filled the shelves and tables of his brother's apartment. The massing of these multiple volumes for a single, sprawling still life indicates Van Gogh's pride and pleasure in his acquaintance with such books; they seem well-thumbed, familiar accoutrements of his daily life, and the picture is more

Figure 17. Van Gogh, *Still Life with Basket of Bulbs*, 1887.

exuberant than reverential. Varied brushstrokes create a complex, lively surface, and the play of complementary hues against the dominant yellow enhances its animate effect.

The recurrent appearance of modern paperbacks in late-nineteenth-century French paintings testifies to their ubiquity; two yellow volumes appear, for instance, in the grassy foreground of Seurat's *Sunday Afternoon on the Grande Jatte*, another may be seen atop the piano in Renoir's portrait of Catulle Mendes's daughters (1888),[132] and Paul Signac made still lifes with paperbound books by the mid-1880s (see Fig. 18). Though Hammacher suggests that Signac's pictures – by virtue of chronological primacy – influenced Van Gogh's still lifes with books,[133] both artists were in fact responding to a contemporary phenomenon – the proliferation of paperbound volumes – as well as adding to a long-standing tradition of book paintings.[134] Van Gogh's *Still Life with Bible and French Novel* was made in Holland, before the two artists met, and was itself descended from an established typos. Thus Signac's paintings – if they affected Van Gogh's work at all – must simply have affirmed a choice the Dutch artist had made previously and independently. Moreover, while Signac's paintings feature single volumes in the company of unlike objects,[135] Van Gogh in his Parisian book pictures grouped multiple volumes that interact visually and conceptually.

The crowded assemblage of Van Gogh's *Romans parisiens* in fact finds closer counterpart in a verbal rendering, a passage from *En ménage* (one of the very "romans parisiens" that Van Gogh had recently read). The protagonist of Huysmans's novel, André Sayant, is a reader of Van Gogh's stripe ("he sought relief from his worries in books"),[136] and his library comprises a similarly large and colorful array of volumes, which he lovingly peruses and proudly appraises. Musing on his books' varied bindings, he ascribes personalities to specific types and, like Van Gogh, seems to delight in their number. Moreover, Huysmans in *En ménage* portrays modern novels as sources of uproarious firepower, lively legions destined to outgun their staid predecessors (cf. Van Gogh's *Still Life with Bible and French Novel*). In the book's fifth chapter, he imagines armed conflict between old and new – the leatherbounds and the paperbacks – staged in

a large bookcase where, marshaled for battle, an army of paperbacks, canary yellow and oxblood, launched explosives, obliterating with their artificial sunlight the quiet volumes: the sad and circumspect La Villières, the severe Jansénistes,[137] without lace or golden trim, the commonplace bindings like sweet but mischievous schoolchildren, prim in their blue or gray linen smocks, the melancholy bindings with a bourgeois and pedantic look; on the left, from another, smaller bookcase . . . two files of volumes tumultuously marching, calling to arms, the yellow uniforms of the Charpentier publishing house, the red tunics of Hachette's foreign legion. (*En ménage*, chap. V)[138]

The interactive relationships unfurled here – fanciful as they may be – bear comparison to those suggested in Van Gogh's multivolume still lifes. The conflictual aspect of Huysmans's passage, however – which is lacking in *Romans parisiens* and only hinted in *Three Novels* – finds clearer parallel in the dialectics of Van Gogh's two-volume works, that is, in both the previously mentioned *Still Life with Bible and French Novel* and in the third and seemingly most complex of the book pictures Van Gogh made in Paris, the *Still Life with Plaster Cast* (Plate 8). In the latter, however, conflict is not generational, but founded in contemporaneous but opposed outlooks.

Painted near the end of his stay in Paris (in the winter of 1887–8), the *Still Life with Plaster Cast* includes two novels Van Gogh read at the capital; closed and clearly titled (though one overlaps the other), they are *Germinie Lacerteux*, bound in yellow, and *Bel-Ami*, bound in sky blue. Equally prominent is the plaster cast of a female nude, which looms above them. Two pink rosebuds, freshly clipped, occupy the lower left corner of the unsettlingly steep surface on which the still life is arranged; it is covered with an unevenly draped, pale yellow cloth that is sharply offset by the deep blue background. The books, centered between the roses and the cast, are further highlighted by their placement on a second layer of cloth (or paper), which is white.

The *Still Life with Plaster Cast* is a study in contrast, both formal and

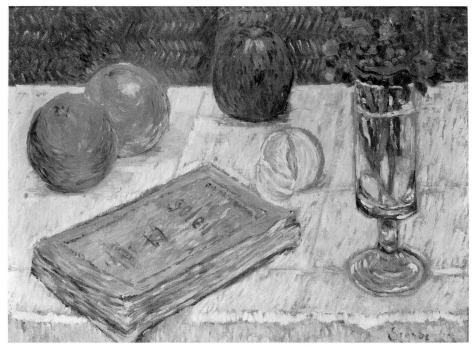

Figure 18. Paul Signac, *Still Life with Maupassant's* [Au] Soleil, 1885.

conceptual. The books at its center seem to be carefully chosen opposites –
each of which Van Gogh especially admired as a model of its type.[139] As
dissimilar yet complementary as the colors of their respective bindings, one
is a modern exemplar of the tragic mode, the other of the comic. Van Gogh
praised *Germinie Lacerteux* for its effective portrayal of despair, whereas
Bel-Ami was a novel that made him laugh. Equally evident is a binarism of
gender: *Germinie Lacerteux* is an exploration of female sensibility, *Bel-Ami*
a picaresque celebration of stereotypic male behavior in both business and
romance. Georges Duroy is a charming and manipulative seducer who ex-
ploits his attractiveness to women, whereas Germinie Lacerteux is an un-
attractive spinster whose desperate desire for love makes her susceptible to
just such a man – in her case, a younger lover who encourages her to go
into debt to provide for him, then abandons the pregnant Germinie for a
woman of his own age. Indeed, the histories of Georges and Germinie might
be seen as two sides of an age-old narrative. Finally, issues of class inform
this comparison, for whereas Duroy uses his innate charisma to transcend
his origins and marry into the aristocracy, the initially respectable Germinie
– employed by a woman of noble descent – embarks on a process of gradual
but relentless degradation and ends in a pauper's grave.

The objects that flank the books of this still life seem to contribute to the
picture's effect of tension. The pink buds – immature blossoms of delicate
form and hue – suggest the innocence of youth and – in their closure – might

also be seen as emblems of chastity. The strongly brushed contours of the full-bodied nude statuette are, on the other hand, evocative of carnality and fecundity. The cut rosebuds are appropriately nearer the Goncourts' volume, which addresses the unfulfilled longings of spinsterhood and the naïveté of its love-starved heroine, whereas the cast stands on the side of *Bel-Ami*, the worldly protagonist of which is a knowing connoisseur of the female form. Van Gogh's own allegiances probably were torn; though he pitied Germinie and likely identified with her botched attempts at romance, he was in awe of Maupassant's easygoing, womanizing hero and wished he could be more like him. Whether he intended it or not, the artist's opposed impulses – empathy for Germinie but a longing to emulate Georges – seem to make themselves felt in the precarious balance of this odd arrangement.

The cast Van Gogh included here was one he often drew from in Paris. Though he had recoiled from using such plaster models in his first years as an artist (see LT189), Van Gogh became accustomed to drawing them at the academy in Antwerp, and in January 1886 he wrote, "I, who for years had not seen any good plaster casts of ancient sculptures . . . and who during all these years have always had the living model before me, on looking at [casts] carefully again, I am amazed at the ancients' wonderful knowledge and the correctness of their sentiment" (LT445). "The ancients," he wrote, "certainly require a great serenity, knowledge of nature . . . tenderness and patience, otherwise they are of no help" (LT448).

It is perhaps no mere coincidence that Van Gogh's reverent remarks on antique fragments were written in the same month that Maupassant's similarly emotive response to an ancient statue, "Sur une Vénus," was published in *Gil Blas*. This article – a reaction to the *Syracuse Venus* (Fig. 19), which Maupassant had recently seen – reads in part:

> She has no head at all, she's missing an arm; but never has the human form seemed to me more admirable and more troubling.
>
> This is not at all woman poeticized, woman idealized, woman as divine or majestic like the Venus de Milo; it is woman as she is, the way you love her, the way you desire her, the way you want to embrace her.
>
> She's fat, with a full bosom, powerful hips, and somewhat heavy legs; this is a carnal Venus whom you imagine lying down as you see her standing.
>
> . . . A work of art is not superior unless it is at once a symbol and the exact expression of a reality.
>
> The Syracuse Venus is a woman, and it is at the same time the symbol of flesh.
>
> . . . She has no head!
>
> What does it matter? The symbol becomes more complete that way. It's a woman's body, nothing but a woman's body that expresses all the genuine poetry of the caress.[140]

According to Maupassant, the statue's incompleteness does not impair its effect, but rather enhances it. Though the body's heaviness suggests the flesh

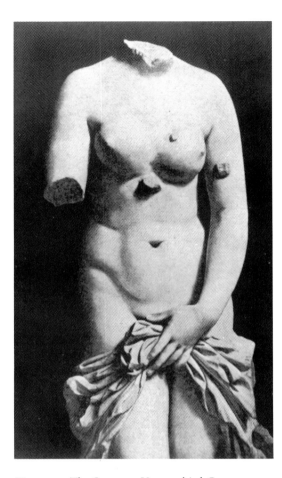

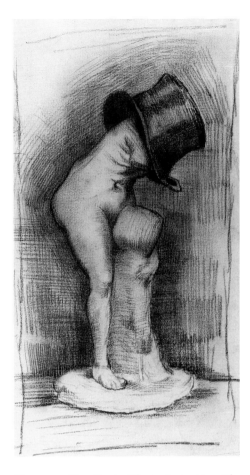

Figure 19. The Syracuse Venus, third Century B.C. Artist unknown.

Figure 20. Van Gogh, *Plaster Statuette with Top Hat,* 1886.

of a real woman, its lack of a head/face removes any possibility of individualization; without it, the Venus is easily seen as a type, an ideal, the emblematic (and readily fetishized) female form.

We know that Van Gogh sometimes read *Gil Blas* at Antwerp, for his letters refer to its concurrent serialization of *L'Oeuvre.*[141] If he read Maupassant's piece, he probably related it to his own contemporaneous study of ancient sculpture, for the author's remarks have much in common with Van Gogh's own recorded views. According to fellow students at the Antwerp Academy, for instance, Van Gogh, when instructed to draw from a cast of the Venus de Milo, scandalized the drawing master by exaggerating the figure's hips and pevis. Apparently he – like Maupassant – found that Venus too "poeticized" and preferred "woman as she is," "a carnal Venus." When chided for amplifying the lower torso of his drawn Venus, Van Gogh reportedly countered that "a woman must have hips and buttocks and a pelvis in which she can hold a child!"[142]

Van Gogh continued to work from plaster casts in Paris (he seems to have had a small collection of them), and there, too, he often distorted the model to suit himself. His Parisian drawings of casts of females are sometimes playful as well; for one small chalk study he perched a silk top hat on a nude statuette to create a cavalier, jesting mood one rarely encounters in his oeuvre (Fig. 20). Among the casts he drew regularly was the nude eventually included in the *Still Life with Plaster Cast;* his other renderings of this figure betray a recurrent desire to expand the figure's hips and thighs (Figs. 21, 22) and amplify its sexual connotations. (For instance, in one drawing [Fig. 22], he added pubic hair and emphatically marked the figure's nipples with sharp, dark jabs.)[143] The reformulations sought in these drawings can again be compared to Maupassant's published preference for plumpness – "powerful hips and somewhat heavy legs" – and it seems quite possible that Maupassant's essay influenced, or at least supported, Van Gogh's revisionist classicism. In the context of the painted still life, the plaster cast can be seen to represent Van Gogh's full-figured female ideal, and as such, it seems a fitting accompaniment to Maupassant's tale of seduction – whether or not Van Gogh knew of the author's tribute to the *Syracuse Venus.* On the other hand, Van Gogh's possible acquaintance with that article encourages speculation that the statuette that flanks *Bel-Ami* is also an acknowledgment of the artist's and writer's shared views on the female form and interest in its traditionalist versus realist interpretation – in literature as well as in art.[144]

CITY AND SUBURBAN VIEWS

Though their specific impact is hard to trace with certainty, Van Gogh's collection of *romans parisiens* doubtless affected the way he saw Paris and, hence, the city views he painted there. From the time of his arrival, he roamed the streets of Paris in pursuit of subject matter,[145] much as fictional counterparts like Zola's Claude Lantier (*Le Ventre de Paris, L'Oeuvre*) and Huysmans's Cyprien (*En ménage*) are said to do. As Welsh-Ovcharov has noted, Van Gogh in Paris drew and painted many of the sites Naturalist authors describe in their novels, but since his portrayals of street life tend to be random and nonanecdotal glimpses of people and places, most do not lend themselves readily to linkage with specific passages.[146] On the other hand, their seemingly candid presentation of working-class milieux observed on the spot justify his pictures' designation as Naturalist, and certain of Van Gogh's urban vistas are elucidated by general comparison with similar images in fiction the artist is known to have read.[147]

Perhaps the most obvious comparisons of paintings and prose can be made between Van Gogh's and Zola's Parisian panoramas. Fairly early in his stay (in the first half of 1886) the artist made a series of drawings and paintings

Figure 21. Van Gogh, *Plaster Statuette*, 1886.

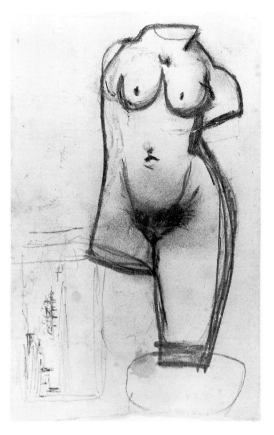

Figure 22. Van Gogh, *Plaster Statuette*, 1886.

of the Parisian skyline as seen from afar, from the elevated vantage point afforded by his Montmartre neighborhood (Fig. 23). Van Gogh's nephew, Dr. V. W. van Gogh, later connected these broad views to the sweeping descriptions of Paris that the painter so admired in Zola's *Une Page d'a-mour*,[148] detailed vistas that take up one-fifth of the novel[149] and that likewise are presented from a viewpoint above the city (though Zola views Paris from its western, rather than northern, periphery). Van Gogh almost certainly recalled Zola's "superbly painted or drawn" (LT212) verbal renderings when he painted the city from Montmartre; a letter written by Theo in the summer of 1887 suggests that the brothers considered their spectacular view a real-life counterpart to the one Zola had described. To a Dutch friend Theo wrote:

As you may know I am now living with my brother Vincent, who is studying the art of painting with indefatigable zeal. As he requires rather a lot of space for his work, we are living in a rather big apartment in Montmartre, which is, as you know,

a suburb of Paris, built on the slope of a hill. The remarkable thing about our dwelling is that one has a magnificent view of the whole town from its windows, with the hills of Meudon, St. Cloud and so on on the horizon, and over it an expanse of sky nearly as large as when one is standing on the top of a dune.

With the different effects produced by the various changes in the sky it is a subject for I don't know how many pictures, and if you saw it you would probably add that it might furnish a subject for poetry too.

A description of a view of this character, though taken from another spot, is to be found in Zola's *Une Page d'amour*, which you may have read.[150]

Though painted precedents for Van Gogh's views exist – for instance, in the work of Daubigny[151] – Van Gogh probably was especially excited to find passages from *Une Page d'amour* materialize before his eyes in his new home and eager to connect his paintings to so recent and illustrious a literary counterpart.

Van Gogh did very little work in the heart of Paris and probably consciously avoided its chic quarters. Instead, he aimed to capture street life in the suburbs, particularly in Montmartre and the semirural region north of his own neighborhood, on the other side of the Butte. This odd terrain at the edge of Paris, neither city nor country, was known as the *banlieue*. It had long fascinated writers (Victor Hugo described it in the 1861 edition of *Les Misérables*, which Van Gogh had read),[152] and in the 1880s several painters, including the Neo-Impressionists and Jean-François Raffaëlli, were drawn to the area.[153] Van Gogh worked there often, and as he did he probably compared what he saw and painted with the written descriptions of the area that abound in Naturalist prose.

Some novelists focused on the desolation of the *banlieue*, and when, for instance, Daudet's pathetic dupe Risler chooses the quarries near the ramparts as the site of his suicide, the locale seems appropriate: "Suicides are not rare in Paris, especially in this vicinity.... Not a day goes by without a corpse being lifted onto this long line of fortifications, as onto the shore of a dangerous sea."[154] And though Cyprien, the artist protagonist of Huysmans's *En ménage*, "acknowledge[s] exultant joy when sitting on the slope of the ramparts," the site nonetheless gives him a "disquieting sense of suffering and distress."[155] Looking out on this landscape with the alert eye of a slumming *flâneur*, Cyprien finds its mournfulness suited to its pitiful habitués:

In this countryside whose ravaged skin caves in on itself like hideous scabs, in these flayed roadways where trails of plaster seem like meal loosed from a sickly skin, he saw a plaintive harmony with the sufferings of the poor wretch coming back from the factory, exhausted, sweating, bruised, stumbling on the rubbish, slipping in the ruts, dragging his feet, choked by fits of coughing, bent beneath the lashing of the rain, under the whip of the wind.[156]

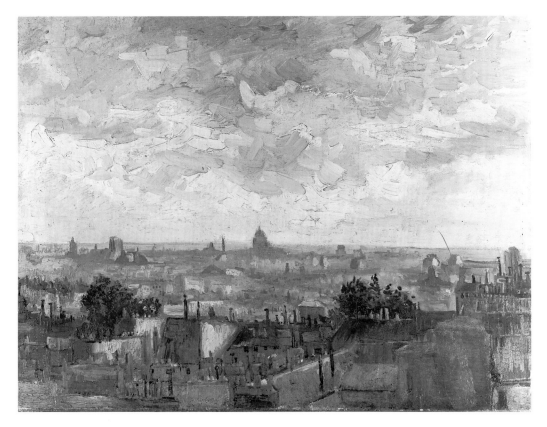

Figure 23. Van Gogh, *The Roofs of Paris,* 1886.

Cyprien views the *banlieue* as the "leper colony of nature" and is convinced that its deadening influence on those consigned to it exacerbates the "incurable evils engendered by drink and famine."[157]

On the other hand, for beleaguered urbanites with little time and money for leisure, the same squalid area could provide a sense of escape. Gervaise, the laundress of Zola's *L'Assommoir,* is delighted to walk to the outskirts of Paris with her idealistic beau Goujet, regarding the excursion as a day in the country. Zola describes the *banlieue* as a "vague terrain," where "between a sawmill and a button factory" one could still find a "strip of green meadow,"[158] and he evokes the workers' affectionate attitude toward this suburban hodgepodge:

In front of them the Butte Montmartre held tiers of high gray and yellow houses, amid clumps of meager greenery; and when they tilted their heads back they saw a vast sky of searing purity above the town, cut by a flock of little white clouds to the north. But the vibrant light blinded them, and they looked, at the level of the flat horizon, to the chalky-looking far-off suburbs, and they followed in particular the panting of the thin chimney of the sawmill, which blew out jets of steam. These great sighs seemed to ease their heavy hearts.

... They lost themselves in the distance, on the wan slope of Montmartre, amid the lofty forest of factory chimneys making stripes on the horizon, in this chalky and desolate *banlieue* where the green thickets of sleazy cabarets moved them to tears. (*L'Assommoir*, chap. VIII)[159]

When Germinie Lacerteux strolls to the *banlieue* with her beloved, the Goncourts record the apparently standard itinerary for lowbrow Sunday promenading: down the northern slope of the Butte, across the ramparts, and into the fields beyond.

Then commenced that which comes where Paris ends, that which grows where grass doesn't, one of those arid landscapes that large cities create around themselves, that first zone of the *intra muros banlieue* where nature is dried up, the earth used up, the countryside sown with oyster shells.

... People were always coming and going. The road was alive, and amused the eye.... Everyone went along peacefully, blissfully, at a purposely lagging pace, with the cheerful waddle and happy laziness of the promenade. Nobody hurried, and on the completely flat horizon line, spanned from time to time by the white smoke of a railway train, groups of strollers made black, almost motionless spots in the distance. (*Germinie Lacerteux*, chap. XII)[160]

Van Gogh's many images of the *banlieue* capture both its desolate and pleasurable aspects – everyday scenes from the workweek as well as the spectacle of Sunday strollers. During his first year in Paris, he made a series of views of the Montmartre quarries, with the Butte and its windmills in the background adding quaint charm. Drably colored and sparsely populated, the area seems dank but tranquil, a place of solitary labor (Fig. 24) and covert assignations (Fig. 25). Another picture from the same era shows a different vista: the almost unrelieved flatness of the fields beyond Montmartre, where a sodden roadway marked by a single, displaced-looking streetlamp seems to mark the outer reaches of urban sprawl (Fig. 26). Though enlivened by scattered indications of vegetation, the St. Denis plain looks generally forlorn, from murky ground to leaden sky. Traversing the foreground on varied trajectories are a man alone, a working-class couple, and a woman with two small children in tow; though the latter especially suggest casual exploration, their destinations within this largely unarticulated terrain are hard to imagine.[161]

Van Gogh's work of the following year, 1887, includes views of Montmartre gardens in which a brighter palette and broken, quasi-pointillist brushwork suggest the alluring sparkle of springtime outside the city (Fig. 27). Later that year, he depicted towering sunflowers in the same area; in one of these pictures (Fig. 28), a woman surveys her small property. Works like these probably were those Emile Bernard referred to when he later recalled, "It was while reading [Zola] that Vincent thought of painting the humble shanties of Montmartre where the lower middle classes come to

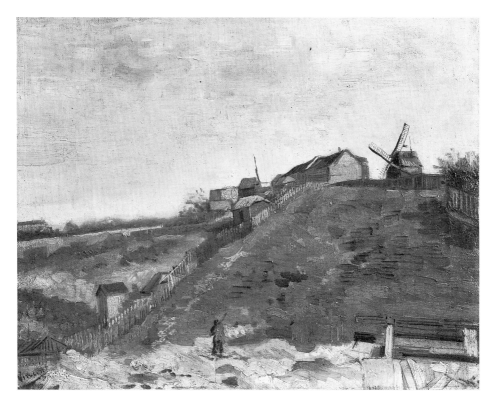

Figure 24. Van Gogh, *Hill of Montmartre with Quarry*, 1886.

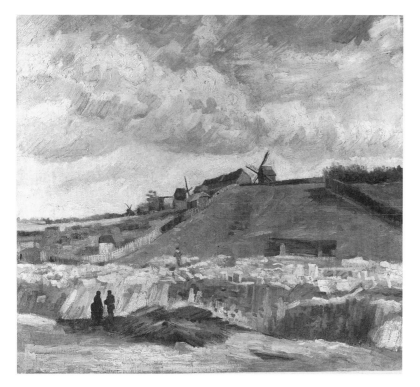

Figure 25. Van Gogh, *Hill of Montmartre with Quarry*, 1886.

Figure 26. Van Gogh, *A Suburb of Paris*, 1886.

cultivate their tiny pieces of sand in the early morning sun."[162] It was also in the warmer months of 1887 that Van Gogh made brightly hued images of the ramparts and their diverse aficionados (Fig. 29), and Welsh-Ovcharov surely is correct in suggesting that memories of *Germinie Lacerteux* resurfaced as he did so.[163] The pertinent passage from that novel includes these lines:

At the fortifications ... [Germinie] ran to sit with Joupillon on the slope. Next to her were masses of families, workers lying flat on their stomachs, small investors looking at the horizons with field glasses, philosophers of misery, propped against the wall with two hands on their knees, the suits greasy with age, the black hats rusty as their red beards. ... She had a multicolored crowd before her eyes, white blouses, the blue pinafores of running children. ... Then, beyond them, in a haze, in a bluish fog, a line of treetops outlined a road. (*Germinie Lacerteux*, chap. XII)[164]

Another, very different scene from *Germinie Lacerteux* undoubtedly inspired Van Gogh's depictions of *la fosse commune*, an indigents' graveyard near Montmartre (Fig. 30). The novel concludes with Germinie's burial there,

Figure 27. Van Gogh,
The Gardens of
Montmartre, 1887.

Figure 28. Van Gogh,
Sunflowers in a
Montmartre Garden,
1887.

Figure 29. Van Gogh, *The Ramparts*, 1887.

Figure 30. Van Gogh, *La Fosse commune*, 1886.

Figure 31 (*above*). Van Gogh, *Couple Walking beside Sunflowers*, 1887.

Figure 32 (*right*). Van Gogh, *Walking Couple*, 1886.

Figure 33. Van Gogh, *Public Garden, Asnières*, 1887.

where her former employer mourns her amid dozens of makeshift crosses. Welsh-Ovcharov notes that an etching of *la fosse commune* – after a watercolor by Jules de Goncourt – served as the frontispiece to the edition of the book that Van Gogh probably owned;[165] its vantage point and composition (particularly the disposition of the crosses) is quite similar to Van Gogh's rendering (of which two nearly identical versions exist). His interest in the Goncourts' novel may have led Van Gogh to seek out the graveyard, and certainly the novel's concluding passages – as well as the etching itself – shaped his perception and representations of the subject.

A final class of Parisian image that may be allied to Van Gogh's reader's-eye view of the capital is that depicting urban couples who woo in the out-of-doors. Many Naturalist novels describe the proletariat's lack of privacy – let alone romance – in their cramped, prosaic quarters and note that lower-class urban lovers (especially those engaged in illicit affairs) often are obliged to create a patch of their own in a public space in order to court in peace and passable seclusion. It is to this end that Gervaise Coupeau and Germinie Lacerteux lead the objects of their desire to the very edge of Paris, and the soldier beloved by Goncourt's *fille* Elisa takes her to an abandoned graveyard in the Bois de Boulogne in the hope of seducing her (and is murdered by her there instead). *L'Oeuvre*'s Claude Lantier and his lover, Christine, discover a secluded arbor at the tip of the Ile St.-Louis; underscoring the importance of this small piece of verdure, Zola writes:

It was a delicious refuge, an asylum amid the crowds, Paris growling all around, on the quais, on the bridges, while they savored the joy of being alone at the water's edge, unbeknownst to anyone. Since then, this steep river bank was their corner of the countryside, the land of open air where they enjoyed hours of sunshine. (*L'Oeuvre*, chap. IV)[166]

Van Gogh's Paris oeuvre includes many images of couples embracing amid trees and bushes or walking arm in arm in the city's parks or suburbs (see Figs. 25, 31–33), and it is likely that the stories of star-crossed lovers that filled his bookshelves fueled his imagination as he dotted landscapes with affectionate pairs. These urban lovers establish the motif of couples in nature that recurred – albeit in more idyllic surroundings – in Van Gogh's work at Arles, St.-Rémy, and Auvers-sur-Oise.

Despite his fascination with Parisian culture, Van Gogh contemplated leaving the capital almost as soon as he arrived. Within months of settling into Montmartre he wrote of his decision to move on (LT459a), and the longer he stayed in the city the more convinced he became of its debilitating effects. Novels like *L'Oeuvre* and *Braves gens* probably served to confirm his sense of the dangerously debauched and demoralizing turns that artistic life in

Paris could take, and he left the city with relief in February 1888, traveling south to Arles. There, his interest in Naturalism continued, though its focus shifted in response to his rural surroundings. Never again would the *romans parisiens* he read and cherished in Paris be so important to him – and so pertinent to his work – as they were during his residence in the city of their genesis.

5

A BEL-AMI OF THE MIDI IN THE LAND OF TARTARIN

Chapter XLVII of the Goncourt brothers' *Manette Salomon* opens with a disparaging glimpse of Parisian winter: "Gray fills the low, flat sky, without a glimmer, without a gap of blue. A gray sadness floats in the air. . . . A cold light, which seems to be filtered through old net curtains, throws its dirty yellow brightness onto indistinct things and forms. Colors slumber as if in the shade of the past and under the veil of fadedness."[1] Anxious to escape this overwhelming drabness, Coriolis, the book's artist protagonist, takes visual refuge in the world conjured by his albums of Japanese prints, their "pages like ivory palettes charged with the colors of the Orient."[2] He is soon transported.

A day from fairyland, a day without shadow that is nothing but light, arose before him from those albums. . . . He lost himself in that azure where the pink blossoms of the trees drowned themselves, in that blue enamel serving as a mount for the snowy flowers of peach trees and almond trees, in those great crimson sunsets. . . . The winter, the grayness of the day, the poor shivering Paris sky – he fled them and forgot them beside those seas as limpid as the sky. . . . He forgot them in those fields of lapis rocks, in that greenness of plants with damp stalks, near those bamboo trees, those efflorescent hedges that make a wall from great bouquets. (*Manette Salomon*, chap. XLVII)[3]

This lavish evocation of the mental transport Japanese prints afforded artistic sensibilities withered by dreary weather in a European capital reflected the Goncourts' own experiences as collectors and must have sparked recognition among many of their readers, including Van Gogh. During his stay in Paris, he had added substantially to the portfolio of woodcuts he began to build at Antwerp, and his study of Japanese graphic arts not only left its marks in his work,[4] but inspired his dream of life in the Far East – a dream that mutated into a desire to move to the South of France. Concern for his health, coupled with nostalgia for country life, contributed to Van

Gogh's generalized desire to retreat to a rural region, but it was his profound enthusiasm for things Japanese that propelled him more particularly toward sunny climes (LT500). If the forty-seventh chapter of *Manette Salomon* cannot be considered a specific impetus for his southward migration,[5] Van Gogh's relocation to Provence may nonetheless be seen as a sustained physical actualization of the same sort of escape Coriolis effected only briefly and conceptually before his albums. Van Gogh would have recognized (indeed, may have recognized) the parallel, for the motivating force behind their respective journeys was much the same: a keen yearning to inhabit the world delineated by Japanese prints.

Oddly enough, Van Gogh left Paris in the hope of finding Japan – or, more realistically, a French variant thereof. "We like Japanese painting," he wrote. "We have felt its influence, all the impressionists have that in common; then why not go to Japan, that is to say to the equivalent of Japan, the South?" (LT500). The Midi, as imaged by authors like Zola and Daudet and the Marseillais artist Adolphe Monticelli,[6] struck him as a potentially satisfying surrogate for the land of the woodcuts: a "new country" (LT463) of bright hues, lush landscapes, flowering fruit trees, and colorful types and costumes. By his own account, Van Gogh journeyed south "wishing to see a different light, thinking that looking at nature under a bright sky might give us a better idea of the Japanese way of feeling and drawing" (LT605), and as the train took him toward his destination, he "peered out to see whether it was like Japan yet! Childish, wasn't it?" (B22). However juvenile or eccentric, this desire colored his vision, and within months of settling at Arles, Van Gogh rejoiced (in a letter to his sister): "I don't need Japanese pictures here, for I am always telling myself *that here I am in Japan*" (W7; his emphasis).[7]

His fifteen months in Arles were spent in a frenzy of work that yielded more than one hundred drawings and close to two hundred paintings. Van Gogh relished the southern environment, spent a good deal of time working outdoors, and seems consequently to have done less reading than he had in Paris. Nonetheless, literature was often on his mind, and he frequently discussed it in his letters – to Theo, his sister Wil, and his friend Emile Bernard – and in conversations with colleagues and acquaintances at Arles, including the Danish artist Mourier Petersen, who also read the Naturalists (LT469); a soldier friend named Milliet, who apparently balked at Van Gogh's attempts to reshape his literary regimen (LT541a); Gauguin, who recalled Van Gogh's obsession with literature in *Avant et après;*[8] and Paul Signac, who later remembered that he and Van Gogh discussed books when they met in the South.[9]

Though Van Gogh's reading habits changed somewhat at Arles, the appraisals he formulated in Holland and Paris remained intact. He continued

to believe that "in literature the French are irrefutably the masters" (W4), and among French writers he favored the Naturalists. Declaring Balzac "a bit out of date" in the late 1880s (LT530), Van Gogh championed his Naturalist successors, reasoning, "Didn't the Flauberts and Balzacs make the Zolas and Maupassants?" (LT525). In letters from the Midi he lauded the Naturalists' daring (LT525), their modernity (LT607), their "great richness and...great gaiety" (W3), and in September 1888 he reiterated the advice he had given his sister a year before: "Read Zola, de Maupassant, de Goncourt as completely as possible in order to get something of a clear insight into the modern novel" (W7).

READINGS AT ARLES

Having already made himself familiar with the recent literature he considered most important, Van Gogh read only about one book per month during most of his time at Arles. (After his nervous collapse in December 1888, his reading became more sporadic.) Though he continued to read and reread works by his favorite authors, Van Gogh – who in Paris mastered substantial portions of the Naturalists' oeuvre – looked once more to authors whose work he had yet to read, including some outside the Naturalist circle. Depictions of urban life seem to have interested him less now than they had in Paris, and at Arles he made frequent reference to books devoted to adventure and travel.

Though Van Gogh's actual reading of Zola had fallen off considerably since 1885, that author continued to occupy his thoughts, and in May 1888 – perhaps because he had read all of Zola's recently published novels – Van Gogh returned to *Au Bonheur de Dames,* a book both he and Theo had found particularly absorbing when they read it in 1884. From Arles he told his brother that that novel "seems to me more beautiful than ever" (LT482), and he was gratified to learn, later that year, that their sister was reading it, too. "It is a very good thing," he told her, "you have at last started to read *Au bonheur des dames,* and so on. There are a lot of things in it – as in Guy de Maupassant too, for that matter" (W9).

In the fall of 1888 Van Gogh read Zola's newly published novel, *Le Rêve,* a fairy-talelike love story set in the medieval center of a small town. Its beautiful young protagonists – artisans absorbed in the Middle Ages – court in the shadow of an imposing Gothic cathedral and marry at its altar, but their story ends in melodramatic tragedy as the bride collapses and dies on the steps of the church. The delicacy, idealization, and preciousness of *Le Rêve* are atypical of Zola's Naturalist oeuvre, and this novel seems the least integrated of the Rougon-Macquart series, but without commenting on the book's story line, Van Gogh focused on the author's technique, highlighting

visual effects. He "thought the figure of the woman...very, very beautiful," but complained that "the figure of the man did not seem very lifelike" (LT593). Ever attentive to the imagistic aspects of Zola's prose, Van Gogh noted that though the dark, looming mass of the great cathedral seemed depressing, it was in fact an effective foil for the book's pale heroine. "That contrast of [the cathedral's] lilac and blue-black," he acknowledged, "did ...make the blonde figure stand out" (LT593).[10] He also was intrigued by Zola's "description of the embroidery all in gold, just because it is, as it were, a question of the color of the different yellows in whole and broken tones" (LT593). Van Gogh doubtless allied this careful verbalization of subtle color shifts[11] to his own recent efforts to explore gradations of yellow in the palettes devised for his series of sunflower paintings (see LT526, LT573, B15). Thus in this, the last Zola novel he would read, Van Gogh found the author's word painting – the feature that initially won his praise when he read Zola in Holland in the early 1880s (LT212) – still remarkable and compelling.

He read nothing new by the Goncourts at Arles,[12] presumably because Edmond de Goncourt had ceased to publish fiction; consequently, Van Gogh's impression of the brothers' oeuvre was more or less fixed at the time he left Paris. His sense of Daudet's work, by contrast, changed considerably as he became increasingly enamored of the jovial Tartarin saga. The first book Van Gogh read at Arles was *Tartarin sur les Alpes*, a sequel published thirteen years after *Tartarin de Tarascon*. Written as a convenient money-maker,[13] *Tartarin sur les Alpes* is a spoof on the pan-European mountain-climbing craze of the 1880s and the spate of Alpine clubs fostered by the vogue. It recounts the founding of such a club at Tarascon and Tartarin's election to its presidency. Under the auspices of his club, Tartarin P.C.A. (i.e., president of the Club des Alpines) journeys to Switzerland to plant their flag atop the Jungfrau. Like its predecessor, this novel is a comedy of errors with a bumbling hero at its center, and Van Gogh found it "hugely" amusing (LT467).

Attuned to the jollity of the author's potboiler, Van Gogh was less favorably disposed toward the other Daudet novel he read at Arles, *L'Immortel*. A scathing attack on the French Academy, this is a work of spleen in which Daudet vents his anger at that venerable and conservative institution.[14] While Van Gogh may well have empathized with the author's descriptions of artistic life in Paris and the petty standards by which works were often judged, the book's bitter tone and distressing content left him longing for escapist literature:

I find [*L'Immortel*] *very beautiful*, but not particularly heartening. I think I shall have to read a book on elephant hunting, or of absolute lies about adventures which are categorically impossible...to get rid of the heartbreak that [it] is going to leave

me with. It is exactly because it is so beautiful and so true that it makes you feel the emptiness of the civilized world. (LT530)

Having removed himself, to some degree, from the "civilized world" of the French capital, Van Gogh in the South was eager for fantasy and adventure. He decided that *L'Immortel*'s "mass of true and subtle observations" made it "dreary" and concluded that it "is not so fine in color as *Tartarin*... [which] is *really great*, with the greatness of a masterpiece, just like *Candide*" (LT531).

Like the Tartarin novels, Voltaire's *Candide* (1758) is a tongue-in-cheek adventure story in which the hero triumphs against all odds, his misfortunes exaggerated to the point of ludicrousness. Subtitled *Optimism*, *Candide* is at once a meditation on human suffering and an attack on the doctrine of optimism current in Voltaire's time. Optimist philosophy held that our world is the best world, its realities essentially good, and that which is perceived as "evil" (e.g., a devastating earthquake) is actually an essential part of some larger and ultimately positive plan. Written in a deceptively simple prose style, *Candide* criticizes the optimists' indifference to human miseries they regard from a distance. Though Van Gogh seems to have misjudged the author's intent, he was nonetheless taken with the book, which he had read in Paris (or possibly before; see LT460). *Candide* is one of the novels most often mentioned in his letters from Arles (see LT481, LT506, LT518, LT549, LT566, LT574, LT585, LT588, LT590, W2, W11), and Pangloss, Voltaire's fictional rendering of an optimist philosopher (considered the epitome of callousness by some critics),[15] was regarded fondly by Van Gogh. The artist seems to have taken that character's optimist maxim – "All is for the best in the best of all possible worlds" – at face value and evidently considered the phrase an admirably stoic expression of realistic resignation. It often was his watchword during difficult times at Arles. Indeed, Van Gogh's references to the philosopher and his motto are so numerous and so casual that the unsuspecting reader of his letters might easily assume that "good old Pangloss" (LT549) was just another Arlesian acquaintance.

Another novelist whose humor Van Gogh vaunted from Arles was Guy de Maupassant; he continued to find the wry tone of the author's short stories and the rakish aura of Bel-Ami particularly appealing. The Maupassant novella he read at Arles, *Pierre et Jean* (1888),[16] is a dispirited account of deception and its price, and Van Gogh must have considered it anomalous to the writer's typically "lighthearted" (LT482) output. A tangled tale involving the disclosure of a heretofore unsuspected paternity, *Pierre et Jean* chronicles the rift that revelation causes between two half brothers on the brink of manhood. Conceding that the story "does not end in happiness,"

Van Gogh pointed out that its characters nonetheless "are resigned and go on in spite of everything" (LT555); a few days later he noted that one of the things that most recommended Maupassant's work was the writer's "absolute insistence" on a "great richness and a great gaiety in art" even when writing of the "most poignantly tragic things" (W3; Van Gogh wrote that the same was true of Zola).

He also was impressed by the now-famous preface of *Pierre et Jean,* wherein the author calls for an inclusive rather than hidebound definition of the designation "novel,"[17] demanding open-mindedness from critics and audiences and advocating audacity on the part of writers. Rejecting preconceived rules and absolutes as detrimental to the author's creation and the reader's experience of new books, Maupassant urges acknowledgment of individual temperament and of the inevitably idiosyncratic nature of perception and artistic practice. "Each of us," he writes, "simply makes himself an illusion of the world...according to his nature....The great artists are those who impose their particular illusion upon humanity."[18] Many of his assertions recall Zola's criticism and practice, and indeed Maupassant writes,

All writers, Victor Hugo as well as Zola, have persistently claimed the absolute right, the unquestionable right, to compose, that is, to imagine or to observe, according to their personal conception of art. Talent proceeds from originality, which is a special way of thinking, of seeing, of understanding and judging.[19]

Thus, he writes, the reader should not make restrictive demands on the writer (e.g., "Amuse me," "Make me dream," "Make me cry");[20] the only legitimate request, Maupassant advises, is: "Make me something beautiful, in the form best suited to you, according to your temperament."[21]

Though clearly sympathetic to Realism and Naturalism in literature, Maupassant reminds his reader that no observer is completely objective and notes that even the most earnest attempts at "truth" are colored by individual bias. Moreover, "The realist, if he is an artist, will seek not to show us a banal photograph of life, but to give us a vision of life more complete, more compelling, more conclusive than reality itself."[22] Art, he suggests, is by its very nature the selective rendering of an idiosyncratically perceived "reality." Such Zolaesque views conformed to Van Gogh's own; in 1885, for instance, the artist had written, "My great longing is to learn to make those very incorrectnesses, those deviations, remodelings, changes in reality, so that they become, yes, lies if you like – but truer than the literal truth" (LT418). Now, from Arles, he told Theo:

I am in the middle of *Pierre et Jean* by Guy de Maupassant. It's good. Have you read the preface, where he explains the artist's liberty to exaggerate, to create in his novel a world more beautiful, more simple, more consoling than ours, and goes on

to explain what Flaubert may have meant when he said that "*Talent is long patience, and originality an effort of will and intense observation*"? (LT470; Van Gogh's emphasis)[23]

Maupassant by now had ascended to the head of Van Gogh's pantheon, second only to Zola in the artist's estimation. The younger writer was, to Van Gogh's mind, the descendant and rightful heir of the older, a pleasing variant on a formidable paradigm. "What Van der Meer [i.e., Vermeer] of Delft is to Rembrandt among the painters," he wrote, "[Maupassant] is to Zola among French novelists" (LT498). He preferred Maupassant to other Naturalists he had begun to read in Paris and at Arles held him up against Jean Richepin, whose novel *Césarine* appeared in 1888. The story of an old soldier, Captain Roncieux, and his failed relationship with his tubercular and artistic son Paul, *Césarine* conforms to Richepin's novelistic penchant for gloom. Convinced that his wife has betrayed him, Roncieux kills her and the man he suspects as her lover shortly after Paul's birth, then vengefully withholds the small fortune Paul was meant to inherit. The novel's central conflict – between cold father and sensitive son – is dramatized by the backdrop of the Franco–Prussian War. Paul dies unreconciled with Roncieux when both he and the unlikely object of his affections – an aging mathematician named Césarine – are victims of street violence during the overthrow of the Paris Commune. Though Van Gogh's experience of *Braves gens* and *La Glu* had familiarized him with the pall created by Richepin's prose, he was especially depressed by *Césarine* – perhaps because it revived memories of his own filial conflicts with the Rev. Van Gogh. "The quarrel of the father and son," he wrote, "is just heartbreaking" (LT555). Though he found "some very good things" in the novel (e.g., the description of the retreating army that opens the book),[24] Van Gogh was distressed by that fact that *Césarine* "like *La Glu*...leaves no hope" (LT555). He preferred the story of *Pierre et Jean*, for "Maupassant, who has written things certainly as sad, lets things end more humanely....Indeed, I much prefer Guy de Maupassant because he is more comforting" (LT555).

At Arles Van Gogh also read the work of Zola's most loyal disciple, Paul Alexis, in the form of a volume of stories, *La Fin de Lucie Pellegrin* (1880).[25] He found the title story (the portrait of a Parisian prostitute who succumbs to tuberculosis) "very fine," "quick with life and...still exquisite and moving, because it keeps the human touch" (LT522). Ostensibly inspired by conversation overheard in a Parisian restaurant, Alexis's story impressed Van Gogh with its verisimilitude and candor; it covered ground the artist considered himself familiar with – "I who have hardly seen anything but the kind of women at 2 francs" – and he was eager to defend its content against charges of undue prurience. "Why should it be forbidden to handle these

subjects? . . . I realize that these loves are not for everyone's understanding. But from the point of view of what is allowed, one could write books treating worse aberrations of perversion than Lesbianism" (LT522). His remarks on this novel demonstrate Van Gogh's continuing admiration for the frank urban Naturalism he had read at The Hague and Paris, even if the majority of his readings at Arles veered more toward escapist fiction.

In that vein, a final notable volume on Van Gogh's Arlesian bookshelf was Pierre Loti's *Mme. Chrysanthème* (1887), a travel memoir by the best-known vagabond of late-nineteenth-century French letters. Loti (1850–1923), whose real name was Julien Viaud, was a captain in the French navy, and his far-flung travels became the subject of several autobiographical novels-cum-travelogues in which the author extols the virtues and notes the deficiencies of non-European places and cultures.[26] The simplistic plots of his "exotic" novels are mainly of a piece: a European man (usually presumed to be Loti himself) arrives in a foreign land, and quickly meets and seduces a native woman (whom he inevitably likens to a doll, an animal, and/or a child) who becomes his primary link to an alien culture. Their brief alliance ends when the hero – his curiosity and lust cursorily sated – departs for his next port of call.[27]

Though Japan proved to be one of his least favorite destinations,[28] and his conquest there – the teen-aged Chrysanthème – a disappointment, Loti's account of his months in Nagasaki proved popular with a French public enthralled by *japonisme*. Van Gogh was one such fan, and though he also read and admired *Le Mariage de Loti* (set in Tahiti) and *Pêcheur d'Islande* (the story of Breton fishermen's expeditions to Iceland), *Mme. Chrysanthème* was not only his favorite Loti novel, but – along with *Candide* and the Tartarin saga – one of the books most often referred to in Van Gogh's letters from Arles after he read it in June 1888 (see LT505, LT509, LT511, LT514, LT519, LT540, LT555, LT561, W7, B7). In his enthusiasm for the life and culture he perceived as Japanese (with the aid of woodblock prints), Van Gogh evidently was unfazed by Loti's repeated assertions that the actual people and locales he saw in Japan did not live up to the author's arts-inspired expectations.[29] Ignoring the negative implications of Loti's account, Van Gogh delighted instead in the insider information it seemed to provide; he was particularly intrigued by the minimalist decor of Japanese houses (LT509)[30] and by the author's descriptions of the Japanese taste for contrast – "the sugared peppers, and the fried ices, and the salted sweets" (LT519; see also W7). Whereas dealer Samuel Bing's published remarks on the Japanese art (in his periodical *Le Japon artistique*) struck Van Gogh as "rather dry" (LT540), *Mme. Chrysanthème* satisfied his desire for detailed images of the culture behind the prints he had so avidly collected.

SEEING THE SOUTH THROUGH A LITERARY LENS

Verbal descriptions preconditioned Van Gogh's vision of the South and continued to inform his mental and pictorial images of the region once he settled there. He was inclined to measure the places and people he encountered against literary representations, and he invoked Daudet and Zola in particular as he sought to describe the southern sights that caught his eye and propelled his work. In letters from Arles, Van Gogh not only compared certain of the portraits and townscapes he made there to remembered passages from contemporary literature, but also expounded on his generalized desire to formulate a painting style that was at once consonant with Naturalist prose (i.e., bold, animate, and "gay") and – by extension – congenial to the rich spectacle he perceived around him in Provence.

Several of Van Gogh's letters document Daudet's impact on the artist's expectations; recollecting his decision to explore Provence, Van Gogh wrote of "my idea of looking for something in the country of Tartarin" (LT617) and noted that he himself had felt the "natural inclination toward the South which Daudet described in *Tartarin*" (LT605). He apparently felt a personal identification with Daudet's hero as well, and as he warmed to his surroundings, Van Gogh became – in his own mind – a self-styled Tartarin: a boisterous, sometimes inept, but well-meaning champion of the Midi. He seems to have aimed to emulate Tartarin's bravado in his own work, and in April 1888, as he recounted the visual splendor of his new surroundings in a letter to Emile Bernard, Van Gogh good-humoredly confided, "I shall have to make a lot of noise,[31] as I aspire to share the glory of the immortal Tartarin de Tarascon" (B4). The artist also empathized with Tartarin's frequent inability to turn good intentions into successful undertakings; according to Gauguin, Van Gogh on at least one occasion invoked the name of Daudet in the face of a creative failure. In *Avant et après* Gauguin tells of an evening at Arles on which Van Gogh – who usually left the cooking to his housemate – attempted to make soup. According to Gauguin, Van Gogh blended foodstuffs as carelessly as he mixed paints, and his concoction was a disaster.[32] On seeing the results, however, he blithely exclaimed, "Tarascon! la casquette au père Daudet" – a reference to the *chasse aux casquettes* described in *Tartarin de Tarascon*. By means of this somewhat enigmatic declaration, Van Gogh probably meant to suggest that he was about as good a cook as Tartarin was a hunter but, like his hero, made up for lack of skill with flourish and worthy intent. It is hardly surprising that Gauguin, remembering Van Gogh at Arles, describes a man whose brains were "scorched" by Daudet.[33]

In the summer of 1888, Van Gogh often recalled Daudet's images of Provence – "that devil of a country where the sun transfigures everything

and makes everything bigger than it is"[34] – particularly as he scouted the broad plain east of Arles, known as La Crau, for picturesque locales. La Crau is bordered on the north by the Alpilles, a minor mountain range that Tartarin and his fellow Tarasconnais are described as ascending for sport in *Tartarin sur les Alpes*, "that chain of little mountains perfumed with thyme and lavender, not very mean nor very high...which create a horizon of blue waves along Provençal roadways."[35] Van Gogh made several drawings in La Crau and in describing his subject to Theo remarked, "The contrast between the wild and romantic foreground, and the distant perspective, wide and still, with horizontal lines sloping into the chain of the Alps [*sic*], so famous for the great climbing feats of Tartarin P.C.A., and of the Alpine Club – this contrast is very striking" (LT490).[36]

In addition to the southern landscape, Van Gogh, who considered himself first and foremost a portraitist (see LT516), was eager to capture Provençal types. His avid reading of *Tartarin sur les Alpes* once he arrived at Arles reaffirmed his notion of the locals' jovial affability;[37] within a month of his move, he was pleased to confirm that the typical southerner was indeed "like Tartarin, being more energetic in good intentions than in action" (LT469), and some weeks later he compared a local official to a comic character in a Tartarin novel (LT487; B6). The extent to which Daudet's writings contributed to Van Gogh's preconceptions is equally well expressed by the degree of disappointment the artist felt when real-life encounters did not live up to that author's fanciful delineations. As early as March 1888, Van Gogh complained, "I see nothing here of the Southern gaiety that Daudet talks about so much, but on the contrary, all kinds of insipid airs and graces, a sordid carelessness" (LT502). Months later, from the asylum at St.-Rémy, he lamented the "languid, clumsy hands" of the typical Provençal worker and conceded that in the South "things [are] colder than one would think when reading *Tartarin*" (LT594).

As the realities of the South sunk in at Arles, Van Gogh was increasingly inclined to compare what he saw there to Zola's harsh portrayals of small-town life and agrarian culture. Zola was raised at nearby Aix-en-Provence (less than fifty miles from Arles) and knew the region well, and recollections of his Provençal youth as well as Naturalist "documentation" informed his accounts of rural life.[38] Van Gogh's perception of his new surroundings was colored by memories of Zola's specifically southern narrative, *La Faute de l'Abbé Mouret*,[39] but the Zola novel most often mentioned by the artist at Arles was in fact not an account of Provence, but rather *La Terre*, the recently published saga of agrarian ambitions in La Beauce, a farming region just south of Paris. That novel's earthy descriptions of provincial types often came to mind as Van Gogh contemplated new acquaintances; in the summer of 1888, for instance, the artist acknowledged that "the actual inhabitants

of this country" – including the grimy tomboy he had just drawn[40] – "often remind me of the figures we see [sic] in Zola's work" (LT501a). His neighbors, he claimed, were "amazingly like the Buteaux" (the brutish and murderous farm couple who figure prominently in *La Terre*; LT519), and the inhabitants of the outlying farming district (particularly those in the village of Fontvieille, where Van Gogh visited some artist acquaintances) provoked more generalized memories of the rural laborers Zola described. Noting the manner in which the savvy locals "laughed at" and "despised" condescending outsiders, Van Gogh lamented his friends' naïveté in dealing with them. "The natives," he remarked ironically, "are like Zola's poor peasants, innocent and gentle beings, as we know" (LT514). This facetious characterization of rural workers was not meant to be taken literally, but instead constituted an inside joke among those in the know – that is, readers like the Van Gogh brothers who (thanks to Naturalist literature) realized that French peasants were more shrewd than innocent, more rapacious than gentle. The untutored urbanite's assumption that such villagers were guileless naïfs promoted the sort of imagery Van Gogh found more appropriate to chocolate boxes than to serious painting and prompted his derision (LT514). His own sense of the peasant's character and disposition – though profoundly influenced by midcentury painting (see LT514, LT519) – had been sharpened by Zola's prose, and when he himself set out to paint a peasant in the summer of 1888, recollections of his readings were very much on his mind (see LT520). *La Faute de l'Abbé Mouret, La Terre,* and *Germinal* had convinced him of the toughness, irascibility, and cunning engendered by the laborer's struggle to survive and opened his eyes to the folly of presuming that "country folk" were "simple and artless" (LT514).

Zola's prose also leapt to Van Gogh's mind as he contemplated his immediate surroundings. Of his neighborhood, he remarked, "You can't help feeling Zola and Voltaire everywhere. It is so alive!" (LT519). "The public garden, the night cafés and the grocer's, are not Millet, but instead they are Daumier, absolute Zola" (LT538). He doubtless meant to suggest that the town he lived in was not rustic and serene in the manner of Millet's quasi-biblical figure paintings, but instead lively and raucous, with inhabitants as brash and amusing as Daumier's caricatures or Zola's irreverent prose portraits. Such letters not only indicate Van Gogh's belief that his experience of Zola's fiction had been good preparation for life in provincial France, but also hint that the Zolaesque qualities he perceived there somehow validated his decision to live and work at Arles.

He found the landscape outside town reminiscent of Zola's prose as well. Quite disparate aspects of the Midi – its aridity and its lushness, its workaday aspect as well as its fantastic qualities – recalled descriptions by his favorite

writer. In June 1888, as temperatures rose and Van Gogh trekked the fields around Arles in search of harvesttime subjects, he remarked on the "harsh" and "scorched" aspects of Provence and thought of Cézanne, who "like Zola is so absolutely part of the countryside, and knows it so intimately" (LT497). These remarks demonstrate Van Gogh's awareness of the fact that both men grew up nearby and suggest his feelings of artistic kinship with them as he examined the Midi. The region around Arles also reminded him of the less brutal, more romantic side of Zola's Provence; an excursion to Mont Majour, a ruined hilltop abbey just north of Arles, called up Zola's lyric rendering of rampant nature in *La Faute de l'Abbé Mouret:*

I have come back from a day in Mont Majour, and my friend the second lieutenant [Milliet] was with me. We explored the old garden together, and stole some excellent figs. If it had been bigger, it would have made me think of Zola's Paradou, high reeds, and vines, ivy, fig trees, olives, pomegranates with lusty flowers of the brightest orange,[41] hundred-year-old cypresses, ash trees, and willows, rock oaks, half-broken flights of steps, ogive windows in ruins, blocks of white rock covered with lichen, and scattered fragments of crumbling walls here and there among the green. ((LT506)

Van Gogh's verbal rendering of Mont Majour accords well with a Zola passage he had read years earlier in which Zola describes Le Paradou – the abandoned Provençal garden of his imagination – as

a vast ground growing with abandon for a century, [a] corner of paradise where the wind sowed the rarest flowers.... The vegetation was enormous there, superb, powerfully uncultivated.... Left to itself, free to grow unabashedly...nature let itself go more each spring.... It broke the masonry of pools, of stairways, of terraces, by driving bushes in there; it crept so far as to take over the smallest cultivated spots, reshaping them as it liked, planting there, like a flag of revolt, some seed gathered from the road, a humble verdure that it made into a gigantic one. (*La Faute de l'Abbé Mouret,* pt. II, chap. 7)[42]

Le Paradou had once figured prominently in the Van Gogh brothers' imaginations as the perfect locale for love (see LT286, LT287), and in 1882 Vincent told Theo, "Who knows, someday I may attack such a Paradou subject" (LT287). Though he did not, on this outing, make any drawings of the garden at Mont Majour, his excursion there may have reawakened that ambition; shortly thereafter he began painting lovers in southern landscapes – a subject whose selection and formulation may well have been indebted to recollections of Zola's novel.

Inspired by the novelty and brilliance of his southern surroundings, Van Gogh at Arles felt impelled to push his painting style forward, to evoke – especially by means of his palette – the vitality of Provence: "scenery which, although in general similar to ours [i.e., that of Northern Europe], is un-

doubtedly richer and more colorful as subject matter and motif" (W3). He saw the Midi as the ideal home for an artists' community devoted to redirecting modern painting and urged his peers to join him there to found a "great studio in the South" (LT542; see also LT492, LT493, LT494a, LT544, LT544a, B16), hopeful that "later on other artists will rise up in this lovely country and do for it what the Japanese have done for theirs. . . . It's not so bad to work toward that end" (LT483). He was eager to see the creation of a Provençal school that in its distinctive Frenchness would be as suitable to its subject as Japanese prints were to theirs. The French colorists he admired – Delacroix, Monticelli, Monet – were quite naturally on Van Gogh's mind as he formulated goals for the southern painting he envisioned (see, e.g., LT477a, LT482, LT492, LT539, LT542); somewhat less predictably, he also was eager to emulate the vibrancy of Naturalist prose in images of the region. In a letter to Emile Bernard – one of the painters he most hoped to lure to Arles – Van Gogh suggested that recent French literature was one of several exemplars to which artists embarked on the collaborative effort he proposed might look:

More and more it seems to me that the pictures which must be made so that painting should be wholly itself, and should raise itself to a height equivalent to the serene summits which the Greek sculptors, the German musicians, the writers of French novels reached, are beyond the power of an isolated individual; so they will probably be created by groups of men combining to execute an idea held in common. (B6)

"Ah," Van Gogh exclaimed some weeks later, "if only several painters agreed to collaborate on important things! The art of the future will show us examples of this perhaps. . . . [But] alas! we haven't got as far as that yet; the art of painting doesn't move as fast as literature" (B9).

In a contemporaneous letter to Theo (early summer of 1888) the artist speculated on the best way to capture the look and feel of Arles. Convinced that "the best thing to do would be to make portraits, all kinds of portraits of women and children," he feared his lack of personal charm would hinder his efforts; "I'm not," he lamented, "enough of a M. Bel Ami for that" (LT482).[43] But if he sometimes felt inadequate to the task, Van Gogh clearly dreamed of making pictures in the mode of Maupassant's verbal imagery. In the same letter, he continued:

I should be heartily glad if this Bel Ami of the Midi . . . whom I feel to be coming, though I know it isn't myself – I should be heartily glad, I say, if a kind of Guy de Maupassant in painting came along to paint the beautiful people and things here lightheartedly. . . . But who will be in figure painting what Claude Monet is in landscape? . . . The painter of the future will be a *colorist such as has never yet existed.* (LT482; his emphasis)[44]

PAINTING THE SOUTH IN A NATURALIST MODE

Though Van Gogh claimed (in September 1888) to feel unequal to the artists he took as models and to be waiting "for the next generation, which will do in portraiture what Claude Monet does in landscape, the rich, daring landscape à la Guy de Maupassant" (LT525), his letters and pictures indicate that he was already attempting to realize that rather tenuous conception in his own work. His comments suggest that the painting he deemed appropriate to Provence (hence to a "great studio in the South") would be lighthearted and gay – in the spirit of Maupassant – and intensely hued – in the manner of Monet's landscapes of the 1880s.[45] Though his admiration for Monet's palette was profound, Van Gogh's insistent references to Maupassant and to Bel-Ami suggest his preference for an art dominated by the figure,[46] and as he surveyed his Arlesian neighbors, the artist noted that "people here are picturesque . . . and whereas in our country a beggar looks more like a hideous phantom, he becomes a caricature here" (W3). The painter he longed to be – the so-called Bel-Ami of the Midi – apparently was an artist who could captivate his compatriots as effortlessly as that fictional charmer had, and then cajole them into modeling for lushly textured, bright-hued likenesses.

Moreover, Van Gogh's work at Arles was increasingly informed by the artistic "daring" he associated with Zola and Maupassant: a commitment to the manipulation of nature according to one's own temperament, to render it more complete, compelling, and – to use Van Gogh's term – "consoling." In March 1888 he noted, "Zola and Guy de Maupassant . . . absolutely insist on . . . a great richness and a great gaiety in art . . . [and] this same tendency is beginning to rule the art of painting too" (W3). By September he asserted: "It is my belief that it is actually one's duty to paint the rich and magnificent aspects of nature. We are in need of gaiety and happiness, of hope and love" (W7). Though certain of his contemporaries might have seen a Symbolist tendency in Van Gogh's aims, the artist himself considered his goals at Arles to be consistent with Naturalist theory and practice, which not only acknowledged, but celebrated the idiosyncrasy inherent to creative practice. As summer ended, Van Gogh reported that "ideas for my work are coming to me in abundance" (LT534), and as his wide-ranging ambitions threatened to outstrip his resources, he drove himself hard, working long hours (LT537) and frequently requesting new infusions of canvas and paint. Though he often complained that a lack of willing models thwarted his attempts to pursue portraiture to the extent he wished (LT482, LT519, LT524, LT529, LT530, W4, B19), he nonetheless managed to amass a substantial portfolio of Arlesian types during the last half of 1888.

In the portraits he made at Arles, the artist was eager to capture repre-

sentatives of various walks and times of life, and thus to build a compre-
hensive portrait of southern society. Rather than focus on that which was
unique to individual sitters, he tended to seek the quintessential and to render
a group by presenting the specimen he found typical.[47] Paradigms for his
enterprise abound in literature and art, high and low. In midsummer 1888,
for instance, Van Gogh told Bernard, "In their quality as painters of a society,
of a nature in its entirety, Zola and Balzac produce rare artistic emotions in
those who love them, just because they embrace the whole of the epoch they
depict" (B13). He noted that Frans Hals, in like manner, "painted the drun-
ken topper, an old fishwife in a mood of witchlike hilarity, the pretty gypsy
whore, babies in their diapers, the dashing, self-indulgent nobleman...all
kinds of portraits, of a whole gallant, live, immortal republic" and Rem-
brandt, in his secular figure pieces, did much the same thing: "the painting
of humanity, or rather of a whole republic, by the simple means of por-
traiture" (B13). A more recent – and perhaps equally influential – prototype
for Van Gogh's project was a series of prints from the popular British illus-
trated journal *The Graphic,* entitled "Heads of the People," which included
such characters as the hooligan, fireman, miner, and debutante. Van Gogh
had admired and collected those prints in the early 1880s (LT205)[48] and
also was familiar with the series that succeeded them, "Types of Female
Beauty" (LT252).[49] His own project, at Arles, was to paint a cross section
of his neighbors in a way that would transcend the boundaries of private
portraiture (and its limited public appeal) to create a generalized and en-
during likeness of Provençal society. To do so, he often cast individuals as
archetypes and subsumed individual quirks within preordained roles of his
own selection. They included soldier, ingenue, peasant, and poet.

Among the first locals he painted were a young man in uniform, known
only as *The Zouave* (Fig. 34), and a girl in lively Provençal costume, whom
the artist christened *La Mousmé* (Fig. 35). In each, a palette of strong,
contrasting colors and a bold play of surface patterns and textures seem
designed to replicate the eye-dazzling effects that impressed Van Gogh in
the South. The "savage combination of incongruous tones" used in *The
Zouave,* he acknowledged, created a "vulgar, even loud" effect (LT501),
and given the artist's stated aims, the raucous look of such works might be
considered the result of his attempts to achieve visual equivalence to the
"richness and gaiety" he also admired in the prose of Zola and Maupassant.
Both paintings address the exoticism that lured Van Gogh southward; the
Zouave's Algerian costume reminds the viewer of Arles's proximity to the
North Africa of Delacroix and Tartarin, and the girl's "naïve" getup of
intensely hued stripes and dots establishes her distance from Paris.[50] More-
over, the title Van Gogh affixed to the latter likeness reflects his desire to
experience Japan in the South. "A mousmé," Van Gogh explained to Theo,

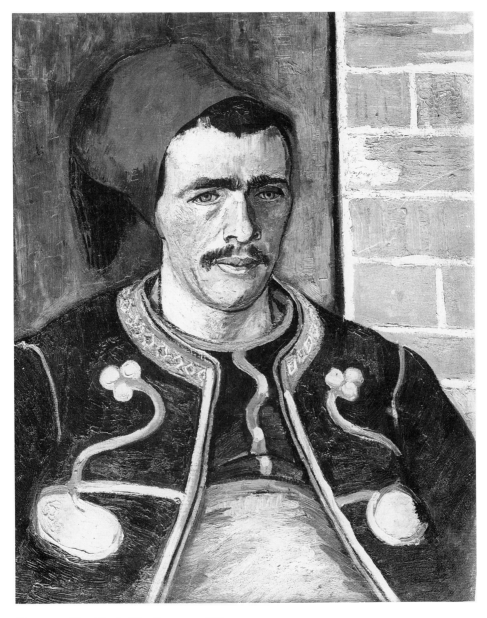

Figure 34. Van Gogh, *The Zouave*, 1888.

"is a Japanese girl – Provençal, in this case – 12 to 14 years old" (LT514).
He had been introduced to that term by Pierre Loti's *Mme. Chrysanthème,*
wherein the author elaborates:

Mousmé is a word that signifies a young girl or a very young woman. It is one of
the prettiest words in the Japanese tongue; there seems to be, within this word,
something of the *moue* [pout] (of the nice and drole little pout that they make) and
especially of the *frimousse* [pert little face] (of the rumpled, rouguish little face that

Figure 35. Van Gogh, *La Mousmé*, 1888.

is theirs). I will use it often, not knowing any in French that would be as good. (*Mme. Chrysanthème*, chap. XI)[51]

Though the sitter's physiognomy is decidedly Western, something in her youthful demeanor, puffy mouth, and lack of conventional coquettishness must have reminded Van Gogh of the offbeat allure Loti describes, and the riotous clashes of her costume (opposed patterns of red and blue, violet and orange) perhaps recalled the Japanese love of contrast so often remarked in *Mme. Chrysanthème*.[52]

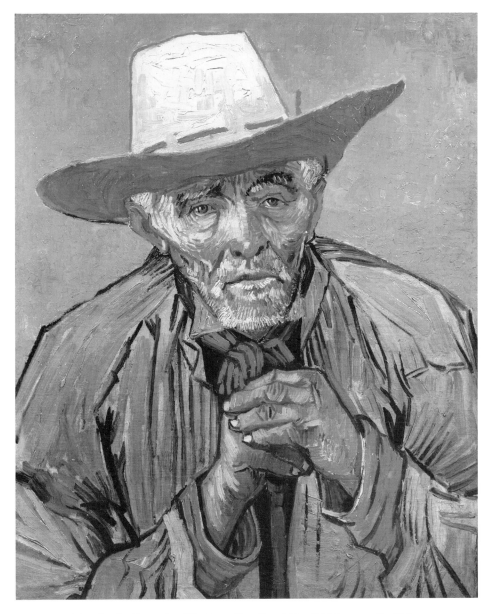

Figure 36. Van Gogh, *Portrait of Patience Escalier, "The Old Peasant,"* 1888.

Somewhat more prosaic types were the subject of Van Gogh's next portrait series – of the postman Joseph Roulin, whom he painted in July (F432, F433), and the gardener Patience Escalier, who posed the following month and soon was dubbed the "old peasant" (Plate 4, Fig. 36; LT529). The paintings of Escalier, animated by variously textured impasto and brash plays of complementary color, are among those Arlesian portraits that conform most closely to Van Gogh's ideas for a decidedly southern style of painting;

their bright, deliberately "crude" surfaces were meant, he wrote, to evoke the southern worker's "sun-steeped, sunburned quality, tanned and air-swept" (LT520). Though the high-keyed hues of his palette had counterparts in Impressionist works, Van Gogh here sought to employ color in a different way, to reflect an intuitive rather than a seen reality. "What I learned in Paris is leaving me," he remarked, "and I am returning to the ideas I had in the country before I knew the Impressionists. . . . Because instead of trying to reproduce exactly what I have before my eyes, I use color more arbitrarily, in order to express myself forcibly" (LT520). He selected the colors for his first rendering of Escalier (Plate 4) on the basis of empathic projection: "I imagine the man I have to paint," he explained, "terrible in the furnace of the height of harvesttime, as surrounded by the whole Midi. Hence the orange colors flashing like lightning, vivid as red-hot iron, and hence the luminous tones of old gold in the shadows" (LT520). And, in the second version (Fig. 36), Van Gogh painted the sunstruck countenance of the blue-clad peasant "against a background of vivid orange which, although it does not pretend to be the image of a red sunset, may nevertheless give a suggestion of one" (LT529). His use of evocative rather than optically "true" color was, in Van Gogh's opinion, the quality that distanced his work from that of Monet and his school.

Though he invoked the example of Delacroix as he discussed his treatment of Escalier (LT520),[53] Van Gogh doubtless was emboldened by literary models as well when he sought to heighten the suggestive aspects of an observed reality. He was quick to note that the palette used in his depictions of the "old peasant" "is color not locally true . . . but color suggesting some emotion of an ardent temperament" (LT533), an assertion that owed a good deal to Zola's and, more recently, Maupassant's calls to arms. Zola had long urged (and exemplified) artistic commitment to personal sensibility, and Maupassant seconded Zola's views in his preface to *Pierre et Jean,* as he defended the artist's liberty to refashion mundane reality toward expressive ends, "according to . . . temperament."

Van Gogh was confident that Theo would grasp the motives behind his distortions, but he speculated that "nice people will only see the exaggeration as a caricature. But what has that to do with us?" he asked. "We've read *La Terre* and *Germinal,* and if we are painting a peasant, we want to show that in the end what we have read has come very near to being a part of us" (LT520). He thus suggested, as he had some months earlier,[54] that he and Theo, by virtue of reading Zola, understood peasants in a way that many of their contemporaries did not. Invoking neither his own rural roots nor his ministry in the Borinage in support of his vision, Van Gogh instead brandished his literary credentials as he asserted his right to paint the working class as he saw fit. At the same time, he acknowledged that his own expec-

tations and perceptions – hence representations – of the peasant were profoundly influenced by Zola's fiction.

Though neither of the Escalier portraits seems to make direct reference to a specific character from Zola's oeuvre, both bear the imprint of that author's prose portraits. The paintings are close-up, sharp-focus views that suggest the scrutiny and candor of the Naturalist; the softened line, dulled colors, and poeticizing haziness of so many midcentury peasant pictures have no place here. The model himself is posed frontally, to confront the viewer directly, and in the first portrait Escalier's piercing gaze gives indication of shrewd, reciprocal scrutiny on the part of the peasant. According to Zola, the agrarian laborer was a resilient being hardened by the travails of rural life; the elderly peasant men he describes are routinely lean and leathery, and so close to nature after their lifelong battles with it that they become almost at one with the landscape. Jean-Louis Lacour – the 70-year-old peasant whose death is recounted in Zola's series *Comment on meurt* – is, for instance, "tall and gnarled like an oak. The sun has dried him, has cooked and split his skin; and he has taken on the color, the ruggedness and the calm of the trees."[55] Lacour was cast from the same mold as Soulas, the aged shepherd of *La Terre,* who "despite his seventy years... was still ramrod-straight, as resilient and knotty as a stick from a thorn bush, his face more worn, like a drunkard's face carved from a tree, under the tangle of his faded-looking hair."[56] Not merely tough-skinned, coarse-featured,[57] and dirty,[58] the peasant Zola describes in prose is an animalistic other who lives by a different set of rules,[59] a "beast" set apart from the rest of humankind by both look and outlook.[60] Van Gogh apparently subscribed to these notions, for shortly after painting Patience Escalier he boasted to Emile Bernard:

Ah! I have [a] figure... which is an absolute continuation of certain studies of heads I did in Holland.

... This time... the color suggests the blazing air of harvesttime right in the South, in the middle of the dog days, and without that it's another picture.

I dare believe that Gauguin and you would understand it; but how ugly people will think it! *You* know what a peasant is, how strongly he reminds one of a wild beast, when you have found one of the true race. (B15; his emphasis)

The painting to which Van Gogh referred was his first portrait of Escalier (Plate 4), in which the undefined bulk of the sitter's looming upper body appears somewhat at odds with his angular, misshapen head, and the model's wizened cheeks, curled upper lip, and keen eyes beneath dark, arched brows lend the face a hard-bitten, even menacing, cast. The untempered vigor of this painting's palette and textures – jarring complementary contrasts laid into an unevenly impastoed ground – imply the sitter's rough-hewn *rudesse,* and his foursquare positioning on the canvas might be seen to suggest the blunt implacability Zola ascribed to most rural men. Van Gogh's image may

be compared, in general terms, to Zola's verbal renderings of old Fouan, the stubborn, mean-spirited, but ultimately pitiable patriarch of *La Terre*, who is introduced thus:

The father, once very robust, seventy years old today, had become so dried up and shrunken by such hard work, by such a keen passion for the earth, that his body was bowed, as if to return to that very earth so violently desired and possessed. Except for his legs, however, he was still vigorous and well-kempt...with the long family nose that sharpened his thin face, its leathery planes cut by great folds. (*La Terre*, pt. I, chap. 2)[61]

Van Gogh's second portrait of Escalier (Fig. 36) seems, by contrast, a sympathetic, even sentimental, treatment. Bleary-eyed beneath shaggy, gray-ing brows, this Escalier – head tilted to one side – has a wistful affect. Leaning on a stick, the model displays his brown and blunt-fingered, work-worn hands and manifests the fatigue one might associate with the "red sunset" behind him. In this rendering, Escalier's attitude suggests that adopted by *père* Fouan toward the end of *La Terre;* some years have passed since his seventieth birthday, and the once-wily peasant, hobbled by old age and the scorn of his offspring, ends his days as a broken-down beast:

He was no longer the tidy old farmer.... In his gaunt, fleshless face nothing remained but the large bony nose, which stretched out toward the ground. He had become a bit more bowed each year, and now he went along doubled over, with little time left before he did a final somersault into the grave....

Up until now, however, Fouan had been able to walk, and that was a consolation, because he was still interested in the land.... He would wander slowly along the roads with the wounded tread of an old man; he would stop next to a field, remaining there for hours, planted on his walking sticks; then he would drag himself to another one and forget himself again, immobile, like a tree that grew there, dried up by old age. His empty eyes no longer clearly distinguished wheat from oats or rye. Every-thing became scrambled, and confused memories arose from the past....

But this last interest he took in life left him when he lost the use of his legs. Soon it became so painful to walk that he scarcely strayed from the village.... Often he forgot himself for the whole afternoon, crouching at the end of a beam to take the sun. A stupor overtook him, his eyes open.... It was, after his will and authority died, the final decline: an old beast suffering, in his retirement, the misery of having once lived the life of a man. But he did not complain at all, accustomed to the idea that a broken-down horse that has served its purpose is put down once it fails to earn its keep. (*La Terre*, pt. V, chap. 2)[62]

Van Gogh's two ways of viewing Escalier seem to reflect two standardized bourgeois reactions to the laborer (both of them clearly articulated and oft-reiterated by Zola): wariness of the bestial other conjoined to condescending pity for his supposedly inalterable condition.

The effect of earthy crudeness Van Gogh aimed for in his renderings of

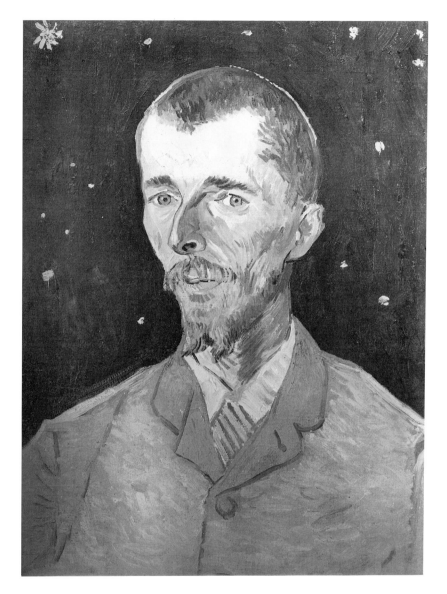

Figure 37. Van Gogh, *Portrait of Eugène Boch, "The Poet,"* 1888.

the old peasant was countered by the otherworldly aura of his next major figural piece, the *Portrait of Eugène Boch* (Fig. 37). Boch was a young Belgian artist working in Provence when he became, under Van Gogh's brush, "the poet" – "that picture which I have dreamed of for so long" (LT531). The Belgian's "face like a razor blade" and "touch of distinction" had intrigued Van Gogh since their first meeting in mid-June (LT505), and by August he had a clear notion of the role his colleague might play:

I should like to paint the portrait of an artist friend, a man who dreams great dreams, who works as the nightingale sings, because it is his nature. He'll be a blond man. I want to put my appreciation, the love I have for him, into the picture. So I paint him as he is, as faithfully as I can, to begin with.

But the picture is not yet finished. To finish it I am now going to be the arbitrary colorist. I exaggerate the fairness of the hair, I even get to orange tones, chromes and pale citron-yellow.

Behind the head, instead of painting the ordinary wall of the mean room, I paint infinity, a plain background of the richest, intensest blue that I can contrive, and by this simple combination of the bright head against the rich blue background, I get a mysterious effect, like a star in the depths of an azure sky. (LT520)

In early September, Van Gogh was able to realize his ambition, for Boch gave him two sittings (LT531). The result was a bust-length likeness in which the model's head is presented at an angle that displays his profile even as his eyes meet the viewer's. His costume is almost implausibly colorful, and the gold, green, and red of his jacket and tie are repeated as striking highlights in his skin and beard. The dark green tints of his hair are set off from the deep blue background by an irregular gold contour that makes the head seem backlit. "In a picture," Van Gogh wrote, as he reported the completion of this portrait, "I want to say something comforting, as music is comforting. I want to paint men and women with that something of the eternal which the halo used to symbolize, and which we seek to convey by the actual radiance and vibration of our coloring" (LT531). By reference to music, Van Gogh implied that he meant to express himself nonimagistically, with the "abstract" component of color;[63] but if its unconventional palette removes the image of Boch from the realm of the ordinary, the picture's most evocative element is the starlit sky that seems to open up behind the sitter – and functions iconographically.

Van Gogh found the Provençal night sky – with its "gemlike" multihued stars – richer than that of the North (LT499), and he was determined to paint it (LT474, B7). Convinced that it did one good "to feel the stars and the infinite high and clear above you" (LT520), he meditated on them to assuage his religious longings (LT543) and clearly ascribed profound meaning to the panorama of a deep-toned sky illumed by sparkling astral bodies. The night sky provoked him to reflect on the cosmic and the eternal, particularly the possibility of life after death and of a continuum of creative activity that linked one generation of artists to another. He pursued these thoughts in a letter to Theo, written in midsummer 1888:

Is the whole of life visible to us, or isn't it rather that this side of death we see only one hemisphere?

Painters – to take them alone – dead and buried speak to the next generation or to several succeeding generations through their work.

Is that all, or is there more to come? Perhaps death is not the hardest thing in a painter's life.

For my own part, I declare I know nothing whatever about it, but looking at the stars always makes me dream, as simply as I dream over the black dots representing towns and villages on a map. Why, I ask myself, shouldn't the shining dots of the sky be as accessible as the black dots on the map of France? Just as we take the train to get to Tarascon or Rouen, we take death to reach a star. (LT506; see also LT511)

His tendency to see the promise of life after death in a skyful of stars was by no means unique to Van Gogh; a short story by Daudet, entitled "Les Etoiles," records, for instance, the Provençal folk custom of equating shooting stars with the transmission of souls,[64] and Whitman, too, presents the night sky as a presage of the afterlife.[65] Van Gogh's starlit musings on an idealized "other side" were part of a broad current of contemporary thought and seem to bear particular comparison to the metaphysical speculation Zola indulges in briefly in *La Joie de vivre*. To the sense of irretrievable loss that his nihilistic protagonist, Lazare, experiences when his mother dies, Zola contrasts the anticipation of reunion that faith affords:

He developed an insurmountable aversion to walks. He became anxious outside, with an uneasiness that turned to discomfort... and he hastened to return, to shut himself in, in order to feel less small, less crushed between the infinity of the water and the infinity of the sky.

If Lazare had had faith in another world, if he had been able to believe that someday you found your dear ones beyond the black wall.... What joy to start afresh a new existence with friends and relatives somewhere else, among the stars! How that would have made his agony sweet, to rejoin lost affections, and what kisses at the encounter, and what serenity to live together again, immortal! (*La Joie de vivre*, chap. VII)[66]

This image of joyous reacquaintance "among the stars" may well have shaped the vision Van Gogh described to Theo; the artist first read *La Joie de vivre* in 1885, the year of his father's death, and evidence that he associated the novel with his own bereavement exists in the *Still Life with Bible and French Novel* (Plate 5). In the summer of 1888, his thoughts apparently returned to Zola's book, for it is included in a still life Van Gogh painted that August (Plate 9).

Van Gogh's own hopes for the afterworld seem to have encompassed cosmic communion with other artists (see LT511), and shortly after painting Eugène Boch as "the poet" he told Theo, "I go out at night to paint the stars, and I am always dreaming of a picture like this with a group of living figures of our comrades" (LT543). When he shared his thoughts on the world beyond with one such comrade, Emile Bernard, he fantasized about enhanced creativity in some future incarnation:

Our real and true lives are rather humble, these lives of us painters, who drag out our existence under the stupefying yoke of the difficulties of a profession which can hardly be practiced on this thankless planet....

But...supposing that there are also lines and forms as well as colors on the other innumerable planets and suns – it would remain praiseworthy of us to maintain a certain serenity with regard to the possibilities of painting under superior and changed conditions of existence, an existence changed by a phenomenon no queerer and no more surprising than the transformation of the caterpillar into a butter-fly....

The existence of [such a] painter-butterfly would have for its field of action one of the innumerable heavenly bodies, which would perhaps be no more inaccessible to us, after death, than the black dots which symbolize towns and villages on geographical maps are in our terrestrial existence. (B8)

Van Gogh's dream of ongoing life and artistic practice in a superior state of being clearly encompassed his colleagues – Boch as well as Bernard – and the painting for which Boch sat is no mere portrait, but an attempt to personify creative genius, idealized, aggrandized, and immortalized against the backdrop of infinity. That he chose to title it "the poet" (rather than "the painter") not only suggests his belief in the interconnectedness of verbal and visual evocation and his advocacy of the artistic license he connected with poetic practice (see LT429), but also indicates the inclusiveness Van Gogh sought in a generalized image of the artistic persona transported beyond the confines of the mundane to the cusp of infinity.

The glorified, even glamorized, image of artistic practice that the portrait of Boch became was offset to some extent by the self-portrait Van Gogh made shortly thereafter (Fig. 38), wherein he addressed the self-imposed privations of the serious artist. In it, the painter made no overt allusion to his own profession, but instead cast himself as the reclusive ascetic his all-consuming work demanded.[67] With his hair and beard cropped close for hot weather, Van Gogh saw something of the "placid priest" in his own aspect (LT514), and he recorded this side of himself with cool and ashen tints, his head *almost colorless* he wrote, "...against a background of pale ma-lachite" (LT537; his emphasis). In a letter to his sister Van Gogh noted, "I ...made a new portrait of myself, as a study, in which I look like a Japanese" (W7), and he elaborated this idea in a letter to Gauguin:

I have a portrait of myself, all ash-colored. The ashen-gray color...is the result of mixing malachite green with an orange hue, on pale malachite ground, all in harmony with the reddish-brown clothes. But as I also exaggerate my personality, I have in the first place aimed at the character of a simple bonze worshiping the Eternal Buddha. (LT544a)

A bonze is a Buddhist monk, and Van Gogh owed his familiarity with this type to Loti's *Mme. Chrysanthème*. In a chapter devoted to bonzes, the author described them as "dressed in black gauze...their heads shaved."[68]

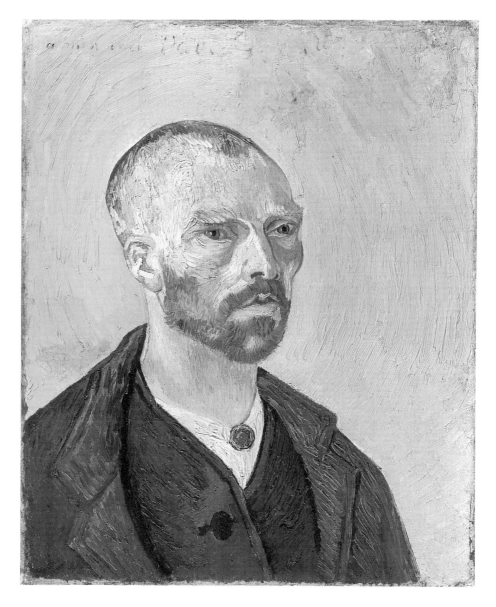

Figure 38. Van Gogh, *Self Portrait*, 1888.

According to Loti, most bonzes are "smiling, amiable," and "despite a certain ecclesiastical unctuousness, they laugh willingly and very good-naturedly; plump, chubby-cheeked, heads shorn, they aren't shocked by anything and they like our French liqueurs well enough."[69] This jovial side of the Japanese monk's existence, however, is nowhere evident in Van Gogh's image of himself, which instead accentuates the self-denial and intent meditation he associated with the roles of priest and painter. The richness and gaiety he

deemed essential to rendering his neighbors was briefly eschewed as the artist regarded himself.

Though portraiture was his obsession in 1888, Van Gogh also was eager to document his surroundings. The Provençal landscape and his favorite Arlesian haunts were less recalcitrant and expensive subjects than the human ones he relentlessly pursued, hence much more accessible vehicles for the development of his southern style. Like his portraits of the locals, Van Gogh's depictions of the town he inhabited not only were Naturalist in intent – with seen phenomena consciously emboldened and enriched according to the painter's own sensibility – but often were shaped by recollections of specific Naturalist novels and passages.

Though Arles is a town of notable monuments (its Roman and medieval architecture earn it three stars in the Michelin guide),[70] Van Gogh rarely painted the best-known sites, preferring its humbler quarters and rural outskirts. In September, for instance, he decided to make a picture of his own rented residence-studio – a two-story building on the Place Lamartine that he fondly called the Yellow House – and its surroundings (Fig. 39). "The subject," he wrote, "is frightfully difficult; but that is just why I want to conquer it. It's terrific, these houses, yellow in the sun, and the incomparable freshness of the blue" (LT543). His further comments indicate that the picture served as a form of autobiography: "The house on the left is pink with green shutters.... That is the restaurant where I go for dinner every day. My friend the postman [Joseph Roulin] lives at the end of the street on the left, between the two railway bridges. The night café I painted[71] is not in the picture, it is to the left of the restaurant" (LT543). He took pleasure in the ordinary, workaday aspect of such a view, and when his soldier friend Milliet derided Van Gogh's decision to paint their less than remarkable neighborhood, the painter defended his picture by noting:

When [Milliet] says he cannot understand anyone amusing himself doing such a dull grocer's shop, and such stark, stiff houses with no grace whatever, remember that Zola did a certain boulevard at the beginning of *L'Assommoir*, and Flaubert a corner of the Quai de la Villette in the midst of the dog days at the beginning of *Bouvard et Pécuchet*, and neither of them is moldy yet. (LT543)

Both of the passages to which Van Gogh referred are particularized Parisian street scenes,[72] and his own painting of the Place Lamartine replicates neither. But the specifics of those literary antecedents clearly were less important to him than the spirit of the verbal renderings cited, each of which suggests authorial delight in the everyday life of mundane locales. Van Gogh considered his own graceless motif vindicated by these writers' attention to the

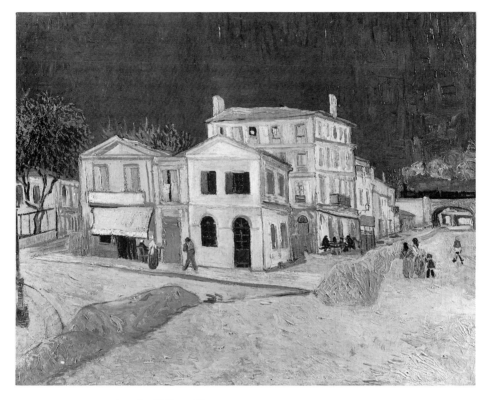

Figure 39. Van Gogh, *The Yellow House*, 1888.

same generic subject – a thoroughfare in a modest, out-of-the-way neighborhood – and he aimed to emulate their realistic reportage in paint. Moreover, both Zola and Flaubert used their descriptions as opening paragraphs, setting the scene for stories about to unfold. In painting *The Yellow House* – his southern home and studio – Van Gogh may have been aware of doing much the same thing, for the place he portrayed was the locus of his plans for renewal and progress in his life and art. "A home of my own," he felt, "can't but help me on" (LT533), and he hoped that the house would also become a magnet to fellow painters (LT532). "Here," he imagined, "there will always be artists coming and going, anxious to escape from the severity of the North. And I think myself that I shall always be one of them" (LT532).

In the late summer and early autumn of 1888, Van Gogh made several views of street life in his neighborhood, as many French painters had done since the 1870s. Most of Van Gogh's street scenes (e.g., F480, F481) were less emphatically autobiographical than *The Yellow House,* and as such came closer in spirit to the sort of Naturalist cityscape he invoked in LT543.

Moreover, one of them in particular, *Café Terrace at Night* (Plate 1), was linked by the artist to the opening lines of yet another contemporary novel, Maupassant's *Bel-Ami*. In a letter to his sister (written in early September) Van Gogh remarked:

So far you have not told me whether you have read *Bel Ami* by Guy de Maupassant, and what in general you think of his talent now. I say this because the beginning of *Bel Ami* happens to be a description of a starlit night in Paris with the brightly lighted cafés of the Boulevard, and this is approximately the same subject I just painted. (W7)

He described the Maupassantian painting as

the outside of a night café. On the terrace there are the tiny figures of people drinking. An enormous yellow lantern sheds its light on the terrace, the house front and the sidewalk, and even casts a certain brightness on the pavement of the street, which takes a pinkish violet tone. The gable-topped fronts of the houses in a street stretching away under a blue sky spangled with stars are dark blue or violet and there is a green tree. Here you have a night picture without any black in it, done with nothing but beautiful blue and violet and green, and in these surroundings the lighted square acquires a pale sulphur and greenish citron-yellow color. It amuses me enormously to paint night right on the spot. They used to draw and paint the picture in the daytime after the rough sketch. But I find satisfaction in painting things immediately. (W7)

Though dedicated to the painstaking observation of this scene "right on the spot," Van Gogh could not resist comparing the seen to the imagined, and drew a parallel between his painting and the first pages of a favorite novel, the passage in which Georges Duroy — a young provincial new to Paris — wanders the fashionable boulevards of the Right Bank, and — for want of money — forestalls his desire to sit down at one of the lively café terraces and order a beer. Of the setting, Maupassant writes:

It was one of those airless summer evenings in Paris. The city, hot as a steambath, seemed to sweat in the stifling night. The granite mouths of the sewers exhaled their stinking breath, and from their low windows basement kitchens threw villainous miasmas of dishwater and old sauces into the street.

Concierges in shirtsleeves sat backward on their caned chairs, smoking their pipes beneath entryways, and passersby moved along at a prostrate pace, heads bare, hats in hand. . . .

The big cafés, full of people, overflowed onto the sidewalk, displaying their drinking clientele under the raw and piercing light of their illuminated façades. In front of them, on little square or round tables, glasses held liquids in every shade of red, yellow, green and brown; and inside the carafes one glimpsed the shine of the fat, limpid cylinders of ice that chilled the beautifully clear water. (*Bel-Ami,* chap. 1)[73]

Like the passages by Zola and Flaubert that Van Gogh mentioned around the same time (September 1888), Maupassant's is a less than perfect match for the picture to which the artist connected it, though their subjects are roughly equivalent. As he roamed his neighborhood by night, a foreigner on his own in a relatively new place, Van Gogh may have identified with Duroy's excitement with a novel environment, his longing to belong there, and even his lack of pocket money, but – as is usually the case in Van Gogh's work – no narrative is implied in the slice-of-life view he rendered in *Café Terrace at Night* (Plate 1). His aspirations to a Maupassantian mode of depiction – a "lighthearted" approach to the "beautiful people and things here" (LT482) – might be discerned, however, in the lush hues and textures of this "night picture without any black in it," a painting in which Van Gogh sought to avoid the effects of "conventional night scenes with their poor sallow whitish light" (W7). Indeed, the painting (and its artist's verbal evocation of it) might even be seen to outdo Maupassant in richness, for the opening chapter of *Bel-Ami* (which contains no mention of starlight) is a more earthy, less romanticized rendering of nighttime street life than the one Van Gogh seems to have recalled – or the one he created. But as the artist was perhaps aware, Maupassant's fascination with the images and colors of Parisian nights equaled his own, and in the summer of 1887 (i.e., during Van Gogh's residence in Paris) the author published an essay that evoked his concurrent love and fear of late-night strolls. Embellishing the sort of scene with which he opened *Bel-Ami,* Maupassant in an essay called "La Nuit" (but subtitled "Cauchemar" [Nightmare]) begins with a first-person, *flâneur's* account of the city at night:

I love the night with a passion. I love it as one loves one's country or one's mistress, with a deep, instinctive, invincible love. I love it with all my senses, with my eyes that see it, with my nose that breathes it, with my ears that listen to its silence, with all my flesh, which the darkness caresses. . . .

So last night I went out, as I do every evening, after my dinner. It was very nice out, very calm, very hot. As I went down toward the boulevards, I saw above my head the black and star-filled torrent cut from the sky by the rooftops of the street, which shaped this rolling rivulet of stars and made it undulate like a real stream.

Everything was clear in the thin air, from the planets down to the gas jets. So many lights sparkled up there and in the city that the darkness seemed luminous. Glittering nights are more joyous than sun-filled broad daylight.

On the boulevard, the cafés blazed; people laughed and strolled and drank. . . . I reached the Champs-Elysées, where the *cafés-concerts* looked like blazing hearths amid the foliage. The chestnut trees polished by yellow light had a painted look, the look of phosphorescent trees. And the globes of electric light, like pale, lustrous moons, like lunar eggs fallen from the sky, like huge living pearls, made the jets of nasty, dirty gas and the garlands of colored glasses go pale beneath their mysterious and regal nacreous luminosity.

I stopped beneath the Arc de Triomphe to look at the star-studded avenue . . . heading toward Paris between two lines of lights, and the stars! The stars up there, the unknown stars thrown randomly into the immensity where they outline those bizarre figures, which make one dream so much, which make one muse so deeply."[74]

Like Van Gogh, Maupassant was struck by the luminosity of the star- and lamplit city, and induced to dreaminess before the spectacle of the night sky. Though his stroll ends on a disturbing note (as the author describes his uneasiness in the lonely darkness of Paris in the wee hours), the night effects rendered in this short piece (which appeared in *Gil Blas*) are more sustained and more poetic than those given in the few and very earthbound descriptive sentences that open *Bel-Ami*, and its initial mood of exhilaration seems closer to the one Van Gogh attempted to inspire in both *Café Terrace at Night* and his nearly contemporaneous *Starry Night on the Rhône* (see Fig. 45). Van Gogh very likely read "La Nuit" and, if he did, may have mentally conflated it with the thematically similar opening of *Bel-Ami*, which he read in the same era. And even if he specifically recalled Maupassant's piece in *Gil Blas* as he worked on the *Café Terrace*, he may have referred his sister to the novel's roughly equivalent passages simply because the book was more accessible to her than a year-old periodical.

By day, the dusty, sun-bleached streets of Arles regained Van Gogh's attention, and the town struck him as decidedly less glamorous than its starry skies. He delighted, however, in its quirky, mundane realities, and in mid-October he told Theo, "It's a queer place, this native land of Tartarin's! Yes, I am content with my lot, it isn't a superb, sublime country, this; it is only a Daumier come to life" (LT552). That observation was linked to his completion of a new neighborhood painting, *Tarascon Diligence* (Fig. 40), the image of two of the old-fashioned coaches that still traversed France (despite its expanding rail system).[75] The foreground vehicle, marked "Service de Tarascon," clearly put him in mind of that town's famous fictional resident, for he asked his brother, "Have you read *Tartarin* yet? Be sure not to forget. Do you remember that wonderful page in *Tartarin*, the complaint of the old Tarascon diligence? Well, I have just painted that red and green vehicle in the courtyard of the inn" (LT552).

The passage from Daudet to which Van Gogh referred is found in the original Tartarin novel, *Tartarin de Tarascon;* it describes the hero's encounter, in Algeria, with a diligence from his faraway hometown. In Daudet's fanciful telling, Tartarin is bumping along in the creaky carriage and drifting to sleep when he hears his name spoken and demands to know who is addressing him.

"It's me, monsieur Tartarin; you don't recognize me? I'm the old diligence that made the run – twenty years ago – from Tarascon to Nîmes. . . . How many times

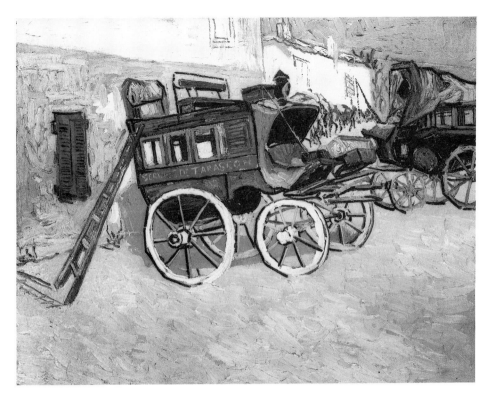

Figure 40. Van Gogh, *Tarascon Diligence,* 1888.

I carried you, you and your friends, when you went to hunt caps [*chasser les casquettes*]....As soon as you began your ride, you old rascal, I recognized you right away!" (*Tartarin de Tarascon,* pt. III, chap. 1)[76]

Astonished to find a Tarascon diligence so far from home, Tartarin wonders how the coach came to be exiled to Algeria.

"Ah! my good monsieur Tartarin, I didn't come here of my own free will, I assure you. Once the Beaucaire railroad was finished, they found me good for nothing and sent me to Africa. And I'm not the only one! Almost all the diligences in France were deported just like me."[77]

Inspired by the sight of a familiar face, the diligence falls into a reverie on their mutual homeland and regales Tartarin with poignant reminiscences. "How I miss it so, my beautiful Tarascon! What a beautiful road...wide, well-maintained, with its milestones, its little heaps of regularly spaced rocks, and to the right and left its pretty plains of olive trees and vines."[78] Having since seen hard times, the diligence – shamed by its shoddy appearance – recalls better days: "You had to see me leave in the morning, washed down and shining, with my wheels newly varnished, my lanterns looking like two suns, and my canopy always rubbed with oil!"[79]

Van Gogh's painting – which in light of Daudet's passage can almost be seen as a figural piece – would seem to return the exiled and delapidated stagecoach to familiar territory and its former condition; it is brightly painted in complementary hues and perched on almost luminous wheels. Though the scene he cited is set in Algeria, Van Gogh was working from a local motif, and while the sight of diligences in Arles called up a particular narrative, the artist made no effort to imbue his painting with anecdote or to allude in any specific way (apart from the inscription on the foreground coach) to the novel that impelled him to paint them. Despite his headful of literary reminiscences, storytelling remained antithetical to Van Gogh's way of working, even if the painting remained tied – in his own mind – to Daudet's "wonderful page" (see also LT571).

Though he assured Theo, "You will see it," Van Gogh included a drawing of *Tarascon Diligence* in his letter and gave a detailed description of its palette.

This hasty sketch gives you the composition, a simple foreground of gray gravel, a very, very simple background too, pink and yellow walls, with windows with green shutters, and a patch of blue sky. The two carriages very brightly colored, green and red, the wheels – yellow, black, blue and orange.... The carriages are painted like a Monticelli with spots of thickly laid on paint. You used to have a very fine Claude Monet, showing four colored boats on a beach.[80] Well, here they are carriages, but the composition is in the same style. (LT552)

The painting was thus rendered in the mode Van Gogh set his sights on in the South: a lively motif, directly observed, is presented with the Naturalist's (or Daumier's) eye for that which is amusing or arresting in everyday life and animated by Monticelli-like brushwork, the striking palette Monet had inspired, and a subtle allusion to a lighthearted prose passage.

The inexplicit nature of the painted literary allusions Van Gogh himself earmarked in his Arlesian oeuvre fosters supposition that others of his pictures from this era bear similar references to books, albeit unremarked in his letters. Particularly susceptible to this sort of interpretation is a group of lyrical and seemingly imaginative images of lovers enveloped in the splendors of southern nature, *Poet's Garden* (see Figs. 41, 43, 44), for although Van Gogh seems to have had little experience of outdoor courtship,[81] its delights were chronicled by both Zola and Maupassant in poetry and prose. The theme of romancing in a Provençal landscape introduced by Zola's early poem "Ce que je veux" was elaborated in the extravagant vision of a modern Eden that dominates *La Faute de l'Abbé Mouret*; Zola's overgrown garden, Le Paradou, is a paradigm of abandon that mirrors – hence encourages – his protagonists' sexual urges, and Van Gogh recalled that quasi-mythic

locale as he explored the similarly fecund grounds of the ruined monastery at Mont Majour in July 1888 (LT506). Just a few weeks earlier, he read and enthusiastically remarked on Maupassant's risqué ode to alfresco love-making, a poem entitled "Au bord de l'eau" (LT498),[82] which details its narrator's riverbank tryst with a lusty laundress and the months of passionate outdoor coupling that follow.[83] As in Zola's verse and prose, the southern landscape of "Au bord de l'eau" is presented as voluptuous and sensuous in and of itself – "The wind seemed to me charged with far-off amours / Heavy with kisses, full of warm breaths"[84] – and as such it becomes the couple's cohort in passion. Van Gogh's contemporaneous interest in Zola's and Maupassant's renderings of southern lovers very likely informed his several images of couples at Arles, whom he captured in garden landscapes and on the banks of the Rhône.

The public garden opposite his house on the Place Lamartine was a favorite subject for Van Gogh in the summer and early autumn of 1888; his first painting of it (F428) was made within days of a visit to Mont Majour (LT508).[85] According to the artist, this garden had varied sectors (LT539). The one nearest the Rhône was heavily trafficked, and Van Gogh's paintings of this area show a locus of such everyday activities as strolling, chatting, reading, and taking the sun (F470, F566).[86] He told Theo that this part of the garden was, for some "reason of chastity or morality, destitute of any flowering bushes such as oleander" (LT539). The oleander, according to Van Gogh, was a plant that "speaks of love" (LT587), and apparently he missed the sensuality such blossoming shrubs suggested when he walked in the Rhône side of the garden. Though he depicted the flowerless sector of this public park in several views, he seems to have been especially fond of its more secluded side, near the brothel-lined rue du Pont d'Arles (LT539).[87] This area was overrun with the oleander Van Gogh missed elsewhere; the shrubs there were, he wrote, "raving mad; the blasted things are flowering so riotously they may well catch locomotor ataxia" (LT541). Locomotor ataxia is a syphilitic nervous disorder that impairs coordination, and Van Gogh's comment – especially conjoined to that which opposed oleanders to chastity – suggests that he saw erotic innuendo in the shrubs' riotous bloom-ing. That Zola shared this point of view is indicated by the emphasis he places on the "unashamed" "abandon" with which Le Paradou grows and blossoms,[88] and the author's belief in the lust-inspiring piquancy of floral forms is made much more explicit by a remarkably bawdy passage from *La Faute de l'Abbé Mouret* wherein a bower of roses mimics feminine flesh and forms.[89] Thus, Van Gogh's own hints to Theo of the carnal connotations of blooming plants may well have relied on his and his brother's long-standing interest in Zola's novel.

It was the blossoming side of the public garden that inspired a series of

Figure 41. Van Gogh, *Round Clipped Shrub in the Public Garden: Poet's Garden II,* 1888.

four paintings Van Gogh called *Poet's Garden.*[90] The first of them (F468) is a pure landscape piece; the second, now lost, is known through drawings (Fig. 41), as well as the artist's verbal description. The focal point of this lost painting was a large clipped bush, the bulbous form of which was repeated in the row of shrubs behind it, "loaded with fresh flowers, and quantities of faded flowers as well, and their green is continually renewing itself in fresh, strong shoots, apparently inexhaustibly" (LT541). Near the oleanders were two sets of figures "sauntering along a pink path": a pair of Arlésiennes with parasols and a man escorting a female companion. Despite this marginal couple, Van Gogh noted that although he was working "in Monticelli's manner," "laying [paint] on thick," he had "not yet done the figures of lovers as [Monticelli] did" (LT541) – a reference, no doubt, to the deceased painter's revival of Rococo-inspired *fêtes galantes,* in which clusters of elegantly dressed young men and women animate garden settings (Fig. 42). Van Gogh addressed that omission – consciously, no doubt – in the third *Poet's Garden* painting (Fig. 43), wherein two brightly hued figures stand hand in hand: "lovers," Van Gogh wrote, "in the shade of the great tree" (LT552).

Though Monticelli's use of the motif surely spurred Van Gogh's conception of lovers in the out-of-doors, the actual renderings of amorous couples in the *Poet's Garden* suite are quite different from those of the Marseillais painter. Van Gogh's "lovers" are modern, working-class men and women in decidedly less frothy dress and surroundings than Monticelli's, and rather

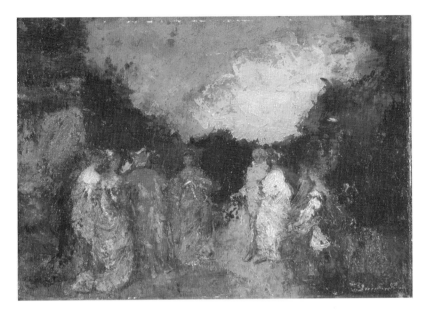

Figure 42. Adolphe Monticelli, *Promenade dans un Parc au Crépuscule*, 1883.

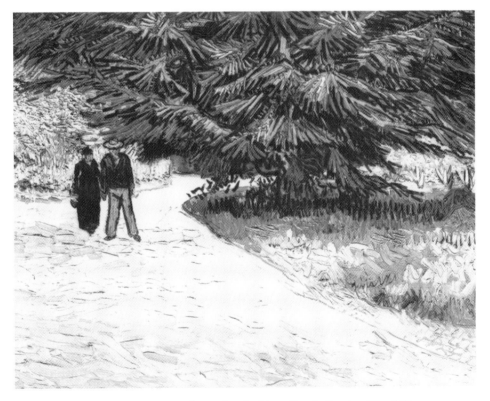

Figure 43. Van Gogh, *Couple under a Blue Fir Tree: Poet's Garden III*, 1888.

than socializing with others of their ilk, they appear in isolated twosomes (which is only infrequently the case in Monticelli's oeuvre). Van Gogh's southern couples seem to have more in common with Naturalist verbalizations than Monticellian prototypes; those who stroll through lush gardens, for instance, have close counterparts in Zola's Serge and Albine, whose favorite pastime is promenading the deserted alleys of Le Paradou:

> He had passed his arm around her waist. They came back under the high forests this way, the majesty of the vaults further slowing the promenade of these overgrown children awakening to love. She said she was a bit tired, and leaned her head against Serge's shoulder. Neither one, however, spoke of sitting down.... What joy could they have gotten from a rest on the grass, compared with the joy they continued to savor walking side by side?... And it was the trees – the maples, the elms, the oaks – that whispered to them their first words of endearment. (*La Faute de l'Abbé Mouret*, pt. II, chap. 11)[91]

Zola's odes to outdoor courtship seem particularly pertinent to the final painting in the *Poet's Garden* series (Fig. 44), in which a couple dominates. Alone on a broad, tree-lined path at twilight, the frontally positioned figures stand at the painting's lower edge, as if on the verge of entering the viewer's space. They occupy a more open and less specific site than those featured in other paintings of the suite, and this picture's crepuscular light sets it apart from its sunlit counterparts. It is the most blatantly "poetic" of the four views and seems more indebted to inspired invention than to particular seen motifs. Van Gogh described this now-lost picture as "a row of green cypresses against a pink sky with a crescent moon in pale citron. An indefinite foreground, sand and some thistles. Two lovers, the man in pale blue with a yellow hat, the woman with a pink bodice and black skirt" (LT556). Apart from their costumes, the figures are, like the foreground they inhabit, indistinct; like most of Van Gogh's Arlesian couples, they have nearly featureless faces and the stiff, regularized postures of stock figures. Rather than glimpsed individuals, they suggest types – or indeed, conjoined, a single "type": the generic motif of lovers – who owe their existence to the artist's imaginings before a sensuous natural scene.

The collective title Van Gogh gave this suite of pictures suggests their relation to literature (or, at least, to literary reminiscences). Though Ron Johnson has made an eloquent case for the series's connection to the Italian and Provençal poets Van Gogh invoked at Arles[92] (Dante, Petrarch, and Boccaccio; Frédéric Mistral and Clovis Hugues),[93] it is probable that the imagery of Naturalist authors – with which Van Gogh was much more familiar – had a more specific impact on the way he envisaged modern courtship in the Midi.[94] Indeed, in an image like *Poet's Garden IV* the painter perhaps satisfied at last his earlier-stated desire to "someday attack a Paradou subject" (LT287). As in *La Faute de l'Abbé Mouret*, the amorous nature of the figures' relationship is underscored, in Van Gogh's picture, by purpose-

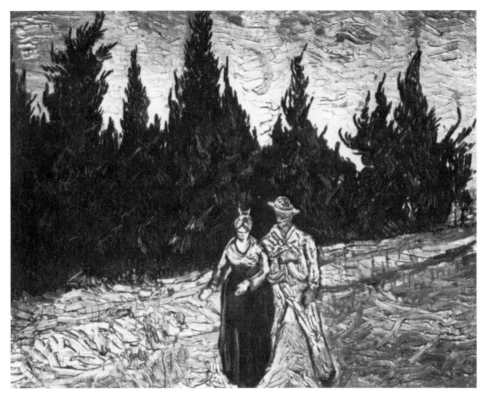

Figure 44. Van Gogh, *Couple in a Lane of Cypresses: Poet's Garden IV*, 1888.

fully enriched surroundings. The scene's unexpectedly vibrant coloration may be linked to the artist's aim (outlined in early September) to develop a language of color with which he might "express the love of two lovers by a wedding of two complementary colors, their mingling and their opposition, the mysterious vibrations of kindred tones" (LT531). The moonlit path screened by cypresses silhouetted on a pink-tinted sky seems engineered for romance, and Van Gogh's image bears comparison to a similarly scripted verbal one from Zola's novel – a scene in which animate nature is assumed to take an active interest in the courtship it nourishes:

As [Serge and Albine] left the forest, twilight had fallen, the moon was rising, yellow, amid the blackening greenery. And it was a delightful return, through the middle of the park, with this discreet star that watched them through the gaps in the great trees. Albine said that the moon was following them. The moon was very soft, warmed by stars. Far off, a great murmur arose from the forests, which Serge listened to, thinking, "They're talking about us." (*La Faute de l'Abbé Mouret*, pt. II, chap. 11)[95]

Another Arles landscape in which spectacular scenery serves as the backdrop for love is *Starry Night on the Rhône* (Fig. 45), a view of the riverbank opposite the gaslit town. As described by Van Gogh, this painting depends on a wide palette of contrasting hues for its effect:

The sky is greenish blue, the water royal blue, the ground mauve. The town is blue and violet, the gas is yellow and the reflections are russet-gold down to greenish-bronze. On the blue-green expanse of sky the Great Bear sparkles green and pink; its discreet pallor contrasts with the harsh gold of the gas. (LT543)

Two colorful little figures of lovers in the foreground. (LT543)

Like his *Café Terrace at Night, Starry Night on the Rhône* was painted from nature, with special attention to night light (LT543). Here, however, the businesses and dwellings of Arles are pushed to the background as the artist records an undeveloped stretch of riverfront, along which lovers walk arm in arm. This subject matter suggests that the painter's thoughts may have turned to "Au bord de l'eau" as he painted it, though perhaps equally important to the picture's inception were Maupassant's prose renderings of splendiferous night scenes. In *Starry Night on the Rhône,* as in the final picture of the *Poet's Garden* series, landscape and figures complement one another to evoke a sense of ardor. The lovers' environs can be seen to foster and enhance their embrace, and such a reading is encouraged by knowledge of the artist's recent remarks on – and evident fondness for – *La Faute de l'Abbé Mouret* and "Au bord de l'eau." Van Gogh labeled both *Starry Night on the Rhône* and the *Poet's Garden* series "romantic landscapes" (LT547) and told his brother: "I know that it will do some people's hearts good to find poetic subjects again, 'The Starry Sky,' 'The Vines in Leaf,' 'The Furrows,' the 'Poet's Garden' " (LT545). In such intentionally "romantic" and "poetic" paintings as these, Van Gogh would seem to aspire to the goal he set for southern painters of the "next generation": to image the "gaiety and happiness... hope and love" he deemed essential, in the rich and daring manner he equated with Naturalist verbalization.

MORE PAINTINGS WITH BOOKS

In Arles as in Paris, the most straightforward of Van Gogh's painted homages to literature were those pictures that featured books as motifs, and in 1888 the artist began to include bound volumes in figural pieces as well as still lifes. Titled or untitled, the books appear to be contemporary paperbacks, and the majority probably were novels; indeed, Van Gogh titled his painting of a woman reading a nameless yellow book (see Plate 13) *Une Liseuse de romans* (A reader of novels). He produced book pictures on a fairly regular basis while at Arles; the first (Fig. 46) was made within a month of his arrival, the last (see Fig. 51) as he contemplated his departure to St.-Rémy.

When Van Gogh reached the South in February 1888, he found the weather surprisingly cold, and the town blanketed by snow. As a result, some of his earliest work consisted of still lifes, including one small study of "an almond branch already in flower in spite of [the snow]" (F392;

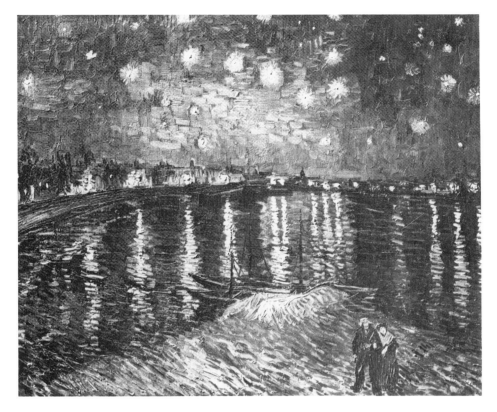

Figure 45. Van Gogh, *Starry Night on the Rhône*, 1888.

LT466), and another rendering of the blossoming sprig in company with a fat yellow book (Fig. 46). Though this pairing of book and blossom might be attributed to mere availability (books being ever close at hand in Van Gogh's varied lodgings), the artist's preestablished predilection for conjoining books and plant life (see Plate 6/Fig. 17 and Plates 7, 8) occasions the surmise that some level of meaning was intended and that in coupling the flowering branch (an emblem of new life)[96] and yellow paperback (probably a modern novel) he meant to highlight the vitality he ascribed to contemporary literature.

The *Still Life with Almond Branch and Book* (Fig. 46) was destined to serve a special cause, for upon its completion, Van Gogh put it aside for his sister Wil (W3). As a birthday gift to this favored sibling, his painting complemented the artist's sustained verbal promotion of modern French fiction; Van Gogh scarcely ever wrote Wil a letter in which he did not "urge" (W7), "strongly advise" (W8), or at least "warmly recommend" (W3) that she read some book or series of books by his favorite writers. Evidently it was on her brother's advice that Wil first read the Naturalists (W9), and though she

was not always so enthralled by their work as he was (W14), she eventually read much of what he recommended. Van Gogh felt such exposure would broaden her horizons and update her outlook (W1), and he came to believe that her familiarity with Naturalist practice eventually benefited her own prose style as well.[97] His decision to present her with the *Still Life with Almond Branch and Book* surely was intended to inspire his sister's further acquaintance with such volumes, and at the same time it was offered, Van Gogh promised Wil another, larger still life with French books (probably from his Paris period), which apparently is lost: "As I should very much like to give you something of my work that will please you, I have set aside a little study of a book for you, and also, on a somewhat larger scale, a flower, with a lot of books with pink, green and bright red bindings – they were my set of seven Parisian novels, the same subject" (W3).[98]

At Arles Van Gogh made a third variant on the theme of Parisian novels (Plate 2), a horizontal canvas littered with haphazardly stacked paperbacks – but no flowers. As in his extant Paris painting of the same title (Plate 7), the Arlesian version of *Romans parisiens* features untitled books of varied hues (most of them yellow and gold); in titling his picture (LT555), however, the artist gave clear indication of the sorts of books presented. Like the earlier still life, this one includes a foreground volume that is open and oriented toward the viewer, and though it lacks a legible text, the outspread volume seems to solicit an audience for modern literature. The books of the Arles picture are more casually arranged – on an upward-tilting tabletop covered by a pink cloth – and seen from a closer and somewhat higher vantage point that enhances effects of immediacy. The seeming spontaneity of this rendering of his library is also implied by Van Gogh's brushwork; the fussy pseudo-Pointillism of the earlier work is replaced by a loose impasto that creates broad expanses of flat, unbroken color. Like its predecessor, this painting documents the artist's familiarity with and affection for such books, and the Arlesian *Romans parisiens* is as exuberant a tribute to modern French novels as Van Gogh ever painted.

Another of Van Gogh's 1888 still lifes with books, *Oleanders* (Plate 9), includes a clearly titled copy of Zola's *La Joie de vivre* – the same novel he included in the foreground of his first book picture, the *Still Life with Bible and French Novel* (Plate 5) painted at Neunen three years before. Though Van Gogh did not mention *La Joie de vivre* in letters from Arles,[99] he may have had a copy of it with him there or may simply have scratched in its title in reminiscence of the book – and of his earlier still life.[100] The novel's inclusion in both paintings inevitably links them, and such linkage almost certainly was foreseen and ordained by the artist. By this device, Van Gogh seems to ask the viewer to measure the difference between the two paintings, and if Zola's novel is a constant, almost everything else about the pictures

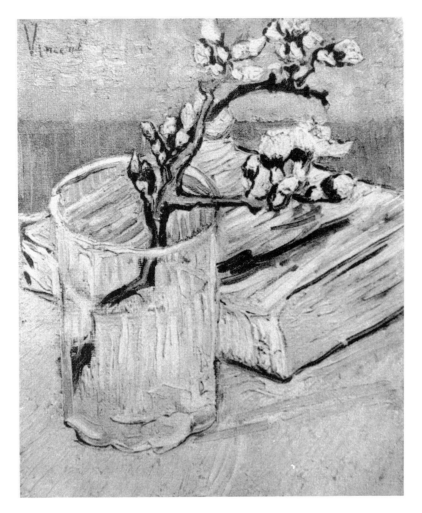

Figure 46. Van Gogh, *Still Life with Almond Branch and Book,* 1888.

points to the distance their maker had traveled in the interval: not just from Holland to the Midi, but from a tradition-bound palette and style to an intently modern and personal one, based on Zolaesque convictions.

Though *Oleanders* surely was painted from real objects in the studio, Van Gogh took liberties with the seen in order to intensify visual effects and conjure mood.[101] The complementary color play of the red and green flowers and leaves was heightened, for instance, by the artist's decision to paint the wall behind the arrangement with a highly textured yellowed chartreuse, despite the fact that his studio walls were whitewashed (LT509, LT534). This yellow-green expanse is countered by the broad area of pink created by the tablecloth, a pink that darkens to lavender in shadow areas and, in addition to contrasting the wall, complements the golden books and their yellow aura. A luminous and decidedly arbitrary red outline encloses the

whole, and though the general effect of *Oleanders* is "realistic," this is a reality tempered by the artist's predilections and consequent manipulations.

The emotional tenor established by the palette and motifs of *Oleanders* is notably different from that of its dreary predecessor. Though the French paperback continues to occupy a peripheral area of Van Gogh's composition (here, as in *Still Life with Bible and French Novel*, the precariously positioned softbound book seems on the brink of falling from the table), *La Joie de vivre* – and the hedonistic pleasure its title implies – has, in the Arles painting, no sobersided opponent, but instead a congenial context. Zola's novel rests atop a kindred volume (untitled, but of similar form and binding) and is flanked by an arrangement of flowering branches in a majolica jug. Van Gogh apparently intended that the book's title (a phrase Zola used ironically) be taken at face value in *Oleanders;* the Arles painting, with its centerpiece of spritely leaves and blossoms (cut from the shrub Van Gogh associated with sensuality and love; LT539, LT587) and its bright modern novels, is plausibly interpreted as a paean to life's joys and a testament to the particular pleasure Van Gogh took in both nature and its artistic interpretation (in both word and image).

As a signifying component of the *Still Life with Bible and French Novel*, Zola's book seems to represent modernity and hope in the face of old-fashioned values (the Bible) and human mortality (the extinguished candles). The volume's reappearance in a transformed setting, three years later, might be seen to suggest that Van Gogh saw the stoicism and hopefulness epitomized by the novel's heroine, Pauline Quenu (and emulated by the artist himself in a trying era), finally rewarded. When paired with its predecessor, *Oleanders* may be considered a self-devised tribute to its maker's own perserverance and to the strides made since the depressing months at Neunen, when he struggled with the awkwardness of his early production, rebutted his brother's epistolary critiques, and lived amid shadows cast by his father's censure and death. By mid–1888 Van Gogh had retooled his life and art, and the palette, paint handling, and celebratory nature of his chosen motifs reflect the confidence he felt in his decisions. The yellow novels – with their implications of modernity and artistic daring – are buttressed by the liveliness of the oleander, a plant Van Gogh admiringly described as "flowering riotously" and "renewing itself inexhaustibly" (LT541). Thus characterized, oleander is an apt metaphor of creative energy, particularly of Van Gogh's own relentless activity in the summer of 1888. In this picture, as in others before it, the juxtaposition of plant life and modern novels stems from Van Gogh's tendency to view both motifs as emblematic of generative power.

It is in Van Gogh's Arlesian oeuvre that the books that animate his still lifes move beyond that realm and into figural pieces, where they lend a cultivated

and thoughtful aura to the personalities evoked and (as in prior contexts) continue to reflect the artist's own esteem for and allegiance to modern literature.

The first of these book-enhanced figural works was made in November 1888, when Van Gogh and Gauguin (who had recently joined him at Arles) persuaded Marie Ginoux, a café owner's wife,[102] to sit for them. Van Gogh, who had been eager to paint a local woman for some months, announced the event with satisfaction, telling Theo, "I have an Arlésienne at last" (LT559). The immediate results of the session with Ginoux were a hastily rendered half-length oil portrait by Van Gogh (Fig. 47), which the artist claimed he had "slashed on" in an hour or less (LT559, LT573), and a careful Conté crayon sketch by Gauguin (see Fig. 58). Both renderings were rehearsals for more finished works by their respective artists, Van Gogh's *L'Arlésienne* (Plate 10) and Gauguin's *Night Café* (Fig. 48).

Van Gogh's two portraits of Ginoux are of almost equal dimensions and show the model seated in a wooden chair and leaning onto a round table set against a bare yellow wall. In each, Ginoux's dark coloring, traditional ribboned headdress, and embroidered fichu establish her regional identity. Moreover, Van Gogh painted her at a three-quarters angle that emphasizes the Roman profile he had identified as one of the Arlésiennes' most striking features (LT482). His delineations of the model are so similar from one version to the next that one writer has called the two paintings "almost identical so far as the portrait itself is concerned."[103] Indeed, at first glance, their differences seem mainly formal – and linked to their respective degrees of finish. The earlier work is more tentatively drawn and colored, and the sitter's face, in particular, is pale and blurred; the second version is more focused and authoritative, its forms crisply defined and infilled with saturated and heavily impastoed color.

The only compositional disparity between the two *Arlésienne*s resides in the contents of their respective tabletops. There, however, a seemingly minor change has substantial ramifications, for the overall effect and meaning of Van Gogh's two portraits is significantly differentiated by the marginal still life included in each. Whereas the parasol and gloves of the first painting seem to constitute the normal accessories of a woman about town in sunny, dusty Arles and indicate that their owner is seated in some public place (which, given the record of her sitting, we may assume to be her husband's café), a very different ambiance is established by the scattering of books in the second version. The well-thumbed paperbacks of the later painting (one of which lies open before the sitter) suggest a more private realm and lead one to interpret Ginoux's pose as one of high-minded reverie. By extension, the faraway gaze that connotes absent-minded distraction in the first painting seems, in the second, to result from thoughtful musing on the printed word.

Figure 47. Van Gogh, *L'Arlésienne (Mme. Ginoux)*, 1888.

Figure 48. Paul Gauguin, *The Night Café*, 1888.

It would seem that Van Gogh's first portrait of Ginoux constituted a quick and relatively unmediated response to the café owner's wife as he routinely saw and knew her. The second picture, by contrast, may be seen as an abstraction of the original – in both form and content. In it, Van Gogh refined the image, strengthening contour and color and sharpening contrast. Its heightened focus and clarity are not merely issues of style, but indeed complement the altered persona of the woman depicted. By honing her image and manipulating her surroundings, Van Gogh literally transformed Ginoux; the bored barfly of the first *Arlésienne* (an image that is consonant with Gauguin's characterization of Ginoux in his *Night Café*) became, in Van Gogh's second take, an intent reader – and in this incarnation she is as much a reflection of the artist as of his model.

What little is known about Ginoux gives no indication that she shared Van Gogh's literary enthusiasms. Though the artist's letters indicate his eagerness to exchange literary asides and appraisals with some of his Arlesian neighbors and with almost all of his correspondents, his remarks on the Ginouxes – and the four extant letters he wrote to them (LT622a, LT626b, LT634a, LT640a) – hold no mention of books or reading. It is therefore

unlikely that Marie Ginoux had a predilection for literature, and it is even less likely that she knew the sorts of books Van Gogh included in the second *Arlésienne,* which – by virtue of their colorful paper bindings – are readily identified as the same sorts of volumes he had painted and labeled "romans parisiens" – that is, Naturalist novels. According to Theo van Gogh, the library of recent French literature that he and Vincent amassed in the 1880s comprised several books that "one can hardly discuss, at least with ladies" (T1a). Few provincial women, even the most "literary," read such books in this era, and the novels' presence in *L'Arlésienne* surely reflects Van Gogh's taste, not Ginoux's.

In portraying Marie Ginoux before his own battered books, Van Gogh probably sought to make her look not just literary, but modern, for as he had told his sister the year before, "One can hardly be said to belong to one's time if one has paid no attention to [French Naturalism]" (W1). His belief in the importance of literary endeavor fostered Van Gogh's interest in other artists' representations of readers, and together they led him to conclude that the reader was an ideal modern type. As early as 1879 he wrote appreciatively of one of Ernest Meissonier's many pictures of readers (LT130), and he continued to esteem that facet of Meissonier's oeuvre even when his general admiration for the artist diminished (LT623; see also LT542, LT590, LT594). Van Gogh was especially fond of a Meissonier portrait in which the sitter was portrayed with a book in one hand, holding his place with a finger as if caught in midpassage, and he noted the "same idea" in a painting of "modern man" made by Albert Besnard c. 1883 (LT602).[104] Besnard's paired images of primitive and modern man figure prominently in a suite of panels he made for the Ecole de Pharmacie in Paris; whereas the primitive, in a swampy landscape, hunches over a crude sketch, his modern counterpart lolls in a loggia overlooking a bustling port, book in hand (Fig. 49, Plate 11).[105] Van Gogh felt that the paintings of Meissonier and Besnard struck what he called a "nineteenth-century note" (LT602), and he ascribed a comparable achievement to Pierre Puvis de Chavannes, whose painting of an "old man reading a yellow novel" (Plate 12) seemed to him an "ideal" figure (LT617).[106] He felt that Puvis's painting of the reader presented "modern life as something bright, in spite of its inevitable griefs" (LT617), and surely some such intent on his own part motivated the transformation of Ginoux.

The readers of Meissonier, Besnard, and Puvis are spiritual antecedents of the second *Arlésienne.* All of them, however, are men. The gender of Van Gogh's reader sets her apart and documents the painter's notably unbiased attitude toward the literary pursuits of women. Unlike his brother (and many of their contemporaries), Van Gogh considered Naturalist novels to be not just acceptable but desirable reading for women, and whereas Theo labeled them "forbidden fruit" for women (T1a), Vincent urged them upon their

Figure 49. Albert Besnard, *l'Homme moderne,* c. 1883.

sister. The campaign he waged to influence Wil's literary predilections may help to explain the artist's desire to foist modern novels on his image of *L'Arlésienne:* As he sought to mold his sister in life, so – in paint – did he reshape Ginoux, rendering her a modern, literate woman of sensibilities similar to his own. Van Gogh's chosen life-style limited his interaction with women of his own class and intellectual disposition, and he had long since confessed that he had little hope of painting "respectable" women, "girls such as our sister" (LT395). The changes wrought in the second *Arlésienne* manifest his desire to paint a different sort of female subject and demonstrate his willingness to re-create a sitter in accordance with his own ambitions. In formulating his image, the painter co-opted a familiar figure for use in a picture that stands midway between portraiture and wishful thinking – one that serves to remove the sitter from her own world and make her a part of his. Such a reading would seem to shed light on the spirit of conquest and possession implicit in his phrase "I have an Arlésienne at last."[107] Having captured Ginoux as she was, the artist set about making her into the woman he would have her be: an idealized other who was likewise a surrogate self.

This thesis is buttressed by the existence of a third figural piece, *Une Liseuse de romans* (Plate 13). This image of a reader (another half-length woman) was painted within days of the two *Arlésienne*s. Clearly Van Gogh's second *Arlésienne* formed a juncture between his first painting of Ginoux – a portrait made from life – and *Une Liseuse de romans*, a picture Van Gogh attempted to paint "from pure imagination" (W9). Gauguin had been encouraging him to rely on memory to invent compositions, and *Une Liseuse* was one such effort (LT562, W9), though her features, costume, and coiffure surely derive from recent work on the Ginoux portraits. That this imagined woman should be seated in a library, reading a yellow book (i.e., a modern novel) with wide-eyed attention, reflects the artist's conviction that everyone

should read and suggests anew that his conception of the ideal woman included a devotion to modern fiction that was modeled on his own. In *Une Liseuse*, the purposeful tinkering with reality that Van Gogh began in the second *Arlésienne* was made complete and resulted in an idiosyncratically conceived paradigm of modern womanhood.

Though she and her costume are dark in tone, the *Liseuse* is set against a bright background, which glows not only with the lamplight at upper left, but with the warmth of the radiant yellow books that occupy the picture's right side. Describing *Une Liseuse* to his sister, Van Gogh wrote only of its palette: "The luxuriant hair very black, a green bodice, the sleeves the color of wine lees, the skirt black, the background all yellow, bookshelves with books. She is holding a yellow book in her hands" (W9; see also LT562). The painting's colors and tonalities emphasize the books' relation to light and conform to Van Gogh's notion that modern literature was at once figuratively and literally illuminating. The artist later made this notion quite clear as he envisioned painting a Parisian bookstore – "an essentially modern subject," he wrote, "because it seems to the imagination such a rich source of light" (LT615).

Books and light were paired again in *Gauguin's Chair* (Plate 14), a portrait of sorts that was made in late November. Though Gauguin painted Van Gogh's likeness during their brief cohabitation, Van Gogh (for reasons he did not articulate) never took his housemate as a model,[108] but instead commemorated Gauguin in what he described as a "study of his armchair of somber reddish-brown wood, the seat of greenish straw, and in the absent one's place a lighted torch and modern novels" (LT626a). The monumentalized chair fills the canvas and is almost figural in form and scale. One of a series of sitterless chairs in Van Gogh's oeuvre,[109] it seems to have been inspired by the painter's recollection of an image made by English graphic artist Luke Fildes on the day after Dickens's death: the author's study, with his vacant seat at its center. Titled "The Empty Chair," Fildes's print appeared in the Christmas issue of *The Graphic* in 1870; when Van Gogh came across it some years later (in 1882), he found it a "touching" and appropriate acknowledgment of the gap left by a deceased talent (LT252).

Though Gauguin was very much alive, Van Gogh seems to have sensed his colleague's increasing displeasure and unease with life in Arles (see LT565), and in painting the unoccupied chair he probably was anticipating Gauguin's inevitable departure. With this image of "his empty seat" (LT626a), Van Gogh memorialized a soon-to-be-absent friend and, beyond that, the demise of their camaraderie. The elegiac connotations of the vacated place are counterbalanced, however, by the hopeful and life-affirming motifs that fill the void: The chair's usual occupant has been replaced by a burning candle and bright paperbacks, which, conjoined, suggest enlightened mo-

dernity. Whether Van Gogh saw the books as potential substitutes for Gauguin's company or as allusions to the intellectual acuity and cutting-edge production he ascribed to his colleague (or both) is uncertain, but the still life's general connotations of illumination and vigorous contemporaneity are unquestionable. Moreover, many viewers have noted the phallic positioning of the candle and the virility implied by its erectness and its flame.[110] This reading is perfectly congenial to the books' previous unions with emblems of germination (bulbs, flowers, blossoming branches) and with Van Gogh's assessments of their author's robust styles and creative potency[111] – here linked, apparently, to his admiration for similar qualities in Gauguin and his oeuvre.[112]

GAUGUIN AT ARLES: A SYMBOLIST CHALLENGE

Paul Gauguin had arrived in Arles in late October, after months of urging and cajoling by both Vincent and Theo van Gogh. Though happily ensconced in Brittany and surrounded by friends and admirers there, Gauguin was plagued by poor health and financial worries, and Theo's promise of a modest stipend – in addition to free room and board at the house in Arles – prompted his move.[113] He remained unimpressed, however, with the region Vincent had championed in letters, and according to his memoir, *Avant et après*, Gauguin found Van Gogh a messy and quarrelsome housemate. In the end, their partnership endured a mere nine weeks, but as Gauguin recalled it later, "That whole time seemed like a century to me."[114]

Personal incompatibility exacerbated Van Gogh's and Gauguin's pronounced artistic differences. Though only five years younger than his colleague, Van Gogh deferred to Gauguin as a superior artist, and Gauguin took that deference as his due.[115] In a letter to Bernard, he characterized Van Gogh as a Romantic and denigrated his love of impasto and complementary color contrast.[116] Gauguin himself preferred thin paint on highly textured canvas (or burlap) and closer-keyed color harmonies. More important, however, he advocated working from the imagination to invent evocative subjects and had no qualms about imaging the supernatural – as in his major work of 1888, *The Vision after the Sermon: Jacob Wrestling with the Angel,* which was completed only a few weeks before his appearance at Arles. Though Van Gogh considered Gauguin a "poet" (LT544a) and a "very great artist" (LT562), imagined subject matter had always made him uneasy; in July, for instance, Van Gogh "scraped off a big painted study, an olive garden, with a figure of Christ . . . because I tell myself that I must not do figures of that importance without models" (LT505). By November, however, he had become more experimental, explaining to Theo that "Gauguin gives me the courage to imagine things, and certainly things from the

imagination take on a more mysterious character" (LT562). Still, Van Gogh remained wary of wandering too far from things seen, and his few "abstractions" (Van Gogh's term for imagined subjects; see B21) relied on motifs recalled from nature and/or other pictures.[117] Invention was neither his forte nor his interest, and his stubborn attachment to an art based on direct observation prevented his full embrace of Gauguin's beliefs and practice. A year later (in the fall of 1889) he repented of his prior flirtation with "abstraction" and warned Bernard that its "charming path" led to a "stone wall" (B21).

Van Gogh's theoretical quarrel with Gauguin[118] can be characterized as one of a series of skirmishes in the primary aesthetic the battle of 1880s: Naturalism versus Symbolism. Whereas Gauguin hoped to give form to his own dreams – "objectifying the subjective," as Gustave Kahn had advocated[119] – Van Gogh continued to "subjectify the objective (nature through a temperament),"[120] in the manner of his literary models. Gauguin was not entirely wrong to label him a Romantic, for Van Gogh (ever more appreciative of Delacroix during his time at Arles; see, e.g., LT520, LT539, LT542) had long acknowledged and lauded the Romantic elements of Naturalism. In November 1885, for instance, he noted: "Romance and romanticism are of our time, and painters must have imagination and sentiment. Fortunately realism and naturalism are not free from it. Zola creates, but does not hold up a *mirror* to things, he creates *wonderfully*, but *creates*, *poetizes*, that is why it is so beautiful" (LT429; his emphasis). Van Gogh was interested in doing much the same thing in the visual sphere, studying his surroundings and contemporaries with a keen eye and registering them with candor, but at the same time feeling free to exaggerate what he saw and/or use expressive color to render the real "poetic" and the natural artful. His convictions were affirmed not only by Zola's prose, but in the practice of other Naturalists – most notably, at Arles, Maupassant and Daudet – and more specifically by the sermon on artistic license that Maupassant preaches in the preface to *Pierre et Jean*.

Relations between Van Gogh and Gauguin became increasingly strained and in mid-December took a particularly emotional turn. Van Gogh wrote of "terribly *electric*" arguments from which they emerged with "heads as exhausted as a used battery" (LT564; his emphasis), and Gauguin later recalled that his decision to leave Arles was precipitated by a drunken dispute in which Van Gogh threw an absinthe glass at him.[121] Two days before Christmas, according to Gauguin, Van Gogh confronted him in the public gardens and threatened him with a razor. Gauguin took a room for the night, and Van Gogh – alone at home – turned the razor on himself, severing a part of one ear and consequently losing a good deal of blood. Van Gogh was hospitalized the following day, and Theo summoned from Paris. Gau-

guin left Arles in haste and never again saw Vincent, who remained at the hospital until 7 January.

LITERARY CONSTRUCTS AND CONSOLATIONS IN THE LAST MONTHS AT ARLES

As in other times of crisis (most notably the period following his dismissal from the evangelical post he had held at the Borinage in 1879) Van Gogh in the wake of his first nervous collapse took refuge in literature. He found that fictional situations not only provided escape from his own problems and anxieties, but also suggested metaphors for his dilemma and modes of describing and explaining the events he sought to reconstruct. Demoralized by his breakdown and by Gauguin's defection from the "studio in the South," Van Gogh mulled at length on what went wrong, and when he finally devised his own version of the story, it was a narrative dependent on literary allusion. In a long letter of mid-January, he recalled the Christmastime drama and attempted to clarify his own role and position by directing Theo (and Gauguin) to *Tartarin sur les Alpes:*

Has Gauguin ever read *Tartarin* in the Alps, and does he remember Tartarin's illustrious companion from Tarascon, who had such imagination that he imagined in a flash a complete imaginary Switzerland?
 Does he remember the knot in a rope found high up in the Alps after the fall?
 And you who want to know how things happened, have you read *Tartarin* all the way through?
 That will teach you to know your Gauguin pretty well.
 I am really serious in urging you to look at this passage in Daudet's book again.
 At the time of your visit here, were you able to notice the study I painted of the Tarascon diligence, which as you know is mentioned in *Tartarin* the lion hunter?
 And can you remember Bompard in *Numa Roumestan* and his happy imagination?
 That is what it is, though in another way. Gauguin has a fine, free and absolutely complete imaginary conception of the South, and with that imagination he is going to work in the North! My word, we may see some queer results yet. (LT571)

Tartarin's "illustrious companion from Tarascon" was none other than Bompard, whose "happy imagination" was introduced in *Numa Roumestan*[122] and revived by Daudet for *Tartarin sur les Alpes.* A dreamer of exotic places, Bompard is also an extravagant liar, who outdoes even his fellow Tarasconnais in the telling of tall tales. As a complement to his own self-identification with Tartarin, Van Gogh retrospectively associated Gauguin with Bompard, and in a separate letter to that artist he urged his erstwhile cohort to read the Tartarin saga in its entirety.[123] It was the letter he sent to Theo, however, that clarified that which Van Gogh expected Gauguin to deduce from such a reading: In LT571 he singled out the climactic

scene of *Tartarin sur les Alpes* and paralleled it to what had transpired between him and his housemate at Arles. In the passage Van Gogh earmarked, Tartarin and Bompard, faced with the danger of traversing a blinding Alpine blizzard, decide, for safety's sake, to tie themselves to separate ends of the same rope. Each vows to lend his companion support, come what may: Should either hiker lose his footing, the other promises to help him regain it, even at risk to his own balance. This pledge is put to the test when the rope that joins them becomes knotted in a crevice and holds tight, causing each man to feel a tug as he tries to advance. Each, in his panic, abandons his promise to support the other and instead decides to save himself by cutting his companion loose. (The rope is later found with a knot at its center and two cleanly cut ends.) The hikers wander away from each other in the storm, but each survives it and makes his way back to Tarascon, guiltily believing that he let the other fall to his death. When they meet again at home, Tartarin and Bompard greet each other with a mix of relief and shame, both aware that – in typical Provençal fashion – they were more heroic in word than deed.[124]

In offering this allusive version of his break with Gauguin, Van Gogh sought to portray their cohabitation as equivalent to a pledge of alliance and mutual support, an agreement to join forces in a treacherous environment (the art world of the late 1880s?) and help each other to survive. He seems to have believed (or wanted to believe) that their final confrontation was the result of mutual betrayal in a moment of confusion, that he and Gauguin had – in the manner of their fictional counterparts – acted in panic and on the basis of false assumptions. This interpretation perhaps allowed Van Gogh to hope that their falling-out was not irreversible, that he and Gauguin might meet again in calmer circumstances and acknowledge their common error. In his own defense, however, he stressed his belief that the Bompardesque Gauguin was exaggerating and imagining things and, further, had never given life in the South a fair chance of success.

The verbal construct he presented Theo indicates the extent to which experienced literature shaped Van Gogh's perceptions and his modes of expressing himself. In trying to explain – to himself as much as to his brother – one of the most emotionally charged incidents of his life, Van Gogh cloaked his recollections in metaphor, relying on pointed reference to a (farcical) fictional situation to convey his sentiments and justify his actions. Two weeks later, he again sought vindication for his agitated state in Daudet's parodic portrayals of Provence when he admitted, "There certainly are signs of previous overexcitement in my words, but that is not surprising, since everyone in this good Tarascon country is a trifle cracked" (LT575).

Meanwhile, as he struggled to regain emotional equilibrium and rebuild his life in the South, Van Gogh in his work fixated on an image tinged by

literary reminiscence and charged with private meaning: *La Berceuse*. In the first months of 1889 he made five nearly identical paintings of Augustine Roulin in the role of this motherly cradle rocker (Fig. 50).[125] The model was in real life married to Van Gogh's friend the postman, and she recently had given birth. In late November the artist set to work on portraits of the entire Roulin family, painting not only the postman-patriarch, Joseph (whom he had painted before), but also his wife, sons, and infant daughter. The first paintings of Mme. Roulin show her holding her baby (F490, F491), but in subsequent sittings Roulin posed on her own for both Van Gogh and Gauguin, and just a few days before his breakdown Van Gogh began the painting that he later titled *La Berceuse*. Completed in late January, it is a picture in which the sitter's maternal role continues to be highlighted, despite her baby's absence. Its title (inscribed on the picture surface, at lower right), which means both "the lullaby" and "the woman who tends the cradle," elucidates the motif of the rope in Roulin's lap, which indicates the means by which the cradle is rocked, and hence suggests its presence (and that of an infant occupant) before her. The model's ample bosom and hips can be seen as other parts of her motherly apparatus, and the full-blown flowers of the background wallpaper might be read as further emblems of her fruitfulness.

A second, almost identical version of *La Berceuse* was begun on the heels of the first, and by the end of January the artist made a third. A fourth version was in progress by the first week of February, and (following a second nervous collapse and hospitalization) Van Gogh announced his intention to paint a fifth in late March. The very existence of these five paintings (F504–508) – one quite similar to the next in size, composition, and detail – gives indication of the resonance the image held for the artist in an era of illness, upheaval, and depression, and the wish he articulated in an April letter to Theo – "Sometimes, just as the waves pound against the sullen, hopeless cliffs, I feel a tempest of desire to embrace something, a woman of the domestic hen type" (LT587) – would seem to shed light on his obsession with the motherly matron of his painting. Surely his unfulfilled longing for a stabilizing female presence (which Van Gogh attributed to "hysterical overexcitement" [LT587]) informed his conception of *La Berceuse* and incited his multiple remakings of the image.

His own remarks on this picture document the wide range of psychological, aesthetic, and religious impulses that shaped it, as well as the literary, musical, and artistic inspirations that contributed to Van Gogh's rendering. The impetus to paint a picture of benevolent maternity apparently first occurred to him in the fall of 1888, as he and Gauguin discussed Loti's *Pêcheur d'Islande,* an account of the hardships endured by Breton fishermen who ply their trade in Icelandic waters. Gauguin evidently was fond of the book (his partisanship doubtless stemmed from both his love of Brittany and his youth-

ful career as a seaman),[126] and Van Gogh later recalled the "intimate talks" it generated between them (LT574). If *Mme. Chrysanthème* was Van Gogh's Loti novel of choice, *Pêcheur d'Islande* was the book he most closely associated with his housemate – and with the image that consoled him in Gauguin's absence.[127] In January 1889 Van Gogh recalled the genesis of *La Berceuse* in a letter to Theo:

When [Gauguin] and I were talking about the fishermen of Iceland and of their mournful isolation, exposed to all dangers, alone on the sad sea ... the idea came to me to paint a picture in such a way that sailors, who are at once children and martyrs, seeing it in the cabin of their Icelandic fishing boat, would feel the old sense of being rocked come over them and remember their own lullabys. (LT574)

His project thus bore from the start the imprint of Loti's novel, wherein the author describes the sea as a nurse who rocks the sailor in his cradlelike ship.[128] And in the depression and uneasiness that followed his breakdown, Van Gogh came to identify – metaphorically, at least – with a tempest-tossed sailor. In a January letter to Gauguin he described his delirium of the previous month in nautical terms and envisioned the *berceuse* as a refuge from the storm:

In my cerebral or nervous fever or madness, I don't know how to say or label it, my thoughts navigated many seas ... and it seems I sang – I, who don't know how to sing at other times – an old nursemaid's song, thinking of the song sung by the nurse [*berceuse*] who rocked the sailors and which I had sought in an arrangement of colors before falling ill.[129]

Van Gogh obviously meant to capitalize on the double sense of the word "*berceuse*" when he affixed it to his painting, a picture in which he not only sought to image the comforting calm of the cradle rocker, but also – through color – to evoke the soothing strains of her lullaby. In the same letter, he told Gauguin that he had resumed work on *La Berceuse*, and remarked, "I believe that if you put this canvas ... on a boat of fishermen, even from Iceland, there would be those who would feel the *berceuse* in it. Oh, my dear friend, to make from painting that which the music of Wagner and Berlioz already is ... a consoling art for broken hearts!"[130] And in a contemporaneous letter to a Dutch friend, after alluding to the somewhat fantastic coloration of both figure and ground in *La Berceuse*,[131] Van Gogh concluded, "Whether I really sang a lullaby in colors is something I leave to the critics" (LT571a).

In comparing its color orchestration to the music of Wagner and Berlioz or to a simple lullaby, Van Gogh underscored the symbolic dimension of his painting, suggesting a nearly intangible veil of meaning and emotion that transcends mere motif and resides in the picture's palette. Indeed, a detailed description of the colors he used was part of every account Van Gogh gave

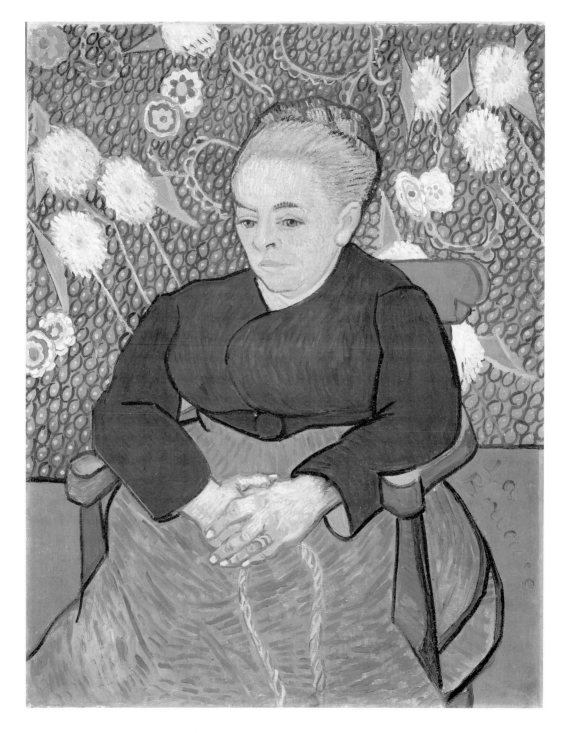

Figure 50. Van Gogh, *La Berceuse*, 1889.

of the picture, and such changes as he made in his variations on the original were mainly adjustments of hue. The color play he composed (of vermillion, bright orange, chrome yellow, and various shades of green) was of an intensity he associated with Provence – "the South cannot be painted with the palette of [the North]," he held (W3) – and conformed to Van Gogh's belief that a riot of garish colors quelled one another through their interaction. "By intensifying *all* the colors," he once told his sister, "one arrives once again at quietude and harmony...something similar to what happens in Wagner's music, which, though played by a big orchestra, is nonetheless intimate" (W3; his emphasis). As he appraised the *Berceuse* specifically, the artist noted that there "discordant sharps of crude pink, crude orange, and crude green are softened by flats of red and green" (LT574). He admitted that the result was neither "correct" (LT575, LT582) nor refined (LT574, LT576), and he acknowledged that the exaggerated vibrancy of the picture's hues might lead some viewers to compare it to a "chromolithograph from a cheap shop" (LT574; see also LT576, LT582). In the end, however, he claimed that the picture's lowbrow look was appropriate. "After all," he wrote, "I want to make a picture such as a sailor at sea who could not paint would imagine to himself when he thinks of his wife ashore" (LT582). The artist thus implied his intentional emulation of the unsophisticated tastes of the untutored seaman and indicated his belief that the "crudeness" of *La Berceuse* was emblematic of a class, its art, and its sentiments. With self-serving condescension, he remarked, "The common people, who are content with chromos and melt when they hear a barrel organ, are in some vague way right, perhaps more sincere than certain men about town who go to the Salon" (LT592).[132]

That the consoling female persona of Van Gogh's *Berceuse*, whose hinted roles included those of mother, nursemaid, and wife, also was allied in his mind to Christian prototypes is made clear by the artist's desire to display the image between his paintings of sunflowers, to create a "sort of triptych" (LT592) – that is, a modern, secular variant on traditional devotional images of saintly women (see also LT605). This conception was linked to Loti's novel as well, for in *Pêcheur d'Islande* the author emphasizes the seafarer's "extreme confidence" in the protection afforded by icons.[133] The particular object of the Icelandic fishermen's veneration is a faïence figurine of the Virgin Mary, affixed to a wall below deck:

Against a panel at the end [of the cabin], a holy Virgin in faïence was fixed to a small board in a place of honor. She was a bit old, the protectress of these sailors, and painted in a naïve style. But ceramic people last a good deal longer than real men; her red and blue robe still created a small effect of real freshness in the midst of all the somber grays in this poor wooden cabin. She must have heard more than

one ardent prayer in hours of anguish; they had nailed two bouquets of artificial flowers and a rosary at her feet. (*Pêcheur d'Islande*, chap. I)[134]

Surely Van Gogh recalled the frightened sailor's attachment to that reassuring personification of the saintly as he fashioned his own naïve-looking icon – a "consoling" image for souls in distress.

Though Van Gogh continued to recall recent literature with affection and admiration and to invoke its situations and protagonists as he strove to interpret his own life, he read little French fiction after 1888. In February 1889 – after a second nervous collapse – the artist was ordered confined by the Arles superintendent of police, and he spent most of March isolated in a private cell, with no access to paints, books, or tobacco. When he gained a day's freedom at the end of the month (thanks to a visit from Paul Signac), Van Gogh on his outing bought the newly published *Ceux de la Glèbe* (1889), a collection of short stories by Belgian Naturalist Camille Lemonnier that focus on the travails of rural laborers. Van Gogh later noted, "This is the first time in several months that I have had a book in my hands," and he wrote that he was impressed by the "gravity" and "depth" of Lemonnier's stories (LT581). Yet *Ceux de la Glèbe* was the last Naturalist book he ever mentioned buying. After completing it, he was inspired to send "for a few more books so as to have a few sound ideas in my head" (LT582), but the volumes he requested did not reflect his most recent enthusiasms. Instead, they were sentimental favorites from his childhood and youth. On 29 March he reported, "I have reread *Uncle Tom's Cabin*, you know Beecher Stowe's book on slavery, and Dickens's Christmas books, and I have given *Germinie Lacerteux* to M. Salles" (LT582; Salles was a Protestant clergyman who had been attentive to Van Gogh in his illness).

His decision to give away *Germinie Lacerteux* and to reread *Uncle Tom's Cabin* (a book he admitted was "perhaps not very well written, from a literary perspective")[135] and Dickens's *Christmas Stories* constituted a mental retreat of sorts. Beecher Stowe and Dickens belonged to a bygone era (she was born in 1811, he in 1812) and – from Van Gogh's viewpoint – to an earlier phase of his own life. Van Gogh once noted that he had read the *Christmas Stories* every year when he was a boy (R30), and we know that he was excited and motivated by the lessons of *Uncle Tom's Cabin* during the era of disillusionment that followed his dismissal from his preacher's post at the Borinage. Dickens's *Stories* (a compilation of many Christmases' worth of magazine pieces) feature sincere, commonsense morality and abundant happy endings, and *Uncle Tom's Cabin* – an unabashedly Christian treatment of the slavery issue – had originally appealed to Van Gogh in its

"wisdom," "love," "zeal," and "interest in the true welfare of the poor oppressed" (LT130). Now he noted (in a letter to his sister): "I have reread *Uncle Tom's Cabin* by Beecher Stowe with *extreme attention*, for the very reason that it is a book written by a woman, written, as she tells us, while she was making soup for the children – and after that, also with extreme attention, Charles Dickens's Christmas Tales" (W11; his emphasis). Van Gogh's mental image of the soup-making Beecher Stowe reflects the longing for a mother figure that also informed *La Berceuse,* and his careful rereading of books he favored in his youth parallels his intent reworking of an image that emblematized stability and calm; in both his work and his reading, Van Gogh in early 1889 seems to have sought the familiar and the familial. A few months later he acknowledged that "reading a fine book, like one by Beecher Stowe or Dickens" was "what braces me" (LT605).

A final still life with book from Van Gogh's Arles period highlights the shifting focus of his concerns. Within the first few weeks of 1889 (i.e., concurrently with his work on *La Berceuse*) the artist made his *Still Life on a Drawing Board* (Fig. 51), which features F. V. Raspail's *Annuaire de la santé,* a manual advocating natural remedies to health problems.[136] As Van Gogh concentrated on curing his ills and alleviating his distress, one part of him sought to be nursed by a kindly woman, while another sought help from modern medicine – in this case Raspail's book. Like the contemporary novels that preceded it in Van Gogh's still lifes, the *Annuaire de la santé* is flanked by objects connoting vitality and optimism: The painting's sprouting onions may be seen to represent energetic new life, the lighted candle illumination and hopefulness. Along with the drawing board that alludes to his work, Van Gogh included other references to the primary sources of solace in the lonely weeks after Gauguin's departure: smoking articles (he had long promoted pipe smoking as a "good remedy for the blues" [LT5; see also B7, W11]) and a letter from Theo. The stimulants with which Van Gogh "kept myself going" in his first months at Arles – caffeine and alcohol (see LT581) – are suggested by the teapot and wine bottle that, if still present, are nonetheless pushed to the periphery of the composition and separated from the more calming objects that rest on the board. Another source of Van Gogh's previous stimulation – modern French novels – is completely eliminated here; the contemporary novel's former position, and its former status as a purveyor of solace and inspiration, are usurped by Raspail's medical text.

As the spring of 1889 progressed, Van Gogh became increasingly resigned to abandoning his self-sufficient life at Arles, and in May 1889 he voluntarily committed himself to an asylum at nearby St.-Rémy. Though he continued to be "sustained" by his recollections of French literature (W11), in the last months of his life he ceased to read the Naturalists. Indeed, his interest in

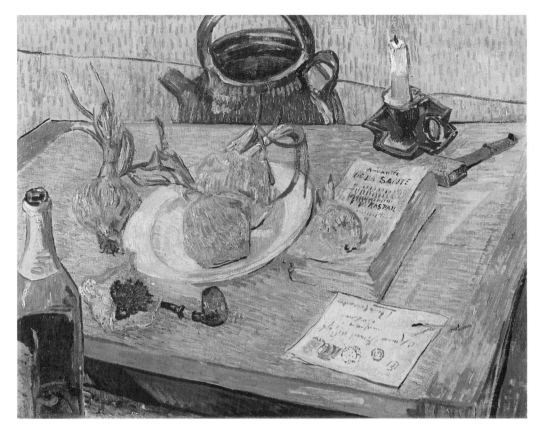

Figure 51. Van Gogh, *Still Life on a Drawing Board*, 1889.

literature of every genre lessened as the mental and emotional agitation induced by his precarious health and undiagnosed illness increased, and the artist by his own account decided to "read little in order to meditate all the more" (W11).

6

THE LATE WORK
Brightness amid Grief

Between bouts of illness at St.-Rémy,[1] Van Gogh continued to draw and paint, and indeed managed a high level of productivity while confined there.[2] The grounds and surroundings of the asylum proved visually inspiring, though the artist's self-imposed institutionalization did little to feed his mind. He felt isolated from his fellow patients, who by his account did "absolutely nothing" and had "not a book" among them (LT592); but his lack of opportunity for literary discourse at St.-Rémy probably was less disturbing to him than it might have been in the days of his most intent bookishness. As Van Gogh noted in a letter to his sister (July 1889), reading was now far from soothing to his stressed psyche. "I am not going to urge you too much to read books or dramas," he told her, "seeing that I myself, after reading them for some time, feel obliged to go out and look at a blade of grass, the branch of a fir tree, an ear of wheat, in order to calm down" (W13).

Though he did inquire after Maupassant's latest novel, *Fort comme la mort,* in June 1889 (LT593), Theo (newly married and busy with his own affairs) did not send it, and Van Gogh did not press the issue. Instead, he reread old favorites (including Voltaire's *Zadig;* LT596) and specifically requested that his brother send him some of Shakespeare's plays. He had not read Shakespeare's work in years and decided he would like to have some on hand "to read here now and then" (LT595). Theo complied, and by midsummer Van Gogh was focusing on the historical plays (LT597), finding a quality there that reminded him of more contemporary literature: "What touches me," Van Gogh wrote, "as in some novelists of our day, is that the voices of these people, which in Shakespeare's case reach us from a distance of several centuries, do not seem unfamiliar to us. It is so much alive that you think you know them and see them" (LT597). These comments recall the praise he had for Daudet's *Sapho* in 1884 ("It is . . . so full of vigor, so 'la nature serré de près' [nature clasped close], that the heroine lives,

breathes, and one *hears* her voice, literally *hears* it, for one forgets one is reading" [LT373; his emphasis]). Further indication that by "novelists of our day" Van Gogh meant the Naturalists exists near the end of the letter. Having reiterated his appreciation for Shakespeare, he shifted gears, to remark: "How fine Zola's books will continue to be, just because there is life in them" (LT597). Apparently, Naturalist literature had become the standard against which Van Gogh measured other writing – even that of Shakespeare.

Though affirmation of his continuing admiration for the Naturalists is scattered throughout his St.-Rémy correspondence, his letters suggest that the artist – unnerved by his now-chronic physical and mental instability – felt unequal to the authors he lionized. His increasingly morbid and fearful turn of mind struck him as inconsistent with the enlightened modernity he had sought to attain in his own life and work, and to Theo he wrote, "I am astonished that with the modern ideas that I have, and being so ardent an admirer of Zola and de Goncourt and caring for things of art as I do, that I have attacks such as a superstitious man might have and that I get perverted and frightful ideas about religion such as never came into my head in the North" (LT607). Clearly he considered his imaginings anathema to the positivist philosophies of the men and books he so recently had championed and emulated.

Sympathetic to her brother's depression in the summer of 1889, Wil van Gogh for the first time ventured to invert their literary dialogue and recommend a book to him. She sent a copy of Edouard Rod's *Le Sens de la vie,* an account of one man's search for happiness – which he finds in bourgeois conventionality. Vincent, if politely appreciative, was a bit sardonic in his response to her gesture:

The terrifying title *Le sens de la vie* scared me a little, but . . . the subject is fortunately hardly discussed in the book. . . . The moral of the story is that under certain circumstances a gentleman prefers ultimately to live with a sweet and very devoted wife and his child, rather than to live in the restaurants and cafés of the boulevards, a life he had led before without committing too many excesses. That is undoubtedly very nice. (W13)

Rod's treatment of this well-worn late-nineteenth-century plot (cf. Huysmans's *En ménage*), struck Van Gogh as blithely naïve, and the gentle derision that marked his letter to Wil was amplified when he described the book to Theo:

I have received . . . a book by Rod, which is not bad, but the title *Le Sens de la vie* is really a little pretentious for the contents.
 . . . For my own use he teaches me nothing about the meaning of life, whatever is meant by it. For my part I might well think him a little trite and be surprised that he has had a book like that published these days and gets it sold at 3.50 fr. (LT596)

His remarks concluded with a condescending aside on their sister's literary judgment, as the artist declared that "good women and [good] books are two different things" (LT596).

Several weeks later, when Wil expressed dissatisfaction with the Goncourts' *Germinie Lacerteux* (one of Vincent's favorite novels)[3] and told her brother that she preferred Tolstoy (W14), his reply took on a sarcastic edge:

It is a very good and fortunate thing, as I see it, that you are not quite enthusiastic about the masterly book by de Goncourt [*sic*]. All the better that you should prefer Tolstoi, you who read books in the first place to draw from them the energy to act. I tell you, you are a thousand times in the right.

But I, who read books to find the artist who wrote them, should I for my part be in the wrong if I like the French novelists so much?

...As for you, don't hurry, and go on courageously with your Russians. (W14)

The patronizing tone of this letter suggests that Van Gogh by now had relinquished his project to educate Wil to his most progressive preferences (see also LT630). He continued to make reference to his own allegiance to Naturalism, however – by means of an allusive reference that his sister may or may not have recognized. Van Gogh's characterization of his aims as a reader, that is, "to find the artist who wrote them," is in fact a paraphrase of Zola's well-known assertion that as a viewer of visual art, "That which I look for before anything else in a painting is a man and not a painting."[4] Moreover, in the same letter to Wil, Van Gogh acknowledged the ongoing link between the way he worked and the books he had read:

The other day I finished the portrait of a woman upward of forty years old, an insignificant woman. The withered face is tired, pockmarked – a sunburned, olive-colored complexion, black hair.

...I often paint things like that – as insignificant and as dramatic as a dusty blade of grass by the roadside – and consequently it seems to me that it is only right that I should have a boundless admiration for de Goncourt, Zola, Flaubert, Maupassant, Huysmans. (W14)

The painting he mentioned (F631) had been posed by the wife of an attendant at the asylum, and clearly Van Gogh was eager to ally his own interest in portraying such an "unhappy, resigned creature of small account, so insignificant" (LT605) – that is, a working-class woman – to the Naturalists' determination to tell the stories of similarly "insignificant" people (protagonists like Germinie Lacerteux, and Gervaise Coupeau of *L'Assommoir*). Thus if he lost the habit of reading while confined to the asylum, Van Gogh nonetheless continued to write and paint as one well versed in literature. Reminiscences of readings continued to send ripples through his work – most

notably as subtexts in his late landscapes and as potent signifiers in two late portraits.

LITERARY UNDERCURRENTS IN VAN GOGH'S LATE LANDSCAPES

With few chances to make portraits at St.-Rémy, Van Gogh (as in his first months at Arles) focused on southern landscape, eager to make "character-istic things" that might demonstrate an "expert knowledge [of] the Provençal south" (LT609). Such expertise relied, of course, on his many months in the Midi, but also devolved from the verbal accounts that had predisposed him to the climate, topography, and vegetation of Provence. Recollections of Daudet's Tartarin novels continued to color Van Gogh's vision (LT610), and more sustained – if speculative – parallels may be seen to link the artist's life and work at the asylum to the psychic dramas of Serge Mouret (the high-strung protagonist of *La Faute de l'Abbé Mouret*), who both recovers his health and falls from grace within the precincts of Zola's fictional southern garden, Le Paradou. Such a linkage depends, of course, on our knowledge of Van Gogh's tendency to think and express himself literarily, describing people, vistas, and his own history in terms of, and in tropes derived from, the fiction he had devoured. From that base, an imaginative leap conjoins Van Gogh, Mouret, and their respective raptures before overpowering and eroticized southern scenes.

An initial connection can be drawn between Van Gogh's decision to enter the asylum and Mouret's retreat to Le Paradou. Though Van Gogh entered a public institution of his own volition and Serge, by contrast, was taken to a private sanctuary by a concerned relative, both were forced from the outside world by nervous crises that Van Gogh in his case, and Zola in Mouret's, attributed in part to the sensory overload induced by Provençal climes.[5] During his first weeks at St.-Rémy, Van Gogh stayed within the walls of the asylum, spending most of his time in the large garden (LT592), which – as he described it – bore some resemblance to Le Paradou, the abandoned domain in which Mouret recuperated: "Deserted . . . planted with large pines beneath which the grass grows tall and unkempt and mixed with various weeds" (LT592). The artist made pictures there of flowers, shaded benches, and "thick tree trunks covered with ivy" (LT592) and assured Theo that these works testified to his well-being: "When you receive the canvases that I have done in the garden, you will see that I am not too melancholy here" (LT593). The garden became a peaceful but invigorating refuge for him, and he later wrote of it as a remedy for the disorientation he felt after his attacks; even as he prepared to leave the asylum, in May 1890, Van Gogh noted, "As soon as I got out into the park, I got back all my lucidity for work"

(LT630). By comparison, Zola describes Mouret as "reborn" on his first day within the walls of Le Paradou:

This first contact with the soil gave him a jolt, a recovery of life that instantly set him on his feet....

He was born in the sun, in that pure bath of light that drenched him. He was born at age twenty-five, his senses abruptly opened, enraptured by the vast sky, by the blissful earth, by the marvel of the horizon displayed before him. This garden, of which he knew nothing the day before, was an extraordinary delight. Everything filled him with ecstasy, from the blades of grass to the stones of the paths, to the unseen breezes that passed over his cheeks....

Health, strength and power were on his face. He didn't smile; he was at peace. (*La Faute de l'Abbé Mouret*, pt. II, chap. 5)[6]

Though Van Gogh himself made no mention to Theo of the asylum garden's similarity to Le Paradou, he probably recalled Zola's walled enclave as he worked in his own, and most especially as he indulged in amorous daydreams there. Van Gogh's early references to Le Paradou portray it as the quintessential locale of romantic dalliance (see LT286, LT287), and he may well have recalled Mouret's sexual awakening and initiation there as he surveyed potential trysting spots in the similarly deserted and overgrown hospital grounds. In May 1889, he sent Theo a drawing (Fig. 52) of a new work that, according to the accompanying letter, "represents the eternal nests of greenery for lovers" (LT592). Many of his depictions of the garden at St.-Rémy portray overgrown corners of nature, and some – by virtue of the artist's low vantage point – bring the viewer into close visual contact with a thicket of animate and shady undergrowth (Fig. 53). An aura of intimacy surrounds these glimpses of a dark, private place, and the central motif of intertwined trees seems to highlight the spot's viability as another Paradou-like lovers' nest. Indeed, Albine (the Abbé Mouret's elfin object of desire) describes such a wooded nook as the secret spot dear to Le Paradou's legendary eighteenth-century lovers: " 'They had discovered in the garden a place of perfect happiness, where they ended up spending all their time.... A spot of cool shade, hidden in a bed of impenetrable undergrowth, so wonderfully beautiful that there they forgot the whole world.' "[7]

Even beyond the confines of the asylum garden, Van Gogh's repressed desire[8] manifested itself in a figural piece of Paradou-like overtones, the *Evening Promenade* (Fig. 54), wherein a couple walks amid olive trees on a hillside lit by a thin crescent moon.[9] This scene almost surely was invented (since Van Gogh was not allowed out past dark), and in devising it the artist may well have drawn on remembered prose. The image certainly bears comparison to Mouret's moonlit walk with Albine along the tree-lined alleys of Le Paradou.[10] The male figure of Van Gogh's picture – red-haired and -bearded – can be read as a wishful self-projection into the role of lover;

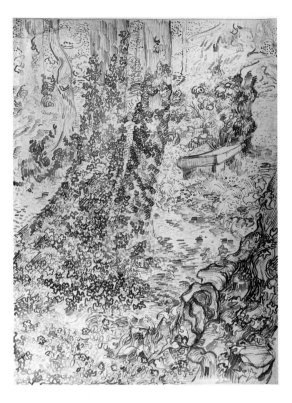

Figure 52 (*right*). Van Gogh, *Trees and Ivy in the Asylum Garden*, 1889.

Figure 53 (*below*). Van Gogh, *Undergrowth*, 1889.

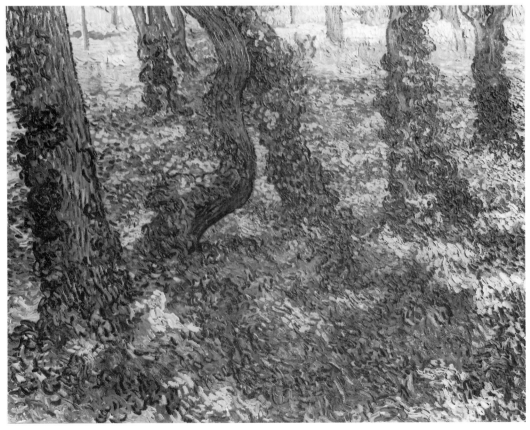

dressed in workman's blue (Van Gogh's favored costume in the South), the man is accompanied by a full-bodied brunette in a yellow gown. As in Zola's descriptions of Mouret's outdoor courtship, the figures and landscape of Van Gogh's painted scene seem physically and psychically attuned; the couple is animated by disjunctive contour and energetic gesture, and their liveliness echoed by the trees, hills, and thickly brushed sky beyond. In addition to accentuating their empathy, the shared motion of the lovers and setting suggests the sensual excitement of this open-air ramble on a warm southern night.

The vivacity of *Evening Promenade* is underscored by its comparison with a somewhat later work, Van Gogh's *Figures in the Undergrowth*, which was made at Auvers-sur-Oise in 1890 (Fig. 55). There, an attenuated woman and man, who appear to be facing in opposite directions, seem overwhelmed by the legion of tall, thin tree trunks that virtually cage them. Despite its lush coloration (blue-violet trees in a yellow-green landscape), the natural setting of *Figures in the Undergrowth* seems regimented and unwelcoming, and the stiffened couple within it reinforces this impression. Van Gogh may have aimed to contrast the *Evening Promenade* here, and – whether he intended it or not – the pictures' pairing might be seen as a commentary on the merits of courting in the voluptuous South rather than in the colder and less yielding northern realms.

Once he had settled into his life at the asylum, Van Gogh began to venture beyond its walls, trekking and painting along the hillsides of St.-Rémy. Many of the pictures he made there suggest (by their heavily impastoed surfaces and gyrating lines) the artist's agitation,[11] and indeed, in July 1889, Van Gogh suffered another nervous collapse while he was busily painting the fields beyond the institution (LT601). In the aftermath of that crisis, he remained indoors for almost two months, longing to paint in the mountains (LT602) but fearful that the windy expanses of the open countryside might induce another attack. The southern landscape became a sort of temptress to him, one that both beckoned and intimidated, and among the many pictures he made when he returned to extramural painting in the fall of 1889 are two – *Entrance to a Quarry* (Fig. 56) and *The Ravine* (Fig. 57)[12] – that seem to betoken the artist's fetishistic fascination with his environment. In each, a play of sinuous curves and angular projections, interspersed with tufts of foliage, suggests the human form, and Van Gogh's particular attention to caves and crevices ringed by hairlike plant life hints at erotic impulse. *The Ravine* holds two small (female) figures, the *Entrance* none, but either setting – populated or not – would appear animate in and of itself.

In this context, Zola's descriptions of Provençal nature are illuminating. That author often compared the southern landscape to a lusty woman, probably never more thoroughly and explicitly than in a passage from *La Faute*

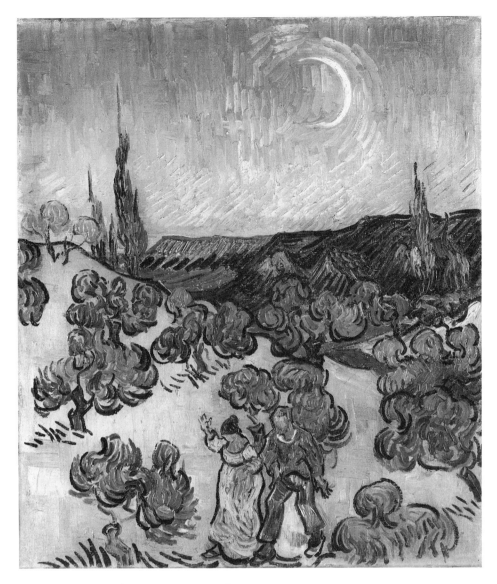

Figure 54. Van Gogh, *Evening Promenade*, 1890.

de l'Abbé Mouret in which the book's feverish protagonist throws open his rectory window in a nighttime delirium and gazes out on the rolling Provençal plain, only to be confronted by a most disquieting sight:

The vast plain stretched out before him, more tragic beneath the oblique pallor of the moon. The thin olive and almond trees made gray spots amid the chaos of the great rocks, up to the dark line of hills on the horizon. There were large patches of shadow, battered ridges, bloody pools of earth where red stars seemed to look at one another, chalky whitenesses like cast-off women's clothing, exposing bodies drowned in shadows, dozing in the recesses of the fields. At night this burning

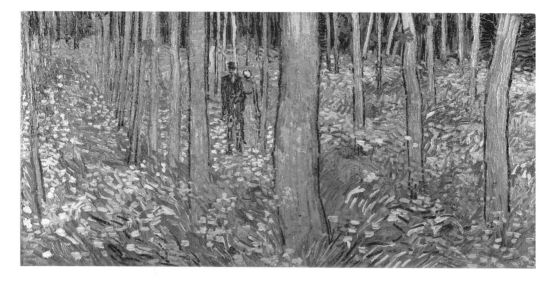

Figure 55. Van Gogh, *Figures in the Undergrowth*, 1890.

countryside assumed a strange, passionate sprawl. She[13] slept in disarray, hips disjointed, twisted, limbs flung wide, while throwing off warm, heavy sighs and the strong scents of a sleeping woman in a sweat. She seemed like some strong Cybele[14] fallen on her back, bosom thrust out, belly beneath the moon, sated by the sun's ardors and dreaming again of impregnation. In the distance, alongside this large body, the Abbé Mouret's eyes followed the Olivettes road – a pale, narrow ribbon that stretched out like the loose lacing of a corset. (*La Faute de l'Abbé Mouret*, pt. I, chap. 16)[15]

Despite its fantastic dimensions, this provocative portrayal of the countryside Zola knew intimately and loved intently is meant to suggest an overwrought viewer's meditation on an actual vista – that is, a corner of nature seen through an excitable temperament. Well versed in the "real" look of such a scene, the Naturalist uses nature as a springboard to emotive expression, here rendering the landscape overwhelming in its outsized and eroticized anthropomorphism. Indeed, Mouret's delusional encounter with the moonlit vision enframed by his own bedroom window ends in a swoon, and the agitated young priest sinks into a coma.

Though Van Gogh did not go so far as to transpose actual body parts onto the landscapes he painted at St.-Rémy, paintings like *The Ravine* and *Entrance to a Quarry* are marked by an eroticized feminization that – if less baldly stated than in Zola's textual description – reflects that author's impact on the painter's experience of Provençal nature. The sort of verbal transformation Zola effected – from landscape to recumbent women in dishabille – relies on specifically stated metaphor, cemented by words. A painted reaction on Van Gogh's part, however similar in impulse and/or intent, could

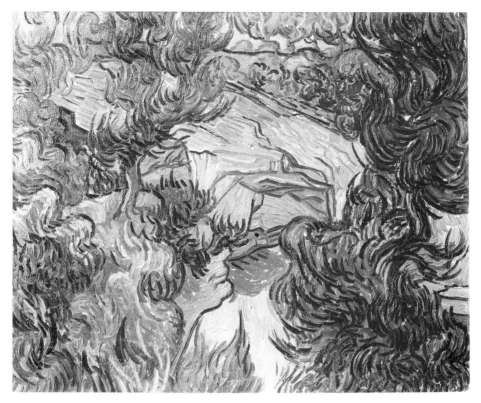

Figure 56. Van Gogh, *Entrance to a Quarry*, 1889.

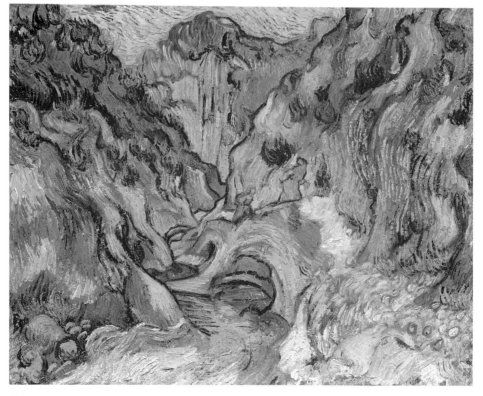

Figure 57. Van Gogh, *The Ravine*, 1889.

remain more ambiguous, its analogies free floating, since the effects of his pictures rely on the abstract elements of line and color as well as on subtle *visual* metaphors that may remain unstated, cloaked by reference to seen motifs and thus readily ignored or discounted by viewers who do not (or choose not to) see them.

Like Zola, Van Gogh sometimes wrote of the Midi as a lively and seductive persona; on one occasion he told of "following what the country said to me" (LT630) in order to attain the goals he set for his St.-Rémy landscapes. During his nervous crises, the landscape seemed especially alive to him, and early in 1890 (recalling a recent period of instability) he noted, "While I was ill...I got up in the night to look at the country. Never, never, had nature seemed to me so touching and so full of feeling" (LT620). He came to believe that the intensity of his emotions before Provençal vistas was sometimes enough to induce an attack, and in a letter to the critic Albert Aurier (written in February 1890)[16] Van Gogh acknowledged, "The emotions that grip me in front of nature can cause me to lose consciousness, and then follows a fortnight during which I cannot work" (LT626a). The violent reaction he described is strangely reminiscent of the response Zola ascribes to Mouret, and this coincidence – however fortuitous – would seem to stem from the fact that both artist and author, in their passionate attachments to the South, credited its landscapes with a forcefulness that, under certain conditions, was capable of overpowering the most sensitive observer. Despite his wariness of the emotions the lush and sunbaked South produced in him, Van Gogh in his last months there made several landscapes – a set of pictures he intended to form a "sort of whole, 'Impressions of Provence,'" because "altogether it is difficult to leave a country before you have done something to prove you have felt and loved it" (LT609).

"A FELLOW SUFFERER": MARIE GINOUX

At the asylum, with the scope of his activities (artistic and otherwise) often circumscribed by illness or by doctors' orders, Van Gogh was drawn once more to a practice he had long found useful: copying after admired works. Explaining his reborn enthusiasm to Theo, the artist wrote:

We painters are always asked to *compose* ourselves and *be nothing but composers.*
So be it – but it isn't like that in music – and if some person or other plays Beethoven, he adds his personal interpretation – in music and more especially in singing – the *interpretation* of a composer is something, and it is not a hard and fast rule that only the composer should play his own composition.
Very good – and I, mostly because I am ill at present, I am trying to do something to console myself, for my own pleasure. (LT607; his emphasis)

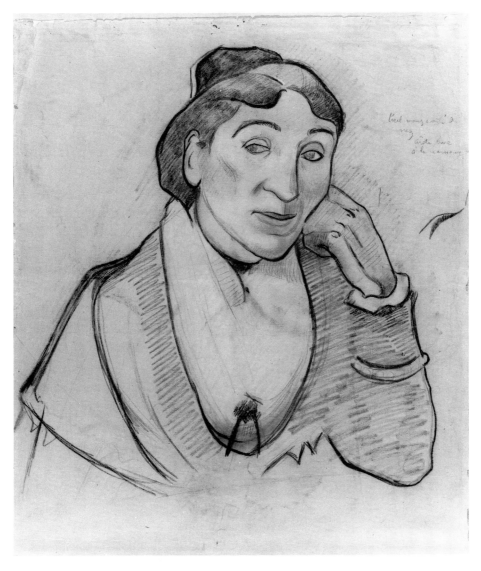

Figure 58. Paul Gauguin, *L'Arlésienne (Mme. Ginoux),* 1888.

More specifically, Van Gogh found that his "interpretations" served his preference for the human form as subject: "Making copies amuses me enormously," he wrote, "and it means that I shall not lose sight of the figure, even though I have no models at the moment" (LT607). Thus for both his amusement and his edification, Van Gogh at St.-Rémy did personalized versions of well-known works by Rembrandt, Delacroix, Millet, and Daumier (using prints Theo sent), as well as a series of painted variants (see Plate 15) on a drawing done by Gauguin: that artist's Conté crayon study of Marie Ginoux, *L'Arlésienne* (Fig. 58). Gauguin's drawing apparently was made at

the same time that Van Gogh made his initial oil sketch of the same model (Fig. 47); the sitter's pose is the same, though Gauguin's rendering (made from a different angle) presents her in an almost full-frontal view, so that Ginoux gazes at, rather than away from, the viewer.

Van Gogh made five versions of the painting he based on Gauguin's portrait sketch (which he evidently brought with him from Arles),[17] and four are extant.[18] They are quite similar in size and composition and — as in the *Berceuse* series — the most notable differences among them are coloristic. Gauguin was pleased by Van Gogh's take-off on his sketch; in a letter to Vincent he called the painting "very beautiful and very odd" and acknowledged, "I like it better than my drawing."[19] Gratified by his colleague's approbation, Van Gogh replied (in a letter he never mailed): "It gives me enormous pleasure when you say the Arlésienne's portrait, which was based strictly on your drawing, is to your liking. I tried to be religiously faithful to your drawing, while nevertheless taking the liberty of interpreting through the medium of color the sober character and style of the drawing in question" (LT643). While emphasizing the mood he had tried to contrive through color, Van Gogh stressed his strict faithfulness to Gauguin's composition; his insistence on the literalness of his painted rendering is, however, something of a misrepresentation. In describing his copies, Van Gogh made no mention of the books he added to Ginoux's portrait — an addition that recalls the modification made to his own earlier rendering of the same sitter (Plate 10), and a liberty that, in this case as in that one, significantly alters the tone of the piece. As before, Van Gogh here recast the model to reflect his own enthusiasms and desires, and a comparison of his Gauguin-based portrait of Ginoux (Plate 15) with Gauguin's own painted image of her, *The Night Café* (Fig. 48), brings the nature of the transformation into clear focus. In the painting Gauguin himself made after his drawing, Marie Ginoux is sandwiched between the billiard table and a café table at her husband's dingy and smoky establishment — a place filled with nighttime patrons. A Zouave soldier shares his table with a sleeping companion, and nearby, Roulin the postman chats with three prostitutes. Ginoux herself, as she appears in the foreground of Gauguin's picture, seems a knowing habituée of this decidedly sleazy haunt. In Van Gogh's renderings of 1890, the same sitter assumes, by contrast, the guise of a demure matron; her books and pastel surroundings suggest a private setting and daytime moment. Moreover, the particular books Van Gogh placed beside her heighten one's sense of Ginoux's propriety, for they are not dog-eared "romans parisiens," but instead (in each of the St.-Rémy portraits) clearly titled editions of *Uncle Tom's Cabin* and Dickens's *Christmas Stories*.[20]

Both the model and books of Van Gogh's retrospective portraits of Ginoux are self-referential icons linked to the artist's personal history. His use of

Gauguin's drawing documents their brief alliance, and indeed Van Gogh wished his former housemate to consider the Ginoux series a "work belonging to you and me as a summary of our months of work together" (LT643). Moreover, the titled (hence particularized) books included in Van Gogh's painted variants call up the era in which Van Gogh returned to them: the period of isolation and despair that followed Gauguin's departure, during which the grieving Van Gogh took solace in the fiction of Beecher Stowe and Dickens. During the time he was working on his paintings of Ginoux, the artist himself remarked (in a letter to his sister): "Portraits are something almost useful and at times pleasant; like furniture one knows, they remind one of things long gone by" (W20).

In addition to commemorating his past, however, Van Gogh's late portraits of Ginoux also reflected his diminished literary present. He was no longer so actively engaged in reading as he once had been, and it is perhaps no coincidence that the books of the Ginoux portraits are closed and stacked rather than actively perused by the sitter whom he had shown before an *open* book in 1888. The Ginoux portraits also betray a shift in Van Gogh's attitudes toward women's literary pursuits; once an advocate of his sister's exposure to the books he most valued, Van Gogh later conceded that French books of the sort he had often urged on her were "books written by men for men, and I don't know whether women can understand them" (W11).[21] In the same letter (W11) he hinted that *Uncle Tom's Cabin* and the *Christmas Stories* – "fine books" that "braced" him (LT605) in a difficult phase of his life – might be better suited to a feminine sensibility than were French novels. His vision of a gender-appropriate bookshelf doubtless crystallized when Wil rejected *Germinie Lacerteux* and recommended Rod's *Le Sens de la vie*. Thus, his previous portrayal of Marie Ginoux as a thoughtful reader of contemporary novels (Plate 10) was superseded, early in 1890, by the image of her as a sedate older woman buttressed by the sentimental and moralizing fiction of a bygone age.

In the St.-Rémy portrait series, hard-edged modernity is forsaken for things soothing and calm. The crisp, angular contours of the earlier image give way to softer, rounded forms, and its bold colors are replaced by silvery pastels. In both content and form, these images of Ginoux reflect the artist's crises of health and confidence. Van Gogh evidently associated the grayed and pastel colors that so often appear in his late work with illness and unhappiness; in November 1889, as he expounded on his artistic practice at St.-Rémy and noted his addition of a "dull dirty white" to the "pure and brilliant" hues of a picture he was painting, the artist mused on his observation that this admixture "softens the tones, whereas one would think that one would spoil and besmirch the painting. Don't misfortune and disease do the same thing to us and our health; and if fate ordains that we be

unfortunate or sick, are we not in that case worth more than if we were serene and healthy...?" (W16).[22]

But if Van Gogh's new image of Ginoux spoke to his own troubled past and present, it was also informed by his awareness of the health problems that beset the model herself. Ginoux had fallen ill around the time of Van Gogh's first mental collapse, and she had fared poorly since.[23] He was struck by this coincidence – by the fact, as he put it, that "we suffer together" (LT622a) – and he wrote to M. and Mme. Ginoux of his belief that "the adversities one meets...do us as much good as harm. The very complaint that makes one ill today...gives us the energy to get up and to want to be completely recovered tomorrow.... One should learn to want to go on living, even when suffering" (LT622a). He obviously took comfort in the knowledge that someone he knew endured a fate similar to his own, and in the St.-Rémy portraits of Ginoux he made a "sober" (LT643) but hope-tinged image of illness and recovery in which concern for the model and himself intermingled. As before, Ginoux became a sort of surrogate for the artist, and Van Gogh portrayed her as he envisioned himself: a sufferer striving to recuperate, braced by the "sound ideas" (LT582) of Beecher Stowe and Dickens. It is thus ironic yet appropriate that Van Gogh soon devised a companion piece for his later image of Ginoux in the portrait of a physician with whom he also felt a strong identification, Dr. Paul Gachet.

"ANOTHER BROTHER": PAUL GACHET

In mid-May 1890, having spent twenty-seven months in the South (a year of it at the asylum), Van Gogh returned to northern France, motivated both by his desire to be nearer to Theo and by his longing for a more independent life. He visited Paris briefly and (finding the city too hectic) traveled on to Auvers-sur-Oise, a small town northwest of Paris that was chosen for its proximity to the capital and for Paul Gachet's residence there. Gachet, a printmaker as well as a physician, was a friend of Cézanne and Pissarro; on the latter's advice Theo sought out the doctor, who was most sympathetic to artists and agreed to keep an eye on Vincent in Auvers. On meeting Gachet, Vincent himself was somewhat skeptical; the doctor, he wrote, had his own "nervous trouble from which he certainly seems to me to be suffering at least as seriously as I" (LT635). He hastened to add, however, that "the impression I got of him was not unfavorable. When he spoke of Belgium and the days of the old painters, his grief-hardened face grew smiling again, and I really think that I shall go on being friends with him and that I shall do his portrait" (LT635). The two men indeed saw a good deal of each other in the next two months, and Van Gogh came to regard Gachet as "something like another brother, so much do we resemble each other physically and also

mentally. He is a very nervous man himself and very queer in his behavior; he has extended much friendliness to the artists of the new school, and he has helped them as much as was in his power" (W22).

Van Gogh's determination to do Gachet's portrait led him to embark on one within ten days of his arrival at Auvers (Plate 16; see LT638). Its dimensions are almost identical to those of the St.-Rémy portraits of Ginoux (one of which Van Gogh had brought with him to Auvers), and the two images – which Van Gogh must have mentally paired from the start – both parallel and subtly offset one another. In each, the sitter is almost frontally positioned and leans on a table, head supported by a balled hand. Ginoux's primness, however, contrasts with Gachet's despondent-looking slouch, and her direct gaze and seemingly resolute good cheer counter the dispirited inwardness implied by his drooping features and averted eyes. The saturated hues of the Gachet portrait contribute to its more forceful effect; as Van Gogh noted, its "scorched" flesh tints are played off against a blue so strong that it makes the face look pale, whereas Ginoux's face "has a drab and lusterless flesh color, the eyes calm and very simple" (W22). Like Ginoux, Gachet is shown with two closed books, one atop the other, their spines turned toward the viewer and inscribed with legible titles. But whereas the books in her portrait are the dated, inspirational tomes Van Gogh associated with weakness and illness, the volumes on Gachet's table are candid and modern "romans parisiens" that the painter probably considered more appropriate to a masculine sitter who was both an artist and a man of science: the Goncourt brothers' *Manette Salomon* and *Germinie Lacerteux*.

It probably occurred to Van Gogh that *Manette Salomon* was particularly well suited to his image of Gachet, since it includes an account of the Parisian art world of the 1840s and artistic camaraderie in the "days of the old painters." *Germinie Lacerteux* is a more contemporary narrative, the story of a passionate, thwarted, and grief-stricken woman whose unattended health problems take her to an early grave. The novel itself is an extended verbal portrait, and Germinie – "a person exhausted by anxiety and weeping and waking" (W14) – continued to haunt Van Gogh long after he read it in Paris. Since he intended, in his portrait of Gachet, to convey the "heartbroken expression of our time" (LT643), this novel was an apt inclusion. Moreover, *Germinie Lacerteux* is the one Naturalist novel Wil van Gogh is known to have disliked enough to say so, and her distaste for the novel may have induced Vincent to consider it a "man's book," too harsh for women, and thus especially appropriate to the portrayal of a progressive contemporary male.

On a broader level, the Goncourt novels included in Gachet's portrait surely allude to the model's and artist's shared links to the contemporary culture and modern spirit such books represented for Van Gogh. It has been

surmised that Gachet was a fellow enthusiast of the Naturalists,[24] but there is no reason to believe this was so. Indeed, the fact that Van Gogh omitted the books from a copy of the portrait, which he made for Gachet (F754), speaks against it. Moreover, Gachet's son – who was 17 at the time of Van Gogh's stay at Auvers – later asserted that the doctor had little interest in the Goncourts. According to Paul Gachet *fils*:

Vincent liked people to share his admirations. . . .

He brought *Germinie Lacerteux* and *Manette Salomon* to Dr. Gachet, so that he might read them; he laid them on the red table the doctor leaned on, and they were "portraitized" at the same time he was, albeit without any relation to his literary tastes. . . .

What was the result of this reading? We don't know, but it encouraged Vincent to lend him, a little later, *La Fille Elisa*, and this last old book remained with the doctor. . . . Afterward it was bound in black cloth, but its original *yellow* cover – dear to Vincent – is still visible inside.[25]

In his painting of Gachet – as in his portraits of Ginoux – Van Gogh used books emblematically rather than verisimilarly. The sitter was not an avid reader of the Goncourts, but their novels function as telling props intended to illume the nature and character of the persona Van Gogh evoked. A degree of wishfulness may also be assumed, since Van Gogh throughout his adult life was eager to win others over to his own literary preferences.

According to Van Gogh, Gachet was very enthusiastic about both his own completed portrait and that of Ginoux:

M. Gachet is absolutely *fanatical* about this portrait and wants me to do one for him, if I can, exactly like it. I should like to myself. He has now got so far as to understand the last portrait of the Arlésienne [i.e., the image of Ginoux made at St.-Rémy]. . . . He always comes back to these two portraits when he comes to see the studies, and he understands them exactly, exactly, I tell you, as they are. (LT638, his emphasis)

An attempt to determine "exactly" what it was Gachet understood (and what the late-twentieth-century viewer might hope to understand) about these two pictures calls for consideration of the artist's contemporaneous account of his goals. In June 1890 Van Gogh told his sister, "What impassions me most – much, much more than all the rest of my métier – is the portrait, the modern portrait" (W22). In the same letter, he elaborated:

I *should like* to paint portraits which would appear after a century to the people living then as apparitions. By which I mean that I do not endeavor to achieve this by a photographic resemblance, but by means of our impassioned expressions – that is to say, using our knowledge of and our modern taste for color as a means of arriving at the expression and the intensification of the character. (W22; his emphasis)

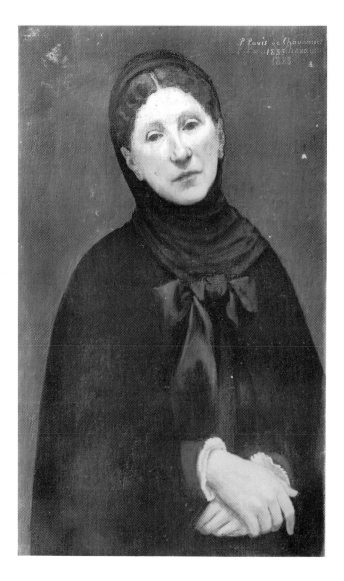

Figure 59. Pierre Puvis de Chavannes, *Portrait of Mme. C,* 1883.

In a subsequent letter he added: "In comparison with the calmness of the old portraits, there is expression in our modern heads, and passion – like a waiting for things as well as a growth. Sad and yet gentle, but clear and intelligent – that is how one ought to paint many portraits" (W23).

The melancholic thoughtfulness that informs Van Gogh's portrayals of his peers reflects the resigned discontent he considered endemic to their era. At the same time, however, he sought to communicate the calm effected by clearheaded stoicism. This conception of the "modern portrait" apparently owed a good deal to the example of Puvis de Chavannes – not to that artist's

large-scale evocations of the West's classical past (which failed to move Van Gogh), but rather to a pair of portraits by Puvis that Van Gogh had long admired. From Arles in 1888, Van Gogh told Bernard:

When [Puvis], so just and so wise – forgetting his Elysian Fields – was so good as to descend amiably into the intimacy of our time, he painted a fine portrait indeed: the serene old man in the clear light of his blue interior, reading a novel with a yellow cover – beside him a glass of water with a water-color brush and a rose in it. Also a fashionable lady, as the de Goncourts have depicted them. (B14)

In December 1890, shortly before he started his series of portraits of Ginoux, Van Gogh wrote to Theo of the same portraits:

The "Portrait of a Man" by Puvis de Chavannes has always remained the ideal figure to me, an old man reading a yellow novel, and beside him a rose and some water-color brushes in a glass of water – and the "Portrait of a Lady" that he had at the same exhibition, a woman already old, but exactly as Michelet felt, There is no such thing as an old woman. These are consoling things, to see modern life as something bright, in spite of its inevitable griefs. (LT617)

Van Gogh must have seen the Puvis portraits he referred to – *Portrait of Eugène Benon*, 1882 (Plate 12) and *Portrait of Mme. C,* 1883 (Fig. 59)[26] – at an exhibition mounted by the Durand-Ruel gallery in November–December 1887 (i.e., near the end of his stay in Paris).[27] Though his memory of them was imprecise as to detail (e.g., the flowers in Benon's portrait are not roses and lie on the table), his more general impressions remained clear and elucidate the goals Van Gogh set for himself in the portraits of Ginoux and Gachet – which can themselves be read as attempts to present "modern life as something bright, in spite of its inevitable griefs."

Just as he mentally paired Puvis's "Portrait of a Man" and "Portrait of a Lady" when he saw them in 1887, so Van Gogh linked his own major male and female portraits of 1890 (LT638),[28] pictures in which he sought to suggest that the inherent sadness of late-nineteenth-century life could be dealt with intelligently. In the Gachet portrait, the melancholy implicit in the sitter's expression and pose is countered by remedies of sorts, both medicinal and intellectual. On the table are tools of the doctor's trade: his hand – which Van Gogh pointed out as the pale hand of an obstetrician (W22) – and foxglove, a plant used in the treatment of heart problems.[29] They are joined by Naturalist novels, which Van Gogh had been wont to characterize as strong medicine for the despairing modern soul (see, e.g., LT219, LT442, W1). The portrait of Ginoux also addresses affliction and its treatment, but the remedies proffered are of a homelier sort: Dickens's common sense and happy endings, Beecher Stowe's Christian faith, and the seemingly maternal goodwill of the sitter herself.

Van Gogh likely conceived these two portraits, in stereotypic terms, as

gendered responses to adversity: the male harsh but honest and progressive, the female backward looking but comforting. Moreover, in addition to being conscious evocations of modern woman and man, the portraits of Ginoux and Gachet also can be read as projections of two sides of the artist himself: the sensitive and nostalgic side that dominated in Van Gogh's youth, resurfaced in his illness, and informed his St.-Rémy portraits of Ginoux, and the dispirited but forward-looking side that waxed during his years in France and associated itself with the Naturalists, then reasserted itself in the company of Gachet, a similarly disheartened but modern-minded man with whom Van Gogh identified so strongly as to see him as "something like another brother."

EPILOGUE

Within weeks of painting Paul Gachet, Van Gogh committed suicide. That
Naturalist novels should have been included in his final evocation of the
"modern" persona is appropriate, since the artist went to his grave believing
that Naturalism represented the cultural cutting edge. Long after their hey-
day, Van Gogh still considered the writers he called "Naturalist" – Zola,
Maupassant, Daudet, the Goncourts – progressive exemplars; their principles
and work to his mind forecast a new age and artistic practice he would not
live to see.

Almost from the beginning of his career as a painter, the methods and
ideals of Naturalist authors informed Van Gogh's practice: Naturalist nar-
ratives and characterizations colored his experience of the world, and his
understanding of the components of Naturalist creativity – direct observation
tempered by individual will and imagination – shaped his notion of the
process by which experience, configured by a particularized sensibility,
spawned art. Naturalist literature also provided Van Gogh a paradigm of
modernity, for it treated contemporary life with seeming candor – blemishes
and sadnesses cataloged and probed – but also with a stoicism he deemed
admirable and necessary. Society's malaise was rendered bearable and even
amusing to Van Gogh by the lush descriptiveness of a Zola, the compassion
of a Goncourt, the hyperbole of a Daudet, or the humor of a Maupassant.

The predilection for downbeat modern subjects that manifested itself in
Van Gogh's first works at The Hague was affirmed and encouraged by the
tenor of several Naturalist novels; like the Goncourts and Zola,[1] Van Gogh
believed working people merited sustained artistic attention, and – encour-
aged by the French novelists' example – he sought out proletarian contacts
and locales in his attempts at accurate visual reportage on that sector of
society. If his art lacked the scope and the class diversity of the novels he
admired, it was primarily because the Naturalist precepts to which Van Gogh

adhered prevented him from painting that which was beyond his immediate purview. During his years as an artist, because he had more direct access to the lower than to the upper classes (for the former could be induced to pose for a price), he painted them almost exclusively – in accordance with Naturalist insistence on "documentation."

The gloom of Van Gogh's early vision dissipated, however, when under the spell of avant-garde Parisian painting he adopted a brighter palette and began to experiment with an expanded vocabulary of brushmarks. And as his interest in the emotive and expressive aspects of color and line burgeoned, the artist was increasingly attentive to the intrinsic subjectivity of Naturalist practice – an aspect of their writing that some members of the movement (Zola, Maupassant, Daudet) not only acknowledged, but showcased. Concession to idiosyncratic perception constituted a facet of Naturalist "truth," as authors strove to be faithful not only to the object (the phenomenon observed), but to the subject (individual sensation and response; i.e., themselves). Van Gogh's mature conception of Naturalism as a mode that, if grounded in empiricism, "poetized" (LT429) and "exaggerated" (LT470) the seen to achieve an expression "truer than the literal truth" (LT418) challenges twentieth-century clichés about the movement's dry, documentary cast and draws attention to the role authorial imagination played in the production of Naturalist novels. The colorful language, extravagant imagery, witty caricature, biting satire, and impassioned reformist pleas that complement and enliven the fruits of Naturalist fact-finding drew Van Gogh's praise and helped him shape his own inclusive variant on a fundamentally realist creative practice.

His assessments of Naturalism and the evidence of Van Gogh's own production further blur the boundaries between Naturalist and post-Naturalist aesthetics – lines of demarcation that Richard Shiff has most effectively called into question.[2] Though Van Gogh felt his use of arbitrary color separated him from the Impressionists (LT520), he did not see his practice as anti-Naturalist. On the contrary, he characterized the coloristic liberties he took as "expressions of an ardent temperament" (LT520) – perfectly in keeping with Zola's definition of art. He experienced Naturalism as a living and changing thing, and knew it in a way many twentieth-century readers do not: as writing marked by emotionality and flights of fancy. In accordance with that understanding of the movement, Van Gogh in his painted Naturalism, though finding impetus in the observed, put comparable emphasis on the projection of his own personality. His mature production is quite accurately described as nature seen through an idiosyncratic temperament eager to assert itself.

Thus, in the face of the Symbolist vogue, Van Gogh was able to maintain his commitment to painting that which he could see – rejecting "abstraction"

(i.e., imagined, invented compositions) as "enchanted ground" (B21) – and at the same time champion expressionism. For instance, when Bernard and Gauguin apprised him (in the autumn of 1889) of their recent endeavors to give visual form to the verbal in depictions of biblical narratives, Van Gogh (though a great admirer of the Bible) experienced a "painful feeling of collapse instead of progress" (LT615) and urged his colleagues to seek evocative effects in nature instead. Insisting that "one can try to give an expression of anguish without aiming straight at the historic garden of Gethsemane" and noting that "it is not necessary to portray the characters of the Sermon on the Mount in order to produce a consoling and gentle motif," Van Gogh proposed a "progressive" alternative to traditional illustration: a pictorial language of rough equivalencies by which visual imagery could speak to the spirit of a text without literally replicating its motifs or personages (B21). The views expressed in his letter to Bernard – though they address biblical pictures specifically – reflect Van Gogh's broader-ranging notions of the means by which ideas should be communicated by pictures (through evocative real-world motifs) and the ways in which images should correspond to texts (vaguely, allusively, nonanecdotally).

A great irony of Van Gogh's literariness was the fact that the seriousness with which he took Naturalism, particularly its tenets of direct observation, effectively precluded his recourse to the most conventional of visual responses to the textual: the imaging of an envisioned character or scene. Even Van Gogh's most blatant pictorial references to specific Naturalist books – their inclusion in some of his still lifes and portraits – remain more verbal than visual; the inscribed titles may call up associations in the attuned viewer's mind (as they apparently did in the artist's), but Van Gogh made no attempt to delimit or concretize such associations by giving form to individual characters or narrative segments.

The literary quotient of Van Gogh's bookless paintings is even harder to assess. Though the artist's readings did, by his own account, influence his personal and pictorial reactions to things he saw and painted (see, e.g., R34, LT520), literary reference in various cityscapes and figural pieces – even those singled out by the artist as somehow allied to texts – is implicit rather than overt, and again, the relationship of image to prose is more firmly established by verbal than visual means: The primary evidence resides in assertions and hints contained in the painter's letters.

Clearly Van Gogh did not intend to give precise form to the mental images reading rendered, but just as clearly he made conscious efforts to ally his work – his way of proceeding as well as specific pictures – to writers and texts he admired. But rather than assign a conjured image to Zola's mining family, or to the Goncourts' tormented Germinie Lacerteux, or to the wild Tarasconnais landscape Daudet described, Van Gogh allowed the people and

things he actually experienced to evoke admired texts in an often freewheeling way – as "realities" that were somehow similar in mood, attitude, or configuration to the verbal fictions that marked his memory. He was content to construct a suggestive (hence – though perhaps unbeknowst to Van Gogh – truly "Symbolist") art from the most mundane components. His attention to the evocative potential of the "real" – especially when processed by an artistic sensibility – had been honed, of course, by Van Gogh's exposure to the same Naturalist prose that spurred him toward certain motifs. Thus his treatment as well as his choice of subjects often relied on literary precedent, and in the final analysis, the Naturalist authors' impact on his mature work is so pervasive as to be at times inextricable from it.

NOTES

INTRODUCTION

1. Van Gogh's malady was never properly di-
agnosed and has been much speculated upon
since his death. The artist himself charac-
terized his problem as a nervous condition
and endured sporadic "attacks" that in-
cluded hallucinations, losses of conscious-
ness, and long periods of disorientation. He
may have suffered from some form of epi-
lepsy, and his self-admitted alcohol abuse
and his infection with a venereal disease in
1882 possibly exacerbated his condition.
Some medical researchers believe Van
Gogh's health problems stemmed from over-
indulgence in absinthe or from digitalis
poisoning, and one recent hypothesis holds
that he had Ménière's syndrome, a fairly
common disorder that results from excess
fluid and pressure in the inner ear. First de-
scribed in 1861, Ménière's syndrome —
which causes vertigo, nausea, and painful
ringing in the ear — was not well known until
the twentieth century and often was mis-
diagnosed.

2. Van Gogh's published letters to family and
friends, of which more than 750 are extant,
are grouped according to recipient, and the
parenthetical citations in this text and the
notes reflect that system. "LT" indicates a
letter from Van Gogh to his brother Theo
(and – only occasionally – to a third party,
e.g., their mother), "W" to his sister Wil-
helmina, "R" to his artist friend Anthon van
Rappard, "B" to Emile Bernard. Within
each of these groups, the letters are num-
bered sequentially. The letters have been
published in their original languages as *Ver-
zamelde Brieven van Vincent van Gogh*, ed-
ited by Johanna van Gogh-Bonger, and in
English as *The Complete Letters of Vincent
van Gogh*, also edited by Van Gogh-Bonger.

3. In addition to Van Gogh's letters, the pub-
lished collections of his correspondence in-
clude a memoir by Van Gogh's sister-in-law,
Johanna van Gogh-Bonger; recollections of
Vincent by various informants; the text of
Van Gogh's first sermon; and several letters
to Van Gogh from his brother Theo. For a
selective commentary on the letters as they
elucidate Van Gogh's oeuvre, see Jan Hul-
sker, *Van Gogh door Van Gogh: De brieven
als commentaar op zijn werk*.

4. The titles Van Gogh mentioned specifically
in his letters were compiled by Dorothy
Miller and are listed chronologically in
Alfred H. Barr, Jr. (ed.), *Vincent van Gogh*,
pp. 44–6.

5. See Carl Nordenfalk, "Van Gogh and Lit-
erature"; F. Bonger-van der Borsh van Ver-
wolde, "Vincent van Gogh als Lezer"; Jean
Seznec, "Literary Inspiration in Van Gogh";
Sven Lövgren, "La Nuit étoilée," in *The
Genesis of Modernism*, pp. 129–55; J. Stel-
lingwerff, "Vincent van Gogh en de Liter-
atuur"; Fieke Pabst and Evert van Uitert,
"A Literary Life, with a List of Books and
Periodicals Read by Van Gogh."

6. In framing my own strategy for verbal–
visual comparison, I found instructive James
D. Merriman's cautionary essay "The Par-

allel of the Arts: Some Misgivings and a Faint Affirmation."

7. Zola, preface to the 1877 edition of *L'Assommoir:* "une oeuvre de vérité, le premier roman sur le peuple, qui ne mente pas et qui ait l'odeur du peuple."

8. Neither Edmond de Goncourt (whose brother Jules died in 1870) nor Daudet considered himself a Naturalist, and in the 1880s both derided Zola's school. Nonetheless, their work often was and is categorized as Naturalist, and Van Gogh considered it so.

9. For example, "L'imagination n'est plus la qualité maîtresse du romancier.... Aujourd'hui la qualité maîtresse du romancier est le sens du réel" (Zola, "Le Sens du réel," *Le Roman expérimental*).

10. Taine (1828–93) had proposed that three key factors – heredity, environment, and "le moment" (contemporary events and esprit) – determined personality. For a discussion of Zola's interest in Taine's work, see John C. Lapp, "Taine et Zola: Autour d'une correspondance"; and R. Butler, "Zola Between Taine and Sainte-Beuve, 1863–1869."

11. Zola was enraptured by Bernard's *Introduction à la médicine expérimentale* and discussed its effect on his literary theories in a series of five articles entitled "Le Roman expérimental," published in *Le Voltaire* from 16 to 20 October 1879 (the first also appeared in *Le Messager de l'Europe*, September 1879); they later constituted the first chapters of Zola's book of the same title. See also Reino Virtanen, *Claude Bernard and His Place in the History of Ideas*, chap. VI; and Alain de Lattre, *Le Réalisme selon Zola: Archéologie d'une intelligence*, pp. 15–17.

12. Among the milieux explored in *Les Rougon-Macquart* are the worlds of politics, finance, agriculture, labor unions, popular entertainment, the church, the demimonde, the railroads, the markets of Paris, and its burgeoning department stores.

13. Before becoming an artist, Van Gogh spent six years as an art dealer at Goupil & Co. The firm dealt mainly in midcentury Realism; in addition to works by the Barbizon School, Goupil handled works by the Barbizon-influenced Hague School. Van Gogh's

tenure there encouraged his enthusiasm for scenes of rural life as well as his early preference for tonal rather than strongly coloristic painting.

14. Reminiscences of Jean-François Millet's oeuvre informed Van Gogh's sense of what peasant painting should be; according to Van Gogh himself, he was looking for a particular sort of physiognomy: "rough, flat faces with low foreheads and thick lips, not sharp, but full and Millet-like" (LT372). His emphasis on these stereotypic aspects of peasant portraiture is discussed by Griselda Pollock in "Van Gogh and the Poor Slaves: Images of Rural Labour as Modern Art," pp. 412–13.

15. Zola in a letter to Henry Céard, 22 March 1885; cited by Philip D. Walker in *Emile Zola*.

16. Ibid.

17. Zola, "Proudhon et Courbet, I," *Mes haines*. "Ma définition d'une oeuvre d'art serait, si je la formulais: Une oeuvre d'art est un coin de la création vu à travers un tempérament."

Zola's word *"création"* is usually translated in English as "nature" – a more neutral and secularized description of perceived surroundings. (Van Gogh himself made the same modification when he transcribed the phrase in French in LT299.) Though the English cognate can be substituted for the French *"tempérament,"* this is a more ambiguous, hence problematic, term. In using it, Zola – despite (or because of?) his amateur's interest in the physiological determinants of personality – did not refer to the received tradition of the four temperaments of medieval physiology, which often had been raised in discussions of creativity (see Rudolf Wittkower and Margot Wittkower, *Born Under Saturn, the Character and Conduct of Artists: A Documented History from Antiquity to the French Revolution*, pp. 102 –3). Rather, he seems to have used the word "temperament" in its more modern sense of "personality" – that is, an individual's characteristic manner of thinking, behaving, reacting.

18. Zola, "Le Moment artistique," *Mes haines*. "Il y a, selon moi, deux éléments dans une oeuvre: l'élément réel, qui est la nature, et l'élément individuel, qui est l'homme.... L'élément réel, la nature, est fixe, toujours

la même....L'élément individuel, au contraire, l'homme, est variable à l'infini."

19. For example, "Ce que je cherche avant tout dans un tableau, c'est un homme et non pas un tableau." Zola, "Le Moment artistique," *Mes haines.*

20. Ibid. "Faites vrai, j'applaudis; mais surtout faites individuel et vivant, et j'applaudis plus fort."

21. Zola's Impressionist connections and their impact on his prose style have provoked a great deal of comment and analysis, including Ima N. Ebin, "Manet and Zola"; Hélène Adhémar and Jean Adhémar, "Zola et la peinture"; Beverly Jean Gibbs, "Impressionism as a Literary Movement"; F. W. J. Hemmings, "Zola, Manet and the Impressionists, 1875–1880"; J. H. Matthews, "L'Impressionnisme chez Zola: *Le Ventre de Paris*"; Randolphe Walter, "Emile Zola et Claude Monet"; Philippe Hamon, "A propos de l'impressionnisme de Zola," pp. 139–47; Nathan Kranowski, *Paris dans les romans d'Emile Zola*, pp. 48–62; Joy Newton, "Emile Zola impressionniste"; and Joy Newton, "Emile Zola et l'impressionnisme." See also Jean-Max Guieu and Alison Hilton (eds.), *Emile Zola and the Arts.* This aspect of Zola's work is elaborated on in Chapter 2, this volume.

22. Certainly in the nineteenth-century environment of limited media options, novel reading was a far more popular and serious avocation than it is today.

23. Paul Gauguin, *Avant et après*, p. 15. "Daudet, de Goncourt, la Bible brûlaient ce cerveau de Hollandais."

 Emile Bernard also recalled Van Gogh's fixation on literature and noted his "admiration sans borne pour les romanciers tels que Zola, Maupassant, Flaubert, etc."; see Pierre Mornand, *Emile Bernard et ses amis*, p. 14.

24. Other constants in his reading habits are these: Van Gogh preferred nineteenth-century literature to that of other eras (the Bible being a notable exception) and prose to poetry. Though he read and discussed both fiction and nonfiction, the majority of the books mentioned in his letters are novels. Van Gogh read mainly French and English authors, though he admired some North American writers as well. His knowledge of German and Russian literature was limited, his interest in Dutch literature almost nil.

25. See Griselda Pollock, "Stark Encounters: Modern Life and Urban Work in Van Gogh's Drawings of The Hague, 1881–3."

26. See, e.g., LT607, in which Van Gogh writes, "I am astonished that with the modern ideas that I have, and being so ardent an admirer of Zola and de Goncourt...that I have attacks such as a superstitious man might have."

27. See F. W. J. Hemmings, *The Russian Novel in France, 1884–1914.*

28. Henry James, *The Ambassadors*, bk. II, chap. 2.

29. Corrections to the transcribed French-language letters are recorded in Artemis Karagheusian, *Vincent van Gogh's Letters Written in French: Differences between the Printed Versions and the Manuscripts.*

CHAPTER 1. VAN GOGH'S LITERARY INTERESTS
BEFORE 1882

1. Nordenfalk, "Van Gogh and Literature," p. 132.

2. The painters of the Pre-Raphaelite Brotherhood had, in the 1850s, taken a keen interest in Keats. Van Gogh seems to refer to the lingering influence of the PRB on English aesthetics and literary fashions in the 1870s.

3. As Edmund Blunden has noted, Keats's "strong pictorial instinct is one of the commonplaces of criticism. Lamb noted it in 1820" ("Romantic Poetry and the Fine Arts," p. 107). See also Laurence Binyon, "English Poetry and Its Relation to Painting and the Other Arts," p. 399.

4. Overviews of the history of literary pictorialism can be found in Irving Babbitt, *The New Laokoön: An Essay on the Confusion of the Arts;* Elizabeth Wheeler Manwaring, *Italian Landscape in Eighteenth-Century England: A Study Chiefly of the Influence of Claude Lorrain and Salvator Rosa on English Taste, 1700–1800;* Rensselaer W. Lee, *Ut Pictura Poesis: The Humanistic Theory of Painting;* Etienne Souriau, *La Correspondance des arts: Éléments d'esthetique comparée;* Jean H. Hagstrum, *The Sister Arts: The Tradition of Literary Pictorialism and English Poetry from Dryden to Gray;* J. R. Watson, *Picturesque Landscape and*

English Romantic Poetry; David Scott, *Pictorialist Poetics: Poetry and the Visual Arts in Nineteenth-Century France.*

5. Horace's famous phrase from the *Ars poetica* literally means, "As a painting, so a poem." In the Renaissance, removed from its original context, "Ut pictura poesis" came to be interpreted as a dogmatic maxim suggesting that a poem ought to be like a painting, although, as Hagstrum notes, "the phrase means less than what it says" (p. 9). In the passage of the *Ars poetica* whence it comes, Horace merely notes that just as some paintings bear looking at twice, "so it is with poetry" (i.e., some poems demand repeated examination, whereas others do not stand up to such scrutiny). Hagstrum concludes that "there is no warrant whatever in Horace's text for the later interpretation: 'Let a poem be like a painting,'" (p. 9). Still, in the Renaissance and beyond, "the greatest critics of antiquity, Plato, Aristotle, and Horace, were invoked as though they had created a full-blown dogma of pictorialism rather than uttered only pregnant hints" (Hagstrum, *The Sister Arts*, p. 58).

6. Many writers and critics have objected to the notion that such mental translation of verbal to visual imagery is completely possible; even in the seventeenth century La Fontaine felt obliged to note,

Les mots et les couleurs ne sont choses
 pareilles
Ni les yeux ne sont les oreilles. (*Conte
 du Tableau*)

In his recent retrospective account of the study of art-influenced literature, James D. Merriman has shown himself equally dubious about presumed equivalences in pictures and prose; in much the same vein as La Fontaine, Merriman warns, "One of the most frequent methodological errors in interarts comparisons has been the failure to recognize that a feature literally present in one art is only figuratively present in another" ("Parallel of The Arts," pt. I, p. 160). The verbal–visual dichotomy has been carefully analyzed by Jean-François Lyotard in *Discours, figure;* see also Anne-Marie Christin, "La Déraison graphique."

7. For a thorough examination of Lessing's theories and their context, see Joseph Frank,

"Spatial Form in Modern Literature." As Frank notes, *Laokoön* was directed against two increasingly popular trends of Lessing's time: narrative painting and pictorial poetry. Subtitled *The Frontiers Between Painting and Poetry,* it attacked the fashionable intermeshing of visual and verbal – which Lessing considered not just excessive but misguided – by attempting to define the two media in exclusionary terms. Painting, Lessing wrote, relies on "form and color in space," poetry on "articulated sounds in time" – that is, "entirely different means" (*Laokoön;* cited by Frank, "Spatial Form," p. 223). Those who attempted to merge the two were, in his view, defying the fundamental properties of their respective arts. Though he was not the first to make such distinctions between painting and poetry (for a discussion of his antecedents see Babbitt, *The New Laokoön*, pp. 52–3), Lessing was the first to describe and apply them systematically (Frank, "Spatial Form," p. 223).

8. Jeffrey Meyers, *Painting and the Novel*, p. 1.

9. "The reader," writes Frank, "is intended to apprehend [the word painting] spatially, in a moment of time, rather than as a sequence" ("Spatial Form," p. 225). Often such stopped-action moments are rendered in the present tense – even if the body of the text takes place in the past; this is meant to heighten the effect of immediacy of perception, and it sometimes offsets the word picture from surrounding passages that comprise narrative sequences – the more common domain of the poet (see Watson, *Picturesque Landscape*, pp. 30–1).

10. Hagstrum writes, "The pictorial in a verbal medium necessarily involves the reduction of motion to stasis or something suggesting such a reduction. It need not eliminate motion entirely, but the motion allowed to remain must be viewed against the basic motionlessness of the arrangement" (*The Sister Arts*, p. xxii). Bernard Richards refers to this tendency when he writes, "The trouble with describing paintings in poetry is that it tends to create a static, tableau-like effect" (*English Poetry of the Victorian Period, 1830–1890*, p. 206).

11. Hagstrum, *The Sister Arts*, p. xxii.

12. Both Hagstrum and Watson discuss the ele-

ments of pictorialism in depth. See also John Dixon Hunt, "Dickens and the Traditions of Graphic Satire," in *Encounters: Essays on Literature and the Visual Arts;* Karl Kroeber and William Wallig (eds.), *Images of Romanticism: Verbal and Visual Affinities;* Donald A. Ringe, *The Pictorial Mode: Space and Time in the Art of Bryant, Irving and Cooper;* Franklin R. Rogers, *Painting and Poetry: Form, Metaphor and the Language of Literature.*

13. Watson compares this to the notion of the "prospect" or "station" in eighteenth-century tourist guidebooks to picturesque landscape (*Picturesque Landscape*, p. 13; see also James A. W. Heffernan, *The Recreation of Landscape: A Study of Wordsworth, Coleridge, Constable and Turner,* p. 9). The idea of a prospect is often reinforced by reference to a spectator, who almost always stands apart from the scene – as an outsider who, according to Watson, is not a member of the local community. Instead this viewer is a "voluntary observer" for whom "the seasons do not mean different kinds of labour, but different and beautiful sensations" (p. 22). For a detailed discussion of the spectator's role, see John Dixon Hunt, *The Figure in the Landscape: Poetry, Painting and Gardening during the Eighteenth Century.*

14. In addition to overt references to the fore-, mid-, and background of a scene (through the use of designators like "in front," "beyond," "behind") many writers evoke the effects of atmospheric perspective as well, with verbal allusions to the altered hues and diminished clarity of faraway sights. In James Thomson's major work, "The Seasons" (1729–30) – a widely acknowledged exemplar of pictorial poetry – distant prospects are described, for instance, as blue in color, dusky in tone, and indistinct as clouds or smoke:

> ... the broken landscape, by degrees
> Ascending, roughens into rigid hills
> O'er which the Cambrian mountains,
> like far clouds
> That skirt the blue horizon, dusky rise.
> ("Spring")

> Heavens! What a goodly prospect
> spreads around,

> Of hills, and dales, and woods, and
> lawns, and spires
> And glittering towns, and gilded
> streams, till all
> The stretching landskip into smoke
> decays! ("Summer")

In "The English Garden" (1772), William Mason makes frank and detailed reference to the painter's process of setting up a spatial schema:

> Of Nature's various scenes the painter
> culls
> That for his fav'rite theme, where the
> fair whole
> Is broken into ample parts and bold;
> Where to the eye three well-mark'd
> distances
> Spread their peculiar colouring. Vivid
> green,
> warm brown, and black opake the
> foreground bears
> Conspicuous; sober olive coldly marks
> The second distance; thence the third
> declines
> In softer blue, or less'ning still, is lost
> In faintest purple.

That a painterly approach was more or less expected of a poet describing landscape is made clear by Sir Walter Scott's lament in a letter (cited by Watson, *Picturesque Landscape*, p. 127):

> I do not by any means infer that I was dead to the feeling of picturesque scenery.... But I was unable with the eye of a painter to dissect the various parts of the scene, to comprehend how the one bore on the other, to estimate the effect which various features of the view had in producing its leading and general effect.

15. Hagstrum writes that for the eighteenth-century reader, "pointing" words (including "here" and "there") were "signs of the pictorial"; when they occur in verse, "the suggestion of pictured landscape is inescapable" (*The Sister Arts*, p. 293). He also notes the use of words like "unveiled" and "displayed" as "slight but unmistakable hints that the scene is to be treated as though it were a work of visual art" (p. 221). On

poets' use of the imperative voice, see Watson, *Picturesque Landscape*, p. 30.

16. See, e.g., the reference to Watteau in the passage from "Mr. Gilfil's Love Story" by George Eliot, cited in note 60.

17. Manwaring's study is replete with examples of such allusion. She notes that seventeenth-century landscape painting (by Claude Lorrain and Gaspar Poussin) inspired by Antique poetry and prose provided images that often were translated back to verse by eighteenth-century writers (*Italian Landscape*, p. 21).

18. See, e.g., "De Avondstond" by Jan van Beers, which is transcribed on pp. 16–17.

19. For general remarks on the "shared vocabulary of the arts" see Rogers, *Painting and Poetry*, p. 42; Watson (*Picturesque Landscape*) provides several specific examples, e.g., on pp. 30, 40–1. On the distancing of the arts-oriented spectator from an everyday scene, see note 13, this chapter.

20. For a discussion of pictorialism in North American literature, see Ringe, *The Pictorial Mode*.

21. Two years later, when he learned that Theo was taking English lessons, Van Gogh was eager to send him a volume of Longfellow (LT51).

22. Van Gogh refers to one of George Henry Boughton's best-known compositions, which now hangs at the New York Historical Society. It is reproduced in Richard J. Koke, *American Landscape and Genre Paintings in the New-York Historical Society*, p. 7.

23. Another early example of this sort of comparison occurs in LT24 (dated 6 April 1875), in which Van Gogh writes:

I copied in your little book "Meeresstille" by [Heinrich] Heine, didn't I? Some time ago I saw a picture by Thijs Maris that reminded me of it. It represents an old Dutch town with rows of brownish-red houses with stepped gables and high stoops; gray roofs; and white or yellow doors, window frames and cornices. There are canals with ships and a large white drawbridge under which a barge with a man at the tiller passes the little house of the bridgekeeper, who is seen through the window, sitting alone

in his little office. Farther on is a stone bridge across the canal, over which some people and a cart with white horses are passing.

And there is life everywhere: a porter with his wheelbarrow; a man leaning against the railing of the bridge and looking into the water; women in black with white bonnets.

In the foreground is a brick-paved quay with a black rail; in the distance a church spire rises above the houses. A grayish white sky is above.

24. See Michael Irwin, *Picturing: Description and Illusion in the Nineteenth-Century Novel*, pp. 4–5.

25. The major source on these issues is Hugh Witemeyer, *George Eliot and the Visual Arts;* he quotes the aforementioned passage from *Adam Bede* in full.

26. Six months later, Van Gogh thought back on Eliot as he read a monograph on Michel, and – apparently comparing them on a one-to-one basis – he remained convinced that "Michel is not nearly so beautiful as the landscape described in *Adam Bede* which impressed us both so much" (LT36).

27. Van Gogh often noted his inclination toward things "left vague" (see, e.g., LT337 and his corresponding difficulties with the concretization of his conceptions [e.g., his remarks on *The Sower* in LT501]). In 1888 he quoted J. K. Huysmans in this vein, citing a line from *En ménage:* "The most beautiful pictures are those one dreams about when smoking pipes in bed, but which one will never paint" (B7; cf. *En ménage*, chap. XVI). Perhaps as early as the mid-1870s – long before he began to paint – Van Gogh already began to make the distinction between that which Wordsworth referred to as the "inward eye" (i.e., the mind and spirit) and the "bodily eye" ("the most despotic of our senses"). In the belief that a too detailed description impaired the imagination, Wordsworth resisted the trend toward pictorialism and lamented the presumption of poets who sought to capture the complexities and mutability of a natural scene; Van Gogh expressed a similar sentiment in 1888 when he wrote of the "incompetence" he sometimes felt as a painter "before the

unspeakable perfection, the glorious splendors of nature" (B7; cf. Watson on Wordsworth, *Picturesque Landscape*, pp. 96–101).

28. Preface, 1869 edition of *Histoire de France*. Indeed, Michelet claims that in writing it, "J'étais artiste et écrivain alors, bien plus qu'historien."

29. Edward K. Kaplan, *Michelet's Poetic Vision: A Romantic Philosophy of Nature, Man, and Woman*, p. xi.

30. Je vois d'ici une dame, je la vois marcher pensive dans un jardin peu étendu, et défleuri de bonne heure, mais abrité, comme on en voit derrière nos falaises en France, ou les dunes de la Hollande. Les arbustes exotiques sont déjà rentrés dans la serre. Les feuilles tombées dévoilent quelques statues. Luxe d'art qui contraste un peu avec la très-simple toilette de la dame, modeste, grave, où la soie noire (ou grise) s'égaye à peine d'un simple ruban lilas....

Mais ne l'ai-je pas vue déjà aux musées d'Amsterdam ou de La Haye? Elle me rapelle une dame de Philippe de Champagne (n.b. au Louvres) qui m'était entrée dans le coeur, si candide, si honnête, suffisamment intelligente, simple pourtant, sans finesse pour se démêler des ruses du monde. Cette femme m'est restée trente années, me revenant obstinément, m'inquiétant, me faisant dire "Mais comment se nommait elle? Que lui est-il arrivé? A-t-elle eu un peu de bonheur? Et comment s'est elle tirée de la vie?"

31. In LT20, written in July 1874, Van Gogh called *L'Amour* "both a revelation and a Gospel" – and indeed it has been labeled a "typical nineteenth-century moral gospel" by Edmund Wilson, who has written extensively of Michelet in *To the Finland Station: A Study in the Writing and Acting of History* (see p. 30). The Van Gogh brothers apparently were fascinated by Michelet's delineation of the female psyche and his account of relations between the sexes.

32. Blunden remarks on this tendency in both eighteenth- and nineteenth-century book reviews ("Romantic Poetry," pp. 101–2), and Richard Stang provides several vivid examples, including citations from the writings of nineteenth-century critic Sydney Dobell, whose remarks on a novel by W. M. Thackery include this passage: "There is a mellow atmosphere about some of his later scenes, a delicacy of aerial perspective, a depth and purity of tone, a poetic handling and freshness of rosy colour, a 'light that never was on sea or shore' " (see Stang, *The Theory of the Novel in England, 1850–1870*, p. 188). The essays of G. H. Lewes (George Eliot's life partner) are also rich in arts analogies; in comparing Charlotte Brontë's *Shirley* with her better-known *Jane Eyre*, for instance, Lewes notes that the latter features a single vantage point, whereas in *Shirley* the "artist paints" a "panorama," thus "not a picture; but a portfolio of random sketches for one or more pictures" (see ibid., p. 111). As Rensselaer W. Lee has noted, "So deeply rooted, in fact, was the association of painting with poetry that it is not unusual to find the critics referring in a way that startles the modern reader to poets as painters" (*Ut Pictura Poesis*, p. 3).

33. See Manwarning, *Italian Landscape*, p. 21. Further discussion of the so-called theory of equivalence can be found in Roy Park, *Hazlitt and the Spirit of the Age: Abstraction and Critical Theory*, chap. VI.

34. Renan spent several years studying for the priesthood, but when his intellectual endeavors set him on a collision course with church teachings, he renounced his clerical ambitions.

35. The first volume of *Les Origines du Christianisme*, entitled *La Vie de Jésus*, was published in 1863. In the following year an abridged version, titled simply *Jésus*, appeared. Renan's intent in the latter was to offer a smaller, less expensive version of *La Vie de Jésus* to a popular audience, and to that end he eliminated some of the book's more recherché passages, as well as the extensive introductory notes on his historical method. The two versions are otherwise not very different; the vast majority of passages from *La Vie de Jésus* are transcribed word for word in *Jésus*. Fieke Pabst and Evert van Uitert ("A Literary Life, with a list of Books and Periodicals Read by Van Gogh") have noted that the copy of Renan that was in Van Gogh's possession at the time of his death (and now is in the collection of the Rijksmuseum Vincent van Gogh) is the 1864 edition, *Jésus*. This does not necessarily in-

dicate, however, that that version of the book constituted Van Gogh's introduction to Renan. It is possible, for instance, that he read the unabridged *Vie de Jésus* in 1875, then lost track of the book (we know that he sent his copy of whatever version he read then to Theo; see LT23), and subsequently replaced it with the smaller, cheaper version when in 1888–9 (i.e., thirteen years and many moves later) his interest in Renan returned (see W11, LT587, LT595, LT597).

36. Renan's book bears more than titular resemblance to David Freidrich Strauss's *Das Leben Jesu* (1835–6) and Charles Hennell's *Inquiry Concerning the Origin of Christianity* (1838). Working around the same time, but independently of one another, both Strauss and Hennell asserted that the Bible was myth, not history. Neither believed that its factual inconsistencies were the result of willful fraud, and each held, moreover, that the correctness of the sentiments and values promoted by Christianity was not undercut by the improbabilities and inconsistencies of the Scriptures. See Willis B. Glover, *Evangelical Nonconformists and Higher Criticism in the Nineteenth Century;* and Basil Willey, *Nineteenth Century Studies: Coleridge to Matthew Arnold*, chap. VIII.

37. Wilson, *To the Finland Station*, p. 37.

38. Noting Renan's talent for description, Gabriel Monod called him "un créateur et un peintre d'une merveille puissance" (*Renan, Taine, Michelet*, p. xii).

39. Whereas Michelet often indulged in the verbal excess characteristic of the Romantic era, Renan favored the restraint and lucidity of a "classic" prose style adopted from seventeenth-century French literature. Wilson finds Renan's prose "pale" and flat in comparison with Michelet's (*To the Finland Station*, p. 44), but Van Gogh wrote admiringly of the "pure French" Renan employed (LT595).

40. The citation in LT26 reads:

> Pour agir dans le monde il faut mourir à soi-même. Le peuple qui se fait le missionnaire d'une pensée religieuse n'a plus d'autre patrie que cette pensée.
>
> Le homme n'est pas ici-bas seulement pour être heureux, il n'y est même pas pour être simplement honnête. Il y est pour réaliser de grandes choses pour la

société, pour arriver à la noblesse et dépasser la vulgarité où se traîne l'existence de presque tous les individus.

41. Petrus Augustus de Genestet (1829–61) was a reform preacher whose collected poetry was published posthumously in the 1860s. Van Gogh's father admired his work and sometimes enclosed De Genestet's poems in his letters to Vincent (see LT87).

42. For a thorough account of the history, structure, and usage of the *Imitatio*, see Williard L. Sperry, *Strangers & Pilgrims: Studies in Classics of Christian Devotion*, chap. III. Sperry notes that whereas in Renaissance times the *Imitatio* sometimes functioned as a surrogate for the Bible (it contains more than a thousand direct quotes from Scripture), its use as a substitute for Scripture was later frowned upon, and in the nineteenth century the *Imitatio* functioned almost exclusively as a complement to Bible study (p. 65). Van Gogh apparently used it that way.

43. Ibid., p. 69.

44. The *Imitatio* states, for instance:

> We ought...to read simple and devout books as gladly as books of high learning and wisdom. Let not the authority of thine author mislead thee, whether he were of great learning or little, but let the love of very pure truth stir thee to read. (*Imitatio Christi*, bk. I, chap. 5)

De Genestet echoed these sentiments in a poem Van Gogh later quoted in R43:

> Niet in boeken heb ik het gevonden
> En van "geleerden" – och, weinig geleerd.
>
> [I have not found it in books
> And from the "learned" – ah, little learned.]

45. Stang, *Theory of the Novel*, p. 5. For a careful analysis of views on the novel among various sects and in different decades of the nineteenth century, see Valentine Cunningham, *Everywhere Spoken Against: Dissent in the Victorian Novel*, pp. 48–62.

46. Van Gogh may have subscribed to the evangelical school of thought that acknowledged the redemptive power of imitable literary examples of goodness. See Elisabeth Jay, *The Religion of the Heart: Anglican Evangelicalism and the Nineteenth-Century*

Novel; and Cunningham, *Everywhere Spoken Against,* pp. 48–62.

47. *Mme. Thérèse* (1863) is a strongly republican account of the events of 1793; *Histoire d'un conscrit de 1813* (1864) details the changing attitudes of the French and other Europeans during Napoleon's expansionist campaigns; *Waterloo* (1865), told – like *Un Conscrit* – from a soldier's point of view, describes not only Napoleon's defeat, but life under the Bourbon Restoration.

48. On Michelet's wide-ranging impact, see Wilson, *To the Finland Station,* pp. 16–17.

49. An inkling of this tendency may be discerned from Van Gogh's earlier remarks on Longfellow, whose work he saw in a new light once he became engrossed in the art world (see LT11a).

50. A complete discussion of Holt's politics can be found in Cunningham, *Everywhere Spoken Against,* chap. VII.

51. "Dissent" is an umbrella term that commonly designates those Protestant sects (including Methodist, Baptist, Quaker, Congregationalist, Presbyterian) that opposed the teachings of the Church of England (itself a hybrid of Catholic and Protestant tenets). Dissenters – or nonconformists, as they also were known – preached asceticism, literal adherence to the Bible, and a personal relationship with God. They fulminated against Catholicism and its influence (particularly the mediating role of a clerical hierarchy) and also warned against the pantheistic tendencies and nature worship they saw as a threat in rural communities. Cunningham notes that political radicalism and religious radicalism were closely intertwined in the nineteenth century; in a section titled "Radicalism and Dissent" (ibid., pp. 91–105) he writes, "The unionist on Monday was the preacher on Sunday, deploying the same sort of Biblical language, and talking often to the same people" (p. 96).

52. Many critics complain that Felix – who clearly functions as Eliot's mouthpiece – is too good to be true. Jerome Thale finds him both "obnoxious" and "somewhat ludicrous" (*The Novels of George Eliot,* chap. V), and though Joan Bennett settles for calling him "over-glamorous," she – like Thale – sees Eliot's characterization of Felix as the

novel's major weakness (*George Eliot: Her Mind and Art,* chap. IX).

53. Late in 1876, for instance – as he sought to reform his life further and wrote to Theo of his longing to be released from the "sins of my youth" – Van Gogh bucked himself up by noting, "Who rejoices in gray hairs? Who can look behind it, like Felix Holt did behind the word *failure?*" (LT82a; his emphasis) Van Gogh seems to have referred to a dialogue that takes place between Felix and Esther in chap. XLV; Felix has been jailed for his role in an uprising, and when Esther laments, "See how you may fail!" he calmly replies:

> "But I'm proof against that word failure. I've seen behind it. The only failure a man ought to fear is failure in cleaving to the purpose he sees to be best. As to just the amount of result he may see from his particular work – that's a tremendous uncertainty: the universe has not been arranged for the gratification of his feelings. As long as a man sees and believes in some great good, he'll prefer working toward that in the way he's best fit for, come what may."

Van Gogh took comfort in this attitude and tried to look behind "gray hairs" to the maturity they represented, behind surface "failure" to inner conviction.

54. Eliot describes Felix as "shaggy-haired... without waistcoat or cravat" (chap. V). Moreover, he is said to pride himself on his simple heritage and roughshod aspect: "My father was a weaver first of all. It would have been better for him if he had remained a weaver.... I mean to stick to the class I belong to – people who don't follow the fashions" (chap. V).

55. Coincidentally, the community Van Gogh preached to (in 1878–9) was one of coal miners – a group of workers Felix Holt was particularly interested in and politically allied to. Van Gogh insisted that "with miners one must have a miner's character and temperament, and no pretentious pride or mastery, or one will never get along with them or gain their confidence" (LT129). Later (in 1884), Van Gogh lived and painted among weavers (Felix Holt's father began his career as a weaver, and Eliot's protagonist lauded

that craft [see note 54]). On a more general level, that which Cunningham has written of Felix Holt – that he "inhabits an uneasy zone between the working and middle classes" (*Everywhere Spoken Against*, p. 182) – might be said of the mature Van Gogh as well.

56. Holt was one of many fictional characters with whom Van Gogh identified on some level; as he told his friend Anthon van Rappard in 1883, "One never finds an exact likeness of oneself in a book – but one occasionally finds things taken from nature in general which are in one's own heart in a vague and indeterminate way" (R21). Van Gogh was also inclined to measure people he knew against fictional characters he found somehow similar (see, e.g., LT280, in which he compares an artist acquaintance to Felix Holt) and, conversely, to write of figures from books as if they were living companions (note, e.g., his extensive discourse with Theo on the character of Octave Mouret, the protagonist of Zola's *Pot-Bouille* and *Au Bonheur des Dames* [LT247, LT378, LT379], as well as his numerous later references to "good old Pangloss" [the philosopher of Voltaire's *Candide*], of whom he writes as one would of an intimate friend [LT481, LT506, LT549, LT574, LT588]).

57. I refer to *The Artist's Bedroom*, 1888 (F482).

58. Of Tryan's work space, for instance, the author writes:

> At the mention of a clergyman's study, perhaps, your too active imagination conjures up a perfect snuggery, where the general air of comfort is rescued from a secular character by strong ecclesiastical suggestions in the shape of the furniture, the pattern of the carpet, and the prints on the wall; where, if a nap is taken, it is in an easy-chair with a Gothic back, and the very feet rest on a warm and velvety simulation of church windows; where the pure art of rigorous English Protestantism smiles above the mantlepiece in the portrait of an eminent bishop, or a refined Anglican taste is indicated by a German print from Overbeck....

> But I must beg you to dismiss all such scenic prettiness, suitable as they may be to a clergyman's character and complexion; for I have to confess that Mr. Tryan's study was a very ugly little room indeed, with an ugly slap-dash pattern on the walls, an ugly carpet on the floor, and an ugly view of cottage roofs and cabbage-gardens from the window. ("Janet's Repentance," chap. XI)

Later, of a landscape vista, she insists:

> There was no line of silvery willows marking the course of a stream – no group of Scotch firs with their trunks reddening in the level sunbeams – nothing to break the flowerless monotony of grass and hedgerow but an occasional oak or elm, and a few cows sprinkled here and there. A very commonplace scene, indeed. ("Janet's Repentance," chap. XXVI)

59. The author had begun to write *Adam Bede* while still at work on *Scenes of Clerical Life*. The former was published in 1859; the latter had been published serially in *Blackwood's Magazine* in 1857 and appeared in book form the following year.

60. Many of the most prominent marks of word painting can be found, for instance, in a single long passage from "Mr. Gilfil's Love-Story":

> And a charming picture Cheverel Manor would have made that evening, if some English Watteau had been there to paint it: the castellated house of grey-tinted stone, with the flickering sunbeams sending dashes of golden light across the many-shaped panes in the mullioned windows, and a great beech leaning athwart one of the flanking towers, and breaking, with its dark flattened boughs, the too formal symmetry of the front; the broad gravel-walk winding on the right, by a row of tall pines, alongside the pool – on the left branching out among swelling grassy mounds, surmounted by clumps of trees, where the red trunk of the Scotch fir glows in the the descending sunlight against the bright green of limes and acacias; the great pool, where a pair of swans are swimming... The lawn with its smooth

emerald greenness, sloping down to the rougher and browner herbage of the park ... and on this lawn our two ladies, whose part in the landscape the painter, standing at a favourable point of view in the park, would represent with a few dabs of red and white and blue. (chap. II)

61. For an extended discussion of the religious themes of *Adam Bede*, see Cunningham, *Everywhere Spoken Against*, pp. 147–71; and U. C. Knoepflmacher, *Religious Humanism and the Victorian Novel: George Eliot, Walter Pater, and Samuel Butler*, chap. IV.

62. In May 1876 – a month after returning to England from Paris – Van Gogh alluded to *Silas Marner* for the first time (in LT66), but in a way that implied that some time had passed since he had read it. Ronald Pickvance has proposed that Van Gogh read the book in France and suggests that his concentrated reading of Eliot there in 1876 was sparked by his close friendship with an Englishman named Harry Gladwell (*English Influences on Van Gogh*, p. 25).

63. Though the other members of Eliot's immediate family were mainstream churchgoers of no great piety, the author embraced evangelism in her preteen years under the influence of a boarding school teacher. Her fundamentalist faith eventually was shaken by the intellectual pursuits of her twenties and her increasing fascination with science, philosophy, and philology. See Rosemary Ashton, *George Eliot*; and Bernard J. Paris, *Experiments in Life: George Eliot's Quest for Values*.

64. *Silas Marner*, pt. I, chap. I.

65. Eliot writes:

> He had inherited from his mother some acquaintance with medicinal herbs and their preparation – a little store of wisdom which she had imparted to him as a solemn bequest – but of late years he had had doubts about the lawfulness of applying this knowledge, believing that herbs could have no efficacy without prayer, and that prayer might suffice without herbs; so that his inherited delight to wander through the fields in search of foxglove and dandelion and

coltsfoot, began to wear to him the character of a temptation. (Ibid.)

Though Eliot characterizes this repudiation as unhealthy and alienating, Van Gogh in this era seems to have felt as uncomfortable about his former fascination with the out-of-doors as Silas did about his: "A feeling, even a keen one, for the beauties of nature," he wrote, "is not the same as a religious feeling.... You know that it is written, 'This world passeth away, and the lust thereof'" (LT38). Later, however, Van Gogh's affection for nature returned in full force, and he expressed an interest in herbal remedies when in 1890 he included sprigs of foxglove in the portrait of his friend Dr. Paul Gachet (Plate 16); the portrait is discussed in Chapter 6, this volume.

66. *Silas Marner*, pt. I, chap. 1.

67. Ibid.

68. Ibid., chap. 10.

69. Ibid., pt. II, chap. 21.

70. Eliot's pity for Marner and those like him is made clear by her asides to a reader she assumes to be more sophisticated than her protagonist; she comments, for instance:

> To people accustomed to reason about the forms in which their religious feeling has incorporated itself, it is difficult to enter into that simple, untaught state of mind in which the form and the feeling have never been severed by an act of reflection. We are apt to think it inevitable that a man in Marner's position should have begun to question the validity of an appeal to the divine judgement by drawing lots; but to him this would have been an effort of independent thought such as he had never known. (*Silas Marner*, pt. I, chap. 1)

71. See Cunningham, *Everywhere Spoken Against*, pp. 43–4; and E. R. Norman, *Church and Society in England, 1770–1970*, p. 161.

72. Van Gogh particularly admired *The Wide, Wide World* by Elizabeth Wetherell (a/k/a Susan Warner) and *John Halifax, Gentleman* by Miss Mulock (known after her marriage as Dinah Maria Craik). Each of these Victorian tearjerkers chronicles the maturation of a courageous, noble-spirited child left alone at an early age. *The Wide, Wide*

World is forthrightly Christian in thrust, and Van Gogh found it "well-suited for young boys," despite its female protagonist (LT64). The rise of Miss Mulock's John Halifax is recounted by his devoted friend Phineas, a rich but sickly boy who admires John's prowess in the world and the strength of his body and character. Phineas is almost passionately drawn to John and compares their friendship to the biblical relationship between Jonathan and David. Theirs is a story of male bonding, a subject dear to Van Gogh's heart throughout his life; see, e.g., his comments on the story of Elijah and Elisha from the Book of Kings (LT72) or his descriptions of the Goncourt brothers' *Les Frères Zemganno* (LT550, LT551).

73. Andersen – like so many other nineteenth-century writers – was intrigued by the interplay of descriptive processes, and his attempts at pictorial prose clearly appealed to Van Gogh; some years later (1882) Van Gogh asked an artist friend, "Don't you think Andersen's *Fairy Tales* are glorious? – he is surely an illustrator too!" (R16). While still living in Paris in early 1876, Van Gogh had asked Theo to send him a copy of Andersen's *Stories of the Moon* – also known as *The Picture Book Without Pictures* – a book in which the moon creates scenes and episodes for an artist alone in his garret, using words as its medium (see LT53).

74. Van Gogh was drawn to Andersen's more somber stories – including "The Snow Queen," "The Red Shoes," "The Story of a Mother," and "The Little Matchgirl" – the violence and morbidity of which strike this twentieth-century reader as ill-suited to a school-age audience. For comprehensive modern appraisals of Andersen's *Tales*, see Elias Bredsdorff, *Hans Christian Andersen: The Story of His Life and Work;* and Bo Grønbech, *Hans Christian Andersen.*

75. Though the biblical quotations in his letters are multitudinous and highly varied, Van Gogh seems to have been especially fond of the Book of Kings, Acts of the Apostles, and the parables. A thorough and systematic study of his interest in the Bible is beyond the scope of this book, but would be an invaluable aid to Van Gogh studies.

76. A compendium of critical writing on *The Pilgrim's Progress* can be found in Vincent Newey (ed.), The Pilgrim's Progress: *Critical and Historical Views.*

77. According to Ronald Pickvance, Van Gogh was recalling Boughton's only painting in the Royal Academy exhibition of 1874, *God Speed! Pilgrims Setting Out for Canterbury: Time of Chaucer.* If this were indeed the picture to which Van Gogh referred, he would be – as Pickvance admits – "confusing a spring evocation of Chaucer's pilgrims leaving a now distant London with an image of Bunyan's pilgrim striving towards the Holy City on an autumnal evening" (*English Influences on Van Gogh*, p. 23). I find this explanation improbable, especially when one considers Van Gogh's much more extensive description of the picture in his first sermon (see *The Complete Letters of Vincent Van Gogh*, edited by Johanna van Gogh-Bonger, vol. I, pp. 90–1). Van Gogh probably was thinking of another Boughton composition, perhaps one in the mode of *Bearers of the Burden*, which was exhibited at the Royal Academy in 1875 and shows four people on a winding road that leads toward distant hills. The terrain is rugged, the sky dark. The women of the picture are laden with bundles, whereas their male companion strides ahead, unencumbered. Though it is not an ideal match for Van Gogh's description, it would seem closer than the scene from Chaucer, and its title seems especially compatible with Van Gogh's verbal evocation and Bunyan's tale. The locations of both *Pilgrims Setting out for Canterbury* and *Bearers of the Burden* are unknown, though the latter is reproduced in Lee MacCormick Edwards, "Hubert van Herkomer and the Modern Life Subject," fig. 166. I am grateful to Allen Staley for his suggestion that *Bearers of the Burden* might be the picture Van Gogh remembered and to Dr. Edwards for sharing her photo of the lost work with me.

78. Van Gogh was consistently inaccurate in his quotation of Rossetti's lines, presumably because he was citing them from memory.

79. Ralph A. Bellas, *Christina Rossetti*, p. 15.

80. His continuing interest in verbal pictorialism is affirmed by his description of a stormy seascape in LT67, which was written from Ramsgate in May 1876. See p. 21, this volume.

81. "Vincent's Sermon," *Complete Letters*, vol. I, pp. 90–1.

82. Compare Psalm 119:105, which is inaccurately quoted.

83. See "Personal Memories of Vincent van Gogh During His Stay at Amsterdam," *Het Algemeen Handelsblad*, 2 December 1910; reprinted in *Complete Letters*, vol. I, pp. 169–71.

84. LT95 contains an informal inventory of the prints Van Gogh chose for himself:

> One after Jamin...one after M. Maris, the little boy going to school; five after Bosboom; Van der Maaten's "Funeral Procession through the Cornfields"; Israëls, poor man on a snowy winter road; and Ostade, studio. Then there is still an Allebé, a little old woman carrying her hot water and live coals on a winter morning along a snow-covered street.

85. *Complete Letters*, vol. I, p. 171. Mendes's recollections are supported by Van Gogh's own account of this practice in LT93, written from Dordrecht:

> I will hang the prints you gave me...so they will remind me of you daily.
>
> Underneath the print after Rosenthal, that monk, I have written: "Take my yoke upon you, and learn of me; for I am meek and lowly in heart: and ye shall find rest unto your souls. For my yoke is easy, and my burden is light; if any man will come after me, let him deny himself, and take up my cross, and follow me – in the Kingdom of Heaven they neither marry, nor are given in marriage."
>
> Underneath the pendant, "The Imitation of Jesus Christ" (after Ruyperez), I wrote what we heard Pa say, "Lord, I long so much to be earnest."

86. The lithograph, after a work by Ruyperez, was titled *The Imitation of Jesus Christ*. Van Gogh had owned an engraving of the Ruyperez during his first stay in Paris (LT33), and Theo had given him another copy when he lived at Dordrecht (LT93); see note 85. From Amsterdam, he wrote appreciatively of that picture's twilight effect, for twilight, according to Van Gogh, speaks "to those who have ears to hear and a heart to understand and believe in God" (LT110).

87. Van Gogh probably did not read Michelet's history in its entirety while at Amsterdam; his assertion that he returned to the book for more "serious study" in the Borinage in 1879–80 (LT133) suggests that he may have read most of it then – when he had much more time to devote to avocational reading.

88. Fénelon (1651–1715) was a controversial theologian who served as archbishop of Cambrai. *Les Aventures de Télémaque* was written as a series of lessons for the young duke of Burgundy, whom Fénelon tutored in the late seventeenth century. Believed to be a covert criticism of Louis XIV and his court, *Télémaque* was confiscated from a French printer and made its first appearance in The Hague, in 1699. It was a popular text for schoolchildren in both France and Holland in the nineteenth century. See James Herbert Davis, Jr., *Fénelon*, chap. 5; and Henri Gérard Martin, *Fénelon en Hollande*.

89. Hedva Ben-Israel writes, for instance, of Carlyle's belief "that history was a bible written by God and that it was the historian's function to interpret Providence and expound the essentially moral nature of the world" (*English Historians on the French Revolution*, p. 130). On Michelet's "moral interpretation of history," see Stephen A. Kippur, *Jules Michelet: A Study of Mind and Sensibility*, pp. 151–6; Kippur describes Michelet's characterization of the Revolution as a period of moral renewal ordained by God and prophesied by the French people.

90. Whereas Carlyle focuses on powerful individuals – the "heroes" who are so much a part of his vision of history – Michelet celebrates "the people," acting anonymously en masse. Moreover, Carlyle's *French Revolution* is more cautionary than Michelet's. Noting the excesses of revolutionary anarchy, Carlyle intones, "Let us do otherwise," whereas Michelet seems more inclined to excuse extreme means if necessary ends are achieved. See John D. Rosenberg, *Carlyle and the Burden of History*, p. 95; and Kippur, *Jules Michelet*, pp. 143–7.

91. Rosenberg notes that almost a third of *The French Revolution* consists of broadly philosophical passages that are essentially ahistorical, and writes: "Of the many voices of the narrator of [Carlyle's] *French Revolu-*

tion, the most distinctive is that of the biblical prophet who 'reads' secular history as a continuation of ancient Scripture and portrays the Revolution as a modern Apocalypse" *Carlyle and the Burden of History,* p. 62–3).

92. See Kippur, *Jules Michelet,* pp. 153–6, and Oscar A. Haac, *Jules Michelet,* pp. 81–2. As Kippur points out, Michelet goes so far as to compare the Jeu de Paume – where deputies of the Third Estate swore in June 1789 not to disband until a new constitution had been drafted – to the stable at Bethlehem (*Jules Michelet,* p. 155).

93. This passage from John's Gospel is also part of the standard Anglican burial service, which Carton in essence performs for himself.

94. See Dennis Walder, *Dickens and Religion,* p. 198. Walder is careful to note, however, that none of Dickens's novels was "*primarily* religious in intention or effect" (p. 15).

95. The seeds of this interpretation may well have been sown by Dickens's own preface, wherein he proposes "to add something to the popular and picturesque means of understanding that terrible time, though no one can hope to add anything to the philosophy of Mr. Carlyle's wonderful book." Dickens not only relied on Carlyle's *French Revolution* as he wrote *A Tale of Two Cities,* but also used much of the same source material. As a result, their books are quite similar on both general and specific levels (even Carton's self-sacrificing substitution is based on a historical incident recounted by Carlyle). See William Oddie, *Dickens and Carlyle: The Question of Influence,* chap. V.

96. Van Gogh was aided in his search for a lay training program by the Methodist minister he had worked for in Isleworth, who joined Vincent and his father in Brussels. The school they chose together had been founded by the Rev. N. de Jong in 1876. According to Van Gogh, he and his father agreed on this Belgian program because "the course is shorter and less expensive than in Holland" (LT123).

97. *Complete Letters,* vol. I, pp. 172, 180–2.

98. *Ibid.,* pp. 222–30; see also LT129 and LT130.

99. In fact, only his first letter from the coal country (LT127) contains a biblical citation.

100. For an elaboration on this attitude – by a minister who knew Van Gogh at the Borinage – see the recollections of the Rev. Bonte in Louis Piérard, *La Vie tragique de Vincent van Gogh;* excerpts from the book are reprinted in *Complete Letters,* vol. I, pp. 222–5.

101. The report of the Synodal Board of Evangelization that reviewed Van Gogh's work is reprinted in *Complete Letters,* vol. I, p. 227.

102. It may be argued that Van Gogh never completely abandoned his urge to preach and, once denied the pulpit, found an alternative forum in his art. I have discussed the evangelistic dimensions of Van Gogh's oeuvre in "The Sower and the Sheaf: Biblical Metaphor in the Art of Vincent Van Gogh."

103. Remarks in LT133 suggest that Van Gogh may have read several of Shakespeare's plays at this time, though only one – *King Lear* – is mentioned by name. His mention of Falstaff in the same letter indicates that he had also read *Henry IV* and/or *The Merry Wives of Windsor,* since Falstaff appears in each of them. In later letters Van Gogh indicated knowledge of *The Taming of the Shrew* (LT152), *Macbeth* (LT326, LT342, LT343), *Richard II* (LT597, W13), *Henry IV* (LT597, W13), *Henry V* (LT597, W13), *Henry VI* (W13), *Henry VIII* (LT599), and *Measure for Measure* (LT599). Van Gogh compared Shakespeare to Rembrandt (LT133, LT136) and remarked: "My God, how beautiful Shakespeare is! Who is mysterious like him? His language and style can indeed be compared to an artist's brush, quivering with fervor and emotion" (LT133).

104. Substantive exploration of these issues is provided by Pollock, "Stark Encounters," pp. 346–53; and idem, "Van Gogh and the Poor Slaves," pp. 406–32.

105. Van Gogh read both novels in translation. He referred to *Uncle Tom's Cabin* by its Dutch title, *De Negerhut,* in his letter of June 1879 (LT130), but he later reread it in French and included a French-language edition of the book in his portrait series of Marie Ginoux (F540–43; see Plate 15), made at St.-Rémy in 1889 (see Chapters 5 and 6). He read Dickens's novel in French in August 1879 and in fact recommended the Hachette edition (from the series Bib-

liothèque des meilleurs romans étrangers) as a "very good French translation" (LT131).

106. J. C. Furnas's *Goodbye to Uncle Tom* remains one of the most penetrating critiques of Beecher Stowe's book; see also James Baldwin's treatment of the novel in his *Notes of a Native Son*. Recent feminist appraisals by Jean Fagan Yellin ("Doing It Herself: *Uncle Tom's Cabin* and Woman's Role in the Slavery Crisis") and Elizabeth Ammons ("Stowe's Dream of the Mother: *Uncle Tom's Cabin* and American Women Writers Before the 1920s") appear in Eric J. Sundquist (ed.), *New Essays on* Uncle Tom's Cabin.

107. Like many nineteenth-century abolitionists, Beecher Stowe felt that institutionalized religion had not done enough to further the cause. Indeed, many American preachers avoided the issue, and several sought biblical justifications for slavery. See Thomas P. Gossett, Uncle Tom's Cabin *and American Culture*, pp. 121–2, 289–90; and Moira Davison Reynolds, Uncle Tom's Cabin *and the Mid-Nineteenth Century United States*, chap. IV.

108. E. Bruce Kirkham, in *The Building of* Uncle Tom's Cabin, cites a letter to her editor in which Beecher Stowe remarks that her novel was "written by God" (pp. 66–7).

109. See Sundquist (ed.), *New Essays*, p. 11.

110. In the same letter (LT130), Van Gogh compared Beecher Stowe's writing to paintings by Hague School artists Anton Mauve, Jozef Israëls, and Matthijs Maris, in the sense that all of them, he felt, extracted larger truths, or "conceptions," from observed phenomena. Van Gogh wrote:

> I still can find no better definition of the word art than this, "L'art c'est l'homme ajouté à la nature" – nature, reality, truth, but with a significance, a conception, a character, which the artist brings out in it, and to which he gives expression...which he disentangles, sets free and interprets. A picture by Mauve or Maris or Israëls says more, and says it more clearly, than nature herself. It is the same with books, [for instance]...*Uncle Tom's Cabin*.

In a letter to her editor, Beecher Stowe affirmed her own pictorialist intent when she wrote, "My vocation is simply that of a painter, and my object will be to hold up [slavery] in the most lifelike and graphic manner possible...[for] there is no arguing with *pictures*, and everybody is impressed by them, whether they mean to be or not" (her emphasis; cited by Sundquist [ed.], *New Essays*, p. 9).

111. For an incisive characterization of Van Gogh's relation to the Brabant peasants he took as subjects for paintings of 1885, see Pollock, "Van Gogh and the Poor Slaves," p. 415.

112. See LT248 – written from The Hague in 1882 – and Chapters 5 and 6, this volume.

113. The early chapters of *Hard Times* are dominated by satirization of the rigidity and reductionism of then-fashionable utilitarian ideology, and Dickens goes on to criticize the laissez-faire economic system favored by Jeremy Bentham and his followers. Dickens's attitudes clearly were shaped by Carlyle, to whom the book is dedicated. See Oddie, *Dickens and Carlyle*, chap. IV; and Walder, *Dickens and Religion*, p. 145.

114. See, e.g., Philip Hobsbaum, *A Reader's Guide to Charles Dickens*, pp. 182–3; Sylvère Monod, "Dickens as Social Novelist," pp. 83–5; and Raymond Williams, "The Industrial Novels: *Hard Times*," pp. 13–14.

115. On Dickens's notion of the "social gospel," see the introduction to Walder, *Dickens and Religion*, and pp. 140–5. An allusion to the Gospels of Matthew and Mark is suggested by the author's division of *Hard Times* into three parts titled "Sowing," "Reaping," and "Garnering" (cf. the parable of the Sower: Matt. 13; Mark 4).

116. As Sylvère Monod notes, the "very ugly light" in which Dickens puts the unionists of *Hard Times* "seriously impairs the defense of the workers he had intended to effect in his book" ("Dickens as Social Novelist," p. 83). Dickens was but one of several midcentury authors who took a dim view of collective action; for a general discussion of prevailing attitudes and their origins, see Patrick Brantlinger, "The Case Against Trade Unions in Early Victorian Fiction."

117. See *Hard Times*, pt. I, chap. 5, wherein Dickens writes, in part:

Who belonged to the eighteen [religious] denominations?... Whoever did, the labouring people did not. It was very strange to walk through the streets on a Sunday morning, and note how few of *them* the barbarous jangling of bells that was driving the sick and nervous mad, called away from their own quarter, from their own close rooms, from the corners of their own streets, where they lounged listlessly, gazing at all the church and chapel going, as a thing with which they had no manner of concern.

118. Van Gogh also linked Hugo to Dickens; see LT136.

119. See Victor Brombert, *Victor Hugo and the Visionary Novel*, chap. II.

120. In his isolation and poverty, Van Gogh was for the most part obliged to read the "books within my reach" (LT133), and he later explained that he had discovered most of his favorite authors of this era "by accident" (LT164).

121. Van Gogh characterized his reading in the winter of 1879–80 as "study" and portrayed himself as trying "to understand the real significance of what the great artists, the serious masters, tell us" (LT133).

122. See *Complete Letters*, vol. I, p. 223.

123. Once he moved to France in 1886, Van Gogh preferred writing in French even to Dutch natives like his brother, sister-in-law, and sister (W8), and he apparently asked that his correspondents do the same, if possible (see T8).

124. See *Complete Letters*, vol. I, p. xxxii.

125. Van Gogh wrote of his admiration for the "plasticity" of Dickens, Balzac, and Brontë (R8). He found Dickens's descriptions on a par with English illustrators he admired (R13) and later referred to Dickens's novels – along with those of Hugo and Zola – as "figure painter's books" (R35). As early as January 1881, Van Gogh made a figure study based on a "type" drawn from Balzac (LT140), and in the summer of that year, when he recommended Brontë's *Shirley* to Theo, he noted, "It is as beautiful as pictures by Millet or Boughton or [H. H.] Herkomer" (LT148).

126. A discerning characterization of Michelet's politics is given by Roland Barthes in *Michelet*, p. 11.

127. For an overview of Michelet's social mission and spiritual leanings, see Kaplan, *Michelet's Poetic Vision*, introduction, esp. pp. xiii–xviii.

128. Kippur, *Jules Michelet*, chap. XIV.

129. Ibid., pp. 193, 210.

130. Wilson, e.g., declares that "Michelet, like many nineteenth-century writers, is at his worst when he is preaching a gospel" (p. 28).

131. Van Gogh refers to the author as "father Michelet" in LT155, apparently both to emphasize his affection and esteem for the writer and to suggest dissatisfaction with his own father. As he cast about for surrogate patriarchs in this period, Van Gogh also looked to artists he admired: J.-F. Millet (see LT161) and Anton Mauve (see LT164).

132. The most thorough account of Beecher Stowe's domestic philosophy and its impact on her late novels can be found in Alice C. Crozier, *The Novels of Harriet Beecher Stowe*, chap. V.

133. Ibid., p. 159.

134. Van Gogh's remarks in LT148 suggest that he saw *Jane Eyre* – Brontë's most popular novel by far – as secondary to *Shirley*, which he found at his uncle's house and read "in three days, though it is quite a voluminous book."

135. For a discussion of these themes in both *Shirley* and *Jane Eyre*, see Terry Eagleton, "Class, Power and Charlotte Brontë."

136. The book's eponymous heroine, Shirley Keeldar, is an heiress who rejects society's pronouncements and marries "beneath herself" in terms of social class in order to satisfy her love for a tutor. The other prominent female character of the novel, Caroline Helstone, questions the passivity preached by the austere cleric who raised her, and instead asserts her personal right to happiness in a chapter titled "Old Maids." "Does virtue lie in abnegation of self?" she asks. "I do not believe it.... Each human being has his share of rights" (*Shirley*, chap. X). Brontë's novel ends with the marriages of Shirley and Caroline, each effected by commitment to feeling and immense perseverance.

137. Like Van Gogh's, Brontë's father was a country cleric. She grew up in the bleak isolation of the Yorkshire moors, and in her youth was sent to a school for daughters of the clergy. Two of her sisters died at the

school, which is portrayed with lingering bitterness in the first section of *Jane Eyre*. In that book as well as in *Shirley,* Brontë presents clergymen as stubborn, repressive, often misguided, and sometimes cruel, and she advocates substantial reform in organized religion.

138. The dates of Van Gogh's favorite authors in this era are as follows: Charlotte Brontë, 1816–55; Thomas Carlyle, 1795–1881; Charles Dickens, 1812–70; George Eliot, 1819–80; Victor Hugo, 1802–85; Jules Michelet, 1798–1874; Harriet Beecher Stowe, 1811–96. All were older – in some cases, a generation older – than Van Gogh's father, who was born in 1822 and died in 1885.

CHAPTER 2. VAN GOGH IN THE HAGUE:
THE ARTIST MEETS FRENCH NATURALISM

1. Mauve (1838–88) was married to a cousin of Van Gogh's and had offered to tutor the younger artist in the basics of watercolor and oil painting.

2. According to his letters, Van Gogh now read only at night, "for I must work in the daytime" (LT180), and "art is jealous, and demands our whole strength" (R9). His letters of this era contain few literary references, and those that appear indicate books read before his move (LT181, LT186). Apparently the only new book he read at this time was nonfictional and art-related: Alfred Sensier's recently published biography of J.-F. Millet (1881).

3. Her full name was Clasina Maria Hoornik; in addition to the diminutive "Sien," she also was known as Christine. Born at The Hague in 1850, she was three years older than Van Gogh and died a suicide in 1904. A brief biographical account is given by Jan Hulsker in "Van Gogh's Dramatic Years in The Hague."

4. See also LT266.

5. See Gerben Colmjon, *The Hague School: The Renewal of Dutch Painting since the Middle of the Nineteenth Century,* introduction; and Ronald de Leeuw, "General Introduction," in *The Hague School: Dutch Masters of the Nineteenth Century.*

6. Jacob (Jacques) van Santen Kolff, though primarily a literary critic, also was interested

in music and the visual arts. A man of reasonably adventurous tastes, he was receptive to new trends and was one of the first Dutchmen to champion Wagner's music and Zola's novels.

7. Jacob van Santen Kolff, "Een Blik in de Hollandsche schilderschool onze dagen" (part V). Van Santen Kolff alluded briefly to another sort of realism – "false" and "unhealthy" – without being more specific about its properties or perpetrators.

8. De Leeuw acknowledges the influence of French art on the Hague School, but rightly notes that Hague School realism tends to be less politicized and more Romantic than that of Millet or Courbet. He also points out that with the exception of Jozef Israëls, Hague School artists were more landscape-oriented and less interested in the figure than were Millet and Courbet (see *The Hague School,* pp. 33–5).

9. Jacob van Santen Kolff, "Over de nieuwste richting in onze schilderkunst naar aanleiding der jongste tentoonstelling te Amsterdam."

10. For example, Philip Zilcken, a watercolorist working in The Hague in the 1880s, later recalled the elaborate joint efforts of Jacob and Willem Maris and the prominent literary critic Jan ten Brink. See Zilcken, "Herinneringen van een Hollandsche schilder der negentiende eeuw, 1877–1929."

11. For details of Breitner's life in The Hague, see P. H. Hefting, *G. H. Breitner in Zijn Haagse Tijd.*

12. According to Griselda Pollock, at the time Breitner worked with Van Gogh, he "was using novels by the Goncourt brothers to justify experiments with working-class material" ("Stark Encounters," p. 332).

13. A preliminary sketch of the woman at left occurs, for instance, in LT178, and a more developed drawing of the same figure is also extant (F913). As Van Gogh told Theo, "When I draw separate figures, it is always with a view to a composition of more figures.... But these larger compositions must ripen slowly" (LT178).

14. Some of Breitner's earliest drawings were copies after engravings from illustrated magazines, and later he created his own illustrations for Dickens's *Pickwick Papers* and

Sir Walter Scott's *Ivanhoe.* See Hefting, *G. H. Breitner,* p. 10.

15. For a thorough discussion of Sensier's book, see Christopher Parsons and Neil Mc-William, " 'Le Paysan de Paris': Alfred Sensier and the Myth of Rural France."

16. Van Gogh had read the Goncourts' *Gavarni* by the fall of 1881 (R1); Breitner made a note of it in a sketchbook of 1882 (Hefting, *G. H. Breitner,* p. 110, n. 6).

17. Ibid., p. 62. In a letter to his patron, A. P. van Stolk, written in March 1882 (the time of his close association with Van Gogh), Breitner mentioned that "a friend" had lent him the book by Michelet; Van Gogh very likely was that unnamed friend. See also G. H. Breitner, *Brieven aan A. P. van Stolk,* p. 30 (letter 24, 28 March 1882).

18. Ibid., p. 24 (letter 15, November 1881). He calls *Manette Salomon* "een van hun mooiste scheppingen."

19. Ibid. "Ik beveel dat boek aan iedereen aan leek of schilder en zal 't me koopen."

20. Though Hefting asserts that Van Gogh read *Manette Salomon* in 1882 (*G. H. Breitner,* p. 62), no hard evidence of his having read the book occurs in the artist's letters until 1889 (LT604; see Chapter 6, this volume). It also was included in a portrait of Dr. Paul Gachet painted in June 1890 (Plate 16). It seems unlikely that Van Gogh read his first novel by the Goncourts – especially *Manette Salomon,* which deals with studio life in Paris c. 1840 – without mentioning it to Theo. Later in the year, when he read Henri Murger's *Les Buveurs d'eau,* he remarked on its discussion of the Parisian art world and reviewed descriptions of painters by various authors, including Murger, Balzac, and Zola (LT248); he did not mention the Goncourts in this context, which he almost certainly would have done had he recently read so monumental an account of studio life as *Manette Salomon.*

21. *The Mystery of Edwin Drood* is the confession of a murderer, told from his cell. Van Gogh's remarks on the novel attest to his ongoing interest in the interrelatedness of the verbal and visual: "I have my books on perspective here, and a few volumes of Dickens, including *Edwin Drood;* there is perspective in Dickens, too. Good God, what an artist" (LT207). But as often is the case

when Van Gogh used visual arts analogy to describe a novelist's technique, his meaning here is unclear. When he wrote of "perspective" in Dickens, he may have meant mental perspective, or actual descriptions of perspectival space, or – in the case of this particular novel – he may have been referring to its unusual structure. In *Edwin Drood,* the central action, told in a third-person voice, is framed by a first-person account by the murderer.

22. It seems most likely that a fellow patient left Zola's novel or lent it to Van Gogh; if one of his artist friends had visited him and brought it he probably would have mentioned it to Theo in so detailed a reference as this one.

23. See Coenraad Busken Huet, *Litterarische fantasien en kritieken,* vol. XXV, pp. 172–6.

24. See E. L. Janssen, "*Dutch Criticism of Zola, 1876–1909*"; Piet Valkoff, *Emile Zola et la littérature néerlandaise;* Jacob de Graaf, *Le Réveil littéraire en Hollande et le naturalisme français;* Bard H. Bakker, "Zola aux Pays-Bas, 1875–1885"; and idem, "Emile Zola and the 'Revolution of the 1880s' in The Netherlands" (though he does not acknowledge it, Bakker draws heavily on De Graaf's landmark study).

25. Jan ten Brink, "De jongste romantische school in Frankrijk."

26. Jan Ten Brink, "Een letterkundige Herkules."

27. Jan Ten Brink, "Parijs van het Trocadero gezien," "Het naturalisme op het toneel," and "Letterkundige nuffigheid."

28. Jan Ten Brink, *Emile Zola: letterkundige studie.* A revised edition of the Zola monograph, with a new preface, was published in 1884.

29. Ibid., p. 3.

30. In an essay called "Le Sens du réel," included in his well-known treatise on the Naturalist novel, *Le Roman expérimental,* Zola himself writes:

> L'intérêt n'est plus dans l'étrangeté de [l'histoire]; au contraire, plus elle sera banale et générale, plus elle deviendra typique.
>
> …L'imagination n'est plus la qualité maîtresse du romancier.... Aujourd'hui

la qualité maîtresse du romancier est le sens du réel.

31. Ten Brink, *Zola*, p. 30; "de zwakkezijde," "De romancier moet evenwel kunstenaar blijven in de keuze van zijne stof."

32. Ibid., p. 3; "mannelijke geest," "Herkulische kracht."

33. The most prominent Tachtigers were Lodewijk van Deyssel (the pseudonym of Albert Thijm), Marcellus Emants, Franz Erens, Franz Netscher (a nephew of Jacob van Santen Kolff), and Arij Prins. In an article written for *De Amsterdammer* (28 January 1883), Van Deyssel referred to Zola as "notre Dante." Some years later, Netscher recalled (in "Karakterschets. Prof. Jan ten Brink"):

> C'est ainsi que l'art de Zola fit son entrée dans notre pays, Jan ten Brink tenant lieu du maître de cérémonies. Nous éprouvons toujours une sorte de respectueuse gratitude en nous rappelant ces jours magnifiques où, initiés par Ten Brink, nous saluions la parution d'une nouvelle oeuvre de Zola comme un événement joyeux et comme une haute jouissance artistique, et où nous tardait que le soir arrivât pour pouvoir nous isoler avec le nouveau roman et nous y donner tout entiers. (p. 233)

34. See Bakker, "Zola and the 'Revolution,'" p. 100.

35. According to an article by Netscher, published in *Het Vaderland* (4 March 1923), Zola was "le maître, grand et loyal, de notre génération." Seven years later, Valkoff wrote, "La littérature hollandaise doit à l'influence exercée par Zola le renouvellement de la langue littéraire, l'audace de représenter avec plus de vérité la vie sexuelle et les misères sociales, et le pessimisme plein de charité" (p. 14).

36. In "Over de nieuwste richting," Van Santen Kolff noted; "Alle kunsttakken en richtingen in onze dagen worden bezield door een machtigen drang naar natuur en waarheid, naar eenvoud in het schilderen van het leven, de natuur, en de mensch, zooals zij zijn" (p. 259).

37. Philip Zilcken, quoted by G. S. de Solpray, "Enquête sur l'influence de l'esprit français en Hollande."

La littérature française eut... vers 1880, une influence sur la peinture, toutefois très relative. Personnellement, je sais que les Goncourt, Zola, les livres de Fromentin contribuèrent à orienter mes pensées en art. Et, dans ces temps reculés déjà, mes maîtres et mes amis les Maris, Breitner, [Willem] de Zwart, Isaac Israëls, [M.A.J.] Bauer, et presque tous les jeunes peintres lisaient avec passion Zola et *Salammbô*, tandis que *Manette Salomon* traînait sur les divans des ateliers.

38. ... grand et noueux comme un chêne. Le soleil l'a séché, a cuit et fendu sa peau; et il a pris la couleur, la rudesse et le calme des arbres. En vieillissant, il a perdu sa langue. Il ne parle plus, trouvant ça inutile. D'un pas long et entêté, il marche, avec la force paisible des boeufs.

39. The first version of *Mes haines* appeared in 1866, in conjunction with another volume of critical essays entitled *Mon salon*. The former brought together most of Zola's recent literary criticism; the latter was a compilation of recent art chronicles. Thirteen years later, the two collections of 1866 were merged and – together with Zola's well-known essay on Manet (1867) – were published in a single volume, again titled *Mes haines*. Van Gogh probably saw the 1879 edition (or excerpts from it); that is the edition he read later at The Hague (in the spring of 1883).

40. In a letter from The Hague, written in late summer 1883, Van Gogh returned to the phrase "l'homme ajouté à la nature" and used it in conjunction with a paraphrase of Zola's famous definition of art as "un coin de la nature [*sic*; Zola's word is '*création*'] vu à travers un tempérament" (see LT229, cited later in the text).

41. Zola, "Le Moment artistique," originally published in *L'Evénement*, 4 May 1866 (reprinted in 1879 edition of *Mes haines*); "Ce que je cherche avant tout dans un tableau, c'est un homme et non pas un tableau." Another version of the same idea appeared in an earlier essay, "Proudhon et Courbet, I," which appeared in *Le Salut publique* (Lyon), 26 July 1865, and was reprinted in both

editions of *Mes haines*. There Zola wrote, "Il faut que je retrouve un homme dans chaque oeuvre."

42. Zola, "Proudon et Courbet, II," *Le Salut publique* (Lyon), 31 August 1865 (reprinted in both editions of *Mes haines*); "Il se sentait entraîné par toute sa chair – par toute sa chair, entendez-vous – vers le monde matériel qui l'entourait.... Trapu et vigoureux, il avait l'âpre désir de serrer entre ses bras la nature vraie."

43. Ce que je demande à l'artiste.... c'est d'affirmer hautement un esprit puissant et particulier, une nature qui saisisse largement la nature en sa main et la plante tout debout devant nous, telle qu'il la voit.

44. Van Gogh often cited texts from memory, and when he did, his recall of authors' phraseology was imperfect; though he often enclosed them in quotation marks, such off-the-cuff renderings are better seen as loose translations.

45. As he worked on *Une Page d'amour*, Zola remarked: "Je veux étonner les lecteurs de *L'Assommoir*. Cette fois *Une Page d'amour* est une oeuvre trop douce pour passionner le public... Mais nous nous rattraperons avec *Nana*" (cited by Armand Lanoux in his preface to *Une Page d'amour* [Paris: Fasquelle, 1981], p. v). For all their differences, these three books – whose protagonists are women – constitute what Naomi Schor has called the "feminine triptych embedded in the Rougon-Macquart." See *Breaking the Chain: Women, Theory and French Realist Fiction*, p. 35.

46. In the preface to a deluxe 1884 edition of *Une Page*, Zola wrote of the cityscape as "le confident tragique de mes joies et de mes tristesses" and claimed, "J'avais rêvé d'écrire un roman dont Paris, avec l'océan de ses toitures, serait un personnage, quelque chose comme le choeur antique." J. Y. Dangelzer has noted that the first tableau of *Une Page* (a morning view) complements Hélène's tender, hesitant first love for Henri; the second (a blazing sunset), her violent burst of passion; the third (a nighttime view), her hope and religiosity in the face of uncertainty. The fourth tableau (a rainstorm) echoes Jeanne's sense of loneliness and betrayal, and brings on her fatal ill-

ness; the fifth (a snow scene) symbolizes the coldness of death – both Jeanne's demise and the death of Hélène's love affair (*La Description du milieu dans le roman français de Balzac à Zola*, pp. 213–14). A more recent study of Zola's use of evocative environments is Winston Hewitt, *Through Those Living Pillars: Man and Nature in the Works of Emile Zola*; for a discussion of *Une Page*, see esp. pp. 115–17.

47. Monet's multiple views of the Gare St.-Lazare, for instance, were painted in 1877, the year before *Une Page* was published. Zola's Parisian tableaux, however, are conceptually closer to Monet's later series (e.g., of Rouen Cathedral or of the grain stacks, both from the early 1890s), in which the artist's vantage point and subject matter remain more constant.

48. This aspect of Zola's prose style has provoked a great deal of comment and analysis; see Hélène Adhémar and Jean Adhémar, "Zola et la peinture"; Ima N. Ebin, "Manet et Zola"; Beverly Jean Gibbs, "Impressionism as a Literary Movement"; Philippe Hamon, "A propos de l'impressionnisme de Zola"; F. W. J. Hemmings, "Zola, Manet and the Impressionists, 1875–1880"; Nathan Kranowski, *Paris dans les romans d'Emile Zola*; J. H. Matthews, "L'Impressionnisme chez Zola: *Le Ventre de Paris*"; Joy Newton, "Emile Zola impressionniste"; idem, "Emile Zola et l'impressionnisme"; Randolphe Walter, "Emile Zola et Claude Monet."

49. Zola began writing art criticism in 1863 (an article on Gustave Doré's illustrations for *Don Quixote* was published by the *Journal populaire de Lille*) and continued to do so for more than thirty years (an article entitled "Peinture" appeared in *Le Figaro* on 2 May 1896). His best-known works in this genre are a series of articles entitled "Mon salon," which appeared in *L'Evénement* in 1866 and 1868, and a critical study of Edouard Manet's oeuvre, which first appeared in *La Revue du XIXe siècle* in January 1867 and was issued as a brochure in conjunction with Manet's retrospective exposition that year. See F. W. J. Hemmings and Robert J. Niess, *Emile Zola, Salons*; Jacques Lethève, *Impressionnistes et Symbolistes devant la*

presse; and Antoinette Ehrard, "Zola et Courbet."

50. Cited by Hemmings, "Zola, Manet and the Impressionists," p. 416, who in turn cites H. Hertz, "Emile Zola, témoin de la vérité"; the original source of the quote is not given by Hertz.

> Je n'ai pas seulement soutenu les impressionnistes. Je les ai traduits en littérature, par les touches, notes, colorations, par la palette de beaucoup de mes livres. ... J'ai été en contact et échange avec les peintres.... Les peintres m'ont aidé à peindre d'une manière neuve, littérairement.

51. Une vapeur, qui suivait la vallée de la Seine, avait noyé les deux rives. C'était une buée légère comme laiteuse, que la soleil peu à peu grandi éclairait. On ne distinguait rien de la ville, sous cette mousseline flottante, couleur du temps. Dans les creux, le nuage épaissi se fonçait d'une teinte bleuâtre, tandis que, sur de larges espaces, des transparences se faisaient, d'une finesse extrême, poussière dorée où l'on devinait l'enfoncement des rues; et, plus haut, des dômes et des flèches déchiraient le brouillard, dressant leurs silhouettes grises, enveloppés encore des lambeaux de la brume qu'ils trouaient. Par instants, des pans de fumée jaune se détachaient avec le coup d'aile lourd d'un oiseau géant, puis se fondaient dans l'air qui semblait les boire. Et, au-dessus de cette immensité, de cette nuée descendue et endormie sur Paris, un ciel très pur, d'un bleu effacé, presque blanc, déployait sa voûte profonde. Le soleil montait dans un poudroiement adouci de rayons. Une clarté blonde, du blond vague de l'enfance, se brisait en pluie, emplissait l'espace de son frisson tiède.

52. Hamon, "A propos de l'impressionnisme de Zola," p. 140.

53. *Une Page d'amour,* pt. I, chap. 5; "foule active de points noirs."

54. Louis Leroy in *Le Charivari,* 25 April 1874.

55. *Une Page d'amour,* pt. II, chap. 5.

56. Ibid., chap. 4.

57. Ibid., pt. III, chap. 4. "Ce qui l'amusait surtout, c'étaient des taches rondes, d'un beau jaune d'or, qui dansaient sur son châle. On aurait dit des bêtes. Et elle renversait la tête, pour voir si elles grimperaient jusqu'à sa figure."

58. Ten Brink, "Paris van het Trocadero gezien"; "schat van kleurenrijke aquarellen," "het letterkundig doek."

59. Probably at Vincent's suggestion, Theo also read *Le Ventre de Paris* in July 1882 (see LT219), and the brothers doubtless discussed it and others of Zola's novels when Theo visited The Hague in August 1882.

60. When Van Gogh started reading Zola's novels, half of the Rougon-Macquart series (i.e., ten of twenty volumes) had been published. Van Gogh seems to have made no attempt to read them sequentially (e.g., he apparently read *Nana* before *L'Assommoir,* though the former is a sequel to the latter).

61. Lantier, a descendant of the Macquart line, is the protagonist of a later volume in the series, *L'Oeuvre;* see Chapters 3 and 4, this volume.

62. See *Le Ventre de Paris,* chap. IV.

63. Cited by Lanoux, preface to *Le Ventre de Paris,* p. v; "gigantesques natures mortes des huit pavillons."

64. Zola used the name "Claude" as a pseudonym of sorts on other occasions; his early semiautobiographical novel is entitled *La Confession de Claude,* and the author signed his first Salon reviews "Claude."

65. *Le Ventre de Paris,* chap. I. "[Claude] rôdait sur le carreau des nuits entières, rêvant des natures mortes colossales, des tableaux extraordinaires.... [Il] ne songeait même pas que ces belles choses se mangeaient. Il les aimait pour leur couleur."

66. For instance, Zola's description of the fruit stand of a woman known as La Sariette becomes increasingly lascivious as the author catalogs her wares. Toward the end of his inventory, Zola writes: "Les pommes, les poires s'empilaient, avec des régularités d'architecture, faisant des pyramides, montrant des rougeurs des seins naissants, des épaules et des hanches dorées, toute une nudité discrète, au milieu des brins de fougère" (*Le Ventre de Paris,* chap. V).

67. *Le Ventre de Paris,* chap. II. "Elle avait une fraîcheur superbe; la blancheur de son tab-

lier et de ses manches continuait la blan-cheur des plats, jusqu'à son cou gras, à ses joues rosées, où revivaient les tons tendres des jambons et les pâleurs des graisses transparentes."

68. Florent finit par l'examiner à la dérobée dans les glaces, autour de la boutique. Elle s'y reflétait de dos, de face, de côté; même au plafond, il la retrouvait, la tête en bas, avec son chignon serré, ses minces bandeaux, collés sur les tempes. C'était toute une foule de Lisa, montrant la largeur des épaules, l'emmanchement puissant des bras, la poitrine arrondie... Il se plut surtout à un de ses profils, qu'il avait dans une glace, à côté de lui, entre deux moitiés de porcs. Tout le long des marbres et des glaces, accrochés aux barres à dents de loup, des porcs et des bandes de lard à piquer pendaient; et le profil de Lisa, avec sa forte encolure, ses lignes rondes, sa gorge qui avançait, met-tait une effigie de reine empâtée, au mi-lieu de ce lard et de ces chairs crues.

69. For a discussion of Van Gogh's represen-tation of the Geest, see Pollock, "Stark En-counters," pp. 334–7.

70. Elliott Grant has noted that *Une Page d'a-mour* stands out as "calmer" and more "up-per class" than the other novels of the series (*Emile Zola*, p. 98).

71. A provocative psychoanalytic reading of Florent's horror of women, latent homosexu-ality, and possessive attitude toward his brother is given by Naomi Schor in *Zola's Crowds*, p. 32; Schor's observations may shed light on Van Gogh's personal interest in *Le Ventre* – particularly on his attraction to Mme. François, whom Schor identifies as a "maternal and masculine" (hence unthrea-tening) female.

72. In the prospectus for the Rougon-Macquart series addressed to his editor, Albert Lacroix, Zola claimed, "Je ferai à un point de vue plus méthodique, ce que Balzac a fait pour le règne de Louis-Philippe." (See "Premier plan remis à l'éditeur A. Lacroix," reprinted in Maurice Le Blond [ed.], *Oeuvres complètes d'Emile Zola*, vol. 2: *La Fortune des Rou-gon*, pp. 357–61). On the other hand, Zola later addressed significant differences be-tween the two series of novels in a short essay

entitled "Différences entre Balzac et moi." For sustained modern discussion, see Alain de Lattre, *Le Réalisme selon Zola*, pp. 53–65; and David Bellos, *Balzac Criticism in France, 1850–1900: The Making of a Repu-tation*, chap. IV, esp. pp. 124–8.

73. The only novels by Balzac that Van Gogh mentioned reading by July 1882 are *L'His-toire des treize* (LT140), *Père Goriot* (LT148), and *Illusions perdus* (LT148). Among Zola's novels, he is known to have read *Une Page d'amour*, *Le Ventre de Paris*, and *Nana*. Though his letters do not nec-essarily constitute a complete account, Van Gogh probably had not read many more books by either author.

74. Ten Brink, *Emile Zola*, esp. pp. 22–32, chap. V, and chap. XIX.

75. Ibid., p. 23.

76. This view of Zola's literary lineage – assid-uously promoted by Zola himself – was commonly accepted by the late 1870s. See Bellos, *Balzac Criticism*, p. 128.

77. It should be noted, however, that Ten Brink (and others) also had written of the analytic streak that linked Zola to Balzac; see, e.g, Ten Brink, *Emile Zola*, p. 27.

78. Early in 1883, while reading *Middlemarch*, Van Gogh remarked, "Eliot analyzes like Balzac or Zola – but English situations, with an English sentiment" (LT267).

79. That Van Gogh linked Dickens to the En-glish draftsmen is made clear by his remark, "I often disliked many things in England, but that Black and White [i.e., graphic art] and Dickens are things which make up for it all" (LT262).

80. See Ronald Pickvance, *English Influences on Van Gogh*, who notes: "Of the English art-ists themselves, the Big Three were Fildes, Herkomer and Holl...[and] it was these three who got constant praise, whose works were most often discussed, and whose ex-ample provided Vincent with a spur" (p. 38). Pickvance adds that "there were, of course, others – Green, Boyd Houghton and Small, for instance – who appealed to Vin-cent" (p. 44).

81. It seems likely that this windfall was due to a visit from Theo, who was at The Hague from 31 July to 15 August, en route to his parents' house in Nuenen. Within two weeks

of his brother's visit, Vincent mentioned reading *La Curée, Son Excellence Eugène Rougon*, and *La Faute de L'Abbé Mouret*, though at the same time he complained of being short of funds, having spent most of what Theo gave him on art supplies (see LT222, LT224, LT226). The books probably were gifts rather than purchases, and Theo perhaps had read them himself before passing them on to Vincent.

82. Though he did not mention *L'Assommoir* by title in his letters until April 1883, a chance comment to Theo in early September 1882 indicates that Van Gogh was familiar with the book by then. He wrote, "Mauve . . . has cigar boxes full of empty tubes in the corners of his studio; they are as numerous as the empty bottles in the corners of rooms after a dinner or soirée, as Zola describes it for instance" (LT228). He evidently referred to the following passage (part of a lengthy description of the heroine's birthday party):

> Et le vin donc, mes enfants, ça coulait autour de la table comme l'eau coule à la Seine. Un vrai ruisseau, lorsqu'il a plu et que la terre a soif. Coupeau versait de haut, pour voir le jet rouge écumer; et quand un litre était vide, il faisait la blague de retourner le goulot et de le presser du geste familier aux femmes qui traient les vaches. Encore une négresse qui avait la gueule cassée! Dans un coin de la boutique, le tas des négresses mortes grandissait, un cimetière de bouteilles sur lequel on poussait les ordures de la nappe. (*L'Assommoir*, chap. VII)

It is hard to imagine that Van Gogh would neglect to mention *L'Assommoir* to Theo, especially in this period, when he seems to have been adding Zola novels to his list as one would add notches to a rifle. One supposes that *L'Assommoir* – one of the best conceived and most enduringly popular books of the Rougon-Macquart series – would have been especially memorable, and indeed, Van Gogh remembered it well (down to the small detail of the bottles piling up in the corner) and for a long time (he wrote of its opening street scene in a letter of September 1888; see LT543). Also, *L'As-*

sommoir held personal associations for Van Gogh, who identified its heroine with Sien (see, e.g., LT280).

I would suggest, then, that Van Gogh read or began to read *L'Assommoir* during Theo's visit to The Hague in August 1882 (see notes 59 and 81); indeed, Theo may well have brought the book to Vincent and probably had read it himself. In any event, it is likely that Van Gogh's failure to mention in a letter the actual reading of a book that left so strong an impression on him (see LT281) stemmed from the fact that he already had done so in conversation.

83. At the same time, Van Gogh's general remarks on the Rougon-Macquart series continue to document his familiarity with secondary sources. In particular, his insights into the character of Pascal Rougon (see LT226) – a character who has only bit parts in the Zola novels written by 1882 – give further indication of his familiarity with Ten Brink's monograph. In a discussion of *La Fortune des Rougon*, Ten Brink calls Pascal an "exception in the family" (een uitzondering in de familie) and elaborates on that which sets him apart; he also discusses Zola's plans for the future of the series and mentions a projected "science novel" centering on Pascal.

84. Adelaïde Fouque, the matriarch of the Rougon-Macquart clan, had two children, Antoine and Ursule, by a man named Macquart (his first name is never mentioned; he is known by reputation as "ce geux Macquart"), whom she did not marry. She had been left a widow early in her life by her husband Rougon (whose first name is likewise unmentioned), by whom she had her only legitimate child, Pierre.

85. Aristide, a real-estate speculator at the time of Haussmann's rebuilding of Paris, does not carry the Rougon name. At the request of his brother Eugène, a prominent politician, he changes his surname to Saccard upon his arrival in the city.

86. Richard B. Grant, *Zola's* Son Excellence Eugène Rougon: *An Historical and Critical Study*, p. 101.

87. Susanna Barrows describes the politicization of the issue of alcohol consumption in French society as well as in Zola's writing.

See "After the Commune: Alcoholism, Temperance, and Literature in the Early Third Republic," pp. 205–18.

88. See F. W. J. Hemmings, *Emile Zola*, pp. 120–2. For an example of the language of *L'Assommoir*, see note 82.

89. Le Blond (ed.), *Oeuvres complètes d'Emile Zola*, vol. VIII, p. 469.

> Montrer le milieu [du] peuple et expliquer par ce milieu les moeurs [du] peuple; comme quoi, à Paris, la soûlerie, la débandade de la famille, les coups, l'acceptation de toutes les hontes et de toutes les misères vient des conditions mêmes de l'existence ouvrière, des travaux durs, des promiscuités, des laisser-aller, etc. En un mot, un tableau très exact de la vie du peuple avec ses ordures, sa vie lâchée, son langage grossier.

90. A sampling of contemporary reactions to *L'Assommoir* is given by Stéfan Max in *Les Métamorphoses de la grande ville dans les Rougon-Macquart*, pp. 87–8.

91. Mon crime est d'avoir eu la curiosité littéraire de ramasser et de couler dans un moule très travaillé la langue du peuple. Ah! la forme, là est le grand crime!

92. Le plus chaste de mes livres... une oeuvre de vérité, le premier roman sur le peuple, qui ne mente pas et qui ait l'odeur du peuple.

93. Il ne faut point conclure que le peuple tout entier est mauvais, car mes personnages ne sont pas mauvais, ils ne sont qu'ignorants et gâtés par le milieu de rude besogne et de misère où ils vivent.

94. Ces femmes ne sont cependant pas mauvaises, l'impossibilité d'une vie droite dans les commérages et les médisances des faubourgs, est la cause de leurs fautes et de leurs chutes.

95. It can also be compared to Zola's "La Fée amoureuse" (1859), an early prose piece; see J. C. Lapp, *Les Racines du Naturalisme: Zola avant les Rougon-Macquart*, pp. 8–14.

96. For an extended discussion of this aspect of the story, see Elizabeth Lowther Hodges, "The Bible as Novel: A Comparison of Two Modernized Versions of Biblical Stories, Zola's *La Faute de l'Abbé Mouret* and Faulkner's *A Fable*."

97. Though the mythic aspect of the Rougon-Macquart series has been much discussed (see, e.g., Schor, *Zola's Crowds;* and Jean Borie, *Zola et les mythes; ou, De la nausée au salut*), the timeless, otherwordly quality of *La Faute de l'Abbé Mouret* sets it apart. Its fantasy aspect remained unparalleled in the series until the publication of *Le Rêve* (1888), a novel that seems even more distanced from chronological and geographic reality. It is perhaps notable that both novels deal with Catholicism, a subject that seems to have brought out an archaizing side of Zola. He once noted that priests – along with prostitutes, murderers, and artists – belong to "un monde à part" (cited by Lanoux in his preface to *La Faute de L'Abbé Mouret* [1981], p. iii).

98. Zola, "De la description," *Le Roman expérimental;* "débauches de la description... débordements de la nature." In this essay – a discussion of the necessity of evocative environments in fiction – Zola asserts of himself and his peers: "Nous avons fait à la nature, au vaste monde, une place tout aussi large qu'à l'homme." In defense of their periodic excesses, he writes:

> Nous cessons d'être dans les grâces littéraires d'une description en beau style; nous sommes dans l'étude exacte du milieu, dans la constatation des états du monde extérieur qui correspondent aux états intérieurs des personnages.
>
> Je définirai donc la description: Un état du milieu qui détermine et complète l'homme.
>
> Maintenant, il est certain que nous ne nous tenons guère à cette rigueur scientifique. Toute réaction est violente, et nous réagissons encore contre la formule abstraite des siècles derniers. La nature est entrée dans nos oeuvres d'un élan si impétueux, qu'elle les a emplies, noyant parfois l'humanité, submergeant et emportant les personnages, au milieu d'une débâcle de roches et de grands arbres.... Il faut laisser le temps à la formule nouvelle de se pondérer et d'arriver à son expression exacte. D'ailleurs, même dans ces débauches de la description, dans ces débordements de la nature, il y

a beaucoup à apprendre, beaucoup à dire.

99. For detailed discussion, see Hewitt, *Living Pillars*, chap. V.

100. C'était le jardin qui avait voulu la faute. Pendant des semaines, il s'était prêté au lent apprentissage de leur tendresse.... Il était le tentateur, dont toutes les voix enseignaient l'amour.

...Sous chaque feuille, un insecte concevait; dans chaque touffe d'herbe, une famille poussait; des mouches volantes, collées l'une à l'autre, n'attendaient pas de s'être posées pour se féconder.

...Alors, Albine et Serge...cédèrent aux exigences du jardin.

...Le parc applaudissait formidablement.

101. See *La Faute de L'Abbé Mouret*, pt. II, chap. 6, and Chapter 5, note 89, this volume.

102. Of the convalescing Serge, Zola writes, "Il fut pris d'une stupeur des sens qui le ramena à la vie végétative d'un pauvre être né de la veille. Il n'était qu'une plante, ayant la seule impression de l'air où il baignait" (ibid., chap. 5). On his first day in Le Paradou, Serge finds his emotional infancy mirrored by his equally unblemished environment:

Serge, les mains pendantes, tournait lentement la tête, en face du parc. C'était une enfance. Les verdures pâles se noyaient d'un lait de jeunesse, baignaient dans une clarté blonde. Les arbres restaient puérils, les fleurs avaient des chairs de bambin; les eaux étaient bleues d'un bleu naïf de beaux yeux grands ouverts. Il y avait, jusque sous chaque feuille, un réveil adorable. (Ibid.)

103. As Hemmings writes in *Emile Zola*, "There is only the ghost of a plot in this book. Nothing ever happens, or what happens is never anything that has not happened before" (p. 143).

104. See, e.g., Lodewijk van Deyssel, "Over het laatste werk van Zola"; and Jan ten Brink, "*Pot-Bouille*," in *Nieuwe romans*, pp. 101–12.

105. Ten Brink, "*Pot-Bouille*," p. 107.

106. Zola's own sensibility clearly had been marked by a study of Michelet, whom P. D. Walker describes as "one of the principal sources of Zola's thought" (Germinal *and Zola's Philosophical and Religious Thought*, p. 26; see also p. 108, n. 18). Further discussion of Zola's debt to Michelet can be found in Allan H. Pasco, "Love à la Michelet in Zola's *La Faute de l'Abbé Mouret*," pp. 232–44.

107. *Pot-Bouille*, chap. II. "Sous la maigre lueur de la petite lampe...il passait des nuits entières à ce travail ingrat, se cachant, pris de honte à l'idée qu'on pouvait découvrir leur gêne."

108. Theo's fascination with Mouret was apparently quite profound; in his self-chastising moments Theo likened himself to Mouret, a comparison Vincent flatly discredited. "No," he argued. "If you were like *that*, you would do well to enter a new business; but you are deeper than he, and I do not know whether you are really a man of business" (LT333; his emphasis).

109. It is unclear whether Van Gogh ever read the first novel of the series, *La Fortune des Rougon* (1871) or its sequel, *La Conquête de Plassans* (1874); he definitely did read the other eight of the first ten novels in the series: *La Curée, Le Ventre de Paris, La Faute de L'Abbé Mouret, Son Excellence Eugéne Rougon, L'Assommoir, Une Page d'amour, Nana*, and *Pot-Bouille*.

110. For a thorough discussion of Van Gogh's artistic development at The Hague, see Griselda Pollock, *Van Gogh in zijn Hollandse jaren*, chap. II; and idem, "Stark Encounters."

111. Anthon G. A. Ridder van Rappard (1858–92) was a Dutch painter whom Van Gogh met in Brussels in the fall of 1880; the two worked together briefly at Nuenen in the summer of 1881 and corresponded until a difference of opinion over artistic matters ended their friendship in 1885. Rappard (as Van Gogh called him) also was an avid reader, and Van Gogh often wrote to him of books as well as pictures (fifty-eight letters from Van Gogh to Van Rappard are extant).

112. This particular poem had been on Van Gogh's mind for some months; in a letter of October 1881 he requested the text from Van Rappard: "I am looking for a poem, I

think by Tom Hood, 'The Song of the Shirt';
do you happen to know it, or do you see
your way to hunting it up for me? If you
know it, I should like to ask you to write it
out for me" (R2). Van Gogh's subsequent
remarks (i.e., in LT186) suggest that he
never received it, for his recollection of the
poem seems vague.

113. Van Gogh was reading both *Notre Dame
de Paris* and *Les Misérables* for the second
time.

114. He seems to have read the Goncourts' *Ga-
varni, l'homme et l'oeuvre* in 1881 and
thereafter lent it to Van Rappard (R1).

115. Edmond de Goncourt (1822–96) was the
exact contemporary of Van Gogh's father;
Jules de Goncourt (1830–70) was some
years younger. Zola (1840–1902), Daudet
(1840–97), and Lemonnier (1844–1915)
were closer to Van Gogh's generation.

116. Zola himself often used the terms "Natu-
ralism" and "Realism" interchangeably, but
more often when referring to art than to
literature; see, e.g., Antoinette Ehrard, pre-
face to Emile Zola, *Mon salon, Edouard
Manet, ecrits sur l'art*, p. 23.

117. They are *Fromont jeune et Risler ainé*
(1874); *Jack* (1876), *Le Nabab* (1877), *Les
Rois en exil* (1879), *Numa Roumestan*
(1881), *L'Evangéliste* (1883), and *Sapho*
(1884).

118. Murray Sachs, for instance, writes that Dau-
det's "declarations of independence" were
"so frequent...as to constitute a tic" (*The
Career of Alphonse Daudet: A Critical
Study*, p. 206, n. 10).

119. See, e.g., P. Bruijn's review of *Numa Rou-
mestan* in *De Amsterdammer;* and Ten
Brink, "Groote en kleine Naturalisten" in
Causerieën over moderne romans, pp. 104–
33. Ten Brink believed Daudet was too
biased and too lyrical to be considered a
"full-blooded Naturalist," but felt he was
more a Naturalist than anything else (pp.
105–6).

120. Van Gogh read *Les Rois en exil* in October
1882 and *Le Nabab* shortly thereafter. He
read *Fromont jeune et Risler ainé* sometime
before August 1883.

121. Though Zola had yet to write his most ex-
tensive account of rural life-styles, *La Terre*
(1888), its tone is forecast by short stories

that precede it and by the first chapters of
La Faute de L'Abbé Mouret, wherein the
inhabitants of a farming village are de-
scribed as *"bêtes"* absorbed in their land and
its cultivation. As described by a local au-
thority – the aged peasant deacon Frère
Archangias – Les Artaud (as the peasants
are known) "sont tout à la terre...des
brutes qui se battent avec leurs champs de
cailloux!" Archangias (the avenging angel
of *La Faute*) cautions Mouret that "Les Ar-
taud se conduisent en bêtes....Ils sont
comme leurs chiens qui n'assistent pas à la
messe, qui se moquent des commande-
ments de Dieu et de l'Eglise. Ils forniquer-
aient avec leurs pièces de terre, tant ils les
aiment!" (*La Faute de L'Abbé Mouret*, pt.
I, chap. 5).

122. Zola's essay on the Goncourts in *Mes haines*
focuses on their novel *Germinie Lacerteux*
(which functions as the title of Zola's cri-
tique). Noting that a book should be an
"haute manifestation de personnalité," Zola
praises the piquant, even "decadent," flavor
of this one and gives a thorough account of
its story line. Probably not coincidentally,
Van Gogh in LT297 told Theo that he had
begun to read *Mes haines*, then, in his next
letter (LT298), asked, "Do you know *Ger-
minie Lacerteux* by Jules and Edmond de
Goncourt?"

It is likely, too, that Van Gogh's friend
Théophile de Bock was also promoting the
Goncourts at this time; Van Gogh's mention
of *Germinie Lacerteux* occurs at the close
of a long account of his recent visit with De
Bock, and more specifically follows an aside
on the books most recently read by that art-
ist (see LT298).

123. Because its hospital locales and situations
were "documented" by the brothers' copi-
ous notes, this novel – for which the authors
also sought to discern and convincingly por-
tray the sensibility of a lower-class woman
– is sometimes described as "pre-
Naturalist." See Richard B. Grant, *The
Goncourts*, p. 52.

124. The next Goncourt novel Van Gogh men-
tioned was *Chérie* (see Chapter 3, this vol-
ume). He apparently did not read *Germinie
Lacerteux* until he got to Paris; a copy of
that novel is included in a still life made there

in 1887–8, *Still Life with Plaster Cast* (Plate 8), as well as the later portrait of Dr. Paul Gachet (Plate 16), which was made in Auvers in 1890 (see Chapters 4 and 6, this volume).

125. As noted earlier in this chapter, it seems that Van Gogh had some prior acquaintance with *Mes haines*. Now, in the summer of 1883, Van Rappard apparently lent him the book by mail; Van Gogh's comments make it clear that he was reading the second edition of *Mes haines* (1879), which included Zola's Salons and his essay on Manet, as well as the mainly literary criticism that constituted the first edition of the book (1866) (see R38).

126. Zola writes that "chaque troupeau a son dieu," "chaque religion a ses prêtres, chaque prêtre a ses aveugles et ses eunuques" and asks, "Où sont les hommes qui vivent seuls?" (preface to *Mes haines*).

127. Zola asserts, "Je n'ai guère souci de beauté ni de perfection.... Il n'y a plus de maîtres, plus d'écoles. Nous sommes en pleine anarchie" (ibid.).

128. Je suis pour les libres manifestations du génie humain. Je crois à une suite continue d'expressions humaines, à une galerie sans fin de tableaux vivants.

129. This two-part critique, entitled "Proudhon et Courbet," was first published in *Le Salut publique* (Lyon), 26 July–31 August 1865; it appears as a chapter of *Mes haines*. Zola's criticism was aimed at Proudhon's recently published posthumous work, *Du principe de l'art et de sa destination sociale* (1865).

130. Zola admonishes ideologues to "laissez au philosophe le droit de nous donner des leçons, laissez au peintre le droit de nous donner des émotions" ("Proudhon et Courbet, II").

131. Moi, je pose en principe que l'oeuvre ne vit que par l'originalité. Il faut que je retrouve un homme dans chaque oeuvre, ou l'oeuvre me laisse froid. Je sacrifie carrément l'humanité à l'artiste. Ma définition d'une oeuvre de art serait, si je la formulais: *une oeuvre d'art est un coin de la création vu à travers un tempérament*. (His emphasis)

Henri Mitterand notes that a similar formulation had cropped up in a letter Zola wrote to Anthony Valabrègue a year earlier (August 1864); see *Emile Zola: Oeuvres complètes*, edited by Mitterand, vol. X, p. 171.

132. Etant donné Victor Hugo et des sujets d'idylles et d'eglogues, Victor Hugo ne pouvait pas produire une oeuvre autre que *Les Chansons des rues et des bois*. ...Le livre est, je le répète, le produit logique, inévitable d'un certain tempérament, mis en présence d'un certain sujet.

133. Il y a, selon moi, deux éléments dans une oeuvre: l'élément réel, qui est la nature, et l'élément individuel, qui est l'homme. L'élément réel, la nature, est fixe, toujours le même.... L'élément individuel, au contraire, l'homme, est variable à l'infini.

134. In "Le Moment artistique," for instance, Zola writes, "Le mot 'réaliste' ne signifie rien pour moi, qui déclare subordonner le réel au tempérament. Faites vrai, j'applaudis; mais surtout faites individuel et vivant, et j'applaudis plus fort."

135. Jamais artiste n'eut moins que lui le souci de la réalité.

136. Le mot 'art' me déplaît; il contient en lui je ne sais quelles idées d'arrangements nécessaires, d'idéal absolu. Faire de l'art, n'est-ce pas faire quelque chose qui est en dehors de l'homme et de la nature? Je veux qu'on fasse de la vie, moi; je veux qu'on soit vivant, qu'on crée à nouveau, en dehors de tout, selon ses propres yeux et son propre tempérament. Ce que je cherche avant tout dans un tableau, c'est un homme et non pas un tableau.

137. Indeed, in another essay, "Les Réalistes du Salon," Zola asserts, "Peindre des rêves est un jeu d'enfant et de femme; les hommes ont charge de peindre des réalités" (*L'Evénement*, 11 May 1866; reprinted in *Mon salon* and in the 1879 edition of *Mes haines*).

138. Comme toute chose, l'art est un produit humain, une sécrétion humaine; c'est notre corps qui sue la beauté de nos oeuvres ("Le Moment artistique").

139. Van Gogh wrote, "Have you noticed that Zola doesn't mention Millet at all?" and speculated, "This omission is probably due to his not being acquainted with Millet's work" (R38); see also LT297, in which he

told Theo, "He doesn't even mention Millet in his general survey."

140. The chapter is entitled "Les Chutes." Zola praises Millet's early work as "poésie vraie ... poésie qui n'est faite que de réalité," but expresses disappointment at his more recent production, which the author finds "molle et indécise." This essay was originally printed in *L'Evénement*, 15 May 1866.

141. Si à présent je vaux quelque chose c'est que je suis seul et que je hais les niais, les impuissants, les cyniques, les railleurs idiots et bêtes.

Here Van Gogh conjoined two separate sentences from the text, but remained true to the spirit of lines found in the preface to *Mes haines*.

142. This essay is followed by "Les Chutes," which – because it contains asides on Millet – Van Gogh apparently had not read, and "Adieux d'un critique d'art," a defensive statement of achievement and a lament for unfinished business.

143. Doré's scenes of London were published in 1872 with an English-language text by Blanchard Jerrold; in 1875 Hachette brought out a French-language version with text by Louis Enault. The London series came late in Doré's career (he died in 1883) and represented a significant shift away from the fantastic; somewhat atypical of his oeuvre as a whole, these images remain his best-known works, and Van Gogh grouped them with the work of those English illustrators whose "startling realism" he admired (LT140). The chronological vantage point from which Van Gogh viewed Doré was substantially different from that of Zola, whose essay "Gustave Doré" originally appeared in *Le Salut publique* on 14 December 1865 – almost twenty years before Van Gogh read it in *Mes haines*.

144. Je me moque du réalisme, en ce sens que ce mot ne représente rien de bien précis pour moi. Si vous entendez par ce terme la nécessité ... d'étudier et de rendre la nature vraie, il est hors de doute que tous les artistes doivent être des réalistes.

145. Il y a des réalistes au Salon – je ne dis plus des tempéraments – il y a des artistes qui prétendent donner la nature vraie, avec toutes ses crudités et toutes ses violences.

Pour bien établir que je me moque de l'observation plus ou moins exacte, lorsqu'il n'y a pas une individualité puissante qui fasse vivre le tableau, je vais d'abord dire mon opinion toute nue sur MM. Monet, Ribot, Vollon, Bonvin et Roybet.

146. Voilà un tempérament, voilà un homme dans la foule de ces eunuques.

147. Indeed, in a later letter to Van Rappard, Van Gogh himself was somewhat critical of Vollon: "I prefer Israëls to Vollon ... because I see something more in Israëls's work, something quite different from the masterly reproduction of the materials, something quite different from the light and brown, something quite different from the color. . . . I see so much more in Israëls's work than in Vollon's" (R43).

148. When and if Van Gogh finished *Mes haines*, he must have found its last critique, "Les Chutes," even more irritating, for in it Zola laments the diminished quality of the late work of Courbet, Millet, and Théodore Rousseau. Van Gogh admired both Courbet and Rousseau (see, e.g., LT215 from The Hague), and he had held Millet in the highest esteem for more than a decade. Indeed, when he attended an exhibition of Millet's drawings shortly after that artist's death in 1875, Van Gogh told Theo, "I felt like saying, 'Take off your shoes, for the place where you are standing is Holy Ground' " (LT29). His image of Millet was sacrosanct and only recently had been burnished by his reading of Sensier's hagiographic memoir. If he ever read "Les Chutes," however, Van Gogh did not comment on it in his letters.

149. Van Gogh perhaps referred to "De Dood van de Boer," which describes the death and burial of Jean-Louis Lacour, and/or to *La Faute de L'Abbé Mouret* (the only rural novel by Zola Van Gogh definitely had read), which includes descriptions of the churchyard-cum-farmyard of Serge Mouret's rectory.

150. Van Gogh found both Zola's and Balzac's characterizations of painters unsatisfying. Zola's artists seemed to him to be Impressionists – "so much for that," he wrote – and "Balzac's painters are enormously tedious, very boring" (R38).

151. Zola's essay on Erckmann–Chatrian, for instance, while guardedly respectful of the authors' historical fiction and their ability to portray lively landscapes, ridicules their creation of unconvincing, puppetlike characters to act in stale, unrealistic situations that are too simplistic to sustain novel-length texts. Van Gogh found this appraisal mainly just and even admitted, "I take the greatest pleasure in permitting him to reproach Erckmann–Chatrian" (R38). He did not remark, however, on Zola's brief critique of Michelet (an aside made in a review of Eugène Pelletan's *La Mère*). Of Michelet's *La Femme*, Zola wrote, "Je lirai M. Michelet, je me bercerai dans sa large et suave poésie, lorsque, l'âme saignante, j'aurai besoin d'un beau mensonge pour me consoler du réel; mais je lirai M. Eugène Pelletan, lorsque, l'esprit sain et ferme, je voudrai le possible et que je me sentirai la force de la réalité."

152. Zola himself had noted that his literary criticism was more readily accepted than his comments on art and attributed this to the sensitive nature of artists; in the dedication to Cézanne that fronts the Salon section of *Mes haines*, the author notes: "J'ai dit franchement mon avis sur les médiocres et les mauvais livres, et le monde littéraire a accepté mes arrêts sans trop se fâcher. Mais les artistes ont la peau plus tendre" ("A mon ami Paul Cézanne").

153. Cf. Zola: "Moi, je pose en principe que l'oeuvre ne vit que par l'originalité" ("Proudhon et Courbet, I"). "Ce que je demande à l'artiste...c'est d'affirmer hautement un esprit puissant et particulier, une nature qui saisisse largement la nature en sa main et la plante tout debout devant nous, telle qu'il la voit....J'ai la plus profonde admiration pour les oeuvres individuelles, pour celles qui sortent d'un jet d'une main vigoureuse et unique" ("Le Moment artistique").

154. In "Le Moment artistique," for instance, Zola writes: "Vous ne pouvez formuler aucune règle, ni donner aucun précepte; il faut vous abandonner bravement à votre nature et ne pas chercher à vous mentir. Est-ce que vous avez peur de parler votre langue, que vous cherchez à épeler péniblement des langues mortes [i.e., tradition]? Ma volonté énergique est celle-ci: je ne veux pas des

oeuvres d'écoliers faites sur des modèles fournis par les maîtres."

155. Van Gogh himself substitutes the more secular, neutral "nature" for "*création*" when citing Zola's famous phrase.

156. "Mediocrity" is one of the more prominent buzzwords of *Mes haines;* summing up his achievements in the book's final essay, "Adieux d'un critique d'art," Zola writes, for example: "Las de mensonge et de médiocrité, j'ai cherché des hommes dans la foule de ces eunuques."

157. See also LT309, LT399, LT533. The Dutch word Van Gogh used was "*temperament,*" the same as in French and English.

158. See Pollock, "Stark Encounters," pp. 333, 346–53.

159. He had been encouraged in this practice by Breitner, who – according to Pollock – was consciously indebted to the example set by the Goncourts' novels of modern Parisian life ("Stark Encounters," p. 332); Pollock rightly suggests that Van Gogh's urban vision drew on the verbal imagery of Dickens and Hugo as well as that of Zola (p. 348).

160. Appraising the work of Théophile de Bock around the same time he read *Mes haines*, Van Gogh observed: "One would look at it with more pleasure if things were put down in a less visionary way. He ought to be a little more realistic" (LT298). A few days later, he criticized the recent work of his friend Breitner in much the same way, calling it "impossible, because the imagination behind it...has no contact with reality" (LT299). Consciously or not, Van Gogh here assumed a critical stance similar to that which Zola took before the early work of Gustave Doré.

CHAPTER 3. THE ASSIMILATION OF FRENCH NATURALISM: VAN GOGH IN DRENTHE, NUENEN, ANTWERP

1. For a description of Nuenen and its economy in the mid-1880s, see Carol Zemel, "The 'Spook' in the Machine: Van Gogh's Pictures of Weavers in the Brabant."

2. Already from Drenthe, Van Gogh told Theo, "Know this, brother, that I am absolutely cut off from the outer world – except from you" (LT343).

3. In Van Gogh's letter, these words are written

in French and placed inside quotation marks ("triomphe de la médiocrité, de la nullité, de l'absurdité"). Though this particular conjunction of words seems to have no direct counterpart in *Mes haines*, each term is used with frequency by Zola there, and the spirit of Van Gogh's phrase is unquestionably Zolaesque.

4. Cf. Zola, "Proudhon et Courbet, I": "'Si vous me demandez ce que je viens faire en ce monde, moi artiste, je vous répondrai: 'Je viens vivre tout haut.'" This assertion followed Zola's denunciation of Proudhon's supposition that artists should serve abstract ideals rather than their own emotions.

5. The other artists and writers cited by Van Gogh in this context were Dupré, Daubigny, Corot, Millet, Israëls, Herkomer, Michelet, Hugo, and Balzac.

6. His financial straits probably did not allow Van Gogh to buy many books (even if he could find what he wanted at Nuenen), and given the Rev. Van Gogh's known distaste for most modern literature, it seems unlikely that his library yielded many interesting new titles. Theo, who often sent Vincent books, probably was little inclined to do so in this era, as his brother berated him almost incessantly, and Vincent probably was loathe to make requests of Theo. Finally, Van Gogh now lacked the circle of friends who had often traded books back and forth at The Hague.

7. Van Gogh's sister lent him a collection of poetry by François Coppée (LT357, R40, R41), and he mentioned reading poems by Jules Breton (R40, R42) and De Genestet (R43) that probably came from his father's shelves.

8. See Zemel, "The 'Spook,'" p. 126; and Linda Nochlin, "Van Gogh, Renouard and the Weavers' Crisis in Lyon: The Status of a Social Issue in the Art of the Later Nineteenth Century."

9. Van Gogh's sense of the book's strong verisimilitude doubtless derived not only from the fact that *Sapho* – like many of Daudet's most successful novels – was autobiographic in origin (see Murray Sachs, *The Career of Alphonse Daudet: A Critical Study*, p. 131) and personal in motivation (it is dedicated to "mes fils quand ils auront vingt ans"), but also from the story line's parallels to his

own experiences with Sien at The Hague.

10. Il se sentait entraîné par toute sa chair – par toute sa chair, entendez-vous – vers le monde matériel.... Il avait l'âpre désir de serrer entre ses bras la nature vraie. (Zola, "Proudhon et Courbet, II"; also see Chapter 2, this volume.)

11. An even closer parallel can be found in LT152, written in November 1881. There Van Gogh wrote: "Nature certainly is 'intangible,' yet one must seize her, and with a strong hand.... The struggle with nature sometimes reminds one of what Shakespeare calls 'the taming of the shrew.'.... In many things, but especially in drawing, I think that 'serrer de près vaut mieux que lâcher.'"

12. Based on a true story (see Sachs, *The Career of Alphonse Daudet*, p. 128), *L'Evangéliste* details the protagonist's gradual renunciation of her mother, fiancé, and would-be stepchildren in favor of a religious sect that denounces earthly love.

13. Van Gogh later used *L'Evangéliste* to criticize his own sister Wil for her alleged coolness toward him (LT408); he also reflected on his own past in light of Daudet's story of misdirected religious fervor and declared: "I am no friend of the present Christianity. ... The present Christianity I know only too well. That icy coldness hypnotized even me in my youth, but I have taken my revenge since – how? by worshipping the love which they, the theologians, call *sin*, by respecting a whore, etc., and *not* respecting many would-be respectable pious ladies" (LT378; his emphasis).

14. Indeed, Naomi Schor notes Mouret's use of a "feminine" strategy – seduction – to effect business success (*Zola's Crowds*, p. 153).

15. Schor characterizes Denise as an avenger who personifies those whom Mouret has consistently exploited: women, employees, and beleaguered *commerçants* (Ibid., pp. 164–5).

16. L'action contient en elle sa récompense; agir, créer, se battre contre les faits, les *vaincre ou être vaincu par eux, tout la joie et toute la santé humaines sont là! ...Je préfère crever de passion, que de crever d'ennui.* (Cf. Zola, *Au Bonheur des Dames*, chap. XI.)

17. Bourdoncle, the character to whom Van Gogh compared Theo in this and subsequent

letters, is described by Zola as intelligent and competent, but lackluster: "Il n'apportait pas le coup de génie de ce Provençal passionné [Mouret], ni son audace, ni sa grâce victorieuse" (*Au Bonheur des Dames*, chap. II). Bourdoncle's main duties at the department store involve surveillance, and he is presented as tight-lipped, prudent, and stubborn, with a cold air and a self-professed hatred of women. Thus, using Zola as his weapon, Van Gogh defended himself while taking a few swipes at his brother as well.

18. Si tu te crois fort, parce que tu refuses d'être bête et de souffrir...alors tu n'es qu'une dupe, pas davantage. (Cf. Zola, *Au Bonheur des Dames*, chap. XI)

19. Van Gogh apparently referred to Breton's *La Glaneuse*, which was that artist's only single-figure work at the Luxembourg.

20. The description of the tea appears in chap. III of *Au Bonheur des Dames*. The women are gathered at the home of Mouret's current mistress, and Mouret charms, captivates, and dominates the gathering as he promotes his business by displaying some fine new lace from his store:

> [Les] dames lui firent place au milieu d'elles. Le soleil venait de se coucher derrière les arbres du jardin, le jour tombait, une ombre fine noyait peu à peu la vaste pièce. C'était l'heure attendrie du crépuscule, cette minute de discrète volupté, dans les appartements parisiens, entre la clarté de la rue qui se meurt et les lampes qu'on allume encore à l'office....
>
> Toutes se rapprochèrent, l'emprisonnèrent du cercle étroit de leurs jupes. La tête levée, les regards luisants, elles lui souriaient....
>
> Elles resserraient encore leur cercle, la bouche entrouverte par un vague sourire, le visage rapproché et tendu, comme dans un élancement de tout leur être vers le tentateur. Leurs yeux pâlissaient, un léger frisson courait sur leurs nuques. Et lui gardait son calme de conquérant, au milieu des odeurs troublantes qui montaient de leurs chevelures....
>
> Dans cette volupté molle du crépuscule, au milieu de l'odeur échauffée de leurs épaules, il demeurait quand même leur maître, sous le ravissement qu'il af-

fectait. Il était femme, elles se sentaient pénétrées et possédées par ce sens délicat qu'il avait de leur être secret, et elles s'abandonnaient, séduites; tandis que lui, certain dès lors de les avoir à sa merci, apparaissait, trônant brutalement au-dessus d'elles, comme le roi despotique du chiffon....

> Les blancheurs mourantes du ciel s'éteignaient dans les cuivres des meubles. Seules, les dentelles gardaient un reflet de neige sur les genoux sombres de ces dames, dont le groupe confus semblait mettre autour du jeune homme de vagues agenouillements de dévotes. Une dernière clarté luisait au flanc de la théière, une lueur courte et vive de veilleuse, qui aurait brûlé dans une alcôve attiédie par le parfum du thé.

In this description – which is woven across many pages – Zola evokes a warm and intimate atmosphere of veiled eroticism into which Octave Mouret sinks comfortably, becoming one of them ("Il était femme"). The women presented are not individuals, but an adoring mass, with collective expressions, gestures, and aromas, and the fading light and softening shadows add to this effect of unity.

21. In subsequent letters Van Gogh made more explicit linkage between seduction and the pursuit of models (see, e.g., LT395, LT482, LT530 W4, B19). I have discussed this attitude in "Favoured Fictions: Women and Books in the Art of Van Gogh."

22. In "Le Moment artistique" Zola writes, "L'élément réel, la nature, est fixe, toujours le même....L'élément individuel, au contraire, l'homme, est variable à l'infini....Donc, une oeuvre d'art n'est jamais que la combinaison d'un homme, élément variable, et de la nature, élément fixe" (reprinted in *Mes haines*).

23. Van Gogh seems to have had in mind Millet's most notorious paintings – the harsh portrayals of peasant life that date to the late 1840s and early 1850s – portrayals he recognized as not just artistically but politically "revolutionary." While denying conscious engagement with politics in this era (LT379), Van Gogh nonetheless referred repeatedly to the events of 1848; for example,

"As men, and as painters, I like the generation of about '48 better than those of '84; *not* the Guizots, but the revolutionaries, Michelet – and also *the peasant painters* of Barbizon" (LT380; his emphasis).

24. Van Gogh intimated that in his desire to concentrate on the figure he found the representation of surroundings distracting; see LT391.

25. Pollock describes the faces' shapes, as well as the female models' short hair and bushy brows, as insistent reminders of the peasants' classed otherness ("Van Gogh and the Poor Slaves: Images of Rural Labour as Modern Art," pp. 411–12).

26. Je me moque de l'observation plus ou moins exacte, lorsqu'il n'y a pas une individualité puissante qui fasse vivre le tableau. . . . Je demande uniquement à l'artiste d'être personnel et puissant. . . . Donc pas plus de réalisme que d'autre chose. De la vérité, si l'on veut, de la vie, mais surtout des chairs et des coeurs différents interprétant différemment la nature.

27. Gautier actually referred quite specifically to Millet's image of *The Sower* (1849–50), a figure, he noted, that seemed to be painted with the very earth the sower worked. Van Gogh's variants are paraphrases. Linda Nochlin notes that Gautier's phrase itself was derived from Michelet's remark in *Le Peuple* (1846) that "the peasant seemed to be made of the very soil he coveted and cultivated so arduously" (see Nochlin, *Realism*, p. 115). Though Van Gogh in LT405 attributes Gautier's words to Millet himself, other references (LT402, LT406) indicate his awareness that these words were written about rather than by the artist. Van Gogh had read *Le Peuple* (see LT266), but gave no indication that he recognized Michelet's book as the initial source of this conceit.

28. Van Gogh clearly subscribed to the centuries-old notion that the best peasant paintings were made by men who were peasants themselves, and he was under the impression that Millet was one such "peasant-painter." In LT400, Van Gogh notes that in order to achieve authenticity in their depictions of rural life, artists must "be content with the food, drink, clothes and board which the peasants content themselves with. That's what Millet did, and in fact he did *not want anything better*, and in so doing he has, in his daily life, given an example to painters which, for instance, Israëls and Mauve, who live rather luxuriously, have *not* done" (his emphasis). When portrayals of rural life fail, Van Gogh asks rhetorically, "Isn't it . . . because the painters *personally* have not entered deeply enough into the spirit of peasant life? . . . Millet said, 'Dans l'art il faut y mettre sa peau.'"

29. J'ai longtemps vécu parmi le peuple. J'étais très pauvre et je l'ai vu de près. C'est ce qui m'a permis de parler de lui sans mensonage. (Cited by F. W. J. Hemmings, *Emile Zola*, p. 111)

30. Le premier roman sur le peuple, qui ne mente pas et qui ait l'odeur du peuple.

31. See especially chap. V of *L'Assommoir*, which includes a graphic account of the almost hypnotic effects Gervaise experiences in her daily dealings with soiled linen.

32. Indeed, if the picture had a literary counterpart in Van Gogh's mind, it probably was Carlyle's description, in *Sartor Resartus* (1831), of a class-divided England in which – as Griselda Pollock has noted – society's most impoverished members, the Poor Slaves, subsist on a diet of potatoes. See Pollock, "The Poor Slaves," pp. 426–7.

33. Colin Smethurst writes that a meeting with Alfred Giard, a left-wing *député*, initiated Zola's interest in the mines. In addition to notes made during an on-site visit in February–March 1884 (arranged by Giard), Zola drew on a book by Louis-Laurent Simonin, *La Vie souterraine, ou les mines et les mineurs* (Paris, 1867). See Smethurst, *Emile Zola: Germinal*, pp. 20–1.

34. *Germinal*, which had been serialized by *Gil Blas* from November 1884 to February 1885, had only recently appeared in book form when Theo read it and sent it to his brother in May.

35. See David F. Bell, *Models of Power: Politics and Economics in Zola's Rougon-Macquart*, pp. 43–4. At the height of his career, Zola was criticized by representatives of the working class for the ambiguity of his political position (see Smethurst, *Emile Zola*, pp. 14–15), and his philosophies continue to be skeptically scrutinized today

– e.g., by André Vial, Germinal *et le "So-cialisme" de Zola;* and Paule Lejeune, Ger-minal: *Un Roman antipeuple.*

36. In his *ébauche* for *Germinal* – in which he characterized the story as "la lutte du capital et du travail" – Zola declared, "Il faut que le lecteur bourgeois ait un frisson de terreur" (cited by Henri Mitterand, *Le Discours du roman*, p. 124).

37. Smethurst notes that Zola's recent education in working-class politics informed his de-scription of the political education of Etienne Lantier, the protagonist of *Ger-minal*. The views of the "possibilistes" – a moderate wing of the Fédération du Parti des Travailleurs Socialistes de France – are mouthed in the novel by the café owner Ras-seneur, a practical man whose first concern is the material circumstances of the workers. Rasseneur puts rather too much faith in Plu-chart, an official of the Workers' Interna-tional who lives in Lille and usually manages to stay above the fray; Pluchart's forte is oration, not action. His radical opposite in the novel's political discourse is Souvarine, a Russian intellectual of aristocratic birth who warmed to socialism at school and turned anarchist; his lines provide a forum for broad assessments of European eco-nomic systems. (According to Smethurst, the views attributed to Souvarine derived from Zola's discussions with Turgenev and his familiarity with that author's work.) Con-versations with Rasseneur and Souvarine and correspondence with Pluchart consti-tute Lantier's introduction to prevailing political discourse (see, e.g., *Germinal*, pt. III, chap. 1; pt. IV, chap. 4; pt. VI, chap. 3). He emerges, Smethurst writes, as a "half-baked Marxist" whose education effects an *embourgeoisement* of sorts – hence sepa-ration from his class. For a detailed account of the political viewpoints presented in *Germinal* and their relation to Zola's con-victions, see Smethurst, *Emile Zola*, pp. 40–7.

38. Despite his ironic jabs at the values, as-sumptions, and patronizing charity of the bourgeois, Zola betrays his own class origins in pitying portrayals of the poor as animal-like in their simplicity, subjugation to their masters, and domination by "instinctual" drives manifested in unrestrained lust and violence. The ambiguity of this authorial po-sitioning has been much remarked. The problems inherent to a political reading of *Germinal* are succinctly addressed by Sandy Petrey, "Discours social et littérature dans *Germinal.*"

39. See Mitterand, *Le Discours du roman*, p. 136.

40. The Dutch word Van Gogh used again and again in discussions of *Germinal* is "*prachtig.*"

41. Repeated images of sowing and reaping as metaphors for social unrest and revolt in *Germinal* recall Christ's use of agrarian im-agery in the parables, particularly that of the sower (Matt. 13, Mark 4). The biblical fla-vor of such imagery is reinforced by Zola's characterization of the miners' awakening zeal as "la foi aveugle des nouveaux croy-ants, pareils à ces chrétiens des premiers temps de l'Eglise, qui attendaient la venue d'une société parfaite, sur le fumier du monde antique" (pt. III, chap. 3). Elsewhere in the novel Zola writes, "Une exaltation religieuse les soulevait de terre, la fièvre d'es-poir des premiers chrétiens de l'Eglise, at-tendant le règne prochain de la justice" (pt. IV, chap. 7).

42. Early in the novel, the reader is introduced to the Abbé Joire, an inoffensive but useless priest. "Il était doux," Zola writes, "il af-fectait de ne s'occuper de rien, pour ne fâcher ni les ouvriers ni les patrons" (pt. II, chap. 2). Joire eventually is replaced by the radicalized Abbé Ranvier, but the peasants' skepticism about the clergy endures. When the new priest berates the bourgeoisie (pt. VI, chap. 2) and attempts to remedy the "dé-plorable malentendu entre l'Eglise et le peu-ple" by telling parishioners that "l'Eglise était avec les pauvres," one miner tells him bluntly that the workers don't need ser-mons and points out, "Vous auriez mieux fait de commencer par nous apporter un pain."

43. Van Gogh's description of a seemingly un-controllable urge to respond to the text by means of an image is reminiscent of his os-tensibly spontaneous graphic reactions to the biblical texts he studied in Amsterdam in 1877–8; see LT97, LT101, and Chapter 1, this volume.

44. The lengthy passages from *Germinal* that Van Gogh transcribes in LT410 are in French.

45. The painting illustrated here (Fig. 9; F141) is the only known *signed* portrait head from this era.

46. Van Gogh transcribed this passage in French and shortened the citation by means of un-indicated ellipses.

47. Addressing the way that Zola plays off the miners' sexual satisfaction against the sexual frustration of Hennebeau, Mitterand notes that this stressed disjunction serves to "isoler biologiquement les deux classes, donc de na-turaliser l'histoire, d'interpréter en termes de nature éternelle les structures transitoires d'une société.... Le discours sur la sexualité est bien, dans *Germinal*, un discours idéo-logique" (*Le Discours du roman*, p. 137). A close textual analysis of social/sexual discourse in *Germinal* is given by Petrey ("Dis-cours social"); for his discussion of Hennebeau's relation to the miners, see esp. pp. 61–8.

48. Zola devotes almost an entire chapter (pt. II, chap. 5) to the sexual initiations and prac-tices of the unmarried youth (including pre-teens) of the mining community. Unwed couples do their lovemaking out-of-doors, particularly in the high corn and lush grasses of summer; it wintertime some have sex against walls to avoid the bare, wet ground. Illegitimate births are numerous; many women have a child or two before marriage – and the men they wed are not necessarily those who deflower them.

49. See especially LT212, in which Van Gogh compared his feelings for his cousin, Kee Vos, with those he had for Sien, his mistress at The Hague. He concluded: "The feeling between Sien and me is *real;* it is no dream, it is reality.... My *illusion* ... was Kee Vos – reality became a woman of the people" (his emphasis).

50. If Van Gogh did have sex with any of his Nuenen models, he kept it to himself. His letters indicate that he was suspected of sex-ual involvement with a young woman he had often painted (who became pregnant), but in addition to denying the accusation Van Gogh pointed the finger at someone else (see LT423).

51. In a subsequent letter, Van Gogh insisted that this self-portrait was apt and pro-claimed, "I will not take it back" (LT347). Instead, he elaborated it in an imaginary dialogue:

> I see two brothers walking about The Hague (*see them as strangers*, do not think of yourself and me).
>
> One says, "I must maintain a certain standing, I must stay in business, I don't think I shall become a painter."
>
> The other says, "I am getting to be like a dog, I feel that the future will prob-ably make me more ugly and rough, and I foresee 'a certain *poverty*' will be my fate, but *I shall be a painter.*"
>
> ...I tell you, I consciously chose *the dog's path through life*; I will remain a *dog*, I shall be *poor*, I shall be a *painter.* (His emphasis)

52. See Pollock, "The Poor Slaves," pp. 413–16.

53. Zola's account of Hennebeau's background is scanty; born in poverty in the Ardennes, the mine manager is said to have grown up in the streets of Paris after being orphaned at an early age. Van Gogh seems to have read a longing for his native region and/or former poverty into Hennebeau's diatribe and apparently envisioned him as one of those he had described a few weeks earlier as people who "retain unfading impressions of the country and remain all their lives homesick for the fields and the peasants" (LT398).

54. Van Gogh later recalled his time at Nuenen as a period of uncharacteristic (for him) physical well-being; see LT520.

55. "L'Histoire de mon livre" was one of a series of articles, *Histoire de mes livres;* it even-tually appeared as a chapter in Daudet's lit-erary memoir, *Souvenirs d'un homme de lettres.* It is one of a number of such accounts to which Van Gogh was drawn – that is, a recollection of the trials an author endured in order to produce a literary work. The process Daudet describes is in some respects typically "Naturalist": one of painstaking documentation of a story that, according to its author, is "moins un roman qu'une étude historique." In addition to describing the

way in which he conceived and wrote *Les Rois en exil*, Daudet includes detailed asides on his health and family life during the time he worked on it.

56. In describing his pursuit of "reality," Daudet not only writes of "cette chasse aux modèles, aux renseignements vrais," but also of "l'ennui de tout ce reportage commandé par la nouveauté d'un sujet tellement loin de moi." While allowing that much of the book was the product of imagination, Daudet emphasizes "une faiblesse dont j'ai fait déjà l'aveu – ce besoin de réalité qui m'opprime et m'oblige à toujours laisser l'étiquette de la vie au bas de mes inventions les plus soigneusement démarquées."

57. Jules Jacquet (1841–1913) and Benjamin Constant (1845–1902) were successful French artists who showed at the Salon regularly from the late 1860s onward; each was inducted into the Légion d'honneur.

58. Léon Lhermitte (1844–1925) was a second-generation French Realist painter known for landscape and peasant scenes. Van Gogh rightly saw him as a successor to Millet and often linked the two artists in his letters of the 1880s.

59. Qu'importe la vérité, ai-je dit, si le mensonge est commis par un tempérament particulier et puissant. (Zola, "Les Réalistes du Salon")

60. Griselda Pollock has noted the prevalence of such postures in Van Gogh's depictions of working women (e.g., see also F1256, LF1269, F1690) and interpreted them psychoanalytically in a lecture presented at Barnard College in January 1989, "Bestiality and the Representation of Peasant Women in 19th-Century French Painting."

61. On n'entendit plus que les appels réguliers des galibots et que l'ébrouement des herscheuses arrivant au plan, fumantes comme des juments trop chargées. C'était le coup de bestialité qui soufflait dans la fosse, le désir subit du mâle lorsqu'un mineur rencontrait une de ces filles à quatre pattes, les reins en l'air, crevant de ses hanches sa culotte de garçon.

See also pt. V, chap. 2, in which Zola describes work in a particularly hot sector of the mine. Discomfited by the heat, men work naked, and a fragile young *herscheuse* is forced to follow suit despite her coworkers' catcalls; describing her as semiclad and down on all fours, Zola likens her to a beast and to a delapidated cabhorse.

62. Une herscheuse de dix-huit ans, bonne fille dont la gorge et le derrière énormes crevaient la veste et la culotte.... Au milieu des blés en été, contre un mur en hiver, elle se donnait du plaisir, en compagnie de son amoureux de la semaine. (*Germinal*, pt. I, chap. 3)

63. On éclata de rire, parce qu'elle leur montra tout à coup son derrière, ce qui était chez elle l'extrême expression du dédain. (*Germinal*, pt. I, chap. 6)

64. Elle guettait les bourgeois, sur les portes de leurs jardins, aux fenêtres de leurs maisons; et, quand elle en découvrait, ne pouvant leur cracher au nez, elle leur montrait ce qui était pour elle le comble de son mépris...Brusquement elle releva ses jupes, tendit les fesses, montra son derrière énorme, nu dans un dernier flamboiement du soleil. Il n'avait rien d'obscène, ce derrière, et ne faisait pas rire, farouche.

65. La Mouquette s'étranglait de fureur, en pensant que des soldats voulaient trouer la peau à des femmes. Elle leur avait craché tous ses gros mots, elle ne trouvait pas d'injure assez basse, lorsque, brusquement, n'ayant plus que cette mortelle offense à bombarder au nez de la troupe, elle montra son cul. Des deux mains, elle relevait ses jupes, tendait les reins, élargissait la rondeur énorme. – Tenez, v'là pour vous! et il est encore trop propre, tas de salauds!

Elle plongeait, culbutait, se tournait pour que chacun en eût sa part, s'y reprenait à chaque poussée qu'elle envoyait.

– V'là pour l'officier! v'là pour le sergent, v'là pour les militaires.

Un rire de tempête s'éleva.... Etienne lui-même, malgré son attente sombre, applaudit à cette nudité insultante.

66. Petrey devotes a subsection of his article on social discourse in *Germinal* to "Le Derrière d'une ouvrière"; see "Discours social," pp. 71–3.

67. La Mouquette, of course, is a fictional figure who herself becomes the lower-class female vehicle for the bourgeois male author's expressions of contempt toward the soldiers.

68. Indeed, Van Gogh acknowledged in the summer of 1885 that the reason he spent "relatively much on models" was that "here as everywhere, people do not like to pose, and if it weren't for the money *nobody* would" (LT417; his emphasis).

69. Some of the earliest examples of *vanitas* still lifes occur in the backgrounds of representations of St. Jerome and other scholars; thus books were among the first *vanitas* motifs. J. van Gelder notes that in this context they were meant to serve as subtle reminders of the limitations of learning; see his "Introduction" in Ashmolean Museum, *Catalogue of the Collection of Dutch and Flemish Still-life Pictures bequested by Daisy Linda Ward.*

70. Their father's Bible was presented to Theo shortly after Van Gogh painted it. It is now in the possession of the Mennonite and Remonstrant Congregations of Leiden and is the subject of an essay by Louis van Tilborgh, "De bijbel van Vincents vader."

71. Tilborgh, citing a break in the spine that makes this Bible fall open at Isaiah, speculates that "it was more by accident than design that Van Gogh depicted this particular page," but does not address the emphasis placed on chap. LIII, or Van Gogh's use of French ("Isaie") instead of Dutch.

72. It is equally possible, however, that the chapter from Isaiah, which – as Mark Roskill notes – "is about the 'suffering servant' released from bondage," refers to the Rev. Van Gogh's passage from worldly cares. See Mark Roskill, "Public and Private Meanings: The Paintings of Van Gogh," p. 162.

73. Carl Nordenfalk, "Van Gogh and Literature," p. 142.

74. See, e.g., Jan Hulsker, *The Complete Van Gogh: Paintings, Drawings, Sketches,* p. 206; Roskill, *Public and Private Meanings,* pp. 162–3.

75. The distinction between public and private meaning in Van Gogh's work has been suc-

cinctly articulated by Roskill, who writes:

> "Public" meanings are those which, in the character of the images themselves and/or the way they are structured and presented, are posited as being accessible to the "unprivileged" viewer. "Private" meanings, in contrast, are those which a "privileged" viewer may be in a position to discern – that is, a viewer who has access to the work's meaning which is not normally available to others, or not available without special bases for familiarity or sources of insight. (*Public and Private Meanings,* p. 158)

For a general discussion of these ideas, see Roskill, "On the Intention and Meaning of Works of Art," and idem, *The Interpretation of Pictures,* chap. II.

76. "Toi, tu ferais mieux … de ne pas perdre ton temps à des bêtises." (Zola, *La Joie de vivre,* chap. I)

77. Une carrière d'honnête homme … Lazare furieux refermait le piano avec violence, en lui criant qu'elle était "une sale bourgeoise." (Zola, *La Joie de vivre,* chap. II)

78. Even when *La Joie de vivre* resurfaced three years later in another of Van Gogh's paintings – *Oleanders* (Plate 9), made at Arles in 1888 (see Chapter 5) – he made no mention of its cast or narrative.

79. Van Gogh apparently bought Goncourt's new novel on a brief trip to Amsterdam in October; see LT426.

80. In his preface to *Chérie,* Goncourt defends his alternative to the novel as "un livre de pure analyse: livre pour lequel – je l'ai cherchée sans réussite – un *jeune* trouvera peut-être, quelque jour, une nouvelle dénomination, une dénomination autre que celle de roman."

81. In its account of its heroine's progress through puberty, *Chérie* is similar to those sections of *La Joie de vivre* that detail Pauline's sexual maturation. The two novels – published in the same year – are so similar in some respects that Goncourt accused Zola of stealing his ideas, for he had been working on *Chérie* for several years and had read parts of it aloud to Zola and others. See Elliott Grant, *Emile Zola,* p. 37.

82. That is, "une sorte de testament littéraire."

83. Le romancier, qui a le désir de se survivre, continuera à s'efforcer de mettre dans sa prose de la poésie, continuera à vouloir un rythme et une cadence pour ses périodes, continuera à rechercher l'image peinte, continuera à courir après l'épithète rare, continuera, selon la rédaction d'un délicat styliste de ce siècle, à combiner dans une expression le *trop* et l'*assez*.

84. "Je suis fatigué, j'en ai assez, je laisse la place aux autres." Though Goncourt did not die until 1896 – twelve years after the publication of *Chérie* – it was indeed his last work of fiction.

85. "Il faudra bien reconnaître un jour que nous avons fait *Germinie Lacerteux* . . . et que *Germinie Lacerteux* est le livre-type qui a servi de modèle à tout ce qui a été fabriqué depuis nous, sous le nom de réalisme, naturalisme, etc." (Edmond de Goncourt [ostensibly quoting Jules], *Chérie*, preface)

86. "Ce sont les trois grands mouvements littéraires et artistiques de la seconde moitié du XIXe siècle, et nous les aurons menés . . . nous pauvres obscurs. Eh bien! quand on a fait cela, c'est vraiment difficile de n'être pas *quelqu'un* dans l'avenir."

87. In LT431 – after asking Theo, "Do you know that the de Goncourts have made etchings and drawings?" – Van Gogh insisted: "You must not think me unpractical when I persist in encouraging you either to draw or to paint. You wouldn't be a failure either."

88. The artists covered by *L'Art du XVIIIe siècle* are the Saint-Aubins, Watteau, P.-P. Prudhon, Boucher, Greuze, Chardin, Fragonard, Debucourt, La Tour, the Gravelots, Cochin, Eisen, and Jean-Michel Moreau.

89. This emphatic reference to the man behind the picture suggests Van Gogh's recollection of Zola's maxim from "Le Moment artistique": "Ce que je cherche avant tout dans un tableau, c'est un homme et non pas un tableau." Van Gogh had referred to it just a few months earlier, in LT418, when he wrote, "Zola says a beautiful thing about art in general in *Mes Haines*, 'dans le tableau (l'oeuvre d'art) je cherche, j'aime l'homme – l'artiste.'"

90. His experiences in Antwerp convinced Van Gogh (temporarily) that an urban environment stimulated his work; see LT454.

91. Van Gogh in Antwerp took a special interest in the work of Rubens and in more recent paintings by Hendrik Leys and Henri de Braekeleer.

92. See Gabriel P. Weisberg, "Japonisme: Early Sources and the French Printmaker, 1854–1882," p. l. For a more specific discussion of the popularity of Japanese prints in Holland, see Fred Orton, "Van Gogh and Japanese Prints: An Introductory Essay," p. 14.

93. Both Orton ("Van Gogh and Japanese Prints," p. 14) and Johannes van Der Wolk ("Vincent van Gogh and Japan," p. 216) believe Van Gogh saw Japanese prints well before 1885, probably when he was working as an art dealer (from 1869 to 1876), and perhaps even before that. The artist, however, never mentioned Japanese prints in his letters until his arrival in Antwerp, and according to Orton (p. 14) there is a "complete absence of any influence of the Japanese woodcuts on Van Gogh's work before 1887" (i.e., when he was living in Paris).

94. Orton, "Van Gogh and Japanese Prints," pp. 14–15.

95. Enfin cette description d'un salon parisien meublé de japonaiseries, publiée dans notre premier roman, dans notre roman d'*En 18 . .*, paru en 1851 . . . oui, en 1851 – qu'on me montre les japonisants de ce temps-là . . . – Et nos acquisitions de bronzes et de laques de ces années chez Mallinet et un peu plus tard chez Mme. Desoye . . . et la découverte en 1860, à la *Porte Chinoise*, du premier album japonais connu à Paris . . . connu au moins du monde des littérateurs et des peintres . . . et les pages consacrées aux choses du Japon dans *Manette Salomon*, dans *Idées et sensations*.

The Goncourts devoted three paragraphs of chap. XLVII of *Manette Salomon* (1867) to the evocation of Japanese prints; *Idées et sensations* (1868; a book of extracts from their not yet published journals) includes two very general references to Japanese aesthetics.

96. "Ne font-ils pas de nous les premiers propagateurs de cet art…de cet art en train, sans qu'on s'en doute, de révolutionner l'optique des peuples occidentaux?"

97. Though the Goncourts certainly were well-known and relatively early enthusiasts of Japanese art, they cannot be considered its European "discoverers." As early as 1927, William Leonard Schwartz questioned the veracity of Edmond's claims to primacy in *japonisme*, noting that the Asia-inspired salon of *En 18 . .* contained mostly Chinese objects (of a sort popular even in the eighteenth century) and pointing out that although Edmond, in the preface to *Chérie*, recalls discovering the first album of Japanese prints known in Paris at La Porte Chinoise in 1860, that shop did not open until 1862. See William Leonard Schwartz, "The Priority of the Goncourts' Discovery of Japanese Art," pp. 798–806. In his more recent study, Weisberg does not include the Goncourts among the initiators of *japonisme* and writes that Félix Bracquemond encountered a copy of Hokusai's *Manga* in the shop of a Parisian printer in 1856 ("Japonisme," p. 1).

98. See *Manette Salomon*, chap. XLVII, which includes what Schwartz calls "three brilliant paragraphs of praise for Japanese color-print albums" (*The Imaginative Interpretation of the Far East in Modern French Literature*, p. 69).

99. In *La Fille Elisa* (1877), Edmond de Goncourt (who wrote the book on his own, after Jules's death) compares a woman's nose to both the ace of spades and a Japanese ivory octopus's sucker: "un petit nez en as de pique, pareil au suçoir que les ivoiriers japonais donnent à la pieuvre" (pt. I, chap. 27). *Les Frères Zemganno* (1879; also written by Edmond alone) features two such references to Japanese art: Gianni's acrobatic posture is at one point compared to those that "les artistes japonais en donnent aux corps des singes dans leurs originales suspensions de bronze" (chap. IV); later, the shadows of iron chairs in a park are said to recall "l'apparence d'une de ces inquiétantes légions de crabes escaladant le bas d'un page d'un album japonais" (chap. LXXIX).

Such similes are discussed by Schwartz in both "The Priority of the Goncourts' Discovery," pp. 803–4, and – at greater length – in *The Imaginative Interpretation*, chap. II.

100. This slogan – written in English ("Japonaiserie *for ever!*" [*sic*]) – occurs in a letter Jules de Goncourt sent to Philippe Burty on 1 August 1867. Burty – a critic and collector who (like Jules) sometimes practiced etching – is credited with coining the term *japonisme* in 1872 (see Cleveland Museum of Art, *Japonisme: Japanese Influences on French Art*, p. xi). Burty's book *Maîtres et petit maîtres* (1877) includes a memoir of Jules de Goncourt wherein the author reprints the letter Van Gogh cites (it was written after a visit to the Exposition Universelle in Paris, where Japanese art was well represented), and Van Gogh almost certainly read it there (see p. 274).

For a brief profile of Burty, his contributions to *japonisme*, and his friendship with the Goncourt brothers, see Debora L. Silverman, *Art Nouveau and Fin-de-Siècle France: Politics, Psychology and Style*, pp. 126–30.

101. On receiving it (in January 1886), Van Gogh wrote to Theo: "Do not let me forget to thank you for sending the second volume of de Goncourt's [*sic*] book. It is a delightful thing to be able to study that period – from which *so much can be learned* by – to use the expression – *notre fin du siècle* [*sic*] in which we live" (LT443; his emphasis).

102. In a subsequent letter Van Gogh asserted, "The books of today, since Balzac, for instance, are different from all that was written in the preceding centuries, and perhaps more beautiful" (LT457).

103. When Van Gogh envisioned hardship, financial woes apparently figured in, and he seems to have assumed that his heroes were as pressed for funds as he was; this certainly was not true of Balzac, the Goncourts, or Delacroix.

CHAPTER 4. "ROMANS PARISIENS": READING NATURALISM IN ITS HABITAT

1. The Van Goghs moved from 25 rue Laval (now rue Victor-Massé) to 54 rue Lepic (a

commemorative plaque now marks their building there). Brief asides on their life together can be found in the letters Andries Bonger (Theo's future brother-in-law) wrote to his parents from Paris (for pertinent excerpts, see LT462a). Bonger describes Theo's distress at Vincent's careless housekeeping and querulous personality.

2. John Rewald, *Post-Impressionism: From Van Gogh to Gauguin;* Bogomila Welsh-Ovcharov, *Vincent van Gogh: His Paris Period, 1886–88,* and *Van Gogh à Paris.* Another source of information on Van Gogh in Paris is Mark Roskill, *Van Gogh, Gauguin and the Impressionist Circle.*

3. Van Gogh later described himself as "going the right way for a stroke" in Paris (LT481), where he not only worked hard, but overindulged in alcohol and tobacco (see LT544). From Arles in 1888, he advocated the creation of a rural retreat where Parisian artists "could go out to pasture when they get too beat up" (LT469).

4. Van Gogh probably got his first glimpse of Impressionist pictures at Theo's workplace, Goupil's successor firm, Boussod et Valadon. Though he dealt mainly in the work of established academic artists there, Theo's superiors allowed him to do a scaled-down business in Impressionist pictures on the gallery's second floor. Since his arrival in Paris in 1879, Theo had befriended several avantgarde artists and amassed a group of paintings by Manet, Monet, Renoir, Pissarro, and Sisley. He doubtless showed them to Vincent, who later remarked:

> One has heard talk about the impressionists, one expects a whole lot from them, and ... when one sees them for the first time one is bitterly, bitterly disappointed, and thinks them slovenly, ugly, badly painted, badly drawn, bad in color, everything that's miserable. This was my own first impression too when I came to Paris, dominated as I was by the ideas of Mauve and Israëls and other clever painters." (W4)

5. A thorough account of Van Gogh's floral still lifes is given by Welsh-Ovcharov, *Van Gogh: Paris Period,* pp. 75–81. Though his interest in color theory did – as Welsh-

Ovcharov points out – predate his experience of Impressionism (see note 6), his introduction to contemporary Parisian art surely accelerated his endeavors to brighten his palette.

6. *Les Artistes de mon temps* (1876) contains an essay on Delacroix, which Blanc wrote in 1864 and which seems to have prompted Van Gogh's first serious work with color plays. He soon read Blanc's *Grammaire des arts du dessin* as well, and in the fall of 1885 (e.g., in LT428 and LT429) he wrote at length about coloristic relationships. Detailed accounts of Blanc's impact on Van Gogh's practice are provided by Carlo Derkert, "Theory and Practice in Van Gogh's Dutch Painting," and Welsh-Ovcharov, *Van Gogh: Paris Period,* pp. 64–74.

7. See Françoise Cachin, *Paul Signac,* p. 37; and Welsh-Ovcharov, *Van Gogh: Paris Period,* pp. 29–32. Signac's comments on his relationship with Van Gogh in Paris are reprinted in translation in Bogomila Welsh-Ovcharov, *Van Gogh in Perspective,* p. 36.

8. For sustained discussion of the impact of Neo-Impressionism on Van Gogh, see Roskill, *Van Gogh, Gauguin, and the Impressionist Circle,* chap. III, and Welsh-Ovcharov, *Van Gogh: Paris Period,* pp. 99–105.

9. Welsh-Ovcharov has compiled a list of exhibitions mounted during Van Gogh's stay in Paris; see *Van Gogh: Paris Period,* app. III.

10. This group of prints (together with additions from Theo's collection) remains intact at the Rijksmuseum Vincent van Gogh in Amsterdam, where it has been the subject of an exhibition: *Japanese Prints Collected by Vincent van Gogh* (1978). Van Gogh himself arranged to show his Japanese prints in Paris in the spring of 1887; they were mounted on the walls of Le Tambourin, a café on the boulevard Clichy that was run by Agostina Segatori. Van Gogh apparently was amorously involved with Segatori at the time, and he commemorated her and his exhibition in F370, which shows Segatori at one of the café's tambourinelike tables. The wall behind her is decked with Japanese prints.

11. See Mark Edo Trabault, "Van Gogh's japanisme"; and Fred Orton, "Van Gogh's Interest in Japanese Prints."

12. A careful and insightful account of Van Gogh's assimilation of Japanese art – notably the gradual supplanting of *japonaiserie* by *japonisme* in his work – is given by Roskill, *Van Gogh, Gauguin, and the Impressionist Circle*, chap. II.

13. In addition to Japanese prints, Anquetin and Bernard drew on such diverse sources as medieval enamel work and popular imagery. Their synthetic style was not labeled until March 1888, when Edouard Dujardin used the term *"cloisonisme"* in an essay for *La Revue indépendante*. When Van Gogh, Anquetin, Bernard, and others showed their work in a joint exhibition at a Montmartre restaurant late in 1887, they billed themselves as artists of the "Petit Boulevard"; see Bogomila Welsh-Ovcharov, *Vincent van Gogh and the Birth of Cloisonism*, pp. 27–8.

14. The religiosity that dominated Van Gogh's outlook during his previous sojourn in Paris (May 1875–March 1876) probably accounts for his failure to engage with Impressionist painting and Naturalist literature in that era.

15. Years later, Van Gogh fondly recalled the "beautiful" bookshops of Paris in LT615, and as he contemplated a return to the city he wrote from St.-Rémy: "In Paris – if I feel strong enough – I should very much like to do at once a picture of a yellow bookshop (gas effect), which I have had in mind for so long" (LT634).

16. Van Gogh in fact titled one of these still lifes (Plate 7) *Romans parisiens*, though none of the volumes it features is specifically labeled. The other paintings feature titled volumes (together they contain a total of five novels) that – as Welsh-Ovcharov has noted – "reflect not only French Realist authors, but specifically Parisian ambients as subject matter" (*Van Gogh: Paris Period*, p. 49).

17. Welsh-Ovcharov has made such comparisons in *Van Gogh: Paris Period*, pp. 141–6 and app. V.

18. Summary accounts of the complex web of ideas, publications, exhibitions, and personal alliances that linked Parisian writers and artists in this era can be found in Rewald, *Post-Impressionism*, chap. III; Sven Lövgren, *The Genesis of Modernism*, preface and chap. I; Joan Ungersma Halperin, *Félix Fénéon, Aesthete & Anarchist in Fin-de-Siècle Paris*, chap. IV. More extensive accounts are provided by A. G. Lehmann, *The Symbolist Aesthetic in France, 1885–1895*; and James Kearns, *Symbolist Landscapes: The Place of Painting in the Poetry and Criticism of Mallarmé and his Circle*.

19. The label *"décadent,"* which was first used pejoratively by enemies of the new literature, lost some of its negative tinge as young writers applied it to themselves; nonetheless, Jean Moréas suggested in his "Manifeste littéraire" of September 1886 that *"symboliste"* was a better term, and Gustave Kahn concurred, noting that *"décadent"* was a "journalists' word." "Symbolist" – a more neutral and evocative adjective – came to have broader currency than "decadent"; the former is indicative of an art, literature, or music of ideas, whereas the latter implies excess, eccentricity, alienation, morbidity. See Gustave Kahn, *Symbolistes et Décadents* (Paris, 1900), preface; reprinted as *Les Origines du Symbolisme*.

20. Mallarmé, for instance, wrote: "Nommer un objet, c'est supprimer les trois-quarts de la jouissance...le suggérer, voilà le rêve" (quoted by J. Huret, *Enquête sur l'évolution littéraire, conversations avec Renan, de Goncourt, Zola, e.a.*, p. 60). The primacy of suggestion as a goal of the painter, poet, or musician was stressed by Téodor de Wyzéwa in a series of essays for the *Revue wagnérienne*, including "Notes sur la peinture wagnérienne et le Salon de 1886" (8 May 1886), "Notes sur la littérature wagnérienne et les livres en 1885–1886" (8 June 1886), and "Notes sur la musique wagnérienne" (8 July 1886). See also Elga Liverman Duval, *Téodor de Wyzéwa: Critic Without a Country*, pp. 32–9.

21. l'ennemie de l'enseignement, de la déclamation, de la fausse sensibilité, de la déclamation objective.

22. See Lehmann, *The Symbolist Aesthetic*, p. 67.

23. ...vêtir l'Idée d'une forme sensible qui, néanmoins, ne serait pas son but à elle-

même, mais qui, tout en servant à exprimer l'Idée, demeurait sujette. L'Idée, à son tour, ne doit point se laisser voir privée des somptueuses simarres des analogies extérieures; car le caractère essentiel de l'art symbolique consiste à ne jamais aller jusqu'à la conception de l'Idée en soi.

24. Les tableaux de la nature, les actions des humains, tous les phénomènes concrets ne sauraient se manifester eux-mêmes: ce sont là des apparences sensibles destinées à représenter leurs affinités ésotériques avec des Idées primordiales.

25. Kahn as cited by Lövgren, *Genesis*, p. 65. "Le but essentiel de notre art est d'objectiver le subjectif (l'extériorisation de l'Idée) au lieu de subjectiver l'objectif (la nature vue à travers un tempérament)."

26. Kahn as cited by Robert Goldwater, *Symbolism*, p. 144.

27. Cited by Guy Robert, *La Terre d'Emile Zola: Etude historique et critique*, p. 405. "Le naturalisme semble bien près d'avoir fait son temps."

28. Ibid., p. 413.

Il y a quelques années un maître puissant et populaire menaçait de régenter et de discipliner les romanciers ses confrères. ... Peu s'en fallut que le public ne ratifiât ce coup d'état littéraire; le naturalisme touchait à la dictature et le document humain bannissait le romanesque du roman. Ce ne fut heureusement qu'une vaine alarme. La fantaisie reprit ses droits.

29. In *La Joie de vivre* (1884), for instance, Zola addresses – if superficially – the effect of German philosophy (particularly the impact of Schopenhauer) on French thought; as Lövgren writes, this "novel of ideas" indicates that Zola "was fully aware of the cultural situation and that he did not hesitate to make use of it in his literary work" (*Genesis*, p. 17; for elaboration, see pp. 16–18). It is also notable that the artistic project that haunts Claude Lantier when he emerges as the hero of Zola's *L'Oeuvre* (1886) is not a painting in the Impressionist vein, but instead an allegorical/symbolic work of the sort undertaken by a younger generation of anti-Naturalist painters.

30. Lövgren points, for instance, to Huysmans's attention to facts and details that suggest the book's foundation in an observed reality (see *Genesis*, p. 12).

31. See Cachin, *Paul Signac*, pp. 9–15. In discussing Signac's youthful predilections, Cachin notes that he paid frank if unorthodox homage to the creative personalities he admired by christening his first boat "Manet-Zola-Wagner."

32. Fénéon often brought together literary associates and painter friends at late-afternoon gatherings in the offices of *La Revue indépendante*. The magazine's premises also functioned as an exhibition space for works by avant-garde painters Fénéon admired. See Rewald, *Post-Impressionism*, pp. 65, 138.

33. These friendships are documented by a caricature of Wyzéwa drawn by Anquetin c. 1890 and one of Dujardin made by Toulouse-Lautrec; they are illustrated by Rewald in ibid., pp. 139 and 136, respectively.

34. Welsh-Ovcharov, *Van Gogh and the Birth of Cloisonism*, p. 23.

35. According to Rewald, Bernard "read constantly" (p. 57). He often shared his poetry with Van Gogh (see letters B4, B5).

36. See Emile Bernard, *Les Hommes d'aujourd'hui: Vincent van Gogh*; reprinted in Welsh-Ovcharov, *Van Gogh in Perspective*, pp. 38–40.

37. Lövgren, *Genesis*, p. 146.

38. Bernard, as reprinted in Welsh-Ovcharov, *Van Gogh in Perspective*, p. 38.

39. Duval, *Téodor de Wyzéwa*, pp. 32–9; see also Elaine Brody, *Paris: The Musical Kaleidoscope, 1870–1925*, pp. 54–5.

40. In August 1886, Jules Laforgue's translation of Whitman's "A Woman Waits for Me" was published by *La Vogue*, and in 1888 Francis Viélé-Griffin's translations of "From Noon to Starry Night" ("De midi à la nuit etoilée") appeared in *La Revue indépendante* and elsewhere. Viélé-Griffin, a U.S. poet of French extraction, was responsible for most of the translations of Whitman's work that appeared in France in the 1880s; see Lövgren, *Genesis*, p. 146.

41. In letter W8 from Arles, Van Gogh advised his sister Wil to read Whitman's poems and suggested that she look for a volume of his work in Theo's library in Paris.

42. See F. W. J. Hemmings, *Emile Zola*, pp. 210–24.

43. The public was well aware of Zola's personal relationship with Manet (the author had defended the painter in print – most notably in a pamphlet published in 1867 – and Manet had reciprocated by painting Zola's portrait in 1868), and probably for this reason most readers assumed him to be the inspiration for *L'Oeuvre*'s hero. More specifically, Zola's description in the book of the painting that launched Claude Lantier's career – a picture of nude women frolicking out-of-doors as a clothed male spectator looks on – is, in its juxtaposition of nude and clothed figures in an outdoor setting, comparable to Manet's *Déjeuner l'herbe*. The fictional Lantier painting probably had more to do, however, with works by Cézanne that were at that time unknown to the public. Cézanne pairs clothed men and nude women in his *Idyll* of c. 1870, and in his *Lutteurs amoureux* of 1880–5, he shows coupled nudes playfully fighting in a manner that suggests the motif Zola ascribes to Lantier: "Deux … petites femmes, une brune, une blonde, également nues, luttaient en riant, détachaient, parmi les verts des feuilles, deux adorables notes de chair" (*L'Oeuvre*, chap. II). In the "premier plan" of Lantier's picture, moreover, Zola notes "un monsieur, vêtu d'un simple veston de velours. Ce monsieur tournait le dos, on ne voyait de lui que sa main gauche, sur laquelle il s'appuyait, dans l'herbe." Unlike the men who chat amiably in the middle ground of Manet's picture – and who are seen in three-quarters view – the solitary spectator/voyeur described by Zola would seem to have closer counterparts in Cézanne's *Summer Day*, 1873–5, or even his *Modern Olympia*, 1871.

44. In an interview for *Le Gaulois* (13 March 1890), Zola looked back on *L'Oeuvre* and remarked that it was "peut-être le seul de mes romans qui ait trouvé un semblant de grâce devant la critique" (cited by Robert, La Terre *d'Emile Zola* p. 411, n18.)

45. The major source on *L'Oeuvre*'s impact on the Impressionist circle is Robert J. Niess, *Zola, Cézanne and Manet: A Study of* L'Oeuvre.

46. Cf. Zola, *L'Oeuvre*, chap. III.

47. See Ronnie Butler, *Zola*: La Terre, p. 7.

48. See T. J. Clark, *The Image of the People: Gustave Courbet and the 1848 Revolution*, p. 96.

49. Butler, *Zola*: La Terre, pp. 12, 16.

50. Zola, "Les Chutes," *L'Evénement*, 15 May 1866; reprinted in *Mes haines*.

51. For a discussion of the standard image of the French peasant c. 1850–87 and its presentation by Zola's predecessors – especially Michelet and the Abbé Roux – see Robert, La Terre *d'Emile Zola*, chap. VII. In his chapter on peasants, Roux wrote, "Je définirais le paysan un animal superstitieux."

52. In the midst of a devastating hailstorm, for instance, the family's austere but impious matriarch addresses the heavens in rage: "Sacré cochon, là-haut!" she rails. "Tu ne peux donc pas nous foutre la paix?" (*La Terre*, p. II, chap. 2).

53. Butler, *Zola*: La Terre, p. 11.

54. In pt. III, chap. 1 of *La Terre*, for instance, Zola describes the joy that Buteaux takes in the land inherited from his father:

> Un an se passa, et cette première année de possession fut pour Buteau une jouissance. A aucune époque, quand il s'était loué chez les autres, il n'avait fouillé la terre d'un labour si profond: elle était à lui, il voulait la pénétrer, la féconder jusqu'au ventre … En mars, il hersa ses blés, en avril, ses avoines, multipliant les soins, se donnant tout entier. Lorsque les pièces ne demandaient plus de travail, il y retournait pour les voir, en amoureux.

> Cf. *La Faute de l'Abbé Mouret*, wherein a priest declares of the locals: "Ils forniqueraient avec leurs pièces de terre, tant ils les aiment!" (pt. I, chap. 5).

55. Cited by Robert, La Terre *d'Emile Zola*, p. 159; "poème vivant de la terre."

56. Ibid.

> Je veux peindre … l'amour du paysan pour la terre, un amour immédiat, la possession du plus de terre possible, la passion d'en avoir beaucoup … On a dit que le paysan est l'animal farouche, meurtrier, au milieu de la terre bienfaisante et calme. Peindre cela en évitant de trop pousser au noir.

57. *L'Evénement*, 8 January 1887.

58. Brunetière wrote, "Est-ce la fin du Natural-isme?...Nous l'espérons du moins." *Revue des deux mondes,* 1 March 1887. Cited by Robert, La Terre *d'Emile Zola*, p. 413.

59. Victor Fournel, *Le Correspondant*, 10 September 1887; cited by Robert, La Terre *d'Emile Zola*, p. 446; "une monomanie de l'ordure," "obsession du bestial."

60. Emmanuel Arène, *La République française,* 19 September 1887; cited by Robert, La Terre *d'Emile Zola*, p. 447; "monomane de l'avilissement et de la basesse."

61. Alfred Capus, *Le Gaulois,* 15 September 1887; cited by Robert, La Terre *d'Emile Zola*, p. 445; "bien sale," "bien ennuyeux."

62. Butler points out that both Huysmans and Mallarmé praised *La Terre* for "its lyrical power, its narrative conviction, and its epic and mythical grandeur" (*Zola:* La Terre, p. 7).

63. *Le Livre,* 10 July 1887; cited by Robert, La Terre *d'Emile Zola,* p. 415; "*la Terre* procède directement du romantisme pur: c'est une représentation du vrai, vu par l'oeil grossissant d'un poète"; "le fantastique et le macabre du romantisme," "l'ordure et... l'hystérie."

64. In an article published in *Gil Blas* on 21 August, "Chez Zola: Réponse à une protestation," Ferdinand Xau quoted Zola as saying, "Je ne connais pas ces jeunes gens.... Ils ne font pas partie de mon entourage; ils ne sont pas donc mes amis. Enfin, s'ils sont mes disciples – et de disciples, je ne cherche point à en faire – c'est bien à mon insu."

65. La déception a été profonde et douloureuse. Non seulement l'observation est superficielle, les trucs démodés, la narration commune et dépourvue de caractéristiques, mais la note ordurière est exacerbée encore, descendue à des saletés si basses que, par instants, on se croirait devant un recueil de scatologie: le Maître est descendu au fond de l'immondice.

66. Montjoyeux, "Les Cinq," *Gil Blas,* 20 August 1887. "Si l'on pardonne à Zola, qui est un maître, ce que vous nommez justement la brutalité de son enseignement...je doute que le public littéraire vous excuse, vous ses élèves, d'avoir déjà la prétention de juger et condamner votre professeur."

67. Goncourt had publicly signaled his falling-out with Zola some years before; in the preface to his novel *Les Frères Zemganno* (1879), Goncourt denounced the sordid turn Naturalism had taken, a charge Zola answered with some pique in an article published by *Le Voltaire,* 6 May 1879. Alan Schom blames Goncourt's jealousy of Zola for this animosity and claims that Goncourt sought to alienate Daudet from Zola, even though the schism between the latter was not so great as Goncourt may have wished. Nonetheless, Schom acknowledges, Zola had isolated himself from his friends well before publication of *La Terre.* See Schom, *A Biography of Emile Zola,* p. 118.

68. See Harry Levin, *The Gates of Horn: A Story of Five French Realists,* p. 365; Sachs, *The Career of Alphonse Daudet: A Critical Study,* p. 141; Schom, *A Biography,* pp. 119–20.

69. Zola's loyal colleague Paul Alexis (using the pen name Trublot) dubbed them the "Cinq cornichons" in *Le Cri du peuple,* and that journal also published a verse by Jules Jouy: "Il était cinq petits enfants/Qui chassaient les gros éléphants" (cited by Robert, La Terre *d'Emile Zola*, p. 434).

70. Anatole France, "La Terre," *Le Temps,* 28 August 1887. "Jamais homme n'avait fait un pareil effort pour avilir l'humanité, insulter à toutes les images de la beauté et de l'amour, nier tout ce qui est bon et tout ce qui est bien."

71. Ferdinand Brunetière, "La Banqueroute du naturalisme," *Revue des Deux Mondes,* 1 September 1887, p. 214. "Jamais [Zola] n'avait substitué plus audacieusement à la réalité les visions obscènes ou grotesques de son imagination échauffée. Nulle conscience et nulle observation, nulle vérité."

72. Ibid. "Des images de débauche, des odeurs de sang et de musc mêlées à celles du vin ou de fumier, voilà, *La terre,* et violà, va-t-on dire, le dernier mot du naturalisme!"

73. Octave Mirbeau, "Le Paysan":

[Zola] a démesurément amplifié ce qu'on appelle les défauts, les vices du paysan; il a rapetissé sans justice ses sublimes qualités. Or c'est le contraire qui arrive dans la nature. Au milieu de la splendeur

des choses, les défauts du paysan, ses vices, ce qu'on appelle sa laideur, s'effacent, et il se montre dans tout la noblesse sévère, dans la grandeur divine de sa mission, la plus pure, la plus auguste qui ait été dévolue à l'homme. Mais il faut le voir comme l'ont vu les gothiques, le faut le comprendre et l'aimer comme le comprit et comme l'aima Millet, qui tout naturellement, sans chercher à le grandir, le *bloqua* en ses fusains, avec la forme plastique et la beauté sculpturale d'un marbre de Michel-Ange.

74. Millet's series *Les Travaux des champs* was initially made for *L'Illustration.* The ten prints (wood engravings by Jacques Adrien Lavieille) also were printed on a single sheet. Van Gogh owned a copy of the latter and eventually made a number of works based on the traditional labors depicted by Millet there; see Louis van Tilborgh and Philip Conisbee, "Les Travaux des champs."

75. See T. J. Clark, *The Absolute Bourgeois: Artists and Politics in France, 1848–1851,* pp. 94–5; 199, nn38, 39.

76. Clark notes that although "almost everyone ... recognized [*The Sower*'s] savagery," most critics also saw it as a "pastoral image, which altered but did not discard the pastoral tradition" (ibid., pp. 94–5). In answer to his own question, "Why did the savagery not annoy them more?" Clark argues that their response depended in part on the fact that "the critics saw the tradition more easily than its transformation. . . . The painter had done a new version of pastoral, but poetic and naive nonetheless. And this manoeuvre was easier for the critics because Millet still obeyed most of the rules of their aesthetic" (pp. 95–6).

77. Fostering the myth of the rural idyll, many writers of the middle to late nineteenth century asserted that country life and surroundings were conducive to contemplation, and ennobling. Among others, Clark cites Mme. Romieu, who writes in *Des Paysans et de l'agriculture au XIXe siècle* (Paris, 1865):

La contemplation involontaire de la nature, toujours solennelle et toujours grande, [communique] à l'homme des champs une gravité recueillie qui con-

traste avec la bruyante verve et l'allure aventureuse des ouvriers de nos chantiers. Le travailleur agricole n'a rien de cet esprit pétulant et hasardeux que l'atelier favorise." (*Image of the People,* p. 191, n106; see also pp. 152–3)

78. *Tartarin de Tarascon* is not mentioned in any of Van Gogh's pre-Paris references to Daudet, but in some of his first letters from Arles he wrote of it as a book previously read – presumably in Paris.

79. Van Gogh mentioned both *Germinie Lacerteux* and *La Fille Elisa* in a letter from Paris; he did not mention *Manette Salomon* and *Les Frères Zemganno* until he had moved to Arles, but referred to both then in a manner that suggests he had read them at some previous time. Since Van Gogh did not mention either of them before his Parisian sojourn, it seems most likely that he read them there.

80. Some uncontroversial extracts from the *Journal* had already been published under the title *Idées et sensations* in 1866 (i.e., during Jules's lifetime).

81. Robert Baldick writes that the *Journal* was "fiercely attacked, ostensibly because the critics were revolted by the authors' complacent egoism, but generally because they felt that they themselves were cited too much or too little, over-criticized or underpraised" (see Baldick, *The Goncourts,* pp. 65–6.)

82. Philippe Gille, *Le Figaro,* 9 March 1887. "Ce que frappe d'abord, c'est la tendre amitié de ces deux jumeaux de lettres, la parfaite harmonie de ce ménage littéraire. Leur journal intime nous montre qu'ils ne se sont pas aimés seulement pour écrire."

83. Other Goncourt novels of this ilk are *Soeur Philomène* (1861), *Renée Mauperin* (1864), *Mme. Gervaisais* (1869), *La Faustin* (1882), and *Chérie* (1884); *Manette Salomon* (1867), in addition to examining the Parisian art world, takes long, hard looks at its namesake character – and studies her impact on that world. The Goncourts also focused on female protagonists in their nonfiction accounts *Histoire de Marie-Antoinette* (1858), *Les Maîtresses de Louis XV* (1860), and *La Femme au dix-huitième siècle* (1862) and in their play *Henriette Maréchal* (1866).

84. Though the Goncourts' housemaid, Rose Malingre, was in their service for thirty years, they apparently knew nothing of her private life until after her death.

85. Il nous faut demander pardon au public de lui donner ce livre, et de l'avertir de ce qu'il y trouvera.

 Le public aime les romans faux: ce roman est un roman vrai.

 Il aime les livres qui font semblant d'aller dans le monde: ce livre vient de la rue....

 Pourquoi donc l'avons-nous écrit? Est-ce simplement pour choquer le public et scandaliser ses goûts?

 Non.

 Vivant au dix-neuvième siècle, dans un temps de suffrage universel, de démocratie, de libéralisme, nous nous sommes demandé si ce qu'on appelle "les basses classes" n'avait pas droit au Roman.

86. Goncourt himself later wrote: "I have given the complete formula of Naturalism in *Germinie Lacerteux* and the books that have followed it have been made exactly according to the method taught by this book" (cited by André Billy, *The Goncourt Brothers*, p. 137).

87. Zola's review appeared in *Le Salut public*, a journal to which he often contributed in the 1860s.

88. In his essay on *Germinie Lacerteux*, Zola writes: "Mon goût, si l'on veut, est dépravé. J'aime les ragoûts littéraires fortement épicés, les oeuvres de décadence où une sorte de sensibilité maladive remplace la santé plantureuse des époques classiques. Je suis de mon âge."

89. Zola's assimilation of the Goncourts' mode, however, was neither immediate nor complete. The stark realism of *Germinie Lacerteux* stands in strong contrast to the Romantically excessive morbidity and haunted hallucinatory quality that marks Zola's *Thérèse Racquin* (1869) – which was published two years after *Germinie Lacerteux* – and Zola never completely relinquished the fevered extravagance encountered there.

90. See, e.g., Zola's essay, *Les Romanciers naturalistes*.

91. Edmond and Jules de Goncourt, *Germinie Lacerteux*, chap. V; "blancheur à la fois malade et angélique d'une chair qui ne vit pas."

92. Baldick, *The Goncourts*, pp. 56–7.

93. Gauguin, *Avant et après*, p. 44; "sourit au peintre, désirant sa clientèle. La belle main blanche sortit.... Van Gogh était un liseur, il pensa à la fille Elisa et sa pièce de 5 francs devint la propriété de la malheureuse. Rapidement, honteux de sa charité, il s'enfuit l'estomac creux."

94. Theodore Robert Bowie, who lists thirty fictionalizations of this genre (including novels and short stories) in *The Painter in French Fiction: A Critical Essay*, calls *Manette Salomon* "the classic novel of the painter's life and the most important work of its kind in French literature" (p. 58).

95. For discussions of the similarities between the two novels and their repercussions, see ibid., pp. 5–6; Niess, *Zola, Cézanne and Manet*, pp. 4–5; and Teddy Brunius, *Mutual Aid in the Arts from the Second Empire to Fin de siècle*, pp. 146–7.

96. For a discussion of the character and manifestations of the Goncourts' "shared hostility toward women," see Jerrold Seigel, *Bohemian Paris: Culture, Politics, and the Boundaries of Bourgeois Life, 1830–1930*, pp. 175–6.

97. The Goncourts' convictions about the dangers womanizing posed to artists and writers were commonplace among their peers; not only Zola, but – according to Roger L. Williams – Daudet, Maupassant, and Flaubert shared them. On the subject of erotic adventures, for instance, Flaubert warned Maupassant: "Take care! Everything depends upon one's goal. A man who opts to be an artist no longer has the right to live like other men!" See Williams, *The Horror of Life*, pp. 232, 283.

98. Most of them bear loose comparison, however, to well-known artists of the era; see Bowie, *The Painter in French Fiction*, app. I, pp. 51–4.

99. Van Gogh also referred to *Manette Salomon* in passing in LT513 and included it in a portrait of Dr. Paul Gachet (see Plate 16).

100. The passage to which Van Gogh referred is

a dialogue in which Chassagnol – an out-spoken painter of strong convictions – is asked, "Alors, qu'est ce qui nous restera comme grands peintres?" He replies, "les paysagistes, les paysagistes" (*Manette Salomon*, chap. XXXV). Though Van Gogh conceded the truth of this prediction in LT604, he was of the opinion that things were about to change and himself fore-cast that the enduring paintings of the last years of the nineteenth century would be por-traits.

101. In his notes for the novel, Goncourt wrote, "L'aîné, la force; le jeune, la grâce" (cited by Billy, *Les Frères Goncourt*, p. 290).

102. Cited in ibid., p. 290; "Il y aurait dans les deux frères une religion du muscle qui les ferait s'abstenir de la femme et de tout ce qui diminue la force."

103. See Williams, *The Horror of Life*, pp. 97–105.

104. Williams writes, "We must suppose that Ed-mond [knew] the facts of Jules's venereal history; but in 1870 he could have had no knowledge of the tertiary stage of syphilis, no reason to associate an infection in 1850 with the dreadful destruction of Jules's brain in 1870" (ibid., p. 105). Williams notes that the first substantive study of the three-stage progress of the disease (undertaken by Alfred Fournier) was not completed until 1894, and that even thirty years after Jules's death, physicians debated its cause (see pp. 105–8).

105. See ibid., pp. 104–5, for the remarks of Goncourt, Zola, and Théophile Gautier on this subject.

106. Maupassant most often contributed to *Le Gaulois* and *Gil Blas*; his pieces also ap-peared in *Le Figaro*, *La Nouvelle Revue*, and *Les Lettres et les arts*.

107. When the Van Goghs' sister, Wilhelmina, stayed with Theo in Paris in the summer of 1888, she reported reading a volume of Maupassant's short stories, a volume that Vincent already had read (W8). This suggests that the book was part of Theo's library in the apartment on the rue Le-pic.

108. Each of these volumes contains several short stories; their titles derive from the lead story in each. *La Maison Tellier, Monsieur Parent,*

and *Miss Harriett* are all specifically recalled by Van Gogh in letters from Arles (LT476, LT555, W8), and in LT506 he makes oblique reference to a short story called "La Rouille," which he surely knew through its inclusion in the volume headed by "Made-moiselle Fifi" ("La Rouille" was originally published in *Gil Blas* in September 1882 – i.e., while Van Gogh was living at The Ha-gue and just beginning to read Zola's fiction).

109. See Howard Sutton, *The Life and Work of Jean Richepin*, pp. 238–40.

110. See Paul Fort and Louis Mandin, *Histoire de la poésie française depuis 1850*. The au-thors write of Richepin as "une romantique de l'école d'Hugo," and note: "Son natu-ralisme est fortement bariolé d'imagination, de littérature" (pp. 54, 55).

111. Louis Desprez, for instance, wrote of Richepin's work: "C'est le coup de pisto-let romantique encore, et non la simplicité sévère et froid de l'écrivain naturali-ste" (*L'Evolution naturaliste*, p. 283; cited by Sutton, *Life and Work*, p. 239).

112. In LT429, written in 1885, Van Gogh re-marked: "Romance and romanticism are of our time. . . . Fortunately realism and natu-ralism are not free from it. . . . Naturalism and realism . . . are still connected with romanticism."

113. In describing Tombre's dependence on al-cohol, Richepin writes of his "théorie de son ivrognerie, qui n'était pas un vice, soutenait-il, mais bien une méthode de travail" (*Braves gens*, chap. X).

114. Sutton compares *Braves gens* to *Les Frères Zemganno* and finds the former "superior in vividness and pathos" (p. 258).

115. Later, recovering from his mental collapse at Arles, Van Gogh recalled that often while painting "I kept myself going on coffee and alcohol. I admit all that," he wrote, "but all the same it is true that to attain the high yellow note that I attained last summer [1888], I really had to be pretty well keyed up" (LT581).

116. *En ménage* is the only novel by Huysmans that Van Gogh mentions in his letters, and when he referred to Huysmans as a Natu-ralist in the summer of 1887 (see W1), it probably was on the basis of this book,

which seems to have formed his first – and lasting – impression of the author.

117. Huysmans, *En ménage*, chap. V; "épris, tous les deux, de naturalisme et de modernité, tellement frottés l'un à l'autre, qu'ils avaient un genre d'esprit semblable, une vision mélancolique de la vie."

118. Ibid., chap. II; "Tu travailleras mieux maintenant que tu es libre."

119. Ibid., chap. XVI; "Au fond, le concubinage et le mariage se valent puisqu'ils nous ont …débarrassés des préoccupations artistiques et des tristesses charnelles."

120. Ibid.

> – Alors, les tableaux?
> Le peintre se frotta la barbe de ses longs doigts.
> – Les tableaux, peuh, dit-il, c'est quelquefois bon de songer à ceux qu'on ne fera jamais, au lit, le soir, quand on ne dort pas!

121. Bernard, "Vincent van Gogh," in Welsh-Ovcharov, *Van Gogh in Perspective*, p. 38.

122. All the titled books in Van Gogh's Parisian still lifes are by authors he termed Naturalist; they include the Goncourts' *Germinie Lacerteux*, Edmond de Goncourt's *La Fille Elisa*, Maupassant's *Bel-Ami*, Richepin's *Braves gens*, and Zola's *Au Bonheur des Dames*.

123. A. M. Hammacher, "Van Gogh's Relationship with Signac," p. 93. Hammacher argues that Van Gogh's book pictures were inspired by similar still lifes made by Signac and discusses the volumes Signac employs as mainly decorative (e.g., "a pleasing element in the disposition of objects on the surface of a table" [p. 92]). It is my belief that Van Gogh (and perhaps Signac as well) used the motif of the modern novel in a more purposeful way than Hammacher allows.

124. Jan Hulsker, *The Complete Van Gogh: Paintings, Drawings, Sketches*, p. 272.

125. Nineteenth-century readers would have recognized the trademark yellow bindings of the Charpentier publishing house, which Huysmans once described as "les uniformes jaunes de l'éditeur Charpentier" (*En ménage*, chap. V) and which Henry James immortalized in *The Ambassadors* as "lemon-colored volumes, fresh as fruit on the tree." (James used the yellow books as emblems of his protagonist's introduction to contemporary French mores [see *The Ambassadors*, bk. II, chap. 2].) Recalling Van Gogh's stay in Auvers-sur-Oise in 1890, Paul Gachet *fils* noted the artist's particular fondness for yellow bindings (see Paul Gachet, *Souvenirs de Cézanne et de Van Gogh à Auvers, 1875–1890*).

126. Indeed, when *La Fille Elisa* was published, some younger critics referred to Goncourt as a disciple of Zola, much to Goncourt's chagrin. See Baldick, *The Goncourts*, pp. 56–7.

127. The designation "roman parisien" clearly appealed to Van Gogh; in a letter to his sister (W3), he used it (in plural form) to refer to his collection of modern novels, and in the same vein he applied it as a title to at least two of his paintings with books (Plates 2 and 7). Though no hard evidence exists, it seems likely that Richepin's subtitle planted the phrase in Van Gogh's mind.

128. I mean to compare Tombre and Elisa, both of whom are daunted – and eventually driven mad – by the expectations of their respective patrons.

129. Other examples are *Still Life with Almond Branch and Book* (1888; Fig. 46), *Oleanders* (1888; Plate 9), and *Still Life on a Drawing Board* (1889; Fig. 51). Cut flowers (which seem to me to lack the branches' and bulbs' connotations of ongoing life) adjoin books in *Romans parisiens* (1887; Plate 7), *Still Life with Plaster Cast* (1887–8; Plate 8), and *Portrait of Dr. Gachet* (1890; Plate 16).

130. After writing at some length on the topic of germination, Van Gogh in W1 turned to books that "shed light in the darkness," volumes he hoped would "remain the light of the world."

131. The authors he classed as Naturalists in W1 (written in the summer of 1887) include Zola, Daudet, the Goncourts, Maupassant, Huysmans, Richepin, and Flaubert.

132. Colin Bailey discusses the book in Renoir's portrait as an allusion to the "energetic literary milieu in which [the sitters'] notorious father moved"; see Bailey's entry in Philadelphia Museum of Art, *Masterpieces of*

Impressionism and Post-Impressionism: The Annenberg Collection, p. 45.

133. Hammacher, "Van Gogh's Relationship," pp. 91–3.

134. Pictures of grouped books constituted a subset of *vanitas* still lifes; they also were common to the trompe l'oeil tradition from the Renaissance forward.

135. In Signac's *Still Life with Maupassant's* [Au] *Soleil*, fruit and cut flowers adjoin the book (a collection of travel reminiscences), which is bound in blue paper. A larger collection of objects fills his *Still Life with Violets* (private collection), which features an untitled paperback. There, the book seems an unlikely companion to a jug and cup that suggest a kitchen still life, and an equally unusual partner to the fan, nosegay, and powder puff (seeming refugees from a woman's dressing table) that also are included. As a group, these objects make little narrative sense, and it would seem that Signac's intent was to explore the disparate forms, textures, and colors provided by the individual components of this random-looking tableau.

136. Huysmans, *En ménage*, chap. XV; "Il demandait à des livres l'apaisement de ses ennuis."

137. La Vallière and Janséniste are two types of leather binding, well known to nineteenth-century bibliophiles. "La Vallière" indicates a light brown binding (of a hue the French call *feuille-morte*) and may have derived from the name of an eighteenth-century collector, the duc de La Vallière. "Janséniste" designates an austere binding without ornamentation, which carries only the book's title and the name of its author; the name refers to the Jansenist sect. See Emile Littré, *Dictionnaire de la langue française;* and *Grand Larousse de la langue française.*

138. une large bibliothèque où, rangée en bataille, une armée de bradels, jaune canari et sang de boeuf, pétardaient, éteignant avec leurs soleils d'artifice toutes les pièces tranquilles: les tristes et discrets La Vallière, les sévères Jansénistes, sans dentelles ni flaflas d'or, les cartonnages ordinaires bons enfants et un peu canailles, pincés dans leur blouse de toile bleue ou grise, les reliures de chagrin aux mines de bourgeoises et de cuistres; à gauche: d'une autre bibliothèque plus petite ... deux files de volumes marchant en tumulte, battant la générale, les uniformes jaunes de l'éditeur Charpentier, les tuniques rouges de la légion étrangère d'Hachette.

139. The iconography of this painting is explored by Lövgren, *Genesis*, p. 132. Though I take exception to certain of his premises (most notably to his suggestion that the picture's two novels are more similar than not), my own reading is informed by his.

140. Guy de Maupassant, "Sur une Venus," *Gil Blas*, 12 January 1886. (Maupassant later incoporated this essay into the text of "La vie errante," 1890.)

Elle n'a point de tête, un bras lui manque; mais jamais la forme humaine ne m'est apparue plus admirable et plus troublante.

Ce n'est point la femme poétisée, la femme idéalisée, la femme divine ou majestueuse comme la Vénus de Milo, c'est la femme, telle qu'elle est, telle qu'on l'aime, telle qu'on la désire, telle qu'on la veut étreindre.

Elle est grasse, avec la poitrine forte, la hanche puissante et la jambe un peu lourde, c'est une Vénus charnelle, qu'on rêve couchée, en la voyant debout.

...Une oeuvre d'art n'est supérieure que si elle est en même temps un symbole et l'expression exacte d'une réalité.

La Vénus de Syracuse est une femme, et c'est en même temps le symbole de la chair.

...Elle n'a pas de tête!

Qu'importe, le symbole en est devenu plus complet. C'est un corps de femme, rien qu'un corps de femme qui exprime toute la poésie réelle de la caresse.

141. *L'Oeuvre* appeared in regular installments in *Gil Blas* from 23 December 1885 to 27 March 1887.

142. *The Complete Letters of Vincent Van Gogh*, edited by Johanna van Gogh-Bonger, vol. II, p. 508.

143. This image of the cast – traced on the verso of a correctly oriented view – is reversed.

144. A contemporaneous passage in the same

vein can be found in *En ménage;* Huysmans's fictional painter Cyprien is also drawn to "modern" Venuses in the Realist mode, whom he prefers to their unnatural-looking classical antecedents. Noting "des générations entières d'artistes [qui] vont acheter des réductions de la Vénus de Médicis, une béguele qui a une tête d'épingle sur un torse de lutteuse de foire!" Cyprien declares, "La Vénus que j'admire, moi, la Vénus que j'adore à genoux comme le type de la beauté moderne, c'est la fille qui batifole dans la rue, l'ouvrière en manteaux et en robes, la modiste, au teint mat, aux yeux polissons, pleins de lueurs nacrées, le trottin, le petit trognon pâle, au nez un peu canaille, dont les seins branlent sur des hanches qui bougent!" (*En ménage,* chap. V).

145. Evidence of Van Gogh's image-gathering urban rambles exists in drawings like F1380–1386.

146. Welsh-Ovcharov, *Van Gogh: Paris Period,* p. 144.

147. Welsh-Ovcharov has done substantial work on such linkages; see especially *Van Gogh: Paris Period,* app. V.

148. Dr. V. W. van Gogh, *Vincent in Paris,* p. 145.

149. Nathan Kranowski, *Paris dans les romans d'Emile Zola,* p. 49.

150. *Complete Letters,* vol. III, p. 529.

151. Welsh-Ovcharov (*Van Gogh: Paris Period,* p. 145) notes that visual antecedents for the sort of panoramic view Van Gogh made at Paris exist in the work of Antoine Vollon as well as that of Daubigny and reproduces a print by Vollon that Van Gogh owned. The Vollon, however, is done from a lower vantage point (on the quai of the Seine) and is not so broad in scope. Van Gogh's specific reliance on any one panoramic prototype is doubtful; Evert van Uitert, for instance, cites other precedents in seventeenth-century Dutch art, the *vedute* tradition of the eighteenth century, and nineteenth-century photographs as well as paintings, including Mesdag's panorama of The Hague, which Van Gogh knew well (see Evert van Uitert and M. Hoyle [eds.], *The Rijksmuseum Vincent van Gogh,* entry 29, p. 152).

152. T. J. Clark cites Hugo's passage in connection with one of Van Gogh's paintings of the *banlieue,* suggesting that it "may have left...traces in Van Gogh's elaborate, bookish mind"; see *The Painting of Modern Life: Paris in the Art of Manet and His Followers,* p. 26.

153. Raffaëlli labeled his images of the area "Caractères de la banlieue" when he exhibited them in 1884. Van Uitert believes Van Gogh probably had seen a catalog of that show (*The Rijksmuseum Vincent Van Gogh,* entry 37, p. 168).

154. Daudet, *Fromont jeune et Risler aîné,* pt. IV, chap. 6. "Les suicides ne sont pas rares à Paris, surtout dans ces parages....Pas un jour ne se passe sans qu'on relève un cadavre sur cette longue ligne des fortifications, comme sur le rivage d'une mer dangereuse."

155. Huysmans, *En ménage,* chap. V; "avouait d'exultantes allégresses, alors qu'assis sur le talus des remparts"; "prenait pour lui une inquiétante signification de souffrances et de détresses."

156. Ibid.

> Dans cette campagne dont l'épiderme meurtri se bossèle comme de hideuses croûtes, dans ces routes écorchées où des traînées de plâtre semblent la farine détachée d'une peau malade, il voyait une plaintive accordance avec les douleurs du malheureux, rentrant de sa fabrique, éreinté, suant, moulu, trébuchant sur les gravats, glissant dans les ornières, traînant les pieds, étranglé par des quintes de toux, courbé sous le cinglement de la pluie, sous le fouet du vent.

In his nonfictional collection of prose passages, *Croquis parisiens,* Huysmans seems to rehearse this image of the *banlieue;* there, he writes:

> Du haut des remparts, l'on aperçoit la merveilleuse et terrible vue des plaines qui se couchent, harassées, aux pieds de la ville....
>
> Vers la brune, par ces temps où les nuées charbonneuses se roulent sur le jour mourant, le paysage s'illimite et s'attriste encore; les usines ne montrent plus que des contours indécis, des masses d'encre bues par un ciel livide; les enfants et les femmes sont rentrés, la plaine semble plus grande et, seul, dans le chemin

poudreux, le mendiant, le mendigo, comme l'appelle la mouche, retourne au gîte, suant, éreinté, fourbu, gravissant péniblement la côte, suçant son brûle-gueule pour longtemps vide, suivi de chiens, d'invraisemblables chiens superbes de bâtardises multipliées, de tristes chiens accoutumés comme leur maître à toutes les famines et à toutes les puces.

Et c'est alors surtout que la charme dolent des banlieues opère; c'est alors surtout que la beauté toute puissante de la nature resplendit, car le site est en parfait accord avec la profonde détresse des familles qui le peuplent. ("Vue des remparts du Nord-Paris")

157. Huysmans, *En ménage*, chap. V; "la maladrerie de la nature"; "les incurables maux engendrés par la boisson et par la famine."

158. Zola, *L'Assommoir*, chap. VIII; "entre une scierie mécanique et une manufacture de boutons, une bande de prairie restée verte."

159. En face d'eux, la butte Montmartre étageait ses rangées de hautes maisons jaunes et grises, dans des touffes de maigre verdure; et, quand ils renversaient la tête davantage, ils apercevaient le large ciel d'une pureté ardente sur la ville, traversé au nord par un vol de petits nuages blancs. Mais la vive lumière les éblouissait, ils regardaient au ras de l'horizon plat les lointains crayeux des faubourgs, ils suivaient surtout la respiration du mince tuyau de la scierie mécanique, qui soufflait des jets de vapeur. Ces gros soupirs semblaient soulager leur poitrine oppressée.

...Ils se perdaient au loin, sur la pente de Montmartre blafard, au milieu de la haute futaie des cheminées d'usine rayant l'horizon, dans cette banlieue plâtreuse et désolée, où les bosquets verts des cabarets borgnes les touchaient jusqu'aux larmes.

160. Alors commençait ce qui vient où Paris finit, ce qui pousse où l'herbe ne pousse pas, un de ces paysages d'aridité que les grandes villes créent autour d'elles, cette première zone de banlieue *intra muros* où la nature est tarie, la terre usée, la campagne semée d'écailles d'huîtres....

...Du monde allait et venait toujours. La route vivait et amusait l'oeil.

...Tous allaient tranquillement, bienheureusement, d'un pas qui voulait s'attarder, avec le dandinement allègre et la paresse heureuse de la promenade. Personne ne se pressait, et sur la ligne toute plate de l'horizon, traversée de temps en temps par la fumée blanche d'un train de chemin de fer, les groupes de promeneurs faisaient des taches noires, presque immobiles, au loin.

161. In a discussion of this landscape, Clark calls it a "working landscape, with anonymous citizens mostly moving fast, going about their business, not stopping or sauntering, not sitting on the grass. There are no dreamers here." He sees in it a forecast of imminent industrialization – the demise of windmills and takeover by factories – and notes, "Things are seeping into one another, and the landscape is taking on a single, indiscriminate shape" (*The Painting of Modern Life*, p. 29).

162. Bernard, "Vincent van Gogh," in Welsh-Ovcharov, *Van Gogh in Perspective*, p. 38.

163. Welsh-Ovcharov (*Van Gogh: Paris Period*) includes a passage from *Germinie Lacerteux*, describing the fortifications at the edge of Paris, in her app. V (p. 244).

164. Aux fortifications...[Germinie] courait s'asseoir avec Jupillon sur le talus. A côté d'elle étaient des familles en tas, des ouvriers couchés à plat sur le ventre, de petits rentiers regardant les horizons avec une lunette d'approche, des philosophes de misère, arc-boutés des deux mains sur leurs genoux, l'habit gras de vieillesse, le chapeau noir aussi roux que leur barbe rousse...Devant les yeux, elle avait une foule bariolée, des blouses blanches, des tabliers bleus d'enfants qui couraient... Puis au delà, dans une vapeur, dans une brume bleuâtre, une ligne de têtes d'arbres dessinait une route.

165. Welsh-Ovcharov, *Van Gogh: Paris Period*, p. 142–3.

166. C'était un refuge délicieux, un asile en pleine foule, Paris grondant alentour, sur les quais, sur les ponts, pendant qu'ils goûtaient au bord de l'eau la joie d'être seuls, ignorés de tous. Dès lors, cette

berge fut leur coin de campagne, le pays de plein air où ils profitaient des heures de soleil.

CHAPTER 5. A BEL-AMI OF THE MIDI
IN THE LAND OF TARTARIN

1. Le gris remplit le ciel, bas et plat, sans une lueur, sans une trouée de bleu. Une tristesse grise flotte dans l'air.... Une froide lumière, qu'on dirait filtrée à travers de vieux rideaux de tulle, met sa clarté jaune et sale sur les choses et les formes indécises. Les couleurs s'endorment comme dans l'ombre du passé et le voile du fané.

2. That is, "ces pages pareilles à des palettes d'ivoire chargées des couleurs de l'Orient."

3. Un jour de pays féerique, un jour sans ombre et qui n'était que lumière, se levait pour lui de ces albums.... Il se perdait dans cet azur où se noyaient les floraisons roses des arbres, dans cet émail bleu sertissant les fleurs de neige des pêchers et des amandiers, dans ces grands couchers de soleil cramoisis...L'hiver, le gris du jour, le pauvre ciel frissonnant de Paris, il les fuyait et les oubliait au bord de ces mers limpides comme le ciel.... Il les oubliait dans ces champs aux rochers de lapis, dans ce verdoiement de plantes aux pieds mouillés, près de ces bambous, de ces haies efflorescentes qui font un mur avec de grands bouquets.

4. See Mark Roskill, Van Gogh, Gauguin and the Impressionist Circle, chap. II.

5. Van Gogh never mentioned the japoniste chapter of Manette Salomon in his letters and never cited the novel in connection with his desire to explore the Midi.

6. The Van Gogh brothers were admirers of Monticelli (1824–86) and avidly collected his work. Van Gogh believed Monticelli's paint surfaces and rich palette were indebted both to the example of Delacroix and to the bold visual effects of sunstruck Provence (LT471, LT477a, LT508). See Aaron Sheon, Monticelli, His Contemporaries, His Influence, chap. VII.

7. Almost as soon as he arrived in Arles (March 1888), Van Gogh told Emile Bernard:

I will begin by telling you that this country seems to me as beautiful as Japan as far as the limpidity of the atmosphere and the gay color effects are concerned. Water forms patches of a beautiful emerald or a rich blue in the landscape, just as we see it in the crépons [i.e., a type of Japanese print, which is crinkly]. The sunsets have a pale orange color which makes the fields appear blue. The sun a splendid yellow. And all this though I have not seen the country yet in its usual summer splendor. (B2)

For extensive discussion of this japoniste aspect of Van Gogh's Arlesian experience, see Tsukasa Kōdera, "Japan as a Primitivistic Utopia: Van Gogh's Japonisme Portraits."

8. Paul Gauguin, Avant et après, pp. 15–17.

9. Gustave Coquiot, Vincent van Gogh, p. 194.

10. Zola's descriptions of the cathedral's façade, transformed and colorized by changes in the light that falls on it, are notable antecedents to Monet's Rouen Cathedral series of 1892–4. In one passage, for instance, Zola writes, "Le soleil enfin la faisait vivre, du jeu mouvant de la lumière, depuis le matin, qui la rajeunissait d'une gaieté blonde, jusqu'au soir, qui, sous les ombres lentement allongées, la noyait d'inconnu" (Le Rêve, chap. IV).

11. Van Gogh seems to refer to the following passage from Le Rêve (chap. VI), in which Zola describes his heroine's embroidered masterwork:

Devant elle, était le dessin qu'il avait fait, mais lavé de teintes d'aquarelle, rehaussé d'or, d'une douceur de ton d'ancienne miniature, pâlie dans un livre d'heures. Et elle copiait cette image, avec une patience et une adresse d'artiste peignant à la loupe.... Elle suivait ce dessin, cousait les fils d'or de points de soie en travers, qu'elle assortissait aux nuances du modèle. Dans les parties d'ombre, la soie cachait complètement l'or; dans les demi-teintes, les points s'espaçaient de plus en plus; et les lumières étaient faites de l'or seul, laissé à découvert. C'était l'or nué, le fond d'or que l'aiguille nuan-

çait de soie, un tableau aux couleurs fondues, comme chauffées dessous par une gloire, d'un éclat mystique. . . .

Elle manoeuvrait dix aiguillées d'or à passer, de tons différents, depuis l'or rouge sombre des brasiers qui meurent, jusqu'à l'or jaune pâle des forêts d'automne.

12. Though he did not read the Goncourts' work at Arles, Van Gogh continued to mention the brothers and their oeuvre, particularly Edmond's *Les Frères Zemganno.* That novel was often on his mind in the summer of 1888, as he pushed himself (physically) and his brother (financially) harder than ever before in an effort to produce pictures. Van Gogh viewed his pictures as a fraternal collaboration in the mode of the Zemgannos' stunts and at one point assured Theo, "You will have created them as much as I. . . . We are making them together" (LT538). In another letter, he asked if Theo had read *Les Frères Zemganno,* telling him, "If you know it, you will know that I am more afraid than I can say lest the effort to get money exhaust you too much" (LT550). Shortly thereafter, he urged Theo to read the book, though he noted, "After reading it my only fear is of asking you for too much money" (LT551).

13. According to Murray Sachs (*The Career of Alphonse Daudet: A Critical Study,* p. 136), his publisher made Daudet an irrefusable offer to revive his popular hero.

14. Daudet was a longtime foe of the French Academy (see ibid., pp. 135–6, 143–7) and had already written ironic appraisals of its doings (see, e.g., chap. IX of *Les Rois en exil,* which satirizes an awards session there). Sachs calls *L'Immortel,* Daudet's book-length treatment of the subject, "a harsh and bitter novel, the most unrelievedly grim portrait of Parisian life he ever composed" (p. 143).

15. See John Butt's introduction to *Candide,* pp. 8–9.

16. *Pierre et Jean* was published serially while Van Gogh was still in Paris, but he clearly did not read it until he settled at Arles (LT470).

17. Maupassant writes that the well-read contemporary critic who "ose encore écrire:

'Ceci est un roman et cela n'en est pas un,' me paraît doué d'une perspicacité qui ressemble fort à de l'incompétence."

18. Chacun de nous se fait . . . simplement une illusion du monde . . . suivant sa nature. . . . Les grands artistes sont ceux qui imposent à l'humanité leur illusion particulière.

19. Tous les écrivains, Victor Hugo comme M. Zola, ont réclamé avec persistance le droit absolu, droit indiscutable, de composer, c'est-à-dire d'imaginer ou d'observer, suivant leur conception personnelle de l'art. Le talent provient de l'originalité, qui est une manière spéciale de penser, de voir, de comprendre et de juger.

20. "Amusez-moi," "Faites-moi rêver," "Faites-moi pleurer."

21. Faites-moi quelque chose de beau, dans la forme qui vous conviendra le mieux, suivant votre tempérament.

22. Le réaliste, s'il est un artiste, cherchera, non pas à nous montrer la photographie banale de la vie, mais à nous en donner la vision plus complète, plus saisissante, plus probante que la réalité même.

23. Van Gogh here gives a characteristically loose rendering of an author's thought. Recounting Flaubert's remarks on his early work, Maupassant writes that his mentor told him, "Je ne sais pas si vous aurez du talent. Ce que vous m'avez apporté prouve une certaine intelligence, mais n'oubliez point ceci, jeune homme, que le talent – suivant le mot de Buffon [a French naturalist, 1707–88] – n'est qu'une longue patience. Travaillez" (*Pierre et Jean,* preface).

24. Van Gogh wrote empathically of Richepin's description: "How one feels their weariness, and without being soldiers, haven't we all marched like that sometime?" (LT555).

25. Alexis dedicated *La Fin de Lucie Pellegrin* to Zola, "pour cet avenir que je rêve toujours à vos côtes, et dans le triomphe certain de notre combat."

26. Oddly, the thing Loti seems to have liked most about foreign locales was their ability to revive indelible but forgotten impressions and sensations of his childhood years. See Alec G. Hargreaves, *The Colonial Experience in French Fiction: A Study of Pierre*

Loti, Ernest Psichari and Pierre Mille, p. 29.

27. This synopsis is provided by Hargreaves (in ibid., p. 34), who notes that the hero's departure is often followed by his death or that of his erstwhile mistress; this is not the case, however, in *Mme. Chrysanthème*.

28. Ibid., pp. 35–6. "Dans ce Japon," Loti laments, "les choses n'arrivent jamais qu'à un semblant de grandeur" (*Mme. Chrysanthème*, chap. XL). He admits that in describing the country, "J'abuse vraiment de l'adjectif *petit*, je m'en aperçois bien; mais comment faire? – En décrivant les choses de ce pays-ci, on est tenté de l'employer dix fois par ligne. Petit, mièvre, mignard – le Japon physique et moral tient tout entier dans ces trois mots-là" (chap. XLIV). Finally, as he prepares to leave the country, Loti confides, "Je cherche à m'impressionner, à m'émotionner sur ce départ, et j'y réussis mal. A ce Japon, comme aux petits bonshommes et bonnes femmes qui l'habitent, il manque décidément je ne sais quoi d'essentiel: on s'en amuse en passant, mais on ne s'y attache pas" (chap. LI).

29. Loti complains, for instance, that "ce type de femme que les Japonais peignent de préférence sur leurs potiches est presque exceptionnel dans leur pays. On ne trouve guère que dans la classe noble ces personnes à grand visage pâle peint en rose tendre, ayant un long cou bête et un air de cigogne" (*Mme. Chrysanthème*, chap. VII). Elsewhere, he reveals, "Une Japonaise, dépourvue de sa longue robe et de sa large ceinture aux coques apprêtées, n'est plus qu'un être minuscule et jaune, aux jambes torses, à la gorge grêle et piriforme; n'a plus rien de son petit charme artificiel, qui s'en est allé complètement avec le costume" (chap. XXXVIII). As for the scenery, he laments, "Tout cela que j'avais vu peint sur les fonds bien bleus ou bien roses des écrans et des potiches, m'apparaissant dans la réalité sous un ciel noir, en parapluie, en sabots, piteux et troussé" (chap. III).

30. As Van Gogh told Theo, *Mme. Chrysanthème* "gave me the impression that the real Japanese have *nothing on their walls*, [in] that description of the cloister or pagoda where there was *nothing* (the drawings and curiosities all being hidden in the drawers)"

(LT509; his emphasis). In a subsequent letter, he reiterated, "Loti's book *Mme. Chrysanthème* taught me this much: the rooms there are bare, without decorations or ornaments" (LT511). Indeed, in the book's most sustained passage on the subject of Japanese interiors, Loti reports on a Buddhist monastery:

> Toute la construction intérieure est du même bois couleur beurre frais, menuisé avec une extrême précision, sans le moindre ornement, sans la moindre sculpture; tout semble neuf et vierge.... C'est le comble de la simplicité cherchée, de l'élégance faite avec du néant, de la propreté immaculée et invraisemblable.
>
> Et tandis qu'on est là... dans ces enfilades de salles désertes, on se dit qu'il y a beaucoup trop de bibelots chez nous en France; on prend en grippe soudaine la profusion, l'encombrement. (chap. XL)

Van Gogh imagined such unadorned spaces to be well suited to viewing art and advised Theo to examine his most recent work "in some café... [with] nothing else in the way, or else outside," noting that at Arles "I work in a bare room, four white walls and red paved floor" (LT509).

31. This is a reference to a Provençal colloquialism, "*fen dé brut*," which Van Gogh encountered in *Tartarin sur les Alpes*. There Daudet writes of "ce terrible cri de guerre en patois tarasconnais: 'Fen dé brut!... faisons du bruit'" (chap. VII). "*Fen dé brut*" became an artistic war cry of sorts for Van Gogh and a phrase he also associated with the brash palette of Monticelli (W8; he erroneously transcribed it "*Fên de brût*").

32. Gauguin, *Avant et après*, p. 17.

33. Ibid., p. 15.

34. Daudet, *Tartarin de Tarascon*, pt. I, chap. 7; "ce diable de pays où le soleil transfigure tout, et fait tout plus grand que nature." Elsewhere, Daudet writes of the "jolies plaines d'oliviers et de vignes" (*Tartarin de Tarascon*, pt. III, chap. 1), "le bleu vibrant et limpide du ciel provençal" (*Tartarin sur les Alpes*, chap. II), and, more particularly, "le soleil tarasconnais et ses prodigieux effets de mirage, si féconds en surprises, en

inventions, en cocasseries délirantes" (*Tartarin sur les Alpes*, chap. II).

35. Daudet, *Tartarin sur les Alpes*, chap. II; "cette chaîne de montagnettes parfumées de thym et de lavande, pas bien méchantes ni très hautes ... qui font un horizon de vagues bleues aux routes provençales."

36. More than a year later, as he painted the hills around St.-Rémy in the fall of 1889, Van Gogh was reminded once more of Daudet's verbal descriptions of the area. As he prepared to send Theo a group of new paintings, the artist remarked, "You'll become better acquainted with good Tartarin's 'Alps' than you are now. Apart from the canvas of the *Mountains* [F622?], you have not seen them yet except in the background of the canvases.... I could certainly do a whole series of these Alps, for having seen them for a long time now, I am more up to it" (LT610).

37. Daudet described his compatriots as "ce joyeux petit peuple, pas plus gros qu'un pois chiche, qui reflète et résume les instincts de tout le Midi français, vivant, remuant, bavard, exagéré, comique, impressionnable" (*Tartarin sur les Alpes*, chap. II).

38. Zola's direct experience of Provençal farms and laborers seems to have been offset by his maternal grandparents' accounts of their early lives in La Beauce. As a young man in Paris, Zola often retreated to the rural region near Bennecourt, and later – when the popular success of *L'Assommoir* (1877) enabled him to buy a country house – he spent several months of each year at Médan, a village of fewer than two hundred inhabitants. Thus, his experiences and impressions of agrarian life and workers were varied, and doubtless conflated in his memory and imagination. Though he made a whirlwind tour of La Beauce before writing *La Terre*, the peasants of that novel are barely distinguishable from the southern farmers Zola had already described in *La Faute de l'Abbé Mouret*. See Guy Robert, *La Terre d'Emile Zola: Etude historique et critique*, p. 32; Philip D. Walker, *Emile Zola*, pp. 181–2.

39. In addition to *La Faute de l'Abbé Mouret*, Zola set two other Rougon-Macquart novels – *La Fortune des Rougon* and *La Conquête de Plassans* – in the Midi. It is possible

that these books remained unknown to Van Gogh, for he never mentioned them in his letters.

40. The drawing is F1507a from LT501; Van Gogh also made a painting of the "dirty little girl" he called "the mudlark" (F535). Though he initially discerned something "vague[ly] Florentine" and Monticelli-like about her (LT501a), a subsequent paragraph suggests that the girl also reminded him of Zola's portraits of the working class, and indeed, Van Gogh's renderings of her bear general comparison to that author's characterization, in *La Terre*, of La Trouille (the Brat), a tough and resourceful goose girl who uses her wits to transcend the squalid life-style provided by her drunkard father. Zola introduces La Trouille as an impudent, elfin 12-year-old, "aux cheveux blonds embroussaillés. Sa bouche grande se tordait à gauche, ses yeux verts avaient une fixité hardie, si bien qu'on l'aurait prise pour un garçon" (pt. I, chap. 3).

41. The translator's adjective, "lusty," is somewhat misleading in the context of Zola's novel, which contains a remarkable passage wherein anthropomorphized roses are depicted as wanton women who seductively display their most private parts (see note 89). Van Gogh's phrase in the original French is "fleurs *grasses* de plus vif orange"; thus the flowers he described were full-blown, but neither explicitly nor necessarily eroticized.

42. Vaste champ poussant à l'abandon depuis un siècle, coin de paradis où le vent semait les fleurs les plus rares ... La végétation y était énorme, superbe, puissamment inculte ... Laissée à elle-même, libre de grandir sans honte ... la nature s'abandonnait davantage à chaque printemps.... Elle cassait les dalles des bassins, des escaliers, des terrasses, en y enfonçant des arbustes; elle rampait jusqu'à ce qu'elle possédât les moindres endroits cultivés, les pétrissait à sa guise, y plantait comme drapeau de rébellion quelque graine ramassée en chemin, une verdure humble dont elle faisait une gigantesque verdure.

43. In the same era, Van Gogh complained to his sister, "I feel grieved because I do not

have the power to make those I want to pose for me do it, wherever I want them, and as long as I want them" (W4); with Bernard, he was more explicit: "I am no longer young and my body is not attractive enough to women to get them to pose for me for nothing" (B19).

44. The landscapes by Monet that Van Gogh knew best – and probably referred to in letters of 1888 – were the intensely hued ones of the 1880s that he had seen at Theo's gallery and in Parisian exhibitions, most notably the show held at the Galeries Georges Petit in May 1887, which included recent (1884–6) views of Bordighera, The Hague, Etretat, and Giverny. Though he did not see it, Van Gogh in June 1888 took a keen interest (LT501, LT501a) in Monet's one-man show at Boussod et Valadon (i.e., Theo's gallery), which his brother described in great detail and which Vincent subsequently saw reviewed by Gustave Geffroy (in *L'Art moderne*, 24 June 1888). That exhibition comprised just ten pictures, all of southern landscapes (made during Monet's winter trip to the Côte d'Azur), and Van Gogh clearly was struck by accounts of their vibrant coloristic effects (see LT501a). For a brief discussion of Van Gogh's reaction to Geffroy's review, see Steven Z. Levine, *Monet and His Critics*, pp. 89–92.

45. For informed characterization of Monet's palette in the 1880s, see Joel Isaacson, *Claude Monet: Observation and Reflection*, p. 38.

46. Though Van Gogh's reference to "rich, daring landscape à la Guy de Maupassant" seems, in context, a way of characterizing Naturalist-inspired figure painting, his mental image of the author as painter may have been tinged by an article Maupassant published in *Gil Blas*, 28 September 1886. Presented in the form of a letter, ostensibly written from Etretat, Maupassant's essay assumes the voice of a minor landscapist who trails his artist-heroes (including Monet) and describes their methods and practice at first hand ("La Vie d'un paysagiste").

47. Van Gogh's ambition to render the "*type* distilled from many *individuals*" was outlined in his letters as early as 1883; see LT257 (his emphasis).

48. See Ronald Pickvance, *English Influences on Van Gogh*, p. 37; and Hope B. Werness et al., *Vincent van Gogh: The Influences of Nineteenth Century Illustrations*, p. 11.

49. Van Gogh much preferred the original series and in December 1882 remarked: "Some people will not admire the 'Types of Beauty' and will remember the old 'Heads of the People' with sadness (this series has been stopped)" (LT252).

50. Van Gogh found Provençal dress striking and artful in its color combinations and pattern plays. In March 1888 he told Bernard, "The way the women dress is pretty, and especially on Sundays one sees some very naïve and well-chosen combinations of colors on the boulevard" (B2), and in June he included a sketch of an Arlésienne wearing a boldly checked bodice and skirt, and dotted sleeves (B6). He mentioned the same phenomenon to Theo in May, remarking,

> Although the people are blankly ignorant of painting in general, they are much more artistic than in the North in their own persons.... They will put a touch of pink on a black frock, or devise a garment of white, yellow and pink, or else green and pink, or else *blue and yellow*, in which there is nothing to be altered from the artistic point of view. (LT481; his emphasis)

51. *Mousmé* est un mot qui signifie jeune fille ou très jeune femme. C'est un des plus jolis de la langue nipponne; il semble qu'il y ait, dans ce mot, de la *moue* (de la petite moue gentille et drôle comme elles en font) et surtout de la *frimousse* (de la frimousse chiffonnée comme est la leur). Je l'emploierai souvent, n'en connaissant aucun en français qui le vaille.

52. Loti's remarks on the Japanese taste for contrast usually concern food, as Van Gogh noted in his letters (e.g., LT519); the sort of pattern play found in the *Mousmé*'s costume may, however, have reminded Van Gogh of similar effects in Japanese prints and, thus, of Loti.

53. "I should not be surprised," Van Gogh wrote, "if the impressionists soon find fault with my way of working, for it has been

54. See LT514 and the preceding section of this chapter.

55. Zola, *Comment on meurt*, chap. V; "grand et noueux comme un chêne. Le soleil l'a séché, a cuit et fendu sa peau; et il a pris la couleur, la rudesse et le calme des arbres." (As I noted in Chapter 2, Van Gogh may have read Zola's description of Lacour in Dutch in 1882; it appeared as "De Dood van de Boer" in *De Amsterdammer* in June.)

56. Zola, *La Terre*, pt. IV, chap. 1; "malgré ses soixante-dix ans...était toujours droit, résistant et noueux ainsi qu'un bâton d'épine, la face creusée davantage, pareille à une trogne d'arbre, sous l'emmêlement de ses cheveux déteints."

57. The peasants Zola describes are almost uniformly distinguished by large features; for example, the Fouans – protagonists of *La Terre* – are readily identified by their oversized noses, and of the second Fouan son, Buteau, Zola writes:

> Chez lui, le grand nez des Fouan s'était aplati, tandis que le bas de la figure, les maxillaires s'avançaient en mâchoires puissantes de carnassier. Les tempes fuyaient, tout le haut de la tête se resserrait, et derrière le rire gaillard de ses yeux gris, il y avait déjà de la ruse et de la violence. (pt I, chap. 2)

58. An extreme example of peasant untidiness is the eldest Fouan son, nicknamed "Jesus-Christ" and portrayed in *La Terre*. His clothes are caked with grime (pt. I, chap. 2), his home is a ruined hovel (pt. I, chap. 3), and both the woman he beds (pt. I, chap. 3) and the drifter he befriends (pt. IV, chap. 3) are unwashed and unkempt. Even those peasants who attempt cleanliness are, according to Zola, fighting an uphill battle; in *Germinal*, the author describes the cleanest workers' homes as repugnant to the bourgeois nose of the mine manager's wife, who smells in them "l'odeur fade de misère, malgré la propreté choisie des maisons où elle se risquait" (pt. II, chap. 3).

59. In *La Terre*, for instance, Zola writes of "cette complicité des paysans avec les révoltés des campagnes, les braconniers, les tueurs de gardes-chasse" (pt. V, chap. 6). Elsewhere he asserts that every peasant is a poacher at heart (pt. IV, chap. 3).

60. This outlook is well voiced by Hennebeau, the mine manager of *Germinal*, whose remarks Van Gogh found compelling (LT410; see Chapter 3, this volume). Hennebeau writes wistfully of the peasant's ability to "vivre en brute, ne rien posséder à soi, battre les blés avec la herscheuse la plus laide, la plus sale, et être capable de s'en contenter!" (pt. V, chap. 5).

61. Le père, jadis très robuste, âgé de soixante-dix ans aujourd'hui, s'était desséché et rapetissé dans un travail si dur, dans une passion de la terre si âpre, que son corps se courbait, comme pour retourner à cette terre, violemment désirée et possédée. Pourtant, sauf les jambes, il était gaillard encore, bien tenu...avec le long nez de la famille qui aiguisait sa face maigre, aux plans de cuir coupés de grands plis.

62. Ce n'était plus le vieux paysan propret. ...Dans sa face amincie, décharnée, il ne restait que son grand nez osseux, qui s'allongeait vers la terre. Un peu chaque année, il s'était courbé davantage, et maintenant il allait, les reins cassés, n'ayant bientôt qu'à faire la culbute finale, pour tomber dans la fosse.

Cependant, jusque-là, Fouan avait pu marcher, et c'était une consolation, car il s'intéressait encore à la terre...Il errait lentement par les routes, de sa marche blessée de vieil homme; il s'arrêtait au bord d'un champ, demeurait des heures planté sur ses cannes; puis il se traînait devant un autre, s'y oubliait de nouveau, immobile, pareil à un arbre poussé là, desséché de vieillesse. Ses yeux vides ne distinguaient plus nettement ni le blé, ni l'avoine, ni le seigle. Tout se brouillait, et c'étaient des souvenirs confus qui se levaient du passé....

Mais ce dernier intérêt qu'il prenait à vivre s'en allait avec ses jambes. Bientôt, il lui devint si pénible de marcher, qu'il ne s'écarta guère du village....Souvent, il s'oubliait l'après-midi entière au bout d'une poutre, accroupi, à boire le soleil. Une hébétude l'immobilisait, les yeux

ouverts. . . . C'était, après la volonté et l'autorité mortes, la déchéance dernière, une vieille bête souffrant, dans son abandon, la misère d'avoir vécu une existence d'homme. D'ailleurs, il ne se plaignait point, fait à cette idée du cheval fourbu, qui a servi et qu'on abat, quand il mange inutilement son avoine.

63. For an account of the aesthetic trailblazing of musicians committed to legitimizing "pure" (nontexted) instrumental music, see John Neubauer, *The Emancipation of Music from Language: Departure from Mimesis in Eighteenth-Century Aesthetics.* Neubauer sees this struggle in music as the "first decisive battle about nonrepresentational art" (p. 2). A more particularized discussion of artists' attempts to emulate music with color is presented in Adrian Bernard Klein, *Colour-Music: The Art of Light.*

64. See Daudet, "Les Etoiles," *Lettres de mon moulin;* the possibility of a connection between Daudet's story and Van Gogh's starry night imagery is noted by Fred Orton and Griselda Pollock, *Vincent van Gogh: Artist of His Time,* p. 66.

65. See Sven Lövgren, *The Genesis of Modernism,* pp. 145–8.

66. Une répugnance invincible de la marche lui était venue. Il s'ennuyait dehors, d'un ennui qui allait jusqu'au malaise . . . et il se hâtait de rentrer, de s'enfermer, pour se sentir moins petit, moins écrasé entre l'infini de l'eau et l'infini du ciel. . . .

Si Lazare avait eu la foi en l'autre monde, s'il avait pu croire qu'on retrouvait un jour les siens derrière le mur noir. . . . Quelle joie de recommencer ailleurs, parmi les étoiles, une nouvelle existence avec les parents et les amis! comme cela aurait rendu l'agonie douce, d'aller rejoindre les affections perdues, et quels baisers à la rencontre, et quelle sérénité de revivre ensemble immortels!

67. As Van Gogh told Bernard in August 1888: "If we want to be really potent males in our work, we must sometimes resign ourselves to not fuck much, and for the rest be monks or soldiers, according to the needs of our temperament. The Dutch [painters] . . . had peaceful habits and a peaceful life, calm, well-regulated" (B14).

68. Loti, *Mme. Chrysanthème,* chap. XL. "Ils

sont vêtus de gaze noire, et leur tête est rasée."

69. Ibid.; "souriants, aimables"; "Nos amis bonzes, malgré une certaine onction ecclésiastique, rient volontiers, d'un rire très bon enfant; dodus, joufflus, tondus, ils ne s'effarouchent de rien et aiment assez nos liqueurs françaises."

70. *Guide du tourisme Michelin: Provence,* pp. 57–63. Van Gogh was intrigued by the "Gothic [*sic*] portico" of St.-Trophime ("so cruel, so monstrous, like a Chinese nightmare" [LT470]) and, with Gauguin, eventually painted several views of the Alyscamps (a Roman burial ground at the town's southeastern periphery), but his letters make no mention of its Antique arena and theater. He seems, in fact, to have taken little interest in the historical center of Arles.

71. Van Gogh refers to his now-famous painting *The Night Café* (F463).

72. The passage that opens *L'Assommoir* is the description of a boulevard on the outskirts of Paris, crowded with workers who hurry along in the early morning light. The scene is presented through the eyes of the transplanted Provençal laundress, Gervaise, who scans the crowd from a second-story window. The urban vista Flaubert uses to begin *Bouvard et Pécuchet* is more readily comparable to Van Gogh's painting, for it includes an almost deserted street (at the northern edge of Paris, near the canal St. Martin) under a hot midday sun. "Sous la réverbération du soleil," Flaubert writes, "les façades blanches, les toits d'ardoises, les quais de granit éblouissaient" (chap. I).

73. C'était une de ces soirées d'été où l'air manque dans Paris. La ville, chaude comme une étuve, paraissait suer dans la nuit étouffante. Les égouts soufflaient par leurs bouches de granit leurs haleines empestées, et les cuisines souterraines jetaient à la rue, par leurs fenêtres basses, les miasmes infâmes des eaux de vaisselle et des vieilles sauces.

Les concierges, en manches de chemise, à cheval sur des chaises en paille, fumaient la pipe sous des portes cochères, et les passants allaient d'un pas accablé, le front nu, le chapeau à la main. . . .

Les grands cafés, pleins de monde, dé-

bordaient sur le trottoir, étalant leur public de buveurs sous la lumière éclatante et crue de leur devanture illuminée. Devant eux, sur de petites tables carrées ou rondes, les verres contenaient des liquides rouges, jaunes, verts, bruns, de toutes les nuances; et dans l'intérieur des carafes on voyait briller les gros cylindres transparents de glace qui refroidissaient la belle eau claire.

74. J'aime la nuit avec passion. Je l'aime comme on aime son pays ou sa maîtresse, d'un amour instinctif, profond, invincible. Je l'aime avec tous mes sens, avec mes yeux qui la voient, avec mon odorat qui la respire, avec mes oreilles qui en écoutent le silence, avec toute ma chair que les ténèbres caressent....

Donc hier, je sortis comme je fais tous les soirs, après mon dîner. Il faisait très beau, très doux, très chaud. En descendant vers les boulevards, je regardais au-dessus de ma tête le fleuve noir et plein d'étoiles découpé dans le ciel par les toits de la rue qui tournait et faisait onduler comme une vraie rivière ce ruisseau roulant des astres.

Tout était clair dans l'air léger, depuis les planètes jusqu'aux becs de gaz. Tant de feux brillaient là-haut et dans la ville que les ténèbres en semblaient lumineuses. Les nuits luisantes sont plus joyeuses que les grands jours de soleil.

Sur le boulevard, les cafés flamboyaient; on riait, on passait, on buvait.... Je gagnai les Champs-Elysées où les cafés-concerts semblaient des foyers d'incendie dans les feuillages. Les marronniers frottés de lumière jaune avaient l'air peints, un air d'arbres phosphorescents. Et les globes électriques, pareils à des lunes éclatantes et pâles, à des oeufs de lune tombés du ciel, à des perles monstreuses, vivantes, faisaient pâlir sous leur clarté nacrée, mystérieuse et royale les filets de gaz, de vilain gaz sale, et les guirlandes de verres de couleur.

Je m'arrêtai sous l'Arc de Triomphe pour regarder l'avenue...étoilée, allant vers Paris entre deux lignes de feux, et les astres! Les astres, là-haut, les astres inconnus jetés au hasard dans l'immensité où ils dessinent ces figures bizarres,

qui font tant rêver, qui font tant songer.

75. For a concise account of the late-nineteenth-century expansion of the French rail system, see Sanford Elwitt, *The Making of the Third Republic: Class and Politics in France, 1868–1884*, chap. III.

76. "C'est moi, monsieur Tartarin; vous ne me reconnaissez pas? Je suis la vieille diligence qui faisait – il y a vingt ans – le service de Tarascon à Nîmes. Que de fois je vous ai portés, vous et vos amis, quand vous alliez chasser les casquettes....Sitôt que vous vous êtes mis à rouler, coquin de bon sort! je vous ai reconnu tout de suite."

77. "Ah! mon bon monsieur Tartarin, je n'y suis pas venue de mon plein gré, je vous assure. Une fois que le chemin de fer de Beaucaire a été fini, ils ne m'ont plus trouvée bonne à rien et ils m'ont envoyée en Afrique. Et je ne suis pas la seule! Presque toutes les diligences de France ont été déportées comme moi."

78. "Que je le regrette, mon beau Tarascon! ...Quelle belle route...large, bien entretenue, avec ses bornes kilométriques, ses petits tas de pierre régulièrement espacés, et de droite et de gauche ses jolies plaines d'oliviers et de vignes."

79. "Il fallait me voir partir le matin, lavée à grande eau et toute luisante avec mes roues vernissées à neuf, mes lanternes qui semblaient deux soleils et ma bâche toujours frottée d'huile!"

80. The painting to which Van Gogh referred has been identified by Mark Roskill as Monet's *Boats at Etretat*, 1884 (*Van Gogh, Gauguin, and the Impressionist Circle*, p. 43); Ronald Pickvance concurs (*Van Gogh in Arles*, p. 189).

81. Van Gogh's letters to Theo and to Emile Bernard indicate that his encounters with the opposite sex were few and far between – and usually obtained at a price (see, e.g., LT522, B8). In an attempt to make the best of his loveless existence, Van Gogh presented his lack of female companionship as conducive to artistic productivity (LT521; B14), but he also held that sporadic sex was a staple most men required. In a letter to Bernard, for instance, Van Gogh remarked, "To do good work one must eat well, be

well housed, have one's fling from time to time, smoke one's pipe and drink one's coffee in peace" (B17).

82. When "Au bord de l'eau" was reprinted in Etampes under the title "Une Fille," municipal authorities there considered legal action against the author until Flaubert intervened on his behalf. Maupassant in a letter to Flaubert boastfully acknowledged that though the language of the poem was not indecent, its subject matter and imagery certainly were. See Francis Steegmuller, *Maupassant: A Lion in the Path*, pp. 123–4.

83. The lovemaking of Maupassant's protagonists is in fact so passionate as to inspire their fear, but though they prudently agree to curtail their liaisons, resolve is thwarted by desire:

> ...à l'heure ordinaire, une invincible
> envie
> Me prit d'aller tout seul à l'arbre
> accoutumé
> Rêver aux voluptés de ce corps tant
> aimé
> Promener mon esprit par toutes nos
> caresses,
> Me coucher sur cette herbe et sur son
> souvenir.

The laundress arrives at the same spot, impelled by her own desire, and the lovers' relations resume; in the end their erotic exertions are so extreme that they die in the act. Maupassant's poem concludes:

> Mais alors, s'il est vrai que les ombres
> reviennent,
> Nous reviendrons, le soir, sous les
> hauts peupliers
> Et les gens du pays, qui longtemps se
> souviennent,
> En nous voyant passer, l'un à l'autre
> liés,
> Diront, en se signant, et l'esprit en
> prière:
> "Voilà le mort d'amour avec sa
> lavandière."

84. Le vent me paraissait chargé d'amours lointaines / Alourdi de baisers, plein des chaudes haleines.

85. Van Gogh's June visit to Mont Majour apparently was not his first; in early March

1888 (i.e., less than a month after his arrival in Arles) he told Theo, "I have seen lots of beautiful things – a ruined abbey on a hill covered with holly, pines and gray olives" (LT467).

86. In discussing Van Gogh's depictions of the Rhône side of the public gardens, Pickvance notes its "flavor of *la vie moderne*" and remarks that this sector "is always presented without symbolic overtones or poetic accretions. It is commonplace and everyday, often with park benches and seated figures" (*Van Gogh in Arles*, pp. 182–3).

87. Pickvance notes that Van Gogh walked through this sector of the garden to reach the rue du Pont d'Arles – which the artist once called the "street of the kind girls" (LT539; Pickvance, *Van Gogh in Arles*, pp. 120, 178).

88. See, e.g., the passage from *La Faute de l'Abbé Mouret* (pt. II, chap. 7) cited in note 42.

89. In a scene that is strangely reminiscent of St. Anthony's temptation, Zola imagines a welter of flowers metamorphosing into an alluring variety of eroticized women in dishabille. While some are cowed by the male gaze, others yield up their most private parts with unabashed, even jovial, exhibitionism.

> C'était une floraison folle, amoureuse, pleine de rires rouges, de rires roses, de rires blancs. Les fleurs vivantes s'ouvraient comme des nudités, comme des corsages laissant voir les trésors des poitrines. . . . Les roses thé prenaient des moiteurs adorables, étalaient des pudeurs cachées, des coins de corps qu'on ne montre pas, d'une finesse de soie, légèrement bleu par le réseau des veines. La vie rieuse du rose s'épanouissait ensuite: le blanc rose, à peine teinté d'une pointe de laque, neige d'un pied de vierge qui tâte l'eau d'une source; le rose pâle, plus discret que la blancheur chaude d'un genou entrevu, que la lueur dont un jeune bras éclaire une large manche; le rose franc, du sang sous du satin, des épaules nues, des hanches nues, tout le nu de la femme, caressé de lumiére; le rose vif, fleurs en boutons de la gorge, fleurs à demi ouvertes des lèvres, souf-

flant le parfum d'une haleine tiède. . . . Le long du sentier, rayé de coups de soleil, des fleurs rôdaient, des visages s'avançaient, appelant les vents légers au passage. Sous la tente déployée de la clairière, tous les sourires luisaient. . . . Les roses avaient leurs façons d'aimer. Les unes ne consentaient qu'à entrebâiller leur bouton, très timides, le coeur rougissant, pendant que d'autres, le corset délacé, pantelantes, grandes ouvertes, semblaient chiffonnées, folles de leur corps au point d'en mourir. (*La Faute de l'Abbé Mouret*, pt. II, chap. 6)

90. The *Poet's Garden* paintings were devised as a decoration for the room Gauguin would occupy at Arles. In a letter to Gauguin, Van Gogh described the scenes as decidedly southern in flavor and wrote, "What I wanted was to paint the garden in such a way that one would think of the old poet from here (or rather from Avignon), Petrarch, and at the same time of the new poet living here – Paul Gauguin" (LT544a). His remarks allude to his belief in the interrelatedness of verbal and visual "poetry" (see also B5), and suggest his desire to find continuity in Provençal life and culture. The amorous nature of the paintings' subject matter may have been inspired by Gauguin's reputation as a ladies' man.

91. Il lui avait passé un bras à la taille. Ce fut ainsi qu'ils revinrent sous les hautes futaies, où la majesté des voûtes ralentit encore leur promenade de grands enfants qui s'éveillaient à l'amour. Elle se dit un peu lasse, elle appuya la tête contre l'épaule de Serge. Ni l'un ni l'autre pourtant ne parla de s'asseoir. . . . Quelle joie pouvait leur procurer un repos sur l'herbe, comparée à la joie qu'ils goûtaient en marchant toujours côte à côte?. . . . Et c'étaient les arbres, les érables, les ormes, les chênes, qui leur soufflaient leurs premiers mots de tendresse.

92. Ron Johnson, "Vincent van Gogh and the Vernacular."

93. Mistral and Hugues were members of a Provençal literary society, Les Félibres, which was intent on reviving the traditions of the region's troubadours. At some point before February 1889, Van Gogh read "fragments" of Mistral's vernacular poem of tragic love and beautiful southern nature, *Mirèio* (1859); the artist, however, was obliged to read it in French translation, as *La Mireille* (LT576).

94. In a letter to his brother (LT539), Van Gogh reported that he had read an article on the Italian poets, but admitted that he did not fully comprehend Dante, Petrarch, and Boccaccio. The Naturalists undoubtedly were more accessible to him, and their imagery probably spurred and served his desire that *Poet's Garden* evoke the new South as well as the old (see LT544a and note 90).

95. Comme ils sortaient de la forêt, le crépuscule était tombé, la lune se levait, jaune, entre les verdures noires. Et ce fut un retour adorable, au milieu du parc, avec cet astre discret qui les regardait par tous les trous des grands arbres. Albine disait que la lune les suivait. La lune était très douce, chaude d'étoiles. Au loin, les futaies avaient un grand murmure, que Serge écoutait, en songeant: "Elles causent de nous."

96. Some months later, while living at St.-Rémy, Van Gogh chose to paint a blossoming almond branch in celebration of his nephew's birth (see F671 and LT627).

97. In May 1889 Van Gogh was pleased to report to Theo that their sister wrote "extremely well" and could describe "a landscape or a view of the town in such a way that it might have been a page out of a modern novel" (LT630).

98. The extant painting that comes closest to this description is Van Gogh's *Romans parisiens* of 1887 (Plate 7), which includes both books and flowers; it contains, however, too many of each to tally with the work described to Wil. The predominantly yellow palette of the Paris picture is also incongruent with that mentioned in W3. It may be assumed that Van Gogh referred to another version of *Romans parisiens,* which was missing by the time De la Faille produced his catalogue raisonné.

99. Van Gogh likewise did not mention *La Joie de vivre* in letters from Nuenen, either before or after including it in his *Still Life with Bible and French Novel.*

100. Van Gogh's erroneous attribution of *La Fille*

Elisa to both Edmond and Jules de Goncourt in his *Still Life with Three Novels*. (Plate 6, 1887) suggests that he might not always have had the actual volumes he commemorated in front of him as he painted.

101. For Van Gogh's remarks on the expressiveness of arbitrary color, see LT520 and LT555; for his comments on the emotive potential of coupled complementary colors, see LT531 and W4.

102. Marie Ginoux was married to Joseph-Michael Ginoux and helped him run the Café de la Gare on the Place Lamartine. Van Gogh had a room there from May to September 1888 and continued to frequent the café after he moved into his rented house. The Ginoux's café was immortalized in Van Gogh's well-known *Night Café* (F463), which was painted on the spot in early September.

103. Jan Hulsker, *The Complete Van Gogh: Paintings, Drawings, Sketches*, p. 372.

104. Besnard's name is mistakenly transcribed "Bernard" in *The Complete Letters of Vincent Van Gogh*, edited by Johanna van Gogh-Bonger.

105. For a full discussion of the Ecole de Pharmacie commission and Besnard's completed panels, see Camille Mauclair, *Albert Besnard, l'homme et l'oeuvre*, p. 35.

106. The portrait to which Van Gogh referred was Puvis's painting of Eugène Benon; Aimée Brown Price has addressed its impact on Van Gogh's work in "Two Portraits by Vincent van Gogh and Two Portraits by Pierre Puvis de Chavannes."

107. Van Gogh's exact phrase, written in French, is "J'ai enfin une Arlésienne" (LT559).

108. Gauguin seems to have intimidated fellow painters in this era; according to Van Gogh, Emile Bernard "says he *dare not* [make a portrait of] Gauguin as I asked him, because he feels afraid in front of Gauguin" (LT539; his emphasis). Though Van Gogh chided Bernard for his hesitancy (see B16), it seems likely that he felt some of the same trepidation when Gauguin came to Arles.

109. The series of empty chairs in Van Gogh's work has been remarked by Albert J. Lubin, *Stranger on the Earth: A Psychological Biography of Vincent van Gogh* (p. 13), who explores that theme in his study.

110. See, e.g., H. R. Graetz, *The Symbolic Language of Vincent van Gogh*, p. 139; and Lubin, *Stranger*, p. 167.

111. Van Gogh idealized admired artistic practice in a similarly phallicistic way, and even went so far as to write of "spermatic" painting (B14). Convinced that "as soon as virility, originality, naturalism of whatever kind come into question, it is very interesting to consult [the Dutch painters]," he urged Bernard to look to their work for exemplars: "I know that the study of the Dutch painters can only do you good, for their works are so virile, so full of male potency, so healthy" (B14).

112. Van Gogh's later rendering of his own chair (F498) – a rough-hewn pine one with straw seat, which contrasts with Gauguin's in almost every way (see Graetz, *Symbolic Language*, pp. 138–42) – is notable for the absence of books. The chair seat holds a pipe and tobacco ("a good remedy for the blues" [LT5; see also W11, B17]), and sprouting bulbs are included in the flower box behind the chair.

113. According to the terms of their agreement, Gauguin was to send Theo one painting per month.

114. Gauguin, *Avant et après*, p. 17; Tout ce temps me parut un siècle.

115. Ibid, pp. 15–19.

116. Paul Gauguin, *Lettres à sa femme et à ses amis*, pp. 154–5.

117. As noted earlier, Van Gogh's *Une Liseuse de romans*, though described by the artist as an imagined scene, relies on his earlier portraits of Marie Ginoux. In like manner, his *Memory of the Garden at Etten* (F496) – an "invented" composition recalling his mother and sister at the family's former home in Holland – depends on Gauguin's *Garden at Arles* for its viewpoint and layout, Millet's *Gleaners* for the posture of a midground figure, and Ginoux's features for those of Van Gogh's sister, Wil, whom he had not seen in several years.

118. Their dispute was indeed more theoretical than practical, since Van Gogh adopted "abstraction" sporadically during Gauguin's stay, and Gauguin, for his part, often worked from nature at Arles.

119. Gustave Kahn, "Réponse des symbolistes."

120. Ibid.

121. Gauguin, *Avant et après*, p. 20; see also Gauguin, *45 Lettres à Vincent, Théo et Jo Van Gogh*, no. 11.1, pp. 84–5.

122. *Numa Roumestan*, a novel Van Gogh read at Nuenen in 1883 or 1884, takes the name of its protagonist, a garrulous and charismatic Provençal who moves to Paris, pursues a political career, and marries a northerner. Daudet uses Numa Roumestan's story to contrast southern and northern values, life-styles, and dispositions, and notes that the southern propensity for imaginative excess (and out-and-out lying) is induced by the intensity of the southern sun.

123. See Gauguin, *45 Lettres*, VG/PG.4, pp. 270–1.

124. Cf. *Tartarin sur les Alpes*, chaps. XIII and XIV.

125. In the role of *La Berceuse*, Roulin joined the ranks of Arlesian types Van Gogh portrayed in 1888: the soldier, *mousmé*, postman, peasant, poet, priest, and reader.

126. For the details of Gauguin's three-year naval career, see Richard Bretell et al., *Gauguin*, pp. 3–4.

127. That Van Gogh associated *La Berceuse* with memories of Gauguin is made clear not only by his remarks on the painting, but also by his desire to present Gauguin with a copy. Though Gauguin's correspondence with the Van Goghs gives no indication of his interest in acquiring a version of *La Berceuse*, Van Gogh on several occasions suggested that his brother arrange for Gauguin to have one (see LT576, LT578, LT592).

128. At the end of the novel, when Loti's sailor protagonist goes down with his fishing boat, the author notes his "marriage" with the sea, "la mer qui autrefois avait été aussi sa nourrice; c'était elle qui l'avait bercé" (*Pêcheur d'Islande*, pt. V).

129. Gauguin, *45 Lettres*, VG/PG.4, pp. 270–1.

> Dans ma fièvre cérébrale ou nerveuse ou folie, je ne sais ... comment dire ou comment nommer ça, ma pensée a naviguée sur bien des mers ... et il paraît que j'ai alors chanté – moi, qui ne sais pas chanter en d'autres occasions – justement un vieux chant de nourrice en songeant à ce que chantait la berceuse qui berçait les marins et que j'avais cherchée dans un arrangement de couleurs avant de tomber malade. [n.b.: I have added some punctuation and accent marks for the sake of clarity.]

130. Gauguin, *45 Lettres*, VG/PG.3, pp. 268–9.

> Je crois que si on plaçait cette toile ... dans un bateau de pêcheurs, même d'Islande, il y en aurait qui sentiraient là dedans la berceuse. Ah! mon cher ami, faire de la peinture ce qu'est déjà avant nous la musique de Berlioz et de Wagner ... un art consolateur pour les coeurs navrés!

131. In this letter to fellow Dutchman A. H. Konig, Van Gogh noted that his picture might be compared to the prose of another Dutch contemporary, Frederik van Eeden. Van Gogh had read Van Eeden's novel-length allegorical fairy tale, *De kleine Johannes*, and in probable reference to it told Konig: "I think I have run pretty well parallel with Van Eeden and his style of writing, which consequently can be considered analogous to my style of painting in the matter of colors" (LT571a). Though his remarks are inexplicit, they probably reflect the artist's attention to the exaggerated and arbitrary color descriptions Van Eeden uses to evoke fantasy and otherworldly phenomena in *De kleine Johannes*; in a letter to his sister the previous summer Van Gogh had remarked on the evocative coloration Van Eeden gave Death (W4). (Van Eeden himself may have sensed a kindred colorist in Van Gogh; he wrote a commemorative appreciation of the painter's work, published in *De Nieuwe Gids* in December 1890).

132. In his characterization of the "common people's" taste, Van Gogh was voicing a widely held belief; as late as 1925, Pierre Louis Duchartre and René Saulnier, historians of popular imagery, noted: "Les couleurs ont toujours exercé un étrange pouvoir de fascination sur les âmes simples, celles du peuple et des enfants. Pour elles, couleur et allégresse sont presque synonymes. Comme aujourd'hui devant une étoffe de vives couleurs, les bouches pincées des paysannes devaient se détendre pour sourire quand le colporteur leur offrait ses belles images" (*L'Imagerie populaire* pp. 49–50).

133. Loti, *Pêcheur d'Islande*, pt. 3; "confiance extrême dans les saints et les images qui protégent."

134. Contre un panneau du fond, une sainte vierge en faïence était fixée sur une plan-chette, à une place d'honneur. Elle était un peu ancienne, la patronne de ces mar-ins, et peinte avec un art encore naïf. Mais les personnages en faïence se con-servent beaucoup plus longtemps que les vrais hommes; aussi sa robe rouge et bleue faisait encore l'effet d'une petite chose très fraîche au milieu de tous les gris sombres de cette pauvre maison de bois. Elle avait dû écouter plus d'une ar-dente prière, à des heures d'angoisses; on avait cloué à ses pieds deux bouquets de fleurs artificielles et un chapelet.

135. Gauguin, *45 Lettres*, VG/PG.1, pp. 264–5; "peut être pas très bien écrit littérairement."

136. Raspail (1794–1878), a chemist and some-time politician of liberal views, was a strong supporter of home remedies. He believed that many medical complaints could be at-tributed to worms and recommended cam-phor for dealing with them.

CHAPTER 6. THE LATE WORK:
BRIGHTNESS AMID GRIEF

1. Van Gogh's sporadic "attacks" included hallucinations and losses of consciousness that could be followed by weeks of depres-sion and disorientation.

2. Van Gogh had long periods of clearhead-edness at St.-Rémy and used them to push his work along intently, for his illness made him keenly aware of his mortality: "Life passes like this, time does not return, but I am dead set on my work, for just this very reason, that I know the opportunities of working do not return. Especially in my case, in which a more violent attack may forever destroy my power to paint" (LT605). When he felt lucid, Van Gogh by his own account worked "very slowly – but from morning till night without slackening," "like one . . . possessed" (LT604).

3. Van Gogh's *Still Life with Plaster Cast* (Plate 8), which features a clearly titled copy of *Germinie Lacerteux*, indicates that Van Gogh read the novel during his years in

Paris. He praised its evocative color effects in a letter to Theo from Arles (LT540) and lauded it once more in his 1889 letter to Wil (W14). Later, he included the book in his portrait of Dr. Paul Gachet (Plate 16), which is discussed later in the chapter.

4. Zola, "Le Moment artistique," *L'Evéne-ment*, 4 May 1866. "Ce que je cherche avant tout dans un tableau c'est un homme et non pas un tableau." (This essay was reprinted in the 1879 edition of *Mes haines*, and Van Gogh encountered it there [see Chapter 2, this volume]; he cited Zola's phrase almost verbatim in LT418.)

5. Van Gogh in his letters noted that the south-ern sun and the blowing of the Mistral could be unnerving and after his first breakdown argued that "everyone in this good Tarascon country is a trifle cracked" (LT575). Zola, for his part, primes the reader for Mouret's mental collapse by emphasizing the disquiet-ing effect that the ardor of the southern land-scape has on the virginal priest. Mouret is portrayed as distracted and even agitated by the sights, smell, and *touch* of his sur-roundings:

> Parfois, en recevant à la face un souffle . . . chaud, il levait les yeux de son livre, cherchant d'où lui venait cette caresse; mais son regard restait vague, perdu, sans le voir, sur l'horizon enflammé, sur les lignes tordues de cette campagne de passion, séchée, pâmée au soleil, dans un vautrement de femme ardente et stérile. (*La Faute de l'Abbé Mouret*, pt. I, chap. 6)

Mouret eventually hallucinates before such a scene, losing consciousness as he looks out onto the view from his bedroom window (pt. I, chap. 16).

6. Ce premier contact de la terre lui donnait une secousse, un redressement de vie qui le planta un instant debout. . . .

 Il naissait dans le soleil, dans ce bain pur de lumière qui l'inondait. Il naissait à vingt-cinq ans, les sens brusquement ouverts, ravi du grand ciel, de la terre heureuse, du prodige de l'horizon étalé autour de lui. Ce jardin, qu'il ignorait la veille, était une jouissance extraor-dinaire. Tout l'emplissait d'extase, jus-

qu'aux brins d'herbe, jusqu'aux pierres des allées, jusqu'aux haleines qu'il ne voyait pas et qui lui passaient sur les joues.…

La santé, la force, la puissance étaient sur sa face. Il ne souriait pas; il était au repos.

7. Zola, *La Faute de l'Abbé Mouret*, pt. II, chap. 8.

"Ils avaient découvert dans le jardin un endroit de félicité parfaite, où ils finissaient par vivre toutes leurs heures.… Un endroit d'ombre fraîche, caché au fond de broussailles impénétrables, si merveilleusement beau qu'on y oublie le monde entier."

8. Before entering the asylum, Van Gogh worried that sexual desire might present a problem to him in the isolating environment of the institution, and he was wary of what might happen if, as he put it, "I should happen to turn amorous again." He suspected that that which he called the "passionate factor" might upset his balance and admitted, "Virtue and temperance, I am only too afraid, will again lead me into those parts where the compass is apt to go overboard pretty quickly" (see LT590).

9. Ronald Pickvance (*Van Gogh in St.-Rémy and Auvers*, p. 189) notes the similarity between this picture and the fourth painting in the *Poet's Garden* series, an image I have already linked to *La Faute de l'Abbé Mouret;* see Chapter 5.

10. See *La Faute de l'Abbé Mouret* pt. II, chap. 11: the pertinent passage is quoted in my discussion of the *Poet's Garden* series (see Chapter 5).

11. Though Pickvance argues that Van Gogh's late paintings "are neither graphs of his so-called madness nor primarily indicators of his mental state" and seeks to defuse routine assertions of the late works' emotionality (*Van Gogh in St.-Rémy and Auvers*, pp. 15–16), their expressionistic impact and intent are to my mind undeniable. Van Gogh himself admitted (in November 1889), "When I compare them with others, some of my pictures certainly show traces of having been painted by a sick man, and I assure you that

I don't do this on purpose. It's against my conscious will" (W16).

12. Van Gogh later painted a second version of *The Ravine* (F661), which is virtually identical to the first in composition, size, and palette.

13. "*Campagne*" is a feminine noun, and the pronoun used to refer to it, "*elle*," under most circumstances would be translated "it." I have chosen to use the English "she" instead, since it better conforms to the sense of Zola's passage, wherein the countryside is anthropomorphized and, more specifically, feminized.

14. Cybele was a nature goddess of the ancient peoples of Asia Minor.

15. En face de lui, la vaste plaine s'étendait, plus tragique sous la pâleur oblique de la lune. Les oliviers, les amandiers, les arbres maigres faisaient des taches grises au milieu du chaos des grandes roches, jusqu'à la ligne sombre des collines de l'horizon. C'étaient de larges pans d'ombre, des arêtes bossuées, des mares de terre sanglantes où les étoiles rouges semblaient se regarder, des blancheurs crayeuses pareilles à des vêtements de femme rejetés, découvrant des chairs noyées de ténèbres, assoupies dans les enfoncements des terrains. La nuit, cette campagne ardente prenait un étrange vautrement de passion. Elle dormait, débraillée, déhanchée, tordue, les membres écartés, tandis que de gros soupirs tièdes s'exhalaient d'elle, des arômes puissants de dormeuse en sueur. On eût dit quelque forte Cybèle tombée sur l'échine, la gorge en avant, le ventre sous la lune, saoule des ardeurs du soleil et rêvant encore de fécondation. Au loin, le long de ce grand corps, l'abbé Mouret suivait des yeux le chemin des Olivettes, un mince ruban pâle qui s'allongeait comme le lacet flottant d'un corset.

16. Albert Aurier (1865–92) wrote the first critical essay on Van Gogh ever published; it appeared in the inaugural issue of *Mercure de France* (January 1890) and was entitled "Les Isolés: Vincent van Gogh." Among other things, Aurier asserted that Van Gogh was a realist, and explained his various deviations from and deformations of seen mo-

tifs by citing Zola's definition of art as nature viewed through a temperament. (Aurier's essay is reprinted in Pickvance, *Van Gogh in St.-Rémy and Auvers*, pp. 310–15.) Van Gogh's reactions to the article were mixed, and his letter of February 1890 was a detailed response to Aurier's remarks.

17. Though Mark Roskill argues that the first of Van Gogh's paintings after Gauguin's sketch was made at Arles in early 1889 and later used as the prototype for copies made at St.-Rémy (*Van Gogh, Gauguin and French Painting in the 1880s: A Catalogue Raisonné of Key Works*, pp. 94–5), the palette and brushwork of the picture (F542) are more consistent, I believe, with his work of the following year. Van Gogh's letters indicate that Mme. Ginoux was very much on his mind in the asylum (see LT622a, LT625, LT626b, LT634a, LT640a), and I agree with those who date all four of the extant Gauguin-based portraits of Ginoux to the first months of 1890 (see D. Cooper [ed.] in Paul Gauguin, *45 Lettres à Vincent, Théo et Jo van Gogh*, p. 313; Jan Hulsker, *The Complete Van Gogh: Paintings, Drawings, Sketches*, p. 440; and Pickvance, *Van Gogh in St.-Rémy and Auvers*, catalog no. 48). Ample verbal evidence for such a dating exists in both Van Gogh's and Gauguin's correspondence (see LT629, LT632, W20; and Gauguin, *45 Lettres*, GAC 41.1).

18. The four portraits that exist today are F540–543; a fifth version was lost when Van Gogh attempted to deliver it to Mme. Ginoux in Arles and suffered an attack of illness. As Van Gogh's doctor told Theo in a letter of 24 February 1890, "I was obliged to send two men with a carriage to Arles to pick him up, and there is no way of knowing where he spent the night.... He had taken the portrait of a woman of Arles with him; it has not been recovered" (cited by Hulsker, *The Complete Van Gogh*, p. 440).

19. Gauguin, *45 Lettres*, GAC 41.1; "très belle et très-curieuse, je l'aime mieux que mon dessin." At Vincent's request, Theo gave one of the Ginoux portraits to Gauguin (see LT629 and Gauguin, *45 Lettres*, pp. 312–13).

20. In Van Gogh's portraits, both books bear French-language titles, *La Cas de l'Oncle Tom* and *Contes de Noël*.

21. The specific books mentioned by Van Gogh in this context are Voltaire's *Candide* and Flaubert's *Bouvard et Pécuchet*.

22. That he associated such coloration with physical and mental distress is further indicated by Van Gogh's remarks on his painted copy after a black-and-white print of Delacroix's *Pietà* (Fig. 16): "There is in it," he wrote, "the grayish white countenance, the lost, vague look of a person exhausted by anxiety and weeping and waking, rather in the manner of Germinie Lacerteux" (W14). In the Goncourts' novel, Lacerteux is insistently described as "lymphatic" and pale, and Van Gogh formed a keen mental image of her coloring, which he considered to be powerfully reflective of her inner state. He used his recollection, moreover, to underscore his own objections to portrait photography, observing, "Unless we are painted in color, the result is nowhere near a speaking likeness.... Would Germinie Lacerteux really be Germinie Lacerteux without her color? Obviously not" (LT540). See also W22, cited in the next section.

23. In a letter written on 1 February 1890 (i.e., around the time that he painted his multiple portraits of Ginoux), Van Gogh told Theo:

> I am a little worried about a friend who it appears is still ill, and whom I should like to go and see; it is the one whose portrait I did in yellow and black, and she had changed so much. It is nervous attacks and complications of a premature climacteric, altogether very painful. Last time she was like an old grandfather. I promised to return within a fortnight, and was taken ill myself. (LT625)

24. See, e.g., Hulsker, *The Complete Van Gogh*, p. 460.

25. Paul Gachet, *Souvenirs de Cézanne et de Van Gogh à Auvers, 1875–1890*.

> Vincent aimait qu'on partageât ses admirations....
>
> Au docteur Gachet, il avait apporté, pour qu'il les lise, *Germinie Lacerteux* et *Manette Salomon;* il les déposa sur la table rouge où s'appuyait le docteur; ils furent "portraicturés" en même temps que lui, d'ailleurs sans aucune relation avec ses goûts littéraires....
>
> Quelle suite eut cette lecture? Nous

l'ignorons, mais elle encouragea Vincent à prêter, un peu plus tard, *la Fille Elisa*, et ce dernier bouquin est resté au docteur ...Il a, depuis, été relié en toile noire, mais sa couverture *jaune*, chère à Vincent, est toujours à l'intérieur. (His emphasis)

26. Puvis's *Portrait of Mme. C* takes as its subject Princesse Marie Cantacuzène, the artist's longtime companion and future wife.

27. Roskill, *Van Gogh, Gauguin and French Painting of the 1880s*, pp. 334–5. See also Aimée Brown Price, "Two Portraits by Vincent Van Gogh and Two Portraits by Pierre Puvis de Chavannes," pp. 714–18.

28. Price links Van Gogh's *Woman by a Cradle* (F369) – a portrait that dates to his Paris period – to Puvis's *Portrait of Mme. C*. The delicate Neo-Impressionistic paint handling in that picture suggests, however, that *Woman by a Cradle* was made in early to middle 1887 (i.e., before Van Gogh could have seen the Puvis portrait exhibited), and it is my contention (supported, I think, by Van Gogh's letters) that the 1890 Ginoux portrait was the work that Van Gogh himself eventually equated with the Puvis in question. Though Mme. Ginoux, as presented in this portrait, is not quite the "fashionable lady, as the Goncourts have depicted them" (B14), she does conform to the other description Van Gogh gave of Puvis's *Portrait of Mme. C:* "a woman already old, but exactly as Michelet felt, There is no such thing as an old woman" (LT617).

29. Foxglove is of the genus *Digitalis*. Its dried leaves contain various glucosides and can be used to stimulate the heart. As Paul Gachet *fils* asserts in his memoirs: "La *Digitale* [i.e., the foxglove included in his father's portrait] fut intentionnellement choisie comme emblème d'une spécialisation professionnelle: celle de certaines maladies du coeur." Dr. Gachet was an advocate of homeopathic remedies, and the *Still Life on a Drawing Board*, which Van Gogh made at Arles in 1889 (Fig. 51), indicates that the artist shared those interests, for F. V. Raspail's *Annuaire de la santé* (a book in which the author describes natural remedies for health problems) is prominently featured there.

EPILOGUE

1. See the Goncourts' and Zola's respective prefaces to *Germinie Lacerteux* and *L'Assommoir*.

2. Richard Shiff, *Cézanne and the End of Impressionism: A Study of the Theory, Technique, and Critical Evaluation of Modern Art*, pt. I.

BIBLIOGRAPHY

PRIMARY SOURCES

Aurier, G.-Albert. "Les Isolés: Vincent van Gogh." *Mercure de France*, January 1890.

Bernard, Emile. *Les Hommes d'aujourd'hui: Vincent van Gogh.* Paris: Vanier, 1891.

Breitner, G. H. *Brieven aan A. P. van Stolk.* Edited by P. H. Hefting. Utrecht: Academische Uitgeverij Haentjens Dekker & Gumbert, 1970.

Gauguin, Paul. *Avant et après.* Paris: Editions G. Crès, 1923.

 Lettres à sa femme et à ses amis. Paris: Editions Bernard Grasset, 1946.

 45 Lettres à Vincent, Théo et Jo van Gogh. Edited by Douglas Cooper. Amsterdam: Rijksmuseum Vincent van Gogh, 1983.

Gogh-Bonger, Johanna van (ed.). *Verzamelde Brieven van Vincent van Gogh.* Amsterdam: Wereld Bibliotheek, 1952.

 The Complete Letters of Vincent van Gogh. Boston: New York Graphic Society, 1978.

Goncourt, Edmond, and Goncourt, Jules. *Journal des Goncourt: Mémoires de la vie littéraire.* Paris: Fasquelle-Flammarion, 1956.

 Préfaces et manifestes littéraires. Edited by Herbert Juin. Paris: Ressources, 1980.

Kahn, Gustave. "Réponse des symbolistes." *L'Evénement,* 28 September 1886.

 Les Origines du Symbolisme. Paris: Albert Messein, 1936.

Littré, Emile. *Dictionnaire de la langue française.* Paris: Gallimard-Hachette, 1964. First published 1873.

Maupassant, Guy. "Sur une Vénus." *Gil Blas,* 12 January 1886.

 "La Vie d'un paysagiste." *Gil Blas,* 28 September 1886.

 "La Nuit (Cauchemar)." *Gil Blas,* 14 June 1887.

Moréas, Jean. "Un manifeste littéraire." *Le Figaro littéraire,* 18 September 1886.

Wyzéwa, Téodor. "Notes sur la peinture wagnérienne et le Salon de 1886." *Revue wagnérienne,* 8 May 1886.

 "Notes sur la littérature wagnérienne." *Revue wagneriénne,* 8 June 1886.

 "Notes sur la musique wagnérienne." *Revue wagnérienne,* 8 July 1886.

Zilcken, Philip. *Au jardin du passé: Un Demi-siècle d'art et de littérature; lettres à une amie.* Paris: Albert Messein, 1930.

 "Herinneringen van een Hollandsche schilder der negentiende eeuw, 1877–1929." Unpublished manuscript. Rijksbureau voor Kunsthistorische Documentatie, The Hague.

Zola, Emile. "De Dood van de Boer." *De Amsterdammer,* 11 June 1882.

 Les Romanciers naturalistes. Paris: Charpentier, 1910.

 Oeuvres complètes d'Emile Zola. Edited by Maurice Le Blond. Paris: Bernouard, 1925–33.

 Oeuvres complètes d'Emile Zola. Edited by Henri Mitterand. Paris: Cercle de Bibliophile, 1969.

 Mon salon, Edouard Manet, ecrits sur l'art. Edited by Antoinette Ehrard. Paris: Garnier-Flammarion, 1970.

Le Roman expérimental. Paris: Garnier-Flammarion, 1971.

Les Rougon-Macquart. Edited by Armand Lanoux. Paris: Fasquelle, 1980–1.

SECONDARY SOURCES

Adhémar, Hélène, and Adhémar, Jean. "Zola et la peinture." *Arts Magazine,* 12–18 December, 1952, p. 10.

Ammons, Elizabeth. "Stowe's Dream of the Mother: *Uncle Tom's Cabin* and American Women Writers Before the 1920s." In *New Essays on* Uncle Tom's Cabin, ed. Eric J. Sundquist. Cambridge University Press, 1986, pp. 155–95.

Ashmolean Museum. *Catalogue of the Collection of Dutch and Flemish Still-life Pictures bequested by Daisy Linda Ward.* Oxford: Oxford University Press, 1950.

Ashton, Rosemary. *George Eliot.* Oxford: Oxford University Press, 1983.

Babbitt, Irving. *The New Laokoön: An Essay on the Confusion of the Arts.* Boston: Houghton Mifflin, 1910.

Bakker, Bard H. "Zola aux Pays-Bas, 1875–1885." *Revue des sciences humaines,* 140 (1975), pp. 581–8.

"Emile Zola and the 'Revolution of the 1880s' in the Netherlands." *Review of National Literatures,* 8 (1977), pp. 97–107.

Baldick, Robert. *The Goncourts.* London: Bowes & Bowes, 1960.

Baldwin, James. *Notes of a Native Son.* New York: Bantam, 1964.

Barr, Alfred H., Jr. (ed.). *Vincent van Gogh.* Exhibition catalog. New York: Museum of Modern Art, 1935.

Barrows, Susanna. "After the Commune: Alcoholism, Temperance, and Literature in the Early Third Republic." In *Consciousness and Class Experience in Nineteenth-Century Europe,* ed. John M. Merriman. New York: Holmes & Meier, 1979, pp. 205–18.

Barthes, Roland. *Michelet.* New York: Hill & Wang, 1987.

Bell, David F. *Models of Power: Politics and Economics in Zola's Rougon-Macquart.* Lincoln: University of Nebraska Press, 1988.

Bellas, Ralph A. *Christina Rossetti.* Boston: Twayne, 1977.

Bellos, David. *Balzac Criticism in France, 1850–1900: The Making of a Reputation.* Oxford: Clarendon Press, 1976.

Ben-Israel, Hedva. *English Historians on the French Revolution.* Cambridge University Press, 1968.

Bennett, Joan. *George Eliot: Her Mind and Art.* Cambridge University Press, 1948.

Billy, André. *Les Frères Goncourt.* Paris: Flammarion, 1954.

The Goncourt Brothers. London: Andre Deutsch, 1960.

Binyon, Laurence. "English Poetry and Its Relation to Painting and the Other Arts." *Proceedings of the British Academy,* 1918, pp. 381–402.

Blom, Margaret Howard. *Charlotte Brontë.* Boston: Twayne, 1977.

Blunden, Edmund. "Romantic Poetry and the Fine Arts" (Warton Lecture on English Poetry, 1941), *Proceedings of the British Academy,* 1942, pp. 101–18.

Boime, Albert. "Van Gogh's *Starry Night:* A History of Matter and a Matter of History." *Arts Magazine,* 59 (1984), pp. 86–103.

Bonger-van der Borsch van Verwolde, F. "Vincent van Gogh als lezer." *Maandblad vor Beeldende Kunsten,* 26 (1950), pp. 55–66.

Borie, Jean. *Zola et les mythes; ou, De la nausée au salut.* Paris: Seuil, 1971.

Bowie, Theodore Robert. *The Painter in French Fiction: A Critical Essay.* Chapel Hill: University of North Carolina Press, 1951.

Brantlinger, Patrick. "The Case Against Trade Unions in Early Victorian Fiction." *Victorian Studies,* 13 (1969), pp. 37–52.

Bredsdorff, Elias. *Hans Christian Andersen: The Story of His Life and Work.* London: Phaidon, 1975.

Bretell, Richard, et al. *Gauguin.* Exhibition catalog. Washington, D.C.: National Gallery, 1988.

Brink, Jan ten. "De jongste romantische school in Frankrijk." *Nederland,* no. 3 (1876), pp. 3–43.

"Een letterkundige Herkules." Two parts. *Nederland,* no. 2, (1877), pp. 113–44, 241–72, 391–430; no. 3 (1877), pp. 270–98.

"Paris van het Trocadero gezien." *Zondagsblad,* 12 May 1878.

"Het naturalisme op het toneel." *Zondagsblad,* 24 November 1878.

Emile Zola: letterkundige studie. The Hague: Nijmegen, Blomhert & Timmerman, 1879.

"Letterkundige nuffigheid." *Zondagsblad,* 23 March 1879.

Nieuwe romans. Haarlem: H. D. Tjeenk Willink, 1883.

Causeriën over moderne romans. Leiden: A. J. Sijthoff, 1885.

Brody, Elaine. *Paris: The Musical Kaleidoscope, 1870–1925.* New York: Braziller, 1987.

Brom, G. *Schilderkunst en literatuur in de 19e eeuw.* Utrecht: Aula, 1959.

Brombert, Victor. *Victor Hugo and the Visionary Novel.* Cambridge, Mass.: Harvard University Press, 1984.

Bruijn, P. "*Numa Roumestan.*" *De Amsterdammer,* 28 January 1883.

Brunetière, Ferdinand. "La Banqueroute du naturalisme." *Revue des deux mondes,* 1 September 1887.

Brunius, Teddy. *Mutual Aid in the Arts from the Second Empire to Fin de Siècle.* Stockholm: Almquist & Wiksell, 1972.

Brusse, M. J. "Onder de mensen." Two parts. *Nieuwe Rotterdamse Courant,* 26 May 1914; 2 June 1914.

Burty, Philippe. *Maîtres et petits maîtres.* Paris: Charpentier, 1877.

Butler, R. "Zola Between Taine and Sainte-Beuve, 1863–1869." *Modern Language Review,* 69 (1974), pp. 279–86.

Zola: La Terre. London: Grant & Cutler, 1984.

Butt, John. "Introduction." In Voltaire, *Candide.* Harmondsworth: Penguin, 1983.

Cachin, Françoise. *Paul Signac.* Greenwich, Conn.: New York Graphic Society, 1971.

Caramaschi, Enzo. *Réalisme et impressionnisme dans l'oeuvre des frères Goncourt.* Pisa: Libreria Goliardica, 1971.

Chadbourne, Richard M. *Ernest Renan as an Essayist.* Ithaca, N.Y.: Cornell University Press, 1957.

Christin, Anne-Marie. "La Déraison graphique." *Textuel,* 17 (1985).

Clark, T. J. *The Absolute Bourgeois: Artists and Politics in France, 1848–1851.* Princeton, N. J.: Princeton University Press, 1982.

Image of the People: Gustave Courbet and the 1848 Revolution. Princeton, N.J.: Princeton University Press, 1982.

The Painting of Modern Life: Paris in the Art of Manet and His Followers. New York: Knopf, 1985.

Cleveland Museum of Art. *Japonisme: Japanese Influences on French Art, 1854–1910.* Exhibition catalog. Cleveland, 1975.

Colmjon, Gerben. *The Hague School: The Renewal of Dutch Painting since the Middle of the Nineteenth Century.* Rijkswijk: N. V. Leidsche Uitgeversmaatschappij, 1951.

Coquiot, Gustave. *Vincent van Gogh.* Paris: Ollendorff, 1923.

Cornell, Kenneth. "Zola's City." *Yale French Studies,* 32 (1964), pp. 106–11.

Crozier, Alice C. *The Novels of Harriet Beecher Stowe.* New York: Oxford University Press, 1969.

Cunningham, Valentine. *Everywhere Spoken Against: Dissent in the Victorian Novel.* Oxford: Clarendon Press, 1975.

Dangelzer, J. Y. *La Description du milieu dans le roman français de Balzac à Zola.* Paris: Presses modernes, 1938.

Davis, James Herbert, Jr. *Fénelon.* Boston: Twayne, 1979.

Décaudin, Michel. *Jean Moréas, écrivain français.* Paris: Minard, 1969.

Derkert, Carlo. "Theory and Practice in Van Gogh's Dutch painting." *Konsthistorisk Tidskrift,* 15 (1946), pp. 97–119.

Desprez, Louis. *L'Evolution naturaliste.* Paris: Tresse, 1884.

Deyssel, Lodewijk van. "Over het laatste werk van Zola." *De Amsterdammer,* 30 April 1882.

"Emile Zola." *De Amsterdammer,* 28 January 1883.

Duchartre, Pierre Louis, and Saulnier, Réné. *L'Imagerie populaire.* Paris: Librairie de France, 1925.

Duval, Elga Liverman. *Téodor de Wyzéwa: Critic Without a Country.* Paris: Droz-Minard, 1961.

Eagleton, Terry. "Class, Power and Charlotte Brontë." *Critical Quarterly,* 14 (1972), pp. 225–35.

Ebin, Ima N. "Manet and Zola." *Gazette des Beaux-Arts,* 27 (1945), pp. 357–78.

Edwards, Lee MacCormick. "Herbert von Herkomer and the Modern Life Subject." Unpublished doctoral thesis. Columbia University, 1984.

Ehrard, Antoinette. "Zola et Courbet." *Europe,* April–May 1968.

Elwitt, Sanford. *The Making of the Third Republic: Class and Politics in France, 1868–1884.* Baton Rouge: Louisiana State University Press, 1975.

Faille, J.-B. de la. *The Works of Vincent van Gogh: His Paintings and Drawings.* Amsterdam: Meulenhoff International, 1970.

Fort, Paul, and Mandin, Louis. *Histoire de la poésie française depuis 1850*. Paris: Flammarion, 1926.

Frank, Joseph. "Spatial Form in Modern Literature." Three parts. *Sewanee Review*, 53 (1945), pp. 221–40; 433–56; 643–53.

Furnas, J. C. *Goodbye to Uncle Tom*. New York: Sloane, 1956.

Gachet, Paul. *Souvenirs de Cézanne et de Van Gogh à Auvers, 1875–1890*. Paris: Les Beaux-Arts, 1928.

Deux amis des impressionnistes: Le Docteur Gachet et Murer. Paris: Editions des Musées Nationaux, 1956.

Gaigalas, Vytas V. *Ernest Renan and His French Catholic Critics*. North Quincy, Mass.: Christopher Publishing House, 1972.

Gibbs, Beverly Jean. "Impressionism as a Literary Movement." *Modern Language Journal*, 26 (1952), pp. 175–83.

Glover, Willis B. *Evangelical Nonconformists and Higher Criticism in the Nineteenth Century*. London: Independent Press, 1954.

Gogh, Dr. V. W. van. *Vincent in Paris*. Amsterdam: Rijksmuseum Vincent van Gogh, 1974.

Goldwater, Robert. *Symbolism*. London: Lane, 1979.

Gossett, Thomas P. Uncle Tom's Cabin *and American Culture*. Dallas: Southern Methodist University Press, 1985.

Graaf, Jacob de. *Le Réveil littéraire en Hollande et le naturalisme français*. Amsterdam: H. J. Paris, 1937.

Graetz, H. R. *The Symbolic Language of Vincent van Gogh*. New York: McGraw-Hill, 1963.

Grant, Elliott. *Emile Zola*. New York: Twayne, 1966.

Grant, Richard B. Zola's Son Excellence Eugène Rougon: *An Historical and Critical Study*. Durham, N.C.: Duke University Press, 1960.

The Goncourts. New York: Twayne, 1972.

Grønbech, Bo. *Hans Christian Andersen*. Boston: Twayne, 1980.

Guide du tourisme Michelin: Provence. Clermont-Ferand, 1978.

Guieu, Jean-Max, and Hilton, Alison (eds.). *Emile Zola and the Arts*. Washington D.C.: Georgetown University Press, 1988.

Gulik, W. van, and Orton, Fred. *Japanese Prints Collected by Vincent van Gogh*. Exhibition catalog. Amsterdam: Rijksmuseum Vincent van Gogh, 1978.

Haac, Oscar A. *Jules Michelet*. Boston: Twayne, 1982.

Hagstrum, Jean H. *The Sister Arts: The Tradition of Literary Pictorialism and English Poetry from Dryden to Gray*. Chicago: University of Chicago Press, 1958.

Halperin, Joan Ungersma. *Félix Fénéon, Aesthete & Anarchist in Fin-de-Siècle Paris*. New Haven, Conn.: Yale University Press, 1988.

Hammacher, A. M. "Van Gogh's Relationship with Signac." In *Van Gogh's Life in His Drawings*. Exhibition catalog. London: Marlborough Fine Arts, Ltd., 1962, pp. 91–3.

Hamon, Philippe. "A propos de l'impressionnisme de Zola." *Cahiers naturalistes*, 13 (1967), pp. 139–47.

Hargreaves, Alec G. *The Colonial Experience in French Fiction: A Study of Pierre Loti, Ernest Psichari and Pierre Mille*. London: Macmillan Press, 1981.

Hatzfeld, Helmut A. *Literature Through Art: A New Approach to French Literature*. New York: Oxford University Press, 1952.

Heffernan, James A. W. *The Re-creation of Landscape: A Study of Wordsworth, Coleridge, Constable and Turner*. Hanover, N.H.: University Press of New England, 1984.

Hefting, P. H. *G. H. Breitner in zijn Haagse tijd*. Utrecht: Haentjens Dekker & Gumbert, 1970.

Hemmings, F. W. J. *The Russian Novel in France, 1884–1914*. Oxford: Oxford University Press, 1950.

"Zola, Manet and the Impressionists, 1875–1880." *PMLA*, 73 (1958), pp. 407–17.

Emile Zola. Oxford: Clarendon Press, 1966.

Culture and Society in France, 1848–1898: Dissidents and Philistines. New York: Scribner's, 1971.

Hemmings, F. W. J., and Niess, Robert J. *Emile Zola, Salons*. Paris: Droz-Minard, 1959.

Hermeren, Goran. "Artistic and Literary Influence." Unpublished doctoral thesis. Umea University, n.d.

Hertz, H. "Emile Zola, témoin de la vérité." *Europe*, 30 (1952), pp. 32–3.

Hewitt, Winston. *Through Those Living Pillars: Man and Nature in the Works of Emile Zola*. The Hague: Mouton, 1974.

Hobsbaum, Philip. *A Reader's Guide to Charles Dickens*. New York: Farrar, Strauss & Giroux, 1972.

Hodges, Elizabeth Lowther. "The Bible as Novel: A Comparison of Two Modernized Versions of Biblical Stories, Zola's *La Faute de l'Abbé Mouret* and Faulkner's *A Fable*." Unpublished doctoral thesis. University of Georgia, 1969.

Heut, Coenraad Busken. *Litterarische fantasien en kritieken*, vol. 25. Haarlem: H. D. Tjeenk Willink, 1881–8.

Hulsker, Jan. "Van Gogh's Dramatic Years in The Hague." *Vincent*, 1 (1970–2), pp. 6–21.

Van Gogh door Van Gogh: De brieven als commentaar op zijn werk. Amsterdam: Meulenhoff, 1973.

The Complete Van Gogh: Paintings, Drawings, Sketches. New York: Abrams, 1980.

Hunt, John Dixon (ed.). *Encounters: Essays on Literature and the Visual Arts*. New York: Norton, 1971.

Hunt, John Dixon. *The Figure in the Landscape: Poetry, Painting and Gardening during the Eighteenth Century*. Baltimore: Johns Hopkins University Press, 1976.

Huret, Jules. *Enquête sur l'évolution littéraire, conversations avec Renan, de Goncourt, Zola, e.a.* Paris: Bibliothèque Charpentier, 1891.

Irwin, Michael. *Picturing: Description and Illusion in the Nineteenth-Century Novel*. London: Allen & Unwin, 1979.

Isaacson, Joel. *Claude Monet: Observation and Reflection*. Oxford: Phaidon, 1978.

Janssen, E. L. "Dutch Criticism of Zola, 1876–1909." Unpublished master's thesis. University of London, 1921.

Jay, Elisabeth. *The Religion of the Heart: Anglican Evangelicalism and the Nineteenth-Century Novel*. Oxford: Clarendon Press, 1979.

Johnson, Ron. "Vincent van Gogh and the Vernacular." Two parts. *Arts Magazine*, 52 (1978), pp. 131–5; 53 (1979), pp. 98–104.

Kaplan, Edward K. *Michelet's Poetic Vision: A Romantic Philosophy of Nature, Man, and Woman*. Amherst: University of Massachusetts Press, 1977.

Karagheusian, Artemis. *Vincent van Gogh's Letters Written in French: Differences between the Printed Versions and the Manuscripts*. Amsterdam: Rijksmuseum Vincent van Gogh, 1984.

Kearns, James. *Symbolist Landscapes: The Place of Painting in the Poetry and Criticism of Mallarmé and His Circle*. London: Modern Humanities Research Association, 1989.

Kippur, Stephen A. *Jules Michelet: A Study of Mind and Sensibility*. Albany: State University of New York Press, 1981.

Kirkham, E. Bruce. *The Building of* Uncle Tom's Cabin. Knoxville: University of Tennesee Press, 1977.

Klein, Adrian Bernard. *Colour-Music: The Art of Light*. London: Lockwood, 1926.

Knoepflmacher, U. C. *Religious Humanism and the Victorian Novel: George Eliot, Walter Pater, and Samuel Butler*. Princeton, N. J.: Princeton University Press, 1965.

George Eliot's Early Novels: The Limits of Realism. Berkeley and Los Angeles: University of California Press, 1968.

Koke, Richard J. *American Landscape and Genre Paintings in the New-York Historical Society*. Boston: Hall, 1982.

Kranowski, Nathan. *Paris dans les romans d'Emile Zola*. Paris: Presses Universitaires de France, 1968.

Kroeber, Karl, and Walling, William (eds.). *Images of Romanticism: Verbal and Visual Affinities*. New Haven, Conn.: Yale University Press, 1978.

Kruglikoff, Alexander. *Alphonse Daudet et la Provence*. Paris: Jouve, 1936.

Lapp, John C. "Taine et Zola: Autour d'une correspondance." *Revue des sciences humaines*, 87 (1957), pp. 319–26.

Les Racines du Naturalisme: Zola avant les Rougon-Macquart. Paris: Bordas, 1972.

Larousse. *Grand Larousse de la langue française*. Paris, 1975.

Lattre, Alain de. *Le Réalisme selon Zola: Archéologie d'une intelligence*. Paris: Presses Universitaires de France, 1975.

Leavis, F. R., and Leavis, Q. D. *Dickens the Novelist*. London: Harmondsworth, 1970.

Lee, Rensselaer W. *Ut Pictura Poesis: The Humanistic Theory of Painting*. New York: Norton, 1967.

Leeuw, Ronald de, et al. *The Hague School: Dutch Masters of the Nineteenth Century*. Exhibition catalog. London: Royal Academy of Arts, 1983.

Lehmann, A. G. *The Symbolist Aesthetic in France, 1885–1895*. Oxford: Blackwell Publisher, 1968.

Lejeune, Paule. Germinal: *Un roman antipeuple*. Paris: Nizet, 1978.

Lethève, Jacques. *Impressionnistes et symbolistes devant la presse.* Paris: Colin, 1959.

Levin, Harry. *The Gates of Horn: A Study of Five French Realists.* New York: Oxford University Press, 1963.

Levine, Steven Z. *Monet and His Critics.* New York: Garland, 1976.

Lövgren, Sven. *The Genesis of Modernism.* Bloomington: Indiana University Press, 1959.

Lubin, Albert J. *Stranger on the Earth: A Psychological Biography of Vincent van Gogh.* New York: Holt, Rinehart and Winston, 1972.

Lyotard, Jean-François. *Discours, figure.* Paris: Klincksieck, 1974.

Manwaring, Elizabeth Wheeler. *Italian Landscape in Eighteenth-Century England: A Study Chiefly of the Influence of Claude Lorrain and Salvator Rosa on English Taste, 1700–1800.* New York: Oxford University Press, 1925.

Martin, Henri Gérard. *Fénelon en Hollande.* Amsterdam: Paris, 1928.

Martineau, Henri. *Le Roman scientifique d'Emile Zola: La Médecine et les Rougon-Macquart.* Paris, 1907.

Matthews, J. H. "L'Impressionnisme chez Zola: *Le Ventre de Paris.*" *La Française moderne,* 29 (1961), pp. 199–205.

Mauclair, Camille. *Albert Besnard, l'homme et l'oeuvre.* Paris: Librairie Delagrave, 1914.

Max, Stéfan. *Les Métamorphoses de la grande ville dans les Rougon-Macquart.* Paris: Nizet, 1966.

Merriman, James D. "The Parallel of the Arts: Some Misgivings and a Faint Affirmation." Two parts. *Journal of Aesthetics and Art Criticism,* 31, no. 2 (1972–3), pp. 153–64; no. 3 (1972–3), pp. 309–21.

Meyers, Jeffrey. *Painting and the Novel.* Manchester: Manchester University Press, 1975.

Mirbeau, Octave. "Le Paysan." *Le Gaulois,* 21 September 1887.

Mitterand, Henri. *Le Discours du roman.* Paris: Presses Universitaires de France, 1980.

Monod, Gabriel. *Renan, Taine, Michelet.* Paris: Colmann Levy, 1894.

Monod, Sylvère. "Dickens as Social Novelist." In *Twentieth-Century Interpretations of* Hard Times, ed. Paul Edward Gray. Englewood Cliffs, N.J.: Prentice-Hall, 1969, pp. 78–85.

Montjoyeux. "Les Cinq." *Gil Blas,* 20 August 1887.

Mornand, Pierre. *Emile Bernard et ses amis.* Geneva: Cailler, 1957.

Netscher, Franz. "Karakterschets. Prof. Dr. Jan ten Brink." *De Hollandsche Revue,* 1 (1896), p. 233.

"Emile Zola." *Het Vaderland,* 4 March 1923.

Neubauer, John. *The Emancipation of Music from Language: Departure from Mimesis in Eighteenth-Century Aesthetics.* New Haven, Conn: Yale University Press, 1986.

Newey, Vincent (ed.). The Pilgrim's Progress: *Critical and Historical Views.* Totowa, N.J.: Barnes & Noble Books, 1980.

Newton, Joy. "Emile Zola impressionniste." Two parts. *Cahiers naturalistes,* 13, no. 33 (1967), pp. 39–52; no. 34 (1967), pp. 124–38.

"Emile Zola et l'impressionnisme." *Cahiers naturalistes,* 17 (1971), pp. 1–14.

Niess, Robert J. *Emile Zola's Letters to Van Santen Kolff.* St. Louis, Mo.: Washington University Press, 1940.

Zola, Cézanne and Manet: A study of L'Oeuvre. Ann Arbor: University of Michigan Press, 1968.

"Emile Zola and Edmond de Goncourt." *American Society of the Legion of Honor Magazine,* 41 (1970), pp. 85–105.

Noble, Thomas A. *George Eliot's* Scenes of Clerical Life. New Haven, Conn.: Yale University Press, 1965.

Nochlin, Linda. *Realism.* Harmondsworth: Penguin, 1971.

"Van Gogh, Renouard and the Weavers' Crisis in Lyon: The Status of a Social Issue in the Art of the Later Nineteenth Century." In *Art the Ape of Nature: Studies in Honor of H. W. Janson,* ed. Moshe Barasch and Lucy Freeman Sandler. New York/Englewood Cliffs, N.J.: Abrams/Prentice-Hall, 1981, pp. 669–88.

Nordenfalk, Carl. "Van Gogh and Literature." *Journal of the Warburg and Courtauld Institutes,* 10 (1947), pp. 132–47.

Norman, E. R. *Church and Society in England, 1770–1970.* Oxford: Clarendon Press, 1976.

Oddie, William. *Dickens and Carlyle: The Question of Influence.* London: Centenary Press, 1972.

Orton, Fred. "Van Gogh's Interest in Japanese Prints," *Vincent,* 1 (1970–2), pp. 2–12.

"Van Gogh and Japanese Prints: An Introductory Essay." In *Japanese Prints Collected by Van Gogh.* Exhibition catalog. Amsterdam:

Rijksmuseum Vincent van Gogh, 1978, pp. 14–23.

Orton, Fred, and Pollock, Griselda. *Vincent van Gogh: Artist of His Time.* New York: Dutton, 1978.

Pabst, Fieke, and Uitert, Evert van. "A Literary Life, with a List of Books and Periodicals Read by Van Gogh." In *The Rijksmuseum Vincent van Gogh.* Amsterdam: Meulenhoff-Landshoff, 1987.

Paris, Bernard J. *Experiments in Life: George Eliot's Quest for Values.* Detroit: Wayne State University Press, 1965.

Park, Roy. *Hazlitt and the Spirit of the Age: Abstraction and Critical Theory.* Oxford: Clarendon Press, 1971.

Parsons, Christopher, and McWilliam, Neil. " 'Le Paysan de Paris': Alfred Sensier and the Myth of Rural France." *Oxford Art Journal,* 6 (1983), pp. 37–58.

Pasco, Allan H. "Love à la Michelet in Zola's *La Faute de L'Abbé Mouret.*" *Nineteenth-Century French Studies,* 7 (1979), pp. 232–44.

Petrey, Sandy. "Discours social et littérature dans *Germinal.*" *Littérature,* 22 (1976), pp. 59–74.

Philadelphia Museum of Art. *Masterpieces of Impressionism and Post-Impressionism: The Annenberg Collection.* Exhibition catalog. Philadelphia, 1989.

Pickvance, Ronald. *English Influences on Van Gogh.* Exhibition catalog. London: Arts Council of Great Britain, 1974.

Van Gogh in Arles. Exhibition catalog. New York: Metropolitan Museum of Art, 1984.

Van Gogh in Saint-Rémy and Auvers. Exhibition catalog. New York: Metropolitan Museum of Art, 1986.

Piérard, Louis. *La Vie tragique de Vincent van Gogh.* Paris: Correa, 1939.

Pollock, Griselda. *Vincent van Gogh in zijn Hollandse jaren: Kijk op stad en land door Van Gogh en zijn tijdgenoten.* Exhibition catalog. Amsterdam: Rijksmuseum Vincent van Gogh, 1980.

"Stark Encounters: Modern Life and Urban Work in Van Gogh's Drawings of The Hague, 1881–3." *Art History,* 6 (1983), pp. 330–58.

"Van Gogh and the Poor Slaves: Images of Rural Labour as Modern Art." *Art History,* 11 (1988), pp. 406–32.

"Bestiality and the Representation of Peasant Women in 19th-Century French Painting." Unpublished lecture. New York: Barnard College, 1989.

Praz, Mario. *Mnemosyne: The Parallel Between Literature and the Visual Arts.* Princeton, N.J.: Princeton University Press, 1967.

Price, Aimée Brown. "Two Portraits by Vincent van Gogh and Two Portraits by Pierre Puvis de Chavannes." *Burlington Magazine,* 117 (1975), pp. 714–18.

Rahv, Philippe. "On the Decline of Naturalisme." *Partisan Review,* 9 (1942), pp. 483–93.

Rewald, John. *Post-Impressionism: From Van Gogh to Gauguin.* New York: Museum of Modern Art, 1956.

Reynolds, Moira Davison. Uncle Tom's Cabin *and the Mid-Nineteenth Century United States.* Jefferson, N.C.: McFarland, 1985.

Richards, Bernard. "Ut Pictura Poesis?" *Essays in Criticism,* 21 (1971), pp. 318–25.

English Poetry of the Victorian Period, 1830–1890. London: Longman, 1988.

Ringe, Donald A. *The Pictorial Mode: Space and Time in the Art of Bryant, Irving and Cooper.* Lexington: University Press of Kentucky, 1971.

Robert, Guy. La Terre *d'Emile Zola: Etude historique et critique.* Paris: Société d'Edition les Belles Lettres, 1952.

Roberts, Neil. *George Eliot: Her Beliefs and Her Art.* London: Elik, 1975.

Rogers, Franklin R. *Painting and Poetry: Form, Metaphor and the Language of Literature.* Lewisburg, Pa.: Bucknell University Press, 1985.

Rosenberg, John D. *Carlyle and the Burden of History.* Cambridge, Mass.: Harvard University Press, 1985.

Roskill, Mark. *Van Gogh, Gauguin and the Impressionist Circle.* Greenwich, Conn.: New York Graphic Society, 1970.

Van Gogh, Gauguin and French Painting of the 1880s: A Catalogue Raisonné of Key Works. Ann Arbor, Mich.: University Microfilms, 1970.

"On the Intention and Meaning of Works of Art." *British Journal of Aesthetics,* 17 (1977), pp. 99–110.

"Public and Private Meanings: The Paintings of Van Gogh." *Journal of Communication,* 29 (1979), pp. 157–69.

The Interpretation of Pictures. Amherst: University of Massachusetts Press, 1989.

Sachs, Murray. *The Career of Alphonse Daudet: A Critical Study.* Cambridge, Mass.: Harvard University Press, 1965.

Santen Kolff, Jacob van. "Een Blik in de Hollandsche schilderschool onze dagen" (part V). *De Banier* 1 (1875), pp. 158–61, 166, 170, 187.

———. "Over de nieuwste richting in onze schilderkunst naar aanleiding der jongste tentoonstelling te Amsterdam." *De Banier* 3 (1877), pp. 222, 249–59.

Schapiro, Meyer. *Vincent van Gogh.* New York: Abrams, 1950.

Schom, Alan. *A Biography of Emile Zola.* New York: Holt, 1987.

Schor, Naomi. *Zola's Crowds.* Baltimore: Johns Hopkins University Press, 1978.

———. *Breaking the Chain: Women, Theory and French Realist Fiction.* New York: Columbia University Press, 1985.

Schwartz, Leonard William. "The Priority of the Goncourts' Discovery of Japanese Art." Publications of the Modern Language Association of America. Menasha, Wis.: Banta, 1927.

———. *The Imaginative Interpretation of the Far East in Modern French Literature.* Paris: Champion, 1927.

Scott, David. *Pictorialist Poetics: Poetry and the Visual Arts in Nineteenth-Century France.* Cambridge University Press, 1988.

Seigel, Jerrold. *Bohemian Paris: Culture, Politics, and the Boundaries of Bourgeois Life, 1830–1930.* New York: Viking, 1986.

Sensier, A. *La Vie et l'oeuvre de J.-F. Millet.* Paris: Mantz, 1881.

Seznec, Jean. "Literary Inspiration in Van Gogh." *Magazine of Art,* 43 (1950), pp. 282–8, 306–7.

Sheon, Aaron. *Monticelli, His Contemporaries, His Influence.* Exhibition catalog. Pittsburgh: Carnegie Institute Museum of Art, 1978.

Shiff, Richard. *Cézanne and the End of Impressionism: A Study of the Theory, Technique, and Evaluation of Modern Art.* Chicago: University of Chicago Press, 1984.

Silverman, Debora L. *Art Nouveau and Fin-de-Siècle France: Politics, Psychology and Style.* Berkeley and Los Angeles: University of California Press, 1989.

Smethurst, Colin. *Emile Zola: Germinal.* London: Arnold, 1974.

Solpray, G. S. de. "Enquête sur l'influence de l'esprit français en Hollande." *Revue de Hollande,* 3 (1916), pp. 581–2.

Souriau, Etienne. *La Correspondance des arts: Eléments d'esthetique comparée.* Paris: Flammarion, 1947.

Sperry, Willard L. *Strangers & Pilgrims: Studies in Classics of Christian Devotion.* Boston: Little, Brown, 1939.

Stang, Richard. *The Theory of the Novel in England, 1850–1870.* London: Routledge & Kegan Paul, 1959.

Steegmuller, Francis. *Maupassant: A Lion in the Path.* New York: Random House, 1949.

Stellingwerff, J. "Vincent van Gogh en de Literatuur." In *Mensen en Boeken.* Goes: Oosterbaan & Le Cointre, 1963.

Sullivan, Edward D. *Maupassant the Novelist.* Princeton, N.J.: Princeton University Press, 1954.

Sund, Judy. "Favoured Fictions: Women and Books in the Art of Van Gogh." *Art History,* 11 (1988), pp. 255–67.

———. "The Sower and the Sheaf: Biblical Metaphor in the Art of Vincent van Gogh." *Art Bulletin,* 70 (1988), pp. 660–76.

Sundquist, Eric J. (ed.). *New Essays on* Uncle Tom's Cabin. Cambridge University Press, 1986.

Sutton, Howard. *The Life and Work of Jean Richepin.* Geneva: Droz-Minard, 1961.

Thale, Jerome. *The Novels of George Eliot.* New York: Columbia University Press, 1959.

Thomas, Deborah. *Dickens and the Short Story.* Philadelphia: University of Pennsylvania Press, 1982.

Tilborgh, Louis van, and Conisbee, Philip. "Les Travaux des champs." In *Van Gogh and Millet.* Exhibition catalog. Amsterdam: Rijksmuseum Vincent van Gogh, 1988, pp. 122–53.

Tilborgh, Louis van, and Noordermeer, Aly. "De bijbel van Vincents vader." *Van Gogh Bulletin,* no. 3 (1988) n.p.

Trabault, Mark Edo. "Van Gogh's japanisme." *Mededelingen van de Dienst voor Schone Kunsten der gemeente 's-Gravenhage,* 9 (1954), pp. 6–40.

Tsukasa Kōdera. "Japan as a Primitivistic Utopia: Van Gogh's *Japonisme* Portraits." *Simiolus,* 16 (1984), pp. 189–208.

Uitert, Evert van, and Hoyle, M. (eds.). *The Rijksmuseum Vincent van Gogh.* Amsterdam: Meulenhoff-Landshoff, 1987.

Uitert, Evert van, et al. *Vincent van Gogh: Paintings*. Exhibition catalogue. Amsterdam: Rijksmuseum Vincent van Gogh, 1990.

Valkhoff, Piet. *Emile Zola et la littérature néerlandaise*. Paris: Champion, 1930.

Veca, Alberto. *Vanitas: Il simbolismo del tempo*. Bergamo: Galleria Lorenzelli, 1981.

Vial, André. *Germinal et le "Socialisme" de Zola*. Paris: Editions sociales, 1975.

Virtanen, Reino. *Claude Bernard and His Place in the History of Ideas*. Lincoln: University of Nebraska Press, 1960.

Walder, Dennis. *Dickens and Religion*. London: Allen & Unwin, 1981.

Walker, Philip D. *Emile Zola*. London: Routledge & Kegan Paul, 1968.

Germinal and Zola's Philosophical and Religious Thought. Amsterdam: Benjamins, 1984.

Walter, Randolphe. "Emile Zola et Claude Monet." *Cahiers naturalistses*, 10 (1964), pp. 51–61.

Watson, J. R. *Picturesque Landscape and English Romantic Poetry*. London: Hutchinson Educational, 1970.

Weisberg, Gabriel P. "Japonisme: Early Sources and the French Printmaker, 1854–1882." In *Japonisme: Japanese Influences on French Art, 1854–1910*. Exhibition catalog. Cleveland: Cleveland Museum of Art, 1975, pp. 1–19.

Welsh-Ovcharov, Bogomila. *Van Gogh in Perspective*. Englewood Cliffs, N.J.: Prentice-Hall, 1974.

Vincent van Gogh: His Paris Period, 1886–88. Utrecht: Editions Victorine, 1976.

Vincent van Gogh and the Birth of Cloisonism. Exhibition catalog. Toronto: Art Gallery of Ontario, 1981.

Welsh-Ovcharov, Bogomila, et al. *Van Gogh à Paris*. Exhibition catalogue. Paris: Musée d'Orsay, 1988.

Werness, Hope B., et al. *Vincent van Gogh: The Influences of Nineteenth Century Illustrations*. Exhibition catalog. Tallahassee: Florida State University Fine Arts Gallery, 1980.

Willey, Basil. *Nineteenth Century Studies: Coleridge to Matthew Arnold*. London: Chatto & Windus, 1968.

Williams, Raymond. "The Industrial Novels: *Hard Times*." In *Charles Dickens's* Hard Times, ed. Harold Bloom. New York: Chelsea House, 1987, pp. 11–15.

Williams, Roger L. *The Horror of Life*. Chicago: University of Chicago Press, 1980.

Wilson, Edmund. *To the Finland Station: A Study in the Writing and Acting of History*. Garden City, N.Y: Doubleday, 1940.

Witemeyer, Hugh. *George Eliot and the Visual Arts*. New Haven, Conn.: Yale University Press, 1979.

Wittkower, Rudolf, and Wittkower, Margot. *Born Under Saturn, the Character and Conduct of Artists: A Documented History from Antiquity to the French Revolution*. New York: Random House, 1963.

Wolk, Johannes van der. "Vincent van Gogh and Japan." In *Japonisme in Art: An International Symposium*, ed. Yamada Chisaburō. Tokyo: Committee for the Year 2001 and Kodansha International Ltd., 1980, pp. 215–23.

Wolk, Johannes van der, et al. *Vincent van Gogh: Drawings*. Exhibition catalogue. Otterlo: Rijksmuseum Kröller-Müller, 1990.

Xau, Ferdinand. "Chez Emile Zola: Réponse à une protestation." *Gil Blas*, 21 August 1887.

Yellin, Jean Fagan. "Doing It Herself: *Uncle Tom's Cabin* and Woman's Role in the Slavery Crisis." In *New Essays on* Uncle Tom's Cabin, ed. Eric J. Sundquist. Cambridge University Press, 1986, pp. 85–105.

Zayed, Fernande. *Huysmans: Peintre de son époque*. Paris: Nizet, 1973.

Zemel, Carol. "The 'Spook' in the Machine: Van Gogh's Pictures of Weavers in the Brabant." *Art Bulletin*, 17 (1985), pp. 123–37.

ILLUSTRATION CREDITS

In most cases the illustrations were made from photographs and transparencies provided by owner institutions. Exceptions are noted parenthetically in the following list. The majority of works by Van Gogh are identified not only by title but by number. These numerical designations have served as standard means of identification since they were assigned by J. B. de la Faille in his catalogue raisonné of 1928 and are preceded by an "F." De la Faille did not number sketches included in Van Gogh's letters; such sketches are accompanied by "LT" designations that indicate the letters in which they appear.

COLOR PLATES

1. Van Gogh, *Café Terrace at Night* (F467), 1888; Rijksmuseum Kröller-Müller, Otterlo

2. Van Gogh, *Romans parisiens* (F358), 1888; Rijksmuseum Vincent van Gogh, Amsterdam

3. Van Gogh, *Peasant Woman, Head* (F86), 1885; Rijksmuseum Kröller-Müller, Otterlo

4. Van Gogh, *Portrait of Patience Escalier, "The Old Peasant"* (F443), 1888; Norton Simon Museum, Pasadena, California

5. Van Gogh, *Still Life with Bible and French Novel* (F117), 1885; Rijksmuseum Vincent van Gogh, Amsterdam

6. Van Gogh, *Still Life with Three Novels* (F335), 1887; Rijksmuseum Vincent van Gogh

7. Van Gogh, *Romans parisiens* (F359), 1887; the Robert Holmes à Court Collection, Perth, Australia

8. Van Gogh, *Still Life with Plaster Cast* (F360), 1887–8; Rijksmuseum Kröller-Müller, Otterlo.

9. Van Gogh, *Oleanders* (F593), 1888; Metropolitan Museum of Art, New York

10. Van Gogh, *L'Arlésienne (Mme. Ginoux)* (F488), 1888; Metropolitan Museum of Art, New York

11. Albert Besnard, detail of *L'Homme moderne* (Fig. 49), c. 1883; Ecole de Pharmacie, Paris (photo by Eloise Quiñones Keber)

12. Pierre Puvis de Chavannes, *Portrait of Eugène Benon*, 1882; private collection, Switzerland (photo by Aimée Brown Price)

13. Van Gogh, *Une Liseuse de romans* (F497), 1888; private collection, Japan (photo courtesy Lefevre Gallery, London)

14. Van Gogh, *Gauguin's Chair* (F499), 1888; Rijksmuseum Vincent van Gogh, Amsterdam

15. Van Gogh, *L'Arlésienne (Mme. Ginoux)* (F541), 1890; Rijksmuseum Kröller-Müller, Otterlo

16. Van Gogh, *Portrait of Dr. Gachet* (F753), 1890; private collection, Japan (photo courtesy Christie's, New York)

Illustration credits

1. Van Gogh, *Bakery on the Geest* (F914), 1882; Dienst voor Schone Kunsten, The Hague

2. Van Gogh, *The Great Lady* (sketch from LT185), 1882; Rijksmuseum Vincent van Gogh, Amsterdam

3. Van Gogh, *Man Reading a Bible* (F1001), 1882; Rijksmuseum Kröller-Müller, Otterlo

4. Van Gogh, *Gentleman at an Inn* (sketch in LT276), 1882; Rijksmuseum Vincent van Gogh, Amsterdam

5. Van Gogh, sketches of women's heads (F1151), 1884–5; Rijksmuseum Kröller-Müller, Otterlo

6. Van Gogh, *Peasant Woman, Head* (F154), 1884–5; Rijksmuseum Kröller-Müller, Otterlo

7. Van Gogh, *The Potato Eaters* (F82), 1885; Rijksmuseum Vincent van Gogh, Amsterdam

8. Van Gogh, *Peasant Woman with Green Shawl* (F161), 1885; Rijksmuseum Vincent van Gogh, Amsterdam

9. Van Gogh, *Peasant Woman, Head* (F141), 1885; private collection, Santa Barbara, California

10. Van Gogh, *Peasant Woman with Sheaf* (F1264), 1885; Rijksmuseum Kröller-Müller, Otterlo

11. Van Gogh, *Women Digging* (F97), 1885; Rijksmuseum Kröller-Müller, Otterlo

12. Van Gogh, *Peasant Woman Carrying Wheat* (F1268), 1885; Rijksmuseum Kröller-Müller, Otterlo (photo by Tom Haartsen)

13. Van Gogh, *Peasant Woman Seen from Behind* (F1262), 1885; Rijksmuseum Kröller-Müller, Otterlo (photo by Tom Haartsen)

14. Van Gogh, *Kneeling Peasant Woman, Seen from Behind* (F1280), 1885; Nasjonalgalleriet, Oslo

15. Damien Lhomme, *Vanité*, 1641; Musée des Beaux-Arts, Troyes

16. Van Gogh, copy after Delacroix's *Pietà* (F630), 1889; Rijksmuseum Vincent van Gogh, Amsterdam

17. Van Gogh, *Still Life with Basket of Bulbs* (F336), 1887; Rijksmuseum Vincent van Gogh, Amsterdam

18. Paul Signac, *Still Life with Maupassant's* [Au] Soleil, 1885; Staatliche Museen Preussischer Kulterbesitz, Nationalgalerie, Berlin (photo by Jörg P. Anders)

19. *The Syracuse Venus*, third century B.C., artist unknown; Museo Nazionale, Syracuse, Italy

20. Van Gogh, *Plaster Statuette with Top Hat* (F1363f), 1886; Rijksmuseum Vincent van Gogh, Amsterdam

21. Van Gogh, *Plaster Statuette* (F1716), 1886; Rijksmuseum Vincent van Gogh, Amsterdam

22. Van Gogh, *Plaster Statuette* (F1716v), 1886; Rijksmuseum Vincent van Gogh, Amsterdam

23. Van Gogh, *The Roofs of Paris* (F261), 1886; Rijksmuseum Vincent van Gogh, Amsterdam

24. Van Gogh, *Hill of Montmartre with Quarry* (F229), 1886; Rijksmuseum Vincent van Gogh, Amsterdam

25. Van Gogh, *Hill of Montmartre with Quarry* (F230), 1886; Rijksmuseum Vincent van Gogh, Amsterdam

26. Van Gogh, *A Suburb of Paris* (F264), 1886; location unknown

27. Van Gogh, *The Gardens of Montmartre* (F316), 1887; Rijksmuseum Vincent van Gogh, Amsterdam

28. Van Gogh, *Sunflowers in a Montmartre Garden* (F388v), 1887; Rijksmuseum Vincent van Gogh, Amsterdam

29. Van Gogh, *The Ramparts* (F1400), 1887; Rijksmuseum Vincent van Gogh, Amsterdam

30. Van Gogh, *La Fosse commune* (F1399a), 1886; Rijksmuseum Kröller-Müller, Otterlo (photo by Tom Haartsen)

31. Van Gogh, *Couple Walking beside Sunflowers* (F1720), 1887; Rijksmuseum Vincent van Gogh, Amsterdam

32. Van Gogh, *Walking Couple* (F992), 1886; Rijksmuseum Vincent van Gogh, Amsterdam

33. Van Gogh, *Public Garden, Asnières* (F314), 1887; Rijksmuseum Vincent van Gogh, Amsterdam

34. Van Gogh, *The Zouave* (F423), 1888; Rijksmuseum Vincent van Gogh, Amsterdam

35. Van Gogh, *La Mousmé* (F431), 1888; National Gallery of Art, Washington, D.C. (Chester Dale Collection)

36. Van Gogh, *Portrait of Patience Escalier, "The Old Peasant"* (F444), 1888; private collection (photo by A. C. Cooper, Ltd.)

37. Van Gogh, *Portrait of Eugène Boch, "The Poet"* (F462), 1888; Musée d'Orsay, Paris (photo by Service Photographique, Réunion des Musées Nationaux)

38. Van Gogh, *Self-Portrait* (F476), 1888; Fogg Art Museum, Harvard University, Cambridge, Massachusetts (bequest of the Maurice Wertheim Collection)

39. Van Gogh, *The Yellow House* (F464), 1888; Rijksmuseum Vincent van Gogh, Amsterdam

40. Van Gogh, *Tarascon Diligence* (F478a), 1888; Henry and Rose Pearlman Foundation, New York

41. Van Gogh, *Round Clipped Shrub in the Public Garden: Poet's Garden II* (F1465), 1888; private collection

42. Adolphe Monticelli, *Promenade dans un parc au crépuscule*, 1883; Louvre, Paris (don Fayet) (photo by Service Photographique, Réunion des Musées Nationaux)

43. Van Gogh, *Couple under a Blue Fir Tree: Poet's Garden III* (F479), 1888; private collection

44. Van Gogh, *Couple in a Lane of Cypresses: Poet's Garden IV* (F485), 1888; location unknown

45. Van Gogh, *Starry Night on the Rhône* (F474), 1888; private collection, Paris

46. Van Gogh, *Still Life with Almond Branch and Book* (F393), 1888; private collection, Switzerland

47. Van Gogh, *L'Arlésienne (Mme. Ginoux)* (F489), 1888; Musée d'Orsay, Paris (photo by Service Photographique, Réunion des Musées Nationaux)

48. Paul Gauguin, *The Night Café*, 1888; Pushkin State Museum of Fine Arts, Moscow

49. Albert Besnard, *L'Homme moderne*, c. 1883; Ecole de Pharmacie, Paris (photo by Eloise Quiñones Keber and David A. Page)

50. Van Gogh, *La Berceuse* (F508), 1889; Museum of Fine Arts, Boston (bequest of John T. Spaulding)

51. Van Gogh, *Still Life on a Drawing Board* (F604), 1889; Rijksmuseum Kröller-Müller, Otterlo (photo by Tom Haartsen)

52. Van Gogh, *Trees and Ivy in the Asylum Garden* (F1522), 1889; Rijksmuseum Vincent van Gogh, Amsterdam

53. Van Gogh, *Undergrowth* (F746), 1889; Rijksmuseum Vincent van Gogh, Amsterdam

854. Van Gogh, *Evening Promenade* (F704), 1890; Museu de Arte São Paulo (photo by Luiz Hossaka)

55. Van Gogh, *Figures in the Undergrowth* (F773), 1890; Cincinnati Art Museum (bequest of Mary E. Johnson)

56. Van Gogh, *Entrance to a Quarry* (F744), 1889; Rijksmuseum Vincent van Gogh, Amsterdam

57. Van Gogh, *The Ravine* (F662), 1889; Museum of Fine Arts, Boston (bequest of Keigh McLeod)

58. Paul Gauguin, *L'Arlésienne (Mme. Ginoux)*, 1888; the Fine Arts Museums of San Francisco (Achenbach Foundation for Graphic Arts, memorial gift of Dr. T. Edward and Tullah Hanley)

59. Pierre Puvis de Chavannes, *Portrait of Mme. C*, 1883; Musée des Beaux-Arts, Lyon

INDEX

Works by artists and writers are listed alphabetically by title at the end of individual entries; italicized page references to works of art indicate illustrations.

The names of fictional characters are italicized.

Index

Index

Index